American Women Artists

from Early Indian Times to the Present

Mary Cassatt, *THE BOATING PARTY*, (1893–94), oil on canvas, 35½ ″× 46⅛ ″

American Women Artists

from Early Indian Times to the Present

Charlotte Streifer Rubinstein

AVON
PUBLISHERS OF BARD, CAMELOT, DISCUS AND FLARE BOOKS

American Women Artists:
from Early Indian Times to the Present
Copyright © 1982 by
Charlotte Streifer Rubinstein

Published by G.K. Hall & Co.
70 Lincoln Street
Boston, Massachusetts 02111
and AVON BOOKS
A division of
The Hearst Corporation
1790 Broadway
New York, New York 10019

Book design by Barbara Anderson

Cover Design: Stephanie Zuras

Front cover art: Detail TWO GIRLS by Isabel Bishop, courtesy
of The Metropolitan Museum of Art, Arthur A. Hearn Fund,
1936 (36.27).

Back cover art: Detail from Grandma Moses: Hoosick Falls,
New York, in Winter. Copyright © 1982, Grandma Moses
Properties, Co., New York.

Typeset in 10/12 Optima
by Compset, Inc. of
Beverly, Massachusetts

**Library of Congress Cataloging in
Publication Data**

Rubinstein, Charlotte Streifer.
 American women artists.

 Bibliography: p. 476
 Includes index.
 1. Women artists—United States.
2. Indians of North America—
Women. I. Title.
N6505.R8 704′.042′0973 81-20135
 AACR2

ISBN 0-380-61101-5

First Avon Printing, October, 1982

DON 10 9 8 7 6 5 4 3 2

Contents

Acknowledgments

All new knowledge is built on the collective efforts of those who came before. I could not have written this book without the work of those art historians and critics—Elsa Fine, Germaine Greer, Ann Sutherland Harris, Lucy Lippard, Eleanor Munro, Cindy Nemser, Linda Nochlin, Eleanor Tufts, and others, whose groundbreaking scholarship in the 1970s began to correct the imbalances and injustices of art history. Their works and others are listed in the opening section of the bibliography.

I particularly want to thank J. J. Wilson and Karen Petersen, co-authors of *Women Artists: Recognition and Reappraisal* (1976), who cheered me on at the outset. They unstintingly shared their archives and pressed upon me many photographs of works by American women artists, which they had laboriously collected.

Scholars in this field also owe a debt to Professor William H. Gerdts, the distinguished American art historian, who in 1965 staged what may be the first historical retrospective exhibition of American women artists, at the Newark Museum. His catalogue and his evenhanded scholarship have been major sources of information.

Many people shared information with me along the way—far more than I can begin to thank. Dorothy Miller, ex-curator of the Museum of Modern Art, sent me a note about women of the 1930s; it was the start of this book. Others were Elsa Fine, editor of the Woman's Art Journal; Stephen Gelber, professor of history at Santa Rosa College; Ton Enman, former director of the Laguna Beach Museum of Art; S. De Renne Coerr, Registrar, permanent collections, The Fine Arts Museums of San Francisco (and former president of the Women's Caucus for Art); Samella Lewis, professor of art history at Scripps College; Josine Ianco-Starrels, director of the Los Angeles Municipal Art Gallery; Dr. Francis O'Connor; Chris Petteys, who is presently compiling the first international dictionary of women artists; art historian Victoria Kogan; author Ira Glackens; Leah Vasquez, assistant gallery director at the University of California at Irvine; artist Jan Wunderman, and Professor Judy Loeb.

I wish to thank all the museums, gallery owners, artists, and private collectors who sent me photographs and gave me permission to reproduce them.

I am grateful to the women artists who granted me interviews and told me "how it was." Some of these were Alice Neel, Louise Bourgeois, Claire Falkenstein, Joyce Treiman, Jeanne Miles, Charmion von Wiegand, and Nell Blaine. Jean Ames, Edith Hamlin, and Emmy Lou Packard gave me first hand descriptions of life on the Federal Art Project in California.

Friends who helped with research were Millie Kouzel, Harriet Springer, Matilda Tourin, Barbara Jones, and above all, my daughter Elaine.

I am grateful to my good friend and "boss," Jody Hoy, chairperson of the Interdisciplinary Studies Department at Saddleback College, who was a source of continual optimism at discouraging times. Drs. Irene and Owen Thomas were encouraging and perceptive readers. Above all, I want to thank my husband, who overturned the stereotypes of male-female relationships by taking over most of the onerous duties in the home, although he was working full-time, to free me for work on this project. His thoughtful reading and suggestions were invaluable.

My editor Betsy Groban and I shared a rare harmony of approach to this book, and I am grateful for her vision and dedication.

Finally, this book might never have been published without my friend Priscilla Oaks, professor of English at California State University at Fullerton. She sent me *Silences*, by Tillie Olsen, when it seemed that I would never finish this project, and promoted my work.

Introduction

The work of American women artists, from earliest times to the present, has displayed astonishing variety, richness, quality, and quantity. Long before the first white settlers arrived, Indian women were decorating pottery and weaving baskets with designs now recognized as masterpieces of abstract art.

Women were among the earliest professional portraitists of the young republic. A woman, Fanny Palmer, turned out more lithographs for Currier and Ives than any other artist on their staff. In the nineteenth century, American women sculptors carried out large-scale public commissions in marble and bronze, and expatriate painters won medals in the Paris Salon. Later, they were among the modernists who exhibited in the 1913 Armory Show, and during the Depression they painted post office murals. Today, of course, they are leaders and innovators: Georgia O'Keeffe and Louise Nevelson are giants of modern art.

American women artists have, in fact, been innovators from the beginning. Henrietta Johnston, in 1708, was America's first pastellist. Patience Wright, who worked at the time of the American Revolution, is considered America's first professional sculptor; Mary Cassatt was America's first impressionist; Gertrude Greene and Alice Mason were charter members of the American Abstract Artists; and Lee Krasner was one of the founders of Abstract Expressionism.

Women have played an active, influential, and continuous role in the creation of every type of art in America. Because of long-standing cultural prejudices and widely accepted stereotypes, however, they have been relegated, in books on American art, to the role of "civilizers" or "carriers of culture"—patrons, collectors, and promoters of the art of men.

It is true, of course, that women have often "carried the culture." For example, Isabella Stewart Gardner created the Gardner Museum in Boston; Louisine Havemeyer and Bertha Palmer collected masterpieces that are today the jewels of the Metropolitan Museum of Art and the Chicago Art Institute; Gertrude Whitney founded the Whitney Museum; Katherine Dreier organized the Société Anonyme Collection; Hilla Rebay was the impresario of the Solomon R. Guggenheim Museum; and Peggy Guggenheim almost single-handedly sponsored the work of Jackson Pollock and other Abstract Expressionists at the start of their careers.

Yet along with these "civilizers" there have always been a large number of professional women artists in America who have worked hard, long, and successfully to earn a living at their craft. Their lives and their work have been very different from the commonly held stereotype of the woman artist as an amateur, working on delicate "womanly" projects in her home—a self-taught folk painter, quiltmaker, needleworker, or at best, a painter of still lifes, or mothers and children.

On the contrary, the study of American women artists shows that in addition to craft masterpieces they have, even in early times, created robust, large-scale, and physically taxing works covering a wide range of subject matter. In the nineteenth century, sculptors such as Harriet Hosmer, Anne Whitney, and Vinnie Ream created life-sized statues of Thomas Hart Benton, Samuel Adams, Abraham Lincoln, and other leading statesmen and intellectuals, several of which are in the U.S. Capitol in Washington, D.C. Other women were well known for their equestrian statues; Theo Kitson specialized in war memorials; and Evelyn Longman, the colleague of the sculptor Daniel Chester French, designed the large bronze doors for the chapel of the United States Naval Academy at Annapolis. Violet Oakley spent twenty years painting historical murals on the walls of the state capitol of Pennsylvania. The canvases of the innovative contemporary abstract painter Helen Frankenthaler are often nine feet in length, and Louise Nevelson's steel sculpture for the San Francisco Embarcadero is over fifty feet high.

Today women are creating every kind of avant-garde art—immense conceptual and environmental works, performances, and collective feminist projects.

It is not surprising to discover that the lives of many of these women were filled with drama. Patience Wright plotted against the British crown during the American Revolution; Edmonia Lewis, who has been called the first black artist to deal with themes of black oppression and aspiration in America, endured a beating by vigilantes in Oberlin, Ohio, before becoming a sculptor at the time of the Civil War. Reading the history of a previously hidden half of the art world also reveals a whole new panorama of American life.

The purpose of this book is not simply to add women to existing art histories, but also to show the relation between women's art and their social and cultural circumstances—the difficulties, the inner conflicts, and sometimes the encouraging factors that played a role in their struggle for achievement. The astonishing fact is that despite enormous obstacles, they did achieve so much and in such numbers.

What is truly startling is how little is known about these women and their achievements today. The foremost textbooks mention only a handful of women artists at best, and usually only one or two. I originally conceived of this book as a slim volume, but after only a few months of research, the material began to take on such gargantuan proportions that I had to limit my scope to fit it into one volume. Architecture, photography, and crafts (except for the Indians, who made no distinction between "art" and "craft") had to be omitted for lack of space, and therefore such giants of American art as Dorothea Lange, Imogen Cunningham, and Diane Arbus are not included.

Included are all the major figures listed in the various surveys and texts on American sculpture and painting. Several nineteenth century books on women artists listed the most important figures of their day. Among these books are Phebe Hanaford's *Daughters of America* (1889), Walter Sparrow's *Women Painters of the World* (1905), Elizabeth Ellet's *Women Artists in All Ages and Countries* (1859), and Clara Erskine Clement's *Women in the Fine Arts* (1904). These works correspond with the rise of the first wave of feminism in America and the suffrage movement at the turn of the century. Also, the superb scholarship in recent books on women's art, inspired by the feminist movement of the 1970s, supplied a great deal of important information.

Art magazines, catalogues of major museum exhibitions, handbooks of world's fairs, membership lists of organizations such as the National Sculpture Society, the National Academy of Design, and the Sculptors Guild, and many other sources uncovered additional artists. Occasionally, minor figures are included if their lives illuminate the situation of women artists in earlier times.

When I reached the 1930s, the selection process started to become extremely difficult. The Federal Art Project gave women all over the country an opportunity to work on a scale previously unheard of. I have included several women never discussed before who did outstanding work on the Project, but it was impossible to include them all. This is a field ripe for further scholarship.

Likewise, it has proved impossible to include all of the women artists producing work of high quality since that time. Understandably, preference was given to those who represented or reflected the major artistic trends of a given era. The curious reader may refer to the bibliography and to a series of appendices for the names of additional artists.

I have tried to be as eclectic as possible and to include women who worked in traditional as well as avant-garde styles. The categories of art history are easily overturned, and it is important to investigate well-recognized and competent artists, whether or not they fit into the current clichés of high art.

This book is the first comprehensive chronological survey of American women artists and is therefore organized by historical periods. Within these periods the work is divided by genre—painting and sculpture. The artists are examined in relation to the artistic movements of their times, with two exceptions: folk art, a separate tradition, is considered as a unit in the chapter on colonial women; and the work of all Indian women up to the present is included in the chapter on Native American women artists to show the continuous history of the longest and one of the greatest heritages of American women artists.

The purpose of this book is to give long-overdue recognition to the hundreds of American women artists, previously unnoticed or ignored, who have been working seriously, continuously, and professionally for over two centuries in this country, and to examine their lives and their work against the background of their times.

Charlotte Streifer Rubinstein
Laguna Beach, California

Earth our mother, breathe and waken
 leaves are stirring
 all things moving
 new day coming
 life renewing

 from *The Birth of Dawn,*
 Pawnee Song

To my daughters, Joan and Elaine,
and my granddaughter, Maggie

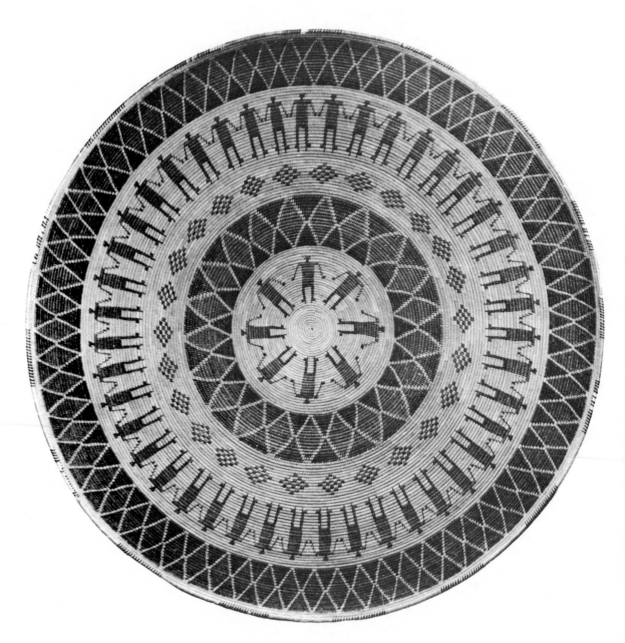

Fig. 1-1. YOKUTS GAMBLING TRAY (c. 1900),
marsh grass root, bracken fern root, redbud,
diameter 83.2 cm.

Chapter 1
Native Americans: The First American Women Artists

I am always thinking about designs, even when I am doing other things, and whenever I close my eyes I see designs in front of me. I often dream of designs and whenever I am ready to paint, I close my eyes and then the designs just come to me.[1]

One might assume these to be the words of a contemporary abstract painter like Frank Stella, but they were spoken by a Hopi woman potter describing her creative process to an anthropologist. A Laguna woman potter expressed the same aesthetic self-consciousness:

Sometimes before I go to bed, I am thinking about how I shall paint the next piece, and then I dream about it. . . . Some people do not think pottery is anything, but it means a great deal to me. It is something sacred. . . . I try to paint all my thoughts on my pottery.[2]

Centuries before the first European settlers came to North America, Indian women with this same high seriousness about their work were producing fine art in basketry, pottery, quillwork, weaving, and painting on leather. Almost all of it was once stored in ethnographic museums, but today it is

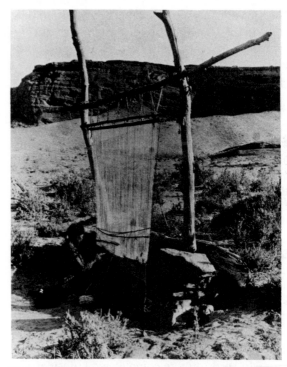

Fig. 1-2. NAVAJO WOMAN WEAVING BLANKET

finding its way into museums of fine art and has become a major influence on modern art.

The art of early American Indian women was generally embodied in their handmade domestic articles—baskets, pots, blankets, carrying bags, and so forth, but it would be a mistake to assume that this art is therefore pedestrian in character. For the Indian women who dug clay for their pots, gathered the reeds and rushes for their baskets, sheared the sheep for blankets, and worked the leather for painting, every aspect of the artistic task was imbued with the divine. A spirit had taught the

1

Indians how to find clay and make pots from it, and clay was the "flesh of a female supernatural."[3] In some tribes men were not allowed near the clay pits, and a religious ritual preceded clay gathering; a goddess, the Spider Woman, had taught the Navajo woman how to weave blankets. In addition, some of the objects made by women, such as ceremonial baskets and pottery or sacred quilled objects, were used in religious rituals. The result was a spiritual aura surrounding these common objects.

By tradition Indian women used geometric and abstract designs (although they also sometimes incorporated animals, flowers, figures, etc.), while men did the narrative paintings, religious murals, and much of the art connected with hunting and warfare. The seemingly "nonobjective" designs of the women artists, however, carried an intensity derived from commonly shared symbols and beliefs, many of which showed humility before the overwhelming forces of nature. For example, in the Southwest, where drought was a constant threat, the stylized clouds on a Zuni pot transformed it into a continuing prayer for rain. The quilled abstract circles on a Plains Indian ceremonial robe invoked the protection of the great spirit of the sun. The cross, which appears so often in quillwork and beadwork, was a symbol of the four sacred directions. Today, in a more complicated industrial and nuclear age, one can turn with new appreciation to this art, which expresses an admirable respect for nature and a harmony with the earth.

Unlike women art students of later times, who found themselves in academies or schools completely dominated by male professors, Indian women learned their skills from their mothers, grandmothers, and aunts. Much of the squaws' work was done in a cooperative or communal setting with other women. Hopi women made their pottery at convivial "pottery bees," and quillworkers gathered at ceremonies where the holy women who headed the quilling societies taught them the craft. Great honor came to the very skilled

and productive craftswomen, and in some tribes an individual's wealth was partially reckoned in terms of the robes, beaded baby carriers, and other objects ornamented by the squaw. Indian women developed superb sensitivity to the colors and textures of the natural materials they knew so intimately, and acquired an extraordinary ability to relate designs to the space and form on which they were placed.

It is not surprising that in recent times, turning back to this design heritage, a group of New York abstract artists of the 1950s called themselves "The Indian Space Group." Max Weber, one of America's early cubists, wrote in 1910 that he found "Indian quilts and blankets . . . much finer in color than the works of modern painter-colorists."[4] His painting was influenced by examples he studied in New York's American Museum of Natural History. Almost all of the Indian women's designs feature the interchangeability and tight interlocking of figure and ground that are so highly prized in modern abstract art. As the celebrated sculptor Louise Nevelson put it:

If I were reincarnated I would want to be an American Indian. . . . I love the geometry of their form and the shallowness of their space. . . . They only work in terms of positive space. . . .[5]

Contrary to the widely accepted notion of the squaw as a mere drudge or chattel, Indian women occupied a dignified position in many tribes. Colonial settlers in the Northeast wrote in some amazement about the Iroquois clan mothers, who selected and deposed the chiefs, were consulted about council decisions, and exerted much political influence.

Societal arrangements varied widely in the hundreds of tribes that existed in what is now the United States, but in many groups descent was (and still is) reckoned through the mother's line. The woman often owned the house, the domestic articles, and sometimes even the fields. It must be remembered

2

that a married white woman of the early nineteenth century had no property rights—her husband could dispose of everything as he chose.

In contrast with the white settler's patriarchal religion, Native Americans worshipped female as well as male deities. Father Sky lived in harmony with Mother Earth; the Navajo Changing Woman controlled the seasons and was celebrated in the long multiple ceremonies called "The Blessing Way."

There was always a clear-cut division of labor in the tasks assigned to men and women, but these tasks varied from group to group, depending upon the social and economic organization. Women did most of the tribal crafts, for example, among the Plains Indians, where the men were fully occupied with hunting and warfare. Men engaged in more crafts in the Pueblo tribes, where they were settled farmers and had more time for sedentary occupations. Weaving is another case in point: in the Pueblos, men were the weavers, but among the Navajos, where men had been nomadic hunters, women were the weavers.

In general, life was hard and industriousness in women was a prized virtue. The physical strength and endurance of Indian women were legendary. George Catlin, the American artist who traveled among the Indians and painted them in the mid-nineteenth century, described the Mandan women swimmers:

The poorest swimmer amongst them will dash fearlessly into the boiling and eddying current of the Missouri and cross it with perfect ease. . . . the strong and hardy. . . . squaws. . . . take their child upon the back, and successfully. . . . pass any river that lies in their way.[6]

Weaving

Navajo Blankets

Navajo blankets, recognized today as masterpieces of abstract design, are entirely the work of women. At a recent exhibition entitled "The Navajo Blanket" at the Los Angeles County Museum of Art, many of the lenders of these artifacts turned out to be leading male artists, such as Frank Stella, Kenneth Noland, Jasper Johns, and Tony Berlant. These men had obviously drawn great inspiration from the "hard-edge" designs of their anonymous female forebears.

The earliest blankets, beginning around 1800 A.D., were simple brown and white stripes in the natural colors of wool. Then came the bold, strong, "chief" blankets, in which boxes and diamonds are superimposed on the stripes, and red bayeta wool and indigo blue are added to the colors. Later came the "eye dazzlers," using many aniline colors and

Fig. 1-3. NAVAJO BLANKET (1885–95), transitional style

complex designs with flashing optical effects.

These more agitated forms are associated with the period when the proud, free Navajo people were rounded up by the U.S. government and subjected to cruel hardships during the Bosque Redondo captivity. The great power and explosive energy of the forms in Navajo weaving are perhaps related to the freedom and high status of the Navajo woman, who owned her own sheep and property and could become wealthy, independent of her husband.

Chilkat Blankets

Whereas the designs of Navajo blankets were woven by women from imagination, without any preliminary drawing, the Chilkat blankets were woven by women of the Northwest coast from designs painted on boards by men. In that highly patriarchal culture, men wished to keep control of the power embodied in the sacred life forms, and therefore only they were permitted to create and paint the designs. The Chilkat robes, worn in ceremonies by aristocratic leaders, displayed the animal totem of the clan. They were woven of cedar bark and the hair of mountain goats.

Fig. 1-4. WINNEBAGO POUCH (c. 1860), nettle fiber, buffalo wool

Twined Bags

Among the Great Lakes tribes, women made twined woven bags for storage and for carrying ritual equipment, using light-colored string from fibers of basswood tree bark and brown buffalo hair. Some of the motifs were the sacred thunderbird and the great cat, who according to legend, lived at the bottom of the lake.

Fig. 1-5. CHEYENNE PAINTED BUFFALO SKIN (WOMAN'S)

Leather Painting

Among the buffalo-hunting Plains Indians, where leather was used for every conceivable purpose, the woman made all the leather for the tribe. She skinned the animals and scraped, stretched, and

Fig. 1-6. CHEYENNE PARFLÈCHE, storage bag of painted rawhide

tanned the hides, using cherished tools that were handed down from mother to daughter.

The woman painted bold geometric designs on buffalo-skin ceremonial robes, buckskin dresses, moccasins and leggings, and rawhide storage containers. Her tool was a sharpened, porous buffalo bone dipped in color, something like an India ink pen. She also made all the paints for the tribe from ochers, charcoal, and so forth, and kept them in skin pouches and animal bladders.

A man's ceremonial robe was decorated with a large "sunburst" design of concentric circles made up of small triangular "arrows" or "feathers." When he wore it he invoked strength and power from the spirit of the sun. The abstract "buffalo" design on a woman's robe perhaps symbolized her relationship with the "earth."[7] Variations in the abstract box-and-border design could show whether the wearer was a young maiden or married woman.[8]

Plains Indian women folded the stiff rawhide into *parflèches* (large leather envelopes used to store dried meat and personal belongings) and decorated them with bold symmetrical designs of triangles, bands, and crosses, surrounded by borders. The repeated designs emphasized and echoed the shape of the object in a very aesthetic way. These motifs, sometimes handed down from mother to daughter, could identify the owner of the storage containers.

Parflèche designs were outlined in black and filled in with areas of red, blue, yellow, and green—colors that originally had symbolic meanings. For instance, among the Lakotas "red was the color of the Sun; blue the color of the moving spirit, the Sky; green the color of the spirit of the Earth. . . ."[9] The symbolism of the designs is still being deciphered.

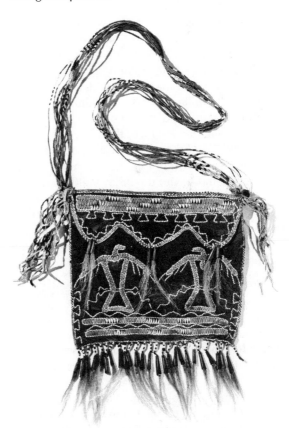

Fig. 1-7. QUILLED POUCH ON BLACK DYED BUCKSKIN, probably Iroquois

Quillwork

The art of decorating tepees, clothing, moccasins, pipe stems, and cradles with bird and porcupine quills was a very ancient and sacred women's craft, unique to North America. The quills were dyed, soaked, split, flattened, and sewn in nine different techniques requiring great dexterity.

Among the Cheyennes a woman could win honor for her achievements at quilling, as a warrior did for his exploits. Cheyenne women of great virtue and skill directed the Sacred Quillworkers' Guild, which taught the craft to women amidst elaborate ritual and ceremony. Men were forbidden to touch or see this work while it was being made. If they violated this ban, it was said, they would become deaf or be gored by a bull.[10]

Quillwork had subtle, natural colors before the coming of the white man's aniline dyes. The shiny surface of the quills contrasts beautifully with the velvety matte surface of the leather. The designs are often symbolic; for instance, the Cheyenne woman's quilled "star" placed below the smoke hole of her tepee was a symbol of the sun and brought blessings on those who used the dwelling. Among the Sioux, elaborately quilled (and later beaded) cradles and robes were particularly cherished. Sioux women were thought to derive their designs from visions of the supernatural Double Woman, and particularly skilled quillworkers commanded high prices for their products.

Beadwork

The trader's beads were eagerly adopted by Indian women from about 1800 because they were brighter and much easier to use than porcupine quills. A great variety of styles developed in different tribes, ranging from the massive geometrics of the Crow to the delicate, double-curving forms of the Micmacs. Later, some groups imitated European embroidery.

Although beadwork sometimes became a form of ostentatious display (women covered themselves

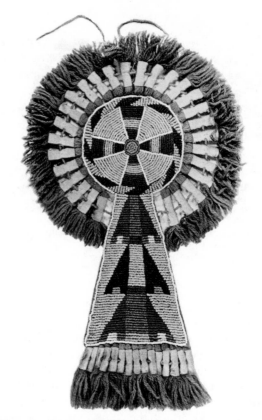

Fig. 1-8. CROW BEADED BRIDLE DECORATION (1875–1900)

with beadwork on headbands, dresses, purses, etc.), it was originally mythic and spiritual in meaning. For instance, the cross symbolizes the four sacred directions. The blue-beaded yoke on a Lakota buckskin dress symbolizes the "lake" where the world originated, and the U-shaped form in the middle represents Old Grandmother Turtle, who helped create the earth. The image confers long life on the wearer because Grandmother Turtle lived to be very old.[11]

There were many other Indian women's crafts: birchbark designs, ribbon appliqué, corn husk masks. Shells, pods, animal teeth, bones, and other materials were strung, woven, and sewn into an endless variety of forms.

Baskets

From around 7000 B.C. Indian women have made baskets in a wide variety of shapes, colors, and patterns, which have been used for every conceivable purpose—storage, carrying, cradles, hats, gaming boards, religious ceremonies, and even cooking. A complex basket could take as long as a year to make.

The small gift baskets covered with colored feathers and pendant shells, made by Pomo Indian women of California, are among the finest in the world. They are often given as wedding presents and are not utilitarian, but are enjoyed for their color and form. The incredibly tight weaving sometimes consists of as many as sixty stitches to the inch.

For thousands of years these masterpieces were anonymous. But starting with the turn of the century, when white traders began to sell them to collectors, they began to know the names of such individual basketmakers as Mary Benson of the Pomo tribe, Mrs. Hickox of the Karok tribe, and Dat-So-La-Lee from the Great Basin Area.

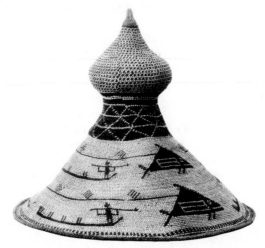

Fig. 1-9. WOMAN'S HAT, NOOTKA SOUND, NORTHWEST COAST (18th century), showing a whaling scene

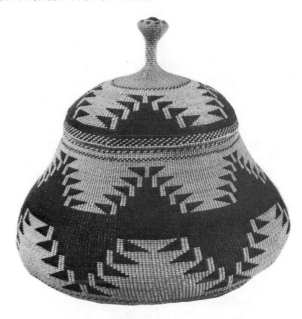

Fig. 1-10. TWINED BASKET WITH LID, KAROK TRIBE, 6¾" × 6¼"

Dat-So-La-Lee, or Mrs. Louisa Kayser (1835–50?–1925), is perhaps the most famous basketmaker of modern times. She is recognized for the tight evenness of her weaving, the classic forms of her baskets, and the perfection of the triangular or flame-shaped motifs, which relate perfectly in spacing to the field on which they are placed.

Born into the Washo tribe around Lake Tahoe on the California-Nevada border, she learned to make baskets for her own daily use, as all Indian girls did. She saw her people's land stolen by white settlers and its streams polluted by the mining industry during the Gold Rush. Most of the Indians in her tribe became beggars or servants to the newcomers.

For years she worked at odd jobs, washing clothes for the miners, or serving as a maid in the Cohn household. When she was about sixty she brought a basketry whiskey flask to Abe Cohn, who had been a child in that household and was now an emporium owner in Carson City, Nevada. Recognizing her talent, he gave Louisa and her husband a

little house next door to his own and told her that he would pay all her food, clothing, and medical bills if in return she would give him her entire output of baskets. He became her business manager and press agent, and she was able to devote herself entirely to her craft, sometimes laboring eight months on a single ceremonial basket.

Dat-So-La-Lee, who could not sign her name and had to use a handprint, was a star at the St. Louis Exposition of 1919. She was reputed to have an artist's temperament, . . . "making it necessary for friends and relatives to tread carefully. Charley [her husband] did the housework. . . ."[12] Once, when Charles was thrown in jail, she became very upset and made what she called a "mad" basket, in which the design became all uneven. But soon after, she resumed the calm perfection of her craft.

Because Abe Cohn carefully recorded, numbered, and named her baskets with fanciful titles based on conversations with her, it became possible to study the development of Dat-So-La-Lee's style as a fine art, as it went through various aesthetic stages. Art historian Dr. Marvin Cohodas traced the changing organization of her triangular motifs from an early period of experimentation to a "classic" phase[13] in which motifs were repeated in scatter units, giving a sense of infinite extension, as in a modern "systemic painting" (see the discussion of Agnes Martin in chapter 8). Later she grouped the triangles in diagonal and vertical bands, emphasizing the closed, curving form of the basket.

Her ceremonial baskets are made of cream-colored thread, scraped from the surface just under the bark of willow twigs, and the motifs are stitched with black bracken fern root, colored by the mud in which it had been buried, and red birch bark. Dat-So-La-Lee gathered all these materials and split and scraped them to thicknesses of a thirty-third of an inch with the aid of a simple tool—a piece of glass. Sometimes the coiling was as close as twenty-six stitches to the inch.

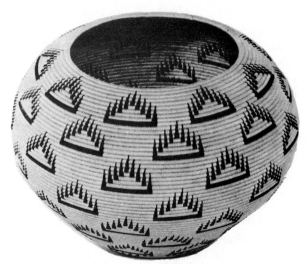

Fig. 1-11. Dat-So-La-Lee, BASKET: "HUNTING GAME OF THE AIR IN SUNSHINE"

Ceramics

Their women make earthen vessels . . . so large and fine, that our potters with wheels can make no better.
Thomas Hariot, *A Brief and True Report of the New Found Land of Virginia* (1590, De Brys edition)

For sixteen centuries Indian women have been making pottery and decorating it with one of the richest design repertoires found anywhere in the world, ranging from geometrics to floral, animal, and figure motifs. Most of this work was done in the settled farming communities of the Southeast, the Mississippi Valley, and beginning around 300 A.D., the Southwest.

In the giant "apartment house" cliff dwellings of the Southwest (multistory buildings with hundreds of rooms) around 1000 A.D., Anasazi potters created magnificent black-on-white, thin-line geometric abstractions.

Two other groups—the Hohokams of Arizona and the Mimbres of New Mexico—developed witty

and fantastic design traditions that included figures, insects, animals, and other life forms. We cannot know with certainty whether all of this work was by women. Most archaeologists, however, assume that it was, because in the earliest accounts of this historical period, everywhere north of Mexico pottery was being made by women.

When De Soto came to the Southeast in the sixteenth century, he found an elaborate Temple Mound culture in the Mississippi Valley, where women made thin high-fired ceramic ware, incised, engraved, carved, and painted with coiled and spiral designs. They even used a negative resist technique, obtained by painting with beeswax, which melted in firing.

Women of this region also created, between 900 and 1700 A.D., magnificent clay effigy funeral vessels shaped as figures, human heads, birds, frogs, fish, and other life forms. The figures and heads found in burial mounds, believed to be images of the dead, are portrayed with great monumentality and expressive power. Roy Hathcock writes:

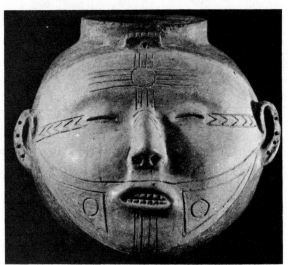

Fig. 1-12. HEAD POT, Arkansas, Mississippian Period (1200–1600 A.D.), clay height 13.8 cm., diameter 18 cm.

Very few ancient civilizations allowed women to make articles which the men used in religious ceremony, but the burial pottery used in funeral services by the Mississippians is an exception to this taboo. ... As in any community there were those who excelled with their talent. ... On many sites, artwork has been discovered which even to the untrained eye appears in every respect to be the results of the same individual. The artist whose works were in much demand no doubt bartered her wares for other needs and produced commissioned pieces as well. Effigy pottery was also traded, carried great distances in some cases, and was highly prized by its owners.[14]

Modern Southwest Indian Ceramics

In the dry Southwest a great tradition flourished, partly because the women needed large water jars (called *ollas*) in which to carry water on their heads from distant springs and wells to their homes. Naturally, the larger and thinner-walled the pottery, the more water they could carry, and girls of the villages competed to see who could make the thinnest, finest, and largest jars, and decorate them most beautifully. Today, of course, much of the pottery is made for sale to collectors.

Nevertheless, to this day Native American women in New Mexico and Arizona continue to coil pottery by hand without a wheel, and decorate it with a brush made of a yucca leaf that has been chewed into fibers at one end. In Acoma, San Ildefonso, Zuni, near Hopi mesas, and elsewhere, potters are still painting geometric designs, deer, birds, flowers, and other motifs that immediately identify their villages. Clouds, lightning, and water serpents are frequently symbols of rain, so urgently needed for agriculture in that dry climate.

For centuries this work was anonymous, but in modern times great potters like Maria of San Ildefonso, Lucy Lewis of Acoma, and Nampeyo, a Hopi from Arizona, have signed their work, and we know their individual histories. They have created magnificent new forms based on old traditions.

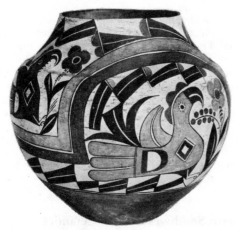

Fig. 1-13. ACOMA POLYCHROME JAR (late 19th century), clay

Maria Montoya Martinez (1811?–1980), of the San Ildefonso Pueblo in the Rio Grande Valley of New Mexico, was awarded honorary doctorates by the University of Colorado and New Mexico State University and was recognized as one of the world's great potters. She and her husband Julian worked together to develop the sophisticated black-on-black ware that has become renowned the world over.

As a small girl Martinez learned to make polychrome pots from her aunt, Tia Nicolasa. In 1908, Dr. Edgar Hewett, who was excavating the ancient Pajarito plateau nearby, brought her some black and charcoal-colored shards and asked her to try to reconstruct the whole pot from the pieces. With great reverence for this ancient work of her ancestors, she carefully duplicated the clay texture and reconstructed the form as she thought it might have been. She and her husband discovered a way to achieve the black color by smothering the flames with dried manure during firing. This produced lots of smoke, which carbonized the pottery. Maria polished the surface with a smooth, round stone before firing, so that the pottery came out with a magnificent silvery-black sheen. To their surprise, a demand developed for this ware.

Julian Martinez, an artistic and creative type, was unhappy as a farmer in San Ildefonso. He took a job as a janitor at the Museum of New Mexico in Santa Fe, and there husband and wife spent long hours studying the ancient archaeological ceramics in the storerooms. Around 1918, with the encouragement of anthropologists Edgar Hewett and Kenneth Chapman, they experimented, and discovered a way of painting decorations in dull, velvety black on the polished, shiny pottery before firing. Maria made the classic pottery forms and polished them, and Julian painted elegant designs, often adapting ancient motifs like *Avanyu*, the water serpent with a tongue of lightning, who symbolizes a flood.

Martinez, who had always been deeply committed to community life in her pueblo, became homesick, and they soon returned to San Ildefonso. There she taught other women in the village the new technique and after her husband's death collaborated with her sons Popovi Da and Adam, and her daughter-in-law Santana. Today Maria's great-granddaughter Barbara Gonzales, Santana, Blue Corn, and many other fine potters work in San Ildefonso.

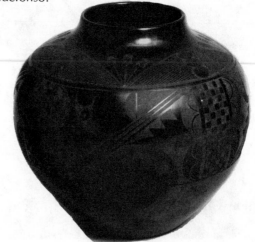

Fig. 1-14. Maria and Julan Martinez, BLACKWARE STORAGE JAR (c. 1935), clay, decorated with arches, feathers, and lines

Until her death in her late nineties, Maria Martinez remained an honored figure in her pueblo. Her inherent refinement of taste was expressed even in the casual but unerring way in which she combined brilliant patterns, Indian jewelry, and an embroidered sash in her clothing. She demonstrated pottery in almost every important world's fair beginning in 1904. She was asked to lay the cornerstone of Rockefeller Center in New York when construction started, and she toured the country for the U.S. government in the 1930s. But she was happiest in her native village, where she enjoyed the festivals and dances and the life of her people, although busloads came from all over the world to visit her.

Nampeyo (1856–1942), or ''The Old Lady,''[15] as she is called by her descendants, created a new classic pottery expression that continues today around the Hopi first mesa in northern Arizona. Pottery was at a low level at Hano when in 1895 the archaeologist

Dr. Fewkes began to uncover the prehistoric village of Sikyatki three miles away. When Nampeyo's husband Lesou, who was a workman helping Fewkes, brought home potsherds to show to his wife (already the finest potter in the village), she received permission to copy the ancient Sikyatki designs with pencil and paper at the archaeological site. Soon she adapted them, with her own variations, along with the ancient squat, wide-shouldered forms.

Nampeyo taught her daughters Annie, Fannie, and Nellie, and then her granddaughters Rachel, Daisy, Leah, and Elva. Her great-granddaughters Priscilla and Dextra have a hard time meeting the demand for their work. And her great-great-grandson Dan Namingha, a well-known modern Indian easel painter, has been inspired by her designs. Even after she went blind, Nampeyo continued to make pots of fine symmetry, which her daughter decorated.

Nampeyo's designs are famed for their fine space relationships and their flowing character, which is

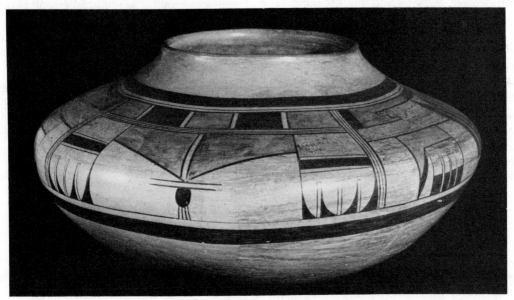

Fig. 1-15. Nampeyo, HOPI POLYCHROME JAR (c. 1921), diameter 36.8 cm.

based freely on the old elongated stylized motifs of reptiles, birds, feather designs, and sky bands. Her daughters have created their own variations, but all of them use a dark brown and rust color, on a creamy orange toned background.

Lucy Lewis (1895?–) comes from the "sky city" of Acoma, atop a high plateau that rises dramatically from a flat plain near Albuquerque, New Mexico. She is famous for her "thin-line" geometric abstractions of black lines on white pottery, sometimes accented with orange areas.

When she was a small child, Lewis learned to make pottery in the usual way by watching her great aunt. She sold some of it at roadside stands, but also made pottery that the *kachinas* gave away during religious ceremonies. After marriage she raised nine children and helped with the farming and cattle, but went right on making ceramics, which her family continued to sell on the old Route 66 (now replaced by a freeway).

Lewis was already fifty years old when she won an Award of Merit at the Gallup Intertribal Indian Ceremonial. For the first time she began signing bowls with her name. After she won the Outstanding Exhibit Award in Santa Fe in 1958, the famous photographer Laura Gilpin took her to the Laboratory of Anthropology at Santa Fe, where she met Dr. Kenneth Chapman and saw for the first time the great works of her ancestors. Very much inspired by these ancient designs, she adapted some of them in her work.

Today four of Lewis's daughters and some of her grandchildren are making pottery. Her work is sought by collectors all over the world.

Architecture

In many tribes the Indian woman was an architect. In later times by contrast, the American woman, has been discouraged from architecture and largely confined to interior decoration.[16]

In 1855, J. G. Kohl, a white traveler, observed with amazement the physical strength of the Ojibwa women who cut the poles and covered the wood frames of their houses with birch bark, lining them with colorful reed mats:

It may be easily supposed that these squaws owing to their performing all the work of joiners, carpenters and masons have blistered hands. In fact, their hands are much harder to the touch than those of the men; and indeed their entire muscular system is far more developed and they are proportionately stronger in the arm.[17]

In certain seminomadic tribes, Indian women constructed various forms of architecture out of frames covered with grasses. Among the Plains Indians, the woman owned, manufactured, transported, erected, and took down the leather-covered tepee.

Women built the great round earth lodges of the Pawnees, the Osages, and other tribes. They inscribed a circle on the ground, thirty to sixty feet in diameter, and then excavated the earth several feet deep inside of it. The round outer wall of posts was topped with a roof of thin tree trunks, over which a layer of thatch and sod was laid. These earth lodges are believed to be the predecessors of the sod houses built by early European settlers.

In the Southwest early explorers found cooperating teams of men and women working on the pueblos. Pedro de Castaneda described them in 1540:

They all work together to build the villages, the women being engaged in making the mixture and the walls, while the men bring the wood and put it in place.[18]

Twentieth Century Native American Painting and Sculpture

By the beginning of the twentieth century, because the official policy of the Bureau of Indian Affairs discouraged all manifestations of Indian culture in

the interest of assimilating the Indians into white society, Indian art was at a low ebb. It was revived, first, because the Indians refused to be assimilated and persistently clung to their own culture so that the Bureau of Indian Affairs changed its policies and allowed the teaching of Indian art in the early thirties; and second, because a number of white anthropologists, artists, dealers, and patrons actively involved themselves in aiding in the revival of Indian art.

Along with crafts, Native Americans began to produce paintings and sculpture for sale to the general public. For the first time women began to paint narrative and realistic pictures, although traditionally the narrative paintings on hides and tepees and the religious murals in the *kivas* had been the tasks of the men.

Dorothy Dunn founded the Art Studio at the Santa Fe Indian School in 1932 and inspired a great outpouring of work. She felt deeply that the Indian, unlike the rest of the population, had a coherent and glorious art tradition, and she encouraged the production of paintings based upon the ancient religious murals, sand paintings, and decorative arts, as well as the myths, ceremonies, and traditional life in the villages. She encouraged a style that emphasized firm outlines filled in with flat colors. Outstanding women who studied with her include Pablita Velarde, Eva Mirabal, Marina Lujan, Sybil Yazzie, Ruth Watchman, and Geronima Montoya, who became the instructor at the Studio after Dunn left in 1937.

In assisting in the revival of Indian art, the art institutions and the white public no doubt influ-

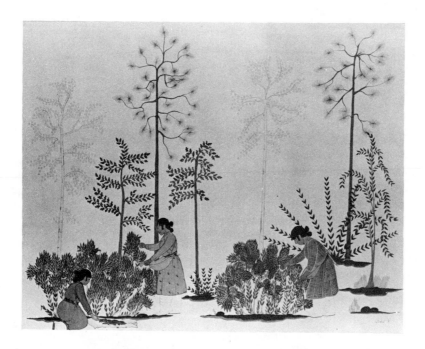

Fig. 1-16. Eva Mirabal (Ea-Ha-Wa), PICKING WILD BERRIES (1937), tempera

enced its character. They wanted an art that was as "Indian" as possible, not one that resembled New York or European art. In recent years, however, a segment of the Indian art community became dissatisfied with the "traditional" approach promoted at the Studio. Indian students who were not taught art in the European mode (lest it spoil the racial purity of their style) went away to universities in California and the East and began to demand a more cosmopolitan approach. The Studio at the Santa Fe School closed in 1962, and the Institute of American Indian Art (a school closer to the New York–Paris tradition and at the same time grounded in the needs and aspirations of contemporary Native Americans) opened in its place. Since the early 1960s the art of certain young American Indian artists has been stylistically part of the mainstream of world art, while the work of others sometimes

reflects the social protest movements of the Indian community. Traditional painters also continue to work. A wide range of approaches can be found in Native American painting today, but all of it expresses a continuity with and a deep pride in the Amerindian heritage.

Native American Painting

Tonita Vigil Peña (Quah Ah) (1895–1949) is of particular interest because she threw off the stereotypes that traditionally assigned narrative and realistic painting to the men. Born in San Ildefonso and related to the distinguished Vigil and Herrera families of artists, she was already painting in the San Ildefonso Day School by the age of seven. By 1919, with the encouragement of anthropologists

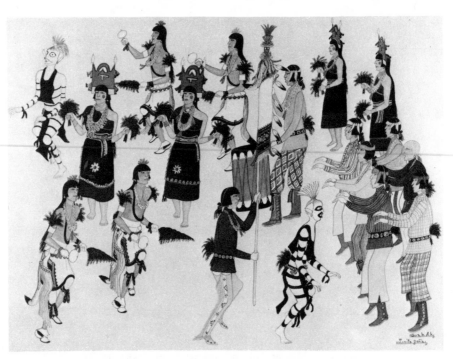

Fig. 1-17. Tonita Peña (Quah Ah), GREEN CORN DANCE, COCHITI PUEBLO (c. 1930), watercolor on paper, 20" × 24"

Edgar Hewett and Kenneth Chapman, she began to depict scenes from her local village in a serene and joyful style.

At a time when most women in the pueblos still felt themselves restricted by tradition to geometric designs, Tonita Peña, although entirely self taught, not only painted figures, but portrayed them in vigorous motion, with feathers and clothing flying and animated faces clearly expressing emotion. In paintings like *Green Corn Dance, Cochiti Pueblo* (1930), she departed from the stiff-profile positioning of traditional San Ildefonso painting and presented figures from different angles. She frequently modeled the forms.

Tonita Vigil married a Peña and moved to Cochiti Pueblo. She liberated Indian women to paint whatever they wanted in any way they wanted, and later taught at the Santa Fe Indian School.

Lois Smoky (Bou-ge-tah) (1907–) was the only woman in the remarkably talented group of Kiowa Indians encouraged in 1917 by Susan Peters, a field worker at the Anadarko Indian Agency in Oklahoma. In 1927 they were invited to live in Norman and paint at the University of Oklahoma. Professor Oscar Jacobson, head of the art school, invited them to his home to discuss world art history, and supported their professionalism in every way, while encouraging them to pursue their own native style. This group became internationally famous in the thirties for their bold, broad style and knowledge of Native American tradition.

Pablita Velarde (1918–) the most famous American Indian woman painter, continues a long and successful career in the "traditional" style of the Santa Fe School. Her murals and paintings show a strong feeling for bold, effective compositions combined with meticulous attention to accuracy in the portrayal of Indian crafts, ceremonies, myths, and daily life. Her works thus function both aesthetically and as anthropological documents. Her murals at the Bandelier National Monument in New Mexico (1939–1948), for example, are valuable

Fig. 1-18. Pablita Velarde, KOSHARES OF TAOS (1947), tempera on board, 13⅞" × 22½"

ethnological studies of the lives of the Pueblo Indians of the Rio Grande area, showing among other details of existence there, the practice of various crafts.

Velarde was born in the Santa Clara Pueblo in New Mexico. In 1933, when only fifteen, she painted a large oil on masonite, which was shown at the Century of Progress World's Fair in Chicago. She had just graduated from the eighth grade. One of the first and most outstanding students at Dorothy Dunn's Art Studio at the Santa Fe Indian School, she graduated in 1936. In 1939 Velarde worked on a Federal Art Project mural showing home activities of the Santa Clara Pueblo, on the facade of Maisel's Trading Post in Albuquerque. Among innumerable tempera and watercolor paintings of authentic scenes of Indian life are *Koshares of Taos* (1947), a scene of pueblo members watching a ceremony, and *The Betrothal* (1953), a marriage scene inside an Indian dwelling.

After teaching drawing in a day school and touring the Midwest and East with the Setons (Ernest Thompson Seton was the founder of the Boy Scouts), she built her own studio in Santa Clara and painted there for several years before moving to Albuquerque. One of two children from her seventeen year marriage to Herbert Hardin, an Anglo, is the outstanding painter Helen Hardin.

In 1960 Velarde wrote and illustrated *Old Father, Story Teller,* a book of tribal legends. In the 1970s she completed four panels for the Museum of New Mexico under a grant from the National Endowment for Humanities, and a large acrylic mural, *The Herd Dance,* for the new Indian Pueblo Cultural Center in Albuquerque. In 1977 she was given the New Mexico Governor's Award for Outstanding Achievement in the Arts. In recent years, Velarde has begun to grind her own paints from earth colors in a *metate,* in a search for ever-increasing authenticity in her work.

Helen Hardin (1943–), the daughter of Pablita Verlarde, shows a transition in her work from traditional Indian painting to more modern, more abstract forms. In some of her pictures traditional figures are seen against abstract backgrounds. In others, like *Medicine Talk,* the primary interest is in the pattern rather than in recording some phase of Indian life. Hardin's color, too, is not put on in flat areas as in traditional Indian painting, but is sometimes spattered or textured.

Hardin spent her first years in Santa Clara, New Mexico, and then moved with her family to Albuquerque. She began to draw and paint early, as might be expected of the daughter of Pablita Velarde, and won her first art competition at the age of six in a contest for boys only, with a drawing of a fire engine. The prize was a doll, substituted at the last moment for a fire engine, because the winner was a girl.

While majoring in art in high school, she took a drafting class and became acquainted with drafting tools and templates, which she later used in her design paintings. At the University of New Mexico in 1961, she studied art history and anthropology and then won a painting scholarship to the special art school for Indians at the University of Arizona. Finding this experience disappointing, she took a temporary detour into textile design and weaving. Later, without the direction of any teacher or school, she independently returned to her most authentic interest—design painting.

At her first one-woman show in Bogota, Colombia, in 1968, almost everything was sold. She has repeatedly won prizes, for example, the 1975 Avery Memorial Prize at the Heard Museum in Phoenix.

Hardin explicitly rejects the tradition in which her mother has painted. "I am not a *traditional* Indian—and I don't do *traditional* work," she has said. Unlike her mother, who grinds her own colors and mixes her own paints, Hardin uses acrylics,

inks, and washes and makes good use of her drafting training with ruled lines, circles, and arcs. Her most characteristic paintings are explicitly modernist in inspiration, although they obviously use Indian themes. For example, *Masks After Picasso* is a cubist abstraction based on Indian masks, just as Picasso based his on African masks. Other paintings, like *Winter Awakening of the O-Koo-Wah* (1972), have an art deco quality. All of her work, however, expresses a deeply felt personal religious mysticism.

"What sets Helen Hardin apart," art historian Norman Nadel has written, "is the fact that instead of holding the ancient traditions of Indian art and belief, she uses these same traditions as a point of departure for her own contemporary and highly original images."[19]

A leading Native American artist, Hardin is a member of the New Mexico Council of American Indians and has appeared on television as both a panelist and an actress.

Pop Chalee (Marina Lujan) (1908–), born in Castle Rock, Utah, of a Taos father and an East Indian mother, shows the influence of her dual Indian-Oriental heritage. She paints lacy, unreal dream forests populated by deer, rabbits, squirrels, and other animals playing among fantastic, stylized trees in flat areas of bold color. Continuing the decorative style she developed under Dorothy Dunn's tutelage at the Santa Fe Indian School in the 1930s, she has painted several murals in airports, stores, and banks in the Southwest.

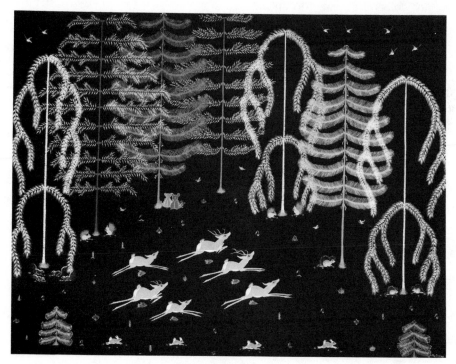

Fig. 1-19. Pop Chalee, BLACK FOREST (1979), opaque watercolor or casein on black paper, 19" × 25"

Yeffe Kimball, an Osage, (1914–1978) was one of the first Native Americans to come to New York and study at the Art Students League and then in Paris. An abstract painter, throughout a long career she was very active on committees promoting the work of Native American artists, and fought to break down the notion of the Indian artist as an unsophisticated primitive, entirely separated from the mainstream of art.

Linda Lomahaftewa (1947–), a Hopi from Phoenix, Arizona, paints abstract acrylic canvases based on geometric Indian motifs, using brilliant psychedelic colors that capture the glow of the southwestern desert. She embodies her positive feelings of being an Indian in a very contemporary form and has said that as she works she thinks of her tribal ancestors praying to their deities for strength and happiness. Her colors are related to ancient symbolic meanings, such as the four sacred directions.

Fig. 1-21. Phyllis Fife, BURY ME NOT AT WOUNDED KNEE (1973), etching, 18″ × 24″

Lomahaftewa, one of the talented students beginning to emerge from the Institute of American Indian Art, studied there from 1962 to 1965 and earned a B.A. and an M.F.A. from the San Francisco Art Institute in 1971. She taught at California State University in Sonoma, at Berkeley, and is now on the faculty of the Institute of American Indian Art.

Phyllis Fife (1948–), born of Creek descent in Oklahoma, paints in an expressive mixed-media style and addresses herself to contemporary issues in Indian life. She combines a social conscience with a deep strain of mysticism and has said that an artist's vision is guided by the hand of the unconscious. Fife attended the Institute of American Indian Art (1963–64), studied with the expressionist painter Howard Warshaw at the University of California at Santa Barbara (1966–67), and earned a B.F.A. at the University of Oklahoma in 1973. She has taught at Northeastern and Southeastern Oklahoma State University.

Other leading Native American artists working today are **Joan Hill (1930–)** of Oklahoma, **Ruth Blalock Jones (1939–), Virginia Stroud, Valjean McCarty Hessing (1934–),** and **Jaune Quick-To-See Smith (1940–).**

Fig. 1-20. Linda Lomahaftewa, NEW MEXICO SUNSET (1977), acrylic, 48″ × 36″

Native American Sculpture

Amanda Crowe, a Cherokee sculptor, received an M.F.A. at the Chicago Art Institute and was awarded the John Quincy Adams Fellowship for foreign study in 1952. She carves in wood and stone, al-though in earlier times stone and wood sculpture among Indians were assigned to the men. Native American women (and men, as well) are now breaking down the stereotyped boundaries that restricted them to certain crafts or certain styles.

Fig. 1-22. Valjean Hessing, THE GOSSIPERS (1976), opaque watercolor, 30″ × 26″

Chapter 2
Colonial Women Artists and American Women Folk Artists

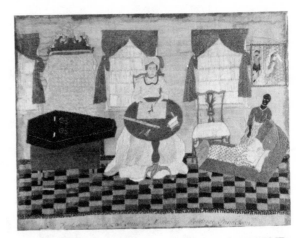

Fig. 2-1. Prudence Punderson, THE FIRST, SECOND AND LAST SCENE OF MORTALITY (c. 1775), silk stitchery painting, 12½″ × 16½″

White women first came to the shores of America in the holds of sailing ships—fleeing with their men from persecution or poverty—and they were forced to wrench a bare subsistence from the wilderness. Of eighteen married women who were on board the Mayflower when it landed in November, only four remained alive in the spring.[1]

Along with continual childbearing, cooking, cleaning, and nursing the sick, women had to manufacture the simplest necessities of life, grow their own food, make their own candles, spin and weave their own cloth, and sew all the clothes for the family. In a world where everything had to be made by hand, women on the whole had little time or leisure for painting. Girls were taught to sew when they were still babies. Under these circumstances the sampler became an early form of expression; the early "paintings" of American women are largely stitchery paintings, in which they practiced and showed off their necessary skills.

Bed rugs and quilts were an absolute necessity against the cold. Because there was a shortage of fabrics, women used all their ingenuity to piece together leftover scraps and in time reached a high level of artistry. They began working on their quilts as young girls; folklore later declared that a girl of twenty-one who had not finished her first quilt would never get married. Today the public pays homage to the genius that was poured into this expression. In exhibitions all over the country, at the Whitney Museum, the Los Angeles County Museum of Art, and elsewhere, the extraordinary qualities of quilts as abstract art have been recognized.[2]

As trade began to flourish and labor remained in short supply, women played a vigorous role in colonial America. They were shopkeepers, tavern and innkeepers, physicians, midwives, printers, publishers, weavers, milliners, and even postmistresses or other petty officials. Nevertheless, legally and politically, the status of women in colonial America was constricted. A single woman or widow had some control over her assets, but a married woman, in accordance with predominant English law, had few property rights; even if she earned money, it legally belonged to her husband. In most cases she had little recourse from an abusive husband, be-

cause divorce was extremely difficult. Black women brought in chains from Africa, were almost all slaves, with no rights whatsoever.

The education of women was limited. In the public schools established in Massachusetts in the middle of the seventeenth century, girls were taught reading, writing, and simple arithmetic after the boys' classes were over, or in the summer, when boys were working on the farms. Wealthy girls sometimes attended boarding schools taught by spinsters or widows, where they learned the added accomplishments of sewing, embroidery, music, and dancing. On Southern plantations, girls were tutored at home. Quakers believed in more equal educational opportunity, and so it is not surprising to discover that a number of early American women artists came from Quaker homes. Young men went off to Harvard and Yale before the American Revolution, but the first women's college did not open its doors in the United States until Mount Holyoke was founded in 1837.

Abigail Adams wrote a now famous letter in 1777 to her husband, John Adams, begging him to see to it that, after the American Revolution, some rights would be granted to women:

In the new code of laws which I suppose it will be necessary for you to make, I desire you would remember the ladies. . . . Do not put such unlimited power into the hands of the husbands. Remember, all men would be tyrants if they could. If particular care and attention is not paid to the ladies, we are determined to foment a rebellion, and will not hold ourselves bound by any laws in which we have no voice or representation.[3]

But the ladies were not remembered. A full century of struggle took place before women won the right to vote.

One would think that such obstacles would have prevented women from creating any painting or sculpture at all in the early days of the country. And yet, amazingly, there were women who managed to jump the barriers and become professionals.

Henrietta Deering Johnston (before 1670–1728?) faced Indian attacks, pestilence, pirates, and the scurrilous behavior of fellow townsmen when she came to South Carolina from Dublin in 1708 as the wife of a clergyman of the Church of England. Her husband, a widower with several children from his first marriage, was already heavily in debt. Under these circumstances she managed to produce more than forty portraits of leading citizens of Charleston—America's first pastels.

She had somehow received training as an artist in Ireland and brought with her precious art supplies—paper and pastels, which could not be bought in North America at that time. It has been pointed out by art historian Anna Wells Rutledge that she may have learned her craft from Simon Digby, Bishop of Elphin, an amateur portraitist who had been her husband's superior in Ireland. Pastel portraiture was at that time unknown in America and was, in fact, unusual even on the European continent, where Rosalba Carriera was only then establishing it as a substantial art form.

The Johnstons' arrival in the New World was not auspicious. The artist and her stepchildren sailed into Charleston harbor alone, because her husband had gone on shore during a brief stop at Madeira and the boat had left without him. He was then marooned on an island and was half-dead of exposure when he was rescued. For nine months Henrietta Johnston acted as both nurse and secretary, because her husband's hands shook too hard with ague for him to write.

The Johnstons soon discovered that they had neither house nor income. An interloper had illegally taken over their church, and months of maneuvering were required to regain control of their congregation. Charleston did not resemble the new Eden they had pictured; it was a primitive village with muddy lanes traversed by chickens and pigs. Mosquitoes attacked from the surrounding swamps, and Henrietta soon contracted malaria.

In one of his many harassed letters to England, the

Reverend Johnston wrote to Bishop Gilbert Burnet in 1709, "Were it not for the assistance my wife gives me by drawing of pictures (which can last but a little time in a place so ill peopled) I shou'd not have been able to live."[4] It seems that Henrietta Johnston, although chronically ill, was supplementing the family income by drawing portraits of local notables. Some of her pictures, in fact, are of her doctor's family and may have been, as art historian Margaret S. Middleton suggests, a kind of barter payment for medical care for herself and her husband.[5]

While the imperturbable Henrietta Johnston was going from house to house painting charming, composed, and gracious portraits of Charleston's distinguished citizens, her husband—ill, poor, and sometimes jeered at by certain locals who were trying to undermine his authority—gave *his* view of them in a letter to England:

The People here, generally speaking, are the Vilest race of Men upon the Earth they have neither honour, nor honesty nor Religion enough to entitle them to any tolerable character, being a perfect Medley or Hotch Potch made up of Bank(r)upts, pirates, decayed Libertines . . . who have transported themselves hither from Bermudas, Jamaica, Barbadoes, Monserat, Antego, New England. . . .[6]

The Reverend Johnston went to England on business, leaving his wife in charge of affairs. During this period two hurricanes nearly flooded the town and blew off the roof of the new church that the Johnstons were building. Indian wars broke out, and hordes of frightened people poured into Charleston for protection. When Gideon Johnston returned from England, he found that his wife, "with great humanity and charity,"[7] was taking care of families who had crowded into their home as refugees.

Amazingly, amidst all their troubles and those of their new country, Henrietta Johnston continued her portraits. During this time she painted Colonel Samuel and Mary Prioleau, Frances L'Escot (daugh-

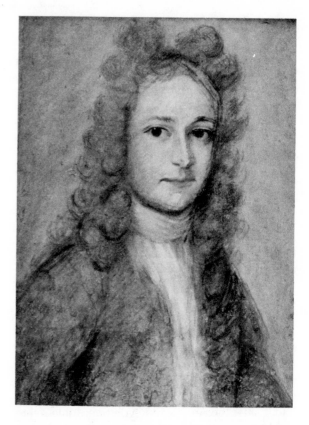

Fig. 2-2. Henrietta Johnston, COLONEL SAMUEL PRIOLEAU (1715), pastel on paper, 12" × 9"

ter of a Huguenot minister), Christiana Broughton, and others. One would never know from the cheerful and elegant pastels of this period that the community was wracked by wars, shortages of food, salt, and water, and other disasters.

In 1716 the hapless Reverend Johnston drowned in a sloop on Charleston Bay, leaving his widow only his debts. The local clergy vainly petitioned the church in England for a widow's pension. In 1725, perhaps trying to find a community in which she could support herself, her niece, and two stepdaughters with her art, Henrietta Johnston traveled to New York to visit friends she knew from South Carolina.

Included among several works attributed to her

from that period are pastels of 1725, signed and dated "New York," showing members of the family of John Moore, ex-secretary of South Carolina, who had migrated north. There is also a portrait of Elizabeth Colden, daughter of Cadwallader Colden, who was later Lieutenant Governor of New York. She was back in Charleston in 1727 and in March 1728/9 the Register of St. Philips Church reads, "Then was buried Henrietta Johnston."[8]

Henrietta Johnston's portraits are drawn in pastels on 9 × 12 sheets of paper and are signed on the back of the original wooden frames. They are crude but sturdy likenesses. The swag of drapery behind the figures is a provincial echo of the baroque style of Europe. Middleton points out that the faces are fairly well drawn, but the arms and hands are stiff-looking and may have been drawn from a set of wooden arms in her possession. Nevertheless, the pictures show an early attempt to bring some feeling of culture and refinement to a raw new land; they give an important record of religious leaders, officials, and landowners who were shaping a new civilization. Anna Wells Rutledge calls them "direct and uncompromising,"[9] reminiscent of the calm courage of the woman who picked her way through the muddy streets carrying her pastels to the homes of South Carolina's distinguished early citizens.[10]

Patience Lovell Wright (1725–1786), who modeled portraits in wax, is considered to be America's first professional sculptor.[11] She was a bold, free spirit who trod the stage of colonial America with a steady thump. A contemporary of hers, Elkanah Watson, wrote this description of her:

The wild flight of her powerful mind, stamped originality on all her acts and langu[a]ge. She was a tall and athletic figure; and walked with a firm, bold step, as erect as an Indian. . . . Her sharp glance was appalling; it had almost the wildness of a maniac's. . . .[12]

Wright was uneducated, but her colorful personality and artistic genius attracted the friendship of some of the great men and women of her time—Benjamin Franklin, the Earl of Chatham, Benjamin West, and others. At the height of her fame she modeled portraits of King George and Queen Charlotte at Buckingham Palace, where she addressed them as "George" and "Charlotte," and according to legend, harangued the king on the question of better treatment for the colonies. An ardent patriot, she sheltered political victims in London and tried to act as a spy for her native land.

Patience Lovell and her eight sisters and one brother were the children of John Lovell, a prosperous but fanatically idealistic Quaker farmer of Bordentown, New Jersey. Since it was against Lovell's principles to kill any living creature, Wright never touched meat until she was an adult and on her own. Her father required that the entire family dress only in pure white clothing from top to toe, both in winter and summer, as an expression of inner as well as outer purity. The girls had to wear wooden shoes, rather than leather ones from slain animals, and went out veiled as a protection from sin. In later years, Wright often recounted to visitors the story of how the bevy of little sisters reacted to this strict regime by creating a rich world of fantasy, gorging themselves on color through painting (they made their own colors from mineral earths, berries, and the like) and modeling small figures in dough and local clay.

At twenty she ran away from her strict home to the exciting city of Philadelphia and lived there for several years. She was quite impoverished when, in 1748, she married Joseph Wright, an older man, a well-to-do cooper from her home neighborhood. They settled down in Bordentown, and for more than twenty years she raised a family of three children. Reports indicate that her husband was less than pleased by her continuing eccentric habit of modeling figures in clay.

She was forty-four when her husband died, leaving her with a peculiar will and an urgent need to support herself and her children. (A fourth child

was born shortly after his death.) Wright always gave full credit to her sister, Rachel Wells, for suggesting a highly creative solution to her financial problems. Wells, herself a widow who had been modeling in wax for some time, suggested that Wright might try portrait busts. The two sisters soon had a flourishing business. Wright moved to New York and developed a novel waxworks show with which they toured Charleston and Philadelphia. The show was received with enthusiasm because Wright, although mostly self-taught, showed an immediate genius for creating uncanny likenesses.

She completed life-sized figures with clothing, color, eyelashes, and glass eyes. These effigies of important citizens like Cadwallader Colden, Lieutenant Governor of New York, were placed in a tableau, reading at a table or engaging in some other lifelike act.

Wright tried wherever possible to get portrait commissions, viewing herself as an artist rather than as a creator of a side show. When she was off on a trip, one of her children accidentally started a fire, damaging many of her pieces. This may be one of the reasons she sailed for England in 1772, with visions of making her fortune in London like her famous fellow countryman, the painter Benjamin West.

With characteristic panache and flair, Wright settled in the very best part of town, near the King's palace in the West End, surrounded by the studios of the leading artists of the day. There she set up her waxworks show, which now included historical scenes and figures of leading celebrities. Soon the sophisticates of London were crowding into her exhibition, amazed by her skill and enchanted with her colorful personality. Wright greeted aristocrats enthusiastically with a big kiss, Quaker style. Then she launched into harangues describing her arcadian upbringing in the New World, attacking the king's encroachments on civil liberties, speaking out candidly in favor of the colonies, and addressing lords and ladies as first-name equals.

So astounding was the verisimilitude of her sculptures that entering visitors were tempted to drop a coin into the outstretched hand of a wax door-maid, believing it to be alive.[13] She was soon referred to as "The Promethean Modeler," and finally the king himself permitted her to come to the palace and model his portrait. Her novel technique of working in wax has been described in several accounts.[14] To keep the wax malleable she modeled the bust under her apron, warming it with the heat of her body. At a certain point she would pull the head out from under the apron and put finishing touches on it under the astonished gaze of the sitter. Her work was invariably accompanied by a torrent of opinions and stories tumbling from her lips.

Wright developed an implacable hatred of the policies of the king. Declaring that "Women are always usful [sic] in grand events,"[15] she gathered information from many sources and tried to act as a spy for her native country. According to various accounts, she is supposed to have stuffed dispatches with secret information in the wax heads of Lord North and others, which she sent by boat to Rachel Wells, who still maintained a waxworks in America.

Legend has it that after Lexington and Concord, Patience Wright, who now referred to King George as "Pharoah [sic]," stomped into the palace and angrily berated the king for his cruel and disastrous policies. William Dunlap wrote wryly in 1834 that "she did not have the manners of a courtier."[16]

Her brashness reached a peak when, with the Revolution actually under way, she insisted publicly that England would never defeat America. After this outburst she hastily turned her waxworks show over to her children and left for Paris, where she modeled a portrait of Benjamin Franklin. When the Revolution was over, Wright settled down quietly in England with her daughter Phoebe, who was by this time married to the successful portrait painter, John Hoppner.

Wright had become a famous personality in her

native land, and Abigail Adams, like many visiting Americans, called on the sculptor when she came to London. The distinguished Mrs. Adams had raised her voice many times on behalf of women's rights, but, even for her, Patience Wright proved a bit too liberated. In a letter Adams described her visit:

I went to see the celebrated Mrs. Wright. . . . She ran to the door, and caught me by the hand, . . . "Why, you dear soul, you, how young you look. . . . I must kiss you all." Having passed the ceremony upon me . . . she runs to the gentlemen. "I make no distinction," says she, and gave them a hearty buss; from which we would all rather have been excused, for her appearance is quite the slattern . . . the queen of sluts.[17]

According to Adams, the artist then expounded at length on her own genius and referred with irritating familiarity to John Adams ("Dear creature, I design to have his head"). Abigail Adams's discomfiture was increased still further when she discovered that one of the guests in the room was not real:

There was an old clergyman sitting reading a paper in the middle of the room; and, though I was prepared to see strong representations of real life, I was effectually deceived in this figure for ten minutes, and was finally told that it was only wax.[18]

Wright now developed a yearning to return to her native country. Planning to make portraits of the nation's new leaders, she wrote to George Washington, who replied that he would be honored to sit for her. Before this could be arranged, however, Wright was injured in a fall and died in England.

The fragile nature of Patience Wright's wax medium has left us few examples of her work. Several bas-reliefs, such as the profile of Admiral Howe at the Newark Museum, are attributed to her. The one piece known positively to be by her hand is the full-length portrait of "The Great Commoner," the first Earl of Chatham, William Pitt. This memorial portrait, commissioned shortly after his death, is in the chapel of Westminster Abbey. Wright portrays the great leader, who spoke up often in favor of the American colonies, as he addresses the House of Lords with a scroll of paper in his right hand, dressed in parliamentary robes of red wool trimmed with gilt braid and fur.

In this portrait she has given us a remarkably expressive and life-like vision of Pitt, whom she

Fig. 2-3. Patience Wright, WILLIAM PITT, EARL OF CHATHAM (1779), wax effigy

admired greatly and described in her letters as the "guardian angel" of America. His lean, haughty noble face, with a suggestion of wry humor in its expression, speaks to us across the centuries. When the sculpture was cleaned in 1935, the Keeper of Muniments at Westminster Abbey wrote that the hands were veined and colored with underslips, and even showed hairs on the surface.[19]

Patience Wright cast a long shadow ahead of her. She spoke out for the things she believed in, despite considerable risk, and longed to play a significant role in public life. Making charismatic use of the media, she moved aggressively to get publicity in the newspapers and to contact important people who might help her. Wright had great natural gifts as a sculptor, but in her era was unable to get the education that would have led an equally talented man to major public commissions in marble and bronze.

Her relationships with her children were also extraordinary. Her daughter Elizabeth emulated her by setting up a waxworks show in the United States. Her son Joseph became a portrait painter and designed the first coins and medals of the young republic. In an early portrait submitted to the Royal Academy in England, he portrayed his mother modeling a wax head of Charles the First (who was beheaded by Cromwell) while she glanced knowingly at King George and Queen Charlotte. This obvious attack on the crown, which caused a furor in London, clearly reflected the courage that Patience Wright had transmitted to her children, and showed the high regard her son had for her.

Hetty Sage Benbridge (17?–?), compared to the robust figures of Henrietta Johnston and Patience Wright, is a frail and shadowy one. The "ingenious miniature paintress"[20] from Philadelphia was the wife of Henry Benbridge (1743–1812), a portrait painter. She flickers in and out of letters and newspaper items for a brief period and then is heard from no more. Ten miniatures have been attributed to her, all probably painted before the American Revolution. She appears in the autobiography of her teacher, Charles Willson Peale, who wrote:

He [Henry Benbridge] married a Miss Letticia Sage, who had acquired some knowledge of miniature painting from her friend Peale. Mr. Bembridge [sic] removed to Charleston, South Carolina and followed his profession of portrait painting, and he died there, and also his wife."[21]

"Miss Letticia Sage" had learned her trade from the genial, kindly Peale, teacher of a generation of artists, including his own daughters and nieces. A true figure of the Age of Enlightenment, he believed that art was not a mystery that belonged only to gifted geniuses. Among his many democratic ideas, which included equality of the sexes, was the notion that anyone of reasonable intelligence could learn to draw and paint. Henry Benbridge, Hetty Sage's husband, was already a successful portraitist

Fig. 2-4. Hetty Benbridge, JOHN POAGE (c. 1775), miniature, watercolor on ivory, 2⅛" × 1⁷⁄₁₆"

in his late twenties who had grown up in the prosperous home of his mother and stepfather, Thomas Gordon, of Philadelphia. He studied painting in Italy for several years, returning with a polished technique quite unusual in the colonies. It was after his return that he married Hetty Sage, probably in the early spring of 1772. She was already a miniaturist, and it is likely that he met her in the circle of Philadelphia artists.

By the time that his wife bore their son in December 1772, Henry Benbridge had already moved down to Charleston, South Carolina, and was establishing a successful portrait practice in that elegant city. His wife was to join him later. Charleston had come a long way from the crude settlement that greeted Henrietta Johnston in 1708. By 1773 it was an urban center where wealthy plantation owners spent much of the year enjoying the sophistication of city life while they left their estates in the care of overseers.

An ominous note is sounded in a letter from Henry to his sister Betsey Gordon, written on the day of his son's baptism:

I was very uneasy about my Dear Hetty's Laying in and what I most dreaded is come to pass, viz, catching cold in her laying in which I am informed had like to deprived me of her, and would have made me a very disconsolate man. . . .[22]

In April 1773 Hetty Benbridge, with her mother and her baby Harry, joined her husband in South Carolina. The *South Carolina Gazette* announced on 5 April 1773 that "Mrs. Benbridge (the wife of Benbridge, Portrait Painter) a very ingenious Miniature Paintress" had arrived from Philadelphia on the *Charles Town Packet*.[23] Her reputation as an artist had preceded her to her new home.

A month after being reunited, the family received a letter from their friend Peale. He sent his regards to Hetty Benbridge and wrote some instructions to her about colors. Henry Benbridge does not mention his wife again in the correspondence that has survived; it is probable, therefore, that she died shortly after arriving in South Carolina.

Robert G. Stewart attributes ten miniatures to Hetty, although none are signed.[24] These are all tiny watercolor-on-ivory miniatures—eight of dignified, long-necked women, one of a child, and one portrait of a man, John Poage—a South Carolina patriot—now in the Henry Ford Museum at Dearborn, Michigan. These paintings have been assigned to her because they differ in color, lighting, and drawing from Henry Benbridge's portraits. They show a marked similarity to the methods used by Charles Willson Peale, her teacher. Because of the way Peale put on his colors, his pictures had a tendency to turn bluish or blackish in the shadows. In contrast, Henry Benbridge's colors stayed bright. Also, Peale taught a method of drawing a head by starting with a long oval, which is apparent in the works attributed to her. They are portraits of refinement and elegance, with less chiaroscuro than appears in the work of her husband.

American Women's Folk Art: A Continuing Tradition

For a long time, especially in the late nineteenth century, American folk art was ignored and regarded as the crude expression of untrained provincials. In the 1920s, however, with the arrival of modern art, perceptive collectors became fascinated by primitive painters and folk artists. They suddenly saw in this work the bold, instinctive sense of design and color that sophisticated artists were striving for more consciously. Jean Lipman, Mary Black, Nina Fletcher Little, Alice Winchester, Dorothy Miller, art dealer Edith Halpert, and others began to collect and study this genre. The Abby Aldrich Rockefeller Folk Art Center and Electra Havemeyer's Shelburne Museum in Vermont were both founded by notable women folk art collectors.

In recent years, spurred by the women's movement, there has been a growing interest in American *female* folk art. Women are proudly acknowledging the masterpieces of quilting and needlework and the long tradition of decorative ornament, and are drawing inspiration from them for new contemporary art. Fabric art, soft sculpture, sculptural weavings, and self-consciously decorative trends in women's art today reflect this return to their roots.

Quilts

There is a common misconception that quilts were an anonymous collective effort, a somewhat haphazard putting together of random pieces by many women at quilting bees. On the contrary, they were almost always designed by one woman and were often proudly signed and dated. An exception was the friendship or album quilt, in which each woman designed one block.

The quilt artist planned the entire work with great thought, at times orchestrating hundreds of tiny pieces, and at others, making special purchases of fabric to balance a color scheme. Outstanding quilt designers were well known in their communities. It should be pointed out that the very lavish and elegant quilts in certain Southern districts were often made possible by the skilled artistry of black women slaves.

A quilting bee was called when the top was finished and was stretched on a frame ready to be sewn to the backing with thousands of tiny stitches. The quilting bee was an important social institution where women came together to work, to socialize, and to share ideas. Interestingly, the great flowering of quilting in the nineteenth century corresponds to the period of the first wave of feminism in the United States. Susan B. Anthony made her first women's rights speech at a church quilting bee in Cleveland. Sometimes the bee was a major social event taking weeks of preparation. The men might join the women for a big dinner and dancing and games afterwards.

Girls were traditionally supposed to complete a dozen-and-one quilts by the time of their marriage. The finest and most elegant of these was usually the bridal quilt. Another type was the "freedom quilt" given to a young man when he turned twenty-one and was at last free from the legal restrictions of being a minor. There were also presentation quilts, given to honor a notable figure, and memorial quilts, made from the clothing of departed loved ones.

Design motifs were cherished, sometimes handed down through generations, and often based on a region and its traditions. The names call up a sense of time and place—the square bars of *Log Cabin,* the *California Rose,* the pointed *Mariner's Compass* of the New England seacoast, which might be transformed to the *Star of Bethlehem* or the *Prairie Star* when the quilter moved to the dry plains and starry nights of the midwest. Politics and history were stitched into quilts with such themes as *Burgoyne's Surrender,* or the *Radical Rose,* in which each flower displayed a black center to show sympathy with the slaves at the time of the Civil War.

The range of aesthetic expression went from the most dazzling abstract effects, anticipating many of the devices of modern Op artists, to the most delicate appliqué of flowers and other realistic forms. Many feminists are now questioning the legitimacy of ranking these works lower than the "high art" of color-field painters and other abstract artists.

Technically, the utmost ingenuity was used to achieve three-dimensional and other complicated effects. The two main types of quilts are *appliqué,* generally considered the more elegant, in which shapes are cut out of whole cloth and sewn onto a background fabric, and *pieced quilts,* in which pieces are sewn together side by side. Pieced quilts often appeal more to lovers of modern design because they lend themselves to bolder statements.

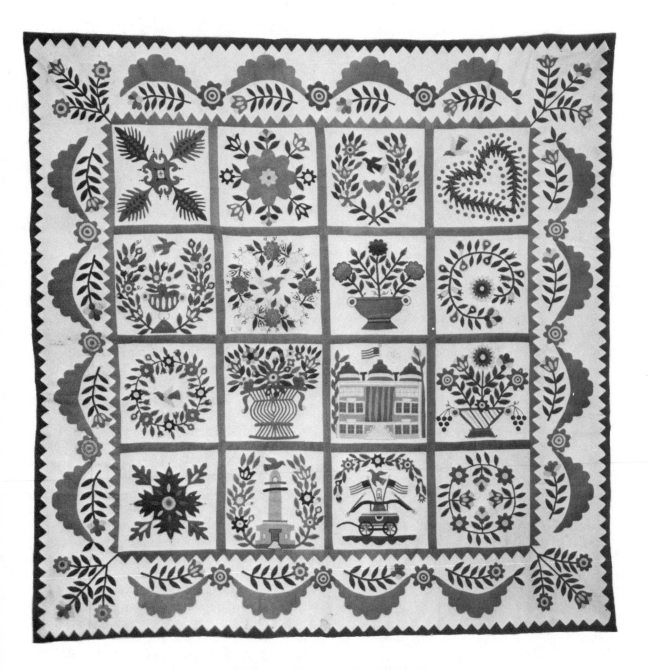

Fig. 2-5. Signed Sarah A. Shafer, BALTIMORE
BRIDE'S QUILT (1850), 103″ × 103″

Most quilts have a tight-structured design built up from equal-sized blocks sewn together. *Crazy quilts* are made differently. Far from crazy, they were made from random scraps arranged in freer, more asymmetrical compositions. The changing moods of color and fabric down through the decades reflect the changing tastes of different periods; Amish quilts, for example, have a wonderful boldness and brightness of design and color, while the Victorian crazy quilts, often used as decorative throws on chairs and couches, were pieced in the mauves, browns, and velvets of that era.

In nineteenth century America, quilts were a part of women's lives in a way we find hard to picture today. Often repeated is the famous remark of the Midwestern farm woman who said that she would have lost her mind without her quilts to work at. For many, the bright colors and imaginative patterns were the principal outlet of creative expression in a life of unrelenting toil.

Theorem Paintings
and Ladies' Seminaries

As America became prosperous before the Civil War, daughters of well-to-do parents began to attend newly opened ladies' seminaries where for a modest extra fee they could add drawing and painting to the curriculum. Itinerant teachers began to travel to various towns and give art lessons. Drawing and painting became an expected part of a genteel lady's accomplishments, and seminary girls turned out countless classical, biblical, and literary subjects, often derived from an engraving or other source. Instruction books and magazine articles giving detailed "do it yourself" directions became very popular, and decks of drawing cards printed with sample pictures to copy were widely sold. Stencil painting, also called *theorem painting,* became the rage.

The reason for this fad was that women wanted to be able to turn out pictures quickly and easily to

Fig. 2-6. Ruth Downer, NEW ENGLAND GODDESS (early 19th century), watercolor on silk, 22" × 26"

decorate their homes. The tedious work of stitchery paintings became less popular in the period leading up to the Civil War, and was associated with the deprivations of frontier days.[25]

Theorem painting was the technique of using ready-made or cut-out stencils placed on paper to trace outlines, which were then filled in with colors. The stencils could be moved about to create still-life groupings. Uncreative as this procedure may seem, in talented hands it resulted in works that have a clear, precise charm. Later, the modern precisionist painters of the 1920s became intrigued with the clean, stylized forms of some of this work, and collected outstanding examples. The craving for a little luxury in the stark early days of the country was reflected in the use of velvets and satins for some of the backgrounds.

Overflowing fruit bowls, symbolizing abundance and prosperity, were the most popular subjects. In the theorem masterpiece *Fruit in Glass Compote* (c.1890) by Emma Cady (1854–1933), the artist used mica flakes on the bowl to simulate the sparkle of glass, and dabbed one color over another

Fig. 2-7. Collata Holcomb, STILL LIFE, FLUTED BOWL (c. 1820), theorem painting, oil on velvet, 14⅞" × 17¼"

to enhance the texture and shade the forms. Cady lived in East Chatham, New York, and listed her occupation as "housework."[26]

Theorem paintings and freehand paintings of this type were often done with meticulous effort in a systematic, step-by-step procedure. Women's painting portfolios have been found that contain stencils, study notes, tracings, color notes, drawing paper, and oiled paper.[27] The artist sometimes had to grind and mix her own colors and prepare her own tracing paper.

Memorials of Grief

Memorials, a class of paintings that expressed grief over the death of a loved one or a national hero, such as George Washington, were almost always by women. These were sometimes presented as a gift to the family of the deceased and usually showed a sobbing group gathered around an urn-topped tombstone, with weeping willow trees drooping over them and a village or church in the background. Infant mortality and early deaths were, of course, very common in the rugged early days of the country.

Memorial paintings reflect late eighteenth and early nineteenth century neoclassicism; the young Republic looked back to the earlier democracies of Greece and Rome. Based on ancient Greek and Roman models, with added Christian and American motifs, they served to demonstrate the new-found erudition and elegance of their creators.

At first the memorials were stitchery paintings. Later, as women began to paint them instead, the brushstrokes were often still applied in patterns that imitated needlework stitches. Eventually this hand-painted folk art was pushed out by printed lithographs, which rolled off the presses in great quantities.

Fig. 2-8. Harriet Moore, RICHARDSON MEMORIAL (c. 1817), 18" × 23¾"

Primitive Painting by American Women

The continuous line of self-taught female folk painters, beginning in the eighteenth century, continues today with such famous folk artists as Grandma Moses, Clara Robertson, and the black folk artist Clementine Hunter. Of course, much of this work still remains anonymous. The recent book *Artists in Aprons*[28] gives a comprehensive discussion of this segment of American women artists. Some of the most famous figures are discussed here.

Eunice Griswold Pinney (1770–1849), an energetic wife, mother, and pillar of the church, painted some of the earliest and strongest primitive watercolors found in America. Her sturdy style is unmistakably different from the timid and often stereotyped watercolors turned out in quantities by schoolgirls in the ladies' seminaries of the early nineteenth century. Although an amateur hobbyist, like most women of her time, she was prolific. More than fifty paintings are signed by or attributed to her hand.

She came from wealthy, respected, and well-educated parents in Simsbury, Connecticut. Staunch Episcopalians, they trained their eight children to use their spare time industriously. The brothers and sisters loved to put on plays in the neighborhood. Jean Lipman has suggested that the dramatic staging of Pinney's watercolors may have been influenced by these early amateur theater experiences.

Eunice had two children by her first husband, Oliver Holcombe. After he drowned fording a stream, she married Butler Pinney of Windsor, Connecticut, in 1797 and had three more children. She is described as an influential, vigorous leader and organizer in her church.

One of her sons became a clergyman, and her daughter, Minerva Emeline, emulating her mother's interest in art, was a painting teacher in Virginia before her marriage. Eunice sent Emeline letters filled with pious thoughts and verse, and sometimes included sample watercolors for her daughter to use as examples in her classes—an early instance of a good female role model.

Eunice Pinney's datable paintings suggest that she did most of them after she was thirty, when she was already a twice-married woman. Her style has a robust, solid look, with decisive contours that reveal a mature personality of force and assurance. Her pencil studies for the finished pictures show that she worked out her compositions carefully with firm, although naive and nonacademic draftsmanship. "A woman of uncommonly extensive reading,"[29] she loved to paint literary subjects such as *Lolotte and Werther* or Robert Burns' poem *The Cotter's Saturday Night* (c. 1815) and is believed to have drawn inspiration for some of her pictures from English engravings.

In *Two Women* (c. 1815), as in other works, there is an intense dramatic confrontation, arranged with a bold play of shapes, curves against rectangles, and diamonds. Subtle variations break the rigid symmetry, and the negative shapes between the forms are beautifully organized. The figures and the perspective of the room are flattened out and the objects altered in a way that strengthens design. She worked with a great variety of themes—memorials, genre, and biblical subjects, and each composition shows originality and invention.

Mary Ann Willson (active 1810–1825) was a totally naive primitive painter whose bold distorted works, executed with crude paints manufactured from berry juice, brick dust, and the like, are reminiscent of the Fauves and the German Expressionists. Her highly original lifestyle was as striking as her work. A recently discovered portfolio of Willson's watercolors, painted around 1810–1825, contained a letter signed "An Admirer of Art."[30] Written about 1850 by a gentleman who knew her, it recounts the few facts we have about her life.

Mary Ann Willson came to the village of Greenville in Greene County, New York, with a woman named Brundage, to whom, according to the letter, she was "romantically attached."[31] The two women bought some land and built themselves a log house. Miss Brundage farmed the land while Mary Ann Willson painted watercolors, which she sold to farmers in the district. Both women regarded the Willson "picters" as extremely beautiful, claiming that they were in demand from Canada to Mobile.

When Brundage died, Willson was crushed by grief and left for unknown parts. The "Admirer of Art" gives us a picture of an alternative lifestyle—a woman farmer and a woman artist supporting themselves independently on the land in 1810—building their own log house and making their own paints!

Fig. 2-10. Mary Ann Willson, THE PRODIGAL SON RECLAIMED (c. 1820), ink and watercolor, 12⅝″ × 10″

Willson's bright colors and astonishing, crude compositions are applied to such high-flown biblical, historical, and literary subjects as *The Prodigal Son Reclaimed* (c. 1820) and *George Washington on Horseback.* The pictures show an uninhibited boldness and strong pattern, combined with a total lack of concern for conventional drawing, perspective, or realism.

Ruth Henshaw Miles Bascom (1772–1848), or "Aunt Ruth,"[32] as she was called, was about forty-seven when she began to make profile portraits of her neighbors and relatives in Massachusetts. These life-sized profiles were done by "taking a shadow." The model cast a shadow upon a piece of paper and she traced it. Then she added coloring with pastel crayons and introduced all sorts of novel variations:

Fig. 2-9. Eunice Pinney, LOLOTTE AND WERTHER (1810), watercolor, 15⅛″ × 11⅝″

cutting out and repasting the face on a different background, gluing on shiny gold paper beads, or introducing charming landscapes with boats, streams, and flowers. In a burst of early "pop" art, she fashioned tinfoil eyeglasses and pasted them on the face.

She was born in Leicester, Massachusetts, in 1772, the oldest of ten children of Colonel William and Phoebe Henshaw. Her father fought in the French and Indian War and helped organize the Minute Men on the eve of the American Revolution.

After spending her early years in Worcester, Massachusetts, in 1804 she married a Dartmouth Professor, Dr. Asa Miles, who died two years later. She then married the Reverend Ezekiel L. Bascom and moved with him many times, as his calling required, to Deerfield, Massachusetts, Fitzwilliam, New Hampshire, and other towns. Beginning in 1836 she settled in Gill, Massachusetts, for a number of years and later died in Ashby, Massachusetts. Many of her portraits were painted in Gill in the 1830s when she was more than sixty years old.

"Spun and sang songs all day until night approached,"[33] Ruth Bascom wrote in her diary as a young girl. Her journals, covering fifty-seven years, are now at the American Antiquarian Society in Worcester, Massachusetts. They give a vivid picture of the busy, sociable life of a pastor's wife, and contain many more references to needlework than to her paintings. One notation describes her technique for painting a rug on the living room floor: "I finished painting my floor at 6 P.M. Striped with red, green, blue, yellow and purple—carpet like."[34]

Bascom was a proper lady, and like other well-to-do women of her day, would have thought it unseemly to take money for her portraits. Her many vivid profiles of New England adults and children in the early nineteenth century have a calm strength of characterization combined with a sensitive feeling for shape, color, and texture.

The life of **Deborah Goldsmith (Throop) (1808–1836)** dispels the myth that only men traveled from

Fig. 2-11. Ruth Henshaw Bascom, WOMAN IN A LACE CAP AND COLLAR (n.d.), pastel and pencil, 19³/₁₆" × 14¹/₈"

town to town as itinerant artists painting family portraits in the early nineteenth century. She signed her works "D. Goldsmith," however, and they might have been attributed to a man had her granddaughter not preserved her letters, her paints, and her albums.

The youngest child of Ruth Miner and Richard Goldsmith, she grew up in North Brookfield, New York. By the time she was a young woman, all her brothers and sisters had left home and her old parents were facing poverty. To help support them and herself, she taught herself portrait skills and traveled

Fig. 2-12. Deborah Goldsmith, THE TALCOTT FAM-
ILY (1832), watercolor on paper, 18″ × 21⁷/₁₆″

to the homes of her customers, remaining until the
family pictures were completed before moving to
the next home. This lifestyle took considerable
pluck for a woman of her day.

While she was staying with the Throop family in
1831, young George Addison Throop posed for her
and fell in love. In a flowery letter filled with words
like *tis, thee, thy,* and *adieu,*[35] George declared his
love. Deborah returned her answer in a letter from a
neighboring town where she had gone to do some
more portraits.

With disarming candor she warned him that they
had different religious ideas, that she was two years
older than he, and that some of her teeth were false!
Despite such ruthless honesty, George Throop was
not dissuaded and they were married that year,
1832. After the birth of two children, Cordelia and
James, Deborah Goldsmith Throop became ill and
died at age twenty-seven in 1836.

Her poems, quotations, and paintings are pre-
served in two albums which, according to art histo-
rian Jean Lipman, reflect a serious philosophical
mind. Her work has a delicate, gentle quality, with
the naive style and pattern of the self-taught artist.

Ruth W. Shute (active c. 1826–1839) was an itiner-
ant portrait painter. The Plattsburgh *Republican* of
24 May 1834 carried the following advertisement:

PORTRATE PAINTING/Mrs. Shute would inform the
ladies and Gentlemen of Plattsburgh that she has taken a
Room at John McKee's Hotel, where she will remain for a
short time. All who may employ her may rest assured that
a correct LIKENESS of the original will be obtained. . . .
Price from $5.00 to $10.00.[36]

Nearby in the same newspaper was a discussion of
Ruth Shute's work:

Mrs. S. is extremely happy in her designs and coloring,
and in transferring the "human face divine" to the can-
vas. Those who whish to "see themselves as others see
them" will do well to improve the opportunity offered by
the stay of Mrs. Shute in our village.[37]

Ruth W. Shute and Samuel A. Shute traveled as a
husband-wife team through New Hampshire,
Massachusetts, Vermont, and upstate New York,
painting the faces of nineteenth century Americans
in small towns. Not only did the Shutes collaborate
on many works signed "R. W. Shute and S. A.
Shute," but Ruth Shute alone painted at least thirty
oils, watercolors, and pastels, including seventeen
signed oil paintings. When Samuel Shute became
ill, they seem to have moved to Champlain, his
hometown in New York State near the Canadian
border. There Ruth Shute continued to ply her trade
alone in nearby villages like Plattsburgh to support
them both.

After Samuel died in 1836, Ruth returned to her
home state of New Hampshire and continued to
travel and paint portraits until her second marriage
in 1840 to a Mr. Alpha Tarbell in Concord, New
Hampshire. Her work is characterized by a lively,
energetic, naive sense of abstract form, pattern, and
color, which like much good primitive art antici-
pates the expressionist aesthetics of the twentieth
century. She used a good deal of pencil shading
around the features of faces, and as art historian
Helen Kellogg has pointed out, gave her figures tiny
hands. Samuel Shute, on the other hand, when

working alone had used less pencil shading and drew large hands. Kellogg solved the precise identity of the two artists by discovering the Plattsburgh ads and other material, which she published in *Antiques World* (1978).

The Shutes often painted backgrounds in monochromatic stripes brushed vigorously in diagonal or horizontal strokes. Sometimes decorative paper cut-outs were applied, as well as metal foil, white gouache, and shiny glazes of gum arabic. The Shutes were evidently always ready to experiment with something new.

The tradition of the naive or self-taught woman folk artist continues uninterrupted to the present day. Perhaps the most famous of recent times is **Anna Mary Robertson Moses (1860–1961),** or Grandma Moses, as she is known all over the world. A hard-working farm woman, she began to paint seriously in her old age when her arthritis got so bad that she could no longer do hard physical labor. Finding herself with unaccustomed leisure, she began to record her vivid memories of rural America, the poetry of the changing seasons, and the shared work and play of Americans living in small country villages that were unscarred by industrial blight.

Anna Mary Robertson was born of a Scottish-Irish farm family in Greenwich, New York. In her vivid memoirs, she describes ten years of untrammeled childhood, picking flowers, floating rafts with her brothers, and learning to sew from her mother. Her first experience as an artist came from her father, who encouraged all the children to draw and paint on cheap, unused newsprint, which he brought home to keep them busy. She always loved something "red and pretty,"[38] as she said, and squeezed out berry juice to brighten up her pictures.

An essay written for school, which she cherished and kept through life, describes her feeling about the importance of decorating and ornamenting the home. She regarded this task as a kind of sacrament. Like many women of her day, she labored with her own hands to bring some modicum of luxury and grace into a rough and simple existence.

At age twelve she went to work as a hired girl, an experience she later looked back on as an education in all the household arts and even in "moralizing," as she put it. She worked very hard taking care of sick and old people and running their homes.

After marrying Thomas Salmon Moses, she journeyed with him to Staunton, Virginia, where she worked with him on a large farm and bore ten children, five of whom died in infancy. Sometimes, as she churned butter outdoors for their dairy business, she thought to herself that she would love to paint the beautiful view of the Shenandoah Valley. They returned to New York State and settled on a dairy farm in the tiny village of Eagle Bridge, where she remained for the rest of her life. Anna Moses occasionally painted pictures as Christmas presents, but never took herself seriously. However, her husband, shortly before his death, began to notice and praise her landscapes. After he died and her children took over the family farm, Moses was too feeble for hard work. It was natural for her, raised in the women's tradition of needlework and quilting, to fill her leisure time with stitchery pictures of such subjects as a covered bridge. These yarn paintings show an unusual feeling for three dimensional depth and form. Her children and sister so admired them that they urged her to paint. Her first oil painting was on a scrap of canvas left over from a threshing machine cover.

Moses' daughter-in-law took her pictures to the women's exchange in the local drugstore. Louis Caldor, a private art collector who happened to be in town on business, saw them in the window. Astonished by their quality, he bought them immediately, then visited Grandma Moses and purchased more work. For several years he tried to interest museums and galleries in her art, but they were very patronizing about the pictures of an un-

educated old lady. Finally, Sidney Janis selected three paintings for a folk art exhibition at the Museum of Modern Art. Otto Kallir of the Galerie St. Etienne gave Anna Mary Moses her first show, entitled "What a Farm Wife Painted," for which the only catalogue was a mimeographed sheet. The public response was immediate. The Phillips Col-

lection in Washington, D. C., was the first museum to buy her work, and soon galleries and museums began to collect and commission her paintings. Eventually they were sent around the world by the U.S. Office of Information, which recognized and promoted Grandma Moses as a kind of national institution.

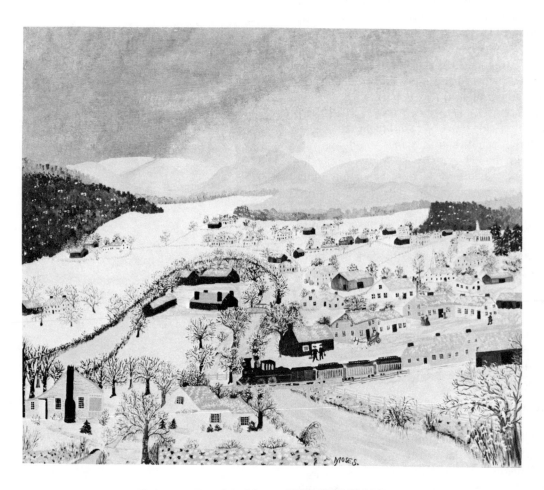

Fig. 2-13. Grandma Moses, HOOSICK FALLS, WINTER (1944), oil on masonite, 19¾" × 23¾"

Otto Kallir induced her to write her memoirs, which were published as *My Life's History* (1952). Her writing style, with its spelling errors and fresh turns of speech, has the same vividness as her paintings. She was entertained in the White House by President Truman. In a television interview with Edward R. Murrow when she was over ninety, Moses ended up asking the questions and bantering with wit and humor as if she were in her own home. On her hundredth birthday flowers and greetings poured into Eagle Bridge from all over the world.

Grandma Moses was appalled when people began to pay her more than she asked for her works. The extravagance seemed almost obscene to the thrifty housewife. A lawyer was eventually retained to manage her affairs.

In paintings like *Hoosick Falls, Winter* (1944), *Wash Day* (1945), and *The Quilting Bee* (1950), she caught the qualities that many Americans most cherish in their national past—close family life, hard work, neighborly kindness and community "belonging," poetic holiday traditions, and a sense of the beauty of the American countryside. In her best work she recorded with keen observation the exact color of the sky in different kinds of weather, the steam rising off the snow, the dark tones of an oncoming storm. From her own experience she captured the precise gestures of farm folk as they stirred maple syrup or cut hay, the running gait of a turkey gobbler, or the lumbering of a horse pulling a heavy sleigh of people through a snowbank. In addition to her precise observation of the landscape and the light, she organized color and pattern with the decorative gift of the folk artist.

Clementine Hunter (1882–) is a black folk artist who worked most of her life as a field hand and kitchen maid on a cotton plantation. After finding a paint brush that had been abandoned by a New Orleans artist, she began in 1946 to paint naively stylized scenes of life among black people in the rural South.

Minnie Evans (1892–), born in a log cabin in Long Creek, North Carolina, is a black artist who while working as a domestic servant began to paint visionary, fantastic compositions, suggestive of the Book of Revelations and surrealist art. Her decorative designs in mixed media and later in oil paint include large eyes, flowers, and mandala-type foliage patterns. She has been a gatekeeper at Airlie Gardens in Wilmington, North Carolina, since 1948.

Tressa Prisbrey (1895–), also called "Grandma," is a folk sculptor who gradually created a fantasy environment called *Bottle Village* in Santa Susana, California. Using bottles, headlights, and other debris embedded in concrete, she constructed thirteen buildings around her trailer to house her odd collection of dolls, gourds, and other cast-off curiosities. The California Arts Council is currently trying to preserve *Bottle Village*.

By 1876 the new mood was already being reflected in art. Bronze realism overtook marble neoclassicism. The native genre tradition was abandoned by an ostentatiously wealthy class who pursued European art styles. These new patrons adorned their mansions with paintings that (they hoped) would waft the aura of a presumably superior culture to our shores.

Chapter 3
The Golden Age, 1800–1876

With the victorious conclusion of the American Revolution, our new nation began to emerge— confident, stable, and expansive. Patriotic fervor brought a "Golden Age," reflected in the Greek Revival in architecture, as public buildings were erected in keeping with the dignity of the young republic. Sculptor Horatio Greenough draped a giant figure of George Washington in the colossal marble folds of a Roman toga. A great demand arose for portraits of illustrious leaders and well-to-do citizens. Later, panoramic landscapes of our native scenery, paintings of historic subjects, and genre scenes of everyday life expressed the idealism and optimism of the era of "manifest destiny," the Westward movement, and Jacksonian democracy.

After the middle of the century this profound idealism, so accurately captured by the marble statues and scenes of American life, began to fade. The horrors of the Civil War, the subsequent incredible pace of industrialization, the corruption in political life, and the monstrous accumulation of wealth by monopolists all worked to alter the temper of the nation.

The Position of Women

In the first half of the nineteenth century, women's lives were terribly restricted. As the country grew richer and more industrial, and men went off to factory and office, women lost the economic power they had shared during colonial and frontier days. Middle-class wives were propagandized to become "ladies of the house" and to pursue the ideals of "piety, purity, submissiveness and domesticity."[1]

By mid-century a small group of courageous women was beginning to organize for women's rights. In 1848 at Seneca Falls, New York, they rewrote the Declaration of Independence to read:

We hold these truths to be self-evident: that all men and *women* are created equal. . . . The history of mankind is a history of repeated injuries and usurpations on the part of man toward woman, having in direct object the establishment of an absolute tyranny over her. To prove this, let facts be submitted to a candid world.[2]

The Civil War began to bring women into public life. They spoke out in support of the Abolitionist movement, organized 7,000 local clubs into the U.S. Sanitary Commission that raised $50,000,000 for war relief, nursed the wounded under Dorothea Dix, Superintendent of Nurses, and worked on farms and in munitions factories. For the first time, women were hired as clerical workers by the federal government.

When the war ended, women were enjoined once more to resume their former roles, and most of them did. Nevertheless, by the time of the Philadelphia Centennial Exposition of 1876, the move-

ment for women's rights was already flourishing and, in fact, caused a heated battle that centered on the exposition's Women's Pavilion.

Women Artists in the Golden Age

It was difficult for women to get a rigorous art education between 1800 and 1870. For a long time it was considered unthinkable for women to draw from the nude model or study anatomy. At first they were excluded from the professional art academies; the ladies' seminaries and private drawing classes gave stilted and limited instruction, suitable for a "polite accomplishment."

It is not surprising, therefore, to discover that many women artists at the beginning of the century were the wives and daughters of painters and were taught at home. As the century wore on, the Pennsylvania Academy of the Fine Arts and the National Academy of Design haltingly opened their doors;[3] but women were not able to draw from the male nude until 1877, in a segregated "Ladies Life Class." Membership in the National Academy of Design was essential to an artist's prestige in that era, but only one woman, Ann Hall, was elected to the position of a full Member before 1900; only eleven became Associate Members; and four were honorary members.[4]

In light of these handicaps, the striking accomplishments of women artists in the Golden Age were doubly remarkable. At mid-century a maverick group of women sculptors, defying the social conventions of the day, emigrated to Rome and founded a kind of women's support community in the arts. From there they shipped home neoclassical works carved in white Carrara marble. They competed for—and won—major government commissions for sculptures, fountains, and bas-reliefs in public places. Other women became portrait, still-life, and genre painters. Despite social and educational obstacles, they participated in every important movement of the period.

Industry was expanding, creating a demand for designers. In 1844 Sarah Worthington Peter, the civic-minded daughter of a governor of Ohio, recognized the dire need for employment of single and destitute women. She opened the Philadelphia School of Design for Women to provide training in engraving, illustration, textile design, furniture carving, and other trades. This school was followed in 1854 by the Cooper Institute of Design for Women in New York and others in Cincinnati, Chicago, and elsewhere. Some of America's finest women artists got their start in these women's vocational schools. The European academies did not accept women students until late in the Golden Age. (For the story of how women stormed those citadels, see chapter 4, "The Gilded Age.")

Portraits

At the beginning of the nineteenth century, there were a number of women miniaturists and portrait painters who limned the features of our new leaders and distinguished citizens. After 1837, the daguerreotype and photography began to replace the painted portrait.

Ellen Wallace Sharples (1769–1849) and **Rolinda Sharples (1793?–1838)** were a loving, mother-daughter artist team. Ellen was the third wife of an English painter, James Sharples, who visited America twice with his family and painted pastel portraits here between 1793–1801 and 1809–1811. She came from a well-to-do English Quaker family and had been her husband's art student in Bath, England, before their marriage. Ellen Sharples took a dim view of her husband's obsessions with various machine inventions and his general improvidence. She recognized early (and with rare prescience) that she would need a trade in the event of poverty or early widowhood (her husband was much older).

For James Sharples to earn a living as an itinerant portrait painter, his family was forced to endure a great deal of travel. After their baby daughter

Rolinda was almost killed in a runaway public coach, James, who loved to tinker with gadgets, rigged up a great oversized traveling caravan—a kind of early mobile home drawn by a large white horse—in which they all trundled through New England towns in snow and rain. The caravan housed James and Ellen, their two boys (who were already helping their father with the family trade), little Rolinda, all their pastels, paper, frames, and even, it is believed, a mechanical device for taking a profile.

It was perhaps during this trundling that Ellen Sharples began to consider her situation with cool detachment. She later wrote in her diary of "the continual fluctuation of the funds and other property in which our money had been invested, the uncertainty in mechanical pursuits in which Mr. S. delighted. . . ."[5] These difficulties convinced her, after they settled in Philadelphia, to use her drawing skills, "which had been learnt and practiced as an ornamental art," to supplement the family income.

In Philadelphia, the nation's first capital, her husband made pastel portraits of the leaders of the new republic congregated there. She began to assist him by making copies to order and was soon swamped with commissions. She remarked with satisfaction in her diary that "they were thought equal to the originals, price the same: we lived in good style associating in the first society."[6] Among her subjects were Alexander Hamilton, George Washington, Martha Washington, the Marquis de Lafayette, and even a North American Indian.

The Sharples's portraits were straightforward renderings, which were much admired in their day. They were so accurate that the dust from powdered wigs could be detected on the subjects' shoulders. Unlike her husband, Ellen Sharples often painted in watercolor. She was also a fine stitchery artist—her profile of George Washington is now at Mount Vernon.

After her husband's death in New York City in 1811, the family returned permanently to England.

Fig. 3-1. Ellen Sharples, GEORGE WASHINGTON (n.d.), pastel on gray paper, 9" × 7"

The young widow wrote in her diary about the stress of suddenly being forced to deal for the first time with banks, lawyers, and business matters. She actively encouraged her daughter Rolinda (who had already begun to paint in the United States) to be "independent of the smiles or frowns of fortune,"[7] and provided her with lessons, gallery visits, and all forms of encouragement. The young Rolinda, described as "always cheerful and happy, ardently engaged in various intellectual pursuits,"[8] soon outstripped her parents and branched out into genre and historical subjects on a more formidable scale. *The Closing of the Bank* (1822) and *The Trial of Colonel Brereton* (1832–34) are complex compositions involving many figures, while *The Village Gossips* (1828) is a typical genre subject. A charming early painting shows Ellen Sharples peering happily around the corner of an easel on which her daughter is painting.

In 1827 Rolinda Sharples was elected an honorary member of the Society of British Artists, and

also exhibited at the Royal Academy. She died in Bristol, England, of breast cancer at the age of forty-five, just as she was at the height of her career.

Ellen Sharples outlived all her children, continuing on in Bristol until the age of eighty. She founded the Bristol Fine Arts Academy (now the Royal West of England Academy) with a gift of £ 2,000, and willed a substantial sum to it upon her death.

Fig. 3-2. Rolinda Sharples, THE STOPPAGE OF THE BANK (1822), oil on panel, 33″ × 47½″

Ann Hall (1792–1863) was a greatly respected painter of delicate miniatures on ivory, and was the first and only woman to become a full member of the National Academy of Design before 1900. Her work was compared by leading critics to that of Sir Joshua Reynolds and Thomas Lawrence. Art historian Elizabeth Ellet wrote in 1859 that Hall's "soft colors seemed breathed on the ivory, rather than applied with the brush."[9]

Hall was born in Pomfret, Connecticut, the sixth of eleven children of Dr. Jonathan Hall and his wife, Bathsheba Mumford. Ann's artistic talents were encouraged early on by her cultivated father, a physician. At the age of five she was already cutting out paper figures and modeling in wax. A family friend, impressed by Ann's ability, gave her watercolors and pencils; she was soon painting flowers, birds,

fish, and insects from nature in the rural area where she lived. Although she later focused on miniature portraits, she never lost her love of flower painting, and frequently incorporated bouquets in her small figure compositions.

During a visit to Newport, Rhode Island, Hall learned the technique of painting miniatures on ivory from Samuel King, Gilbert Stuart's teacher. Later, in New York, she studied oil painting with Alexander Robertson, one of the earliest art teachers in America. Her supportive brother Charles, a prominent New York businessman, sent paintings from Europe for her to copy. Critics later noted the glowing "old master" color in her miniatures, influenced by these early copies.

By 1817 she was already exhibiting miniatures at the American Academy of Fine Arts in New York City. She moved to New York in the mid-1820s and became the first woman artist admitted to the newly formed National Academy of Design in

Fig. 3-3. Ann Hall, ANN HALL, MRS. HENRY WARD (ELIZA HALL) AND HENRY HALL WARD (1828), miniature watercolor on ivory, 4″ × 4″

1827. She was elected an associate in 1828 and, unanimously, to full membership in 1833; she exhibited miniatures steadily in its annual exhibitions from 1828 to 1852. In the 1829 exhibition, her miniature of a captive Greek girl taken by the Turks in the Greek War of Independence was much admired and was reproduced in an engraving.

Hall was reportedly besieged with commissions from distinguished New York families, her group miniatures bringing the high price of five hundred dollars.[10] As befitted a "proper lady," she never appeared at meetings of the Academy except on the one occasion when she was requested to attend because the men lacked a quorum on an urgent vote.

Ann Hall's work was admired in her own period for its delicate style, although today it may seem overly permeated by the "pretty" religiosity of the Guido Reni tradition of madonnas and children. Modern taste veers toward the less sentimental strength and honesty of Sarah Goodridge.

A rare full-sized oil composition shows Hall at work with the paraphernalia of an itinerant artist in the living room of her sister's home, surrounded by three generations of family members. She never married, and died in the New York home of her sister and brother-in-law, Eliza and Henry Ward, at the age of seventy-one.

Sarah Perkins (1771–1831), of Plainfield, Connecticut, painted a number of pastel portraits, mostly of her family, in the 1790s when she was in her twenties. Like many women of her day, she was probably too burdened with family responsibilities in later life to continue with creative work.

Her mother died of tuberculosis when she was twenty-four, and she took charge of seven younger children. Her father died four years later, leaving her the sole support of the large family. In 1801 she married General Lemuel Grosvenor, a widower with five children, and went on to have several children of her own, bringing her total responsibil-

ity to sixteen.

The pastel portraits of her early youth show such competence that it has been suggested that she received training from Joseph Seward in nearby Hampton. Her father was the proprietor of the Plainfield Academy in Connecticut, and she may have studied there. Her sturdy characterizations show strong, three-dimensional modeled forms—in contrast with most folk artists, whose works tend to be flat.

Jane Stuart (1812–1888) or "Miss Jane," as she was fondly called by wealthy Newport, Rhode Island society in her declining years, was the youngest daughter of Gilbert Stuart, the famous portraitist of George Washington. Jane was eager to learn the family trade, but her caustic and temperamental father refused to give her any training, preferring to keep her as an assistant to grind his colors and fill in his backgrounds. Asked why he did not instruct his daughter, he replied, "When they want to know if a puppy is of the true Newfoundland breed, they throw him into the river; if true, he will swim without being taught."[11]

As a child, Jane Stuart snooped eagerly when her father was instructing artists, storing up many things he said to them. She never dared interrupt him in his studio when he was working, and was likewise forbidden to enter in his absence. Her father, who laid out his tools in a meticulous arrangement, noticed at once if any of his equipment had been handled. If it had, he flew into a rage, especially if anyone had touched his precious brushes, which he pampered and cared for with loving attention.

Yet, there is evidence that Stuart was secretly "very vain of her genius."[12] One day Jane Stuart stumbled over a portrait lying unstretched on the floor of the attic. Enchanted, she could not resist starting a copy and was terrified when her father's steps approached the door. Unexpectedly, he merely said, "Why, Boy, you must not mix your

Fig. 3-4. Jane Stuart, SCENE FROM A NOVEL: OR A SUBJECT FROM LITERATURE (1834), oil on canvas, 36" × 28"

colors with turpentine. You must have oil.''[13] Then he dashed out again.

Her famous father died penniless when she was sixteen. Although she was the youngest in the family and had only the most rudimentary training, necessity made Jane an instant professional and the sole support of her mother and three sisters. She set up a studio in Boston, painted miniatures and portraits in oils, and made endless copies of her father's famous paintings of George Washington.

She was commissioned to copy his classic *Athenaeum* portrait *ad nauseum,* as were many other leading artists of the early republic. Poor copies are often mistakenly attributed to her. Several fine versions, one in the Kennedy School of Government, Harvard, show that she actually made some of the best copies. She pointed out that her work was often mistaken for her father's and sold as his by unscrupulous dealers unless she discovered the deception and put a stop to it.[14]

Her painting *A Scene From a Novel* (1834) shows a quaint, independent narrative style with romantic literary content and stylized oval forms. Other portraits, such as *Caroline Marsh* (c. 1840), have a certain stiff charm and are totally different from her father's polished work. Unfortunately, her Boston studio burned down in the 1850s, destroying much of her work and almost all of the correspondence and mementos of her father's life.

She spent her later years in Newport, where she was a colorful personality, telling fortunes, match-making, and reminiscing about life with her father for *Scribner's Monthly* magazine.[15] She looked and acted uncannily like Gilbert Stuart, and teased her mother to distraction as he had. Her most sardonic humor, however, was turned upon herself. Her father's bold features were, as she was the first to say, ugly on a woman. She described herself as too homely to get married and delighted in telling a story that pointed up her unattractiveness: One evening, walking to a friend's house in Newport, she heard footsteps behind her and realized that a man attracted by the rear view of her fine figure and small, elegant feet, was following her. She turned on him as they approached a corner street lamp, revealing her face. According to her own words, he slunk away exclaiming "an angel to chase; a devil to face!"[16]

Yet her droll wit and proud bearing made her a favorite at Newport's social affairs. She "faced down the [Newport] millionairesses in their diamond tiaras wearing a tiara she had self-manufactured from black velvet and artificial pearls."[17] With cheerful self-mockery, she turned up at a charade party dressed as "The Missing Link," a gorilla in a bearskin. But later in the evening she reappeared dancing proudly in a fancy court dress, masquerading as one of Cinderella's

ugly sisters, "with a flower-filled brass candlestick placed as chief ornament on the top of her head."[18]

The poignancy of her position as an impoverished and elderly spinster, despite her long career and acquaintance with many of the celebrities of her day, was revealed when the house she and her sister had been renting for years was sold out from under them. A few wealthy friends quietly took up a collection and bought them the small home in Newport in which they passed their last years.

Sarah Goodridge (1788–1853), of Templeton, Massachusetts, evidently rated more artistic attention from Gilbert Stuart than his own daughter. He frequently instructed Goodridge and permitted her to paint a famous miniature of him from life.

Unlike Ann Hall and Jane Stuart, who came from sophisticated homes, Sarah Goodridge grew up on a farm; she scratched her earliest pictures with a pin on sheets of peeled birch bark and drew with a stick on the sanded kitchen floor. She was the sixth of nine children of Ebenezer and Beulah Goodridge.

As a child, Goodridge began to sketch recognizable likenesses of her friends at the local district school. At the age of seventeen, while keeping house for her oldest brother in Milton, Massachusetts, she attended the local boarding school for a few months, and after moving with him to Boston, received a few art lessons. For the most part, however, Goodridge taught herself to paint miniatures on ivory by following the instructions in a small booklet.

She taught school for two summers in her hometown of Templeton. During the third summer, with only this primitive training, she settled into a career as an artist. She made portraits of her friends, charging fifty cents for a large crayon drawing and $1.50 for a watercolor. Goodridge then became a housekeeper for another brother, but continued to paint. After an artist from Hartford gave her a few more lessons in miniature painting in watercolor on

Fig. 3-5. Sarah Goodridge, PORTRAIT OF GILBERT STUART (c. 1825), miniature on ivory

ivory, she opened a studio in Boston in 1820, and moved in permanently with her sister Beulah and brother-in-law Thomas Appleton, an organ builder.

The meeting with Gilbert Stuart in 1820 was the turning point of her life. Her younger sister and biographer, Eliza Goodridge Stone (also a miniaturist), described this encounter in a sketch written for a book on Stuart:

Mr. Stuart was taken to Miss Goodridge's painting room, and introduced to her by a mutual friend. He seemed pleased with her work, and gave her an invitation to his studio. She went frequently, and carried, by his request, her unfinished pictures, in their various stages, for him to criticize. At such times he gave her many hints, for which she was very grateful, for it was the most useful instruction she had ever had. She was wanting in a knowledge of

perspective, and Stuart advised her to go to Mr. David L. Brown's drawing-school. Heads, and heads only, she loved to paint.[19]

Jane Stuart reported the events surrounding Goodridge's famous miniature of Stuart in *Scribner's Monthly* magazine (July 1877):

My mother, being very much dissatisfied with the portraits painted of Stuart, implored him to set to Miss Goodridge, the miniature artist; and, as she was a great favorite of his, she would frequently invite her to the house, hoping he could be induced to sit to her. One afternoon he said, 'Goode, I intend to let you paint me.' She then came prepared, when he gave her every advantage, considering how much he disliked what he called 'having his effigy made.' It is the most lifelike of anything ever painted of him in this country, although the expression is a little exaggerated.[20]

"Honest" might be a more appropriate word for Goodridge's depiction of the great master. Although "she worshipped his genius," she seems to have caught the spirit of the choleric, whimsical, practical-joking, snuff-addicted Stuart more accurately than his daughter's idealized version. Gilbert Stuart was so pleased with this unflattering 1825 portrait that he preserved it in a bracelet with his own and his wife's hair. The miniature was engraved by Asher Durand for the National Portrait Gallery, and Goodridge painted two replicas, which are now in the Metropolitan and Boston Museums.

Goodridge's talents had developed so much under Stuart's instruction between 1820 and 1824 that she was commissioned to paint Daniel Webster (c. 1826), General Henry Lee, and many others. Her work has a directness and force that contrasts with the fragile loveliness of some of her contemporaries, such as Ann Hall. She is regarded today as one of the most distinguished American miniaturists of the nineteenth century.

A prolific artist who averaged about two miniatures a week, Sarah Goodridge supported her mother for eleven years, nursed a paralytic brother, and raised her orphaned niece, until her eyes failed her around 1850. According to her sister Eliza, she was amiable and generous to the point of impracticality. Nevertheless, the artist was so successful in her profession that, after many years of living in other peoples' houses, she was able to buy her own cottage in Reading, Massachusetts, in 1851. There she retired with the Appletons, leaving them a small legacy after her death.

Sarah Miriam Peale (1800–1885) was, in her time, the leading portrait painter of Baltimore and St. Louis. Frequently referred to as America's first truly professional woman artist, she supported herself with great success for sixty years, entirely with her craft. She learned her trade in Philadelphia from her father, James Peale, and was also encouraged by her famous uncle, Charles Willson Peale, the leader of a dynasty of "Painting Peales."

Much has been written about the Painting Peales and even about the "female painting Peales."[21] Sarah's famous Uncle Charles named his children, optimistically, after great artists. Four of his sons were called Raphaelle, Rembrandt, Rubens, and Titian Peale; four of his girls were Sophonisba Anguisciola, Angelica Kauffmann, Rosalba Carriera, and Sybilla Miriam Peale[22]—all noted women artists of earlier times. Charles Willson Peale was a leading artist, scientist, and patriot who had studied painting with Benjamin West in England and had met Angelica Kauffman, the internationally famous woman artist of the eighteenth century.

An extraordinarily enlightened man in many ways, Charles championed the equality of the sexes. He once wrote his daughter about a series of his lectures in which he was "launching forth to prove that the female sex has been absurdly called 'the weaker vessel.'"[23] Charles sponsored his niece Sarah by bringing her with him several times to important social events in Washington, D. C., where she charmed capital society with her elegance and gracious manners, and made important professional contacts.

Sarah's father James, a Philadelphia miniaturist and still-life painter, gave all his children art lessons. Two other girls in the family achieved distinction with "lady-like" miniatures and still lifes, but some mysterious chemistry of pluck and talent prompted the lively "Sally" to move beyond these limits and decide at eighteen to do larger works on canvas—an unusual preference for a woman at that time. Her style became much more vigorous than her sisters'.

Sarah's first large painting was a self-portrait in 1818. Historian Charles Coleman Sellers reports that her father mixed her paints and left the room. When he returned to find a picture of a flirtatious-looking, bright-eyed girl with a head full of curls, leaning forward, bust swathed in loose red draperies, he is reported to have sputtered, "Damn it! Why didn't you do as I told you?"[24] On the other hand, her uncle Charles declared it to be "wonderfully like."[25]

In any era, families of painters constitute a kind of community, and the Peales were no exception. Sarah was friendly with the Sullys, another distinguished American painting family. Thomas Sully, who encouraged his own daughter's talents, took Sarah and her older sister Anna to hear lectures on artistic anatomy, a subject generally closed to women in that prudish era. Of the "painting Sullys," Blanche, Ellen, Rosalie, and Jane all became painters. Sarah and Anna Peale exhibited at the Pennsylvania Academy and were the first women elected academicians in 1824. Jane Sully was elected in 1831.[26]

In 1825 Sarah left Philadelphia and settled in Baltimore. During the next twenty-one years she painted more than a hundred of its leading citizens, including a posthumous picture of mayor John Montgomery, for which she received one hundred dollars from the city. Although she was competing with many of the leading male painters of her day—Jacob Eichholtz, John Wesley Jarvis, Thomas Sully, and others—she painted far more Baltimore portraits than any other artist.

Even though she was quite well connected, commissions did not simply fall into Sarah Peale's lap; a certain amount of initiative was required. For instance, during the much publicized U.S. visit of the Marquis de Lafayette in 1824, she wrote to him soliciting a commission. As a result, he invited her to Washington and sat for her four times. Unfortunately, this painting is lost.

In the 1840s, Peale painted portraits of such famous Washington politicians as Daniel Webster, Senator Thomas Hart Benton, and Senator Henry A. Wise.[27] Her sitters look respectable, cheerful, well-to-do, optimistic, and intelligent. They have a typically American air of down-to-earth propriety and seem entirely capable of building a new and rationally ordered nation. Very often, they appear about to smile.

In her early portraits there is a strong feeling for decorative design that almost clashes with the literal realism of her approach. This emphasis on decorative detail and rhythmic line distinguishes her from the other Peales; in fact, she surpassed her father in fine rendering of lace, furs, jewels, and so forth. Her style synthesizes two generations of Peale artists. The firm drawing is clearly derived from her father and uncle, while her richer color and technique of glazing (particularly translucent white over purple) was perhaps learned from her European-trained cousin Rembrandt during a three-month period of study with him in Baltimore.[28]

Sarah Peale looks out at us from a later *Self-Portrait* (c. 1830) with a bright, sharp-eyed, down-to-earth, attractive face. Her uncle said of her that "she broke all the beaux's hearts but as usual would have none of them."[29] Apparently, she chose to remain single in order to pursue her craft, and in this she took a path also chosen by other famous women artists of the nineteenth century such as Harriet Hosmer and Rosa Bonheur. These women made a decision that marriage, and especially motherhood

Fig. 3-6. Sarah Miriam Peale, MRS. RICHARD COOKE TILGHMAN
(c. 1830), oil on canvas, 30½" × 25½"

in a period before reliable contraception, would prevent them from pursuing their careers.

In 1846, when Peale experienced poor health, Senator Trusten Polk and others persuaded her to visit their town, St. Louis. She decided to settle there and was universally recognized for thirty-two years as the city's leading portrait painter. Toward the end of her life, she turned increasingly to still-life painting and won prizes at the St. Louis fairs (in 1859, 1861, 1862, 1866, and 1867). The evolution of Sarah Peale's still lifes reflects the change in American taste; the early Baltimore table-top fruit paintings are tight and precise, imitative of Charles Willson and James Peale. Responding to the Romantic era, the later ones are more loosely painted, and the subject matter is often out of doors, on the ground, or hanging from a branch. Similarly, her portraits range from the elegant and precise neoclassical studies of her early career to the more down-home interpretations of the Jacksonian era.

In 1878 Sarah returned to Philadelphia to share the home of her older sisters Margaretta and Anna (widowed after the death of her second husband). Sarah outlived her sisters, painting principally still lifes, and died peacefully in Philadelphia in her eighties.

Anna Claypoole Peale (1791–1878), Sarah's older sister, assisted her father James with his miniatures as his eyesight began to fail, and helped him with backgrounds of canvases. She remained primarily a miniaturist, of whom her uncle Charles wrote to his own daughter, "Her merit in miniature painting brings her into high estimation, and so many Ladies and Gentlemen desire to sit to her that she frequently is obliged to raise her prices."[30]

When her generous uncle brought Anna to Washington and shared a studio with her, to his surprise, she attracted more commissions than he did.[31] Some of their sitters were Andrew Jackson, Henry Clay, and President James Monroe. The two artists breakfasted with the President and attended glittering receptions at the White House. But there was much more work than play. According to a contemporary account, "So incessant was her (Anna's) application to work" during this 1819–20 period "that during the summer she was obliged to travel for the recovery of her health and to give rest to her eyes. Several times they were attacked with inflammation and at one time she had cause to dread the total loss of sight."[32]

Anna Peale developed a sprightly style of painting miniatures. She emphasized the lively skin tones of the subject with a rich, dark background, and created a sense of warmth and intimacy sometimes lacking in her father's ivories.[33] The complex variety of brush strokes produced the effect of tiny oil paintings. She sometimes shared the commissions with Sarah—Anna did the miniatures and Sarah painted the larger canvases.

Anna Claypoole gave up painting briefly after her first marriage, in 1829, to the Reverend Dr. William Staughton, a Baptist minister and college president. When he died three months later, she resumed painting vigorously, but again stopped her work when she married General William Duncan, "a gentleman highly esteemed in social life," in 1841. Outliving her second husband as well, she continued painting miniatures in Philadelphia until late in life. The contrast between the career of the twice-married Anna, who automatically interrupted her professional life after each wedding, and the uninterrupted professional life of the unmarried Sarah, shows the heavy hand of the social mores of the day, even in the forward-looking Peale family.

Margaretta Angelica Peale (1795–1882), another of James Peale's daughters, was a talented still-life painter, who is discussed later in this chapter.

Mary Jane Simes (1807–1892), granddaughter of James Peale, was the protégée of her talented aunts, Sarah and Anna, and carried the miniature painting tradition of the Peales into the third generation. Dunlap, the American Vasari, wrote that "Mary

Jane Simes, herself a living miniature, rivals her aunt in the same style."[34]

Mary Jane lived for a while with her widowed mother and her aunt Sarah in Baltimore. She was also, according to author Elizabeth Ellet, Anna Claypoole Peale's only student. Her miniatures are similar to Anna Peale's, but are slightly more primitive and harsher in color. She exhibited in Philadelphia and Baltimore between 1825 and 1835, but ceased painting after marrying Dr. John Yeates, with whom she had four children.

Mary Jane Peale (1827–1902), daughter of Rubens Peale, studied with her uncle Rembrandt and Thomas Sully. Her father's eyesight was poor, and unlike the other Peales, he was not a painter. When his museum business failed, he retired to a farm in Pennsylvania, and Mary Jane, who had been building a career as a portrait painter in New York, returned to care for her aging parents.

In an amusing reversal of Peale tradition, *she* taught her father to paint. He became an elderly "primitive," but joining him in still-life painting, Mary Jane produced her most sophisticated works—misty flower studies, with a distinctive personal quality that has been compared to Odilon Redon.[35]

Other "Painting Peales"

Maria Peale (1787–1866), Rosalba Carriera Peale (1799–1874), an early lithographer, Emma Clara Peale (1814–?), and Harriet Cany Peale (c. 1800–1869) wife of Rembrandt Peale, also became artists—all products of the liberated and encouraging Peale family.

Genre Painting

Let not my justice, gallantry and wit,
A Lilly Martin Spencer here omit.
The humor of the lower life she shows
Wherein but few superior she knows.[36]
 John Frankenstein, *American Art: Its Awful Attitude: A Satire* (1864)

Lilly Martin Spencer (1822–1902), the outstanding female genre painter of the Golden Age, was a prodigy from Marietta, Ohio, whose scenes of every day family life and sentimental subjects were widely reproduced in engravings and lithographs. At the height of her popularity, her paintings sold for as much as those of George Caleb Bingham, a leading male genre painter. In addition to an enormous output of paintings, she bore thirteen children (seven of whom survived) and supported all of them, as well as her husband, at her easel.

The atmosphere surrounding her childhood and early youth included the same element of vigorous encouragement from a liberated father that feminist historians have uncovered in the histories of many leading women artists of early times.[37] Gilles and Angélique Martin were French intellectuals who went from Brittany to Exeter, England, where Lilly was born. In 1830 they immigrated to the United States with the idea of forming a utopian colony of families. They were idealists and reformers, active in support of the three main causes of the century: abolitionism, women's rights, and the temperance movement. Gilles Martin strongly supported and encouraged his daughter's talent—going so far as to leave his family in Marietta, at one point, to accompany her to bustling Cincinnati, remaining there with her so that she could study art.

As a child, however, Lilly Martin was educated at home. The Martins had an extensive library from which she acquired knowledge of Shakespeare and the classics, which in later years provided imaginative material for her paintings. She is described as "a strong fervent energetic child, with jet black hair,

large black flashing eyes, bold forehead, wild as the deer on the hills and as full of joy and gladness as the grey squirrel that bounded limb to limb in the great walnut by the brookside not far from her father's door."[38]

Her talent revealed itself at an early age. At seventeen she covered the plaster walls of her family home, Tupperford Farm, with charcoal murals that included full-sized portraits of the family, "a view from a public piazza out upon a water scene bordered by hill and dale." Also, there were figures "shaded and finished in the most exquisite manner . . . some talking politics and some making love."[39] This description in the local newspaper also mentioned several domestic scenes—a boy teasing a cat, a child taking his first steps, a woman baking bread with her hands in the dough. It is pleasant to speculate on the character of a family that permitted its walls to be covered with charcoal murals. These works soon became a tourist attraction for the surrounding area.

In 1841 Lilly Martin held her first public exhibit of paintings in the local Episcopal church, charging a twenty-five-cent admission fee to raise funds for her education. This exhibition attracted so much attention from critics that the wealthy Cincinnati patron of the arts, Nicholas Longworth (who sponsored some of America's most famous artists of that period), offered to finance her training in Boston and Europe, but she refused his offer. Many have conjectured about the reason she turned down such an important opportunity. Longworth reportedly stipulated that she would have to study for seven years with European masters before exhibiting her work. Many American artists of the time were trying to build a native tradition and objected to "foreign" training.

After lessons from local painters, Lilly Martin studied briefly with James Beard and John Insco Williams in Cincinnati, mastered the bare rudiments of oil painting, and soon surpassed her teachers, whose work was somewhat stiff and pro-

vincial. She wrote home to her mother, "I work at my painting from morning 'til night," adding that Cincinnati was "literally full of portrait painters who are set up with their sign . . . and all that, but I shall beat them all, I hope one day."[40]

In 1844 she married Benjamin Rush Spencer, a sweet-natured man with whom she shared forty-six years in an unusual marriage. Benjamin Spencer, recognizing soon after their marriage that his wife would be the breadwinner of the family, took over many of the domestic duties of hearth and home, and assisted her in the business side of her work.

For a few struggling years she exhibited wherever she could—the Cincinnati Society for the Promotion of Useful Knowledge, the Young Men's Mercantile Library, and even at art supply stores. In 1847 she wrote her mother that her prospects looked much brighter. A sudden increase in her income came from painting sales through the Western Art-Union in Cincinnati. For five dollars this organization gave subscribers an engraving of a painting by an American artist and a chance to win an original oil in a lottery drawing.

The New York and Cincinnati Art-Unions, although obviously commercial and sometimes vulgarizing in their effects, generated a large number of sales and reached a wide audience for American artists. The works were displayed in advance of the lottery and were widely publicized. The Art-Unions flourished until they were declared to be illegal gambling promotions in 1852.

In 1848 the Spencers moved to New York City to "very comfortable lodgings over a cofin [sic] store in a very eligible situation on broadway."[41] Lilly Spencer wanted to seek fame in the main center of galleries, art schools, and patrons. Yet soon, she found herself competing with polished, European-trained peers. She wrote to her mother that New Yorkers were severe critics. She suddenly felt inferior and would have to study very hard to catch up: "I do not actually get half as well paid for my works, than I did west, and however have to do ten

times better work."[42]

In spite of a growing family and the grinding labor of painting all day to support her husband and many children, she took night classes at the National Academy of Design to improve her drawing and knowledge of perspective.

At first Spencer aspired to allegorical and Shakespearean subjects, but convenience and public demand soon led her to make use of her family as the models for domestic, sentimental scenes, such as *The War Spirit at Home, Celebrating the Victory at Vicksburg*. Her drawing and technique improved under the double spur of lessons and close study of works in the New York galleries.

In 1854 the Cosmopolitan Art Association began to promote her work. Praising her painting *Shake Hands?* (1854), the Association declared that it was like "the incomparable pictures by the Flemish artists."[43] This reference to "the Flemish artists" is significant—the Art Association had bought the entire Düsseldorf Gallery of German works and informed the public that the American painters would have the "privilege of competing with the Düsseldorf pictures, for popular favor."[44]

The engravings and lithographs sent to subscribers by art unions and the Cosmopolitan Art Association spread Lilly Spencer's fame and made her name a household word. Since she received no payment, however, she mused wryly that "fame is as hollow and brilliant as a soap bubble, it is all colors outside, and nothing worth kicking at inside."[45] Such sad phrases are in marked contrast to the earlier, gushing letters to "Dear Ma"—in which she speaks of her great aspirations. Although she was exhibiting at the prestigious National Academy, she and her husband were nevertheless frantically pursuing every avenue for commercial sales to provide for their many children.

In such paintings as *Fi! Foe! Fum!* (c. 1858), *Picnic, Fourth of July* (c. 1864), and *Shake Hands?* Lilly Martin Spencer achieves the level of excellence of our best American genre painters. With frank good humor and close observation, she portrays both the warmth and the din of family life. There is a refinement of paint quality and design, and a subtlety of color and form in the still lifes that can be likened to that of Dutch artists of the seventeenth century.

One cannot help comparing some of Spencer's domestic scenes with those of the French painter Jean-Baptiste Simeon Chardin. *Shake Hands?* has a Chardin-like subject—a housemaid with floured hands, standing amidst a beautifully rendered kitchen scene of metal pots, fruits, and meats. Unlike Chardin, however, Spencer has her smiling housemaid reaching out toward the viewer, addressing the audience with ingenuous friendliness. The painting captures the flavor of Jacksonian democracy, deliberately breaking down class distinctions and reducing artistic "distance."

Spencer's *Picnic, Fourth of July*—a complex composition of many figures organized in a mean-

Fig. 3-7. Lilly Martin Spencer, THE WAR SPIRIT AT HOME. CELEBRATING THE VICTORY AT VICKS-BURG (1866), oil on canvas, 30″ × 32½″

Fig. 3-8. Lilly Martin Spencer, FI! FO! FUM! (1858), oil on canvas, 35⅞" × 28⅝"

dering S-curve against a beautiful painted setting of river and park-like meadow—preserves the rural charm of the United States at mid-century. The central figure is her lifelong model, her husband Benjamin Rush Spencer. Shown in the portly form of middle years, he has just tumbled on the ground from a swing, while friends, children, animals, and servants are grouped in various attitudes of work and play. Spencer's work was uneven in quality, however, and certain paintings are flawed by the weak draftsmanship that concerned her so much.

As the years passed, Lilly Martin Spencer's efforts became a grinding labor with lessening reward. Photography had increasingly usurped portrait commissions, and the native scene was no longer popular with the art-buying public. Collectors were looking toward Paris and other European centers for art.

Late in her life many of her works were auctioned for as little as ten dollars, and at the end she bartered works for bread to keep alive. A poignant photograph shows her, white-haired, bent over her easel with a work in progress the day before she died at the age of eighty.

Herminia Borchard Dassel (?–1857) was born in Germany and achieved success in America with paintings of literary subjects, genre scenes, and portraits. Her father was a wealthy banker in Königsberg, Prussia, and as a child Herminia Borchard was surrounded by servants, teachers, horse-drawn carriages, and all the trappings of European upper-class society. When her father was bankrupted in the crash of 1839 and left with only a small farm, she was forced to help her older brothers and sisters with the chores.

At this time Herminia decided to become a professional painter:

> She would attend to her household duties in the morning and then, with port-folio in hand, wander off over the dusty or muddy road to the city, and again returned to attend to the flowers and cabbages, and the making of cheese and butter.[46]

Her early education undoubtedly included drawing lessons, and she quickly secured a commission to paint a full-sized portrait of a local clergyman. "This she painted in the church with her model on the altar,"[47] while the country folk gawked with amazement.

An exhibition of painter Carl Sohn's work inspired her to go to Düsseldorf to study with him for four years, supporting herself with the sale of paintings of peasant life. Düsseldorf was at that time the center of the school of anecdotal and historical painting, which also attracted American artists like Emanuel Leutze, painter of *Washington Crossing the Delaware* (1851).

After returning to Königsberg, Borchard reportedly managed to save up a thousand dollars by painting portraits, and set off on a tour of Italy escorted by her brother. A somewhat sensational account of her journey describes the bold-spirited artist picking up models in the streets of Vienna and bringing them to her room to pose—a rather daring activity for a woman of that day.

She was studying in Italy when the Italian Revolution of 1848 broke out. Although her brother returned to Germany, she decided to immigrate to the United States, against the pleas of family and friends who begged her not to expose herself to the hazards of a sea voyage and an unknown country. She arrived in America in 1849 with a letter of introduction to "Mr. Hagedorn,"[48] a Philadelphia art patron and began immediately to exhibit scenes of Italian peasant life at the American Art-Union in New York and at the National Academy.

Borchard was apparently very personable and able to make her way easily in foreign countries. Five months after her arrival in America she married a Mr. Dassel, and despite "the cares and sorrows incidental to the care of a family, and to an arduous profession,"[49] she continued a successful career. Exhibiting steadily, she painted portraits of wealthy New Yorkers and their children, literary subjects such as *Othello,* and continued her genre painting.

Instead of painting Italian peasants, however, Herminia Dassel switched to America's exotic "peasants"—the Indians. Along with artists like George Catlin and Alfred Jacob Miller, she responded to the public's fascination in this period with the romance of the noble, but tragic Native American. She visited Nantucket in 1851 and painted *Abram Quary, the Last Indian on Nantucket Island (1851).* He is shown seated in his small hut, tame and barefoot, in conventional clothing, with a basket of newly gathered herbs at his feet. His civilized shoes are placed to one side on the floor, suggesting that they hurt his feet. Through the window the white man's sailing ships and buildings can be seen in the harbor.[50] Dassel's portrait of a dark-eyed *Nantucket Indian Princess* is another sympathetic portrayal.

During her visits to Nantucket, Dassel also painted a portrait of Maria Mitchell, America's famous woman astronomer, gazing through her telescope, and another composition showing Mitchell's sister Kate assisting their father with his celestial observations (1851).[51] Dassel's work was typical of the industrious genre painters who were very successful in the middle of the nineteenth century before photography overwhelmed the field of image-making, and before collectors began to scorn American art, and go to Paris and Italy for their purchases.

Fig. 3-9. Herminia Borchard Dassel, ABRAM QUARY, THE LAST INDIAN ON NANTUCKET ISLAND (1851), oil on canvas, 33" × 30"

History Painting

History painting played a part in the art of the Golden Age, for the obvious reason that it memorialized America's heroes and glorified the young nation in narratives on the walls of public buildings. Paintings like Emanuel Leutze's *Washington Crossing the Delaware* (1851) created symbols that continue to live in the American consciousness. Although it was very difficult for a woman to get the necessary training in anatomy and life-drawing that such compositions demanded, there were a few women painters in this genre.

The term *history painting* also applies to ambitious mythological, biblical, and allegorical works. The popularity of such paintings, sometimes called "machines" because of their large size and complicated trappings of ancient costumes, furniture, and architecture, reached an apogee in the Paris Salon of the nineteenth century.

Cornelia Adele (Strong) Fassett (1831–1898) achieved prominence with her major work, *The Electoral Commission in Open Session* (c. 1879), which hangs in the U.S. Capitol. Clara Erskine Clement wrote in 1904, "No picture in the capitol attracts more attention, and large numbers of people view it daily."[52]

Cornelia Strong was born in Owasco, Cayuga County, New York, the daughter of Captain Walter and Elizabeth (Gonsales) Strong. At age twenty she married Samuel Montague Fassett, an artist and photographer. She studied watercolor painting in New York City with the Englishman J. B. Wandesforde and apparently spent three years after her marriage studying drawing and oil painting with Castiglione, La Tour, and Matthieu in Rome and Paris.[53]

In 1855 the Fassetts moved to Chicago, and during the next twenty years Cornelia Fassett painted prominent Chicago citizens and had seven children, while her husband ran a photographic studio. In 1874 she was elected an associate member of the Chicago Academy of Design.

In 1875 the Fassetts and their brood moved to Washington, D.C. Mr. Fassett had suffered losses in his photographic studio during the Chicago fire, but now got a job as a photographer to the Supervising Architect of the Treasury Department. The couple set up adjacent studios over a music store in a business building at 925 Pennsylvania Avenue. Cornelia Fassett painted such luminaries as Presidents Grant, Hayes, and Garfield, and Vice-President Henry Wilson. Her portrait of Supreme Court Justice Waite was displayed at the Philadelphia Centennial Exposition of 1876. She was elected to the Washington Art Club, and her studio entertainments reportedly became an important part of the social life of Washington.

Fassett's imagination was seized by a historical event that she decided to memorialize in a large painting. When the Hayes-Tilden presidential election was declared a tie, it had to be referred to a fifteen-member electoral commission for final decision. Feeling ran high in the country, and the debate itself was a dramatically charged event. Although the government did not commission the painting, she obtained permission to pose the participants in the old Supreme Court chamber where the debate took place. Her large canvas, *The Florida Case in Open Session Before the Electoral Commission, February 5, 1877*, shows William M. Evarts making the opening argument in the chamber before a large and distinguished audience of Washington notables. Fassett painted more than two hundred individual portraits in the work over a period of several years, both from life and from portrait photographs taken by her husband.

While the work was in progress, the *New York Arcadian* reported:

Her great work, the Electoral Commission, . . . is slowly approaching completion. . . . The large number of people present are naturally . . . grouped. There are in the

crowd ladies enough in bright colors to relieve the somberness of the black-coated men, and the effect of the whole picture is pleasing . . . aside from its great value as an historical work.[54]

After the completion of the painting in 1879, there was considerable debate and controversy over whether the government should buy it. It was finally purchased in 1886 for $7,500 (the $15,000 price reported in several books of the day is inaccurate), and was placed in the northeastern corner of the Senate wing of the U.S. Capitol.[55]

In 1903 *Pearson's Magazine* described the painting as follows:

As you face the picture, the portraits of two-hundred and fifty-eight men and women, who twenty-six years ago were part of the legislative, executive, judicial, social and journalistic life of Washington, look straight at you as if they were still living and breathing things. . . . Each face is so turned that the features can easily be studied, and the likeness of nearly all are so faithful as to be a source of constant wonder and delight.[56]

Fig. 3-10. Cornelia Adele Fassett, THE ELECTORAL COMMISSION OF 1877 (1879), oil on canvas, 61″ × 75″

This ambitious work—an extraordinary achievement for a woman of that period—appears a bit naive today. A pastiche of 258 faces, all in sharp focus whether near or far, it gives somewhat the effect of a giant rogue's gallery. In 1877 it was a *tour de force* of realism, very much in tune with the nineteenth century predilection for "casts of thousands."

Cornelia Fassett continued to paint private citizens, as well as government leaders. Her portrait of the New York historian Martha J. Lamb (1878) in her Victorian study has been described as capturing "the quintessence of upper-class American life. . . . The portrait of an energetic New York lady is like an illustration of an Edith Wharton novel."[57]

Cornelia Fassett continued a successful career, primarily painting miniatures in later years. She was hurrying from a Washington party to a later reception with one of her daughters when she was struck by a heart attack at age sixty-seven, leaving her husband and seven children as survivors.

Imogene Robinson Morrell (?–1908) was a history painter, highly praised in art books of the late nineteenth century, who created large patriotic "machines" with titles like *The First Battle Between the Puritans and the Indians* and *Washington and His Staff Welcoming a Provision Train at Newburg, New York, 1778* (1874).

Born in Attleboro, Massachusetts, to Otis and Sarah Dean Robinson, she began to study art at sixteen in Newark, New Jersey, and New York City. In 1856 she went to Düsseldorf to study with Adolf Schroedter and Camphausen, the court painter.

While teaching at Lasell Seminary in Auburndale, Massachusetts, in the 1850s, Robinson became a friend of her talented student Elizabeth Gardner (later the first American woman to win a gold medal at the Paris Salon). For a short while the two women ran a School of Design at Worcester and then sailed to France together in 1864.

Robinson studied privately with Thomas Couture

and painted patriotic pictures containing figures, horses, and other ambitious subject matter. Even the Franco-Prussian War and "its horrors had not power to draw her from her work."[58] She reportedly enjoyed the friendship of Meissonier, Bouguereau, and other Paris artists.

She married Colonel Abram Morrell in 1869 and a few years later returned to the United States to live in Washington, D.C. On the way to Washington her history paintings were exhibited at the Mechanics Fair in Boston and at the 1876 Philadelphia Centennial Exposition, winning medals in both places. The *Boston Journal* said that they "show great genius, inspired by patriotic enthusiasm. . . . Each figure and every animal was painted from a living model."[59]

Her art was also described glowingly in the press at the time of the Philadelphia Centennial:

In the painting of the horses, Mrs. Morrell has shown great knowledge of their action, and their finish is superb. The work is painted with great strength throughout, and its solidity and forcible treatment will be admired by all who take an interest in revolutionary history. . . . In the drawing of the figures of Standish and the chief at his side, and the dead and dying savages, there is a fine display of artistic power, and the grouping of the figures is masterly. . . . In color the works are exceedingly brilliant.[60]

In 1879, less than ten years after their marriage, Morrell's husband died and she fell upon hard times. That year she opened a school in Washington ambitiously called the National Academy of Fine Arts, but it failed. She apparently expected the gov-

Fig. 3-11. Cornelia Adele Fassett, MRS. LAMB IN HER STUDY (1878), oil on millboard, 15¼" × 24¼"

ernment to buy her patriotic paintings for the U.S. Capitol, but this did not happen, and they languished instead in a Washington warehouse, where in 1886 two hundred paintings were destroyed by fire. The government, however, did purchase a portrait of General John A. Dix (1882), which now hangs in the Capitol building.

In a lurid article in the *Washington Post* on 23 November 1908, the day after her death, friends claimed that Morrell had been wealthy, but that her property had disappeared "after she had put her business in the hands of incompetent advisors." According to this article, she was literally thrown out on the street at one point, but was saved by the charity of Elizabeth Gardner, who had become a famous expatriate artist. Gardner sent her old friend an allowance that allowed her to spend her last days in a run-down boarding house in Washington, reminiscing to her landlady about her halcyon days in Paris, when she was winning fourteen medals and was at her artistic peak.[61]

Ida Waugh (?–1919), a painter of religious and allegorical subjects, was selected, along with Mary Cassatt and Cecilia Beaux, for the Gallery of Honor in the Woman's Building at the World's Columbian Exposition in 1893. The Prang Chromolithograph Company commissioned her to paint sentimental compositions of children for their popular reproductions. She is named as a fine figure painter of the turn of the century in the book *Recent Ideals of American Art* (1890). And yet, her work has virtually dropped out of sight.

Both of Waugh's parents were Philadelphia painters. Her father, Samuel Bell Waugh, was a portrait and landscape painter, and her mother, Eliza Young Waugh, was a miniaturist. Records show that the artist was enrolled in the first ladies' life class at the Pennsylvania Academy in 1869, and was elected Associate member of the Pennsylvania Academy the same year. She exhibited portraits, history paintings, and allegories, as well as

sculptures, at that venerable institution from 1863 to 1905. Her work was shown in the 1876 Philadelphia Centennial Exposition. A reproduction of *Hagar and Ishmael* in *Recent Ideals* gives some notion of her style. Portraits by Ida Waugh are in the College of Physicians, Philadelphia, and at the University of Pennsylvania Museum.

Landscapes

Scenes of rural life painted through a golden mist of romanticism expressed deep optimism about the future of the new, free nation. The Westward movement opened up vistas of unprecedented scale and monumentality in the Grand Tetons, Yellowstone, and Yosemite, and offered a sense of limitless space available for restless spirits and brave hearts. Thomas Cole, Frederick Church, and Albert Bierstadt combined the American landscape vision with the arcadian dream of Europe. Women artists, too, responded to the American landscape with enthusiasm, although their ability to travel alone in the wilderness was restricted and undoubtedly hampered full participation in this genre.

Charlotte Buell Coman (1833–1924) helped bring the Barbizon landscape tradition from France to America, and over a long career developed into a *tonalist* painter, famous for her misty "blue" scenes. Although she began to paint seriously at the relatively late age of forty, she continued into a triumphant old age and was hailed at her death as the dean of American women landscape painters.

Born in Waterville, Oneida County, New York, where her father owned a tannery and shoe factory, Charlotte Buell married early, left her comfortable home, and traveled with her husband to the frontier town of Iowa City to live the rough life of a pioneer wife. But when he died a few years later, she returned to Waterville. In addition to the loss of her husband, Coman suffered another severe blow during these early years—she became almost totally deaf.

Refusing to wallow in self pity, Coman decided that she could not live an aimless life and began to study art. By the age of forty she had made a serious commitment to professionalism. Despite this late start, and despite the fact that her hearing was severely impaired, she continued to develop and absorb new ideas until she was ninety. She remained a person noted for her wit, good humor, and charm, and could even joke about her handicap. In a late interview, Coman bantered that there were some advantages to being hard of hearing—she was saved from attacks by the critics because they were embarrassed to shout caustic remarks loudly into an ear trumpet!

Coman's first teacher was James Renwick Brevoort of New York City, a successful landscape painter and member of the National Academy, who used the careful, detailed technique of the Hudson River school. This training was followed by approximately ten years of study abroad, first in Paris (with Emile Vernier and with the English landscape painter Harry Thompson) and later in Holland. Greatly influenced by the French Barbizon painters Jean-Baptiste Corot and Charles-François Daubigny, Coman began to emphasize light and atmosphere, and to work in a broad, brushy manner, eliminating unnecessary details. In 1875 she was already exhibiting at the National Academy of Design in New York, and her painting *A French Village* won loud praise at the 1876 Philadelphia Centennial Exposition. Her canvases of those years, listed in *Appleton's Cyclopedia* (1888) and other books, have typical Barbizon and *plein-air* titles such as *Near Fontainebleau* (shown at the Paris Exposition of 1878), *Peasant Home in Normandy, Sunset at the Seaside, France,* and *Old Windmills in Holland.* Critics frequently compared her works to those of Corot.

After returning permanently to the United States in the early 1880s, Coman set up her studio in New York and turned away from European subjects, devoting herself entirely to the American landscape.

Influenced by the tonalist movement, she now tried to evoke a spiritual mood or atmosphere of reverie, using misty effects in close values, usually dominated by one hue—green or blue. Her color is described as "quiet, but of a subtle delicacy, pervaded with a fine poetical feeling."[62] This mood of "quietism" was a reaction by a group of artists in the 1890s against the crass materialism of the Gilded Age and the cacophony of industrialism that was inundating American life. Two of her good friends were the tonalist painters George Inness and Alexander Wyant, who appreciated her work so much that they both presented her with examples of their own work as tokens of their admiration.

Instead of painting intimate scenes of village or barnyard in rich color and impasto brushwork (*A Farmer's Cottage, Picardy, France* [1884]), Coman now began to paint broad, blurry vistas seen from overhead with a high horizon line. A typical work is *Early Summer* (1907)—a subtle harmony of thinly painted greens. Looking down into a misty valley, the viewer notices a blurred road rambling back to a few houses. *Clearing Off* (1912), in the Metropolitan Museum of Art, shows the mist rising as the sun begins to reach it. Though small in size, these panoramas are monumental in effect.

Coman won many awards (among them, the Shaw prize of the Society of American Artists, 1905, and the second prize at the Society of Washington Artists). She was elected an associate of the National Academy of Design in 1910 and was included in a Detroit exhibition of one hundred American artists selected as the best painters from current shows. Despite these successes, however, she always signed her paintings "C.B.Coman" and she is listed as "C. B." in the roster of the National Academy. Several other women—A. B. Sewell and R. E. Sherwood (Amanda and Rosina) also used their initials, no doubt because they wanted to avoid discrimination against women by male jurors of exhibitions. (Indeed, as late as the 1940s, Irene Rice Pereira was known as I. Rice Pereira and Grace

Fig. 3-12. Charlotte B. Coman, A FARMER'S COTTAGE, PICARDY, FRANCE (1884), oil on canvas, 23″ × 34″

Fig. 3-13. Charlotte B. Coman, EARLY SUMMER (n.d.), oil on canvas, 75.9 × 91.4 cm.

Hartigan signed her early work "George.")

Coman painted into her last years, ever-changing and growing. When told that she painted almost as well as a man she rejoined good humoredly, "Well, I should hope I paint better than most of them."[63] The book *Biographical Sketches of American Artists* reported in 1924 that she had been doing her best work after reaching the age of eighty. However, after her death, her work dropped into obscurity until the feminist wave of the seventies brought it to light again in such exhibitions as "Nineteenth Century American Women Artists" at the Downtown Branch of the Whitney Museum in 1976.

Fidelia Bridges (1834–1923), of Salem, Massachusetts, lived a harmonious life in calm communication with nature. She fastened on the microcosm rather than the big vista, painting intimate watercolors of small fragments of nature in a style that progressed from the extreme detail of Pre-Raphaelitism to an increasingly Oriental simplification.

Bridges was the third of four children of a shipmaster in the China trade who died in Canton in 1849. When her mother died soon afterwards, Fidelia became a mother's helper in the Quaker household of the Brown family—generous and kindly people who remained her lifelong friends. In later years she returned time and again to the Browns in Brooklyn, using the upper floor of their mansion as a studio.

She also became a close friend of Anne Whitney, a sculptor at the start of her career who had a strong influence on Bridges. The two women discussed art and woman's place in society. Whitney was a confidante, a role model; she urged the fragile Fidelia, who had a growing interest in painting, to strike out on her own.[64]

Although Bridges was orphaned early and never married, her ability to form close attachments to the key people in her life seems to have been a striking characteristic of her personality, and reappeared in her relationship with her teacher, William Trost Richards. Bridges studied painting in Philadelphia with Richards, at the time a follower of the English Pre-Raphaelite school. He led her into a style in which she lovingly recorded every detail of nature with botanical accuracy. A study of ferns, for example, would show every leaf and hair. Richards became her friend and mentor, and when she set up her own studio in downtown Philadelphia in 1862, he sponsored her among his wealthy patrons. She often went sketching in the country with the Richards family and probably served as a mother's helper to Richards's wife as well. During this period she was exhibiting at the Pennsylvania Academy.

In 1867 Bridges went to Rome for a year of study, where she shared living quarters with Anne Whitney and the Boston painter Adeline Manning. After traveling alone on the continent, she returned and began to branch out into her own personal artistic style.

Turning entirely to watercolor, the artist concentrated on close-up studies of small fragments—grasses and birds, weedpods and flowers, focusing on minutely detailed elements in the foreground in delicate, yet vibrant colors. She was very successful in this genre and was elected an associate of the National Academy of Design in 1874 and a member of the Water Color Society in 1875; she was also invited to exhibit at the Philadelphia Centennial Exposition. She received many commissions for chromolithographic prints from Louis Prang and Company.

In this period Bridges formed another close attachment—this time to the family of artist Oliver I. Lay—and began to spend summers near them in Stratford, Connecticut. The wild flowers, the fields, the river, and especially the birds of that region (her favorite subjects), were very much in tune with the delicate lyricism of her vision, and inspired such works as *Daisies and Clover* (1871) and *Thrush in Wild Flowers* (1874). She would row out alone among the reeds and sit in the boat under a small

Fig. 3-14. Fidelia Bridges, MILKWEEDS (1861), watercolor, 16″ × 9½″

umbrella, sketching details.

Gradually, she moved away from the all-over detail of her Pre-Raphaelite days and began to simplify her backgrounds, leaving bare spaces of white paper. Her asymmetrical compositions of birds on branches or weeds took on an almost oriental flavor. In May 1875 the landscape painter John

Frederick Kensett wrote in *Art Journal,* "Her works are like little lyric poems, and she dwells with loving touches on each of her birds 'like blossoms atilt' among the leaves. . . ." In the watercolor painting *Untitled* (1876) the air fairly quivers with summer warmth in the beautifully orchestrated negative spaces between the flowers.

In 1892 Bridges moved to a house on a hill in the village of Canaan, Connecticut. Tall, willowy, and refined in dress, she became a village personality. She spent a quiet old age in a circle of literary and artistic maiden ladies, riding her bicycle to sketching excursions or to "woodland picnics and afternoon teas."[65] The children of the Browns, the Richardses, and the Lays, all of whom she had helped to raise, remained her friends as they grew up, and visited her frequently. When she died, the citizens of Canaan erected a small bird sanctuary in her memory.

Fig. 3-15. Fidelia Bridges, UNTITLED (c. 1876), watercolor, 35.5 × 25.4 cm.

Annie Cornelia Shaw (1852–1887) painted out of doors in the Adirondack mountains, on the Atlantic's "rugged shores, and on the prairies of the West."[66] She was the first woman elected a full Academician by the Chicago Academy of Design in 1876.

Born in West Troy, New York, Shaw grew up in Chicago. At age twelve she won a silver medal for a pencil drawing at the Illinois State Fair, and at sixteen she began four years of study with painter Henry C. Ford of Chicago. In 1873, at age twenty-one, she was elected an Associate of the Chicago Academy of Design, and the following year Shaw opened her first studio in the Metropolitan Block, Chicago. In 1876 she exhibited *Illinois Prairie* at the Philadelphia Centennial Exposition and was elected a full member of the Chicago Academy.

Her method is described as vigorous and free in the manner of the Barbizon School. *The Chicago Graphic* said, "She made it her rule to work directly from nature, and her paintings were not only begun out of doors, but were almost invariably finished there."[67] Some of her works were *Ebb Tide on the Coast of Maine* (1876); *Returning From the Fair* (1878), a painting of cattle on a road curving back through the forest to a glowing distant prospect; and *Fall Ploughing* (1884). Annie Shaw was also a well-known Chicago art teacher and was described as "enthusiastic and industrious, always ready to help . . . young artists . . . a genial winning nature."[68] During the summers she traveled to various parts of the country to paint on location.

Shaw exhibited at the Pennsylvania Academy, the Metropolitan Museum of Art, and the Boston Museum of Fine Arts, and her work was bought by leading collectors of the time.[69] She later opened studios in New York and Boston. The Chicago Art Institute elected her an honorary Associate in 1886 (a rare honor), and held a memorial exhibition and sale of her paintings in December 1887, after her death. Two hundred and seventy paintings are listed in that catalogue, but only two small pictures have

been located. The Art Institute of Chicago acquired Shaw's *Landscape with Bull and Sheep* in 1892 and *The Russet Year* in 1894. In a pattern familiar to scholars of women artists, both were subsequently sold and are now unlocated.[70]

Sarah Cole (active 1846–1852), landscape painter of Catskill, New York, exhibited at the National Academy in 1848 and 1850–52, at the Maryland Historical Society in 1849, and at the American Art-Union in 1848–52. The sister of Thomas Cole, pioneer of the Hudson River School, she sometimes accompanied him on sketching trips.

Ellen Maria Carpenter (1836–1909?) was a popular landscape painter and teacher of art in Boston. Such paintings as *A View from Mariposa Trail of the Yosemite Valley, Pleasant Valley on the Merrimach (sic),* and *Lake Amitash in Amesbury* were described as "revealing at times the menacing suggestion of great rivers and of high solitary mountains."[71]

Ann Sophia Towne Darrah (1819–1881) exhibited many landscapes and marine paintings at the Pennsylvania Academy (1856–83) and at the Boston Athenaeum (1855–64). Her work is typical of the self-taught women painters of the era.

Out on the Western frontier, unknown to art historians, were women landscape painters whose names never turn up in books on art of the nineteenth century. They are gradually being rediscovered.

Mary Elizabeth Michael Achey (1832–1886), descendant of a Dutch painter, followed her husband to army posts from Missouri to Colorado, sketching all the while. When her daughter "Doughty" died of diphtheria, she blamed her husband for falling asleep during a nightwatch over the sick girl and took off alone with her two sons.

She opened a studio in Central City, Colorado. In 1868 the *Central City Register* publicized her "Oil Painting Carnival," featuring a raffle of thirty paint-

ings, including *Pike's Peak with Buffalo Chase* (c. 1868), *The Beer Boys* (c. 1868), and six portraits.[72] Achey traveled to Napa Valley, California, as a portrait painter in 1876 and finally settled on a homestead outside of Aberdeen, Washington, around 1880.

Over five hundred paintings were completed by this tough-minded pioneer, who supported her sons alone with her art. A recent exhibition in Aberdeen included views of early settlements, Indian encampments, scenery, Civil War army camps, and portraits of the settlers in the newly developing West.

Helen Tanner Brodt (1838–1908) was raised in New York and attended the National Academy of Design. In 1861 she married Aurelius W. Brodt and followed him two years later to Red Bluff, California, where he was a schoolteacher. While teaching and raising a family, she painted ranch scenes, missions, landscapes, and pioneer portraits in Red Bluff, Petaluma, Oakland, and Berkeley. Her *Carmel Mission* depicts the venerable building when no other structures around it were yet erected.

Helen Henderson Chain (1849–1892) painted the Colorado Rockies, climbing Pike's Peak and other mountains (sometimes with her art students) in search of her subjects. Thomas Moran, American painter of Western panoramas, praised her work, and several of her paintings are in Denver's Colorado Historical Society.

Still-Life Painting

Women artists have a long, noble history in the field of still-life painting, dating back to such major figures of European art as Rachel Ruysch in seventeenth century Holland and Anne Vallayer-Coster of eighteenth century France. The obvious reason for excellence in this field is that women could set up still lifes at home or in a small space. The problems of access to models, training in anatomy, space

requirements, and the need for political clout in obtaining important commissions, all made figure and history painting much more difficult for women to accomplish.

It is no surprise, therefore, that the catalogue of the first professional art exhibition in America, the Columbianum of 1803 in Philadelphia, lists a still life by "Miss Birch." All of the Peale women painted still lifes. There were, in fact, many more women still-life painters than can be included in this book.

Margaretta Angelica Peale (1795–1882) was the most talented still-life painter among James Peale's daughters. Her fruit paintings have been described as "haunting. . . . There is a psychological quietness about . . . some of her . . . works that makes her the most interesting of all the Peale women. . . ."[73]

She appears at age twenty-five in a portrait by her father—a serious young studio assistant with dark eyes in an artist's robe. She exhibited pictures "for sale" at the Pennsylvania Academy from 1828 to 1837, but only eleven still lifes have been found out of at least fifty mentioned in records between the 1820s and 1865. An early, illusionistic *trompe l'oeil*, *Catalogue Deception* (1813?), shows a museum catalogue hanging on a wall, its curling pages tempting the viewer to turn them.

Like her father James and her cousin Raphaelle, Margaretta Peale used clear outlines, generalized forms, and the characteristic Peale lighting and composition. In *Still Life: Grapes and Pomegranates* fruit spills diagonally out of a basket set on a table top whose front edge is parallel with the picture plane. The fruit contrasts with a background lit diagonally from light to dark in the opposite direction. In a few of her still lifes there is a stark personal and individual quality.

Several of Margaretta Peale's portraits are at George Washington University. She never married and at her death was sharing a home in Philadelphia with her sister, Sarah Miriam Peale.

Fig. 3-16. Anna Eliza Hardy, BASKET OF ARBUTUS (n.d.), oil on canvas, 13½" × 11½"

Anna Eliza Hardy (1839–1934) created her first painting at age sixteen to please her father, Jeremiah Pearson Hardy. An itinerant portrait and landscape artist of Bangor, Maine, he promised her a gift of one of his landscapes as a reward. This experience opened up a lifetime devoted to the creation of small, beautifully rendered fruit and flower studies, which combine illusionistic realism with a strong decorative feeling *(A Basket of Arbutus)*.

She remained in her father's studio until his death and was trained exclusively by him, except for brief interludes with Abbott Thayer, and in Paris with Georges Jeannin. She exhibited at the National Academy in 1876–77.

Her early fruit paintings—simple, striking arrangements, such as a composition of three oranges set off against a piece of green velvet on a table top—were her best work. Hardy lived a very long life, and the crisp precision and close observation of her early work gave way to the blurry, pastel-colored, impressionistic flower painting so popular at the turn of the century.[74]

She is described as a beautiful woman with red-gold hair, delicate fair skin, and a bird-like manner, living a frugal but high-minded life with her fascinating family. The multitalented Hardys hold an honored place in the history of Bangor, Maine. Her father's sister, Mary Ann Hardy (1809–1887), was a fine miniature painter, also taught by him.

One of the charming tales in the history of American art is the story of **Maria Louisa Wagner (c. 1815–1888)** and her beloved crippled older brother Daniel—an inseparable team of itinerant artists. Traveling together for years through the Chenango Valley of upstate New York in a covered wagon drawn by two horses, they painted portraits, miniatures, and landscapes. Eventually they became successful New York City artists.

Their parents, Frederick and Annie Walworth Wagner, migrated to Norwich, New York, from Worcester, Massachusetts, in 1806, when Daniel was four and Maria not yet born. Daniel seemed doomed to a bedridden and lonely life because of a hip ailment from a childhood accident. He was in his teens when his sister was born, and the toddler became his constant companion. They entertained themselves by learning to draw and paint with whatever crude and primitive materials were available. By the time Maria was sixteen, she was quite capable as an artist. Daniel, an accomplished artist as well, had recovered sufficiently to travel with her through towns like Binghampton, Utica, Whitetown, and Ithaca in the late 1830s, painting portraits and miniatures.

When they met attorney William H. Seward (later the Governor of New York) in Auburn, he so admired their work that he gave them a letter of intro-

duction and urged them to go to the state capital at Albany, where he was sure they would get profitable commissions. Between approximately 1842 and 1860 they ran a successful studio there, painting such notables as Millard Fillmore (at that time a New York congressman and state controller). In 1852 Fillmore, then president, invited them to paint his family and others in Washington.

Maria Wagner exhibited between 1839 and 1868 at the National Academy, the Boston Athenaeum, the American Art-Union, and the Pennsylvania Academy. Her charming still life *Spring Flowers* (c. 1849) shows the fresh, honest clarity of style characteristic of the American school of the first half of the century.

From 1862 to 1868 Maria and Daniel Wagner operated a successful studio in New York City, and Maria began to concentrate on landscape paintings. Around 1870, apparently financially independent, they retired, still inseparable, to the peaceful serenity of their home town of Norwich. According to legend, Maria Wagner was inconsolable when her brother died in 1888, and she died later that year. They are buried side by side in Norwich cemetery.

Fig. 3-18. Susan C. Waters, SHEEP IN A LANDSCAPE (1880s?), oil on canvas, 24″ × 36″

Susan Catherine Moore Waters (1823–1900), a noted animal painter, was born in Binghampton, New York, and grew up in Friendsville, Pennsylvania. At the age of fifteen she was already earning her tuition at a female seminary by making drawings for her natural history teacher. In Friendsville she met and, in 1841, married William C. Waters, a Quaker who encouraged her talent.

Between 1843 and 1845 she was a very active itinerant portrait painter, traveling with her husband in southern New York State and Pennsylvania. Her early portraits have a frontal directness and force, as in *Mary E. Kingman* (1845), a portrait of a wide-eyed three-year-old with a fruit basket, now in the Wiltshire Collection in Richmond, Virginia.

By 1855 Susan and William Waters were living in Mt. Pleasant, Iowa, and finally settled permanently in Bordentown, New Jersey, in 1866. Until her death she painted animals and still lifes and also made daguerreotypes and ambrotypes.

Waters's still lifes sometimes show animals with their food, such as a cat with a delectable fish or a squirrel with a bowl of nuts. Her forte and passion, however, was the depiction of sheep, which she studied from living models in the sheep pen in her own backyard (*Landscape With Sheep*).

Fig. 3-17. Maria Louisa Wagner, SPRING FLOWERS (c. 1849), oil on canvas, 13⅜″ × 16¼″

Maria Martin (Bachman) (1796–1863) of Charleston, South Carolina, painter of birds, flowers, and insects, was one of the three assistants who worked with John James Audubon, the ornithologist and renowned painter of birds. As a naturalist-painter, she followed an old tradition among women artists dating back to Maria Sibylla Merian, a seventeenth century German who painted watercolors and published books of engravings of the plants and animals of Surinam and Europe.

The youngest of four daughters of John Jacob Martin (a Lutheran descended from French Huguenots), Maria had wide-ranging interests in music, literature, art, and the natural sciences. She lived with her sister Harriet, who never physically recovered from bearing fourteen children, and her brother-in-law John Bachman, a Lutheran pastor in Charleston. For many years she helped her ailing sister by running their home and caring for their children. She eventually married Bachman in 1849 after her sister's death and shared with him a lifelong interest in birds and animals, collaborating with him on articles and books.

Maria Martin was permanently influenced by Audubon's visit to Charleston in 1831. He gave her instructions and encouragement after seeing her early sketches and paintings, and taught her to paint birds, a genre that became a passion with her. Soon she was investigating all the local birds and making meticulous studies of plants in the public gardens of Charleston.

Audubon wrote, "Miss Martin, with her superior talents, assists us greatly in the way of drawing." In 1833 he commented that "the insects she has drawn are, perhaps, the best I've seen."[75] The backgrounds Martin created for him are scientifically precise renderings of bird habitats. She accomplished the difficult task of developing an aesthetic composition to balance Audubon's birds, which were customarily painted in detail first, perched on a branch or a twig.

During a five-year period she assisted Audubon on volumes 2 and 4 of his great work, *The Birds of America* (1827–38). Martin never took money for her labor; that would not have been considered proper in the antebellum South. For this reason, her important contribution remained largely anonymous until research by scholar Alice Ford in the 1950s revealed that Martin was perhaps the most important woman naturalist-artist of the nineteenth century.

Rosa M. Towne (1827–1909), the sister of landscape painter Sophia Anne Towne Darrah, was a botanical illustrator who prepared volumes of scientifically accurate watercolors of flowers and shrubs, some of which are at Harvard's botanical museum. One of her folios delineated all the plants mentioned in Shakespeare's works, painted from live specimens. She was elected an Associate Member of the Pennsylvania Academicians in 1869.

Anna Botsford Comstock (1854–1930) began drawing the insects for the books of her entomologist husband and became a famous wood engraver of insects in such works as *Introduction to Entomology* (1888). Her wide-ranging interests led her later in life to become the leading figure in the nature-study movement in American education and the first woman professor at Cornell University.

Katherine Furbish (1834–1931), is known for her drawing of an endangered species, the Furbish Lousewort, which was named after her. Years later, in 1976, it caused the U.S. government to halt construction on a huge dam in Dickey, Maine, while a debate raged with environmentalists. A lifelong resident and botanist of Brunswick, Maine, she painted more than a thousand meticulously accurate watercolors of flowers and plants and assembled them into portfolios, *The Flora of Maine,* which she presented to Bowdoin College in 1909.

Furbish began her hobby at the age of twelve with her father. A proper Victorian lady, she nevertheless crawled on hands and knees through the bogs of

Maine (where only Indians had ever been before), traveled alone in the Aroostook wilderness between 1879 and 1881, and was almost trapped in a bog and devoured by mosquitoes. But she lived to the age of ninety-seven.[76] Bowdoin College now recognizes the exquisite quality and accuracy of the paintings which had gathered dust, unnoticed for many years.

Virginia Granbery (1831–1921) was a prolific artist in her time, although most of her paintings are lost today. More of her fruit paintings were reproduced by Louis A. Prang lithographers of Boston than those of any other artist. Her tight drawing and warm colors, as found in *Basket of Cherries,* were well suited to lithographic reproduction.

Born in Norfolk, Virginia, Granbery grew up and received her art education in New York at the Cooper Institute, the National Academy of Design, and elsewhere. She became an outstanding art teacher at the Packer Institute in Brooklyn. In fact, her classes grew so large that after eleven years she resigned from overwork, but continued to paint. Her sister, Henrietta Augusta Granbery (1829–1927), was a teacher at Professor West's Seminary in Brooklyn and a landscape and still-life painter.

Many other women still life painters of the nineteenth century are discussed by art historians William Gerdts and Russell Burke in *American Still Life Painting* (1971). Some of them are Matilda Browne, Mrs. E. B. Duffey, Mrs. Amelia Henshaw, Julia McEntee Dillon, Kathleen Honora Greatorex, Maria Theresa Gorsuch Hart (wife of landscape artist, James Hart), Julie Hart Beers Kempson (sister of William and James Hart), Nina Moore, Helen Searle Pattison, Emma Thayer, Sarah Wilhelmina Wenzler, Miss L. Whitcomb, O. E. Whitney, Abbie Luella Zuill, Ellen Robbins, Maria Benson Homer (the mother of Winslow Homer), and Sarah Whitman. Fanny Palmer (who is discussed below with graphic artists) created most of the still lifes for Currier and Ives. Because they were mostly un-

signed, the public is not aware of her prodigious productivity in this genre, as in *Landscape, Fruit, and Flowers* (1862).

Graphic Artists: Drawing, Lithography, Engraving, Etching, and Illustration

Frances Flora Bond Palmer (1812–1876), or Fanny Palmer, was one of the most prolific artists on the staff of Currier and Ives. She created at least two hundred documented lithographs for them, ranging from farm scenes to dynamic images of railroad express trains and epics of the Westward movement. In addition, she is known to have worked on many more that were issued anonymously without a signature or the credit line "F. F. Palmer."[77] Her lithographs were bought in great quantities by the American public. In a certain sense, perhaps no other artist expressed so clearly the optimistic spirit of the new nation and the romantic drama of the Western frontier.

She was particularly outstanding for her atmospheric landscapes, although her range of subjects was wide. She also made significant contributions to the technical side of the art, including a method of printing a background tint and an improvement in the lithographic crayon, which she worked out with Charles Currier. Palmer not only made the designs; she also drew them directly on the lithographic stones. As print collector Harry T. Peters writes, "There seems to have been no task to which she was unwilling to set her hand."[78]

Palmer was born in England, the eldest of three children of a wealthy attorney, Robert Bond. She received an excellent education at Miss Linwood's school in London and was cultivated, cheerful, and charming. In the 1830s she married Edmund Seymour Palmer, an improvident "gentleman" who liked shooting and drinking, but disliked work. They were poor when they immigrated to the United States in the 1840s with her sister, brother-in-law, and brother Robert Bond.[79] Fortunately, her

Fig. 3-19. Fanny Palmer, SEASON OF BLOSSOMS (1865), colored lithograph for Currier & Ives (large), 15.12″ × 23.4″

education had included art lessons; so she could provide for her growing family by working as a lithographic artist.

Around 1845 Fanny Palmer and her husband set up a lithographic business in New York City called F. & S. Palmer, but it failed. Edmund Seymour Palmer became a tavern keeper and came to an ungraceful end in 1859 by falling downstairs drunk in a Brooklyn hotel. Fanny Palmer's life was further burdened by a son who never worked and whom she supported until his death of tuberculosis in 1867.

By 1849 Palmer was already doing assignments for the legendary Nathaniel Currier lithograph company. Two views of Manhattan and *High Bridge at Harlem, New York* date from that year. Her fullest flow of creativity came in the 1850s, when she turned out many folios of country landscapes and farm scenes, including *American Farm Scenes* (1853), *American Country Life* (1855), and *American Winter Scenes* (1854). Because of her excellence in landscape, she was often taken out to the Long Island countryside in Currier's carriage to sketch the scenery on site in soft pencil. Figure

drawing was her weakest skill, and other artists in the company sometimes assisted her in this.

In 1857 James M. Ives joined the company and had a dynamic influence on Fanny Palmer's style. *The Mississippi River in Time of War* (1865), *The Lightning Express Train Leaving the Junction* (1866), and *Across the Continent, Westward the Course of Empire Takes its Way* (1868) reflect the new mood. The wide panoramic view in *Across the Continent,* pierced by the strong diagonal of the railroad track, perfectly expresses the American spirit of "manifest destiny."

According to M. Cowdrey, a scholar of Palmer's art, Ives also had an adverse influence.[80] In Palmer's last years with the firm, he drew many of the figures in her compositions rather poorly and in a manner not fully in harmony with her style. This is evident in *Haying Time, High Water,* and other late prints.

The Rocky Mountains, Emigrants Crossing the Plain (1866), which depicts a wagon train, is a monumental work that became for the American public the very symbol of the Westward migration. As Roy King and Burke Davis point out in *The World of Currier and Ives,*[81] Palmer never went west of Hoboken, and as a consequence, her mountains look something like the Alps. Yet she caught the authentic spirit of the Western crossing.

Between 1862 and 1867 Palmer created all but one of the firm's signed still lifes, and she is believed to have made an enormous number of the anonymous fruit and flower prints. Palmer lived in Brooklyn during her years at Currier and Ives. She was described as "a small, frail woman with large dark eyes and . . . an English complexion"[82]—always cheerful, kind, and hardworking. Never wealthy, she worked so hard for over twenty-five years in the same stooped position over the lithographic stones that she became hunchbacked in later life.

Her compositions were reproduced on calendars, greeting cards, and advertising, and were an integral part of American popular culture. She is now recognized as an important American graphic

artist of the nineteenth century. When she died, almost unnoticed, of tuberculosis at the age of sixty-four, a small newspaper obituary referred to her as "the relict of Edmund S. Palmer of Leicester, England."[83]

Mary Nimmo Moran (1842–1899), one of the outstanding American landscape etchers of the nineteenth century, was born in Strathaven, Scotland, the daughter of a weaver, Archibald Nimmo. Her mother died young, and when Mary was five, her father brought her and her brother to Crescentville, Pennsylvania, near Philadelphia. At twenty, she married Thomas Moran, who eventually became a famous painter of Western panoramas.

Mary was a small Scottish beauty with broad brow framed by dark curls tumbling to her shoulders. Though she had only an elementary school education, she was bright and vivacious, and her husband, just beginning his own career, taught her to paint in oils and watercolors along with him. Soon she was exhibiting at the Pennsylvania Academy of the Fine Arts and the National Academy of Design.

The Morans had three children. After the birth of their first child, they traveled abroad in 1867. Mary and Thomas painted their way through France, Italy, and Switzerland, met the great French artist Corot, and visited galleries and museums. After their return, Thomas Moran's painting for Congress, *The Grand Canyon of the Yellowstone,* supplied them with $10,000, which they used to buy a house in Newark. Some of Mary's finest paintings, such as *Newark From the Meadows* (c. 1880), were of the surrounding New Jersey countryside.

In 1879, when poor health prevented her from accompanying her husband to the Grand Tetons, he gave her some copper plates and suggested that she

Fig. 3-20. Mary Nimmo Moran, VIEW OF NEWARK FROM THE MEADOWS (1880 or before), oil on canvas, 8¼″ × 16″

might enjoy trying some etchings during his absence. While he was away she began etching directly from nature. On his return, Thomas Moran was so delighted with his wife's bold, free etching style that he submitted four of her prints to the New York Etching Club. Mary Moran had indeed found her métier; she worked furiously, and in the 1880s was recognized as the leading American woman etcher.

In 1880 "M. Nimmo" was elected a member of the New York Etching Club. In 1881, when her work was shown with the Royal Society of Painter-Etchers in London, she was made a member of that society, and John Ruskin and other English critics praised her strong style. When the Morans held a joint exhibition of etchings in 1889, some critics found her work even more vigorous than her husband's.

In nearly seventy landscape etchings she portrayed English and Scottish scenes; views of New Jersey; East Hampton, Long Island, where they later lived; the hills of Pennsylvania; the subtropical forest of Florida; and other regions. Her career peaked in 1893 when she won a diploma and medal for her prints at the World's Columbian Exposition in Chicago. In 1899, at age fifty-seven, she died of typhoid fever after exhaustively nursing her daughter through a bout of the same illness.

Eliza Pratt Greatorex (1819–1897) was well known for her etchings and her distinctive style of pen-and-ink drawing. One of America's earliest women illustrators, she is best known for a series of views of old New York City.

Eliza Pratt was born in Ireland, the third daughter of a Methodist minister, the Reverend James Calcott Pratt, who moved the family to New York in 1840. In 1849 she married the well-known church organist Henry Wellington Greatorex. When he died suddenly in 1858, Eliza Greatorex was already an amateur artist who had exhibited picturesque pen-and-ink sketches at the National Academy in 1855.

She began to support herself and her two young daughters, Kathleen and Elizabeth, by teaching art at Miss Haines School for Girls in New York and selling her own work.

She studied in the 1850s and '60s with William Wotherspoon and James and William Hart, New York landscape artists, and in Paris with Émile Lambinet. During this period she exhibited at the Pennsylvania Academy, the Boston Athenaeum, and elsewhere and was elected an Associate member of the National Academy of Design in 1869.

One of the joyous aspects of Eliza Greatorex's career was the nurturing way in which she was able to draw her daughters into her artistic life. The three women became, as Charles Shively says, "an affectionate and energetic artistic sorority."[84] Like so many Americans of artistic sensibility, in a pattern described in the novels of Henry James, Greatorex and her daughters slowly became seduced by the culture of Europe. Eliza, "Nellie," and "Nora" first went abroad to Munich in 1870, studied at the Pinakothek, and then traveled through Germany and Italy. From this trip came Greatorex's *Etchings in Nuremberg* (1875) and *Homes of Ober-Ammergau* (1872).

After returning from sophisticated Europe, Greatorex and her daughters traveled in 1873 to primitive Colorado, where, she wrote, "no false standard of life, no unworthy desires or excitements" could come between her own "and nature's great heart."[85] This journey resulted in a book, *Summer Etchings in Colorado* (1873), containing landscape etchings and a diary of the trip. The well-known author Grace Greenwood, vacationing at the same resort near Pike's Peak, wrote the preface.

Around 1874 Eliza Greatorex began to invest all of her energy in projects connected with the 1876 Philadelphia Centennial Exposition, in which she showed eighteen sketches. She also collected panels and woodwork from historic houses and churches being torn down in New York, and painted

historic scenes or buildings on them. Etchings and paintings of scenes around New York were published in *Old New York, from the Battery to Bloomingdale* (1875), with commentary by her sister, the novelist Matilda Pratt Despard.

The lure of Europe brought Greatorex and her daughters back to Paris in 1879, ostensibly for training in engraving with Charles Henri Toussaint. Greatorex remained in Paris and died there in 1891. Her daughter Elizabeth lived on into the twentieth century as a successful Parisian artist. Kathleen Honora became a well-known decorative artist, still-life painter, and book illustrator.

"Francesca" (*née* Esther Frances) Alexander (1837–1917), of Boston, was famous for her saintliness and her sensitive drawings of Italy and Italian peasants. She worked and lived most of her life in Florence with her expatriate parents. Art historian E. P. Richardson writes that Italy's "timeless beauty . . . attracted painters. A number of Americans of a variety of temperaments made their home there." Among them was "Francesca Alexander, a friend of Ruskin and at one time the center of a little Anglo-American cult."[86]

Francesca's father was a self-taught portraitist, and her mother was a domineering woman from a wealthy Massachusetts family who put much energy into charitable causes. She censored her daughter's life, her mail, and her friends, and sent her out of the room even when she had reached middle age to protect her from "unseemly" conversation. After her mother died at the age of 101, the docile Francesca took to her bed and never got out, dying a year later.

The plain, other-worldly Esther (as she was originally named) spent her life helping the unfortunate and nursing the sick. To encourage the family's wealthy American friends to aid her charities, she began to do biographical sketches and drawings of poor Tuscan peasants as gifts for the donors. In the process, she studied the lives and folkways of the

Fig. 3-21. Francesca Alexander, SAINT CHRIST-OPHER AT THE SHORE, in *Roadside Songs of Tuscany* (1885)

people and made exquisite drawings of them and of their environs in Tuscany. She was discovered by John Ruskin, who found in her drawings the medieval spirituality and intense, honest observation for which he yearned.

He became a close friend of the family—she was his "sorella" and her mother was his "Mammina." He promoted her work in his lectures given as Slade professor at Oxford. Her illustrated books, especially *Roadside Songs of Tuscany* (1885), were very successful.

Mary Hallock Foote (1847–1938) was a famous illustrator and author of sixteen successful novels about Western life. Her career extended chronologically from the Golden Age to the historic Armory Show of 1913 in New York. Her painting *The Old Lady,* shown in the Armory Show, was bought by the Art Institute of Chicago in 1915.

Hallock was born into an old Quaker family at Milton-on-the-Hudson, New York, in the beautiful Hudson River Valley. In the liberal Quaker tradition, her family fostered the accomplishment of girls as well as boys. She showed talent early at the Poughkeepsie Female Collegiate Seminary, and in 1864, at age seventeen, entered the three-year art course at the Cooper Union Institute of Design for

Women. This was one of the earliest and most distinguished professional art schools for women (now a fine coeducational art school).

At "The Cooper" Hallock studied with sculptor William Rimmer and with wood engraver William J. Linton, who later called her the best designer of wood engravings in the country. Wood engraving, before the days of photo-engraving, was a major commercial art form. She began illustrating books for the publisher Fields, Osgood and Company, and was already an established professional when she married Arthur De Wint Foote, a mining engineer from Hanaford, Connecticut, in 1876.

For the next nineteen years Mary Foote followed her husband to mining towns in Idaho, California, and Colorado. She endured considerable disappointment and hardship along the way, as well as a certain amount of adventure. She almost lost her young son in the harsh winters of Colorado. Her husband suffered a humiliating financial failure in an irrigation scheme in Boise, Idaho, making her the sole support of the family for a period. In 1895 the Footes finally settled in Grass Valley, California, where Arthur was chief engineer at the North Star Mine for thirty years.

Throughout this period, while raising three children, "Molly" Foote continued to build a national reputation as an illustrator and also a novelist of life in the Western silver mining towns that she knew so well. Perhaps her most notable illustrations of

Fig. 3-22. Mary Hallock Foote, A PRETTY GIRL IN THE WEST (1889), pencil and wash drawing, 5¼″ × 7⅞″

Western life are eleven full-page wood engravings for *Century* magazine in 1888–89 called *Pictures of the Far West.* She was in the handbook of the Woman's Building at the World's Columbian Exposition in 1893 as the leading woman illustrator in the country.

Foote had established a friendship with Richard and Helena de Kay Gilder in New York before her marriage. This distinguished editor-artist team exerted a great influence on American literary and artistic taste at the turn of the century. Richard Gilder was for years her editor at *Scribner's Monthly Magazine* (later *Century Magazine*), and Helena de Kay Gilder wrote an article about her in *The Book Buyer Magazine.* The two women shared confidences in letters through the years.[87]

Foote was apparently somewhat torn between her own inclination to write in a realistic manner and the publishing industry's commercial demands for love stories. In her art she encountered a similar conflict between her desire to draw vigorously on location and her position as a "genteel" lady in the raw Western mining towns where she lived. In this respect, she differed from robust spirits like sculptor Harriet Hosmer, who permitted no conflicts about propriety to stand in their way.

Emily Sartain (1841–1927) was a Philadelphia engraver, painter, and internationally respected art educator. She and her seven brothers were the fourth generation of a family of talented engravers that traced its artistic ancestry back on both sides. Emily showed marked ability early and was encouraged by her father, a prominent artist and engraver.

Sartain studied with the conservative history painter Christian Schüssele for six years (1864–1870) at the Pennsylvania Academy of Fine Arts and with Evariste Luminais for four years in Paris. Also, she copied the masters on her own in the galleries of Italy and Spain. She was a close friend of painter Thomas Eakins, who may have been in love with

her. Her painting *La Pièce de Conviction* (1875?) was accepted by the Paris Salon in 1875. In 1876 she received a medal for it under the title of *The Reproof* at the Philadelphia Centennial Exposition.

After returning from Europe, Sartain became a specialist in the velvety technique of mezzotint engraving, and was the only woman in the United States to practice this craft at the time. She had been taught it at an early age by her father. From 1881 to 1883 she was editor of *Our Continent,* an illustrated magazine published in Philadelphia, and also exhibited in the 1883 Paris Salon.

In 1886 Sartain was appointed principal of the Philadelphia School of Design for Women, a position she held until her retirement in 1920, at which time she was succeeded by her niece, Harriet Sartain. Thomas Eakins urged her to take the job when it was offered to her because he felt she would make a great contribution. This school, founded in 1844, was the first in the United States to teach industrial art to women. Sartain drastically changed the curriculum in accordance with her philosophy that commercial and fine artists should receive the same rigorous training, including work from the living model, perspective, and thorough grounding in design. She was responsible for bringing avant-garde teachers like Robert Henri to the school. The Philadelphia School of Design, still a fine women's professional art school (today the Moore School of Art), counts among its illustrious alumnae Alice Neel, who has spoken lovingly of the excellent instruction she received there at the start of her career.[88]

Sartain's innovative influence spread beyond her own school. She became internationally recognized as a pioneering art educator and in 1900 was the American delegate to the international congress on industrial art in Paris.

An important Philadelphia civic leader, Sartain was a founder of the New Century Women's Club (1877), the Plastic Club of women artists (1895), and a summer art school at Natural Bridge, Virginia

(1891). She also continued to exhibit at the Pennsyl-
vania Academy, winning the Academy's Mary
Smith Prize in 1881 and 1883. In 1893 she was one
of the few women chosen to be a judge of art at the
World's Columbian Exposition in Chicago.

Sartain carried her fine and commercial art train-
ing into a wide arena as an inspiring educator who
opened new doors to American women artists.
Some other women graphic artists of this period
include Alice Donlevy, wood engraver and or-
ganizer; Blanche Dillaye, etcher; and the Maverick
sisters, members of a famous family of engravers.

Sculpture

American male sculptors had begun to immigrate
to Italy early in the nineteenth century. In 1825
the American neoclassical sculptor Horatio
Greenough went to Rome, lured by the ancient
artifacts and ruins, the cheap marble, the low cost
of living, the low-paid but highly skilled carvers
who would enlarge a sculptor's clay model into
marble, and the camaraderie of the international
community of artists gathered around the Spanish
Steps.

A strange phenomenon that occurred at mid-
century was the exodus of a group of American
women sculptors who braved seas and censure to
join their brethren in Rome. Henry James referred to
them as "that strange sisterhood who at one time
settled upon the seven hills in a white Marmorean
flock."[89] Although an international conclave of ar-
tists and intellectuals lived abroad, the United
States was the only country that exported a large
band of women sculptors.

The leader of this exodus was Charlotte
Cushman, an extraordinarily energetic woman
from Boston who began as a contralto singer and
then became a famous actress and lecturer. During
her successful career she often traveled abroad and
spent a considerable amount of time in Rome.
Aware that many of the leading American male

sculptors were studying and working there, she
suggested to Harriet Hosmer that women should
have the same opportunity. She gathered around
herself a coterie of these women and some male
artists as well.

Sculptor William Wetmore Story, while living in
Rome, wrote about the group in an 1852 letter to his
friend, the poet James Russell Lowell. With ambiva-
lent feelings of admiration, contempt, and alarm he
described

the emancipated females who dwell . . . together under
the superintendence of W. who . . . dances attendance
upon them everywhere, even to the great subscription
ball the other evening. Hatty [Harriet Hosmer] takes a
high hand here with Rome, and would have the Romans
know that a Yankee girl can do anything she pleases, walk
alone, ride her horse alone, and laugh at their rules. . . .
The Cushman sings savage ballads, in a hoarse, manny
voice, and requests people recitatively to forget her
not. . . . Page is painting her picture. . . . Miss Hosmer, is
also, to say the word, very willful, and too independent
by half, and is mixed up with a set I do not like, and I can
therefore do very little for her.[90]

Harriet Hosmer (1830–1908), the most famous
woman sculptor of the nineteenth century, was
brought up in Watertown, Massachusetts. Her
father, a physician, adopted a radical approach to
the education of his daughter. His wife and his three
other children had died of tuberculosis, and he was
determined that Harriet should not suffer the same
fate. He decided to build up her resistance with a
vigorous program of camping, hiking, horseback
riding, and mountain climbing. (In fact, a peak she
climbed in Missouri is named after her.) Her father
also decided to grant all her wishes whenever
feasible.

The result of Dr. Hosmer's avant-garde approach
to Harriet's education was a very avant-garde per-
sonality. She ran faster and could shoot straighter
than any boy in Watertown. She played practical
jokes on neighbors, climbed forty-foot trees in
search of birds' nests, collected snakes, and was
declared incorrigible by the local school.

Fig. 3-23. Photograph of HARRIET HOSMER working on statue of Senator Thomas Hart Benton

his daughter's unusual friend. When Hosmer began studying sculpture with Paul Stephenson in Boston, the Boston Medical School would not admit her to its anatomy course. Crow arranged for her to live with his family in Missouri and take private anatomy lessons with Dr. McDowell at the Medical College of St. Louis. Legend has it that she toted a pistol for self-protection while going to and from classes.[91]

Back in Watertown, in a studio her father built for her on his property, Hosmer carved her first major opus at the age of twenty-two—a neoclassical marble bust of *Hesper* (1852), the evening star. This was a typical, ethereal, mythological subject of the day. Charlotte Cushman saw this work and, impressed, urged Hosmer's father to permit her to go to Rome. In her usual intrepid fashion, Hosmer was determined to study with John Gibson, the important British sculptor living in Rome. She managed to convince the reluctant Gibson to give her a place in his studio by showing him daguerreotypes of *Hesper*.

In Gibson's atelier, she was seen by wealthy British families who visited him when traveling abroad. British collectors thought very highly of the tiny, piquant Hosmer and gave her many important commissions. Fanny Kemble, her mentor, had feared that Hosmer's lack of manners would keep her from advancing. But European royalty considered her an "original" and loved to watch her at work. Looking like a small, handsome boy, she wore a velvet beret atop her short, curly brown hair, a mannish suit and tie, and sometimes baggy Zouave trousers when she climbed on a high ladder to model a heroic-sized commission.

Hosmer was immediately drawn into the circle of artists and intellectuals clustered around the Spanish Steps. This circle included W. W. Story (American lawyer-turned-sculptor), Robert and Elizabeth Browning, and Nathaniel Hawthorne and his wife Sophia, an artist. Hawthorne was gathering material for his novel *The Marble Faun* (1860),

Eventually, Hosmer became so unmanageable that her father shipped her off to Mrs. Charles Sedgewick's school in Lenox, Massachusetts, an institution that adhered to his free and liberal educational policies. At Mrs. Sedgewick's she met many distinguished people—Nathaniel Hawthorne, Ralph Waldo Emerson, and above all, Fanny Kemble, a famous English actress and a woman of powerful independent temperament. Kemble took Harriet fishing and riding and was a role model and inspiration to the young girl. She encouraged her to pursue a career as a sculptor.

At Sedgewick's, Hosmer made another contact that helped her career. Dr. Wayman Crow, the father of a close school chum, became interested in

Fig. 3-24. Harriet Hosmer, MEDUSA (c. 1854), marble, height 27"

which portrays two women artists in Rome. Soon Hosmer was joined by sculptors Anne Whitney, Emma Stebbins, Louisa Lander, Margaret Foley, Edmonia Lewis, and Florence Freeman.

The lives of some of these free spirits were somewhat bizarre. They wandered at night through the streets of Rome. Harriet was fond of leaping on a horse for a midnight ride on the Campagna—a caprice that shocked middle-class Italians and Americans alike. Hints of scandal and unexplained disappearances attached to some, while others went on to lead long, successful, and conventional lives.

Hosmer never felt the taint of moral scandal, but she did endure other kinds of public torment. As the first woman who had ever attempted to break into the all-male enclave of neoclassical sculptors, she was subjected to the contempt and ridicule of her male colleagues. Author Joseph Leach reported that "American sculptors . . . like William Wetmore Story, Paul Akers, Randolph Rogers, and Thomas Crawford . . . all presented friendly smiles to her face. But behind it, they scoffed at her hopes to play their game."[92] Writing to James Russell Lowell, Story said, "If Harriet Hosmer displays any true creative talent, will she not be the first woman?"[93]

In addition, her usually permissive father wrote that he had suffered financial reverses, and asked her to return home. But the obstinate Hosmer decided to support herself and remained in Rome. Within ten years she had achieved such fame and received so many commissions that she opened one of the most palatial studios in the city and hired a staff of male stonecutters to work under her direction.

Her first important commission came from her sponsor, Dr. Wayman Crow. He ordered a kneeling figure of *Oenone* (1855), the sad bride who was abandoned by Paris for the beauteous Helen. In 1856 Hosmer achieved a significant financial success with a "fancy piece," a statue of *Puck* sitting on a toadstool. Over thirty copies were ordered by an international clientele of wealthy patrons, in-

cluding such social luminaries as the Prince of Wales.

In 1857 she created *Beatrice Cenci,* the tragic heroine of Shelley's verse drama. She also designed a tomb for Mlle. Falconet, daughter of an Englishwoman, in the church of S. Andrea della Fratte, a few blocks from the Spanish Steps. One of her noblest works is *Zenobia in Chains* (1859). This dignified figure of the conquering queen of Palmyra, brought in chains to Rome, was typical of the subjects that inspired the independent women sculptors. Hosmer did a tremendous amount of archaeological research for this work. Several lifesized copies were bought by collectors such as Potter Palmer and Alexander T. Stewart—tycoons who were filling their mansions with white neo-Grecian marbles, distributed among the potted palms and neoclassical columns. All of these life-sized versions have vanished, but a small one is at the Wadsworth Atheneum in Hartford, Connecticut.

Nathaniel Hawthorne greatly admired *Zenobia* when he saw it in Hosmer's studio in 1859. He described it as "a high heroic ode. . . . There is something in Zenobia's air that conveys the idea of music, uproar and a great throng all about her . . . her deportment—indicating a soul so much above her misfortune. . . . [Her] manacles serve as bracelets; a very ingenious and suggestive idea."[94] With these chains, Hosmer was creating a feminist symbol—noble woman transforms her very manacles into a beautiful ornament, wearing them proudly despite her tormentors.

Zenobia in Chains was hailed as a landmark achievement for a young woman, but after it was exhibited in England, several publications suggested that it was really the work of her teacher, John Gibson. Hosmer immediately retaliated with libel suits, and all these publications were forced to issue retractions.

Elizabeth Barrett and Robert Browning, who were much admired by the expatriate colony as the

Fig. 3-25. Harriet Hosmer, ZENOBIA IN CHAINS (1859), marble, height 49"

protypical Romantic poets and lovers, were fond of Hosmer. At their request, she made a cast of their clasped hands in bronze. One of Hosmer's major public commissions was the large bronze statue of *Senator Thomas Hart Benton* (c. 1861). The likeness of the Missouri politician dressed in a Roman toga was unveiled before a crowd of 40,000 in Lafayette Park, St. Louis, in 1868. This was one of the last American sculptures showing a public figure draped in classical garments. Harriet Hosmer was stubbornly committed to neoclassicism and refused to portray her subject in modern dress, even though realism was becoming the dominant style.

Hosmer formed close associations with several English noblewomen and received commissions for sculptures for their estates. For Lady Alford she designed a set of gates for an art gallery and several fountains. The sculptor's later years were spent largely in British castles in the company of British and European aristocrats.

After the Civil War her work began to taper off. She failed to get several large commissions she sought, as the trend toward realism and away from ideal marbles came into full prominence. The artist did, however, create a large statue of Queen Isabella for the World's Columbian Exposition in Chicago in 1893. In the absence of commissions, she began to spend much of her time designing perpetual motion machines and other inventions—outgrowths of a lifelong interest in science.

Harriet Hosmer's unusual upbringing apparently gave her a sense that she could accomplish whatever she set out to do. The incorrigible child became the indomitable adult. Unwilling to compromise her independence, she had made the decision early on not to marry. She explained,

I am the only faithful worshipper of Celibacy, and her service becomes more fascinating the longer I remain in it. Even if so inclined, an artist has no business to marry. For a man, it may be well enough, but for a woman on whom matrimonial duties and cares weigh more heavily, it is a moral wrong, I think, for she must neglect her profession or her family, becoming neither a good wife and mother nor a good artist. My ambition is to become the latter, so I wage an eternal feud with the consolidating knot.[95]

Hosmer reached the heights of fame and was looked upon as a model of achievement by women. But she also had to suffer ridicule and attacks by those who were offended by such an example. In a letter to the Reverend Phebe A. Hanaford, one of the first American women to become a clergywoman, she wrote:

I honor every woman who has strength enough to step out of the beaten path when she feels that her walk lies in another; strength enough to stand up and be laughed at if necessary. That is a bitter pill we must all swallow at the beginning; but I regard those pills as tonics quite essential to one's mental salvation. . . . But in a few years it will not be thought strange that women should be preachers and sculptors, and everyone who comes after us will have to bear fewer and fewer blows. Therefore I say, I honor all those who step boldly forward, and, in spite of ridicule and criticism, pave a broader way for the women of the next generation.[96]

(Mary) Edmonia Lewis (1843?–1909?), daughter of a Chippewa Indian mother and a black father, is recognized today as the first important black sculptor in America. Although her early life was scarred by prejudice, she surmounted all the obstacles arising from her mixed heritage, and became one of the leading nineteenth century American women sculptors in Rome. Art historian David C. Driskell has written:

A sensitive awareness of her (Lewis') own racial origins and an unending desire to expose the inequities of American society were basic elements in the work of this independent, rather caustic young woman. . . . Perhaps it was her works that first expressed the themes of racial injustice that would become the core of black American art in the 1920's and 1930's.[97]

Lewis was born in upstate New York, orphaned at four, and raised by her mother's tribe under the Indian name of Wildfire.[98] She has said of her early years,

My mother was a wild Indian and was born in Albany, of copper color and with straight black hair. There she made and sold moccasins. My father, who was a Negro, and a gentleman's servant, saw her and married her. . . . Mother often left her home and wandered with her people, whose habits she could not forget, and thus we, her children, were brought up in the same wild manner. Until I was twelve years old, I led this wandering life, fishing and swimming . . . and making moccasins.[99]

In 1856 Lewis received a rare opportunity for a pre–Civil War black. With help from her brother and several abolitionists,[100] she enrolled at Oberlin

College, the first coeducational and interracial college in the United States. At Oberlin, Edmonia pursued a liberal arts curriculum, but in 1862 her education was disrupted by a frightening criminal charge. She was accused of trying to poison two white roommates with drugged wine. Seized and brutally beaten by a vigilante mob, she was then arraigned in court for a preliminary hearing. Her case became a *cause célèbre* that was defended by James Mercer Langston, a black lawyer—later the first black man to be elected to Congress. The poison turned out to be an aphrodisiac, and the case was dropped for insufficient evidence. Lewis was carried from the courtroom on the shoulders of a crowd of her supporters.[101]

Lewis considered returning to the comparative peacefulness of her mother's tribe, but instead plucked up her courage and went to Boston, carrying a letter of introduction to William Lloyd Garrison, the abolitionist leader. In Boston, dazzled by the gleaming statues that shone forth in public buildings, she decided to study sculpture. Garrison introduced her to Edward Brackett, a neoclassical sculptor, who gave her a lump of clay and a plaster hand to copy; she mastered the skills rapidly in a series of informal exercises. Her first work—significantly—was a medallion honoring the abolitionist martyr John Brown.

By this time the Civil War was under way. Lewis was one of the many spectators who watched as the heroic Robert Gould Shaw, a white colonel from a distinguished Boston family, led a regiment of black troops to Boston's port of embarkation. When he died in battle in South Carolina, Lewis paid him homage with a portrait bust, a work so popular that one hundred plaster replicas were sold. With the proceeds and additional support from her patrons, the Story family of Boston, she bought a ticket to Rome. Lewis arrived there in 1867 and received a warm welcome from Charlotte Cushman and her flock. She took a studio on Via San Niccolo di Tolentino, near the Piazza Barberini not far from where Harriet Hosmer and other women sculptors lived.

Largely self-taught, she became superbly skilled in the technique of direct carving in marble. "When the art historian Henry Tuckerman visited Miss Lewis's studio in Rome, he expressed amazement at the ease with which she produced sensitive surfaces in marble, achieving an almost ideal mastery of that medium."[102] Tuckerman also praised a fresh strain of naturalism in her work, which he recommended to the American neoclassicists of the day.

In the first five years after her arrival, she produced a number of ambitious carvings, deeply expressive of the alienation of blacks and of their aspirations to freedom. *Forever Free* (1867), now at Howard University, depicts two black slaves, a standing man and a kneeling woman, looking up to heaven joyfully on the day of the Emancipation Proclamation. Both have broken their chains, but still retain a few fetters on their wrists.

Lewis also carved a powerful full-length figure of Hagar, the Egyptian maidservant of Abraham's wife Sarah. In the biblical story, Hagar bore Abraham a child, and as a result, was cast out and forced to wander in the desert to escape the jealous rage of Sarah. *Hagar in the Wilderness* (1868) obviously refers to the position of black women in white society. About this work Lewis wrote, "I have a strong sympathy for all women who have struggled and suffered."[103]

Hagar in the Wilderness, one of the jewels of the black art retrospective at the Los Angeles County Museum in 1976, flows upward with a graceful spiral movement, culminating in the strong head that looks up to heaven for release from oppression. The head departs from the neoclassical style. The nose is not perfectly straight, the masses of hair are crinkled, and the brow is carved with delicate furrows of pain. The marble surface is sensitively wrought, with contrasts between the smooth skin, the crinkled hair, and the pitted texture of the circular base. Lewis also identified with the Indian side

of her heritage in a number of works, such as *Hiawatha* (1868) and *Old Indian Arrow Maker and His Daughter* (1872).

A few years after arriving in Rome, in contrast to some of her anticlerical colleagues, Lewis converted to Catholicism. One of her proudest moments came when Pope Pius IX visited her studio and blessed a work in progress. Her sculpture of the Pope and a marble altarpiece of a Madonna and Child (bought by the British Marquess of Bute for $3,000) are unusual subjects among the women sculptors.

Edmonia Lewis traveled to California in 1873 when five of her works were exhibited before large crowds at the San Francisco Art Association. In San

Fig. 3-26. Edmonia Lewis, HAGAR (1868), marble, height 52"

Jose her bust of *Lincoln* (c. 1870) and two cherubic figures of children, *Asleep* (1871) and *Awake* (1872), were purchased and today can be found in the San Jose Public Library.

Lewis was entertained lavishly in Boston and Philadelphia around the time of the Philadelphia Centennial Exposition of 1876. Her startling sculpture *Death of Cleopatra* (symbolic of Africa) was a very controversial work at the Exposition, but nevertheless won an award. A contemporary critic wrote:

> This was not a beautiful work but it was a very original and very striking one. . . . Its ideal was so radically different from those adopted by Story and Gould in their statues of the Egyptian Queen. . . . The effects of death are represented with such skill as to be absolutely repellent. . . . However . . . it could only have been produced by a sculptor of very genuine endowments.[104]

This work is now lost.

She was accepted and written about by the art colony of Rome, and her studio was bustling with well-paid commissions at the height of her career. Yet one can imagine the loneliness, pain, and confusion endured by this woman, who was always looked at to some degree as an exotic "outsider." A description intended to be complimentary, shows clearly that at least some of her contemporaries saw her only through racial stereotypes:

> Edmonia Lewis is below the medium height, her complexion and features betray her African origin; her hair is more of the Indian type, black, straight and abundant. She wears a red cap in her studio, which is very picturesque and effective; her face is bright, intelligent, and expressive. . . . Her manners are child-like, simple and most winning and pleasing. She has the proud spirit of her Indian ancestor, and if she has more of the African in her personal appearance, she has more of the Indian in her character.[105]

After the Centennial, former President Ulysses S. Grant posed for her in Rome, and she was showered with other commissions. Soon, however, her career dropped off and references to her fade away. In 1886 Frederick Douglas and his wife noted that they

saw the "oddly dressed"[106] Edmonia Lewis while they were taking a walk on the Pincian Hill in Rome. The Catholic *Rosary* magazine referred to her in 1909 as aging "but still with us."[107] The circumstances of her death are unknown.

Anne Whitney (1821–1915), a brilliant woman of wide-ranging interests, began a sculpture career in her thirties. At the same time she was an active feminist and a lifelong fighter for social justice. She carried out many important public commissions between the ages of fifty and eighty.

Whitney emerged as a productive sculptor at a time when very few women had entered the field. As is so often the case, she came from a very supportive background, a well-established family from Watertown, Massachusetts, whose ancestors in America dated back to 1635. Her parents were free-thinking, liberal Unitarians and abolitionists, and she was privately tutored and encouraged in all her interests.

Whitney was unable to marry the man she loved because of insanity in his family.[108] She thought a great deal about the empty life facing her in a society that offered so few opportunities for single women. Determined to find a meaningful career, she first became a poet, publishing a volume in 1859. She taught school in Salem for a few years, and then, under the influence of Elizabeth Blackwell, the pioneering woman doctor, she became an ardent feminist and even gave readings to raise money for Blackwell's hospital.

When she turned to sculpture, she started by modeling portraits of her family. Then she carried out a full-length marble ideal figure of *Lady Godiva* (1861) about to loosen her garments and ride naked through the marketplace, willing to endure humiliation to free the oppressed peasants of Coventry from excessive taxation. Thus the theme of social justice emerged in Whitney's work from the start. She was largely self-taught, but learned anatomy at a Brooklyn hospital and studied privately in Boston

Fig. 3-27. Anne Whitney, ROMA (1869), bronze, height 27"

with sculptor William Rimmer, an eccentric and independent genius.

After the Civil War, when she was already past fifty, she went to Rome with painter Adeline Manning, her life-long friend. Between 1867 and 1871 Whitney worked hard, participating little in the busy social life of the art colony. One of her most striking, vigorous works is *Roma* (1869), which shows her sympathy with the oppressed Italian people on the eve of their struggle for national unification. Rome is shown as a seated beggar holding a penny in one hand and a license to beg in the other—a strong, unidealized image, with ravaged face and work-worn hands. The *Laocoon, Apollo Belvedere,* and other symbols of the city's past greatness are modeled in relief along the hem of the statue's garment. The Pope and Italian authorities,

however, were offended when she included a satirical portrait of a cardinal in the folds of the garment, and she had to send the statue in haste to Florence to escape difficulties.

After her return to Boston in 1871, Whitney received many commissions, among them a statue of Samuel Adams for Statuary Hall in the U.S. Capitol, which she worked on in Thomas Ball's studio in Florence. Also, from this period are a bronze *Leif Ericson* (1887), cast twice for Boston and Milwaukee, and portraits of college presidents in the Massachusetts area.

Whitney endured one of those maddening episodes of discrimination, repeatedly encountered by women artists throughout history. In 1875 she won an anonymous competition for a statue of Charles Sumner, the abolitionist senator from Massachusetts. When the jury learned that the winning artist was a woman, the commission was taken from her and given to Thomas Ball. She pretended indifference, but wrote to her enraged family, "It will take more than a Boston Art Committee to quench me."[109] Twenty-seven years after her defeat, Whitney obtained justice at last. In 1902, when she was eighty-one years old, her large statue of Sumner, finally cast in bronze, was unveiled in Harvard Square in front of the old Harvard Law School.

Works that reflect her involvement with themes of black and women's liberation include a statuette of the Haitian hero *Toussaint L'Ouverture* (1870) in prison, a colossal reclining figure of *Africa* (1863–64) awakening to freedom (now destroyed), and portrait busts of Harriet Beecher Stowe and another author, Harriet Martineau (1892). Her early neoclassical sculpture, *Lotus Eater* (1867), anticipated the liberated women of the 1970s—it was "a rare male nude by an American woman sculptor."[110]

During her long career, the style of her sculpture followed the cycle from marble neoclassicism to bronze realism. Long overlooked in surveys of American art, she is finally beginning to receive the critical attention she deserves. Art historian Wayne Craven declares that in her seated figure of *William Lloyd Garrison* (1880), she "managed to overcome the problem of contemporary dress that had plagued sculptors for decades."[111] Milton Brown also praises the "perceptive characterization" in this portrait and calls her later work "straightforward naturalism, in the manner of Thomas Ball, though with a modest sincerity and sensitivity."[112]

Vinnie Ream Hoxie (1847–1914), of Madison, Wisconsin, was a beautiful and charming prodigy who, in her teens, won a $10,000 commission for a statue of Abraham Lincoln to be placed in the Capitol rotunda in Washington. Mary Todd Lincoln objected, and others accused her of using "women's wiles" to get the commission. Many art critics and leading citizens declared that she was too inexperienced for the job. The nineteenth century art historian Henry Tuckerman criticized Congress for selecting a novice, and Charles Sumner angrily declared in the Senate, "You might as well put General Grant aside and place her on horseback in his stead."[113] But Ream gathered testimonials to her competency and won her fight.

The truth was that she had undoubtedly produced a more authentic image of Lincoln than the nineteen other sculptors competing with her. The reason was simple. She had modeled a bust of the great man from life in 1864–65 shortly before he was assassinated. Hearing that Ream was a poor girl starting out in her career, Lincoln had granted her half-hour daily sittings for five months. Now she could still recall his melancholy expression and his generous nature as she worked on her memorial statue in 1866.

Ream arrived at this impressive position at the young age of eighteen by sheer talent (and a talent for being in the right place at the right time). Her father held a modest civil service post in Washington, and Ream took a job as a post office clerk to help family finances. When she visited Clark Mills'

Fig. 3-28. Vinnie Ream Hoxie, ABRAHAM LINCOLN (1871), marble

sculpture studio in a wing of the Capitol, she was very much moved by the encounter. Immediately, she rushed home, modeled a medallion of an Indian head in clay, and presented it to Mills for his criticism. Impressed, he took her as a student. Because of her natural talent, and also because she had the good fortune to be working right in the nation's capital, she was soon commissioned to model busts of important men—Senator John Sherman, General Custer, Horace Greeley, and others. These patrons helped her arrange the sittings with Lincoln.

When Ream went to Rome in 1869 to put her *Lincoln* into marble, she became the darling of the international art colony there. Her coquettish and ingratiating ways, her beautiful face and long dark curls, combined with a lively mind and an eager, rushing manner, drew everyone to her and her studio. George Healy and George Caleb Bingham painted her portrait; William Wetmore Story, who had earlier ridiculed Harriet Hosmer behind her back, admired Ream. The combination of feminine charm, serious dedication to work, and a very open and generous nature made her irresistible.

After twenty months in Europe she returned for the unveiling of *Lincoln* in 1871. Wisconsin's Senator Carpenter and other members of the audience found that the sculpture, with its flowing lines and grave head bowed slightly forward, conveyed the artist's reverence and captured the quality of Lincoln's personality.

Over the years the sculpture has been both criticized and admired. Lorado Taft objected to the absence of "body within the garments,"[114] but many critics have found the work honest and realistic and compared it favorably with other, more pretentious statues of Lincoln that were being erected all over the nation at the time.

Ream executed a considerable body of work during her early years in addition to her many portrait busts. Among her neoclassical pieces were *Spartacus, Indian Girl, Dying Standard Bearer,* and *Violet,* all now lost. *Sappho,* a statue of the Greek poetess, is considered her finest neoclassical work. The "Tenth Muse," shown with the lyre, was a popular subject with sculptors of the period.

In 1875 Ream received a $20,000 federal commission for a statue of Admiral Farragut to be cast in bronze taken from the propeller of Farragut's flagship. The ten-foot statue, her major work, was unveiled in Farragut Square in Washington in 1881. At the 1876 Philadelphia Centennial Exposition she displayed *The Spirit of the Carnival* (an elaborate *tour de force* of garland carving), *Miriam,* and *The West.*

Her later life contrasts sharply with the lives of the rest of the "flock" of women sculptors, none of

whom married. At age thirty, in 1878, Ream married Lieutenant Richard Leveridge Hoxie, later to become brigadier general. Her home in Farragut Square became a center of Washington social life. She had a son, and deferring to her husband's wishes, gave up sculpture and became a social leader and charity worker, playing the harp at informal gatherings in her home.

Many years later, already ill, she returned to her profession, executing a statue of Governor Samuel Kirkwood of Iowa for Statuary Hall in the Capitol building. Her husband rigged up a boatswain's chair on a rope hoist to make her work easier. She had just completed a model of the Cherokee Sequoyah for the state of Oklahoma when she died at sixty-seven of a kidney ailment. *Sequoyah* was finished in bronze by the sculptor George Zolnay and today is in the U.S. Capitol. Over her grave in Arlington, Virginia is a bronze replica of her *Sappho*.

Emma Stebbins (1815–1882) during a visit to Rome in 1857 decided to become a sculptor at the relatively advanced age of forty-two. She is most remembered for her famous fountain, *The Angel of the Waters* (1862), which stands in the middle of Central Park in New York City.

The third daughter of John Stebbins, a wealthy New York banker of old New England lineage, Emma was encouraged in her many talents from childhood. She was already an exhibiting painter at the National Academy of Design when during a visit to Rome her friend Harriet Hosmer advised her to study there with Paul Akers, a sculptor from Maine.

In Rome Stebbins met Charlotte Cushman, the patron saint. She became Cushman's constant companion and lived with her in her apartment atop the Spanish Steps. She modeled a portrait bust of Cushman in 1859, from which three replicas were made, and eventually became her biographer. Through Charlotte Cushman, Stebbins met such ac-

Fig. 3-29. Vinnie Ream Hoxie, SAPPHO, TYPIFYING THE MUSE OF POETRY (1865–70), marble, 62″ × 25″ × 16″

85

complished women as George Sand, Elizabeth Barrett Browning, and Rosa Bonheur. Cushman's influence helped her win a major commission, the large bronze statue of *Horace Mann* (1864), which stands in front of the State House in Boston. Harriet Hosmer, who competed for this opportunity, was hurt and envious because Charlotte Cushman was their mutual friend.

Stebbins was perhaps also helped by her brother Henry, president of the New York Stock Exchange and head of the Central Park Commission. Her brother's possible influence, as well as family contributions to the expense of casting the bronze in Munich, helped Emma Stebbins carry out her most important commission, *The Angel of the Waters,* or *Bethesda Fountain,* as it is also called. The fountain has been universally admired since its installation in Central Park in 1873.

One of New York's largest and most beautiful fountains and one of the country's best-known monuments, it has long been a gathering place for the city's varied citizens; in the late 1960s it was a center where hippies congregated. The fountain takes its name from the New Testament passage in which the Angel of the Waters gives healing powers to the Bethesda pool in Jerusalem. Four figures grouped below the angel represent Temperance, Purity, Health, and Peace.

Columbus (1867) was bought by the famous New York collector Marshall O. Roberts and placed in Central Park at 102d Street, with much fanfare. In later years, however, this statue was upstaged by the large monument at Columbus Circle. Moved several times, it was nearly ruined from neglect and vandalism, but it now stands proudly in the modern Brooklyn Civic Center. Two of Stebbins's most innovative works, *Industry* (1860) and *Commerce* (1860), portrayed as a miner and a sailor, respectively, in modern clothes, are departures from the neoclassical stereotypes of the period.

In 1870 Stebbins and Cushman returned to the United States and lived together in Newport, Rhode Island, until Cushman's death in 1876. Stebbins spent her last years working on a biography of the actress and published *Charlotte Cushman: Her Letters and Memories of Her Life* in 1878, four years before her own death.

Fig. 3-30. Emma Stebbins, ANGEL OF THE WATERS (BETHESDA FOUNTAIN) (c. 1862), bronze

Louisa Lander (1826–1923), whose career was damaged by scandal, was perhaps the strangest of the "white Marmorean flock" in Rome. Born in Salem, Massachusetts, she began sculpting early and had already received commissions in Washington, D.C., before going to Rome in 1856 to become a student-assistant in Thomas Crawford's studio.

In Rome Lander was introduced to her fellow Salemite, the novelist Nathaniel Hawthorne. While Hawthorne was posing for an oversized portrait bust (now at the Essex Institute in Salem), he became fascinated by the sculptor and decided to use her as the model for the free-spirited women artists in his novel *The Marble Faun* (1860). He wrote in his notebooks:

During the sitting I talked a good deal with Miss Lander, being a little inclined to take a similar freedom with her moral likeness that she was taking with my physical one. There are very available points about her and her position: a young woman, living in almost perfect independence, thousands of miles from her New England home, going fearlessly about these mysterious streets by night as well as by day; and no household ties; nor rule or law but that within her; yet acting with quietness and simplicity, and keeping, after all within a homely line of right.[115]

Soon afterwards, Lander was apparently judged guilty of something unsavory by W. W. Story and other members of the American art colony, who actually conducted a special court of inquiry into her case. Patrons and colleagues ostracized her; even Hawthorne found it prudent to avoid her. Proudly defying public opinion and gossip, Lander continued to work, but was forced to continue her sculpture at her own expense because commissions had ceased. The sculptor John Rogers found her busy in her studio scaling up a large version of *Virginia Dare* in 1859, and wrote home, "She snaps her fingers at all of Rome."[116]

This statue, *Virginia Dare* (1860), was subsequently haunted by a series of misadventures. The sculpture portrays the first child of English parentage born in the New World, and shows her as she might have looked if she had grown to womanhood—gazing out to sea, draped in a fishnet, with a heron near her feet. The real Virginia Dare, a member of the Lost Colony, actually died in infancy. The boat that carried the marble *Virginia Dare* from Italy to Boston was shipwrecked off the coast of Spain and lay at the bottom of the sea for two years; Lander had to pay salvagers to retrieve it. After removing the stains and repairing the broken pieces, she exhibited it in Boston, where it was nearly destroyed in a gallery fire. It was then bought by a New York collector, who died without paying for it. When the executors of his estate refused to pay, it was again shipped back to Lander.

The sculptor moved to Washington, D.C., where she spent the rest of her life in obscurity. She failed to convince the state of North Carolina to buy her cherished work for the World's Columbian Exposition of 1893, but finally willed it to the state after her death. *Virginia Dare* was displayed in the Hall of History in the state capitol at Raleigh from 1926 to 1938, then shunted around to various basements and state offices and sometimes subjected to indignities. On one occasion it was "improved" with eyebrow pencil and lipstick by a prankster.[117]

After further shuffling by the National Parks Service, the statue was finally sent in the early 1950s to the Elizabeth Garden on Roanoke Island, where it now stands in peaceful dignity in the place where Virginia Dare was allegedly born. Most of Lander's other works, including *Undine, the Water Spirit* (c.1861), *Evangeline*, and *Ceres*, have disappeared.

Margaret Foley (c. 1827–1877) was a self-taught sculptor-prodigy from rural Vermont who worked her way up to a distinguished career in Rome. She began to whittle and carve as a young girl growing up in the quiet country town of Vergennes. After working in a textile mill in Lowell, Massachusetts, she moved to Boston in 1848 and specialized in cameo portraits.

Foley emigrated to Rome in 1860 and expanded her oeuvre to larger marble medallion portraits of such noted sitters as poet *William Cullen Bryant* ([1867], Amherst College). She also modelled portrait busts in the round (Theodore Parker [1877]), and religious and ideal pieces (*Jeremiah* and *Cleopatra*). Foley won international recognition and received many commissions for medallion portraits done in a crisply delineated, noble style. But a growing neurological illness was stalking her career.

Despite poor health, the energetic artist completed a major opus—a marble fountain basin supported by three children, which branched out into lacy acanthus leaves at the top. This work was sent to the 1876 Philadelphia Centennial Exposition where it was placed in the horticulture section.

Fig. 3-31. Margaret Foley, FOUNTAIN (c. 1874–76), marble

Today it is in the new Horticulture Center, West Fairmount Park, Philadelphia.

In 1877 Foley, ill and exhausted, left for her annual vacation in the Tyrol with her British author-friends, the Howitts. She died in Merano, to the sorrow of her colleagues in Rome.

Blanche Nevin (1841–1925) was a Philadelphia sculptor, well known in her day, but now shrouded in obscurity. Her only work that can be located is one of two statues representing Pennsylvania in Statuary Hall in the U.S. Capitol.

In Philadelphia she studied sculpture with Joseph Alexis Bailly and at the Pennsylvania Academy of the Fine Arts. Then, oddly, she went to Venice rather than Rome. Nevin achieved some recogni-

tion for *Maud Muller,* a sculpture based on Whittier's poem, and executed portraits and ideal busts.

In 1876 she sent two life-sized plaster statues to the Woman's Pavilion of the Philadelphia Cennnial Exposition—a recumbent *Cinderella,* described unkindly as "sitting with an air of discouragement among the ashes, in pose as if the dying gladiator had shrunk back into infancy and femininity,"[118] and an *Eve*. A contemporary engraving shows these two large works as the central focal points of the women's art display.

Nevin was a competent technician. She won a commission to carve a figure of John Peter Gabriel Muhlenberg (1887), which was unveiled in 1889 in Statuary Hall.

Florence Freeman (1825–1876), a Bostonian who went to Italy in 1861 under the protective wing of Charlotte Cushman, specialized in bas-reliefs for mantelpieces. The most famous of these was *Children and Yule Logs with Fireside Spirits*. Other members of the flock referred to her as "Hilda," after one of the protagonists of Hawthorne's *Marble Faun*.

Sarah Fisher Ames (*née* Clampitt) (1817–1901), the first woman sculptor to settle in Rome in the mid-nineteenth century, was born in Lewes, Delaware, studied in Boston and Rome, and married the painter Joseph Alexander Ames.

She was prominent in antislavery circles and served as a nurse during the Civil War. She did portrait busts, of which the best known is *Abraham Lincoln* (purchased 1868 by the U.S. Capitol).

The Philadelphia Centennial Exposition

The Philadelphia Centennial Exposition of 1876 climaxed the early phases of the art of the Republic. A number of women artists were represented in the main exhibition in Memorial Hall. Among the sculptures were six works by Edmonia Lewis, in-

cluding her award-winning *Cleopatra;* Vinnie Ream's *Spirit of the Carnival, Miriam,* and *The West;* Anne Whitney's *Roma,* her bronze bust *Le Modèle,* and her statuette of Charles Sumner; Florence Freeman's mantelpiece *Children with Yule Log;* and Margaret Foley's *Jeremiah* and *Cleopatra.* Foley's fountain, which had depleted her reserves of money and energy, was set in the center of Horticulture Hall, sending out sprays of water amid the plants and the Arabic horseshoe arches surrounding it.

Among the painters and graphic artists were Emily Sartain and Imogene Robinson, both of whom won medals, as well as Fidelia Bridges, Eliza Greatorex, Susan C. Waters, Virginia Granbery, Annie C. Shaw, Cornelia Fassett, and Elizabeth Gardner. Not all of the women's art, however, was shown in the main exhibition hall; some of it was displayed in a separate building—the Woman's Pavilion. The setting up of this pavilion was a startling last-minute development.[119]

At first there had been no consideration given to a separate exhibition of the work of women artists. But the organizers of the Exposition had been unable to raise the necessary operating funds as the event approached. They sought the help of Elizabeth Duane Gillespie, granddaughter of Benjamin Franklin and distinguished social leader and organizational wizard. Gillespie threw back a challenge of her own. She would agree to rally the women of the country in a national fundraising effort in return for a special area in the main hall devoted entirely to the contributions of women in all fields. The members of the Centennial Board of Finance (all males) agreed, and Gillespie and her newly formed Women's Centennial Executive Committee organized an elaborate national network of women who worked very hard and raised a large sum of money in a short period of time.

Shortly before the exposition date, however, Gillespie was informed that no space was available for the women's exposition because the booths of

Fig. 3-32. Lithograph of THE WOMEN'S PAVILION, PHILADELPHIA CENTENNIAL EXPOSITION (1876)

foreign nations had used up almost every square foot in the hall. If women wanted a show they would have to raise more money and build a separate building. Alternating between depression and rage, Gillespie conferred with her committee and decided to accept the conditions of a separate building. Unable to find a woman experienced in architecture on such short notice (the first woman would not graduate from a school of architecture until 1880), she engaged the services of H. J. Schwarzmann, chief architect of the Exposition. Schwarzmann quickly planned the building, which was erected in a prominent position on the fair grounds.

In the art section were two life-sized plaster sculptures by Philadelphia's Blanche Nevin, *Cinderella* and *Eve;* a marble bust by Florence Freeman; and Margaret Foley's bas-reliefs of *Charles Sumner* and *Joshua.* Among two-dimensional works were drawings by Eliza Greatorex; a painting of a young girl sewing, by Emily Sartain (as well as some of her steel engravings); sketches for *Harper's Weekly* by a young artist named Jennie Brownscombe (discussed in chapter 4); and wood engravings by Alice Donlevy. Also, there were special student exhibitions from the newly created art schools for women: the Women's Art School of Cooper Union, the Lowell School of Design at the Massachusetts Institute of Technology, the Pittsburgh School of Design, and the Cincinnati School of Design.

The already well-known artist Lilly Martin Spencer showed *Truth Unveiling Falsehood* (her most important allegorical work), *We Both Must Fade,* and several of her "cabinet-sized" paintings. *Truth Unveiling Falsehood* was awarded a medal and, along with two portraits of members of New York's Connally family, was installed in the subsequent Permanent International Exhibition, remaining there until 1880. Large photographs of *Truth Unveiling Falsehood* were sold during the period it was on display at the Exposition.

There was a great deal of controversy about the appropriateness of the separate building. Some women artists showed in both the Main Hall and the Woman's Pavilion. Lilly Spencer's correspondence reveals that she would have preferred to be in the Main Hall despite the fact that the Women's Committee offered to pay the shipping costs for her work. Radical feminists attacked the exhibition for being too conservative. Elizabeth Cady Stanton did not support the Pavilion, saying, "The Pavilion was no true exhibit of woman's art. . . . Upon its walls should have hung . . . framed copies of all the laws bearing unjustly upon women—those which rob her of her name, her earnings, her property, her children, her person. . . ."[120] For Stanton, true women's art consisted of such things as shoes, watches, and other objects made by women working for slave wages in factories owned by men. The author William Dean Howells declared himself "puzzled" by the exhibition.[121]

Leaflets and provocative incidents, such as the unexpected, unscheduled presentation of a Declaration of Rights for Women at the huge Independence Day gathering that year, added extra fireworks to this important Fourth of July. The raging controversies that surrounded the Woman's Pavilion demonstrated vividly the ambivalent position of women in the United States in 1876.

The Woman's Pavilion stood as a symbolic bridge between the Golden Age and the Gilded Age. It was a model for the Woman's Building that would be designed, by a woman architect, for the Chicago Columbian Exposition of 1893. In the next fifty years, women would seize the vote and enter all fields of art in still greater numbers.

Chapter 4
The Gilded Age, 1876–1900

The "Gilded Age" in America after the Civil War was a period of opulence and enormous industrial expansion. Families such as the Fricks, the Vanderbilts, and the Morgans amassed great fortunes, built huge mansions in ornate European styles, and demonstrated their wealth and good taste by collecting French, Italian, and German paintings.

There were visionary women among these collectors. In Boston, Isabella Stewart Gardner ("Mrs. Jack") built and lived in a Venetian palace filled with old-master paintings and turn-of-the century American art; today it is the Isabella Stewart Gardner Museum. Far in advance of most Chicago collectors, Bertha Honoré Palmer bought French Impressionist paintings that now make up an important part of the Art Institute of Chicago.[1]

Louisine Elder Havemeyer, wife of the "sugar king," sometimes rode in a streetcar instead of a private carriage to save money for her purchases of El Grecos, Goyas, Manets, and Courbets. The Havemeyer Collection, once on view only to a select audience at Sunday concerts in her Tiffany-decorated Fifth Avenue mansion, is today a cornerstone of the Metropolitan Museum of Art.

It was considered unsuitable for the wives of rich men to earn money, but they were very active in the cultural life of their communities; they formed clubs, classes, settlement houses, and museums. In Cincinnati, for example, the Women's Art Association under Elizabeth Perry founded the Cincinnati Art Museum (1880) and the Cincinnati Academy of Art.[2]

Patriotic monuments, plazas, and public buildings (such as the Library of Congress and the Boston Public Library) were erected in such large numbers that the Gilded Age is often called The American Renaissance. An influential tastemaker in this movement was Mariana Griswold van Rensselaer (Mrs. Schuyler van Rensselaer) of Boston. A discerning critic and the author of many books and articles on art, architecture, and landscape design, she advocated the integration of all the arts—murals, sculpture, and architecture—in the manner of the Renaissance. Americans, drawing upon old stylistic traditions, were creating new symbols to express the emergence of the country as a leading industrial nation and world power.

Surprisingly, despite the enduring myth of overstuffed women amidst overstuffed furniture—ornamental but useless—women artists were extraordinarily active in the Gilded Age. They painted and sculpted, creating fountains, busts, and equestrian statues that still adorn our city squares and public buildings. Like their male counterparts, they also crossed the sea to study in French academies; European techniques were now considered far superior to our own.

Art, along with teaching, writing, and nursing, was one of the few respectable occupations open to the ever-growing number of unmarried or impoverished genteel women who needed some means of supporting themselves.[3] Women were still not accepted in the professions, and factory work was considered outside the pale of polite society. Such work was thought suitable only for the masses

of poor immigrant women who were pouring into the country and were working for low wages under miserable conditions in garment industry sweatshops or as domestics in homes and hotels. In addition to those who needed to earn a living, a number of upper-class women seeking outlets for their energy went into art as amateurs or cultural volunteers and found themselves irresistibly swept up into professionalism.

The suffrage movement was well under way and undoubtedly contributed to the enthusiasm with which women artists entered such "masculine" fields as woodcarving and large-scale mural design. This feminist movement found artistic expression in the Woman's Building at the 1893 Chicago World's Columbian Exposition, where architecture, murals, and sculpture were created by women working together under the command of Chicago civic leader Bertha Honoré Palmer. The memory of this legendary project (since destroyed) became a beacon for the new women's movement of the 1970s. In fact, the present day Woman's Building in Los Angeles, a center of feminist creativity, was named after it.

Women and the Art Academies

Most of the women artists in earlier periods had been taught at home by fathers or husbands or had studied privately. For a long time women had been kept out of the leading academies here and in Europe, and had not been permitted to draw from the nude model (life-drawing), training considered essential to an artist's development. In the Gilded Age, this situation changed, but equal opportunity came slowly and painfully.

American Art Academies

The Pennsylvania Academy, founded in 1805, permitted women to exhibit in annual shows from the beginning, but the first record of women students in Academy art classes does not appear until 1844.

That year the Board of Directors passed a resolution allowing women to draw from the collection of nude antique plaster casts for one hour on Mondays, Wednesdays, and Fridays in a safely segregated class.

Drawing from a live nude model was still unthinkable. In 1856 the Academy abolished "Ladies Day" and permitted women to draw from plaster casts of the *Apollo Belvedere* and *Laocoon* with the men, but not before a "close-fitting but inconspicuous fig-leaf" was placed on the offending works. In 1868 the first ladies' life-drawing class with a nude female model was established; in 1877 the male nude was introduced.

The Academy was taking a very advanced position for the times and was frequently attacked by outraged citizens who felt that their young women were being corrupted. The following letter was addressed to the academy director in 1882:

Does it pay for a young lady of a refined, godly household to be urged as the only way of obtaining knowledge of true art, to enter a class where every feeling of maidenly delicacy is violated, where she becomes . . . so familiar with the persons of degraded women & the sight of nude males, that no possible art can restore her lost treasure of chaste and delicate thoughts! . . . The stifling heat of the room adds to the excitement, & what could be a cool unimpassioned study in a room at 35°, at 85° or even higher is dreadful.[4]

The National Academy in New York admitted some women students to its Antique School (drawing from casts) in 1831, but women were not enrolled on a regular basis until 1846. A women's life-drawing class finally started in 1871, but women could not attend anatomy lectures until 1914. The Art Students League, which opened in 1875, took a much more liberal attitude toward women from the beginning, and included women on its governing board. As the Midwest became settled, excellent new coeducational art schools, such as the Cincinnati Art Academy, the St. Louis Art Academy, and the Art Institute of Chicago,

began to provide equal educational opportunities for women.

European Academies

Women were not permitted to study in the prestigious École des Beaux-Arts until the very end of the nineteenth century. They were admitted only when French women artists, organized in the Union of Woman Painters and Sculptors, stormed the École in 1896.[5]

The less prestigious Julian and Colarossi academies opened their doors earlier,[6] and women rushed in to take advantage of segregated classes taught by famous French academicians. Women artists took one step forward and two steps back, as they fought for the right to draw the nude model alongside their male peers at the Julian. May Alcott (Louisa May Alcott's sister), studying art in Paris, wrote angrily:

The lower school as it is called, or male class, no longer opens its doors to women, for the price, being but one half of the upper [women's] school, attracted too many. Also, with better models, and a higher standard of work, it was found impossible that women should paint from the living nude models of both sexes, side by side with the Frenchmen.

This is a sad conclusion to arrive at, when one remembers the brave efforts made by a band of American ladies some years ago, who supported one another with such dignity and modesty, in a steadfast purpose under this ordeal, that even Parisians . . . were forced into respect and admiration of the simple earnestness and purity which proved a sufficient protection from even their evil tongues; M. Jullien himself confessing that if all ladies exercised the beneficial influence of a certain Madonna-faced Miss N. among them, anything would be possible. . . .

. . . .women of no other nationality could have accomplished it; so, let those who commonly represent the indiscreet, husband-hunting. . . . butterfly, as the typical American girl abroad, at least do her the justice to put this fact on record, to her credit.[7]

The Julian continued to charge higher prices and

give inferior instruction to women until late in the century.

In England, women sneaked in under men's names and petitioned constantly to be admitted as students to the Royal Academy, but once accepted, they were not permitted to draw from the nude male model until 1893. Even then, the Academy strictly specified, in its annual report of 1894, that the model should wear

ordinary bathing drawers and a cloth of light material 9 feet long by 3 feet wide, which shall be wound round the loins over the drawers, passed between the legs and tucked in over the waistband; and finally a thin leather strap shall be fastened round the loins in order to insure that the cloth keep its place.[8]

The Academy of Rome remained closed to women through the nineteenth century.

At a time when accurate rendering of the human body was central to art, one can appreciate how crippling these handicaps were. Yet the widening of opportunity, despite restrictions, led to an admirable flowering of fine draftsmanship, and at the turn of the century several American women artists were hailed by leading critics of the period as equals of the outstanding men.

Sculptors

In the Gilded Age American sculptors essentially abandoned neoclassical idealized marble figures carved in tight, smooth surfaces and moved toward greater realism. Such realism was made possible by the use of sensitively modeled clay cast in bronze. Wrinkles and baggy trousers, buttonholes and lapels, could be faithfully rendered in this medium. This new realism, however, was still being used to create public monuments that expressed civic virtue and moral earnestness. Many American male sculptors, trained at the École des Beaux-Arts, also introduced the flamboyant French neobaroque spirit into American sculpture.

There was already a unique American tradition of

women in sculpture. In the Gilded Age a few fortunate women, like the men of the day, were hired as apprentices to certain key masters. Augustus Saint-Gaudens, who raised the new style to a level of nobility, employed Helen Mears and other women sculptors as his assistants. Daniel Chester French, the great public sculptor of the *Minute Man* (1873–74) hired Evelyn Longman to help him. Frederick W. MacMonnies, who brought to American sculpture a certain theatrical vitality and sensuousness typical of the French neobaroque style, permitted Janet Scudder to work in his French atelier.

A particularly large group of women sculptors were taught by Lorado Taft (1860–1936), a Beaux-Arts-trained instructor at the Art Institute of Chicago. Several of his women assistants, nicknamed "The White Rabbits," helped him build many of the large sculptures for the Chicago World's Columbian Exposition of 1893.

Janet Scudder (*née* Netta Dewee Frazer Scudder) (1869–1940), one of Lorado Taft's assistants, became famous for light-hearted garden fountains like the *Frog Fountain*. She found success after hardship and struggle in her early years.

Scudder came from a gloomy home in Terre Haute, Indiana. Her mother died when she was very small, and her father, struggling to support seven children, had remarried a woman unsympathetic to Janet. Scudder was a tomboy, later recalling in her autobiography, "I could skin a cat, hang by my toes. . . . As for skating on ice in moonlight, no one could outdistance me."[9] She remained adventurous and uninterested in so-called female pursuits for the rest of her life.

Her first artistic impulses were stirred by the illustrations in two books of Longfellow's poems. Disregarding the poetry, she became enchanted by the pictures and copied a Viking in full armor hundreds of times on scraps of old, used envelopes. When the house caught fire, she was seen lugging the two heavy volumes down the burning steps.

Scudder was still a child when she won a prize at the county fair for a hammered brass tray in the form of Medusa's head. At her Saturday drawing lessons at Rose Polytechnic Institute, the director immediately recognized her drive and urged her impoverished father to send his daughter to study at the Cincinnati Art Academy.

In Cincinnati at age eighteen, Scudder took every course she could register for, specializing in woodcarving,[10] a remunerative craft at that time. To help with tuition she sold wooden mantelpieces, elaborately carved with grapes and bowknots, for the enormous sum of sixty dollars each. She studied clay sculpture with Professor Louis Rebisso, who was considered a genius in Cincinnati because he was working on an equestrian statue of Ulysses S. Grant in Lincoln Park, Chicago. Rebisso's encouraging words, "You are going way beyond me,"[11] filled her with a faith in herself that helped during the very difficult years ahead.

That summer her favorite brother drowned; her family home was closed up except for two or three rooms; and her father died. Scudder reacted *against* these experiences with a renewed will to live and a kind of toughness.

After finishing her training, she found a job as a woodcarver in a Chicago factory. She was fast and skillful, but the union there did not permit women members. Despite her outraged cry that "women have as much right to support themselves as men,"[12] the union soon forced her dismissal.

Fortunately, at this time all of Chicago was preparing for the great exposition of 1893. She was hired by Lorado Taft to be one of his assistants on the sculptures for the front of the Horticulture Building.

So heady was the feeling among the small group of women assistants at being given this opportunity to learn their craft and be paid for it too, that on receiving their first month's pay, they opened the envelopes and carpeted the floor with five-dollar bills. Later not even a dangerous fall from the top of a high scaffold could dampen Scudder's en-

Fig. 4-1. SCULPTURAL STUDIO IN HORTICUL-
TURAL BUILDING, August 24, 1892 (preparing for
the Chicago World's Columbian Exposition, 1893)

thusiasm. The chapter in her autobiography,
Modeling My Life (1925), that describes this period
is an important document in the history of Ameri-
can women artists.

Taft had been given the job of scaling up many of
the monumental pieces created for the exposition
by other sculptors. When he told the chief architect,
Daniel Burnham, that he would like to employ
some women among his assistants, Burnham repor-
tedly said, "That was all right . . . to employ any one
who could do the work . . . white rabbits if they will
help out."[13] Out of that group, dubbed "The White
Rabbits," came many of the leading women
sculptors of the period—Bessie Potter Vonnoh, Enid
Yandell, Julia Bracken, and Caroline Brooks (who
later married sculptor Hermon MacNeil). Taft's sis-
ter Zulime, a painter who later married author Ham-
lin Garland, was also in the group.

The Exposition was important to Scudder for
another reason. From a distance she saw Frederick
MacMonnies supervising the installation of his
monumental fountain, an elaborate mythological
boat with rowers, and she became determined to
study with him. After the Exposition Scudder went

to Paris with Zulime Taft, carrying a letter of intro-
duction to MacMonnies from a friend of his wife.[14]
She overcame MacMonnies's initial rebuffs, and at
last was admitted to study in his studio.

The men in the studio were accustomed to off-
color bantering with the female life model. The
model was enraged at the idea of a woman profes-
sional in the studio, and carried on a campaign of
assaults against Scudder, lying down in grotesque
positions and screaming tirades at her in French. It
took months before the artist was able to overcome
the model's resistance.

Scudder progressed rapidly in her work—in fact,
too rapidly for one of MacMonnies's assistants, who
jealously plotted to get her out. One day, when
MacMonnies was away, the assistant told her that a
figure on which she had worked for months had
been ruined in casting because she had used too
much vaseline in the clay, and that the master was
generally dissatisfied with her work. Scudder left for
New York in despair without discussing the matter
with her revered mentor. Years later, in a conversa-
tion with MacMonnies, she found out that the en-
tire story had been a fabrication. He had in fact
viewed her as his best assistant and had been hurt
and bewildered by her abrupt departure.

In New York Scudder endured the loneliness and
grinding poverty of a young woman trying to make
her way as a professional in that era. She was given
a phony commission for a lamppost design by an
architect who was interested only in seducing her.
The leading sculptors she visited with letters of
introduction treated her with brutal indifference.
Finally, a wealthy fellow art student, Matilda Brow-
nell, rescued her from this desperate situation.
Brownell's father used his influence to get Scudder
the commission to design the seal for the New York
Bar Association, and this commission opened the
door to other jobs—architectural ornaments, por-
trait medallions, and funeral monuments. At last
self-supporting, she returned to Paris as soon as
finances permitted, and before long the Luxem-

bourg Museum honored her by acquiring a number of her medallions.

Scudder's artistic style took a decisive turn during a trip to Italy in the late 1890s. In Florence, Naples, and Pompeii, the cherubs of Donatello and the decorative statues in the gardens of Roman villas seemed to her the most delicious form of sculpture, bringing pleasure into people's daily lives. On her return to Paris, inspired by a street urchin who begged his way into her studio and became her model, she executed the *Frog Fountain* (1901), a bronze garden statue of a small boy gleefully dancing in the water spraying from the mouths of three frogs. She had found her métier. Stanford White, a leading American architect and taste-maker of the period, subsequently gave her many commissions for the gardens of John D. Rockefeller and other millionaires, and the Metropolitan and other museums began to acquire these works.

Scudder's sculpture reflects the Beaux-Arts-dominated tradition of the period. Her style was, as she openly admitted, based on the Renaissance and on the lively, animated manner of her teacher MacMonnies. In this mode, however, she was an original. She innovated a new genre of garden sculpture that became very popular in America.

Her *Femina Victrix* (1915), a sleek figure of a woman poised on a globe holding a laurel wreath, was a study for an intended victory fountain in Washington, D.C., in honor of the suffrage movement. The model was the ethereal dancer Irene Castle. In this and certain other works, Scudder used the boyish, slender, female body image that was to become popular in the "liberated" twenties. In very late works (a mother and child, and an angel for a church in Palm Beach, Florida) there is a new, grave serenity that is almost Gothic.

Scudder had a long, productive career, moving in artistic and socialite circles in France and New York. In 1913 she bought a house in Ville d'Avray, outside of Paris, with a proper garden setting for her works in progress. Ten of her pieces were shown at

Fig. 4-2. Janet Scudder, FROG FOUNTAIN (1901), bronze statuette, height 37½"

the Panama-Pacific Exposition in San Francisco in 1915 and earned her a silver medal. In 1920 she was elected an Associate Member of the National Academy. During World War I, her passionate devotion to France led her to serve with the Red Cross in that country. France made her a chevalier of the Legion of Honor in 1925. When World War II broke out she returned to Rockport, Massachusetts, where she died at age seventy-eight.

Julia Bracken Wendt (1871–1942), another of Lorado Taft's "White Rabbits," was described by him as "the leader of the women sculptors of the West."[15] Born in Apple River, Illinois, the twelfth child in an Irish-American Catholic family, she enrolled at the Art Institute of Chicago at age seventeen and assisted Taft in his studio for six years. While helping him with sculpture for the Chicago World's Columbian Exposition of 1893, she also carried out an independent commission for the Illinois pavilion, *Illinois Welcoming the Nations* (1893), which was cast in bronze and placed in the state capitol at Springfield. By her early twenties she was a well-established sculptor in Chicago and had won important prizes.

In 1906 she married William Wendt, a landscape painter often referred to as "the painter-laureate of California," and moved to Los Angeles with him. Ultimately, they settled in Laguna Beach, California, a beautiful art colony on the ocean. There they built a studio with a view of the sea framed by eucalyptus trees, and continued successful careers, sometimes exhibiting together.[16] Julia Wendt taught for seven years at Otis Art Institute in Los Angeles (1918–25) and served on the municipal art commission.

In 1911 the people of Los Angeles raised $10,000 for Julia Wendt to create a heroic three-figure allegory for the rotunda of the new Los Angeles County Museum. In flowing Beaux-Arts-inspired rhythms of green bronze on a marble stone base, Wendt created three female figures representing Art, History, and Science, together holding aloft an electric light globe that illuminated the rotunda. Henrietta Housh, founder of the Los Angeles Fine Arts League and organizer of the fundraising campaign for the statue, addressed the large group of dignitaries at the unveiling of *Art, Science, and History* on 30 May 1914: "Then, too, this was a part of suffrage work . . . to see that something was done to show appreciation of the woman, here in our midst who had the power to create a monumental and symbolic group."[17] The new museum's Curator of Art Everett Maxwell declared that "at last Los Angeles possesses one really good public statue. . . . It has for the last three years occupied the center of the stage in the field of local art."[18]

Ironically, in the 1950s, at the peak of the wave of modern art and architecture, a circular box containing display cases for minerals was built around the statue, hiding it and the rotunda architecture completely. For years, visitors looking at the minerals and crystals had no idea that Julia Wendt's *Art, Science, and History* was imprisoned behind the display wall. In 1980, with the revival of interest in nineteenth century architecture and sculpture, a new mineral room was added to the museum; Wendt's eleven-foot-high work was brought to light again as the focal point of the newly carpeted and refurbished rotunda. The fate of Wendt's statue is reminiscent of the turbulent histories of Emma Stebbins' *Columbus* (1867) and Louisa Lander's *Virginia Dare* (1860).

Julia Wendt's works have a characteristic, flowing quality of rhythmic grace, and at the same time, great strength. She was a fully developed technician, not only in bronze, but also in wood and marble. Wendt was known for a series of relief portraits of famous men of the century—Leo Tolstoy, Ralph Waldo Emerson, Abraham Lincoln, and William Morris. She executed a full-sized James Monroe (1900) for the state capitol in Springfield, Illinois, and numerous other figures, portrait busts, plaques, and memorials (including a King

Edward Peace Memorial for Saskatoon, Canada, in 1913). Among many honors, she won a gold medal for sculpture at the 1915 San Diego Exposition, and was one of the most important Los Angeles sculptors of her day.

Wendt's obituary on the editorial page of the Los Angeles *Evening Express* in 1942 described her as a spiritual person who fed beggars and birds and helped all those in need. She left an unfinished portrait bust of her husband.

Bessie Onahotema Potter Vonnoh (1872–1955) was described by Lorado Taft as "another eager spirit out of the West whose little bronzes are welcome the world over."[19] She became famous for small genre subjects, such as *Young Mother* (1896) and *Girl Dancing* (1897), with a lively, spontaneous style.

Born in St. Louis, Missouri, Bessie Potter studied at the Art Institute of Chicago and became another of Taft's "White Rabbits," assisting him with

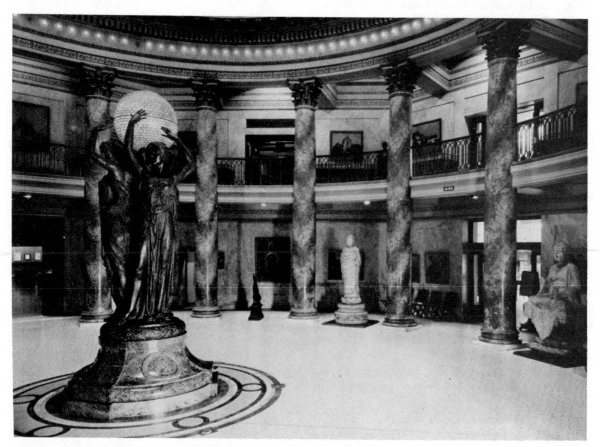

Fig. 4-3. Julia Bracken Wendt, THE THREE GRACES: HISTORY, SCIENCE AND ART (1914), rotunda of Los Angeles County Museum of Natural History, bronze on stone base, height 11'

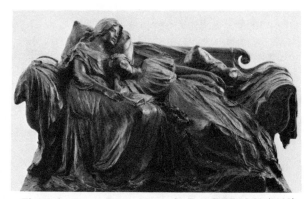

Fig. 4-4. Bessie Potter Vonnoh, DAYDREAMS (1903), bronze, 10½″ × 21¼″ × 11″

sculptures for the 1893 Chicago exposition. According to Taft, Potter was first inspired to do her genre groups when she saw the elegant bronze figurines by Prince Paul Troubetskoy in the Italian section of the Fair: "These remarkable plastic sketches quite captivated Miss Potter and she forthwith set about 'doing Troubetskoys' as she termed her new diversion."[20] Although critics detected some resemblance between her small figures and the sketchy Tanagra terra cotta figures of Hellenistic Greece, Taft hastened to assure them that Potter had indeed developed a style all her own.

She further deepened her style on a trip to Paris in 1895, where she may have been affected by the simple, tender, domestic subjects of Auguste Renoir and Mary Cassatt. On her return to America in 1896, she completed *The Young Mother,* her most popular statuette. This work, reproduced many times, is now in the Metropolitan Museum of Art and other museums. *Enthroned* (1902) and *Girl Dancing* (1897) are other works in the same spirit.

In 1899 Bessie Potter married the well-known painter Robert Vonnoh and moved to New York City. She exhibited her small bronze groups in a 1913 one-woman show at the Brooklyn Museum. In the twenties and thirties she focused on larger pieces, such as the Burnette Fountain in Central Park and a fountain for the Roosevelt Bird Sanctuary in Oyster Bay, Long Island. Her major portrait commissions were of Major General S. Crawford for the Smith Memorial in Philadelphia and James S. Sherman for the U.S. Capitol.

Bessie Potter Vonnoh's enchanting small groups are outside the mainstream of large, grandiose public works that were the principal achievements of Augustus Saint-Gaudens and other major sculptors of the period. Rather, they deal with the joy and beauty of contemporary middle-class domesticity, well-dressed mothers in modern dress with their well-fed babies.

In a small format Vonnoh's sculptures combine a spontaneous, unlabored quality, with sincerity of feeling, and a plastic sense of form. The flickering, impressionistic surfaces reflect the contemporary French influence. Later the Ash Can School of

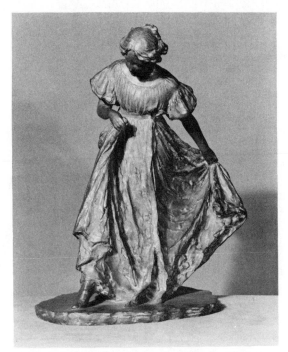

Fig. 4-5. Bessie Potter Vonnoh, GIRL DANCING (1897), bronze, height 14″

sculptors would also deal with subjects of daily life in small, spontaneous bronzes, but they would choose as their subject matter the lives of the ragged, the poor, and the urban worker.

The most striking quality of the work of **Enid Yandell (1870–1934)** is its impressive physical range. Her statue of Athena (since destroyed), which once stood in front of a reproduction of the Parthenon at the 1897 Tennessee Centennial Exposition in Nashville, was twenty-five feet high—at that time the largest figure ever designed by a woman. Yet she also designed a little silver tankard for the Tiffany Company, on which a fisher boy kisses a mermaid whenever the lid is lifted, and yearns toward her over the edge as long as it is closed.

Another of Lorado Taft's "White Rabbits," Yandell was born in Louisville, Kentucky. After graduating from the Cincinnati Art Academy, she left the Midwest to study in New York with the French sculptor Philip Martiny and in Paris with Auguste Rodin and Frederick MacMonnies. In 1893 she helped Lorado Taft and also did a great deal of independent work for the Chicago World's Columbian Exposition, including a statue of Daniel Boone (now standing in Louisville, Kentucky) and the caryatids for the Woman's Building. She won a Designer's Medal at the Exposition.

Her works, both large and small, seem to attempt (like so much art of this period) to embody literary and sometimes rather ponderously philosophical ideas. *The Carrie Brown Memorial Fountain* (1901) in Providence, Rhode Island, is such an attempt. Yandell won this commission by competing with many leading sculptors. A memorial to Carrie Brown Bajnatti, it was a gift to the city from her widowed husband. (The subject came from the prominent Providence family after which Brown University is named.)

According to Yandell, her aim in this sculpture was to portray "the attempt of the immortal soul within us to free itself from the handicaps and entanglements of its earthly environments. It is the development of character, the triumph of intellectuality and spirituality I have striven to express."[21] In the *Memorial Fountain,* Life is represented by a large, heroic woman with a muscular back (Lorado

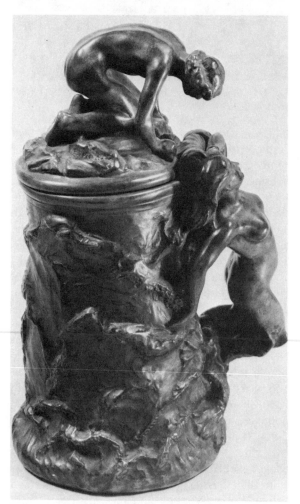

Fig. 4-6. Enid Yandell, KISS TANKARD (c. 1899), art nouveau lidded tankard, bronze, height 11⅝"

Taft referred to this figure as "amazon"-like), struggling to free herself from such base, earthly tendencies as duty, passion, and avarice, which are represented by comparatively diminutive men. There is also an angel, the Soul, whose mantle of Truth flowing from its shoulders forms a drapery for the whole composition.

In later years Yandell lived and taught sculpture in Edgartown, Massachusetts, on Martha's Vineyard. She also executed the Emma Willard Memorial in Albany, the Hogan Fountain in Louisville, the Mayor Lewis Monument in New Haven, and other fountains and busts. She was one of the first women members of the National Sculpture Society, and her sculpture *The Five Senses* was in the 1913 Armory Show in New York City.

A favored protégée of Augustus Saint-Gaudens, **Helen Farnsworth Mears (1871–1916),** of Oshkoṣh, Wisconsin, executed a full-sized sculpture of Frances Willard for the U.S. Capitol. Hers was the prototypical story of artistic tragedy—early recognition and success followed by neglect and early death.

Mears's parents although poor, encouraged the gifts of their three daughters. The whole family was possessed by the American dream of upward mobility. Mears's mother Elizabeth, a writer who published poetry and wrote plays under the pseudonym Nellie Wildwood, is considered the first poet of Wisconsin. Mears's father had studied surgery in his early years and took an intense interest in his daughter's sculpture, teaching her anatomy, fashioning homemade tools, and setting up a workshop for her in the woodshed.

Helen and her sister Mary, a writer, were soulmates who lived and traveled together throughout their lives. Mary believed intensely in her sister's genius and helped her in every conceivable way, even after her sister's death.

At a young age Helen Mears modeled a remarkable sculpture called *Repentance* (c. 1890), depicting a figure curled up in grief. A photograph of it caught the eye of Saint-Gaudens. He reportedly wrote and invited her to study with him, but the family was too poor to send her to New York. Instead, in the woodshed she worked on a clay maquette of a figure with an eagle, which she called *Columbia*. When the World's Columbian Exposition was being planned, Elizabeth Mears invited members of the state commission to their home to view her daughter's work. The maquette was rescued from the woodshed and placed on the dining room table. This won her first important commission—the figure with the eagle scaled up to a nine-foot statue, entitled the *Genius of Wisconsin* (1892) for the Exposition.

Mears studied with Lorado Taft for six weeks at the Art Institute of Chicago, then labored all winter in a freezing shed on the exposition grounds, making the model for the statue. Around this time, the wealthy Milwaukee philanthropist Alice Chapman began to take an interest in her. With Chapman's help and a $500 prize from the Milwaukee Women's Club, the Mears sisters took off for New York so that Helen Mears could at last study with the great Saint-Gaudens at the Art Students League.

After only a few weeks at the League, Saint-Gaudens welcomed Mears into his own studio to be his assistant. From him she received a rigorous apprenticeship, working in the busiest sculpture atelier in New York, through which many famous sculptors, architects, and patrons passed daily.

In 1896 Alice Chapman offered to pay for a trip abroad, which was considered essential to an artist's development in that period. Mears studied at the Académie Julian and the Académie Vitti. Afterwards, she and her sister Mary toured Italy, looking at the museums and monuments. While they were in Italy, Saint-Gaudens invited Helen to return to Paris to assist him on his large equestrian statue of General Sherman.

Their time in Paris was glamorous and productive for both sisters. Helen Mears spent half her time helping the sculptor on his huge piece, and the

other half working on her own bas-relief portrait of Saint-Gaudens in a studio at 34 Rue Notre Dame des Champs. Meanwhile, Mary Mears was writing a novel about student life in Paris. With Saint-Gaudens and his friend, Dr. Henry Shiff, they frequented the cafes and visited historic places together after work. But soon Helen Mears felt she had to strike out on her own.

In 1898 the Mears sisters returned to Oshkosh, which seemed unutterably dreary and provincial after Paris. In 1899, however, with the help of the wealthy Alice Chapman, they returned to New York and opened a studio at 46 Washington Square.

During this time Mears competed for and won the commission for a nine-foot marble sculpture of Frances Willard for Statuary Hall in the U.S. Capitol. Willard had been a famous professor, orator, national organizer of women, and leader of the Women's Temperance Union. Mears's aim was to capture the moment when the leader faced her audience just before the start of an oration.

By correspondence, Mears and Saint-Gaudens discussed details such as the disposition of Willard's shawl. He also gave her general advice and encouragement. When *Frances Willard* was unveiled in 1905 to wide acclaim, her mentor wrote, "It is as strong as a man's work, and in addition has a subtle tangible quality exceedingly rare and spiritual."[22]

In 1906 Marian MacDowell, wife of the American composer Edward MacDowell, was aware that her husband was dying and commissioned Mears to model a bas-relief portrait of him from sittings in New York City and at the MacDowell summer home, Hillcrest, in Peterborough, New Hampshire. Mears created an extremely sensitive, tragic profile of the dying musician, who suffered from a nervous disorder at the end of his life, perhaps because of overwork and stress.

While Mears was working on the sculpture, the visionary Marian MacDowell was, with her husband, planning to create the MacDowell art colony

Fig. 4-7. Helen Farnsworth Mears, DAWN AND LABOR (1909), bronze, 28″ × 18″ × 15″ (photo shows work in plaster before casting)

on the grounds of Hillcrest. It was to be a kind of memorial to his memory, a retreat for people in all the arts. Marian MacDowell felt strongly that the jangling effects of city life had played a part in destroying her husband's nervous system. She wanted to offer a haven in the New Hampshire countryside, where writers, musicians, and artists could work quietly for periods of time, surrounded by the peaceful ambience of nature.[23] In 1907 the Mears sisters were the first recipients of MacDowell fellowships at the famed colony, and records show that they also spent time there during the next four summers.

In 1910 Mears was recommended to design a

Fig. 4-8. Helen Farnsworth Mears, THE FOUNTAIN OF LIFE (1899–1904) (destroyed), plaster, 14′ × 13½′

figure to stand atop the dome of the Wisconsin state capitol. After showing her model to the Capitol Commission, she was given the impression that the job was hers and was well into the project before discovering that the commissioners were still debating whether to hire her. According to various accounts, she brought her model to Daniel Chester French for some technical advice, after which he applied for the commission and got it.[24] This was a great setback to Mears, which damaged her reputation and self-confidence severely. Her mentor Saint-Gaudens was no longer there to defend or at least console her—he had died in 1907.

She worked for five years on a three-part wall fountain, *The Fountain of Life* (1904), which she considered her major work. Although this won (in plaster), the silver medal at the St. Louis Exposition in 1904, it was never carried out in marble or bronze. After the artist's death the plaster decayed and crumbled in the storage room of the Milwaukee

Art Institute, while Mary Mears made numerous attempts to raise the funds to have it cast and placed in a beautiful setting. When *Fountain of Life* was sent to a possible patron, it arrived smashed beyond recognition.

According to biographer Susan Porter Green, between 1914 and 1916 Helen and Mary Mears lived through a period of such intense poverty that they sometimes had to choose between food and clay. Helen Mears drove herself, despite the circumstances, to work on many sketches and projects, including *Fountain of Joy* and other works in which she tried to realize her idealistic visions and embody her Christian Science philosophy. One very late work, *End of Day* (1914), showing a tired laborer, seems almost prophetic.

Fig. 4-9. Helen Farnsworth Mears, END OF THE DAY (1914), bronze, 12″ × 7″ × 11″

In 1916, after seeming to recover from a severe grippe, Helen Mears died unexpectedly at age forty-five. It was whispered that she had died of malnutrition. Mary Mears was left with one dollar and a dingy studio filled with half-finished wax and plaster works. She spent the rest of her life promoting her sister's reputation and raising funds to get the works cast.

Today the artist is something of a cult figure in Wisconsin, where women's clubs sponsor Helen Mears scholarships, and where several retrospectives have been held. Mears was searching for an expressive quality in her work that was perhaps best realized in her floating and dreamlike two-figure composition *Dawn and Labor* (1909). Perhaps it was her special sensibility—romantic and visionary—that kept her from achieving the same commercial success as other women sculptors of her time.

Evelyn Beatrice Longman (1874–1954) was probably the most successful woman sculptor of her time. In contrast to the stormy lives of many artists, her history reads like a novel by Horatio Alger.

Born in a log cabin, she went on to create bronze doors, marble memorials, portraits, and exposition pieces, in such numbers that a list of her works and prizes would barely fit on this page. At one time her sculpture *The Genius of Electricity* (1916) was known to most Americans as "The Spirit of Communication," because it was used as a symbol on the cover of the telephone directory in many areas.

Longman was born near Winchester, Ohio, to English parents. Her father was a poor musician with six children who eked out a living by farming. By the age of fourteen Evelyn was working full-time in a large wholesale house in Chicago while taking night classes at the Art Institute of Chicago. She saved for six years to be able to study full-time, first at Olivet College, and then at the Art Institute of Chicago with Lorado Taft from 1893 to 1900. She graduated from the Art Institute with the highest

Fig. 4-10. Evelyn Longman, BRONZE CHAPEL DOORS, UNITED STATES NAVAL ACADEMY, ANNAPOLIS (1906–9), bronze, 276" × 120"

honors and was immediately put in charge of the summer modeling class.

Longman left for New York to assist the well-known sculptors Herman MacNeil and Isidore Konti on decorations for the 1901 Pan-American Exposition. The master sculptor Daniel Chester French was impressed by her and hired her as his only woman assistant. She worked for him for three years and gradually built up an independent career as well.

One of her important early works, *Victory* (1903), was placed atop the Festival Hall at the 1904 Louisiana Purchase Exposition in St. Louis. This sculpture, in which Longman substituted a male figure for the traditional female Victory, was chosen

Fig. 4-11. Evelyn Longman, THE GENIUS OF ELEC-
TRICITY (1916), gold leaf over bronze, height 24',
weight 8 tons

to be the central emblem for the exposition and was
awarded a silver medal. In 1906 she competed
anonymously against thirty-three rivals, including
some of the best-known men sculptors in America,
and won the commission for a massive pair of
bronze doors for the entrance to the chapel of the
United States Naval Academy at Annapolis.

The symbolism she used in these 22 × 10 foot
doors is typical of public patriotic sculpture at the
turn of the century. The overhead panel bears the
motto. "Not for Self But for Country". The left door,
symbolizing Peace, shows Science instructing a
midshipman; on the right door (symbolizing War),
appears Patriotism, her fist clenched upon a can-
non. The young man at her side represents youth

responding to Patriotism's call, about to join other
marchers going off to war.

Of this work Daniel Chester French said, "Miss
Longman is the last word in ornament."[25] This
commission was followed by innumerable others,
including bronze doors for Wellesley College.

Longman's *Genius of Electricity* (1914–16), the
now-familiar winged male figure holding a bolt of
electricity, has been a famous landmark in Man-
hattan since its installation in 1916 atop the Ameri-
can Telephone and Telegraph Building at 195
Broadway. The twenty-one-foot gilded bronze fig-
ure will soon be moved from its high perch to a
place of honor as the central corporate symbol in
the ground-floor lobby of the new A..T. & T. head-
quarters (designed by Philip Johnson) on Madison
Avenue.

Among Longman's portrait assignments was the
six-foot bust of Thomas A. Edison, the only one for
which he ever gave sittings. For this portrait she
spent two weeks at Edison Laboratories in Florida
shortly before the inventor's death, taking more
than sixty measurements of his head.

Longman was the first woman sculptor to be-
come a full member of the National Academy of
Design. Her style is strong; details of the bronze
doors at Annapolis can be described as Michelan-
gelesque. Her draftsmanship is assured, and her
rhythmic compositions have a classical purity of
line. Famous for hard work and technical skill, she
reportedly finished all her marble pieces with
hammer and chisel after they were roughed out by
the marble carvers. This was rare among the
Beaux-Arts sculptors. The Metropolitan Museum of
Art owns a replica of *Victory* (1903) and a portrait of
Henry Bacon.

Longman frequently collaborated with Bacon,
the famous architect, and was present at con-
ferences on the design of the Lincoln Memorial.
They were both prominent exponents of "Imperial
Classicism," the neoclassical revival style in vogue
for the many public buildings and monuments

being erected in an age of burgeoning wealth and grandeur. Their award-winning *Fountain of Ceres* (1915), in the Court of Four Seasons at the 1915 Panama-Pacific Exposition in San Francisco, portrayed the goddess standing on a drum-shaped base enriched with reliefs of girls in Greek draperies. They also collaborated on an Illinois centennial column for Logan Square, Chicago.

Longman lived in New York City until her marriage in 1920 at the age of fifty-two to Nathaniel Horton Batchelder, headmaster of the Loomis School in Windsor, Connecticut. After her marriage, in her studio at the school, she made war memorials and post office friezes for Connecticut towns. She died at Osterville, Massachusetts, on Cape Cod, in 1954.

Theo Alice Ruggles Kitson (1871–1932) specialized in robust war memorials. Regiments of her bronze soldiers, muskets at the ready, appear in over fifty public sculptures erected in various parts of the country.

Born in Brookline, Massachusetts, Ruggles studied in Paris with the painter Pascal, the sculptor Dagnan-Bouveret, and in New York with Henry Hudson Kitson, whom she married in 1893. By age nineteen she had already won honorable mentions at the Paris Exhibition of 1889 and the Paris Salon of 1890.

The Kitsons moved to Framingham, Massachusetts, maintaining studios in Boston. Among her works are *The Volunteer,* a Civil War monument of 1902; a statue of Tadeusz Kosciusco, the Polish patriot and American Revolutionary soldier, in Boston Public Gardens; an equestrian *Victory* at Hingham, Massachusetts; and *The Hiker* (erected in 1965), in honor of Spanish-American War Veterans, near the gates to the Arlington National Cemetery. She also made scores of busts for the battlefield at Vicksburg.

Lorado Taft praised her *Volunteer,* applauding the power and strength of the work, but then added (in a remark that reveals more about him than about her), "One is almost compelled to qualify the somewhat sweeping assertion that no woman has as yet modelled the male figure to look like a man."[26]

Kitson's bronzes are self-confident and filled with patriotic idealism in the realistic style of the time.

Elisabet Ney (1833–1907) was an exotic and romantic figure in the history of American sculpture. She was born in Münster, Westphalia, Prussia, the daughter and granddaughter of stonecutters.[27] Her father carved tombstones and viewed himself as a sculptor.

Ney (whose full name was Franzisca Bernadina Wilhelmina Elisabeth) grew up in her father's workshop and had determined by the age of eight that she, too, would be a sculptor. A beautiful, headstrong, and unconventional girl, she insisted that she be allowed to study drawing with a local artist. Later she demanded training in Berlin under the famous sculptor Christian Daniel Rauch. This proposal was greeted with fear and opposition by her parents, who felt that her morals and her Catholic faith would be compromised in Protestant Berlin. They finally allowed her to enroll at the Royal Bavarian Academy of the Fine Arts in Catholic Munich. Ney was tentatively accepted and then admitted in 1853 at age twenty as the first woman sculpture student.

Her parents' fears proved justified: Elisabet Ney was a true rebel. She did in fact reject the church. She wore her hair short, created her own costumes, and took a very advanced feminist position. Her male colleagues, attracted by her beauty, soon found out that she was involved exclusively in becoming a professional artist.

Recognized as a brilliant student, she left the Munich academy in 1854 to study in Berlin with the aged Rauch, whom she idolized. Through the circle surrounding him, Ney was introduced to the glamorous world of the German intelligentsia—the naturalist Alexander von Humboldt, the pianist-

conductor Hans von Bülow, and various poets and novelists. She executed portrait busts and medallions of such famous friends as the philosopher Arthur Schopenhauer and Cosima von Bülow, the woman who left her husband and ran off with Richard Wagner.

On a visit to Heidelberg she met and fell in love with Edmund Duncan Montgomery, a young medical student, the illegitimate child of a famous Scottish legal figure. Ney refused to marry him, however, because of her principled opposition to marriage. Only many years later would she consent to marry Montgomery—after she had become a well-known sculptor. Even then, she refused to change her name and denied that they were married, referring to him as "my best friend."

Ney rapidly became famous. In Rome she made a bust of Garibaldi and was commissioned by the King of Prussia to fashion a bust of Bismarck. Late in 1867 she was summoned to Munich to serve as court sculptor to King Ludwig II of Bavaria, who gave her a huge studio in his palace. Here she and Montgomery got into difficulties because of their irregular liaison and perhaps because of some political intrigue relating to Bismarck's efforts to unify the German nation.[28] They were forced to flee from Munich in 1870, leaving the statue of the "Mad King" still uncompleted. Works from her sojourn in Germany include her life-sized marble statue of King Ludwig II, now at Castle Herrenchiemsee near Munich, and her bust of Ludwig, now at Castle Hohenschwangau.

Ney and Montgomery fled to the United States, as have many others seeking freedom. At first they attempted to found a utopian colony in Thomasville, Georgia, but it failed after two years. They purchased a large piece of land near Houston, Texas, called "Liendo Plantation," where Montgomery spent his time working on philosophical writings and Ney channeled her intense nature into raising their two sons. One boy died, and her relationship with the other one, Lorne, was so tortured

that in later years she denied that he was her son.[29] After her unhappy experience with motherhood, Ney returned to her sculpture. Starting all over again after twelve years was difficult, but in 1890 she received commissions for statues of Sam Houston and Stephen F. Austin for the Texas exhibit at the Chicago World's Columbian Exposition of 1893.

Ney and Montgomery moved to the state capital, Austin, in 1891, and the sculptor established a studio called Formosa, today the Elisabet Ney Museum. The vociferous, daring, outlandishly dressed Ney pursued members of the state legislature, government officials, and important women in the community, campaigning in German-accented English to bring art to the Texas wilderness. She became Austin's local exotic celebrity.

Fig. 4-12. Elisabet Ney, LADY MACBETH (1905), marble, 73¾″ × 25¾″ × 29½″

By 1895 she had secured commissions for several marble portrait busts of leading Texans. By 1901, with the help of Senator Dibrell, she was given a $26,500 appropriation for statues for the state capitol and other works. With this money, earned at an advanced age, she was able to carry out one of her lifelong dreams: subsidizing the publication of her husband's books on philosophy.

In 1902 and 1903, during triumphant returns to Germany, she completed an ambitious work, *Prometheus Bound*. At seventy-two she finished one of her finest sculptures—a marble statue of *Lady Macbeth*, which is now in the National Museum of American Art in Washington, D.C. This work, with its literary subject, its agitated forms, conveys the *Sturm und Drang* emotionalism of the Romantic movement.

In their seventies Elisabet Ney and Edward Montgomery continued to receive the great and important creative people of their time—Anna Pavlova, Ignace Paderewski, Enrico Caruso, and others. A powerful, independent figure, Elisabet Ney was able to create, by her force of character and her daring, a world shaped to her ambitions.

Adelaide Johnson (1859–1955), often considered the sculptor of the women's suffrage movement in the United States, is best known for her monument to the three feminist leaders Susan B. Anthony, Lucretia Mott, and Elizabeth Cady Stanton.

Born at Plymouth, Illinois, Johnson studied at the St. Louis School of Design, and at age seventeen won two prizes for woodcarving at the 1877 St. Louis Exposition. For several years she worked in the field of interior design before leaving for Europe in 1883. She studied painting in Dresden and in 1884 entered the sculpture workshop of Giulio Monteverde in Rome, where she stayed for eleven years. There she also studied with Fabi Altini, president of the Art Academy of St. Luke.

Johnson returned from Rome fully equipped with a classical European training and before long became famous for her busts of leading women. Her head of Susan B. Anthony, now in the Metropolitan Museum of Art, was sculpted for the Court of Honor of the Woman's Building at the Chicago Exposition of 1893. Lorado Taft said of it: "Your bust of Miss Anthony is better than mine. I tried to make her real, but you have made her not only real, but ideal."[30]

In 1920, after women had finally won the right to vote, Johnson was commissioned to memorialize the founders of the women's rights movement in the United States. The monument to Mott, Anthony, and Stanton was erected in the U.S. Capitol building in 1921.

A colorful original, Johnson was often in the public eye. When she married the English businessman Alexander Jenkins in her Washington, D.C., home, they were united by a woman minister and her

Fig. 4-13. Adelaide Johnson, SUSAN B. ANTHONY (1892), marble, height 24"

husband adopted *her* name. (They were divorced in 1908). For many years she dreamed of creating a museum dedicated to the history of the women's movement, which would house her statues, but she was repeatedly frustrated in this effort. In her old age, poverty-stricken and faced with eviction from her home, she mutilated many of her sculptures, and then called in the press as witnesses, in order to dramatize her plight. Congressman Sol Bloom and others came to her aid. She died at the age of ninety-six.

Painters

In the Gilded Age American women crossed the sea and entered the European art academies in great numbers. There, like their male counterparts, they were swept into various European art movements.

The conservatives studied with teachers like William-Adolphe Bouguereau. For them, success meant recognition at the annual salon exhibitions in Paris. Their style is often called "academic" because it derives from the teachings of the great conservative academies, such as the École des Beaux-Arts. *Academic paintings* were, for the most part, smooth-surfaced, carefully modeled, and detailed renderings of historical, biblical, Near Eastern, and classical subjects. They used authentic costumes, furniture, and so on. These "machines," as they were called, were often idealized or sentimentalized allegories with moral or religious themes. Wealthy patrons wanted to see Cupid and Psyche or Moses Among the Bulrushes, rather than grimy scenes of the life around them. Elizabeth Gardner (Bouguereau), Sarah Dodson, and Anna Lea Merritt were among the women working in this manner.

However, a new democratic and realistic spirit had entered European painting when Jean Francois Millet and others began to work more directly from nature, using scenes from peasant and farm life as their subjects.[31] Some of these artists actually lived and painted landscapes in the country village of Barbizon—hence the name of the school. They used a broader, looser technique than the academicians, and began to study the effects of outdoor light.

Following the Barbizon painters, a variety of artists experimented with peasant subjects and with the effects of outdoor light, ranging from the gray light of Jules Bastien-Lepage to the glare effects of Mario Fortuny and Joaquin Sorolla. Helen Knowlton, Elizabeth Nourse, Cecilia Beaux, and others, were influenced by these Barbizon and *plein-air* movements. In France Edouard Manet and Gustave Courbet began to portray bourgeois and even working-class subjects with unvarnished realism.

Beginning in 1874, the radical Impressionists enraged the public with their startling new ways of presenting daily reality—breaking up the form with small dabs of bright color that caught the fleeting effects of light and weather. Rejecting allegory, sentimentality, and historical subjects dealing with the past, they wanted above all to be "of their own time"—to catch the spirit of modern life—the crowds, cafes, and living rooms of Paris, and the landscape and light of the countryside. They "cropped" the picture, cutting off the edges of the figures as in a fast snapshot. Or they chose startling new bird's eye or close-up viewpoints, or caught the subject "through the keyhole," in informal, unposed gestures. Although these artists were virulently attacked by the critics, Mary Cassatt joined their ranks.

In Munich the Americans William Merrit Chase and Frank Duveneck developed a style of bold, direct "fast brush" painting, somewhat in the manner of Frans Hals, the seventeenth century Dutch artist. They painted into dark backgrounds with large, quick brush strokes, easily discernible in the finished picture. These strokes of paint have a sensuous beauty and richness all their own, quite apart from the pictorial subject. Many women artists

were influenced by these methods.

Yet another group of women artists, some of whom gathered around Thomas Eakins in the United States, continued the straightforward American realist tradition. Among them was Eakins's wife, Susan.

At the end of the century, Post-Impressionism, art nouveau, symbolism, tonalism, and the Decorative Arts movement, introduced a more subjective, decorative, and less naturalistic direction. Realism was on the wane, and abstract and formalist directions were beginning. Lucia Kleinhans Mathews, Candace Wheeler, and others responded to the influence of the Arts and Crafts movement. The late styles of such women as Elizabeth Nourse and Sarah Dodson reflect the new trends.

The attachment of women artists to various charismatic men teachers, such as Thomas Eakins and William Merritt Chase, was due in large part to the fact that there were no women professors at either the American or European academies. It was 1895 before Cecilia Beaux received the first such appointment.

Academic and History Painters

Elizabeth Jane Gardner (Bouguereau) (1837–1922)[32] was one of the first American women artists who dared to invade the all-male establishment of the French art academies. According to her obituary in the *New York Times,* she "literally opened Paris ateliers to the women of the world."[33] She also became the first American woman to exhibit, and later to win a medal, at the Paris Salon. Yet she spent her career painting ideal figure pieces in the manner of her mentor and husband, the renowned academic painter William Bouguereau. In a way, she exemplified the schizophrenic position of women artists in the Gilded Age.

Born in Exeter, New Hampshire, Gardner graduated in 1856 from Lasell Seminary in Auburndale, Massachusetts. There she received the proper young lady's training—drawing from outline cards and dabbling in watercolors. At Lasell she became friends with her teacher Imogene Robinson, a bold spirit who went off to study in Düsseldorf and seems to have had a strong influence on her pupil. While copying old masters in Boston, trying to supplement her ''polite'' art education, Gardner became convinced that her drawing was inadequate and that she, too, needed thorough European training. In 1864 she sailed for Paris with Robinson.

Disappointment greeted her. According to Gardner, not a single Paris art school was open to women. She later reminisced:

It was the audacity and ignorance of youth. . . . I never dreamed on quitting America that all Paris had not a studio nor a master who would receive me. . . . I had forgotten, if I ever knew, that the few French and European women then familiar to the Salon . . . like the women painters who had preceded them, were the wives, sisters or daughters of painters, and it was in the ateliers of their kinfolk they lived and worked.[34]

Gardner decided to try dressing like a man. The famous French animal painter, Rosa Bonheur, had already done this to facilitate her study of animal anatomy in the slaughterhouses of Paris. Gardner's hair was already short; it had been clipped in America before she left because of a fever. She put on boy's clothes (this required special permission from the chief of police) and was thereby admitted to the government school of drawing and modeling at the Garden of Plants. Later she also attended the Gobelins Tapestry School, where she was the first woman to enter its classes. Gardner later explained: ''This subterfuge enabled me to study from life in the company of strong draftsmen. I am indebted to it for whatever virility my drawing may have.''[35]

Her teacher was the academic artist William Bouguereau, a renowned painter of glossy nineteenth century idealized nudes and classical and religious subjects. He was a kind and concerned man, and she was able to make him see the injustice of closing women out of the academies.

Through his intervention, according to Gardner, the Académie Julian was opened for the first time to her—the "droll *Americaine*"—and three other young women. As she later said, "This number soon increased, for the precedent established, women not only flocked hither from all parts of the world, but they divided the honors with the men. . . ."[36]

Gardner became an accomplished painter, the first American woman to exhibit in the Paris Salon, in 1866, and the first to win a gold medal (for her painting *Impudence* in 1877). Her studio on the Rue Notre Dame des Champs became a mecca for visiting Americans traveling abroad.

Gardner's famous teacher Bouguereau not only admired her talent—he also fell in love with her. Their romance was one of the most commented upon in the Latin Quarter. He was a widower with two children, and his mother objected strongly to the marriage both on religious grounds and because she felt that two careers would cause unhappiness.[37] Out of deference to her, the lovers postponed marriage for twenty years, continuing to work in separate studios across the way from one another. Upon the mother's death at ninety-one in 1896, Bouguereau, aged seventy-one, and Gardner, aged fifty-eight, were married. They lived in Bouguereau's elegant studio-home until his death in 1905.

Gardner clearly adopted the style and technique of her mentor. In an oft-quoted remark, she frankly revealed, "I would rather be known as the best imitator of Bouguereau than be nobody."[38] Nevertheless, her work deserves a new assessment and comparison with that of her teacher. Certainly, her technical skill and draftsmanship are notable.

She painted idealized allegorical, biblical, and genre subjects in a carefully drawn, smoothly modeled style, with the brushless gloss of fine china. *Corinne* and *The Fortune Teller* won medals at the Philadelphia Centennial Exposition in 1876. *Soap Bubbles,* a genre painting of a woman and two children blowing bubbles, was one of the most celebrated paintings in the World's Columbian Exposition of 1893 and was reproduced in books about the fair.

Whereas William Bouguereau sometimes painted thinly veiled sensuous allegories, such as *Nymphs and Satyr* (1873), long a famous landmark at Hoffman's bar in New York, Gardner avoided any taint of sensuality. She dealt exclusively with the noble, the sweet, the sentimental, and the ideal. In *He Careth,* a typically sentimental allegory, there is a certain nobility in the figures of mother and child. The small bird eating crumbs on the window sill

Fig. 4-14. Elizabeth Gardner (Bouguereau), HE CARETH (n.d.), oil on canvas, 47⅜" × 31¾"

hints that God watches over His smallest creatures, child and bird alike. The fine drawing and broad arrangement of the masses of light and dark lift the painting above the purely anecdotal and sentimental level. *The Dove Fanciers* is an example of the classical and historical allegories popular among salon painters of the period, who reconstructed the past with costume and prop.

Elizabeth Gardner Bouguereau was a woman who knew she wanted success in the main arena of the male art establishment of her day, and went after it with unwavering force of character. Yet Gardner stopped painting during her marriage. In later interviews she conceded that her husband's mother had been right—she would never have been able to pursue a career if she had married as a young woman.

After her husband's death in 1905, she once again produced four major paintings a year until she was hampered by rheumatism. Her last years were devoted to helping French soldiers during World War I. She died in her summer home at St. Cloud, outside of Paris.

Anna Lea Merritt (1844–1930) was a Philadelphia Quaker who counted among her ancestors Andrew Robeson, the first Chief Justice of Pennsylvania. She was privately educated and began to study drawing with William H. Furness at age seven. In 1867 she toured Europe with her family, continuing her art studies at the Louvre, in Rome, and in Dresden with Heinrich Hoffman.

In London in 1871 Anna Lea met her fate when she studied with Henry Merritt, the artist and critic. In her memoir, *Henry Merritt: Art Criticism and Romance* (1879), she reveals her situation to have been an example of the quasi-erotic dependence many nineteenth century women artists had on their male teachers:

Every impulse I had previously felt driving me to become an artist was now merged in the great wish to please my master. . . . How he scolded me; how ruthlessly he rubbed out again and again, the work of days. . . . He would sketch upon it in crayon . . . trying various effects. . . . I used to stand behind him, breathless with excitement. . . . The lesson over, I was often permitted to go with him to the window to fill his pipe.[39]

By the time Merritt said, "Little pupil, we shall be married," she had already been recognized as a professional, having won a medal at the Philadelphia Centennial Exposition of 1876. Although she intended to abandon her career, as was proper at the time, her husband (who was old enough to be her father) died shortly after their wedding in 1877. After memorializing him in her book, illustrated with twenty-three of her etchings, Anna Merritt returned to painting.

Her paintings were exhibited over a thirty-year period at the Royal Academy in London. They included *The Pied Piper of Hamelin, Camilla, Eve Overcome by Remorse,* and *Love Locked Out* (1884), a sentimental allegory showing cupid pushing at a large golden door that bars his entry. Shown at the Royal Academy in 1890, *Love Locked Out* was the first work by a woman artist purchased by the British government through the Chantrey Bequest; it is now in the Tate Gallery in London.

A comparison between Merritt's painting *War* (1883) and Lilly Martin Spencer's earlier painting *War Spirit at Home* (1866), illustrates the influence of the European academic tradition on American artists in the late nineteenth century. Spencer portrays a realistic family scene. A mother reads the news of Grant's victory at Vicksburg in the *New York Times* with one hand, and balances a baby on her lap with the other; her three other small children gleefully march around the room in paper bag and newspaper hats, beating on pots and pans and blowing toy trumpets. The facial expressions of the mother and her tired-looking housemaid in the background show their sober awareness of the horrors the nation is enduring during the Civil War. Merritt's high-flown allegory *War*, on the other hand, portrays a bevy of idealized Pre-Raphaelite

beauties in an antique classical setting. They react sorrowfully as a Roman military parade passes outside. The central figure holds a large symbolic key, while her small son, wearing a hunting horn around his neck, gazes into the distance, dreaming of military glory. Both paintings contrast the naive military spirit of children with the sober reflections of mature women. But Merritt's painting is a costume piece, a salon "machine," while Spencer's is earthily realistic. Still, Merritt's is a competently painted picture, whose ripe forms and intertwining composition are influenced by Peter Paul Rubens.

In 1890 Anna Merritt settled permanently in Hurstbourne Tarrant, a small English village celebrated in her book *A Hamlet in Old Hampshire* (1902). In 1893 she received medals for two works at the Chicago World's Columbian Exposition (a mural in the Woman's Building and *Eve Overcome by Remorse*). She then painted a mural for St. Martin's Church in Surrey (1893–94). Merritt was a member of the Royal Society of Painter-Etchers and carried out numerous portrait commissions, including *James Russell Lowell* (1882), now at Harvard University.

The artist made frequent visits to her hometown, Philadelphia, and was an enthusiastic organizer who promoted ties between expatriate painters and her native land. She helped arrange the exhibition "American Artists at Home and In Europe" for the Pennsylvania Academy in 1881.

Despite her personal view that she had experienced no discrimination in the arts because of her sex, she wrote an amusing article in *Lippincott's Magazine* in 1900. It was called "Letter to Artists,

Fig. 4-15. Anna Lea Merritt, WAR (1883), 39¾" × 55"
(compare with Lily Martin Spencer, THE WAR SPIRIT AT HOME, Fig. 3-7)

Especially Women Artists," which sounds surprisingly like a feminist statement today:

The chief obstacle to a woman's success is that she can never have a wife. Just reflect what a wife does for an artist; darns his stockings; writes his letters; visits for his benefit; wards off intruders; is personally suggestive of beautiful pictures; always an encouraging and partial critic. It is exceedingly difficult to be an artist without this time-saving help.[40]

Catharine Ann Drinker Janvier (1841–1922), traditional Philadelphia painter and illustrator of historical and biblical subjects, was the first woman permitted to teach at the Pennsylvania Academy. She was also the first mentor of Cecilia Beaux, one of the great women artists of the turn of the century.

When Catharine Drinker's father, Sandwith Drinker, a sea captain in the East India trade, became a merchant in Hong Kong, the family moved to the Far East. A young child at the time, Catharine grew up in that colorful environment, received an excellent education, and became friends with interesting Americans living in Hong Kong, including Townsend Harris, the first American consul-general to Japan. When her father died in Macao in 1857, the family returned to Baltimore. During the sea voyage the sixteen-year-old Drinker, who had been trained in seamanship by her father, navigated the *Storm King* after the captain became drunk.

Upon her mother's death, Drinker, at seventeen, became the principal support of her brother (Henry Sturgis Drinker),[41] her sister, and her grandmother. At first, she took over her mother's girls' school in Baltimore. She began to study art at the Maryland Institute, and then moved to Philadelphia to teach at Miss Sanford's Girls' School. In Philadelphia she studied with the Dutch painter Adolf van der Whelan and with Thomas Eakins at the Pennsylvania Academy. Her professional attitude is shown by a letter to the Committee on Instruction at the Academy in which Drinker requested an evening class in life-drawing for "serious women students," as opposed to "amateur ladies."[42] In 1880 she won the Mary Smith Prize at the Academy for her painting *The Guitar Player,* and also published a book called *Practical Keramics for Students* (1880).

Cecilia Beaux, her cousin's niece, visited her studio often and became her student. In her autobiography *Background with Figures* (1930) Beaux describes the inspiration she drew from Drinker while working in her studio. It was filled with objects from the Far East, reminders of Drinker's exotic childhood. When Drinker was hired to give a series of lectures on perspective at the Pennsylvania Academy, it was the first appearance of a woman on the teaching staff. Later, her talented protégée Cecilia Beaux became the first full-time woman teacher at the same institution.

Drinker was thirty-seven when she married Thomas Allibone Janvier in 1878. They traveled to many parts of the world, particularly to Provence, in the south of France, where they spent long periods of time. In the 1890s she won much recognition for translations of Provençale romances, including *Reds of the Midi* (1896) and *The White Terror* (1899), by Felix Gras. In 1904 she published *London Mews,* a book of pictures and verse.

Drinker had an extremely versatile mind. She was accomplished in mathematics, literature, and languages, in addition to art. The phenomenon of the painter-writer or painter-poet is one that recurs frequently in the history of American women artists. Other examples are Anne Whitney, Lilla Cabot Perry, Peggy Bacon, Kay Sage, Alice Trumbull Mason, Helen Knowlton, Maria Oakey Dewing, Florine Stettheimer, Mary Hallock Foote, and Barbara Chase-Riboud.

Jennie Augusta Brownscombe (1850–1936) was a kind of Norman Rockwell of her era. Through her calendars, commercial prints, and paintings of American history, she reached into thousands of American homes.

Born in a log cabin on a farm in Wayne County,

Pennsylvania, with forebears going back to America's first settlers, Brownscombe had an authentic concern with American colonial history. She maintained a lifelong interest in the Daughters of the American Revolution, the Mayflower Descendants, and the American Scenic and Historic Preservation Society. An only child encouraged by a sensitive mother, Brownscombe wrote poetry and was already showing paintings and winning ribbons at the Wayne County Fair while still in the Honesdale, Pennsylvania, public schools.

In 1871 she attended the Cooper Institute School of Design for Women and then the National Academy and the Art Students League. Nostalgic Americana turned up in the first painting she sold, *Grandmother's Treasures* (1876), exhibited at the National Academy Annual in 1876. By then her father had died, and she was supporting herself and earning tuition by selling illustrations to *Harper's Weekly* and *Scribner's* and also by teaching at the Art Students League.

In 1882 she studied in Paris and Brittany with Henry Mosler, the American genre painter. She returned to the United States after 1883 and settled permanently in New York City, but continued to spend winters in Rome between 1886 and 1895. She exhibited at the Royal Academy in London, at the Watercolor Society in Rome, and in New York, Philadelphia, and Chicago.

Starting in 1882, Brownscombe's work became famous through more than a hundred copyrighted prints, engravings, and calendars, which reproduced compositions with titles like *Love's Young Dream* and *Sunday Morning in Sleepy Hollow*.

In Rome, around 1890, she met George Henry Hall, the well-known genre and still-life painter, who would exert a strong influence on her style. During the summers they shared a studio in Palenville in the New York Catskill resort area until his death in 1913. From the 1890s on, Brownscombe

Fig. 4-16. Jennie Brownscombe, FIRST THANKSGIVING AT PLYMOUTH (1912–13), oil on canvas, 27" × 43"

became more and more involved with colonial and revolutionary subjects in a long series of paintings of American history that included *The Peace Ball*, (1895–97) and *The First American Thanksgiving* (1912).

An attractive, slender woman with large brown eyes and a reserved manner, Brownscombe never married. She was a hard-working professional to the end of her long life. At age seventy-two, she illustrated Pauline Bouvé's *Tales of the Mayflower Children* (1927). As late as 1931, after a stroke, she painted *Children Playing in an Orchard* for the Lincoln School in her hometown of Honesdale. Brownscombe paid little attention to the changes in the art scene, remaining very successful with a precise, traditional style of narrative art based on thorough research.

Mary Lizzie Macomber (1861–1916) painted decorative and allegorical panels in the Pre-Raphaelite style. This movement, which had developed in England, exerted an influence in this country during the Gilded Age.

Born in Fall River, Massachusetts, of Pilgrim and Quaker stock, Macomber at nineteen began three years of painting fruit and flower pieces. Her teacher was Robert S. Dunning, a leader of the Fall River School of still-life painting. She then studied figure painting for a year at the Boston Museum of Fine Arts. After dropping out for three years because of illness, she worked briefly with Frank Duveneck in Boston and opened a studio there. By 1889 she was painting Pre-Raphaelite pictures such as *Love Awakening Memory* (1891) and *Love's Lament* (1893)—works filled with Madonnas, Annunciations, and Magdalenes with "sweet, solemn sadness, illuminated by immortal faith" and "delicate coloring . . . with refined, spiritual conceptions."[43] *St. Catherine* (1896), which won the Dodge prize at the National Academy exhibition in New York in 1897, is an example of her refined, rarified style, somewhat in the manner of Sir Edward Burne-Jones.

Fig. 4-17. Mary C. Macomber, ST. CATHERINE (1896), oil on canvas, 34½″ × 24″

The Pre-Raphaelite artists attempted to copy the manner of the early Renaissance painters, which they combined with meticulously depicted realistic details. Because of their horror of the new industrial society, they looked back nostalgically to an earlier period in a quasi-religious effort to return to a nobler spirit.

After a 1903 studio fire destroyed much of her work, Macomber took a trip to England, France, and Holland. Influenced by Rembrandt, she began to use broader brushwork and dramatic lighting. At her funeral in 1916 at Boston's Old South Church, a large group of artists and connoisseurs mourned her passing. They recognized that Macomber had carved out a small but distinctive place for herself in American art.

Sarah Paxton Ball Dodson (1847–1906) was an expatriate painter of classical and biblical subjects in the grand manner of the nineteenth century academies. Born in Philadelphia, she studied in 1872 with the history painter Christian Schüssele at

the Pennsylvania Academy and then in Paris with Evariste Luminais and Jules Lefebvre.

Her theatrical painting *Bacidae* (1883) was one of a series of salon pictures done in a bold and energetic style. It shows two priestesses of Bacis—an ancient crone and a younger woman—in the divine ecstasy of prophecy after consulting the reeking entrails of a chicken. This work includes the customary trappings of classical furniture and costumes. The paint is applied in a vigorous manner with a rich color scheme of purple, white, and blue-green, heightened by a red accent of blood on the floor. Another well-known work by Dodson is her large canvas *The Signing of the Declaration of Independence* (1883).

In her late style Dodson turned toward symbolism, becoming mystical and poetic, somewhat in the manner of Henry Tanner, the black expatriate artist of religious themes. Sarah Dodson moved to Brighton, England, and continued to paint landscapes in addition to figure paintings. Long in frail health, she became seriously ill in 1893, but nevertheless continued to work until her death in 1906.

Cecile Smith de Wentworth (1853?–1933), a prominent academic portrait painter, was far better known in France than in her native America. Born in New York City to a Catholic family, she attended the Sacred Heart Convent, and then went to Paris to study in the studio of the academic painter Alexandre Cabanel. Sometime in the next few years she married Josiah Winslow Wentworth.

In 1889 "Mme. C. E. Wentworth" appeared for the first time in the exhibition catalogue of the Paris Salon. At the Universal Exposition in Paris in 1900, she won a bronze medal for her portrait of Pope Leo XIII. The Pope decorated her with the title of Grand Commander of the Order of the Holy Sepulchre, and conferred on her the papal title of Marchesa. For the next thirty years the Marquise de Wentworth exhibited portraits and religious subjects at the Paris Salon, winning many honors. In 1901 she

Fig. 4-18. Sarah Paxton Ball Dodson, THE BACIDAE (1883), oil on canvas, 79¼" × 61¾"

was awarded the title of Chevalier of the Legion of Honor, and she also became an *officier de l'instruction publique*.

Her best-known work is a portrait of Pope Leo XIII in the Vatican Museum in Rome; another of General John J. Pershing is now in the Versailles Museum. She also painted William Howard Taft, Theodore Roosevelt, and Queen Alexandra (wife of Edward VII) of England. The Luxembourg Museum bought her painting *La Foi* (shown in the 1893 Salon) and it is now in the new Paris museum of nineteenth century art, the Musée d'Orsay. She was particularly noted for the alert, spontaneous expression of her sitters.

Although she maintained a studio at 15 Avenue

des Champs Elysées in Paris throughout most of her career, the Marquise de Wentworth remained an American citizen. Impoverished after her husband's death in 1931, she moved to Nice on the Riviera. When she died in the Nice municipal hospital, the American embassy in Paris sent money to cover her funeral expenses.

Lydia Amanda Brewster Sewell (1859–1926), painter of arcadian classical compositions, was the first woman to win the Clarke Prize at the National Academy of Design, in 1903 for *The Sacred Hecatomb.* At the Chicago World's Columbian Exposition in 1893, her mural *Arcadia* was exhibited in the Woman's Building. She also exhibited *A Sylvan Festival, Pleasures of the Past,* and *Sappho* in

Fig. 4-19. Cecile de Wentworth, GENERAL PERSHING (1918), oil on canvas, approx. 10′ × 6′

the United States Fine Arts Division at the fair, winning a bronze medal.

Born in North Elba, Essex County, New York, Sewell studied at Cooper Union with Douglas Volk and R. Swain Gifford; at the Art Students League with William M. Chase and William Sartain; and in Paris at the Académie Julian under Tony Robert-Fleury and William Bouguereau, and with Émile Carolus-Duran. Her work was shown in the Paris Salons of 1886, 1887, and 1888. Her honors comprise a lengthy list. Among them are the Dodge Prize, National Academy, 1888; a bronze medal, Pan-American Exposition, 1902; a silver medal, Charleston, 1902; and a bronze medal, St. Louis Exposition, 1904. She was made an Associate of the National Academy in 1903.

Sewell's prize-winning *Sacred Hecatomb,* described as a decorative composition suitable for a large hall in a country house, showed a group of maidens and youths singing and dancing and leading bulls through a sunlit forest. Art critic Charles Caffin praised the skillful light effects and the free, animated movement of the figures. Her portraits of well-to-do sitters are in the elegant English manner of Thomas Lawrence or Gainsborough.

Sewell was married to Robert Van Vorst Sewell, a mural painter. They lived on 67th Street in New York City and at their home, Fleetwood, in Oyster Bay, Long Island.

Barbizon, Peasant, and "Fast Brush" Painters

Helen Mary Knowlton (1832–1918), along with William Morris Hunt, greatly influenced the artistic sensibility of Boston in the Gilded Age. Through books like *Talks on Art* (1875), she and Hunt introduced conservative Boston to the works and methods of Jean Francois Millet, Gustave Courbet, and other French painters.

Knowlton came from a distinguished family in Worcester, Massachusetts, where her father had

been the newspaper editor and mayor. She and her sister took over the newspaper for a while until Knowlton decided to concentrate on the study of painting.

In 1868, she was part of a group of about forty aristocratic Boston women art students who organized a class to be taught by William Morris Hunt at his Park Street studio. He was considered one of the most exciting painters and personalities in the area. A charismatic pacesetter, famous for his scintillating dinner conversation, Hunt had gone to Europe and fallen under the influence of Millet, a painter of humble peasants toiling in the fields. He came back to proselytize for a new approach to art. Hunt felt that artists should portray real people doing real work. They should execute paintings in a broad, fresh manner without too much overworking. Broad charcoal drawing should replace the niggling detail of pencil.

The enthusiasm unleashed by this women's art class was understandable in straitlaced Boston, where a woman was not even supposed to attend an exhibition without a male escort. A truly professional painting class for women was new—made possible only because Hunt himself was acceptable. He was a member of the upper classes and had married an elegant and well-born wife.

After three years, realizing that he was devoting too much energy to teaching, Hunt put Knowlton in charge of the class. During his periodic visits, she hid behind a screen, jotted down his "sparkling, erudite"[44] remarks, and kept notebooks on his methods. At a visitor's suggestion she proposed to Hunt that she immortalize his ideas in a book, *Talks on Art,* which appeared in 1875. After she wrote a second book, *Hints for Pupils in Drawing and Painting* (1879), illustrated with his charcoal drawings, she became a critic for the *Boston Post.* Through Hunt and Knowlton's combined influence, collectors in Boston began to buy Millet, Courbet, and Manet. Knowlton continued to paint and take charcoal sketching trips with former students of Hunt,

but in 1878 a fire destroyed most of her best work.

Hunt, whose performance as a painter never quite measured up to his brilliant conversation about art, unexpectedly committed suicide after exhausting himself on a ceiling mural for the New York state capitol in Albany. In her book *The Art-Life of William Morris Hunt* (1899), Knowlton put forth the view that Hunt was a genius who had not yet received proper recognition. She worked on a memorial exhibit of his work at the Boston Museum and painted a portrait of him that expressed her devotion.

Elizabeth Nourse (1859–1938), painter of European peasant life, was described by a noted Paris journalist in 1906:

Fig. 4-20. Helen Mary Knowlton, PORTRAIT OF WILLIAM MORRIS HUNT (1880), oil on canvas, 40⅛″ × 30³/₁₆″

She paints like a man six feet tall, yet she is frail, delicate. . . . With clear, strong strokes she interprets the life of the poor and humble. . . . Through the homely scenes which she loves to depict, shine forth the fundamental truths of humanity.[45]

The expatriate painter came from a French Huguenot family that had fled to America to escape religious persecution. She was a direct descendant of Rebecca Nourse, "The Witch of Salem," who was put to death in 1692, a victim of the infamous witch hunts in Massachusetts. Her parents, however, converted to Catholicism from Protestantism, and she remained a devout Catholic throughout her life.

Born in Cincinnati, Ohio, she trained at the Cincinnati School of Design. After her twin sister, also an artist, married the noted woodcarver Benn Pitman,[46] she left for Paris in 1887. She put her furniture in temporary storage, expecting to return soon, but like so many of her American colleagues of the Gilded Age, she stayed a lifetime.

It took courage for Nourse to leave for Europe. Her parents had recently died and left her with no income. After graduating from the School of Design, she was offered an excellent position as a drawing instructor. Friends urged her to take this secure job, but she preferred to risk poverty and the unknown for the opportunity to study in Paris. By teaching and decorating the homes of wealthy Cincinnati residents after school, she managed to save enough money to maintain herself and her sister, Louise, in Europe for a few years.

At the Académie Julian her professor, Gustave Boulanger, found her to be so far ahead of most of the students that he advised her to work on her own. He felt that her strongly established personal style might be deformed by too much academic teaching. After only three months at the Julian, she painted independently, with private criticism from Émile Carolus-Duran (the excellent teacher of John Singer Sargent) and Jean-Jacques Henner. Within a year, the first painting she submitted to the Paris

Fig. 4-21. Elizabeth Nourse, PEASANT WOMEN OF BORST (1891), oil on canvas, 38⅝″ × 21⅝″

Salon was accepted and hung "on the line" (at eye level)—a singular honor for a newcomer. Later the Luxembourg Museum bought her painting *Closed Shutters* (1910).

Nourse traveled throughout Europe and even as far as Russia to research the peasant life she so accurately recorded in the paintings. She exhibited regularly at the traditional Salon Champs Élysees. Later she broke away from the Paris Salon and joined the group of artists who had set up the more daring Salon Champs de Mars. She identified with a younger group, influenced by the French painter Jules Bastien-Lepage, who were experimenting with observations of gray diffused light under cloudy skies—effects that produced shadowless forms, modulated by very close value tones. This technique created a curious new kind of realism, and at the same time emphasized the two-dimensional surface of the picture.[47] In these works she used a subtle palette of grayed tones.

Nourse was also part of a movement of European artists at the time who were elevating the humble laborer and agricultural worker into subjects of nobility. Particularly interested in hard-working peasant women and their children, she went to extreme lengths to achieve authenticity—climbing rickety staircases in ramshackle tenements, searching the faces of peasants on the dikes to find the right models, and feeding her child-models bread and jam to keep them posing.

The artist lived for a while in Volendam, Holland, in the 1890s. There she painted a series showing fishermen's wives waiting on the dikes for the return of their men. Nourse, who was described as frail, would set up her easel outdoors for hours in all kinds of rough weather, alarming the kindly local peasants, who feared that she would contract pneumonia.

In *Fisher Girl of Picardy* (1889), a young woman and boy are dramatically silhouetted in an S-curve against a gray, cloudy sky, anxiously scanning the horizon. The composition is compact; the feel of the weather and color of the sky are precisely observed. And the figures are above eye-level, emphasizing a heroic aspect.

Soon Nourse began to receive many honors. In 1891, during her only return visit to the United States, she had a triumphantly successful solo show at the Cincinnati Art Museum followed by the museum's purchase of *Peasant Women of Borst* (1891). Her paintings figured prominently in the 1893 Chicago Exposition. She won a gold medal for *The Family Meal* (c. 1893), showing peasants and their children saying grace. Another painting, entitled *Good Friday*—a robust study of kerchiefed peasant women on their knees in church—was reproduced in books about the fair.

In 1895 Nourse was one of the first women elected an associate of the newly formed Société Nationale des Beaux-Arts, and her work was acclaimed by Auguste Rodin, Dagnan-Bouveret, Cazin, and other noted French artists. Before his death Puvis de Chavannes had said to her, "I am rejoiced to know that you have obtained the recognition which your talent so richly deserves."[48]

After 1900 Nourse's realistic style softened and became more linear, perhaps influenced by art nouveau and the misty mysticism of Eugene Carrière. Realism as a movement was making way for symbolism and more expressionistic and stylized trends.

During World War I she remained in Paris to help the refugees and the wounded. Excerpts from her diary, published in the magazine *Art and Progress*[49] in 1914, show her extreme courage under difficult conditions. For this heroism, and for her distinguished service to humanity, Notre Dame University awarded her the Laetere Medal in 1921, making her the first woman so honored.

Nourse was recognized as a major figure in the American expatriate group. Her pictures of the poor, workworn peasants of Europe were painted with humanistic compassion and strength. In 1977 Los Angeles critic Henry J. Seldis described her

style as so "sculptural and forceful [that] it could well be regarded as a forerunner of social realist painting."[50]

Elizabeth Otis Lyman Boott Duveneck (1846–1888) was raised by her father, Francis Boott, a composer and music critic, in a beautiful villa near Florence. He had moved there from Boston when his wife died, leaving him alone with his eighteen-month-old daughter Elizabeth.

Boott carefully educated "Lizzie" in languages, literature, piano, and riding, and encouraged her talent for drawing. He preserved the sketchbooks she maintained from the time she was eight years old. Henry James, their family friend, based the following description in his novel *Portrait of a Lady* (1881), on Francis and Elizabeth Boott:

The image of a quiet, clever, sensitive, distinguished man, strolling on a moss-grown terrace above the street Val D'Arno and holding by the hand a little girl whose bell-like clearness gave a new grace to childhood.[51]

Boott and his daughter circulated in the English-speaking expatriate colony in Italy, which included the American sculptor Horatio Greenough, Nathaniel Hawthorne, and Robert and Elizabeth Barrett Browning. As a child, Lizzie Boott was often a guest at the Palazzo Barberini in Rome, where the sculptor William Wetmore Story entertained a steady stream of intellectuals and held poetry readings and amateur performances.

In 1865 Boott returned to Boston with her father. There she studied painting eagerly in the women's class taught by William Morris Hunt, an influential artist, critic, and proponent of the work of Jean Francois Millet, Gustave Courbet, and other French painters of earthy, everyday subjects. She attended an exhibition of the radical new Midwestern painter Frank Duveneck and was sufficiently impressed by his work to buy a painting.

Later, while studying with Thomas Couture near Paris, she took a side trip to Venice to seek out Duveneck and decided to work with him as a private student in Munich. She tried to master his bold, direct, energetic style of impasto painting into rich dark backgrounds. During this instruction they fell in love, to the consternation of Boott's father, who considered Duveneck unpolished, coarse, and an entirely unsuitable husband for his refined and well-bred daughter. Frank Duveneck had broken into a harmonious thirty-five-year relationship between father and daughter.

Boott and Duveneck were finally married, after a long delay, in 1886. Henry James, a longstanding admirer of Elizabeth Boott (she was, in fact, the model for Pansy Osmond in *Portrait of a Lady*), watched this progression with pain, and perhaps some jealousy. In a letter to a friend, he wrote: "He is . . . ignorant and not a gentleman (though kindly and simple). His talent is great though without delicacy. . . . For him it is all gain, for her it is very brave."[52]

After their marriage the Duvenecks painted and lived happily with her father at the Villa Castellani where she grew up, near Florence. Elizabeth seems to have exerted some influence on her husband's art, and vice versa. In letters to her friends she had decried the gross and ugly character types and excessive use of black in the work of the Munich School. Frank Duveneck's work of this later period shows more brilliance, light, and color—the Italian models are softer, more beautiful than the rough types he had painted in Germany. On the other hand, Elizabeth Duveneck was somewhat influenced by her husband's "fast brush." These influences are evident in a trio of portraits of a black family, newly freed after the Civil War, which she painted during a trip to Georgia in the 1880s shortly before her marriage. The vigorously brushed heads show a mother with corncob pipe in her mouth, a dignified father, and a son, Jerry. The young boy looks fearfully, but hopefully, out toward

Fig. 4-22. Lydia Field Emmet, GRANDMOTHER'S GARDEN (c. 1912), oil on canvas, 32″ × 43″

the new life opening up to him. This was a typical Barbizon subject, glorifying the humble but noble tiller of the soil.

Remembering the death of his own wife forty years before, Francis Boott was anxious when his daughter became pregnant at the age of forty. After the birth of their son in December 1886, she wrote, "It seems strange after so many years of spinsterhood to get so much domestic life in so short a time."[53] And later: "I am beginning to work again, though not very steadily yet for the baby is very absorbing. I find I am constantly thinking about him and wondering in my ignorance if everything is done that ought to be."[54]

In 1887 the Duvenecks moved to Paris so that Frank could have more artistic opportunities. Elizabeth, busy with her baby, household tasks, social engagements, and long stints of modeling for a portrait that her husband was painting for the Salon, caught a chill in the cold Paris winter and was dead of pneumonia in five days. Her distraught husband spent a long period after her death creating a sensitive marble portrait of his wife, which was placed on her grave in the Allori Cemetery in Florence.

Elizabeth Duveneck painted charming watercolors and oil paintings of Italy, European genre subjects, and floral still lifes, some of which show the influence of Couture's soft, luscious style.

A regular exhibitor at the National Academy of Design between 1875 and 1886 (the year of her marriage), she had a well-received exhibition of sixty-six paintings at the Doll and Richards Gallery in Boston in 1884, and was emerging as a full professional at the time of her death.

William Merritt Chase (1849–1916), with his white goatee, pince-nez glasses, elegant clothes and omnipresent red carnation, was the leading teacher of "the fast brush school." He also gave art in New York a social cachet, as rich families, usually leery of permitting their daughters to hobnob with the rabble of bohemian art students, entrusted them to Chase's classes with pleasure.

At the Chase School (later called the New York School of Art) and the Art Students League, as well as in his summer school at Shinnecock Hills, Long Island, and elsewhere, Chase trained dozens of top-notch women artists. He treated them with dignity and believed in their professionalism. In fact, his assistants at Shinnecock Hills were Rhoda Holmes Nicholls, an outstanding watercolorist from England, and Lydia Field Emmet, a society portrait painter who conducted the preparatory classes. He promoted joyful, fresh, rapid work and urged direct observation of nature. Often he took his students out of doors to paint in a light-filled American version of the French *plein-air* movement.

Annie Traquair Lang (1885–1918), a favored pupil, painted works so much like his that a portrait of Chase by her was sold at a very high price—it was thought to be a self-portrait. His most famous student was Georgia O'Keeffe. She later said of him:

I think that Chase as a personality encouraged individuality and gave a sense of . . . freedom to his students. Making a painting every day for a year must do something for you. . . . When he entered the building a rustle seemed to flow from the ground floor to the top that 'Chase had arrived.'[55]

The women who studied with Chase included Candace Wheeler, who became head of Associated Artists and was a leading designer and tastemaker of the Gilded Age; her daughter-painter Dora Wheeler Keith; Rosina Emmet Sherwood, painter and designer for Associated Artists; Lydia Field Emmet, who was called "the painter of American Aristocracy" and also designed stained glass windows for Tiffany and Co.; Ellen "Bay" Emmet Rand (see chapter 5), who became one of the country's leading portrait painters; Charlotte Lilla Yale and Georgiana Howland, both fine landscape painters; Marion Campbell, later overshadowed by her husband, Charles Hawthorne; Helen Torr, later overshadowed by her husband, Arthur Dove; Ethel Paxson; Helen Lee Peabody; Helen Appleton Reed; Caroline Van Hook Bean; Adelaide Gilchrist; Matilda A. Brownell; and Katherine Budd. Yet the greatest woman artist who painted with a "fast brush"—Cecilia Beaux—never studied with Chase at all.

Cecilia Beaux (1855–1942) said, "It doesn't pay to paint everybody."[56] Along with John Singer Sargent, she was one of the outstanding painters of the social and intellectual elite at the turn of the century.

Beaux was the daughter of a French father and a mother of Connecticut Puritan stock. Her mother died twelve days after she was born and her father, overcome with grief, returned to his native Provence. Cecilia and her sister were raised in Philadelphia by maternal relatives.

Although her uncle and aunts had suffered financial setbacks, they raised Beaux in a genteel tradition. Cecilia was tutored at home, and her personal-

Fig. 4-23. Cecilia Beaux, MOTHER AND DAUGHTER (1898), oil on canvas, 83" × 44"

ity was molded by her grandmother, a gentle and refined Puritan, who taught her that anything worth doing was worth doing well. Her beloved maiden aunt Eliza, a music teacher and amateur watercolorist, put her to work meticulously copying lithographs. In later life she was ready to take appalling pains to get a picture "right" and was contemptuous of those who did not.

Her relatives recognized her talent early. After two years at Miss Lyman's (a patrician girl's school) Cecilia was placed in the studio of her uncle's cousin, the history painter Catharine Anne Drinker. Here the "wonders of light" were first revealed to her as she copied prints of Greek sculpture in conté crayon. She greatly admired Drinker, the first part-time woman instructor at the Pennsylvania Academy; Beaux later became the first full-time woman instructor in the same institution.

For a while Beaux conscientiously copied tedious plaster geometric forms and casts at the school of Adolf Van der Whelan, a Dutch painter living in Philadelphia. Never did she imagine, however, that she was heading towards a career as a professional artist. The turning point came when she joined a private women's painting class, critiqued twice a month by William Sartain, a Munich-trained painter. (Her uncle Will Biddle did not want her to study with the "rabble of untidy and indiscriminate art students"[57] at the Pennsylvania Academy. The radical teaching policies of Thomas Eakins, with his nude models and anatomy dissections of bloody corpses did not seem to be the proper influences on his gently reared niece. Nevertheless, Beaux was influenced by Eakins, whose powerful realistic work was strongly influential in Philadelphia.) With Sartain, Beaux painted from a model for the first time. He taught her to appreciate the sensuous joy of brushwork and to sum up the forms in a few bold strokes.

Beaux became totally dedicated to her profession at this point and resisted marriage because she felt it would interfere with her career. To maintain herself, she took on all kinds of art jobs—including drawing lithographs of fossils for a geological report and decorating china plaques with portraits of children that "parents nearly wept over."[58] She later called this "the lowest depth I ever reached in commercial art."[59]

In 1883 she painted her first major composition, *Les Derniers Jours d'Enfance*. In her autobiography Beaux describes the lengths she went to in constructing the background. She required her sister to travel for an hour on the trolley with her young child, day after day, to pose for her. This profile painting, similar in composition to Whistler's painting of his mother (which had been exhibited in Philadelphia), combines Whistler's space relationships with the solid realism and old-master earth-tones of Thomas Eakins.

After Beaux won the Mary Smith prize at the Pennsylvania Academy, her friend the capable artist, Margaret Lesley Bush-Brown,[60] insisted on taking the painting with her on the boat to Paris, where she submitted it to the Salon in 1887. It was accepted and Beaux's career was launched.

Beaux became a well-established Philadelphia portraitist. Her work at this time was very draftsmanlike in its realism. Well-modeled heads emerge from dark backgrounds, as in traditional portraiture. The emphasis is on the character of the sitters, who are seen with searching concentration. In 1887, however, she produced a remarkable and highly acclaimed portrait in which the sitter, ten-year-old Fanny Travis Cochran, wears a white dress with a yellow satin sash whose subtle modulations of color light up the picture against a lustrous chocolate-brown background. It was her first *tour de force* painting in white tones, which was followed in later years by a series of "white" paintings. That same year, at age thirty-two, Beaux went to Paris. Living on a tight budget in cold, dingy student rooms, she worked in the crowded women's class at the Académie Julian, where there was so little space that students could only draw, not paint, from the

model. Painting had to be done on one's own. She discovered that she was far ahead of most of the students; instructors William Bouguereau and Tony Robert-Fleury could only praise her work. M. Julian, after placing her composition, *The Supper at Emmaus,* in a permanent place of honor on the wall, advised her to move away from the "old master" tones toward "greater vivacity, resonance . . . and brilliancy"[61]

In Paris Beaux became aware of Edouard Manet, John Singer Sargent, and the Impressionist movement, but resisted any overpowering influence, slowly selecting those qualities from the great spectacle around her that seemed appropriate to her emerging style. All her life she avoided being a follower.

Her peak experience in France was neither the Académie Julian, nor her exposure at the Louvre to Rembrandt and Titian; it was her summer in Brittany, working with painters Charles Lazar and the expatriate Alexander Harrison at Concarneaux. The light and color of the peasant village—in which all forms, natural and human, seemed to relate in subtle, grayed harmonies—made a lasting impression on her sensibilities. Alexander Harrison, while working on his opalescent painting *The Wave,* critiqued her work and discussed the theories of Jules Bastien-Lepage and other new artists with her. Perhaps Harrison influenced the subsequent lightening of her palette. Beaux had always imagined that her artistic talent came from her French heritage; so the trip seemed like a homecoming: "Ofttimes during her life she romanticized her good fortune in carrying in her blood the poetry of France, inherited through her French father, and the steadfastness of purpose derived from good New England stock on her mother's side."[62] She returned to France seven times in later years.

Settling in a studio in Washington Square, New York City, around 1890, Beaux now burst forth with a series of "white" paintings, followed by a series of impressive double portraits. She was acclaimed for her psychological insight, luscious brushwork, and subtle color. She had thrown off the "brown sauce" of earlier works. Her painting was fluid—singing whites, lavenders, and yellows, were played off against brilliant passages of black. The black cat in *Sita and Sarita* (1893) is reminiscent of similar treatment in Manet's *Olympia* (1863). Her sensuous appreciation of such textures as fur or silk accompanied her interior revelations of human character.

In New York she became a celebrity and a friend of the intellectual leaders Helena de Kay Gilder and Richard Watson Gilder (editor of *Century* Magazine) and their set—John La Farge, Augustus Saint-Gaudens, Henry James, Eleanora Duse, Isabella Stewart Gardner of Boston, Mariana Griswold Van Rensselaer (a leading art critic of the Gilded Age), and others.

Beaux is sometimes considered a mere society painter. Her double portrait *Mother and Daughter* (1898), which won four gold medals, reveals her profound insight into her upper-class sitters. A strong mother is matched by her young daughter, who is about to make her social debut and yearns for the same attention as her mother. The tall, narrow format, and the shadowy suggestion of an eagle on a Chinese painting in the background, reinforce the proud dignity of the figures. The mother seems to be thinking of past triumphs, while the daughter's sharp eyes look out at the viewer, riveted on the present moment. Economical handling of textures and forms give a deceptive look of freedom to the execution.

The Dancing Lesson (1898) also has the effortless look of a "fast brush" painting, but in her autobiography Beaux reveals that this archetypal image (an older sister guiding an uncertain younger sibling's steps) took an entire year to complete in the unheated barn of the Gilders's summer home at Tyringham, Massachusetts. Beaux built a wooden platform for her young models (Dorothea and Francesca Gilder), but the artist waded in rubber boots through puddles of water on the dirt floor while

Fig. 4-24. Cecilia Beaux, DOROTHEA AND FRANCESCA (THE DANCING LESSON) (1898), oil on canvas, 81" × 46"

working on the picture in the rainy season. Such indefatigable effort reflects her view of the "function of Plastic Art . . . to develop its special Power so that it can reach farther and farther, deeper and deeper, into what the mind of man can grasp and enjoy through SIGHT."[63]

Although Beaux was interested in character and human relationships, her principal concerns were "imaginative insight and design."[64] The abstract underpinnings of her work were carefully constructed. Her most daring composition is *After the Meeting* (1914), a Matisse-like calligraphic study of Dorothea Gilder in a loosely brushed, striped dress, seated in a boldly flowered chair. The chair is cropped by the edge of the picture, the figure caught in a momentary gesture. The dark angular screen leads the eye into the background. This work was described as "a masterpiece of animation, spatial ambience, brilliant color and bold fabric design. . . ."[65]

When William Merritt Chase awarded her the Carnegie Institute gold medal for *Mother and Daughter,* he expressed the viewpoint of his era: "Miss Beaux is not only the greatest living woman painter, but the best that has ever lived."[66] She also won gold medals at the Pennsylvania Academy and the Paris Exposition; *Sita and Sarita* was bought by France's Luxembourg Gallery. She received honorary degrees from the University of Pennsylvania and Yale, and was elected to the Academy of Arts and Letters. She was summoned to the White House to do a portrait of Mrs. Theodore Roosevelt and her daughter, and after World War I was commissioned by the U.S. War Portraits Commission to paint French Premier Georges Clemenceau and Cardinal Mercier.

For twenty years, starting in 1895, Beaux was a painting instructor at the Pennsylvania Academy—a singular honor, reflecting her importance in the art world. She brought to the classroom the same demands for "quality" that she had learned as a child and once told a student who refused to clean

her palette that painting "was a great deal of trouble."[67]

She painted continuously until she broke her hip (which never healed properly) in 1924. The artist then wrote her autobiography *Background with Figures* (1930), lectured, traveled, and was surrounded by admiring friends at Green Alley, her country home in Gloucester, Massachusetts.

Beaux objected to being identified as a "woman artist" and looked forward to the day "when the term 'Woman in Art' will be as strange sounding a topic as the title 'Men in Art' would be now."[68] That day has not yet come. Although Beaux was admired by the prominent art historian Bernard Berenson and artist William Merritt Chase, she is still barely mentioned in surveys of American art.

Lucia Fairchild Fuller (1870–1924) was one of a small group that revitalized the declining art of miniature painting during the Gilded Age. Although she chose to work as a "painter in little," Fuller was quite capable of creating large-scale works, and was one of several women asked to create murals for the Woman's Building of the World's Columbian Exposition in Chicago in 1893.

Fuller's grandfather was the first mayor of Madison, Wisconsin, and her uncle was governor of Wisconsin. She began her art career at the Cowles Art School in Boston, studying with Dennis Bunker, a follower of John Singer Sargent. In 1889 she studied in New York with William Merritt Chase and H. Siddons Mowbray, a well-known muralist. Chase introduced her to Whistlerian concepts of design and Japonaiserie, and Mowbray gave her a sound foundation in figure drawing (as exemplified by Fuller's *Girl Drying Her Foot* [c. 1900]).

In 1893 she married Henry Brown Fuller, a fellow art student at Cowles Art School. He became a respected artist, but Lucia Fuller became even more widely known for her talent and originality. The Fullers had two children, but eventually separated, and Lucia returned to Madison.

In 1899, along with painters William Baer, I. A. Josephi, and Laura Coombs Hill, Lucia Fuller founded the American Society of Miniature Painters. Aiming to revive this genre, which had been eclipsed by the coming of photography, these artists pressured the academies to allow them to exhibit as a separate group. In their work they strove for a jewel-like delicacy and refinement.

Anna Mary Richards (Brewster) (1870–1952) was one of the best-known American women artists at the turn of the century. Born in Germantown, Pennsylvania, she was the sixth child of Anna Matlack Richards and William Trost Richards (the famous marine painter and teacher of Fidelia Bridges). Her mother, a Quaker and poet, tutored all her children at home. Under this beneficent instruction, Anna became an artist at age ten; her brothers became professors at Harvard and Columbia Universities, and one was a Nobel Prize winner in chemistry. Anna Richards sketched and painted farms, the seacoast, and other subjects with her father. At age fourteen she exhibited and sold, at the National Academy of Design, *The Wild Horses of the Sea* (c. 1884), a painting of waves.

When her brothers went to Harvard in 1888, the family moved to Cambridge, and Anna attended the Cowles Art School in Boston, studying with Dennis Bunker. The following year, she studied in New York with John La Farge and William Merritt Chase. In her late teens she won the Dodge Prize for the best picture by a woman at the National Academy, and in the 1890s she studied at the Académie Julian in Paris. Richards painted with her father in England, Ireland, and Norway, and they exhibited together.

With her parents' approval she settled in Clovelly, England, to try living and working alone. Paintings dating from this period were exhibited in Baltimore in 1896. She then rented a studio in London for nine years in Cheyne Gardens, Chelsea, near Thomas Carlyle and James McNeill Whistler,

and became part of the Pre-Raphaelite set surrounding George Frederick Watts. Watts praised her Pre-Raphaelite allegorical paintings and her illustrations for several of her mother's books—among them, an illuminated edition of her mother's sonnets, *Letter and Spirit, Dramatic Sonnets of Inward Life* (1898).

In London she met and, in 1905, married William Tenney Brewster, a professor at Barnard College. They lived in New York near the university until the death of their only child in 1910, then settled in Scarsdale, New York, and summered at Cedar Swamp Pond, their camp at Matunuck, Rhode Island (the subject of many landscape paintings). For the next forty years Anna Richards was active in Scarsdale activities and was the founder of the local art association. During extended travels at the time

of her husband's sabbatical leaves, she painted more than two thousand landscape sketches in Egypt, Greece, Jerusalem, Italy, and elsewhere.

Richards used a rapid, effortless technique, working directly from the subject without alteration, showing the influence of Chase. She was very prolific, often painting one picture in the morning and another in the afternoon. Deliberately avoiding a mannered style, she refused to identify with any art movement, attempting to capture the specific quality, color, and light of the particular scene in front of her. Her husband described her as a "Wordsworthian" who painted with her eye on the object.

About sixty of Richards's many landscapes are owned by Barnard College; Columbia University has seven portraits of professors; and in the Scarsdale Public Library some of her paintings record the

Fig. 4-25. Anna Richards Brewster, A STORM AT CLOVELLY, DEVON (1895), oil on canvas, 9" × 16"

look of that community before it developed into a suburb. The Lyman Allyn Museum in New London, Connecticut and many other museums own her work as well. Her devoted husband published a four-volume study of her oeuvre, *A Book of Sketches by Anna Richards Brewster* (New York, 1954–60), after her death.

Impressionism

Although six biographies have been written about **Mary Cassatt (1844–1926),** and she is included in every survey of American art, her unique contribution seldom emerges with sufficient clarity and force. Cassatt is not only the greatest woman artist of the nineteenth century; she is also "worthy of consideration as the most significant American artist, male or female, of her generation."[69]

A vanguard figure far ahead of her times, Cassatt was the only American in the pioneering French Impressionist group in Paris. She exhibited side by side with Edgar Degas, Auguste Renoir, and Claude Monet, and was accepted by them as an equal. Her paintings, it is believed, were the first American impressionist works shown in the United States, before Theodore Robinson, Childe Hassam, and other Americans were swept into the impressionist wave.

Painting was not the only field in which Cassatt was an innovator. Her color etchings added "a new chapter to the history of graphic arts,"[70] and she has been called "one of the great pastellists of the 19th century."[71]

Yet Cassatt suffered from all the pressures a well-bred society woman faced if she wished to become a professional painter in the 1860s. "I would almost rather see you dead,"[72] was reportedly the reaction of her father when she announced that she intended to study painting abroad. When Cassatt, already famous in Europe, returned on a visit to Philadelphia in 1898, the following notice appeared in the *Philadelphia Ledger:*

Mary Cassatt, sister of Mr. Cassatt, President of the Pennsylvania Railroad, returned from Europe yesterday. She has been studying painting in France and owns the smallest Pekingese dog in the world.

A well-known French critic had called her "along with Whistler, the only artist of eminent talent . . . that America actually possesses."[73] In Philadelphia she was notable only for owning a small dog.

The first seven years of her life, spent around Pittsburgh and Philadelphia, left a decidedly American imprint on her. Even as a child, Cassatt showed a certain physical vigor and independence of mind unusual in a girl of that period. She was her older brother Alexander's favorite companion, and he later remembered that she was "always ready for a walk, a ride or a gallop on horseback. . . . It didn't matter when or in what weather."[74] He also remembered that they fought frequently. She had, he recalled, a "pretty quick temper."

Yet this very American child had another heritage in her background. Her father, descended from the French Huguenot Jacques Cossart who came to New Amsterdam in 1662, prided himself on his French ancestry. Her mother—a cultivated Francophile—was fluent in French. When Mary was only seven years old, her father, a stockbroker and real estate speculator (and a restless man who did not really enjoy business), took the family abroad and spent four years with them in Heidelberg, Darmstadt, and Paris. He adored Paris, and there is no doubt that Mary was also attracted to French culture at this time and dazzled by the art she saw in European museums. By the time the family returned to America and settled in Philadelphia, she had already confided to her brother Alexander that she intended to study painting in Europe, and the young man was planning to make enough money to help support his sister's art education.

In 1861, at age seventeen, she enrolled at the Pennsylvania Academy of the Fine Arts and for four years was an outstanding and hard working student.

"Miss Cassatt and I are still the head of the ladies," said her friend Eliza Haldeman.[75] Cassatt, however, found the Academy training very constricting. At that time it consisted mainly of copying antique casts and mediocre paintings in the school collection. Compared to Europe, America was a cultural backwater in the 1860s, with no great museum collections whatsoever. She pleaded with her father for permission to study the old masters abroad.

Mr. Cassatt was alarmed at her seriousness. In his opinion the daughter of a gentleman could dabble in "polite accomplishments," but it was unthinkable to pursue a real career. Yet the decision to go to Europe was crucial for Cassatt, and she knew it. Art historian Frederick Sweet has pointed out that had she remained in Philadelphia, she would have been treated as an eccentric spinster and would never have moved into the larger world of the French avant-garde.

In 1866 her father finally gave his consent. The family placed her carefully in Paris with respectable friends, and she worked on her own, copying the old masters in museums. Edouard Manet and Gustave Courbet were at that time shocking the establishment, showing their paintings in private pavilions at the 1867 World's Fair, and she may have seen and been impressed by them.

According to art historian Jo Ann Wein, Cassatt exhibited in the Paris Salon as early as 1868.[76] She submitted *The Mandolin* (a picture of a seated girl playing a mandolin) under her middle name, Stevenson, because she was still too insecure to use the family name. She and Elizabeth Gardner were the only two American women in the Salon. That summer she wrote home in high spirits from a sketching trip to the French Alps with a friend, that they were "roughing it most artistically" and had tramped twelve miles in the snow to glimpse Mont Blanc. Although her friend, Cassatt said, "calls herself a painter, she is only an amateur and you must know we professionals despise amateurs."[77]

Cassatt's European studies were abruptly cut short when the Franco-Prussian war broke out and her parents insisted that she come home. Back in the United States, in the social circle of her family, the young artist was restless and felt out of place. She wrote to a friend:

How wild I am to get to work; my fingers fairly itch and my eyes water to see a fine picture again. No amount of bodily suffering . . . would . . . seem . . . too great a price for the pleasure of being in a country where one could have some art advantages.[78]

She tried to sell some of her paintings for the return ticket because her family was already pressing her to earn her own way; the Cassatts were not enormously wealthy.

During this interlude Cassatt painted a baroque *Portrait of Eddy Cassatt* (1872), showing her three-year-old nephew dressed up in red velvet and lace. This painting shows that the artist was not an early prodigy, although she was tenacious, hardworking, and very high in her standards. With fixed determination she developed her gifts, studying continuously from the age of seventeen to the age of twenty-nine—with little encouragement from her family—until her style matured to the point where she felt ready to open her own studio.[79]

As soon as the war ended, Cassatt eagerly returned to Parma, Italy, and was impressed by the fresh, natural-looking mothers and children painted by the great sixteenth century artist, Antonio Correggio—an influence visible in her later work. She also studied engraving with Carlo Raimondi, head of the Parma Art Academy. That year, still disguised as "Mary Stevenson," she again sent her entry to the Paris Salon, *On the Balcony During the Carnival* (1872)., Her brother Alexander wrote patronizingly, but fondly, to his fiancée that his sister was "in high spirits as her picture has been accepted for the annual exhibition in Paris, and not only has it been accepted but it has been hung on the 'line.' . . . I suppose she expects to become famous, poor child."[80]

In Spain, Belgium, and Holland, Cassatt admired and copied the work of Peter Paul Rubens, Frans Hals, and Diego Velasquez ("Oh, my man, but you know how to paint!").[81] Her salon entry, *Toreador and Young Girl* (1873), shows a vigorous, spirited style and rich, lively color, which had already been influenced by her radical contemporaries Manet and Courbet.[82]

By 1873 Cassatt was exhibiting regularly in the United States and at the Paris Salon, and selling her work. Now viewing herself as a professional, she opened a studio in Paris. Louisa May Alcott's sister, May Alcott, was then an art student in Paris and visited her. In a letter to her family Alcott gave a pleasant picture of a confident young woman at the start of her career. She described a tea party in Cassatt's studio where several American visitors

ate fluffy cream and chocolate, with French cakes, while sitting in carved chairs on Turkish rugs, with superb tapestries as a background, and fine pictures on the walls looking down from their splendid frames.

Statues and articles of *vertu* filled the corners, the whole being lighted by a great antique hanging lamp. We sipped our chocolat [sic] from superior china, served on an India waiter, upon an embroidered cloth of heavy material. Miss Cassatt was charming as usual in two shades of brown satin and rep, being very lively and a woman of real genius, she will be a first-class light as soon as her pictures get circulated and known for they are handled in a masterly way.[83]

Mary Cassatt was clearly a presence even before she joined the French Impressionists.

Around this time Cassatt discovered the work of Edgar Degas. She later reminisced:

How well I remember, seeing for the first time Degas' pastels in the window of a picture dealer on the Boulevard Haussman. I used to go and flatten my nose against that window and absorb all I could of his art. It changed my life.[84]

At the 1874 Salon, Degas, in turn, noticed her painting *Ida* (a bluntly honest head of a cheerful middle-aged woman, painted à la Courbet). He ob-

served: "It is true. Here is someone who feels as I do."[85]

Cassatt became totally disenchanted with the Salon when she was forced to paint out bright colors on one of her pictures to conform to the jury's drab tastes. She vowed never to submit to the Salon again after it rejected two of her increasingly avant-garde works. She was already painting like an Impressionist when Degas visited her studio in 1877 and invited her to exhibit with the Independents (dubbed "Impressionists" by hostile critics). He looked around the room and with characteristic acidity said, "Most women paint as though they are trimming hats. . . . Not you."[86] Cassatt later told her biographer:

I accepted with joy. At last I could work in complete independence without considering the opinion of a jury. I had already recognized my true masters. I admired Manet, Courbet and Degas. I hated conventional art. I began to live.[87]

Cassatt began a forty-year relationship with Degas, which continued, with stormy intermissions, until his death in 1917. Both artists were impeccable in manners, costume, and bearing (Cassatt was described as carrying her umbrella "with an air"). Both were cultivated, witty, proud, quick to take affront, and both were utterly devoted to pursuing the highest standards in their art. They came from upper class families (he was from a banking family) and could perhaps relate better to one another than to their more grubby bohemian colleagues. Degas wrote to his friend, the Comte Lepic:

You know she is a good painter, devoting herself particularly just now to studies of light and shade on flesh and on dresses for which she has great feeling and skill. . . . This distinguished person by whose friendship I am honored as you would be in my place. . . .[88]

The two artists were devoted to the "new realism" of the Impressionist movement. They wanted to portray the life of their own day as honestly and unsentimentally as possible using brilliant color and daring compositions. Both of them, how-

Fig. 4-26. Mary Cassatt, GIRL ARRANGING HER HAIR (1886), oil on canvas, 29½″ × 24½″

ever, scorned Claude Monet's method of dissolving the form in evanescent dabs of color, and remained dedicated to solid drawing and design. In fact, they insisted on being called Independents rather than Impressionists.

From Degas, Cassatt learned to use pastels in vibrating layers of color (wetting them in places to create runny effects, and then working into them again). Like him, she framed her compositions from unusual angles of vision, cropped the image as in a snapshot, and captured her subjects in unposed, natural, and relaxed gestures.

There is, however, a warmth and optimism in Cassatt's work that contrasts with the cynicism and pessimism of Degas. Her subjects were different—women at the theater, drinking tea, or mothers and children, while Degas painted horse races, prostitutes, ballerinas, and cafe *demi-mondaines*. Cassatt's "fleeting moment" is less

fleeting than that of Degas; a basic sense of permanence and stability underlies her work, although she may capture a child's instantaneous gesture or a mother's enfolding arm. There is also a kind of blunt honesty in her work—for example, in the homely face of the *Girl with the Zinnia,* or the buck-toothed *Girl Arranging Her Hair* (1886)—which has a distinctly American flavor.

Cassatt backed the Independents wholeheartedly and exhibited with them in 1879, 1880, 1881, and 1886, although they were at first attacked by the critics. She ardently espoused their principle of no jury, no prizes, and turned down awards in the name of that principle in later years, saying:

Liberty is the first good in this world and to escape the tyranny of a jury is worth fighting for. . . . No profession is as enslaved as ours.[89]

She proselytized her wealthy American friends to buy Impressionist paintings, and, in fact, helped Degas to survive a period of near-bankruptcy by promoting his work.

In 1877, the same year that she met Degas, Cassatt's mother, father, and sister came to live with her. Mr. Cassatt had always loved Paris and perhaps used his daughter as an excuse to retire on a modest income and settle there. For Cassatt, who had always been devoted to her family, it was the beginning of eighteen years of nursing all three of them through long and ultimately fatal illnesses. She carried out these duties unstintingly, making all the arrangements for summer places, new apartments, travel, and so forth. When her beloved sister Lydia was dying of Bright's disease in 1882, her father wrote home to his son Alexander: "Lydia says she [Mary] has developed into a most excellent nurse. As far as her art is concerned the summer has been lost to her."[90] Mr. Cassatt was beginning to take pride in his daughter's achievements as she earned distinction from the critics, but not enough pride to relieve her of the traditional burdens that were always considered the duties of unmarried Victorian

women. These obligations drastically reduced her output; she produced half as many works as Degas.

Despite these handicaps, Cassatt began, in the late 1870s and 1880s, to receive recognition from French critics in the Impressionist shows. She was also admired by Camille Pissarro and by Paul Gauguin, who bought one of her pastels. In a series of dramatic compositions, she showed women in loges at the theater, the great swinging arcs of the seats echoed in the figures, fans, and chandeliers, and reflected in mirrors. (The use of mirrors to extend and enrich her compositions remained a favorite device throughout her career.) She painted *A Cup of Tea* (1880), showing two women in an elegant interior, and a splendid portrait of her intelligent-looking mother, *Reading the Figaro* (1878?), again reflected in a mirror.

Her color became blonde and brilliant, her works were filled with light, and her brushwork developed a distinctive "creamy" touch, something like Manet's. The use of stripes and decorative patterns in some of these works shows an awareness of Japanese art. Her native country, however, largely ignored the achievements of its prodigal daughter when she sent some of the first Impressionist works ever seen in the United States to the Society of American Artists in 1879.

Cassatt's beloved older brother Alexander, now president of the Pennsylvania Railroad, visited the family in Paris in 1880. Delighted with her high-spirited nieces and nephews, she painted the first of a series of mothers and children—a subject that ultimately occupied one third of her total oeuvre.

The admiring critic J. K. Huysmans wrote that she was now

an artist who owes nothing any longer to anyone, an artist totally spontaneous and personal. . . . It is a miracle how in these subjects . . . Miss Cassatt has known the way to escape from sentimentality on which most . . . have foundered. . . Oh! those babies! Good grief . . . how their pictures make my hair stand on end. A whole crew of English and French daubers have painted them in such stupid and pretentious poses. For the first time . . . I have seen . . . family life painted with distinction . . . a penetrating feeling of intimacy. . . .[91]

Cassatt is trenchantly honest in these mother-and-child paintings. The exact gesture is precisely observed, sometimes awkward; the women are often homely, the children caught in informal poses, sprawled with legs apart, as in *Mother About to Wash Her Sleepy Child* (1880). Close study reveals consistent insight in different works; Cassatt is sympathetic to the simple women who had total care of their children, as in *Emmie and Her Child* (1889), and reveals the detachment of some upper-class women whose children were raised by nursemaids.[92] For this reason, she increasingly used simple farm women from the countryside as her models.

Fig. 4-27. Mary Cassatt, IN THE OMNIBUS (c. 1891), color print with drypoint and soft ground, 14⁵/₁₆" × 10½"

She continued to explore this theme for the rest of her career, in fresh and surprising compositions—sometimes seen from a bird's eye viewpoint, as in *The Bath* (1892), and sometimes in intimate close-up, as in *Breakfast in Bed* (1897), where one can almost smell the child's flesh.

Degas, a formidable wit, could also be a ruthless critic. In one of his typical doubled-edged critiques, he first praised her *Mother and Son in Front of a Mirror* (1901) for its fine composition and color, calling it "the painting of the century," but added scathingly, "it is the little baby Jesus with his English nanny."[93] He was more correct than he knew. For Cassatt was recording what she saw; Victorian women worshipped their male children.

The artist herself carried the scars produced by such attitudes and wrote to her friend, the staunch suffragist Louisine Havemeyer:

You are the only Mother I have known who had not a marked preference for her boys over girls. My Mother's pride was in her boys. I think sometimes a girl's first duty is to be handsome and parents feel it when she isn't. . . . It isn't my fault though.[94]

In her fine pastel of the egalitarian *Mrs. Havemeyer and Her Daughter Electra* (1895), the subjects' poses reflect a very different attitude, with mother and daughter's joined hands forming a V in the lower center of the design—one of the artist's rare symmetrical compositions.

In the 1880s Cassatt's work was at its most "impressionistic," using broken color and scintillating brushwork to give the effect of spontaneity, immediacy, and contemporaneity. Beginning around 1890, however, she began to seek a more timeless, monumental image, influenced by the Post-Impressionist movement and also by Japanese art.

In 1890 Cassatt and Degas visited a large exhibition of Japanese woodcuts at the Beaux-Arts Academy. She was inspired to do a set of ten color prints in drypoint and aquatint in a very personal style. These are considered by many critics to be her most innovative and beautiful creations. Showing women at simple daily tasks—sealing a letter or bending over a washbasin—they are drawn with great economy and strength, using firm contours, decorative patterns, flat shapes, and bird's eye viewpoints.

Degas praised them unreservedly. After looking at the sensitively drawn contour of a woman's back in *La Toilette* (1891), he asked if she had first modeled the forms. Then he added, "I am not willing to admit that a woman can draw that well."[95]

In 1891 Berthe Honoré Palmer, while in Europe on an organizing trip as president of the Board of Lady Managers of the Chicago World's Columbian Exposition, asked Cassatt to paint a tympanum mural for one end of the main hall of the Woman's Building. An ardent suffragist, Cassatt accepted and spent a full year on the fifty-foot triptych, *Modern Woman* (1893). She was living at the Chateau Bachivillers, a rented country place, when she went to work on it. To facilitate her work, she built a glass-roofed studio with a trench in the ground, into which she could lower the huge canvas when she wished to paint the upper part. The effort was so demanding that she had to recuperate from exhaustion after its completion.

The center panel shows young women in modern dress plucking the fruit of knowledge and science; on the left, three young girls pursue the flying female figure of Fame; on the right, two women play instruments, while the third holds up her skirt in a dance. The three panels are united by a common, park-like setting, with a high horizon line.

The artist reportedly used brilliant colors, recognizing that the mural would have to project visually from a site forty feet above the ground. Although this work was poorly received by American critics at the fair, who preferred more banal paintings, her dealer Durand-Ruel eagerly offered to buy it before it was shipped to the United States. But it vanished with the fair, leaving only fuzzy photos to convey a faint idea of the work.

Baby Reaching for an Apple (1893) gives some

notion of her style at the time. In flattened shapes pushed up to the front plane, a mother in pink dress holds up her healthy, naked baby, creating a glowing mass of variegated pinks against the sunlit, apple-green background. The heads merge, and the dark eyes of mother and child join in psychological unity. Long curves and countercurves of tree branches and dress play against tighter curves of the baby's head and buttocks. The mother's arm, pulling down the branch, and the baby's eagerly reaching arm move in toward the focal point—the apple. In this painting, which may at first appear to be an ordinary composition of a mother and child, Cassatt has created a symbol of the older generation helping the younger to develop and reach out for knowledge. She substitutes a new, noble Eve for the denigrated figure in the Bible. *The Boating Party* (1893) is another good example of her monumental style of this period.

In 1893 Cassatt was able to buy the Chateau de Beaufresne, in Oise, with her own earnings. There she worked eight hours a day, kept horses and her beloved Belgian griffon dogs, grew magnificent roses, and concerned herself with local politics.

That same year her successful one-woman show at Durand-Ruel's in Paris marked her full acceptance into the French art world. It pained her greatly, however, when her exhibition at Durand-Ruel in New York two years later drew little notice from American critics. Burning with anger at the treatment of her mural and her work in her native land, she wrote to her friend Sarah Hallowell:

After all, give me France. Women do not have to fight for recognition here if they do serious work. I suppose it is Mrs. Palmer's French blood that gives her the . . . determination that women should be *someone* and not *something*.[96]

As the years passed, Degas, increasingly blind and impoverished, became an embittered recluse. Cassatt's relationship with him was punctuated by arguments and reconciliations. When asked how she could put up with his temperament, she replied:

Oh, I am independent! I can live alone and I love to work. Sometimes it made him furious that he could not find a chink in my armor and there would be months when we just could not see each other, and then something I painted would bring us together again and he would go to Durand-Ruel's and say something nice about me, or come to see me himself.[97]

The full extent of their relationship remains a mystery. Intriguingly, in later life she burned all his letters to her. When asked about a possible love affair, she exclaimed, "What! . . . with that common little man? What a repulsive idea!"[98] The two artists finally broke irretrievably over the Dreyfus Affair around 1900—the more democratic Cassatt supported the cause of Alfred Dreyfus, convicted of treason, while the conservative aristocrat Degas was violently against him. Nevertheless, when Degas was blind and ill in his last years, Cassatt could not bear to see him neglected, and traveled to the South of France to persuade his niece to come to Paris and look after him. After his funeral, she wrote:

His death is a deliverance but I am sad. He was my oldest friend here and the last great artist of the 19th century. I see no one to replace him.[99]

The retired president of the First National Bank, James Stillman, who lived in a palatial home in the Parc Monceau (where a footman stood behind the chair of every dinner guest), sought her advice for his art purchases, and the two were close friends between 1900 and 1914. A collector of twenty-four of her works, Stillman admired her forthrightness, intelligence, and taste, and reportedly asked her to marry him. But the independent Cassatt, already in her sixties, refused.

Beginning in 1901, Cassatt traveled to Spain and Italy with her good friends the Havemeyers, advising them on purchases of works of art. She took this role very seriously because she wanted to see great collections of old masters, as well as of the new French artists, brought to the United States. Over the years through the Havemeyers, the Palmers, the

Searses, and others, she was responsible for such magnificent bequests to American museums as El Greco's *View of Toledo,* Goya's *Majas on the Balcony,* and many other masterpieces.

In 1904 Cassatt was made a Chevalier of the Legion of Honor in France. In the United States the Pennsylvania Academy and the Art Institute of Chicago recognized her greatness and awarded her several prizes, which, as usual, she rejected. A successful artist, working on her own estate in Oise, Cassatt was an imposing figure in French and American cultural circles. Tall, thin, and aristocratic, with flaring nostrils and a ramrod-straight back, wearing designer clothes and feathered hats, she was a rebel in white gloves. Her tea table talk was filled with good rebellious causes.

"Miss Cassatt," wrote Vernon Lee, the British woman author, "is very nice, simple, an odd mixture of a self-recognizing artist, with passionate appreciation in literature, and the almost childish garrulous American provincial. She wants to make art cheap, to bring it within reach of the comparatively poor, and projects a series of colored etchings for it."[100]

One of Cassatt's principal causes was feminism: "Just think how much better if women knew all about the men's work. At present men lead double lives. What we ought to fight for is equality it would lead to more happiness for both."[101]

She expressed herself in all companies with ruthless candor, and as was to be expected, this trait was not always appreciated. Her conventional sister-in-law felt threatened by her and wrote to a friend: "The truth is I cannot abide Mary and never will. . . . I have never yet heard her criticize any human being in any but the most disagreeable way. She is too self-important and I can't put up with it."[102]

Cassatt entertained such leading intellectuals and artists as Georges Clemenceau, Stéphane Mallarmé, George Moore, Ambroise Vollard, and Berthe Morisot. In literature she enjoyed Tolstoy and in art Courbet, but scorned novelists like Henry James and Edith Wharton and painters like John Singer Sargent and Cecilia Beaux. In her opinion, they were "society" artists, and "superior people soon get over that."[103] She also had contempt for the emerging Cubist movement and the clique around Gertrude Stein, and called them "awful people" with "awful paintings." Time, she believed, would expose them all.

In later years Cassatt was increasingly alone. She regretted the fact that she had no children of her own. One by one, her circle of relatives died, and each loss was accompanied by the deepest grief. She developed diabetes and cataracts. And the color in her late works became somewhat shrill.

As she lost her eyesight and stopped painting, Cassatt became understandably cranky and bitter, but the humanistic concerns underlying her art caused her to take an increasing interest in the world at large. The barbarity of World War I led her to hope that women's suffrage might bring an end to future wars. She wrote to her closest friend, "Louie" Havemeyer: "Is this wholesale slaughter . . . necessary to make women wish an equality such as they never before had . . . taking active part in governing the world?"[104] Proceeds from an exhibition of her work in New York were donated to the suffrage cause.

Cassatt was appalled at the profiteering of Frenchmen around her, who talked of the money they had made during the war. She described Woodrow Wilson in unprintable language, and detested the Versailles Treaty. The artist used her prestige to help the women workers at the button factory in the neighborhood of her chateau, and declared on one occasion, "If I weren't a weak old woman, I'd be a Socialist."[105]

Toward the end of her life, a group of young Americans visited her occasionally and drew inspiration from her reminiscences and her vigorously held ideas (one described her as "fiery and peppery"). Artist George Biddle called her "the most

vital, high-minded and prejudiced human being I have ever known."[106] The influential art editor and critic Forbes Watson said, "One couldn't listen to her, pouring out her ardor and her understanding, without feeling his conviction in the importance of art to civilization intensified."[107]

Cassatt died at Beaufresne at age eighty-two. To the end she was attended by her devoted housekeeper of forty years, Mathilde Vallet.

Lilla Cabot Perry (1848–1933), along with Mary Cassatt, helped introduce French Impressionism to the United States. A close friend and next-door neighbor of Claude Monet, she absorbed at first hand his theories and methods, and shaped them to her own sensibility.

Descended from Boston Brahmin families, the Lowells and the Cabots, Lilla Cabot was raised and educated in the most elite Boston circles. After her marriage in 1874 to Professor Thomas Sargent

Perry, a teacher of eighteenth century literature, her home became a salon for intellectuals—including Henry James, William Dean Howells, and her brother-in-law, the painter John La Farge.

In the 1880s she began to study art with Robert Vonnoh and Dennis Bunker at Boston's Cowles School. In Paris, she attended the Julian and Colarossi academies, studied with Alfred Stevens, and exhibited at the salons and expositions.

She also wrote poetry, and between 1886 and 1923 she published four volumes. Later, when she became an apostle for impressionism in America she wrote, lectured, and led art organizations.

In the summer of 1889, Perry, with Cecilia Beaux, visited Claude Monet in Normandy and was powerfully impressed with his personality and his work. The Perrys summered for ten years next door to Monet's home in Giverny—the one with the famous water-lily garden. Perry, admired by Monet, had frequent discussions with him and with Camille

Fig. 4-28. Lilla Cabot Perry, THE TRIO, TOKYO, JAPAN (1898–1901), oil on canvas, 29″ × 39¾″

Pissarro, who also lived nearby. Although some of her works, such as *Haystacks, Giverny* (c. 1896), are in the precise idiom of Monet, in her figure painting the forms are more clearly structured and defined.

Perry recorded Monet's artistic methods and personality in magazine articles: "When you go out to paint, try to forget what objects you have before you, a tree, a house . . . or whatever. Merely think, here is a little square of blue, here is an oblong of pink. . . ."[108] He urged her to put down the first instantaneous impression, which he regarded as the truest and most unprejudiced one.

When Perry returned to Boston in 1889 with a Monet painting, *Étretat,* perhaps the first Monet ever seen in Boston, she was astonished that "hardly anyone liked it, the one exception being John La Farge."[109] She lectured and wrote articles about impressionism and encouraged her wealthy friends to buy Monet's work.

While her husband taught English literature at Keiogijiku College in Tokyo from 1893 to 1901, Lilla Cabot Perry painted more than eighty pictures of Japanese life and scenery. (The Perry family felt strongly related to Japan; Professor Perry was the grand-nephew of the famous Commodore Perry, who had opened up Japan to the West.)

Lilla Cabot Perry's later life was spent in the elegant Back Bay section of Boston, with summers in Hancock, New Hampshire. The scenery around Hancock became the subject of the light-filled landscapes of her later period.

In 1914 she became a founder and first Secretary of the Guild of Boston Artists. She frequently exhibited with them and at the Boston Museum of Fine Arts, the Corcoran Gallery, and the Pennsylvania Academy of the Fine Arts.

Devoted to her family, and painting primarily for her own enjoyment, Perry's paintings reflect the interests of a cultivated upper-class woman—her daughters were frequent models. The elegance of Japonaiserie and the exquisite country settings or tea tables of her environment fill her work. She painted directly on the canvas without preliminary sketches and drew sparkling pastels of both figures and landscapes.

Mary Louise Fairchild MacMonnies (Low) (1858 –1946) painted *Primitive Woman* (1893), the companion mural opposite Mary Cassatt's *Modern Woman* in the Woman's Building at the 1893 Chicago Exposition. Born in New Haven, Connecticut, a descendant of Governor William Bradford of the *Mayflower,* she attended the St. Louis Art Academy (her family had moved to that city). Later she studied in France at the Académie Julian and with Carolus-Duran.

In Paris she met and married, in 1888, the famous sculptor Frederick MacMonnies. Successful artists, living in an elegant apartment on the Rue de Sèvres in Paris, they frequently entertained James McNeill Whistler and other friends.

Fig. 4-29. Mary Fairchild MacMonnies Low, FIVE O'CLOCK TEA (1891), oil on canvas, 89" × 61"

Both the MacMonnieses achieved distinction at the 1893 Chicago Exposition. Mary's mural was well received (muralist Puvis de Chavannes praised it extravagantly before it left Paris), and she also had two paintings, *June Morning* (c. 1893) and *Tea Al Fresco* (c. 1893), in the United States Fine Arts exhibition. Her husband's large sculpture *Barge of State* (1893) was the central fountain at the exposition.

The MacMonnieses and their two daughters summered at Giverny in their converted fourteenth century monastery, with its walled flower garden and lily pool, near their good friends Claude Monet and his family. The couple sometimes painted together *en plein air;* Frederick MacMonnies had a sculpture studio in the barn, and Mary MacMonnies painted in a second studio at the other end of the property. Next door Isadora Duncan danced nude at dawn in her garden.[110] Giverny in the 1890s was a delightful summer colony where many American artists came to breathe the aura of Monet, although he seldom socialized with them. Among them were portrait painters "Bay" and Lydia Emmet (see chapter 5) and sculptor Mabel Conkling.

After Frederick MacMonnies fell in love with one of his art students, he and Mary were divorced. She then married Will Hickok Low, the academic mural painter, in 1909 and moved to Bronxville, New York, with him. After her second marriage Mary Low dropped her earlier name and expunged all references to her former husband. It was still considered a disgrace to be a divorced woman at that time.

Mary Low's technique went through several phases. She painted in a light-filled style influenced by her teacher, Carolus-Duran, and then entered a "misty" tonalist phase. After marrying Low, her work, principally portraits, became more academic and dark. In later years she returned to a brighter, impressionist style. She became an associate of the National Academy of Design in 1906 and won numerous awards.

The Society of American Artists

Helena de Kay Gilder (1848–1916), although a painter, is perhaps better known as a founder of the Society of American Artists and the Art Students League, two institutions that broke the stranglehold of the old-guard National Academy of Design. De Kay studied privately with Winslow Homer and John La Farge, and also at the Cooper Union Institute and the National Academy of Design. She and her friend Maria Oakey attended the first life-drawing class that was opened to women at the Academy, in 1871.

The two young women alarmed their parents by sharing a studio in New York, where they associated with artists and intellectuals of the day, including Henry James, Abbott Thayer, and John La Farge. De Kay married Richard Watson Gilder, poet and editor of *Scribner's* and *Century* magazines. Their home on East 15th Street near Union Square (a former stable renovated by the fashionable architect Stanford White) became a turn-of-the-century salon for a group of New York artists. Many of them had just returned from their European expatriate years and were full of new ideas. Among other things, they were dissatisfied with the jurying practices of the National Academy of Design.

At her home in 1877, Gilder, Augustus Saint-Gaudens, Walter Shirlaw, and Wyatt Eaton formed the Society of American Artists. The goal of this new group was to provide a forum for new and diverse trends in art, and one of its expressly stated aims was to encourage women artists.

In 1875 Helena Gilder was one of the founding members of the new Art Students League, which became a center of progressive art teaching in the United States. From its classrooms were to emerge powerful American women painters such as Georgia O'Keeffe, Isabel Bishop, and Peggy Bacon. The League, from its inception, espoused the principle of equality between men and women, both as

teachers and as students. In the early years of the League, women dominated the Board of Control, but this percentage diminished later.

Gilder exhibited paintings at the National Academy of Design and showed a figure painting, *The Last Arrow* (c. 1878), at the first exhibition of the Society of American Artists in 1878.

The Gilders maintained a second residence in Venice, the meeting place in the 1880s for artists, authors, and wealthy Americans. The couple exerted an influence on such women painters as Cecilia Beaux, with whom they toured Europe.

Helena Gilder's career as painter and organizer declined with the increased burden of family life after 1886. When she gave up her activities in the Society of American Artists because of family pressures, no other woman held any position on its board. This group eventually merged back into the National Academy in 1906.

Maria Richards Oakey Dewing (1845–1927) was a still-life painter who was compared, at the turn of the century, to Henri Fantin-Latour and John La Farge. She is typical of the many talented nineteenth century women artists now being rediscovered after a period of neglect. Art historian Jennifer A. Martin stumbled across her work while studying the paintings of her well-known husband, Thomas Wilmer Dewing. Martin uncovered approximately fifteen works out of an estimated one hundred, many of which may still be buried in collections around the United States.

Maria Oakey was born in New York. Her mother was a cultivated upper-class Bostonian who wrote articles for *Scribner's* (such as "Recollections of American Society"). Her father, a descendant of Gilbert Stuart, loved to read essays on art to his daughter.

In the 1860s Oakey studied at the Cooper Union School of Design for Women and with La Farge, who had a decisive influence on her work. She also worked with William Morris Hunt in Boston and

with Thomas Couture in France in 1876. Between 1871 and 1875 she was enrolled at the National Academy of Design and participated in the formation of the Art Students League.

The late 1860s were exciting years for Oakey. To the consternation of her parents, she shared a studio on Broadway with Helena de Kay and mingled with the artistic elite of New York—including Abbott Thayer, Henry James, and La Farge, of whom she said, "We all owed (him) an unpayable debt."[111] She reminisced about this period in an article for *International Studio* in 1921.

In 1877 Maria Oakey exhibited in the first show of the Society of American Artists, which her friend Helena Gilder had just helped organize. She also showed figure paintings regularly at the National Academy and at Boston's Copley Society. She wrote articles, poems, and three books, *From Attic to Cellar: A Book for Young Housekeepers* (1879), *Beauty in Dress* (1881), and *Beauty in the Household* (1882).

In 1881 she married Thomas Wilmer Dewing, a well-known Washington Square artist. After the birth of her daughter Elizabeth, to whom she was exceedingly devoted, Maria stopped writing until 1915 and abandoned figure painting altogether. She continued, however, to paint still lifes, perhaps because they were easier during a period when she was occupied with household duties. Possibly, she did not wish to compete with her husband in his area of expertise—the figure—although she did collaborate on some of his works. Her work won medals at the 1893 World's Columbian Exposition and the 1901 Pan-American Exposition, and she was given a one-woman show at the Pennsylvania Academy in 1907.

The Dewings spent their summers (along with Augustus Saint-Gaudens, Abbott Thayer, Kenyon Cox, Maxfield Parrish, and actress Ethel Barrymore) in the art colony of Cornish, New Hampshire. Maria Dewing is described during this period as a highly intelligent, cultivated woman of wit, capable of bicycling elegantly to a dinner party in an evening

dress with a train. After falling off several times, she merely dusted herself off and proceeded with aplomb.[112]

Both Maria and Thomas Dewing gloried in the flower garden of their beloved home, Doveridge, in Cornish. Many of her still-life paintings are based on this garden. She had gained some expertise in botany and took a scientific interest in structure: ''I know how the poppy bursts its calyx, so that when I paint poppies they are true to nature.''[113] Her botanist's eye was combined with the lyric qual-

ities, soft color, and atmospheric veils that give her paintings a poetic quality. Royal Cortissoz, a famous art critic, wrote at her death: ''There was no mistaking her quality, her accent. She had her own vision.... Save for La Farge we have had no one who could work with flowers the magic that was hers.''[114]

Maria Dewing was strongly influenced by Japanese art, and Japanese objects appear in her indoor studies. In the outdoor paintings, such as *Garden in May* (1895), she often used a close-up,

Fig. 4-30. Maria Oakey Dewing, GARDEN IN MAY (1895), oil on canvas, 60.1× 82.5 cm.

142

worm's eye view, tilting up the field of flowers to fill the entire canvas, as in a Japanese screen by Ogata Korin. Shallow depth, asymmetrical arrangements, and a decorative sense are combined with close observation of nature.

Shortly before her death, Dewing admitted her frustration and regret that she had abandoned her early dreams of painting ambitious figure compositions. She was, she said, haunted by visions of figures set in grand landscapes, which she still saw in her mind's eye but had stopped painting after her marriage.[115]

Realism

Susan Hannah Macdowell Eakins (1851–1938) is not as well known as her husband, Thomas Eakins, the great American realist who was asked to resign from his teaching job at the Pennsylvania Academy for encouraging his women students to draw from the completely nude male model. Although he regarded her as perhaps the best woman painter of the period, she subordinated her career to his and is only now getting the recognition she deserves.

Susan Hannah Macdowell, the fifth of eight children, grew up in Philadelphia. Her father William Macdowell, an avowed liberal and freethinker, gave his children considerable freedom and encouragement. A respected engraver, he was in contact with many Philadelphia artists. Macdowell permitted his daughter to set up her studio in the attic, and he and other members of the family posed for her frequently.

In 1876 Susan Macdowell first saw Thomas Eakins at the Hazeltine Gallery, where his painting of a surgical operation, *The Gross Clinic* (1875), was shocking Philadelphia with its bloody realism. She was impressed at once and decided to study with him at the Pennsylvania Academy. Macdowell was twenty-five when she enrolled at the Academy in 1876, and she studied there for the next six years. One of Eakins's finest students, she was the first winner of the Mary Smith prize, as well as a

leader of the student body.

Macdowell became Eakins's loyal confidante and they were married in 1884. After their marriage she continued to paint sporadically, but loyally took over all tasks necessary to free her husband for time in the studio—shipping his work, answering correspondence, and entertaining the students, guests, nieces, nephews, cats, dogs (and even a monkey) that kept their home bustling.

Susan Eakins became a staunch and good-humored ally for her husband and helped him survive the tense and difficult years after he was asked to resign from the Academy. Because of his uncompromising realism and his insistence on the use of the nude model, he was ostracized by the narrow-minded Philadelphia art community. Frozen out by dealers and critics, he barely sold anything during his lifetime.

Susan Eakins was a voracious reader and theater-goer, and an accomplished pianist who frequently held informal musicales at their home, which sometimes became the settings for her husband's pictures. She was also a photographer, and she promoted the Philadelphia Salon of Photography. Like her husband, she used her photographs as reference material for her paintings. It is believed that some of the photographs thought to be by Thomas Eakins may in fact be hers.

Throughout their marriage, both artists had separate studios in the house. Eakins greatly respected his wife's work and once said that she knew more about color than he did. After his death in 1916 she returned energetically to painting, producing a considerable body of work during the 1920s and '30s. Once she began painting again, she hardly left her studio until at age eighty-six a fall left her dizzy and somewhat crippled.

Art historian Susan Casteras has analyzed the changes in Susan Eakins's style. As a student and during her marriage, she adopted the sober realism of her husband, the rich earth-tones, and even the grave mood, which may be seen in *Two Sisters*

Fig. 4-31. Susan Hannah Macdowell Eakins, POR-TRAIT OF THOMAS EAKINS (c. 1889), oil on canvas, 50″ × 40″

(1879). This dignified image is built up with the curves and arcs of female bodies and growing plants.

When left on her own, without the tragic intensities of her husband's nature to influence her, Susan Eakins's natural temperament seems to have emerged. She was basically a "joyous and very giving individual—not especially receptive to the darker vision of life."[116] *The Lewis Sisters at Home* (1932) shows her informal, looser, and brighter late style, with vivid red, blue, and yellow flashing out from a dark background. The draftsmanship here is weaker, however,—the figures have less structure than in her earlier work.

A fascinating comparison may be made between Thomas Eakins's famous portrait head of his wife and her portrait of him. He portrays her mobile, sensitive face—concerned and aware of tragedy—cocked slightly to one side, listening with compas-sion to him. In her painting of him, he is boyish and warm, ready to pour out his troubles. He leans forward informally in work clothes—the arcs and curves of his body and surrounding forms suggesting a person of sensuality and earthiness—played off against the cross of his easel.

Susan Eakins deliberately avoided promoting herself. When artist William Sartain wrote a sketch of her husband in 1917 for *Art World,* Sartain wanted to include the statement "He married Susan MacDowell, an artist of talent. . . ." But Susan asked him to remove the sentence.[117]

In 1973, thirty-five years after her death, Eakins's first one-woman exhibition at the Pennsylvania Academy took place, and her work is now being recognized for its solid draftsmanship and fine composition. At a 1976 exhibition of nineteenth century women artists, she was singled out by art critic Lucy Lippard, who described her work as "incisive and adventurous, full of both life and thought."[118]

Claude Raguet Hirst (1855–1942) painted *trompe l'oeil* still lifes of old books, pipes, candlesticks, and similar objects. Born in Cincinnati, she was a New York artist who at first exhibited flower and fruit paintings at the National Academy of Design in 1884 and 1885. In 1886, after William Harnett, painter of "magic-realist" still lifes, took the studio next door in the East 14th Street building where she worked, she evidently became his friend and imitator.

Harnett had a large following for his paintings of traditionally masculine objects, such as guns, pipes, hunting horns, and tobacco jars. In a manner derived from Dutch painting, he arranged these objects in interesting compositions, sometimes hanging on a wall. His realism was so meticulous that often viewers are convinced that they can touch the objects.

Hirst adopted Harnett's format, often using similar masculine objects. After 1890 her paintings at

Fig. 4-32. Claude Raguet Hirst, STILL LIFE: COMPANIONS (or BOOKS, PIPE AND TOBACCO SACK) (c. 1896), watercolor on paper, 10″ × 14½″

the National Academy exhibitions bear titles like *Books, Pipe, and Tobacco Sack (or Companions)* (c. 1896). In *Still Life* (c. 1885–90), however, she replaced the masculine objects with objects associated with women, such as yarn, thimbles, and needles. Unlike other painters of the "Harnett School," Hirst frequently painted in watercolor rather than oil. At some point before 1911 she married W. C. Fitler, the landscape artist, but little is known about her life. After a period of success, her work was neglected, and she died penniless at the age of eighty-seven.

Alice Barber Stephens (1858–1932) was one of the best-known illustrators in America in her time. She was born on a farm near Salem, New Jersey, the eighth of nine children in a family of Quaker and early American ancestry. She started to draw as a child and was still in elementary school when she took art classes at the Philadelphia School of Design for Women. At fifteen she was already supporting herself with such commissions as a series of wood engravings of prominent women for the Philadelphia periodical *Women's World*.

In 1876 she began to study with Thomas Eakins at the Pennsylvania Academy. The rigorous Eakins found her so competent that he asked her to execute

wood engravings of his own work under his supervision. In her classes were Susan Macdowell (who later married Eakins) and Barber's future husband, Charles Hallowell Stephens. Her painting *Female Life Class* (1879), commissioned by the school, shows her friend Susan Macdowell at an easel, painting from the nude female model.

Training with Eakins deepened Barber's style, and she branched out into oil, watercolor, and charcoal. After a year abroad studying at the Académie Julian in Paris and sketching in Italy, she returned home and married Stephens, who became an instructor at the Pennsylvania Academy. In 1893 they had a son, Daniel Owen.

In the ten years following her marriage, Alice Stephens was inundated with commissions at her Chestnut Street studio in Philadelphia, winning medals and prizes at many expositions in America and Europe. She became more successful than her husband and was so overworked and exhausted that in 1899 she refused the tempting offer to teach life-drawing at the Pennsylvania Academy—an unusual honor for a woman. She was at that time illustrating books by Henry Wadsworth Longfellow, Nathaniel Hawthorne, George Eliot, and other authors for the Houghton Mifflin and Thomas Y. Crowell publishing companies, while continuing to do illustrations for *Harper's, Cosmopolitan,* and other magazines.

In 1901 she began a fifteen-month vacation abroad with her family to recover from overwork, and then settled down permanently in a converted stone barn in the Pennsylvania countryside. In addition to her commercial work, Stephens relaxed by painting landscapes and portraits of local Quaker and German types for her own enjoyment.

After 1902, Emily Sartain, at that time director of the Philadelphia School of Design for Women, hired Stephens to teach life drawing there, in the school in which she had received her first professional training. Stephens and Sartain were cofounders of the Plastic Club of Philadelphia, and

Stephens had a retrospective there in 1929.

In her later illustrations she became a master of black-and-white wash, or charcoal with added washes of warm ocher or orange. *Buying Christmas Presents* (published in *Harper's Weekly,* 1895), with its dynamic diagonal composition, echoing curves, and verticals, and vigorous realistic drawing, shows a breadth and vigor far above most commercial hack work of the day. Stephens's career demonstrates clearly the importance of the new opportunities women had won with the development of professional art schools for women and with the opportunity to study the nude model in advanced schools like the Pennsylvania Academy.

Fig. 4-33. Alice Barber Stephens, BUYING CHRISTMAS PRESENTS (1895), watercolor and gouache.

A number of the women artists discussed in this book drew strength from, and in some cases made sacrifices because of, attachments to dominant male artists. **Anna Elizabeth Klumpke (1856–1942)** was one who was attached to a woman, the French animal painter Rosa Bonheur.

From the time she was a little girl living in San Francisco and was given a "Rosa" doll (the world-famous painter was so popular in the nineteenth century that dolls were made in her image), Anna Klumpke followed Rosa Bonheur's career in the newspapers. This interest was undoubtedly encouraged by her strong-willed and cultivated mother.

Dorothea Toll Klumpke left her husband, a San Francisco real estate tycoon, and took Anna and her three other daughters to Switzerland, where they were privately tutored and encouraged in their ambitions. Each distinguished herself in a different way: Augusta was the first woman intern at a Paris hospital and made discoveries in anatomy; Dorothea was an astronomer with a doctorate in mathematics from the Sorbonne; Julia was a violinist-composer; and Anna became a capable artist.

When the Klumpkes moved to Paris to enable Augusta to enter medical school, Anna attended the Académie Julian in 1883–84, studying with Tony Robert-Fleury and Jules Lefebvre. She also copied the old masters at the Louvre. Klumpke showed a great deal of promise—she won the grand prize for outstanding student of the year at the Julian. Her painting of her mother was favorably received at the Paris Salon, and in 1889 she was the first woman to win the coveted Temple gold medal at the Pennsylvania Academy of the Fine Arts for the finest figure painting in their annual exhibition. She donated this work, *In the Wash House* (1888), to the Academy the following year in appreciation of this honor.

Throughout this period, Rosa Bonheur remained her inspiration and role model. Klumpke returned to America and worked as a painter and teacher in Boston for a number of years. In 1898 she obtained

Fig. 4-34. Anna Elizabeth Klumpke, IN THE WASH HOUSE (1888), oil on canvas, 79″ × 67″

an interview with her idol Bonheur in order to do her portrait. The latter was at this time in a deep depression caused by the death of her close friend Nathalie Micas, with whom she had lived for many years. Still, she welcomed the younger artist and eventually invited Klumpke to stay with her at By, in Fontainebleau, and to write her (Bonheur's) biography. Klumpke proved to be a perfect companion for the elderly artist and painted a magnificent portrait of her, now in the Metropolitan Museum of Art.

After Bonheur's death in 1899, Klumpke wrote the biography *Rosa Bonheur, Sa Vie, Son Oeuvre* (1908). She also arranged memorial exhibitions and set up the Rosa Bonheur Museum in Fontainebleau. She inherited Bonheur's studio-estate at By, and divided her later years between By, San Francisco,

and Boston. In 1940 she published *Memoirs of an Artist,* describing her own career.

Klumpke painted vigorous portraits of Bonheur and of Elizabeth Cady Stanton, a leader of the suffrage movement. These, along with her genre painting *In the Wash House,* showing women working joyously together, reveal a robust feminism and an honest, realistic style.

Paintings of American Indians by George Catlin, Karl Bodmer, and other male artists are included in every survey of American art. A lesser-known fact is that there were several women painters who dealt with these themes as well. One of these was **Grace Carpenter Hudson (1865–1937),** born in Potter Valley, California, near Ukiah. She began to study art at

Fig. 4-35. Anna Elizabeth Klumpke, ROSA BONHEUR (1898), oil on canvas, 46″ × 38½″

the Hopkins Art Institute in San Francisco at the age of thirteen and progressed so swiftly that in two years she won the Alvord Gold Medal from the San Francisco Art Association for a figure drawing.

Grace Carpenter returned to Ukiah, where she painted, taught, and drew illustrations for *Sunset* and other journals. In 1890 she married John Hudson, a physician who became so involved in her study of the ethnography of the Pomo Indians of Mendocino County that he gave up his practice entirely to join her in this pursuit.

In 1893 she showed paintings of Indians in the women's department of the California state building at the Chicago World's Columbian Exposition. After several field trips, including one to Hawaii to paint native children and another to Oklahoma to paint the Pawnee tribe for the Field Museum in Chicago, the Hudsons went to Europe in 1905 and then settled permanently in Ukiah.

They lived in a house with a totem pole standing in front of it. From her early years, Grace Hudson had been well acquainted with California Indians, and now she devoted herself entirely to studying and painting them. Her compositions, primarily of the Pomo Indians, are an important historical record, although she sometimes sentimentalized her subjects. Her works are at the Oakland Museum, the National Gallery of Art in Washington, D.C., and other collections.

Art historian Clara Erskine Clement's comments on these works reveal the prejudices of the late nineteenth century—the contempt for Native Americans that in our day has been reversed:

Mrs. Hudson's pictures of Indians . . . are very interesting, although when one sees the living article one wonders how a picture of him . . . truthful in detail, can be so little repulsive. . . . If we do not sympathize with her choice of subjects, we are compelled to acknowledge that her pictures are full of interest. . . .[119]

Fig. 4-36. Grace Carpenter Hudson, KA-MO-KI-YU (FOUND IN THE BRUSH) (1904), oil on canvas, 23″ × 34″

The Arts and Crafts Movement

The Arts and Crafts movement, which flourished briefly in America at the turn of the century, began as a utopian doctrine preached by William Morris and John Ruskin in England. Reacting against the ugliness and misery of the new industrial society, they urged a return to an earlier era of handicrafts, such as the Middle Ages. Morris became a designer of handmade furniture, wallpaper, and textiles.

Anthea Callen, in *Women Artists of the Arts and Crafts Movement* (1979), gives a detailed account of the women in England and in the United States who made important contributions to this movement in ceramics, embroidery, metalwork, woodcarving, book illustration, and other applied fields. She also reveals how women were frequently exploited and shut out of the most creative work by their "utopian" male mentors.

Under the leadership of a lively group of socially elite women, Cincinnati became one of the earliest

American centers of the Arts and Crafts movement. Even before the Philadelphia Centennial Exposition, women in Cincinnati entered the fields of woodcarving and furniture carving.[120] They also started the art pottery movement, which spread across the United States to New Orleans and other cities. Candace Wheeler, Lucia Kleinhans Matthews, Maria Longworth Nichols (founder of Rookwood Pottery), Mary Louise McLaughlin, Mary Chase Perry (founder of Detroit's Pewabic Pottery), Adelaide Alsop Robineau, Sadie Irvine (designer for New Orleans Newcomb Pottery), Frances Glessner (silversmith), Julia Munson, and Agnes Pitman are a few of the many American craftswomen of this period.

Candace Thurber Wheeler (1827–1923) was the founder of the design firm Associated Artists. One of eight children of Abner and Lucy Thurber, she was raised on a dairy farm in Delhi, New York, in the Delaware Valley uplands. Hers was a home where creativity was encouraged. She read poetry, and her mother taught her the home crafts of weaving, spinning, dipping candles, and so on. At age seventeen, after attending the Delaware Academy in Delhi, she married Thomas M. Wheeler, a New York businessman. They had four children.

The Wheelers were interested in art and literature, and entertained leading artists of the time, such as Frederick Church, Albert Bierstadt, and Eastman Johnson at their cottage, Nestledown, in Jamaica, New York. In the mid-nineteenth century, Brooklyn and Long Island were still small villages where it was easy to meet the local colony of artists and writers. Thomas and Candace Wheeler became art patrons. They attended openings and lectures at William Merritt Chase's Tenth Street Studio, and bought paintings from him. Eastman Johnson encouraged Candace Wheeler to study art.

During a prolonged family trip abroad, Candace Wheeler began to study painting in the studio of a Dresden art professor. She did not imagine at the time that she was preparing herself for a professional career.

In 1876 her eldest daughter died. Overcome with grief, Wheeler needed a creative outlet to draw her out of her sorrow. While wandering disconsolately around the 1876 Philadelphia Centennial Exposition, she was inspired by the exquisite needlework on display in a purple velvet pavilion set up by the Kensington School of London. The Kensington School was training "decayed gentlewomen" to earn a living with this craft.

In the Victorian era there was a large group of educated but destitute women who had no respectable means of securing employment. Often cruelly referred to as "surplus women," they led lives of dire poverty, or half-lives as governesses or unpaid domestics in the homes of their nearest married relatives. Although they performed the drudgery of running a home, they achieved none of the status of married women, and were in fact scorned and ridiculed by society.[121]

Candace Wheeler was seized with a desire to help these indigent women support themselves. In 1877, together with many of the wealthiest women in New York, she helped organize the Society of Decorative Art of New York City. This charity group exhibited and sold women's handicrafts and ran classes in embroidery and china painting. Serving as vice-president, Wheeler received an instant education in marketing and design. She is described as charming and vivacious, dashing about with "her hair parted in the middle and puffed on the sides" and rings gleaming on "ruffled hands."[122]

In 1879 Louis Comfort Tiffany, a New York painter and one of the pioneers of art nouveau in America, invited her to join him in a company called Associated Artists. This enterprise, he hoped, would revolutionize the taste of Americans in interior design. Candace Wheeler was put in charge of textiles, embroidery, tapestry, and needlework, while Tiffany designed glass, and artists Samuel Colman and Lockwood de Forest supervised carv-

ing and other crafts. Among Wheeler's commissions were the redecorating of the White House, the Union League Club in New York, and Mark Twain's home in Hartford, Connecticut.

In 1883 Wheeler broke away from Tiffany and set up her own tremendously successful textile company, also called Associated Artists, but composed entirely of women. Two of her chief assistants were her daughter Dora and the painter Rosina Emmet, both of whom had studied with William Merritt Chase. Candace Wheeler was expressly intent on proving that women could make a good living in industry if they were well trained.

Wheeler and her assistants designed all kinds of textiles, suiting the motifs and the colors to the situation (for example, bells and wheels for curtains in a railroad car). The firm created large tapestries that were almost paintings in embroidery, frequently using American themes such as *Evangeline*. Wheeler invented new methods, techniques, and stitches, for which she acquired British and American patents.

Influenced by the utopian dreams of William Morris, Candace Wheeler encouraged her brother in 1883 to develop Onteora Park, a summer colony in the beautiful northern Catskill Mountains. There, well-to-do, high-minded city people who shared her devotion to Arts and Crafts ideals vacationed in "a cluster of silvery, peeled log cabins, unconventionally bedecked with wasps nests, animal pelts, and wild flowers," while "poetry readings, chamber music, and amateur theatricals drowned out the jarring cadences of urban, industrial America."[123] Wheeler's friend Mark Twain was present (and no doubt chuckled) at the ceremony dedicating her daughter Dora's art studio at Onteora:

Through the open door came a small acolyte waving a censer, who scattered oil and wine upon a great altar-like pile of brush . . . next a priest in . . . robes covered with signs of the Zodiac . . . and four . . . virgins of the Sun in flowing robes with torches . . . while a voice from a shadowed angle chanted an invocation.[124]

For the library of the Woman's Building at the 1893 Chicago World's Columbian Exposition, Candace Wheeler and her daughter Dora Wheeler Keith collaborated on decorations in vivid blues and greens. Writing about the women's displays at the Exposition, Wheeler proudly pointed out that American women were now creating many of the designs being used by American manufacturers for wallpapers and fabrics.

Candace Wheeler also wrote important and innovative books and articles on color and decoration. She played a significant part in the art nouveau movement in the United States and opened up an entirely new field of employment for women. She lived to the age of ninety-six, busily writing and painting, and died in her daughter Dora's New York apartment.

Lucia Kleinhans Mathews (1870–1955) and her husband Arthur Mathews were leaders of the California Decorative Style—the West Coast expression of the Arts and Crafts Movement. They designed hand-crafted and hand-decorated furniture, screens, boxes, picture frames, and candlesticks, and also created murals, paintings, and graphics.

Lucia Kleinhans was born in San Francisco, attended Mills College for a year, and then enrolled at the Mark Hopkins Institute of Art (San Francisco's version of a French Academy), where Paris-trained Arthur Mathews was director. She became Mathews's student and married him in 1894. After her marriage she studied one summer in James McNeill Whistler's Académie Carmen in Paris.

A unique and successful team, the Mathewses expressed their views in a magazine, *Philopolis*, which they started in 1906 after the San Francisco earthquake and fire "to consider ethical and artistic aspects of the rebuilding of San Francisco."[125] Like William Morris, they said, "Have nothing in your houses which you do not know to be beautiful."[126] Lucia Mathews designed many of the vignettes, decorative borders, and initials for *Philopolis*.

Together the Mathewses opened The Furniture Shop, and between 1906 and 1920 made custom-designed furniture and other objects for homes and public buildings. Lucia Mathews supervised the color selections and carved and painted relief panels, boxes, and standing screens. She emphasized floral elements, often drawn from California horticulture, in a decorative manner reminiscent of Japanese or Chinese art, whereas her husband used more classical, Beaux-Arts elements. She also painted pictures.

Lucia and Arthur Mathews were both influenced by Whistler and Pierre Puvis de Chavannes and made a particular point of designing the picture frames for their paintings—carving and coloring them specifically to enhance the works. Lucia was also an enthusiastic gardener who advised the designers of San Francisco's Golden Gate Park. The Mathewses championed a doctrine of total harmony in the environment, a philosophy shared by Bernard Maybeck, Greene and Greene, and other architects and craftsmen of the California Decorative School.

The Chicago World's Columbian Exposition of 1893

The Chicago World's Columbian Exposition of 1893—a White City extravaganza of buildings in Renaissance styles, built on a marshy lagoon—generated a vast outpouring of art and sculpture. The history of the fair's Woman's Building, a project initially instigated by Susan B. Anthony, shows the progress the women's movement had made since 1876.

A Board of Women Managers was created by Congress, with Bertha Honoré Palmer, a leading Chicago socialite, at its head. A competition was launched to find the best design for a building by a woman architect. Thirteen designs were submitted, and Sophia Hayden, the first woman graduate of the Massachusetts Institute of Technology architecture program, was given the commission and an award of one thousand dollars. Lois Howe of Boston and Laura Hayes of Chicago came in second and third, respectively. This was in marked contrast to the Philadelphia Centennial, only seventeen years earlier, when the architect was a man.

The project, however, was not without its controversy. Louise Bethune, a successful architect from Rochester, New York, refused to submit a design. She argued that competition is evil, especially competition of women against other women, and especially when the winner was not receiving "equal pay for equal work."[127] The award, she contended, was trivial for the amount of effort involved.

Nevertheless, Sophia Hayden, only twenty-two and fresh out of architecture school, created an elegant Renaissance building. It contained a large central Hall of Honor surrounded by many meeting rooms, a library, and a roof-garden restaurant in which to dine and look out at the dazzling White City reflected in the lagoon. The style of this building reflected her own recent training and was in harmony with the classical motif established for the Exposition.

A critic for the *American Architect* magazine expressed virulent hostility toward women and their work:

The building is neither worse nor better than might have been expected. . . . The roof garden that crowns the building is a 'hen-coop' for petticoated hens, old and young. . . . It seems a question not yet answered how successfully a woman with her physical limitations can enter and engage in a profession which is a very wearing one.[128]

But this was not the only response. Sophia Hayden was given an award "for delicacy of style, artistic taste, and geniality and elegance of the interior hall."[129] She also received an Artist's Medal from the Exposition jury at the dedicatory exercises. From Richard Morris Hunt, the famous architectural

Fig. 4-37. Photograph, INTERIOR VIEW OF WOMAN'S BUILDING, looking at Cassatt mural in background, World's Columbian Exposition, Chicago (1893)

leader, Hayden received a gracious letter of commendation. Daniel Burnham, director of the Exposition's architecture, who had originally frowned on the idea of securing a woman architect at all, urged her to open an office in Chicago.

The "feminine" quality of the building was proudly espoused by the women's committee in their handbook for the fair: "Today we recognize that the more womanly a woman's work is, the stronger it is."[130] This sentiment foreshadowed the present-day demand from certain feminists for a distinctive, "feminine " imagery in art.

Despite a limited budget of only $200,000 (less than that for any other building), constantly changing requirements, and interference from the male Board of Architects, Sophia Hayden's building was the first one erected on the site. But she suffered "brain fever,"[131] a temporary nervous breakdown, along the way. The stress was so great that Hayden never built another building. Ironically, Lois Howe, the runner-up in the competition, had a long and successful career.

The sculptured pediment and groups on both sides of the facade were modeled by Alice Rideout, a nineteen-year-old sculptor from San Francisco. Enid Yandell created the Caryatids that held up the roof garden. The central figure of the pediment held a myrtle wreath in one hand, scales of justice in the other. On the right was Woman the Benefactor; on the left, Woman, the Artist and Litterateur, stood in high relief in a "joyous, hopeful" style, "in contrast to the usual large, heavy, dull-looking stone women."[132]

The library, designed by Candace Wheeler, famous art nouveau tastemaker and head of Associated Artists, was described as a cool and comfortable blue, green, and gold retreat from the din and heat of the exposition. The painted library ceiling by Dora Wheeler Keith, Candace Wheeler's daughter and partner, was in the "ideal" style of the period. Lilies, woven into garlands, were draped around four medallions, each of which contained a symbolic figure. A central group contained three figures—Science, Literature, and Imagination.

Exhibits at the building showed arts and crafts by women from around the world. In addition to Mary Cassatt's avant-garde mural Modern Woman, other murals revealed the level of academic competence achieved by women painters in this period. Mary Fairchild MacMonnies' Primitive Woman (1893), showed woman's role in earliest times: planting seeds, making wine, caring for children, driving a plow pulled by white oxen. Lucia Fairchild's Women of Plymouth (1893), portraying the harsh life of early America, contrasted with Amanda Sewell's Arcadia (1893)—a dreamscape of classical figures with a goat in a sylvan setting. "The pair of half-nude girls in the foreground have a pagan loveliness," said the handbook.[133] The murals of Lydia Emmet and Rosina Emmet Sherwood symbolized women's new accomplishments in the fields of science, art, and scholarship, as well as the traditional roles of wife and mother.

The Woman's Building became the scene of many important meetings and conferences, all related to the advancement of the rights of women. A day-care center was established next door for the children of women visiting the building.

All was not sweetness and light, however. Many women artists objected to the idea of a separate exhibition for women, and Bertha Palmer had difficulty in obtaining their work. Harriet Hosmer's large Isabella was shown in front of a pampas grass palace in the California exhibit and then shipped to a San Francisco fair where it disappeared. Anne Whitney objected to having her sculpture shown, as she put it, "with draperies and bedspreads," but was finally persuaded to create a central fountain for the Hall of Honor.

Black women were greatly angered by the refusal of the Board of Lady Managers to authorize a separate black women's exhibit and by inadequate representation on the board. In addition, Mrs. Palmer had an annoying habit of interfering with the artists.

She was worried about what appeared to be excessive nudity in the photos of Mary MacMonnies' mural-in-progress, and urged her to cover the ladies. Mrs. MacMonnies sent the following reply from Paris:

I think that one of the objects of the Woman's Building is surely to show what I may call our "virility," which has always been conspicuous by its absence. I don't know how much of the nude has been used by the men in their paintings, but I know that in their sculpture the whole exhibition is full of it. Well, are we going to recoil and once more bear the reproach of timidity and feebleness? A figure draped from head to foot may easily be made more immodest than one entirely nude.[134]

The work of American women was represented all around the fair, not only in the Woman's Building. Sarah T. Hallowell, after a long struggle with chauvinistic bureaucrats who opposed her appointment, was made assistant director of art for the entire exposition. Among the art judges were Harriet Hosmer, Emily Sartain, and Mary Hallock Foote. The *Catalogue of the Department of Fine Arts* (United States Division) shows that five women won awards for watercolor, two won awards for black-and-white drawings, and Mary Nimmo Moran took a prize in etching. Among the oil paintings were works by Mary Macomber, Elizabeth Nourse, Elizabeth Gardner, Anna Lea Merritt, Cecilia Beaux, and Susan Macdowell Eakins. Some of their work was illustrated in books describing the fair. All in all, there was striking evidence of the skill and accomplishment of American women artists in the Gilded Age.

Fig. 4-38. Lydia Emmet, Decorative panel, ART, SCIENCE, AND LITERATURE, World's Columbian Exposition, Chicago (1893)

Fig. 4-39. Mary Fairchild MacMonnies, PRIMITIVE WOMAN, World's Columbian Exposition, Chicago (1893)

Fig. 4-40. Dora Wheeler Keith, CEILING OF LIBRARY, World's Columbian Exposition, Chicago (1893)

Chapter 5
The Ash Can School and The Armory Show, 1900–1929

At the turn of the century, in the final days of the Gilded Age, certain artists turned toward a twilight mode aptly described as "the color of mood."[1] They painted misty landscapes drenched in one pervasive color and scenes of lonely, introspective women reading or playing an instrument in elegant interiors. Side by side with this "tonalism" and "quietism," a cheerful American version of impressionism swept the country.

Charlotte Buell Coman (see chapter 3) was painting hazy, "blue" landscapes in the final stage of her long, successful career, and Lilian Westcott Hale was doing soft, atmospheric studies of women and children. Hale won a gold medal at the 1915 Panama-Pacific Exposition in San Francisco, where many women created important sculptural monuments and won prizes for paintings. Perhaps the most gifted women working in this genre were the photographers Gertrude Kasebier, Annie Brigman, and others who captured their subjects in a soft veil of tone, echoing the mood of the tonalist painters.

Parallel with these trends, a large group of women artists continued successful careers in traditional, representational modes, or as illustrators in the Golden Age of Illustration between 1890 and 1910. The excellence of some of this work—neglected because it was part of a style considered *retardataire*—deserves reconsideration.

But America was changing. The genteel art of the tonalists and impressionists did not express the clamorous industrial society of the new twentieth century, with its noisy syncopation of streetcars and elevated trains, street lights and theater marquees, skyscrapers and smokestacks, and ever-growing crowds of people from all classes of society, including poor immigrants, factory girls, and ragged urchins. Behind the dynamic new visual reality was a dazzling new intellectual reality, with Einstein, Planck, Marx, and Freud shaking all previous notions of the universe and the people within it.

Between 1908 and 1929, a succession of shocking new art movements broke into the public consciousness, and women artists played an integral part in all of them. First was the Ash Can School in 1908, with its raw, realistic views of lower-class city life; in 1913 the Armory Show brought European and American modern art—cubism and fauvist distortions—to the forefront. The public alternately laughed, raged, and wondered at this work; they had just barely accustomed themselves to a kind of muted, even saccharine impressionism.

A group of American modern artists gathered around Alfred Stieglitz, the great photographer and impresario of the avant-garde. Even before the Armory Show he began to sponsor their work at his Gallery 291, showing many different trends, such as expressionism, cubism, and later, precisionism. Among this group was an artist named Georgia O'Keeffe who became a towering figure, one of America's greatest painters.

During this period of experimentation and shake-up of values, other women forged independent and unique styles. Romaine Brooks and Florine Stettheimer are examples of these

mavericks, deeply rebellious personalities who created their own forms from their personal visions.

Women also continued in their historical roles as sponsors and patrons in the art community between 1900 and 1929. The collection of Lillie Bliss became the core of the New York Museum of Modern Art, and Katherine Dreier formed the Société Anonyme Collection, now at Yale University. Gertrude Stein, one of the first collectors of Picasso and French Cubist art, influenced young American painters like Anne Goldthwaite and Marguerite Zorach, who visited her apartment on the Rue de Fleurus in Paris. Stein's friends Etta and Dr. Claribel Cone, two sisters from Baltimore, amassed one of the world's great collections of Matisse and other modern art—the Cone Collection—today a separate wing of the Baltimore Museum of Art.[2]

A woman artist who spanned in a curious way the entire spectrum of art from the conservative to the ultramodern was Gertrude Vanderbilt Whitney. Daughter of an American tycoon, she sculptured some of the large-scale public monuments of this period.

Although she herself preferred to work in the tradition stemming from the Renaissance, she was an open-minded person of genuinely eclectic tastes. Working in her studio in MacDougal Alley in Greenwich Village, she came to know and respect the young painters and sculptors creating a new American art. She sponsored, exhibited, and purchased their vanguard works, eventually amassing such a large collection that in 1931 Whitney decided to create a new museum of American art, the Whitney Museum.

The Position of Women

The period leading up to and during World War I was one of mounting feminism and activity, as the suffrage movement reached its height, culminating in the passage of the Nineteenth Amendment in 1920. Women became sales girls, telephone opera-

tors, and typists. They formed the Women's Trade Union League (1903) and also went out on strike in the garment industry to protest deplorable conditions. They enrolled at colleges in great numbers and a few entered the professions. Isadora Duncan created a revolution in dance, Gertrude Stein held court at her famous salon in Paris and composed "Cubist" literary works, and Edna St. Vincent Millay wrote poetry in Greenwich Village. Jane Addams fought for social legislation, Margaret Sanger began her struggle for birth control, and Jeanette Rankin became the first congresswoman. As men went off to fight in World War I, women took their places in the factories and on the farms.

In the "roaring" twenties, the image of the "flapper," drinking, smoking, and jazzing it up in short skirts, came to symbolize the increased social and sexual liberation of women. This liberation, however, proved to be largely an illusion. Most women were asked to give up their jobs after the war. They had won the vote, but their basic roles remained largely the same, and although a few women fought their way to personal freedom, Mary Cassatt's vision of women "taking their places in governing the world" had not yet come about.[3]

Women in The Golden Age of Illustration

The turn of the century, with its new high-speed presses, half-tone plates, and four-color printing process, is often referred to as "the Golden Age of Illustration." In newspapers, magazines, and books an extremely high level of imaginative re-creation accompanied the written word. The rich and vivid pictures that adorned such books as *Treasure Island* and *Little Women*[4] are truly unforgettable. There was a demand for thousands of illustrators, and women did outstanding work in this field.

Howard Pyle (1853–1911), who carried illustration as an art form to new heights, was one of the most

important teachers of this period. He invited a selected group of talented students, a third of whom were women, to his special classes at Chadds Ford, Pennsylvania, and Wilmington, Delaware. Recent scholarship about Pyle's classes has revealed a curious phenomenon. His women students tended as a group to work in a more linear, decorative manner, influenced by art nouveau, while the men tended to be more realistic.[5] From this phenomenon it has been concluded that teachers are not the only influence on a student body: *Students teach one another.* The women students of Pyle were such good friends that their artistic style was affected by mutually shared influences. Many of them remained in Philadelphia and formed a coterie.

The remarkable trio of Violet Oakley, Jessie Willcox Smith, and Elizabeth Shippen Green met in his classes at Drexel Institute in Philadelphia. Becoming friends, they set up a kind of early collective, living in an old colonial inn called The Red Rose. Oakley became one of the important mural painters of the early twentieth century. Smith and Green became nationally recognized illustrators.

Violet Oakley (1874–1961) once said that if she could be reincarnated, she would like to be a monk of the Middle Ages. She wanted her murals to exert a "spiritual force" that would "flow forth constantly from the walls. . . ."[6] Awarded the largest mural commission ever given to a woman in the United States when she decorated the new state capitol of Pennsylvania, Oakley studied about William Penn, the subject of her murals, and became involved with his visionary ideas about world peace and religious freedom. She spent her life painting, lecturing, and writing on these themes.

Born in Bergen Heights, New Jersey, Oakley came from a long line of artists on both sides of her family and remarked that her urge to draw was "hereditary and chronic."[7] Both her grandfathers, George Oakley and William Swain, were members of the National Academy of Design.

From the time she was an infant, Oakley suffered from severe asthma. Her family did not permit her to go to college because she was considered too frail to withstand the rigors of study. Although born an Episcopalian, she converted to Christian Science and found that the new faith helped her to cure herself of asthma. In later years she was able to complete a succession of large mural assignments demanding great physical endurance. At the age of eighteen she studied at the Art Students League with Carroll Beckwith and Irving R. Wiles, and then at the Académie Montparnasse in Paris with E. Aman-Jean and Raphael Colin. While studying with Charles Lazar in England, she was permanently influenced by Pre-Raphaelite painting.

Oakley rejoined her family in Philadelphia in 1896 and enrolled briefly at the Pennsylvania Academy with Cecilia Beaux and others. At this time her sister Hester praised an art teacher, Howard Pyle, the famous illustrator who was enthralling a generation of young art students at Drexel Institute. Oakley joined his class in 1897 and found her principal mentor.

In Pyle's class she met Jessie Willcox Smith and Elizabeth Shippen Green, who became Oakley's closest friends, and this trio founded a highly original women's support group or cooperative. They took a studio together in Philadelphia and then moved to an enchanting country home near Germantown, where they developed their careers together, sharing rent and resources and creating a unique and magical environment in which to live.

Oakley's father had died, and she needed to support her aging mother. Pyle immediately recognized her talent and put commercial jobs her way, teaming her up with Jessie Willcox Smith to illustrate an 1897 edition of Henry Wadsworth Longfellow's *Evangeline.* He also encouraged her to try stained glass, a field in which she was immediately successful. She was commissioned to design the Epiphany Window for the Church Glass and Decorating Company in New York, and soon after, she

completed murals, mosaics, and stained glass for All Angels Church in New York City.

In 1902 Oakley received an extraordinary commission: eighteen murals for the Governor's Reception Room in the new state capitol that was about to be built at Harrisburg, Pennsylvania. (The main part of this job, the remainder of the capitol decorations, was awarded to Edwin Austin Abbey.) This was the first time any public mural assignment on such a grand scale had been given to a woman.

Oakley and her mother toured Florence, Perugia, Venice, and Assisi to study great mural designs of the past. She plunged into a period of intense study and meditation. Choosing the theme of the founding of the colony of Pennsylvania by William Penn, she became immersed in his Quaker ideas about universal brotherhood, freedom of religion, and a world court of arbitration to supplant wars. Oakley deeply identified with Penn, a visionary who had been frequently jailed for his convictions, and she came to believe that the mural assignment was a "sacred mission."

The murals were unveiled in 1906 to great acclaim, and the Pennsylvania Academy awarded her its coveted gold medal of honor amidst a pelting of flowers at its one hundredth anniversary celebration banquet in 1905. Oakley summarized her research for the murals and put forward her philosophical beliefs in a book called *The Holy Experiment* (1922).[8] Her murals made her famous, and she was kept very busy with varied commissions, murals, stained glass, and portraits.

In 1911, when Edwin Austin Abbey died, Oakley was appointed to finish the murals for the state capitol, an enormous job that occupied her for sixteen years. The canvas for the *Unity Panel* in the senate chamber alone was nine feet high and forty-six feet wide. *The Creation and Preservation of the Union* was the theme of the senate chamber series of nine murals, and *The Opening of the Book of the Law* was the subject of sixteen murals carried out in the Supreme Court room between 1917 and 1927.

Between 1913 and 1917, while working on these murals and numerous other commissions, Oakley

Fig. 5-1. Violet Oakley, PENN'S VISION (1902–6) mural in the Governor's Reception Room, State Capitol, Harrisburg.

taught a class in mural decoration at the Pennsylvania Academy. Among the students she inspired was Edith Emerson, a Philadelphia painter who became her assistant. Emerson served the memory of her teacher as the head of the Violet Oakley Memorial Foundation in Philadelphia.[9]

In 1927, not content to rest after these heroic efforts, Oakley decided to devote the remainder of her life to the cause of world peace. She went to Geneva, Switzerland, to draw and paint the deliberations then under way for the League of Nations. She later exhibited these drawings in many parts of the world to promote the ill-fated League. Pictures of these drawings and reproductions of her Supreme Court murals were combined in a book called *The Law Triumphant* (1933).

Oakley worked in the academic mural tradition that flourished at the turn of the century, but she transformed its hollow forms with passionate feelings for social justice. In murals like *Slave Ship Ransomed* (c. 1905), showing William Penn freeing slaves, or *Anne Askew Refusing to Recant* (c. 1905), depicting the martyred Englishwoman who preferred death at the hands of Henry VIII to compromise of principle, she dealt with themes profoundly involved with human values.

Jessie Willcox Smith (1863–1935) was famous for her *Good Housekeeping* magazine covers (she did over two hundred of them) and for her illustrations for Charles Kingsley's *The Water Babies* (1916) and other children's books. When she was assigned her first cover for *Good Housekeeping* in 1917, the editors wrote that she was ideally suited to help them hold up "the highest ideals of the American home, the home with that certain sweet wholesomeness one associates with a sunny living-room . . . and children."[10] These were the kinds of assignments for which women were thought particularly suited.

Smith is described as a shy, gentle, imaginative person who captured a special expression on her children's faces by telling them fairy tales while painting them for her illustrations. She had not shown any artistic talent in her early years and fell into her career quite by accident. At age seventeen, when she was teaching kindergarten, her cousin asked her to be a chaperone while she gave drawing lessons to a gentleman friend. After two nerve-racking lessons the young man gave up in disgust, but Smith's talents were revealed.

She entered the Philadelphia School of Design for Women and continued at the Pennsylvania Academy in 1885, studying briefly with the great American realist Thomas Eakins. Smith described the Academy as a place filled with serious young artists who paced up and down the cold and clammy corridors, head down, afflicted with "academy slump."[11] A mood of neurotic gloom was felt to be a necessary part of the life of a great artist.

She was already doing advertisements when she began to study with Howard Pyle at Drexel Institute in 1894. The atmosphere in Pyle's classes was diametrically opposed to that at the Academy. He made the field of illustration seem delightful and easy. He taught his students to imagine vividly the scenes they were going to illustrate, after which, he said, the drawings would naturally follow. In this class Smith met Oakley and Green. Pyle teamed Smith with Oakley to do illustrations for an 1897 edition of H. W. Longfellow's *Evangeline*. In an introductory note Pyle wrote proudly, "The drawings possess both grace and beauty."[12]

Smith, Green, and Oakley took a studio together at 1523 Chestnut Street in Philadelphia, splitting the monthly eighteen-dollar rent three ways. In 1902 the trio, already known for their illustrations, moved to The Red Rose, a remodeled colonial inn dating back to 1786, on an enchanting country estate. They worked and lived there with several of their parents and a good friend, Henrietta Cozens, who took care of the magnificent formal garden behind their new home—an exact copy of one at Stoke Poges in England.

A new landlord evicted the inhabitants of The Red Rose in 1905, but they were rescued when friends offered them a home and carriage house on beautiful grounds sloping down to the Wissahickon Creek in Chestnut Hill, Pennsylvania. They moved into the main building and converted the carriage house into shared studio space; the larger half was assigned to Oakley because of the requirements of her large mural projects. They dubbed their new home "Cogslea"—C for Cozens, o for Oakley, g for Green, s for Smith, and lea for the slope on which the buildings were located. In memory of their enchanted years at The Red Rose, they planted an English garden at Cogslea exactly like their earlier one. The three artists were described in the press as "that group of very clever young women . . . [who] live out their daily artistic lives under one roof in the gentle comraderie of some old world 'school.'"[13]

Elizabeth Green broke up the Cogslea ménage in 1911 when she married and moved away. In that same year Smith took a new home at the top of the hill (only a mile away from her old friend Violet Oakley) which she called "Cogshill." There, with her friend Henrietta Cozens, her aunt, and her brother, she continued a successful career into old age.

Elizabeth Shippen Green (Elliott) (1871–1954) studied at the Pennsylvania Academy with Thomas Eakins, Robert Vonnoh, and Thomas Anshutz. At eighteen she published her first illustration, entitled *Naughty Lady Jane*, in the *Philadelphia Times*, for which she received the munificent sum of fifty cents.

Green had already worked for the *Ladies Home Journal, Saturday Evening Post, Harper's Weekly,* and other publications when she enrolled in Howard Pyle's class at Drexel Institute in 1894. There she met Violet Oakley and Jessie Willcox Smith, who would become her lifelong friends. Pyle had an enormous impact on all his students, not only be-

cause of his technical instruction, but because of his positive, optimistic, and richly imaginative philosophy.

Green shared the Chestnut Street Studio with Oakley and Smith and then moved with her friends to studio-homes entitled The Red Rose and Cogslea. In 1911, at the age of forty, Green married Huger Elliott, an architecture professor at the University of Pennsylvania. Although she was reluctant to break up the fourteen-year shared household, she followed her husband's job odysseys to Providence (where he was appointed Director of the Rhode Island School of Design) and then to Boston and New York. After her husband's death in 1951, she returned to the Philadelphia area to be near her friends in her last years.

Green illustrated over twenty books, most of them after her marriage, and did countless pictures for leading magazines of the day. For many years she was under an exclusive contract to *Harper's* magazine. Her illustrations, influenced by art nouveau and the Pre-Raphaelite movement, suggest stained glass in their use of outlines enclosing areas of brilliant color. This decorative quality is combined with the solid draftsmanship encouraged by her teacher Thomas Eakins. Green was also noted for pen-and-ink work and for a strong style of line against mass.

Students of Howard Pyle

Other women illustrators who studied with Howard Pyle include Elenore Plaisted Abbott (1875–1935), illustrator of *Treasure Island;* Ethel Franklin Betts Bains; Anna Whelan Betts; Elizabeth F. Bonsall (1861–1956); Bertha Corson Day (Bates) (1875–1968); Ida Dougherty; Charlotte Harding (Brown) (1873–1951), one of the most original designers in the group; Ethel Penniwell Brown Leach (1878–1960); Margaretta Hinchman; Ellen Bernard Thompson Pyle (1876–1936), who married Pyle's brother and did covers for the *Saturday Evening*

Post; Katherine Pyle (1873–1938), Howard Pyle's younger sister; Olive Rush (1873–?), later a prominent artist in Taos, New Mexico; Sarah K. Smith, who became an instructor at Wheaton College; Alice Barber Stephens (see chapter 4); and Sarah Stillwell Weber (1878–1939).

Other Women Illustrators

Several outstanding women illustrators were not students of Pyle, for example: Christine S. Bredon, Fanny Young Cory (1871–?), and Rose Cecil O'Neill Latham Wilson (1875–1944), known as Rose O'Neill, creator of the kewpie doll and illustrator for *Puck* magazine. Poster artists, influenced by the Arts and Crafts movement and art nouveau, include Florence Lundborg (1871–1949), a well-known California muralist; Ethel Reed (1878–?); Alice Glenny (1875–?); Blanche McManus (1870–?); and Blanche Ostertag and Helen Dryden.

Later, during the Jazz Age, Neysa McMein (1888–1949) designed all the covers for *McCall's Magazine* between 1923 and 1937. Famous as a creator of "flapper" types, she was a member of the Vicious Circle—a group of writers, actors, and artists who met daily for lunch at the Hotel Algonquin in New York City. Among the leading illustrators and cover designers for *Vanity Fair* magazine were Fish (Mrs. Walter Sefton) and Gordon Conway (1894–1956). Conway's *Zina* and *Jazz Lint* series capture the spirit of the Jazz Age.

Tonalist and Traditional Painters

Between 1900 and 1929, while the Ash Can movement and modern art were shocking the American public, a group of successful women artists continued to paint in more traditional ways.

Lillian Genth (1876–1953), one of the well known academic figure painters of the early twentieth cen-

tury, was noted for studies of nudes in arcadian settings, such as *Depths of the Woods* (c. 1911). She was born in Philadelphia and studied on scholarship at the Philadelphia School of Design for Women with Elliott Daingerfield, and then with James McNeill Whistler in Europe. Her work attracted a steady clientele through the period of the early modern movement and the 1913 Armory Show, for there was a large audience that preferred poetic subjects painted in a soothing fashion.

Fig. 5-2. Lillian M. Genth, DEPTHS OF THE WOODS (n.d.), oil on canvas, 88.7 × 73.7 cm

Lilian Westcott Hale (1880–1963) was born in Hartford, Connecticut, and lived most of her life in Dedham, Massachusetts. She studied with William Merritt Chase and at the Boston Museum School with Edmund Tarbell and with Philip Hale, an impressionist, whom she married.[14] A fine draftswoman, she sometimes made her soft, atmospheric oil paintings of women and children look like charcoal drawings, producing veils of tone by allowing the texture of the canvas to show through a kind of

drybrush technique. Her painting *L'Edition de Luxe* (1910) shows an elegant, well-dressed woman reading a rare book in a room that suggests refined, upper-class life. Her choice of subject matter was clearly different from artists of the radical Ash Can School. Hale won a Gold Medal of Honor at the 1915 Panama-Pacific Exposition in San Francisco, and many other awards.

Ellen Gertrude Emmet Rand (1875–1941) was, like Cecilia Beaux, a foremost portrait painter of the important and the rich. Her paintings of Franklin D. Roosevelt[15] and Augustus Saint-Gaudens are major portraits of these great men.

Emmet's grandfather was an Attorney General of New York State and her mother was related to the brilliant family of Henry and William James. She was also a part of a clan of female painters fondly referred to by James as "The Intertwingles." Rosina Emmet Sherwood and Lydia Field Emmet were both first cousins (see chapter 4).

Young "Bay" Emmet, as Ellen was teasingly called by her cousin Henry James, showed artistic ability early and studied under Dennis Bunker in Boston and at the Art Students League in New York with William Merritt Chase from 1889 to 1893. By the age of eighteen she was doing fashion sketches for Vogue magazine and later contributed to *Harper's Weekly*.

At age twenty-one she went abroad with her family, and in London met the famous portrait painter John Singer Sargent. Emmet stayed for three years in Paris, studying painting with Frederick MacMonnies, and became an excellent draftswoman.

In 1900 she opened her own studio in Washington Square (downstairs from Cecilia Beaux), and in 1906 Copley Hall in Boston, which had given solo shows only to the greatest artists of the day—Whistler, Monet, and Sargent—gave her a one-woman exhibition of ninety paintings.

Fig. 5-3. Lilian Westcott Hale, L'EDITION DE LUXE (1910), oil on canvas, 23" × 15"

Following a pattern occurring repeatedly among leading women artists, "Bay" Emmet married late. In 1911, at age thirty-six, she married William Blanchard Rand, a state legislator and gentleman farmer from Salisbury, Connecticut. She spent summers at his farm, horseback riding and hunting, and the rest of the year at her New York studio with their three sons, who were born in 1912, 1913, and 1914.

When the family fortune was decimated in the crash of 1929, Ellen Rand—determined to see her sons through college—concentrated very hard on obtaining commissions. By 1930 she was getting as much as $5,000 for her portraits, and during the Depression years (1930–1939) her income averaged about $75,000 a year. The Metropolitan Museum of Art in New York bought her portraits of Saint-Gaudens and Benjamin Altman, and she won numerous awards including a gold medal at the 1915 Panama-Pacific Exposition.

Women of The Ash Can School

The new century's first decade, called the Progressive Era, was a period of social reform, as American society tried to correct the economic inequities of the Gilded Age. Jane Addams and other reformers pushed for legislation to improve the dreadful working and living conditions of the masses of poor immigrants who had poured into America hoping to find new opportunities in this promised land.

"Trust-busting" laws were passed to curb the uncontrolled power of the monopolies, and "muck-raking" books by such authors as Lincoln Steffens and Upton Sinclair were written to expose the corruption in big city politics and elsewhere. Responding to these same grim realities, a group of artists, labeled the "Ash Can School," tried in sketchy realistic paintings to capture both the letter and the spirit of daily life in the slums and city streets of New York. These artists (John Sloan, George Luks, Everett Shinn, William Glackens, Robert Henri, etc.) were attacked and called "vulgar" until a landmark show, entitled "The Eight," at New York's Macbeth Gallery in 1908 aroused great public interest and toppled once and for all the monopoly of the National Academy. The Ash Can artists believed in freedom of expression, and after the success of "The Eight" show, began to sponsor independent exhibitions open to all without jurying. Artists began to show their work through courageous dealers, instead of being limited to the conservative, juried salons, which frequently rejected their paintings.

Although there were no women among The Eight, a number of women artists and illustrators were associated in one way or another with the Ash Can movement. The group was connected socially as well as artistically. Hilarious and lively, they met at the Café Francis and Mouquin's or at each other's homes. At the inspiration of Everett Shinn, they put on amateur theatrical performances in a small theater he had built behind his studio at 112 Waverly Place in Greenwich Village. Edith Dimock Glackens, Flossie Shinn, and May Preston all acted with the "Waverly Place Players" in such uproarious farces as The Prune-Hater's Daughter. A delightful picture of this group can be found in William Glackens and the Ash Can Group (1957), by Ira Glackens (son of William).[16]

Most of the women were suffragists, and some of their husbands backed them up. Ira Glackens has described the big suffrage parade of 1913. On a warm, sunny day, huge numbers of women, many of whom had come from distant points, marched down Fifth Avenue in tailored, white, long-skirted suits, carrying purple and gold banners. Beautiful floats went by. Each profession—women doctors, women professors wearing mortar-boards, sales girls—carried identifying signs. In the artists' con-

tingent were Abastenia St. Leger Eberle, Janet Scudder, Edith Dimock Glackens, and others. A group of brave men, including William Glackens, also marched by, accompanied by boos and applause that could be heard for blocks away. Still, it took seven more years before women won the right to vote.

Ash Can School Illustrators and Painters

May Wilson Preston (1873–1949), an illustrator associated with the Ash Can School, also exhibited work in the 1913 Armory Show. Wilson was a high-spirited girl, born in New York to middle-class parents who tried to dissuade her from becoming an artist. They sent her to Oberlin College in Ohio, hoping to turn her thoughts into other channels, but by the third year a teacher at Oberlin urged her parents to allow the irrepressible Wilson to become an artist.

She studied at the Art Student's League between 1892 and 1897, but when she was not admitted to the life drawing class, she protested that the League was bogged down by its old-fashioned ideas. In 1899, a year after marrying the artist Thomas Henry Watkins, she went to Paris to study with James McNeill Whistler. Her husband died a year later, and she was propelled into a career as an illustrator. She won her first job by telling the editor that she chose his magazine because it was the worst one around and therefore might buy her work. She made him laugh so hard that he gave her the job. Shortly after that she illustrated her first story for *Harper's Bazaar*.

The artist met Edith Dimock while taking classes with her friend William Merritt Chase at the New York School of Art, and with her and another art student, Lou Seyme, Wilson moved into the Sherwood Studios at 58 West 57th Street. The three girls became known in the art community as "The

Sherwood Sisters" because of the fun and high jinks at their weekly studio open house. Wilson married James Moore Preston, a young Ash Can painter, and Edith Dimock married William J. Glackens, one of the original Eight.

For many years May Wilson Preston was the only woman in the Society of Illustrators, to which many Ash Can artists belonged. (A number of them were newspaper artists.) She was very successful as an illustrator for writers Ring Lardner, F. Scott Fitzgerald, P. G. Wodehouse, and Mary Roberts Rhinehart, in the *Saturday Evening Post* and other magazines. The lengths to which May Preston went to achieve honesty and authenticity in her work have become legendary. For one assignment, in order to experience how it would really feel to be an applicant for a job as a cook, she asked a friend to write a fake letter of reference. Taking the pseudonym of Elizabeth Pope, she masqueraded in an appropriate costume and spent an entire day as an applicant at an employment office, observing all the details of setting, people, and atmosphere.

She also won prizes for her paintings in New York, London, and Paris. Several works were in the Armory Show and she was awarded a bronze medal at the 1915 San Francisco Panama-Pacific Exposition. Preston was also an activist in the National Woman's Party and worked hard for woman's suffrage.

When the Depression began, the discouraged Prestons moved to a remodeled barn in East Hampton, Long Island, where May Wilson Preston spent her declining years growing vegetables and flowers in the countryside.

Edith Dimock (Glackens) (1876–1955) came from a wealthy Hartford family and studied at the Art Students League and with William Merritt Chase. After marrying the painter William Glackens in 1904, she devoted most of her energy to making him comfortable and raising their children. She was a

droll woman who painted droll water colors, some of which are at the Barnes Collection in Philadelphia. All eight of her works in the 1913 Armory Show were sold, including two bought by John Quinn, the pioneer collector of modern art. Several drawings were in the first Independents exhibition of 1910.

Florence Scovel Shinn (1869–1940), of Philadelphia, was well-known for her humorous pen-and-ink illustrations, characterized by a lively, sketchy, Ash Can quality. She married artist Everett Shinn, who had, like her, trained at the Pennsylvania Academy. After her divorce from Shinn (who married three more times), she abandoned art and began to write books that preached a new positive-thinking philosophy. Her book *The Game of Life and How to Play It,* published at her own expense, went into forty printings and was followed by another hit in 1940, *The Secret Door to Success.*

Called "The Pocket Venus" by friends because of her petite beauty, she was famous in the Ash Can group for her wit and sense of fun. Everett Shinn often publicly bemoaned his divorce from her and brought his new wives around for her approval.

Fig. 5-4. Florence Scovel Shinn, ON THE FENCES AND WALLS THROUGHOUT ALL OHIO, ink on paper, 14½" × 11¾", illustration for *Century* magazine (February 1900)

Robert Henri (1865–1929) was the energetic leader, organizer, and teacher who is considered the "father of the Ash Can movement." At the Philadelphia School of Design, the New York School of Art, the Art Students League, and elsewhere, Henri inspired a generation of women artists, many of whom painted the urban scene in an energetic slashing style.

Quite a few exhibited with him at the landmark "Exhibition of Independent Artists" (1910), which he organized with John Sloan, Walt Kuhn, and others. (There was such a crowd attending this show that police had to be called out to avert panic.) Exhibitors included Clara Tice, who also backed the show with money; Florence Howell Barkley (1880/81–1954); Hilda Belcher (?–1963); Frances H. Bolton; Bessie Marsh Brewer (1884–1952); Ada Gilmore; Elizabeth Grandin; Amy Londoner; Edith Haworth (1878–1953); Ethel Louise Paddock (1887–); Josephine Paddock (1885–); Clara Greenleaf Perry (1871–1960); Hilda Ward (1878–1950); Ethel McClellan Plummer (1888–); and Mary C. Rogers (1881–1920).[17]

Henri loved to expound his theories about art and life. **Margery Austin Ryerson (1886–),** an admiring ex–art student and well-known artist, was responsible for putting his ideas down in a famous book, *The Art Spirit* (1923), which preached freedom of expression and individualism for the artist. A Vassar graduate, Ryerson proposed the idea of the book to Henri and worked with him on it, culling articles, letters, lectures, and other materials. She also used her class notes, taken years before at the Art Students League. *The Art Spirit* has become a classic, one of the most influential art books ever written in the United States. Ryerson is the second female Boswell in American art. The first—Helen Knowlton—in the late nineteenth century, promoted the paintings and the thoughts of William Morris Hunt by writing down his ideas in *Talks on Art* (1880).

Marjorie Organ (Henri) (1886–1936), who exhibited several drawings in the Armory Show, was another Ash Can journalist-artist, and the second wife of Robert Henri. Her sketches have left a sprightly record of their coterie.

Born in New York City, she was a witty, beautiful, red-headed Irish girl. At age seventeen she left college, and after a few months of study with Dan McCarthy, a newspaper artist, became a cartoonist for the *New York Journal.* Organ was the only woman in an office with ten male journalist-illustrators.

Among her popular comic strips were "Strange What a Difference a Mere Man Makes" (in the *World*) and "Reggie and the Heavenly Twins" (in the *New York Journal*). When her newspaper colleague Walt Kuhn took her to Mouquin's for dinner, he pointed out Henri, the leader of The Eight, to her. She attended Henri's lectures, was attracted by his electric personality, and was soon modeling for him during a secret courtship.

After her marriage to Henri in 1908, their studio in New York became a center for lively Thursday Studio Evenings, when artists, journalists, and writers dropped by. Isadora Duncan occasionally floated in, in her "flowing robes,"[18] and John Butler Yeats, the garrulous Irish portrait-painter, father of the poet William Butler Yeats, sometimes joined them. Marjorie Organ Henri's sketch *Studio Evening* shows three cronies—her husband, John Sloan, and Yeats—in a typical evening of tales, discussions, jokes, and songs. Anarchism, socialism, and theories about art were among the topics hotly debated during the Thursday Studio Evenings.

The Henris spent many beautiful summers in France, Spain, on Achill Island in Ireland, and in Santa Fe, where Sloan and a lively colony gathered because they admired the Indians and the climate. In all these places, however, Marjorie Henri spent much of her time posing for her husband. When friends chided her for not taking her own work seriously, she was "heard to remark that the extra

Fig. 5-5. Marjorie Organ, STUDIO EVENING (ROBERT HENRI, JOHN BUTLER YEATS, JOHN SLOAN) (c. 1910)

grain of ego she needed might have spoiled her understanding disposition."[19] The Boss, as she called him, had enough ego for both of them, and besides, she did consider Henri's art more important than her own. She was very careless with her drawings, and if Henri had not matted and filed them when he came across them, none would remain.

Marianna Sloan (1875–1954) was the youngest sister of John Sloan (famous member of The Eight). She exhibited landscapes and city scenes at the Pennsylvania Academy between 1893 and 1915 and at the Royal Academy in London. She won a bronze medal at the St. Louis Exposition in 1904,

and the Pennsylvania Academy awarded her a Lambert Fund purchase prize for *A Rocky Beach* in 1915.

In addition to being a fine artist, John Sloan was an exceptional teacher who trained many exceptional woman students, among them Peggy Bacon, Doris Rosenthal—well known in the thirties—and Helen Farr Sloan, who became his second wife.

Ash Can School Sculptors

Ethel Myers (May Ethel Klinck Myers) (1881–1960) was an Ash Can sculptor who created witty caricature bronzes of city types, such as *The Gambler* (1912) and *The Matron* (1912), and showed nine of them in the Armory Show. It is now clear that Myers was one of the most creative of the Americans who exhibited at the Armory Show. She subordinated her career to that of her husband Jerome Myers, the Ash Can painter, and never achieved the recognition she deserved in her lifetime.

Ethel Klinck (an orphan adopted by Michael and Alfarata Orr Klinck) studied at the Chase School and the New York School of Art between 1898 and 1904. She became an Ash Can painter, depicting the streets and people of the Lower East Side in expressionist pictures like *Hester Street* (1904). Her interest in urban realism made her an admirer of the work of Jerome Myers, whom she married in 1905. After her marriage she branched out into sculpture, creating powerful small bronzes and plasters that showed city types in a caricatured but strangely monumental way—reminiscent of Honoré Daumier, but with her own unique style.

Despite the fact that her sculptures were much admired in the Armory Show (William Glackens described them as "a revelation"), between 1920 and 1940 Ethel Myers devoted most of her energy to helping support her family by designing women's clothes and hats for celebrities. After her husband's death in 1940, she spent much of her time promoting

his reputation with lecture tours throughout the United States (1941–1943) and running a Jerome Myers Memorial Gallery in New York City. From 1949 until her retirement in 1959 she was art director of the art and ceramics department of Christodora House, a New York settlement house, and returned to her own work.

Fig. 5-6. Ethel Myers, THE MATRON (1912), bronze, height 8″

Myers's sculptures have energy and originality. Whether she portrays the cleaning woman "dressed to kill' on her day off, or the elegant sophisticate at an opening night at the opera, she stylizes the forms, raising them from the topical to the monumental in broad sweeping movements. People's clothing becomes the "uniform" by which they bravely put themselves forward in the battle of life. Although her husband's autobiography, *Artist in Manhattan* (1940), briefly praises her work, he makes few references to Ethel Myers's life as an artist. Her work was exhibited at the Art Institute of Chicago, the Pennsylvania Academy, the Brooklyn Museum, and the Whitney Museum.

Mary Abastenia St. Leger Eberle (1878–1942) was an Ash Can School sculptor whose small bronzes portray the teeming life of the slums of New York City in the period when waves of immigrants were coming from Europe, looking for work and new opportunity. Born in Webster City, Iowa, Eberle spent her childhood in Canton, Ohio. Her family encouraged her in music, and she became an accomplished violinist. But even as a youngster, her greatest interest was in clay modeling. When her father, a physician, took her to visit the studio of a patient who was a sculptor, she decided at once that this was her work.

Eberle took sculpture lessons (enjoying them much more than regular school) from a local Canton artist, Frank Vogan. During the Spanish-American War, her father was stationed as an army surgeon in Puerto Rico and the family moved there. She wandered the Puerto Rico streets, finding inspiration among the natives for a number of small sculptures that showed their daily lives.

Eberle came to New York in 1899 to study at the Art Students League with Kenyon Cox and sculptor George Grey Barnard. Recognizing her ability, he put her in charge of his class when he had to be away. She also received criticism from Gutzon Borglum.

Fig. 5-7. Abastenia St. Leger Eberle, ROLLER SKATING (1906), bronze, 13" × 11¾" × 6½"

In New York Eberle shared a studio and was a close friend of Anna Vaughn Hyatt, who became a famous animal sculptor. They collaborated on such large joint efforts as *Men and Bull* (1904), in which Eberle did the figures and Hyatt the animals. It won a bronze medal at the St. Louis Exposition of 1904.

Eberle went to Naples to study further and to have works cast in bronze. Characteristically, she found the shrill, teeming Neapolitan street life much more fascinating than the ancient monuments.

In 1908 she returned to the United States. When she got off the boat in New York, the raucous vitality of the dynamic modern city overwhelmed her, and she recognized that "the present work-a-day world with all its commonplaces"[20] was her material. That year (the same year as "The Eight" exhibition) she showed four genre pieces of contemporary subjects at the National Academy of Design. In 1910 *Windy Doorstep,* a study of a kerchiefed woman sweeping, won the Barnett Prize at the National Academy of Design.

She said in 1913, "I made little journeys over to the East Side . . . and smelt its pungent odors and saw its children playing in the streets. . . ."[21] From this careful study of slum life the artist began to create exuberant small sculptures, such as *Roller Skating* (1906) and *Dance of the Ghetto Children* (1914), but she also began to observe its crime, prostitution, and "awfulness." Eberle began to read the works of Jane Addams, the great social reformer and settlement house worker, and developed a social conscience.

At the Armory Show in 1913 she exhibited a controversial plaster sculpture, *White Slave* (now lost), which showed an evil old man auctioning off a young girl into a life of prostitution. This was the period when exposés of criminal gangs preying on poor immigrant girls were widespread in novels and newspapers. It is interesting to compare Eberle's feminist view of this subject with previous male treatments—Hiram Powers's voluptuous *Greek Slave* (1847) or Jean Léon Gerôme's titillating *Slave Market* (1862).

Fig. 5-8. Cover of *The Survey* (May 3, 1913), illustrating THE WHITE SLAVE by Abastenia St. Leger Eberle

In 1913 Eberle said, "The artist has no right to work as an individualist. . . . He is the specialized eye of society. . . . Artists must see for people— reveal them to themselves."[22] Among her other social concerns, Eberle was an ardent suffragette who headed the group of women artists in the suffrage parade of 1913.

In 1914 Eberle moved into a studio on Madison Street on the Lower East Side and set up a playroom adjoining her studio so that she might observe the neighborhood children closely. Her small bronzes have a lively, animated, "reporter" quality related to the Ash Can School of painting; they are done in a broad, sweeping, almost caricature style.

Eberle's socially conscious work was too "ugly" to be commercially successful in her day. The

socialist press applauded her social realism, and museums recognized her originality and bought her work, but after a brief period of success she had few private collectors. A severe illness in 1919 greatly reduced her productivity after the age of forty.[23]

Long overlooked, it is only in the last few years that Eberle's compassionate studies of old ragpickers, unemployed workers, and poor immigrant mothers have been recognized as pioneering works of the Ash Can movement.

Post-Impressionism, Fauvism, Cubism, Nonobjective Art, and The Armory Show

No sooner had the Ash Can artists taken over the art world with their urban American realism than new movements began to enter from abroad. In 1913 the American Society of Painters and Sculptors organized a huge exhibition in a large armory building, where they showed the work of the new American independents and also the daring art being created in Europe by Henri Matisse, Pablo Picasso, Marcel Duchamp, Constantin Brancusi, and Post-Impressionists like Gauguin and Van Gogh.

The Ash Can artists were not prepared for the outcome. The startling new works of the Europeans stole the attention of the public, many of whom were outraged, but all of whom crowded the exhibition with unprecedented attendance. Seventy thousand people packed the Armory in New York, and almost 200,000 attended when it traveled to the Art Institute of Chicago, where irate students burned Matisse in effigy outside.

The results of this show were profound. Collectors like Katherine Dreier (who exhibited two paintings in the exhibition) began to buy abstract art, and a trend toward abstraction and away from realism began. This trend has continued to the present day, with a brief detour in the 1930s.

The Ash Can artists were no longer the avant-garde. One of their chief complaints was that another "foreign" or "European" wave was turning their countrymen away from the long tradition of American realism. American art has from its inception been subject to alternating pendulum swings between native American realism and European styles. One of the American women who showed in the exhibition, Marguerite Zorach, had just returned from Europe with some of these "foreign" ideas. In addition, there were more than forty other American women in the Armory Show.[24]

Marguerite Thompson Zorach (1887–1968) was one of a handful of young artists who introduced fauvist and cubist styles to America between 1910 and 1920. Later overshadowed by her husband, sculptor William Zorach, it was not until 1973 that scholar Roberta Tarbell ran across her early work and pointed out its pioneering importance.[25]

Thompson was born in Santa Rosa and raised in Fresno, California, where her father was a lawyer for the Napa vineyards. Her genteel parents, descendants of New England seafarers and Pennsylvania Quakers, saw to it that she had extra tutoring in languages and piano while she was still in elementary school, as well as four years of Latin at Fresno High School.

She also began drawing when she was very young—the family recalls a picture of two seagulls drawn at the age of three—and her teachers recognized her talent early. Thompson was a brilliant student, one of a small group of women admitted to Stanford University in 1908. She was about to start on a conventional path when she received a letter that was the turning point of her life. Her Aunt Harriet Adelaide Harris wrote to her from Paris inviting her to study art in Europe, and enclosed the fare. Herself an amateur painter, Aunt Addie knew about the notebooks her niece had been filling with drawings from the age of six. Sensing Thompson's

unusual gifts (which her parents did not), she also missed the company of her young niece, whom she described as "just about the only human who ever really loved her."[26]

Aunt Addie, however, did not anticipate the furor that would erupt when she cut the silken cord that tied Marguerite Thompson to her family. She had pleasant visions of her niece at the École des Beaux-Arts turning out slick academic paintings to hang "on the line" at the Paris Salon. Instead, on her very first day in Paris, Thompson went to see the famous Salon D'Automne of 1908, the exhibition that presented the works of Matisse, André Derain, Anne Rice (an American woman), and others to a startled world. The bold colors and shocking distortions in these paintings had caused the critics to refer to the artists as *Fauves,* or "wild beasts."

During her first year in Europe, fired with enthusiasm for this new art, Thompson painted *Luxembourg Gardens* (1908), a brilliantly colored, loosely brushed work with heavy black outlines. This was followed by bold, thickly painted views of Arles and other places in the South of France. In this period Thompson was earning her expenses by sending accounts of life abroad to her hometown newspaper.

In Paris she visited Gertrude Stein, an old San Francisco friend of Aunt Addie. At Stein's salon on the Rue de Fleurus, Thompson met Picasso and became friends with the modern sculptor Ossip Zadkine. After one short stint with the conservative painter Aubertin, and another at the École de la Grande Chaumière, she enrolled at an avant-garde school called La Palette, run by a Scottish Fauve painter, John Duncan Fergusson.

At La Palette, Thompson met William Zorach, a first-generation Lithuanian Jew from Cleveland, Ohio. He was a young commercial lithographer who had saved up just enough money to study in Paris. On long walks along the Seine they discussed modern art and eventually their future together.

Zorach has described his first impression of Thompson in his autobiography *Art Is My Life* (1967). Seeing her paint a nude in wild yellow and pink, encircled by a bright blue line, he wondered why a nice girl was painting such mad pictures. He asked her whether she knew what she was doing and why, and discovered that she did know. Thompson seemed well bred and sheltered, but with an inner assurance and strength of character. She designed her own clothes and wore a striking black turban with a big red rose in the middle of it.

Alarmed at her niece's strange paintings and growing romance with an unsuitable young man from a poor immigrant background, Aunt Addie insisted that Thompson join her on an extended tour of the Orient on the way home to Fresno. Although the artist hated to leave Paris, the journey to Egypt, Palestine, India, and Japan left her with memories of Oriental art that figured importantly in her later work. *Judea Hill in Palestine* (1911), one of her strongest early works, was painted on this trip.

At home in Fresno, Thompson's family, embarrassed by her modern paintings, hid her paints and tried vainly to interest her once again in Fresno society life. But she found this existence suffocating and waited for Zorach to save enough money in Cleveland so that they could get married.

During the summer of 1912, while camping near Shaver Lake in the High Sierras with her family, Thompson executed a bold series of California paintings and ink drawings that were among the most advanced works being painted in America at that time. In *Man Among the Redwoods* (1912), in bold, slashing strokes of vivid blue, green, and orange against the dazzling, whitish sky and distant mountains, she captured the huge scale of the trees of the Sierras, which dwarf the small figures, indicated by a few compact lines. Heavy black and blue outlines emphasize the direct, simple shapes. She also made bold, economical ink drawings, influenced by Oriental art.

That year, she exhibited in the Royar Galleries in Los Angeles. Critics noticed the blazing color and strength of these paintings, done when Thompson was perhaps at the full height of her creative energy. Zorach soon sent for Thompson, and just before joining him in New York, she selected a small group of works to take with her. At this time she threw out a large body of early drawings and paintings at the city dump. The ones she saved remained rolled up for over fifty years until they were retrieved by her son Tessim in 1968.

Marguerite and William Zorach lived through exciting years as pioneers in American art, on 10th Street in Greenwich Village. Among their friends were Max Weber, Abraham Walkowitz, Marsden Hartley, Charles Demuth, Marianne Moore, and others. Immediately after their marriage in 1913 the Zorachs exhibited fauvist paintings in the Armory Show. Although William Zorach received no critical notice whatsoever, Marguerite was honored with a blistering attack for her painting *Study:*

In the study by Marguerite Zorach, you see at once that the lady is feeling very, very bad. She is portraying her emotions after a day's shopping. The pale yellow eyes and the purple lips of her subject indicate that the digestive organs are not functioning properly. I would advise salicylate of quinine in small doses.[27]

During a summer in Provincetown, a lively art colony where Eugene O'Neill was staging his new plays with the Provincetown Players, the Zorachs mixed with avant-garde artists and literary people, designed wild expressionist sets for the plays, and were introduced to the ideas of cubism. From this period came Marguerite Zorach's cubist paintings *Provincetown* (1916) and *Sunrise-Moonset Provincetown* (1916).

In 1916 the Zorachs were chosen for the important Forum Show at the Anderson Galleries, another landmark of modern art. Up to this point, they had been considered artists of equal importance and worked in similar styles. But after 1916 William's career began to overshadow Marguerite's.

The Zorach children were born in 1915 and 1917. In his autobiography, William describes the difficulty Marguerite had in concentrating on her painting when her children were young. Her husband was very supportive and shared the household chores, but she found that painting required long blocks of uninterrupted time. Never at a loss, she turned to needlework, an art form that could be developed in tiny increments while she worked out the full composition in her head. She found the colors of wool and silk even more brilliant than paint. The tapestries slowly developed into rich and complicated compositions, paintings in thread.

These embroideries began to sell, and Marguerite Zorach devoted herself almost exclusively to them between 1918 and 1924. She began to charge high prices for them because of the long time they took to complete. For many years, when William Zorach was a struggling sculptor, the family survived on the income from these tapestries, purchased by Abby Aldrich Rockefeller, and other important patrons. Although the Zorachs were very poor, Marguerite would not permit her husband to go back to commercial lithography because she felt it would impair his creativity.

William collaborated with her on *Maine Islands* (1919) and on one or two other early tapestries, but found that he could not match her skill at the intricate work. He turned to carving, found his métier, and became one of America's leading sculptors.

Although favorably reviewed by the critics, Marguerite's stitcheries were inevitably relegated to a lesser rank of "crafts." The Museum of Modern Art refused to accept a gift of one of them because it did not fit into any of their categories. Today the women's movement recognizes needlework and honors quilts, soft sculpture, and weaving as high art forms, part of women's long creative tradition.

In the late 1920s and 1930s Marguerite Zorach returned to painting while continuing her stitcheries. In 1925 she became the founder and first president of the New York Society of Women Ar-

Fig. 5-9. Marguerite Zorach, SAILING WIND AND SEA (1919), oil on canvas, 25″ × 30″

tists, the avant-garde wing of women painters, whose lively exhibits drew surprised praise from the critics. Yet she never regained equal footing with her husband.

Marguerite Zorach's art proved too radical during the days of the federal art programs in the 1930s. After she had completed two large murals for the post office and court house of her hometown, Fresno, and had, in fact, already been paid by the government, the two presiding Fresno federal judges looked at pictures of the finished works and "frowned judiciously."[28] They wrote to the Public Buildings Commissioner, W. C. Reynolds, "It is our opinion that some decoration emblematic of justice and especially the American concept of justice, would be much more appropriate in the courtroom than the suggested murals."[29] Marguerite Zorach had painted Fresno farmworkers picking and drying grapes for raisins, in a modern, stylized manner. The judges no doubt expected a figure of blindfolded Justice with scales, in a Greek robe.

The murals were never installed, and subsequently they disappeared in Washington, D.C. In 1966 the Marguerite Zorach Mural Committee of Fresno was still trying to locate the paintings and place them in new government buildings. Healey Tendel, the head of the committee, wrote to the General Services Administration, "It is unbelievable that they were ever rejected. Mrs. Zorach is a noted American artist, and it does not seem possible that the paintings were destroyed."[30]

Marguerite Zorach continued to exhibit, although her productivity tapered off in the 1950s. Her artist daughter Dahlov Ipcar exhibited with her mother in 1962. Shortly before her death in 1968, Marguerite Zorach gave her son Tessim a small roll of her early 1911–1912 canvases. He had them restored and framed, and Roberta Tarbell, an art historian writing about William Zorach, saw them and recognized their pioneering importance.

William and Marguerite Zorach are typical of many husband-and-wife artist teams in which the husband's reputation overshadows the wife's. This phenomenon, however, cannot be attributed in any way to William Zorach's attitude. He considered his wife a great artist and was hurt that she did not receive as much recognition as he did in the art world. They continued a shared working relationship throughout their lives. Their son Tessim says that his father continued to be influenced by his mother's designs, and drew many of the ideas for his sculptures from her. One of William Zorach's most famous sculptures, *The Spirit of the Dance* (1932), was, according to his son, suggested by a drawing his wife made for a silk stitchery. In addition, she assisted him on his commissions, tracing drawings and doing other tasks. She was somewhat retiring about promoting herself, and the art establishment then (as now) tended always to regard the male as the major creator.

Marguerite Zorach, after moving through phases of fauvism and cubism, worked during the rest of her career in a more representational, but still somewhat geometrized and expressionistic style. Her complex imagery can be seen in the stitchery *The Family of Tessim and Peggy Zorach* (1944), which shows her son and his wife, children, pets, and household objects.

Katherine Sophie Dreier (1887–1952)

No one would have been more surprised than Marcel Duchamp, Man Ray or I that the Société Anonyme, which we created with so much gaiety in 1920, would, with time, develop into an organization possessing a collection unique because it became an expression of the history of the new movement in art which swept Europe.
 Katherine S. Dreier[31]

Katherine Dreier must be ranked along with Alfred Stieglitz as one of the impresarios of modern art in the 1920s. She was the youngest daughter in a family that fostered individual development and service to the community. Her sisters Margaret Dreier Robins and Mary E. Dreier became early presidents of the Women's Trade Union League of Chicago and New

York, and her older sister Dorothea Dreier became a painter. Katherine worked for several years for women's suffrage and other causes, in addition to her role in the art world. Her family encouraged her artistic talent as well.

After studying at Pratt Institute (1900) and privately with Walter Shirlaw (1904–5), whom she considered an important influence, she also trained in Paris (1907), London, and in Munich (with Gustav Britsch, 1912). Even before the 1913 Armory Show, Dreier had painted a mural for the chapel of St. Paul's School in Garden City, Long Island, and had a solo show at London's Doré Gallery in 1911.

She exhibited two paintings in the Armory Show (*Blue Bowl* was selected for a traveling exhibition). Overwhelmed by the new abstract art she saw there, particularly Marcel Duchamp's *Nude Descending A Staircase* (1912), she joined the antic and iconoclastic New York Dada group that gathered at Walter Arensberg's apartment. This was the period when Duchamp, a principal member, submitted a urinal entitled *Fountain,* signed "R. Mutt," to the 1917 Independents' open show. It was banned.

Rather than engage in such madcap acts, Dreier decided to champion the cause of modern art. In 1920 she joined with Duchamp and Man Ray to form an "international organization for the promotion of the study in America of the progressive in art." When this organization, the Société Anonyme, opened its doors at 19 East 47th Street, New York, it was the first museum of modern art in the United States.

The date chosen for its opening had significance for Dreier. Her artistic talent and independent spirit, as is so often the case with women artists, were partly due to her enlightened family. In fact, on the thirtieth anniversary of the founding of the society, she wrote: "I want first to pay tribute to my father, Theodor Dreier, who . . . had also the vision . . . ahead of his time, of giving the same privilege to his daughters as he gave to his son. . . . And thus it

was that we chose the [anniversary of the] date of his landing in America, April 30, 1849, on which to open. . . ."[32] The Société Anonyme was not only the first museum where Americans could look at abstract art, but it introduced more than seventy important modern artists for the first time here— including Paul Klee, Kurt Schwitters, Casimir Malevich, Joan Miró, and Georges Vantongerloo. The organization sent traveling exhibitions across the United States, which brought for the first time the works of Vasily Kandinsky, Piet Mondrian, Constantin Brancusi, Jacques Villon, and others to people who would never have otherwise had the chance to see them. It also sponsored lectures and publications (Dreier wrote a monograph on Kandinsky, for instance) and a symposium on dada. Some of the lecturers in those early years were Louis Eilshemius, Marsden Hartley, Walter Pach, Elie Nadelman, William Zorach, and Alfred Stieglitz.

The first anniversary celebration of the Société in 1921, "An Evening with Gertrude Stein," included readings by Marsden Hartley and Henry McBride of Stein's unpublished works. Dreier was the first president of the group, and Duchamp, her principal advisor, was an important influence on the collection.

The Société's first art acquisitions were several paintings donated to them by artist John Covert when he resumed his business career. Other works were subsequently bought from the exhibitions organized by the society. The Société Anonyme collection—unique because it was chosen by artists, not critics or curators—was given to Yale University permanently in 1941.

By 1918 Dreier had adopted a totally nonobjective style in her own work. Reflecting her view that modern art is a "cosmic force," many of her nonobjective paintings, composed of organic shapes floating among mellow colors, hint of such forces. In 1923 she wrote in *Western Art and the New Era,* "The function of art is to free the spirit of man and to invigorate and enlarge his vision. . . ."[33]

Fig. 5-10. Katherine S. Dreier, ABSTRACT PORTRAIT OF MARCEL DUCHAMP (1918), oil on canvas, 18″ × 32″

From 1930 to 1933 Dreier lived and painted in Paris and belonged to the Abstraction-Création Group. Her work was in many exhibitions, including the Museum of Modern Art's "Fantastic Art, Dada, Surrealism" (1936) and "Classic and Romantic Traditions in Abstract Painting" (1939). Dreier's long and fascinating career deserves much closer study than it has yet received.

Dorothea Dreier (1870–1923), Katherine Dreier's sister, was a postimpressionist painter. Some of her works are in the Société Anonyme Collection at Yale University. Several of Dorothea's views of New York and Europe were painted as early as 1908 and have been compared with Paula Modersohn-Becker's.

Anne Wilson Goldthwaite (1869–1944), painter of the South, was another early "modernist" in the Armory Show. She came from a distinguished Montgomery, Alabama, family and was raised by an aunt after her parents died. She "came out" into society and seemed destined for the life of a Southern belle, until her beau was killed in a duel. An uncle in New York, who knew of her early interest in art, suggested she come North and study it seriously.

She studied etching with Charles Mielatz at the National Academy of Design and painting with Walter Shirlaw (her principal influence). In 1906 she went to Paris, met Gertrude Stein, and came under the influence of Cézanne, Matisse, and Picasso. Goldthwaite later recalled her first glimpse of Stein. She was sketching in the Luxembourg Gardens when she looked up and saw a friend of hers talking to a woman "who looked something like an immense dark brown egg. She wore, wrapped tight around her, a brown kimona-like garment and a large flat black hat, and stood on feet covered with wide sandals."[34] When Stein invited her home, she wondered if she should accept; perhaps this shabby woman could not afford to serve her tea. Stein brought her to an elegant studio filled with antique Italian furniture and walls "covered with the most remarkable pictures I had ever seen."[35]

In Paris Goldthwaite was one of a group of students who organized the Académie Moderne, taught by Charles Guérin and Othon Friesz. She returned to New York just before World War I and exhibited in the 1913 Armory Show. At this exhibition she met and became a lifelong friend of Katherine Dreier. Between 1922 and 1944 (the year of her death) she was a very popular teacher at the Art Students League, remembered as an amiable, wise, and tolerant personality, and an early advocate of women's rights and civil rights.

A New Yorker by adoption, Goldthwaite periodically returned for long visits to her native Montgomery and went back to her Southern roots in her etchings and paintings. Her relaxed, leisurely, whimsical graphics and paintings of her hometown have made her perhaps the leading regional painter of the South. Although she embraced the modern movement very early, her work was expressive rather than abstract. She caught the flavor and ambience of life in rural Alabama in etchings like *Saturday in Alabama* (c. 1920) and watercolors like *The Coiffeur.* Of her sympathetic studies of the poor Southern Negro, with his shack and mules, or of family members enervated by the summer heat, art historian Adelyn Breeskin writes, "The slow rhythm of lines, the very ease in execution, the sense of hot sun . . . mark these as among the most vivid and eloquent graphic works yet produced of the South."[36]

Just before her death she completed two murals on Southern life for the post offices at Atmore and Tuskegee, Alabama. One-woman exhibitions were held at the Syracuse Museum of Fine Arts (1924), and posthumously at Knoedler's (1944) and the Montgomery Museum of Fine Arts (1977).

Jane Peterson (1876–1965), a postimpressionist watercolorist, was one of New York's most important women artists during her lifetime. Born in Elgin, Illinois, she came to New York to study at Pratt Institute. After graduating in 1901, she studied with Frank Vincent Dumond, and gave art lessons to earn money for a trip abroad. She studied with Frank Brangwyn in London, Joaquin Sorolla in Madrid, and in 1909 with Jacques-Émile Blanche in Paris.

Peterson's paintings of American life from Maine to New York City to Miami are often compared to the work of Maurice Prendergast; her tapestry-like watercolors, made up of dabs of strokes in vibrant colors, are in a style somewhere between impressionism and postimpressionism. Very well known in the 1920s, she had many one-woman shows; she taught watercolor at the Art Students League between 1912 and 1919, and later at the Maryland Institute in Baltimore. In 1922 the New York Society of Painters judged her *Toilette* to be the outstanding work in their exhibition.

Fig. 5-11. Jane Peterson, FLAG DAY (n.d.), gouache and charcoal on paper, 23⅛″ × 17⅜″

In 1925, at the height of her fame, she married Moritz Bernard Phillip, an art patron and retired corporation lawyer. For the next forty years she continued her long and active career. Her last exhibition was at the Newhouse Galleries in New York in 1946. Although her work tapered off after this show and fell into relative neglect, she continued to work and receive awards into old age. In 1970 an exhibition at New York's Hirschl and Adler Gallery brought her work back into public prominence.

In carefully structured compositions of brilliant, translucent color, Peterson left a record of America's parks and beaches, city streets, and summer colonies. A personal quality of stroke, along with an art nouveau line, captures the fleeting effects of light and movement.

Louise Herreshoff (1876–1967) was a fauvist painter whose work was returned to public attention purely through chance, after having been almost completely lost. Talented and wealthy (her family was related to the famous Herreshoff boat designers), she worked in relative obscurity, living with her doting Aunt Elizabeth in Providence, Rhode Island. She studied in France at the turn of the century (her painting *Le Repos* [1899] was in the 1900 Paris Salon) and then returned to America and developed a bold fauvist style of brilliant color and slashing brushwork.

After her beloved aunt's death in 1927, Herreshoff became discouraged, stashed all her work away in the attic, and after a near-breakdown, took up china collecting. At sixty-six she married Euchlin Reeves, a man twenty-six years her junior. Together they amassed a famous china collection, which she bequeathed to Washington and Lee University.

When workmen from the university picked up the china after her death, they noticed a pile of "frames" and almost left them in the attic. On an impulse they took the pictures on the truck with the china, and at the university their high quality was immediately recognized. The art department and Norman Hirschl, an expert called in to make a critical estimate, soon realized that Louise Herreshoff had been a pioneering American expressionist.

The Corcoran Gallery in Washington gave her a one-woman exhibition in 1976. Showing the work of a previously unrecognized American talent seemed a fitting way to celebrate the Bicentennial.

Alfred Stieglitz (1864–1946) was a prime mover of American modern art. Between 1905 and 1917 in his Gallery 291 (so named because it was located at 291 Fifth Avenue in New York City), he exhibited first the work of modern photographers and, starting in 1907, the work of painters also. He pioneered a new trend, Photo-Secessionism, in his own field (photography) and showed the work of many fine women photographers, such as Annie W. Brigman, Gertrude Kasebier, and Jan Reece. Beginning in 1908, Stieglitz exhibited Picasso, Matisse, Braque, and Brancusi for the first time in America. He discovered and showed the work of an entire group of early modern American masters: Arthur Dove, Marsden Hartley, John Marin, Alfred Henry Maurer, and Max Weber. He was also the first to show an unknown artist named Georgia O'Keeffe.[37]

Pamela Colman Smith (1877?–c.1950) was the very first painter to have an exhibition at Stieglitz's Gallery 291 in 1907. (Previously, Stieglitz had shown only photography.) Smith was an art nouveau painter and illustrator, influenced by the sinuous lines of Aubrey Beardsley and Walter Crane. She was an American living in England—a "free soul," unconventional in her life and art, an occultist and mystic who, among other things, designed a set of tarot cards. Her watercolors, such as *Beethoven Sonata No. 4* (1907), now in the Stieglitz Collection at Yale University, have an other-worldly symbolist and fairy-tale flavor.

Fig. 5-12. Pamela Colman Smith, BEETHOVEN SONATA (1907), watercolor, 15⅜" × 11"

Georgia O'Keeffe (1887–) is considered by many art historians and critics to be America's greatest living painter. The simplified abstract shapes of her flowers, bones, mountains, and clouds reveal a classic order hidden in nature. Her work has maintained its high position through all the changes that have swept through the art world since her first appearance in it in 1916.

The second of seven children, O'Keeffe was born on a large farm in Sun Prairie, Wisconsin, to an Irish father and a Dutch-Hungarian mother. Her childhood memories are of a harmonious family living healthy lives close to nature.

She grew up among strong matriarchs; her grandmothers were both capable frontier wives who raised their families alone after one was widowed and the other abandoned by her husband. Her unmarried aunts, Lola and Ollie, both became

professional women at a time when that was still unusual. The first painting that made an impression on O'Keeffe was a framed watercolor of a red rose by her grandmother. O'Keeffe began to draw early and claims to have known by the age of ten that she would be an artist. The family moved to Williamsburg, Virginia, in 1902, when she was fifteen.

O'Keeffe's temperament was rebellious from the beginning. She found school—even art school—dull and constricting to her spirit. Whether in a Wisconsin parochial school, where the sisters kept telling her to draw her lines more lightly, or in the Art Institute of Chicago, where she drew from plaster casts, she somehow knew that the scholastic vision of art had nothing to do with the beauty she experienced and wanted to express. Her finest memory of her early education was of hikes in the woods near Chatham, a girl's boarding school she attended in Virginia.

At Chatham, a remarkable art teacher (and the school's principal), Elizabeth May Willis, immediately recognized O'Keeffe's talent, gave her liberty to work at her own pace, and awarded her a special art diploma at graduation. She urged O'Keeffe's mother to send her to professional art school and, unknown to O'Keeffe, followed her student's career with great pride in the following years.

After a year of cast-and-figure drawing with John Vanderpoel at the Art Institute of Chicago in 1905–6, O'Keeffe enrolled at the Art Students League in New York. There William Merritt Chase stimulated her love of paint and color. She did well at the League, winning a prize for still-life painting of a dead rabbit and copper pot. Yet even this success did not fulfill her. She felt that her pictures were imitations of her teachers and of the oft-repeated formulas of traditional art. O'Keeffe grew increasingly discouraged and stopped painting entirely for several years.

The move to Williamsburg had been disastrous for her family. Her father was in debt and her

mother was dying of tuberculosis. To support herself, O'Keeffe took a job in Chicago, drawing lace and embroidery for advertisements in 1909. After a year of this exacting work (she later said it was good training), she was forced to return home to her family's new location in Charlottesville, Virginia, because a bout with measles had weakened her eyes.

Art historians and biographers have always stressed the role of men in O'Keeffe's life, especially that of her teacher, Arthur Wesley Dow and her mentor, Alfred Stieglitz. Not enough attention, however, has been given to the key role of certain women at critical moments in her life. In 1912, after her return to Charlottesville, it was O'Keeffe's sisters who urged her to take a class at the University of Virginia, taught by Alon Bement, a follower of Arthur Wesley Dow. (Later in her life, her friends Anita Pollitzer and Dorothy Brett would also prove helpful.)

Bement, like Dow, was teaching oriental principles of design, stressing the balance of light and dark (notan), and the importance of filling the space beautifully, with sensitivity to the openings between the shapes. He introduced O'Keeffe to modern art—the Postimpressionists—and later to Vasily Kandinsky's book *On the Spiritual in Art* (1914), which develops the idea that colors and shapes are expressive without regard to subject matter. Recognizing O'Keeffe's talent, Bement urged her to study with Dow himself at Teachers College of Columbia University. He also offered her a position at the University of Virginia as instructor of a summer class, which she taught in the summers of 1913–1916.

During the next four years O'Keeffe had a variety of teaching jobs. She enjoyed teaching Mexican children as supervisor of art in the public schools of Amarillo, Texas, and felt strangely at home on the wide, bleak, treeless plains of the Texas panhandle. The stubborn artist, however, became locked in a struggle with the local school board. She refused to order the dull, stale copybooks the board insisted that she use in the art classes, feeling that they would destroy her students' creativity. Rather than give in, at the end of the year she went North to study with Dow at Columbia.

It was at Teachers College in New York that O'Keeffe had one of those rare accidental experiences so crucial to an artist. She was walking down a school corridor when she heard music coming out of Bement's classroom. She slipped in quietly and joined his students, who were drawing abstract lines and shapes suggested by songs coming out of a victrola—"The Volga Boatmen," with its heavy beat, and the high, reedy "Land of the Sky-Blue Waters." This experience moved her deeply and was a kind of turning point for her.

Returning to a new job at a small college in South Carolina, O'Keeffe excitedly began to experiment during every spare minute with a new approach to painting. She began by drawing simple shapes and lines in charcoal while listening to music. Then she progressed to watercolor. One day in 1915 she shut herself in her room and placed her drawings and paintings against the walls. Seeing in them the influences of others, she decided to throw out anything that did not express her own ideas alone. Above all, she refused to conform, to make herself a prisoner of the ideas of others.

Now she embarked upon a series of charcoal drawings that would express her private vision. O'Keeffe mailed some of these drawings to Anita Pollitzer, a friend who had studied at Columbia with her; they were a kind of private letter, and she admonished Pollitzer not to show them to anyone else. But Pollitzer immediately took them to Alfred Stieglitz, the famous photographer and impresario who was running 291, the most avant-garde gallery in New York. When Stieglitz saw O'Keeffe's drawings, he reportedly exclaimed, "Finally, a woman on paper!" He hung them in a show, along with the paintings of two other artists, in May 1916. When O'Keeffe heard about this intrusion into her privacy,

the artist charged into the gallery and insisted that he take down her work. Stieglitz, however, convinced her to leave the work on the walls; eight years later, he convinced her to marry him.

Stieglitz, a second generation German-Jewish intellectual, twenty-three years older than O'Keeffe, was a charismatic leader who drew around his caped figure a coterie of new American modern artists. He sponsored twenty one-woman shows for O'Keeffe, beginning in April, 1917.

At first, O'Keeffe's paintings, such as *Blue Lines* (1916) and *Light Coming on the Plains* (1917), were almost totally abstract. Like Kandinsky, she found that lines and shapes had a beauty of their own, similar to the sounds of music. Yet her work, from the beginning, was suggestive of landscapes, the plains of Texas, and growing plants.

In the 1920s O'Keeffe's works became more representational. She began to paint flowers, city scenes, and farmhouses, but in a simplified and abstract manner, with striking viewpoints and magnifications of size. O'Keeffe lived in New York with Stieglitz on the thirtieth floor of the Shelton Hotel, and spent summers at Lake George in a farmhouse on his family estate. *Radiator Building* (1927), *The Shelton with Sunspots* (1926), and *New York Night* (1929) are dramatic views of the skyscrapers seen from her window. During summers at Lake George she painted austere compositions of sides of barns and a series of clamshells and old shingles. At this time O'Keeffe began to blow up images of flowers, moving in closer and closer until the vibrating center of a flower sometimes took up the whole canvas.

Writers on modern art sometimes suggest that in her "blow-ups" O'Keeffe imitated the photographs of her husband. She has pointed out that the similarity of their concerns sometimes led her and Stieglitz to work with similar images, but that she influenced him as much as he influenced her. He was, in fact, sometimes reluctant to accept her new statements—the views of the city and the flower

Fig. 5-13. Georgia O'Keeffe, NEW YORK NIGHT (1929), oil on canvas, 40″ × 19″

paintings—until critical accolades for her work had won him over.

The clique of men around Stieglitz did not accept O'Keeffe at first. Her art seemed simplistic, and her colors too bright at a time when they were all involved with European movements like Cubism, which shattered objects into complex shards of drab color. O'Keeffe has always disliked modern art jargon and said in her autobiography (*Georgia O'Keeffe*, [1976]) that she never did find out what the word *plastic* meant.[38] When questioned, she will always give some extremely simple and concrete origin for her works—a starry night, or the simple presence of bones on the desert creating a dramatic form against the blue sky.

Stieglitz took five hundred photographs of O'Keeffe between 1917 and 1937. She has said that she lost interest in painting the figure because she could not bear to make people pose for her for long periods of time, as she had had to pose for Stieglitz.

Around 1928 O'Keeffe found that her sources of inspiration were drying up. The din of the city oppressed her. Raised on the plains of the Midwest, she needed a wider sky, open space, and color, in order to thrive. She had never enjoyed having many people around her and required long periods of privacy to work. The continual crowds of family and friends surrounding Stieglitz during the summers at Lake George and in New York were abrasive to her spirit. At Lake George, she said, "The people live such pretty little lives, and the scenery is such little, pretty scenery."[39]

In 1929, at the invitation of painter Dorothy Brett and Mabel Dodge Luhan, she spent the summer in Taos, New Mexico. After that, she was in New Mexico every summer, returning to Stieglitz during the winter. Her aging husband, upset and threatened by these separations, transferred his role of mentor to another woman for a time, according to O'Keeffe's biographer.[40] Torn between her needs as an artist and her devotion to Stieglitz, O'Keeffe tried to make concessions, and returned to Lake George for a while in 1932. But it was a turbulent period, during which her husband interfered with some of her important career decisions—standing in the way, for example, of her decision to paint a mural for New York's Radio City Music Hall.[41]

It was not in Georgia O'Keeffe's nature to bend to another's will. Her biographer writes: "Tense, drained and despondent, she suffered from severe headaches and a hyper-sensitivity to noise. She felt terrified upon venturing onto the crowded street that she might lose her mind."[42] She was finally hospitalized for nervous exhaustion and required a considerable period of convalescence before she could work again. After this, the two strong personalities made an accommodation. Stieglitz accepted the summers in New Mexico, but they shared their thoughts and feelings in thousands of letters during the separations, and spent the winters together.

In 1940 O'Keeffe bought a ranch far from the road in a remote spot near Abiquiu, New Mexico, and in 1945 she bought a second house in the village itself. After Stieglitz died in 1946, she moved to Abiquiu permanently, dividing her time between the ranch and the house. When O'Keeffe first arrived there, she was the only Anglo in a village consisting entirely of people of Indian and Spanish heritage. She grows her own vegetables and grinds the wheat flour by hand for home-baked bread. From her studio on top of a hill she looks out upon the many changing colors of the mountains and the road winding off into the distance. In the Southwest, the vast spaces, the forms of rocks and hills, the sun-bleached bones of cattle, and the clear night sky, have supplied her with endless subjects for her nature paintings. After her first trip to New Mexico, she hauled back a "barrel of bones" from the desert and painted those skulls and pelvises for many years afterwards.

O'Keeffe has always found her own country tremendously inspiring and only began to travel abroad in later life. Her airplane trips resulted in

extraordinary paintings of clouds seen from above, moving swiftly backward toward an infinite horizon. Many of the artist's later works contain a suggestion of infinity.[43] Roads wander off into the silvery distance, or an open patio door is modulated so that the viewer senses that he or she is looking into infinite space through the opening. These works seem to have mystical or transcendental overtones.

The fact that O'Keeffe's paintings have been interpreted in many different ways over the years is in a sense a tribute to the richness of her imagery.[44] In the Freudian era of the 1920s and also in the present period of the new feminist movement, critics have found female genital imagery in some of her softly folding, fleshy forms surrounding a central opening. O'Keeffe vehemently denies that she intended sexual imagery in her work.

In the 1920s she was also labeled a "precisionist"—because, like Charles Sheeler, Charles Demuth, and others, she used a smooth, precise, hard-edged way of simplifying forms to emphasize their abstract qualities. In the 1940s she was called a "surrealist" because of the strange associations of images, as in combinations of skulls and flowers. Again, O'Keeffe denies any interest in the exploration of the subconscious, saying that she was included in a surrealist show before she even became aware of the movement. Yet there is no doubt that her work evokes subconscious and dreamlike associations. In 1946 she was given the first retrospective by a woman artist ever held at the Museum of Modern Art. In the 1960s she was hailed as a forerunner of minimal art and Color Field Painting, because of the way in which she often reduced her compositions to one or two large simple shapes, locked inexorably to the frame in one holistic image. In 1964 she had a major retrospective exhibition at the Art Institute of Chicago.

From the beginning O'Keeffe has used large bold patterns, big clear color areas, and crisp edges. Her most consistent innovation has been her technique of magnifying and framing parts of familiar objects so that they undergo a sea-change. Their customary relationship to their background is destroyed; their usual psychological unity is unseated. Instead, she selects out of an ordinary object—a shell, a flower or a bone—new and startling shapes and colors. To quote art historian Milton Brown:

The microscopic vision basic to O'Keeffe's style causes a 'heightening of reality.' . . . In enlarging the details of some common object it brings to our attention facts which we have never perceived and thus increases our awareness of common things, but at the same time destroys the normal appearance of things, presenting us with startling formal relationships which have all the characteristics of abstractions.[45]

Art historian Barbara Rose views O'Keeffe's work as part of an ongoing stream of American transcendental thought, linked directly with Henry David Thoreau and Ralph Waldo Emerson, who found divinity by looking closely at a leaf or a flower. In O'Keeffe's worship of what she called the "wide and the wonderful" in nature, her dislike of conformity, her resistance to city life, technology, and organized society, and her search for a serenity in nature that will be there when human destructiveness has vanished, she carries forward to the present an early tradition in American life.

O'Keeffe has said that personal courage, a kind of "nerve," is the first requirement for an artist. As if to give life to this dictum, she took a trip down the Colorado River in a rubber raft in her seventies. The self-reliance, independence, and adventurous spirit of Georgia O'Keeffe are a model for all women.

Elsie Driggs (1898–), of Hartford, Connecticut, is best known as a precisionist painter who in the 1920s responded to the clean, abstract beauty of the machine age in geometrically simplified compositions. Her painting *Pittsburgh* (1928), was inspired by a trip to the Jones and Laughlin steel mills, of which she said: "The particles of dust in the air seemed to catch and reflect the light to make a

backdrop of luminous pale gray behind the shapes of simple smoke stack and cone. To me it was Greek."[47] And, in fact, the critics called her series of approximately seven paintings in this mode "a new classicism."

Her romantic feelings about industrial forms were part of the general optimism during the booming prosperity of the twenties. Driggs painted the *Queensborough Bridge* (1927) and several other works in the precisionist mode, but starting in the thirties she turned away from this style.

Driggs studied at the Art Students League (1919–1925) and with Maurice Sterne in Rome. Her work has been shown, among other places, at the Daniel Gallery (1924–1932) and at the Rehn Gallery. She received a Yaddo Foundation fellowship in 1935

and executed murals for the Federal Art Project in the 1930s. She is the widow of artist Lee Gatch.

Gertrude Whitney, Juliana Force, and the Whitney Studio Club

When **Gertrude Vanderbilt Whitney (1875–1942),** heiress to a great family fortune, began to study sculpture in her twenties, her socialite friends winked at one another in tolerant amusement. She surprised them by becoming one of America's distinguished sculptors of public monuments. She also generously promoted an entire generation of young American artists and founded the Whitney Museum of American Art, perhaps the foremost museum devoted exclusively to modern American art.

Fig. 5-14. Elsie Driggs, PITTSBURGH (1927), oil on canvas, 34½″ × 40″

Gertrude Vanderbilt was the fourth child of the railroad magnate Cornelius Vanderbilt II, and great-granddaughter of Commodore Vanderbilt, one of America's first industrial tycoons. She was raised in a luxurious and socially elite environment in Newport, Rhode Island, and New York City, surrounded by the magnificent art collections of her father, a patron of the arts. She was privately tutored and then attended New York's exclusive, all-female Brearley School.

Until her marriage in 1896 to Harry Payne Whitney, the sportsman son of the statesman and financier William Whitney, Gertrude Vanderbilt displayed only a modest skill in watercolor and drawing. The Whitneys divided their time between a large Long Island estate and a Fifth Avenue mansion.

Despite three children and heavy social obligations, Gertrude Whitney started to study sculpture very seriously, first with Hendrik Christian Andersen, then with James Earle Fraser at the Art Students League in New York City, and finally in Paris with Andrew O'Connor. Fraser and O'Connor were capable sculptors of public monuments, who seem to have channeled her interest in the same direction. In Paris she also received private criticism from Auguste Rodin and was greatly influenced by his work. Whitney received a commission for a life-sized figure, *Aspiration,* for the Buffalo Exposition of 1901, and showed a sculpture at the St. Louis World's Fair in 1904. Burdened by her famous name, which she felt would never allow her the freedom of unbiased criticism from her viewers, she exhibited under a pseudonym. Finally, her statue *Paganism Immortal* (1910) won a distinguished rating at the National Academy, and she began to exhibit under her own name.

Whitney was not taken seriously by the art community at first. Nevertheless, she worked very hard to master her craft, feeling the lack of the customary long apprenticeship in the atelier of a senior sculptor. Realizing that she needed a studio away from home, she remodeled an ivy-covered stable on MacDougal Alley in Greenwich Village in 1907. There, for the first time, she began to become integrated into the community of serious young artists.

Whitney became one of the pivotal sponsors of American art. In 1908 the rebellious Eight of the Ash Can group held their landmark show at the Macbeth Gallery. Whitney bought four of the seven works sold at the show. Concerned with the hardships faced by young artists of independent views who were beginning to rise up against the conservative National Academy, she turned over part of her MacDougal Alley studio to them for exhibition space. In 1913 her contribution helped finance the historic Armory Show. She maintained an open mind about new trends, despite the fact that in her own work she continued to create public sculpture in a conservative style.

Whitney's studio became the informal drop-in center where the young generation of New York artists met and talked eagerly about new trends in the art world. Peggy Bacon, in her amusing etching *Frenzied Effort* (1925), shows a group of the "regulars" feverishly engaged in sketching from the nude model at Whitney's place. In 1914 Whitney expanded into the adjoining building and hired an assistant, Juliana Force. Originally a secretary with no particular art training, Force became a talented administrator and ultimately an influence in the shaping of modern American art.

Between 1915 and 1930, Whitney started a series of organizations to encourage young artists by exhibiting and purchasing their work. In 1915 she organized the Friends of the Young Artists. In 1918, with Force's help, the Whitney Studio developed and grew into the Whitney Studio Club and then into the Whitney Studio Galleries, a marketing center for the work of unrecognized talents.

At the Whitney Galleries' annual exhibitions, Gertrude Whitney purchased the award-winning works. In addition, she had been collecting the work of her contemporaries all along. By 1929 her collection had become so comprehensive that she

offered to build a new wing for it at the Metropolitan Museum of Art, with an endowment to maintain it. The Metropolitan Museum director responded by saying, "We don't want any more Americans. We have a cellar full of that kind of painting."[48]

Undaunted, Whitney set up her own museum, with Juliana Force as chief administrator. The Whitney Museum of American Art opened in 1931 on West 8th Street with a display of the work of little-known artists—Edward Hopper, Charles Sheeler, Stuart Davis, John Sloan, William Zorach, Peggy Bacon, and many others now considered American masters. Once an informal intimate establishment based on personal contacts, today the Whitney Museum is a monumental concrete structure on Madison Avenue designed by Marcel Breuer. It is, perhaps, the leading museum of modern American art in the country.

Whitney and Force were wonderful foils for one another. Whitney was reserved and quiet; Force, with red hair and blue eyes, was gregarious, outgoing, opinionated, and dynamic. The latter's apartment above the Whitney Museum, with its swagged drapes and elegant furniture, was the scene of many lively parties attended by the artistic and intellectual community of New York. (At one such affair, Force sat drinking champagne in the bathtub with artist Gerald Kelly.)

Parallel to her activities as a public benefactor, Whitney moved ahead vigorously with her own sculpture, executing more and more important public commissions in her Greenwich Village studio and at a second studio on her Long Island estate—a huge glass-roofed Roman palace set amidst lush grounds inhabited by peacocks, parrots, and macaws. She often worked in her favorite fantasy costume of Turkish harem pants, turban, and turned-up shoes. She also maintained a third studio in Paris, and many of her large sculptures were carried out there.

In 1912 she completed *Aztec Fountain* for the Pan-American Union building in Washington, D.C.

In 1915 her *Fountain of El Dorado,* depicting man's frantic search for gold, won a bronze medal at the Panama-Pacific Exposition in San Francisco. (It was later erected in Lima, Peru.)

In 1914 she competed for and won the $50,000 *Titanic Memorial* (1931) commission, her most important work. This monument is a noble example of Gertrude Whitney's style at its best. Eighteen feet high, carved in granite, atop a six-foot pedestal resting on a wide base,[49] the seminude figure of a man takes the shape of a cross, symbolic of sacrifice and resurrection. This image, "the last inspiration of a departing soul,"[50] appears about to float forward into a spiritual realm. The memorial was dedicated to the fifteen hundred Americans who perished when the Titanic ocean liner struck an iceberg and sank on its maiden voyage in 1912. The luxury ship, thought to be unsinkable, had symbolized the confidence and opulence of America before the first World War. Whitney made many studies for the *Titanic Memorial* (a marble head is at the Whitney Museum), and it was finally completed and installed in Washington, D.C., in 1931.

Whitney's work was deeply affected by World War I. With her usual munificence she funded a hospital at Juilly, France, and directed it herself until 1915. Horrified by direct contact with the bloody realities of war, she moved away from the lofty abstract allegories of her earlier artistic style and, in realistic friezes and sketches, showed the frenzied action of soldiers in battle and the sufferings of the wounded. One of her resulting works, *The Washington Heights War Memorial,* at 168th Street, New York, won the New York Society of Architect's Medal in 1922. Her *World War I Memorial* (1926) for the harbor of St. Nazaire, France, was destroyed by the Germans in World War II. Two other monuments by Whitney are *Columbus Memorial* (1929), which rises 114 feet to dominate the port of Palos in Spain, and a huge bronze equestrian statue of Buffalo Bill Cody (1924)—one of the largest in the world—in Cody, Wyoming.

Fig. 5-15. Gertrude Vanderbilt Whitney, TITANIC MEMORIAL (1931), granite, height 15′

Fig. 5-16. Gertrude Vanderbilt Whitney, HEAD FOR TITANIC MEMORIAL (1924), marble, 12¾″ × 7″ × 9″

Over the years Gertrude Whitney and her husband became estranged. According to her biographers, she led a secret shadow life of romantic liaisons and bohemian adventures in reaction to his philandering.[51] Cruelly wounded and too independent to accept a passive role, she wrote in her diary:

There is only a little while and we are given so many feelings and possibilities. Shall we die without trying all? . . . You [G.W.] are a great personality. You *must* use it. . . . Take it, play with it, use it lovingly and exquisitely play on the strings of it. Play havoc with all other forces. Admit no master. Get away with the things other people struggle alone to look at. . . .[52]

And yet, on a certain level, the Whitneys maintained a kind of solidarity.

In 1932 she published a novel, *Walking in the Dusk,* under the pseudonym of E. J. Webb (still another example of the woman artist-cum-author). In 1934 the newspapers were filled with lurid stories about the court case in which she won the custody of her niece, Gloria Vanderbilt, the "Poor Little Rich Girl" who is today one of America's best-known clothing designers.[53] Whitney's privacy was invaded, and her health was undermined by the continuing sensational publicity during and after the trial. But she was convinced, perhaps mistakenly, that it was her duty to protect the child from neglect. The lawyer opposing her attempted to prove, among other things, that the Whitney Museum was filled with pornographic art.

Three years before her death at sixty-seven, she sculpted *To the Morrow* (also called *The Spirit of Flight*) for the 1939 New York World's Fair. Had Gertrude Whitney's artistic activities been limited to sculpture, she would have a secure place in the history of American art as a conservative sculptor of public monuments. But she went well beyond her personal artistic talents to become perhaps the greatest patron of modern American art in this century, and to found the Whitney Museum, her greatest creation.

Women of the Whitney Studio Club

American women artists who were promoted prominently at the Whitney Studio and the Whitney Studio Club between 1918 and 1930 include Katherine Schmidt, Dorothy Varian, and Dorothea Schwarcz (Greenbaum) (see chapter 6)—all of whom were students together and friends—as well as Molly Luce, Nan Watson, Lucile Blanch, Georgina Klitgaard, and Isabel Whitney. All these women led exciting and artistically productive lives in New York City, and in the art colony of Woodstock, New York, where many of them congregated. An important member of the Whitney group who was also a leading figure in the Woodstock colony was **Peggy Bacon (1895–)**.

Take lightly that which heavy lies;
what all respect, do you despise;
some flippancy your soul may save.
—A goose is walking on your grave—
 "Motto" by Peggy Bacon[54]

Margaret Francis Bacon, known to the world as Peggy, is a kind of twentieth century Honoré Daumier or Pieter Bruegel. Her prints, pastels, and paintings are comments on the foibles of humanity. They combine cutting laughter and warmth toward the human race.

Her parents, Elizabeth Chase and Charles Roswell Bacon, were New York painters who had met as students at the Art Students League. Her father had studied in Paris and painted with the American impressionist Theodore Robinson at Giverny. The Bacons, who moved in the artistic and cultural milieu of the turn of the century, took Peggy to museums and gave her art supplies at a young age, without, however, encouraging any professional aspirations. One summer when the family was on vacation in an art colony—Cornish, New Hampshire—Lucia Fairchild Fuller, the miniature painter, encouraged Peggy to become an artist.

According to Bacon's biographer, Roberta Tarbell, her parents actually wept when she decided to study art, because they were personally acquainted with the hard lives of many artists.

In 1913 her father, despondent because of his lack of patrons and recognition, committed suicide. Despite this shock, Bacon somehow found the strength to continue at the School of Applied Arts for Women and with Jonas Lie's summer landscape class. Lie was very generous and encouraging, and arranged a sale of her work that netted her enough money to study illustration with Howard Giles in 1914 and 1915. Since that time she has illustrated more than sixty books, of which she wrote nineteen, and has always been able to support herself with art, even during the Depression.

In the summers of 1915–1917, Bacon lived in the avant-garde art community of Provincetown, Massachusetts and studied there with Andrew Dasburg and B.J.O. Nordfelt, two modernists. At the Art Students League in New York between 1915 and 1920, she came under the influence of the Ash Can School instructors John Sloan (whom she found "oh so amusing"),[55] George Bellows, and others. Bacon responded to Ash Can urban scene subjects, but was also fully aware of the formalist modern trends coming in from Europe. During visits to New York museums and galleries, she was also moved by the work of Daumier, the great French caricaturist. She herself was already turning to caricature.

The League was not teaching printmaking, but Bacon and Anne Rector, a fellow student, found an old printing press in a corner and began to teach themselves etching. Gradually, drypoint (done by scratching directly on a metal plate with a needle) became her main medium of expression. In madcap drypoints that satirized other students and teachers, Bacon established her stylistic approach while still a student. In *Dance at the League* (1919) and other classroom scenes, she crammed as many real characters as possible into a composition, each a wonderfully funny and penetrating caricature of a recognizable person. Her style was exaggerated, stylized, and expressionistic. She simplified forms geometrically and used strong patterns of stripes and hatching in a manner suggestive of German Expressionism.[56] In 1915, while a student at the League, she wrote her first book, *The True Philosopher and Other Cat Tales* (1919), with thirteen fantasy drypoints as illustrations.

Bacon repeated the romantic pattern of her father and mother. She met Alexander Brook in the lunchroom at the League and married him in 1920. They became part of a gregarious, witty, fun-loving group of young artists living in Woodstock and Greenwich Village during the 1920s and '30s.

After a trip to England in 1920, they settled in Woodstock, a thriving art colony that was at that time a maelstrom of artistic and political ideas. Bacon and Brook soon became part of the radical group of young modern artists. Referred to as the Rock City Rebels (because they lived around Rock City, a mile north of Woodstock), members of the group integrated cubism and abstraction with recognizable subject matter. Bacon now referred to the Ash Can artists as "The Academy" and "Un-Woodstockian."[57] Woodstock, they felt, "would be as famous as Barbizon."[58]

Although somewhat hampered by the care of her two young children, born in 1920 and 1922, Bacon tenaciously continued to work. She abandoned painting, her first love, because she felt outclassed by her husband, a fine painter and colorist who "was very critical of her paintings. Her sense of inadequacy in the face of his natural ability . . . along with the increasing success of her drypoints, probably explains why she did not paint in oil for more than three decades."[59] She turned entirely to satirical etching, lithography, and illustration, using them as surgical instruments with which to probe the life around her.

In 1922 Bacon and Brook had a two-person exhibition at the Joseph Brummer Gallery in New York City that fixed them in the galaxy of important

young artists. By 1923 they moved to New York City and were in the center of artistic activity there. Brook was assistant director, under Juliana Force, of the Whitney Studio Club and wrote for art magazines, while Bacon illustrated children's books and created small pen-and-ink drawings to accompany her poems. Her etching *The Social Graces* (1935), shows a lively party given by Juliana Force at her apartment, with various notables in the art world, including the ebullient Force dancing in a mood of happy sophistication. Bacon also contributed satirical drawings to the *New Masses*, the most impor-

tant Marxist magazine of the twenties, but she was not truly political in her art—rather, she crucified various forms of grossness, stupidity, and pomposity.

At their summer home near the art colony of Croton, New York, Bacon and Brook shared an urbane social life with their artistic friends. Bacon's *A Few Ideas* (1927) is an etching of the cocktail hour at George Biddle's house—a world of bright, zany people, cats, dogs, and martinis. One can almost hear the sarcasm and "debunking" à la H. L. Mencken, as the Biddles, Yasuo Kuniyoshi and his

Fig. 5-17. Peggy Bacon, A FEW IDEAS (1927), drypoint etching, 8″ × 9″

wife Katherine Schmidt, John Carroll, and Jules Pascin gathered in one room.

In the late 1920s and 1930s Bacon executed a series of powerful pastel caricature studies. When seven of these were shown at Stieglitz's Intimate Gallery, Charles Demuth wrote that they would stand up against the work of Lucas Cranach, Pieter Bruegel, and Toshinsai Sharaku. On a 1934 Guggenheim Foundation Fellowship, she completed a book, *Off With Their Heads!,* which consisted of thirty-nine ruthless black-and-white caricature portraits of famous critics, artists, and other notables, accompanied by written vignettes. These studies were based on firsthand acquaintance with Georgia O'Keeffe, Heywood Broun, the art critic Henry McBride, and others.

She was besieged by magazines commissioning her to do caricatures, but after a while this work became too painful for her. People were enraged or cruelly wounded by her unforgettable noses or mouths, intensified, as she said, "to the point of absurdity" to make "a clairvoyant comment upon the subject's peculiarities."[60] As a result, Bacon turned to genre scenes of Manhattan and of life at the summer colonies in Ogunquit, Maine, and Provincetown.

In 1940 Bacon and Brook were divorced. Bacon taught at colleges and enjoyed the experience of being vice-president of the National Institute of Arts and Letters in 1960 and 1962. She illustrated over twenty books in the 1950s and 1960s and wrote a mystery novel, *The Inward Eye* (1953), for which she was awarded the Edgar Allan Poe Mystery Award for best novel of the year by the Mystery Writers of America.

After a long hiatus, Bacon began to paint again in the 1950s. Into her mid-eighties (until her recent illness) she lived in a little wooden house over a beautiful cove at Cape Porpoise, Maine, near her son Alexander, a newspaper publisher. Despite failing eyesight, with the aid of a magnifying glass on her drawing board, she developed a very personal mixed-media technique, using intricate lines over washes of color.

Elements of fantasy still crept in—eyes peer through the windows of old Victorian houses; spooky and surreal vegetation grows in elfin forests. But the general mood of the paintings, containing a solitary figure trimming the bushes or mowing the lawn, is that of quiet, contemplative New England small-town life.

Graphic Artists
(not in the Whitney Studio Club)

Two other exceptional graphic artists in this period are: **Wanda Gag (1893–1946),** whose illustrations, woodcuts, and lithographs raised the medium to a high level (they were shown at the Weyhe Gallery and elsewhere); and **Clare Leighton (1901–),** an Englishwoman who settled permanently in the United States in 1939. She designs exquisite wood engravings.

Two Independents

Florine Stettheimer (1871–1944) has been called a "rococo subversive"[61] because of the subtle social satire hidden in her deceptively wispy fantasy paintings. Her deliberately naive compositions have been described as "camp"[62] by art historian Linda Nochlin. They convey a wry, witty view of such diverse Americana as Wall Street and weddings, beauty contests and high fashion, and even the museum establishment itself.

Stettheimer was born in Rochester, New York, the fourth of five children of a prominent German Jewish banking family. Their father left the home when the children were small. The eldest daughter and son married, but the three youngest daughters, Florine, Carrie, and Ettie, became extremely close with their mother and with each other. Never marrying, they chose instead to pursue a life of arts, letters, and upper-class bohemianism.

Ettie wrote two novels under the pen name of Henry Waste, after obtaining a doctorate in philosophy at the University of Freiburg.[63] Carrie spent twenty-five years on a unique doll house containing a tiny art gallery hung with miniature replicas of works by modern masters, all painted by the artists themselves—Marcel Duchamp, Gaston Lachaise, Alexander Archipenko, and Elie Nadelman. It is now at the Museum of the City of New York.

In the 1890s Florine Stettheimer studied painting at New York's Art Students League and then in Munich, Berlin, and Stuttgart. Her early work shows that she was an accomplished draftswoman; her later stance was a deeply rebellious rejection of traditional modes of drawing and design, for new expressive purposes.

Between 1906 and 1914 the three Stettheimer sisters and their mother traveled abroad where they could live inexpensively in an epicurean manner. But World War I forced them to return to New York. In their elegant apartment at Alwyn Court on 58th Street, they created a salon that attracted such brilliant figures as Marcel Duchamp, Georgia O'Keeffe, and Gaston Lachaise, authors Sherwood Anderson, H. L. Mencken, and Carl Van Vechten, and art critics Leo Stein and Henry McBride. The unconventional "Stetties," as they were called, combined exquisite food, Victorian high propriety, out-of-date, harem-skirted attire, and off-beat wit—an irresistible combination to upper-echelon bohemia.

Celebrities joined them at their summer place, André Brook. In her painting of a different vacation spot, *Lake Placid* (1919), Stettheimer shows her coterie swimming and diving while her mother views them all from a nearby deck in her customary long, dark, formal attire.

Stettheimer's first and only one-woman show during her lifetime, at Knoedler's in 1916, was a humiliating fiasco. She had draped the walls of the gallery, with her customary flair, in delicate white muslin, and crowned the decor with a copy of her white-and-gold bed canopy. No purchasers appeared, and critics ignored this early "feminist" environment, which was sixty years ahead of its time. Stettheimer was wounded and drew inward, exhibiting only occasionally at such group shows as the large unjuried annuals of the Society of Independent Artists.

After their mother's death in 1937 the Stettheimer sisters took separate apartments. Florine moved to a luxurious duplex at the Beaux Arts Studios on New York's Bryant Park, and decorated it with cellophane curtains and flowers, white furniture carrying her initials, and a baroque boudoir of lace with a canopied bed. In this setting she continued the Stettheimer Salon.

In 1934 critics acclaimed the sets and costumes Stettheimer had designed for the Gertrude Stein–Virgil Thompson avant-garde opera, *Four Saints in Three Acts*. Concocted out of cellophane, crystals, feathers, lace, and seashells, and using strange shrill high key colors, these sets revealed her talent once again to the art world. Since the time of her humiliation at Knoedler's eighteen years before, Stettheimer had been privately forging a personal style. In her paintings she used wispy, androgynous figures drawn in a mock-naive manner, in various fantastic-symbolic settings. A series of four pseudo-baroque works, the *Cathedrals of New York*, glorify and at the same time satirize her favorite city. The *Cathedrals of Broadway* (1929), the *Cathedrals of Fifth Avenue* (1931), the *Cathedrals of Wall Street* (1939), and the *Cathedrals of Art* (1942, unfinished) all belong to the Metropolitan Museum of Art.

In the *Cathedrals of Fifth Avenue*, for example, Stettheimer satirizes the hoopla of a fashionable wedding—flags are waving, mounted police keep back the crowds, and photographers snap pictures of the newly married couple exiting on a red carpet from St. Patrick's cathedral. Meanwhile, a Rolls Royce with a dollar sign on its grill (simultaneously the F. Stettheimer initials) is pulled up to the en-

Fig. 5-18. Florine Stettheimer, THE CATHEDRALS
OF FIFTH AVENUE (1931), oil on canvas, 60″ × 50″

trance, containing the Stettheimer sisters, charmed witnesses to the scene. The word "Tiffany's" is blazing in precious jewels in the sky, along with the eagle and the American flag. Fathers of the church reach down from heaven to give their blessing to this quasi-commercial marriage à la mode.

Spring Sale at Bendel's (1922) contains subject matter previously excluded from the male-dominated art world. Elegantly dressed women snatch at garments on counters and racks in the rococo interior of a high-fashion department store, while the black-suited figure of the male buyer, amidst this pink and magenta world, looks on like a disdainful maestro from a staircase. Stettheimer's attitude toward the scene is not the sort of heavy-handed satire one might expect. The artist sees the crass and bizarre aspect of the scene, while delighting in the color, excitement, and joy of the female world.

Stettheimer also shows her admiration for black jazz and black culture in pictures like *Asbury Park South* (1920), a study of a segregated New Jersey beach. She shared her good friend Carl Van Vechten's passionate interest in the Harlem Renaissance.

After her early bruising experience, Stettheimer never exposed herself in another one-woman show, but chose instead to have private "unveilings" of her works. Meanwhile, her reputation as a cult figure grew among the cognoscenti. Stettheimer had melodramatically announced periodically that she was going to have her hundred paintings buried with her in a mausoleum after her death. But she willed them instead to her sister Ettie, who placed them carefully in museums. In 1946 a posthumous memorial exhibition was held at the Museum of Modern Art. Her book of poetry *Crystal Flowers* was published in 1949. The art gallery at Columbia University featured her work in 1973, and a 1980 retrospective at Vassar College added still further to Stettheimer's growing reputation.

Beatrice Romaine Goddard Brooks (1874–1970) has been called the "thief of souls"[64] because her haunting portraits "steal" the personalities of her *haut monde* subjects. Her art rose on the ashes of a ghastly childhood, which she wrote about in unpublished memoirs, *No Pleasant Memories.*[65] She spent her early years with her mother, whom she saw as a kind of terrifying ringmaster hysterically cracking a whip, and her pitiful but menacing, insane older brother. So pervasive were her fearful feelings that she still said in her eighties, "My mother stands between me and life."[66] This phrase was used by Meryle Secrest for the title of her biography of Brooks, *Between Me and Life* (1974).

Brooks's mother, Ella Waterman Goddard, was a rich, unbalanced woman—a believer in the occult who talked about her "demon of destruction"[67] and had inherited a Pennsylvania coalmining fortune. Her oldest child, a fragile blonde boy named St. Mar, was sickly and strange from his earliest years, and went slowly mad between the ages of seven and sixteen. Ella Goddard focused her love and energy on him, traveling restlessly about Europe in search of a cure, all the while pretending he was normal and including him in the bizarre peregrinations of the family.

Romaine Goddard was born in a hotel in Rome during one of these odysseys. Her father, Major Harry Goddard, perhaps repelled by the mother's insistence on organizing family activities around St. Mar, left them soon after and played virtually no role in his daughter's life. Because she could manage her brother better than any one else, Romaine was made his constant caretaker. This was a frightening role, especially as the boy grew older and his obsessions took on sexual overtones. Her mother's reaction to her was unpredictable and could turn vicious, as she hissed, "I will break your spirits . . ."[68] or accused her of having "devil's eyes."[69]

When Goddard was seven, her mother went abroad and left her with Mrs. Hickey, the family washerwoman, who lived on the top floor of a Third Avenue tenement in New York. Romaine found her existence in the squalid slum peaceful compared to the nightmarish life with her mother and brother. Mrs. Hickey permitted her to indulge her favorite activity—drawing—and gave her a dresser drawer for her art supplies. It was in this unlikely setting that her talent first took root. Her grandfather finally retrieved her and sent her to St. Catharine's Hall, an Episcopal school in New Jersey. During the next four, relatively calm years, she succeeded in making some kind of personal integration.

At age twelve she rejoined her mother and brother in their inceasing round of travel, occultism, and madness. St. Mar's paranoia could be dangerous—one night at dinner, imagining persecuting demons, he threw a knife, which nearly hit his sister. In northern Italy, her mother put her into a convent, expecting her to become a nun, but it became apparent that Romaine had somehow managed to develop a tough inner core. She quietly resisted the authorities, refused to kiss the ivory crucifix, and was caught drawing cartoons of the priest. The sisters finally decided that Goddard's destiny did not lie in the church.

After she left the convent, her mother sent her to Geneva to attend the kind of finishing school that prepares young women for marriage to rich men. For a time, elegant taffeta dresses replaced the long green stockings that had made the young girl weep at the convent. Finally, at age twenty-one, after a brief period of professional singing, she prevailed successfully upon her estranged mother, through the family lawyer, for a stipend of three hundred francs a month.

Independent for the first time, she began to study art in Rome. She was the only woman student at the Scuola Nazionale during the day and the Circolo Artistico in the evening. Because she dared to draw from the nude model, she was subjected to lewd approaches from fellow students, who left obscene pictures on her work bench. Meryl Secrest's biography indicates that Romaine—beautiful, but alone and vulnerable in Italy—was deserted by an Englishman she loved and may have had other bruising experiences in which men took advantage of her.

In 1899 Goddard left Rome and took a studio in an abandoned chapel on the beautiful island of Capri. Experiencing the first real joy she had ever known, she began to paint seriously and became part of the unconventional colony of artistic, intellectual, and occasionally homosexual refugees from Victorian society, who made Capri their base at that time. Norman Douglas, in *South Wind* (1917), has described this group, which included Somerset Maugham, Axel Munthe, and Compton Mackenzie. Goddard received her first portrait commission at this time.

This idyll was abruptly interrupted when she was summoned to Nice. Her brother had died, and her distraught mother was trying in vain to bring him back from the grave through séances and the intervention of a spiritualist. Her mother died soon after, and Goddard was visited for years by repeated hallucinations. She never completely rid herself of the sense of being haunted by her mother's irrational hatred, but she did inherit her mother's fortune.

Hoping for greater freedom as a married woman, she entered into a marriage of convenience with John Ellingham Brooks, who has been described as "a homosexual dilettante from Capri."[70] When he began to talk about "our money,"[71] suggest that she rearrange her will, and attempt to constrain her freedom of action, she fled to England, vowing never to become anyone's meal ticket and domestic servant. Brooks pursued her, but she sent him back to Capri, buying him off with an allowance of

three hundred pounds a year.

For the first time Romaine Brooks was in command of her life, her money, and her art. She opened a studio in London on the same block where Whistler had painted, and in 1904 she traveled to St. Ives in Cornwall. There, in a small studio looking out at the sea, she painstakingly learned to create paintings in which the nuances of gray were so refined they could barely be distinguished. This became her personal style. *The Charwoman* (1904) and *Maggie* (1904) are two paintings from this period.

Having established a strong personal identity through her work, Brooks moved to Paris, and began to circulate in the *haut monde* of the French artistic, literary, social and homosexual elite. She adopted a severe and mannish style of dress—dark suit, collar, and tie, and short hair—and created a stir with her black, white, and gray apartment decor. She was much sought after for interior decorating jobs as well as for portraits.

In 1910 her one-woman show at the Durand-Ruel Gallery was very well received. Claude Roger-Marx wrote in the catalogue introduction that she had a "gift of cold irony."[72] In this active and successful period she created a succession of portraits of people with whom she had intense relationships. Among them was Gabriele D'Annunzio, the flamboyant Italian nationalist, author, and womanizer (later supporter of Mussolini), who was in Paris fleeing from bad debts and former mistresses. Brooks was briefly infatuated with him and became his longtime friend and admirer.

Ida Rubinstein, the sensational mime and ballerina of the Ballet Russe, inspired several of Brooks's paintings—nudes of an emaciated elegance characteristic of turn-of-the-century symbolist paintings. She also painted the beautifully fragile Rubinstein in costume, capturing the floating grace of her movements.

In 1915 Brooks met Natalie Clifford Barney, the woman with whom she had an intense, forty-year relationship—undoubtedly, the major love of her life. Like Brooks, Barney was a wealthy, cultivated expatriate and the daughter of an artist, Alice Pike Barney.[73] Natalie Barney was famous for her essays in elegant French prose, her open lesbianism, and her salon on the Rue Jacob, which was attended by Rainer Maria Rilke, Marcel Proust, Paul Valéry, Colette, Guillaume Apollinaire, and others.

Barney was a strong, independent woman who lived by her own rules and was called "the wild girl from Cincinnati" and "The Amazon." In a characteristic aphorism she said, "I have perhaps gotten more out of life than it actually possesses."[74] Barney's books deal with the ideal of androgyny—a world in which sexual differences and antipathies are eliminated. In a painting called *The Amazon* (1920), Brooks shows Barney with a small image of a horse (the latter was an avid horsewoman), as a symbol of her free spirit.

In her 1923 self-portrait, Brooks shows herself in a dignified vertical format, as a lonely figure, whose dark-eyed face is shadowed under a mannish top hat, standing against a landscape of ruins. She is the *lapidé*, the stoned outcast of society, asserting the strength to survive.

In 1924 Brooks painted a harsh, powerful portrait of Lady Una Troubridge, companion of Radclyffe Hall, the author of the famous lesbian novel *Well of Loneliness* (1928). Lady Troubridge is savagely presented wearing a tuxedo and a monocle, accompanied by two dachshunds. The diagonals in this portrait, starting with the twisted diagonal of the mouth, are echoed in the tilt of shoulders, dogs, and even in a few diagonal brushstrokes in the background. A tense, taut quality, an almost whip-like movement is achieved.

Brooks's career reached its peak in 1925 with exhibitions in Paris, London, and at Wildenstein Galleries in New York. The London exhibition was staged in a gala manner by her friend, the Baroness Émile D'Erlanger, an important society leader and interior decorator, shown in her painting as a powerful Valkyrie figure with a tamed ocelot (supposedly her husband) standing in front of its cage.

Fig. 5-19. Romaine Brooks, SELF PORTRAIT (1923), oil on canvas, 117.5 × 68.3 cm

In the 1930s, during an illness, Brooks began to write her haunted memoirs, *No Pleasant Memories.* Also she started to make surrealist drawings, which the artist Edouard MacAvoy has called "messages which come from the depths of the night."[75] Drawn in one continuous line, without conscious premeditation, they show the fears that haunted her subconscious world. In *Mother Nature* (c. 1930) she shows a universe in which babies are being devoured by sharks; in another she is being wrapped in a mummy-like shroud. These drawings are signed with a wing held down by a chain.

In the 1940s Brooks began to feel isolated and neglected. Surrealism and the modern abstract movement were in full sway. She became reclusive, increasingly refusing to subject herself to the real or imagined back-biting of society and the judgment of critics. During World War II, Brooks and Barney chose to live near Florence, in the Villa Gaia in Fiesole. Her friendship with Barney became complicated, stormy, and bitter in later years. She died at the age of ninety-eight in a darkened apartment in Nice, attended primarily by her chauffeur and servants, largely forgotten by the public.

After a brief period, principally during the 1920s, in which her work had been widely acclaimed, Brooks remained out of the public eye for almost forty years. Barney, who had continued to believe in her genius, had encouraged her to contribute a large number of paintings and drawings to the National Collection of Fine Arts in Washington. In 1971, recognizing Brooks's unique and forgotten gifts, the National Collection staged an important retrospective exhibition, accompanied by Adelyn Breeskin's catalogue *Romaine Brooks, Thief of Souls.*

Brooks's work is often described as Whistlerian. It is true that Charles Freer, the great collector of Oriental art, had introduced her to Whistler's work, and there is no doubt that Brooks's painting owes a debt to symbolism and to Whistler's subtle tonalities. Yet her work has an entirely different content and quality. Her ruthless honesty, which made her sitters plead with her not to exhibit their portraits, cannot simply be placed in the same category with the refined aestheticism of Whistler and his school. Brooks's early study of a nude, *The White Azaleas* (1910), is reminiscent of Whistler, but the figure is small and vulnerable, while the Japonaiserie of a vase of white flowers is huge. Her compositions are closely related to the emotional content of the work, often using bars and cages. The chilly Whistlerian color schemes are more than an aesthetic ploy—they express a pervasive grimness of soul.

Her female nudes, described as "icily erotic"[76] or imitative of the symbolist emaciated ideal, have poignant aspects as well. In *Weeping Venus* (1916–18), the figure is shown lying before a barred background suggestive of a cage or prison cell. Interest-

ingly, Brooks's lover Natalie Barney wrote a poem called *Weeping Venus,* in which she speaks of the sorrow of women in whom love is tied to child-bearing.[77]

In Brooks's paintings, sensitive brushwork and occasional flashes of brilliant color are so hidden in a muted scheme that they are almost lost in photographic reproduction. Yet with these subtle means the artist created a body of independent and daring art.

Some "Second Generation" Impressionists, 1900–1929

Impressionism—once a radical style—was now the most popular kind of painting. Listed below are a few of the many excellent women painters who recorded, in dabs of bright color, the light-filled American landscape from Maine to California. Many of them won prizes at the 1915 Panama-Pacific Exposition, where impressionism reached a high water mark in the United States.

Euphemia Charlton Fortune (1885–1960), of Carmel, was considered one of the new generation of California artists. She studied in London and at the Art Students League and in 1915 won a silver medal at the Panama-Pacific Exposition. Art historian Richard J. Boyle has observed that she really went beyond impressionism into a kind of post-impressionism, with a very idiosyncratic style in which she "used the bright palette and broken brushwork more for expressive than for impressionist purposes. The loose, casual construction" of such works as *Summer Landscape* (1914) seems to "prefigure the work of Richard Diebenkorn and the modern California painters."[78] She influenced the Oakland Society of Six, a group that introduced modernism and fauvism into the San Francisco Bay area.

Fortune, a devout Catholic, in 1928 founded the Montery Guild, dedicated to a revival of ecclesias-

tical art. With nine other artists and craftspersons, she decorated over thirty churches across the country and received a gold medal from Pope Pius XII in 1952 for a twenty-five-foot mosaic in the Cathedral of the Immaculate Conception, Kansas City, Missouri. It was called "the greatest single artistic achievement of Catholic America."

Other Impressionists

Three women who also won silver medals at the Panama-Pacific Exposition were Bostonians Gretchen Rogers and Gertrude Fiske (1878–1969), a founder of the Guild of Boston Artists and the first woman on the Massachusetts State Art Commission; and Mary Curtis Richardson (1848–1931) of San Francisco.

Mabel M. Woodward (1877–1945) and Nancy Jones Love (1877–), Providence impressionist, were both teachers at the Rhode Island School of Design. A well-known Philadelphia impressionists was Martha Walter (1875–1976), prolific painter of colorful, light-hearted beach scenes and landscapes. Harriet Randall Lumis (1870–1953), of Springfield, Massachusetts, has recently been rediscovered and given an exhibition at the Springfield Museum of Art.

Anna A. Hills (1882–1930), of Laguna Beach, was a leading member of the so-called California "Eucalyptus School."

Women and American Art Colonies

The explosion of work by women painters was accelerated by the proliferation of art colonies and art schools, which sprang up in America at beautiful resort locations. Women artists played a large role in these communities and flourished at the open art exhibitions organized by the local art associations, where they were not at the mercy of the biases of chauvinistic male jurors.

Woodstock, New York, and Provincetown, Massachusetts, were prominent, but there were many others, among them Gloucester, Massachusetts; Ogunquit, Maine; and Laguna Beach, California. One of the most important—a paradigm for others—was the Taos art colony in New Mexico. Here D. H. Lawrence and his wife Frieda came in search of romantic primitivism. Heiress Mabel Dodge Luhan transferred her famous Greenwich Village salon to the Southwest, married a Native American from the Taos pueblo, and entertained her guests with Indian dances in her adobe palace.

The Honorable Dorothy Eugenie Brett (1883– 1977) became an expressionist painter of the Taos Indians. Born to a conventional, wealthy, and titled London family, she overcame its objections and attended London's Slade School of Art (1910–1917). On a visit to Taos in 1924 she was enchanted by its beauty and remained there. Like her friend D. H. Lawrence, she was drawn to the poetic mysticism of the Buffalo Dance and other rituals, and attempted to capture their spirit in free, brilliantly colored paintings. In 1929 she invited Georgia O'Keeffe to join her in Taos, an offer that resulted in O'Keeffe's move to the Southwest.

Some other women artists of the Taos and Santa Fe colony are Olive Rush (1873–1966), Mary Greene Blumenschein (?–1958), Blanche Grant (1874–1948), Gina Knee (1898–), Bettina Steinke (1913–), Gene Kloss, (1903–), Helen Greene Blumenschein (1909–), Eugenie Shonnard (1886–1978), and Catherine Carter Critcher (1868–1964) (the only woman in the Taos Society of Artists).

Sculpture, 1900–1929

The outpouring of monumental conservative sculpture by American women reached a peak at the 1915 Panama-Pacific Exposition in San Francisco. While the earthquakes of the modern movement were shaking the ground under the traditional National Sculpture Society, its members ignored the tremors and commissioned public monuments in the grand style of the late nineteenth century. Among the many imposing sculptures by women were: Gertrude Vanderbilt Whitney's large fountain (three male nudes supporting a bowl of grapevines in the foyer of the Palace of Fine Arts) and her *Fountain of El Dorado,* flanked by friezes with more than forty figures; Evelyn Beatrice Longman's *Fountain of Ceres,* showing the goddess of agriculture on a pedestal carved with reliefs of dancing Greek maidens; Edith Woodman Burroughs's *Fountain of Youth,* a nude girl flanked by relief panels; Harriet W. Frishmuth's *Girl With the Dolphin;* and nine works by Janet Scudder.

The demand for large public monuments, however, was shrinking. The horrors of World War I and the onset of the new industrial society had produced a mood of profound skepticism and cynicism. An often-cited example of the changing attitude of the public is the Victory Arch, erected in temporary materials in 1919 in Madison Square, New York, for the parade of soldiers returning from World War I. This monument, executed by several famous sculptors, including Gertrude Vanderbilt Whitney and Gaston Lachaise, never received enough public support to be translated into stone.

Sculptors began to turn inward to more personal, private expressions, creating smaller works for private collectors. Many sculptors began to use the animal motif and garden sculptures as vehicles for exploring different kinds of formal and emotional statements. There was also a trend toward direct carving in stone and wood—allowing the shape and grain of the material to influence the form. Before this time, sculptors had hired craftsmen to carve their work from clay or plaster models. The influence of primitive art, cubism, and expressionism began to be felt, and some sculptors

began to move toward simplification, stylization, and abstraction in their work.

Traditional Sculptors

Anna Vaughn Hyatt Huntington (1876–1973) was one of America's greatest sculptors of animals. Her heroic equestrian statues adorn Balboa Park in San Diego, Riverside Drive in New York, and many other public sites. Her works are always described in such terms as "virile" and "powerful," belying the stereotype of weakness and timidity in the work of women artists.

Anna Vaughn Hyatt was born in Cambridge, Massachusetts, the child of Aduella Beebe and Alpheus Hyatt, a prominent paleontologist. Like her father, she had a lifelong interest in animals and became an expert in animal anatomy and behavior. Her interest in animals developed at a very young age during summers on a family farm in Maryland. Searching for her once at dinnertime, her family found her lying in a field, nose to nose with a horse, watching the action of its jaw muscles as it chewed on a cud of grass. Later, as a student, she spent long hours drawing and modeling at the New York Zoological Park.

Hyatt was at first an accomplished violinist, while her older sister Harriet Hyatt (Mayor) studied sculpture. According to *Biographical Sketches of American Artists* (1924), it was during a period of nervous exhaustion at age nineteen that she turned to clay for recreation. She helped her sister model a dog and found that she enjoyed sculpture.

Like her sister, she studied with sculptor Henry Hudson Kitson of Boston and at the age of twenty-four exhibited forty animal sculptures at her first one-woman exhibition, at the Boston Arts Club. This large number of works was a harbinger of a career marked by prodigious productivity.

She studied for a short time at the Art Students League in New York City with Hermon MacNeil and received private instruction from Gutzon Borglum. At the Art Students League she became friends with Abastenia St. Leger Eberle, sharing a studio and collaborating for two years with her on large works, for which Hyatt modeled the animals and Eberle did the figures. In 1904 their joint sculpture *Men and Bull* won a bronze medal in St. Louis. The two young women both became important American sculptors, but went in different directions. Eberle turned to small genre scenes of city life, in Ash Can style, while Huntington in later years carried out large traditional equestrian and animal sculptures.

In 1907 Anna Hyatt modeled several of her magnificent jaguars at Auvers-sur-Oise, France, and in 1908 finished a colossal lion in Italy for Dayton, Ohio. In 1909 she put aside all commissions and devoted herself entirely to the creation of a full-sized equestrian statue of Joan of Arc.

The theme of the militant saint haunted her, and she spent time in Orléans and Rouen immersing herself in the spirit of her subject. She rented the studio of Jules Dalou (a nineteenth-century sculptor) in the Latin Quarter of Paris, with doors that made it possible for her to bring a horse into the studio to serve as a model for the saint's steed. Here, with one woman assistant, she massed a ton of clay, built a huge armature, and devoted herself entirely to the task. Typically, Hyatt went to extreme lengths to model the armor correctly from studies of ancient fragments and tomb-tracings.

A plaster cast of the complete *Joan of Arc* won an honorable mention at the Paris Salon of 1910. Hyatt was commissioned in 1914 to execute it in bronze for Riverside Drive, New York. Replicas have subsequently been erected in the city of Blois, France; in Gloucester, Massachusetts; and in front of the California Palace of the Legion of Honor in San Francisco. For this work, considered one of the finest equestrian monuments in the world, the government of France made her a chevalier of the Legion of Honor. The equestrian *Joan of Arc* shows the saint before her first battle at Orléans rising in her stirrups on her horse, gazing at the cross-shaped sword which she holds outstretched before her.

Fig. 5-20. Anna Hyatt Huntington, EL CID CAMPEADOR (1927), bronze, 176¾″ × 74″ × 139⅜″

Hyatt won many awards, among them the Saltus Medal for *Diana of the Chase* (1922), the Shaw Prize for *Bulls Fighting* (1928), and the Pennsylvania Academy gold medal for *Greyhounds Playing* (1936). In 1928, at the age of forty-seven, she married Archer Milton Huntington, a poet and philanthropist. Returning from their honeymoon in the West Indies aboard their yacht *Rosinante,* they stopped at a harbor on the South Carolina coast and were delighted with the beauty of the area. They bought a 6,635 acre tract of land there, and in 1931 founded Brookgreen Gardens on it, near Charleston. Orginally intended to be an outdoor nature setting for Anna Huntington's works, the estate blossomed into an outdoor museum containing the works of traditional American sculptors, including many women.

Sharing her husband's passion for Spanish culture, Anna Huntington next entered her "Spanish phase." An equestrian statue of the great Spanish military hero El Cid was completed in Seville in 1927, and replicas were erected on the grounds of the Hispanic Society of America in New York and in several other cities. Three of her works stand in Balboa Park, San Diego, in one of America's most romantic plazas. This space, ringed by ornamental Spanish buildings that remain from an earlier exposition, has as its dramatic focal point her *El Cid* placed before the entrance to the big concert shell. On the other side of the large square, in front of the San Diego Fine Arts Museum, two other bronzes, *Young Diana* (1924) and *Youth Taming the Wild* (1927), complete a triangle of her works.

Huntington's sculptures are sometimes considered part of the "heavy handed academic statues of the official sculptors."[79] A contrary view is that they belong to a post-1900 school of animal and garden sculpture that serves as a bridge between the earlier grandiose public monuments and the later modern movement.[80]

In the early twentieth century, sculptors began to move away from public commissions expressive of patriotism and civic virtue. One of the first symptoms of this trend was a flood of sculptures in which animals were used as a kind of metaphor for personal feelings and expressions of mood and attitude. "Animals have many moods, and to represent them is my joy,"[81] said Anna Huntington.

These works, smaller and more suitable for purchase by private collectors, show different experimental approaches, ranging from the primitivistic direct carvings of William Zorach to the powerful, but relatively academic approach of Huntington. They gave sculptors the opportunity to explore private and personal views of life and new concepts of form. Huntington carried out many public monuments that continued the European Beaux-Arts tradition, but her rhythmic expressive animal groups are also part of the new thrust in American sculpture.

In 1939 the Huntingtons moved to their large estate, Stanerigg Farm, in Redding Ridge, Connecticut, and donated their Fifth Avenue mansion to the National Academy of Design.[82] On a plateau above Long Island Sound, amidst her Scottish deerhounds and other animals, Anna Huntington lived and worked for the rest of her life. The couple held Sunday teas for scholars and intellectuals, at which Archer Huntington could be found reciting lines from the Koran or Spanish poetry while Anna discussed science or art with their guests.

Working vigorously into her last years, Huntington won a special medal of honor from the National Sculpture Society for her achievements and her aid to fellow sculptors. She was selected as "Woman of the Americas" in 1958 by the Union de Mujeres Americanas and received honorary degrees from Syracuse University and the University of South Carolina. She died at Stanerigg Farm at age ninety-eight, leaving works in progress.

Malvina Hoffman (1887–1966) created 105 large bronzes called *The Races of Man* (1933) for the Hall of Man at the Field Museum in Chicago. This huge sculptural display reveals the beauty, dignity, and worth of people from all ethnic backgrounds. *The Races of Man* is only one part of her total oeuvre. One must turn back to Renaissance or baroque times to find sculptural achievements of comparable magnitude to those of Malvina Hoffman.

Hoffman's personal strength and courage were nurtured in the artistic and supportive environment in which she grew up. Her father, fifty years older than she, but close in spirit, was a pianist with the New York Philharmonic. Their home on 43d Street in New York was always full of friends who came to play, accompany, and listen to music. From both parents she received interest and support in her career. Shortly before his death, her father told her, "I am seventy-eight years old and can leave you very little of this world's earthly goods, but if I can leave you my ideals, perhaps they will be worth more to you than anything else."[83]

Fig. 5-21. Malvina Hofmann, SENEGALESE SOLDIER (1928), black stone, height 20^{1}/$_{16}$"

Hoffman was already studying art at the Women's School of Applied Design and at the Art Students League in her teens, while attending the Brearley School (an exclusive girls school in New York, also attended by Gertrude Vanderbilt Whitney). Soon discovering that sculpture, not painting, was her medium, she began to study with Herbert Adams, George Grey Barnard, and Gutzon Borglum.

Her father's death in 1909 left the family impoverished, and Hoffman worked incessantly at her craft, desperate to make a living and driven by "haunting memories of long vigils by sickbeds."[84] Her first important work was a portrait carved in marble—a bust of her father. This first effort was accepted by the National Academy of Design for its annual exhibition.

Hoffman had become familiar with Auguste Rodin's work in the home of a New York collector, Mrs. John Simpson. Securing a letter of introduction to Rodin from Simpson, Hoffman and her widowed mother sailed for France in 1910 with a small amount of money they had managed to save.

At first Rodin refused to see her. In her autobiography *Heads and Tales* (1936) Hoffman describes her strategy for gaining admission to his studio. She came to the door three times with her letter of introduction, but on Rodin's order the housekeeper turned her away. Finally, insisting that she had come all the way across the Atlantic to see him and was not going to leave, she sat down outside his door and refused to move.

At last Rodin gave the order to admit her, but he barely acknowledged her presence. He was showing a group of frock-coated officials around the studio and left her standing in the corner while he talked to them about his work. As part of his explanation of a sculpture, he began to recite a French poem, but forgot it halfway through. Hoffman broke into the conversation and completed the poem in French, finally impressing upon him that she was not just another American dilettante. He had to

leave, but asked her to wait for him, and then absent-mindedly locked her in his studio. She stayed there, trapped, hungry, and cold, for the rest of the day, sustained only by the rapture of examining the master's work.

Hoffman became a favorite pupil and friend of Rodin between 1910 and 1914. During this period, at his suggestion, she went to New York to master anatomy in Dr. George Huntington's dissection classes at the College of Physicians and Surgeons. When she returned to Paris, her supportive mother relieved her of all household burdens, and Hoffman worked in her own studio, taking night classes at the Colarossi Academy and receiving searching criticism from Rodin at his studio once a week. At this point she became sharply aware of how handicapped she was as a woman in the field of sculpture, with no long historical tradition of accomplishment on which to build. (Feminist art historians have since relieved this situation somewhat by uncovering the buried treasure of women artists.) Ivan Mestrovic, the great Yugoslavian sculptor, advised her to overcome this disadvantage by becoming a better technician than the men.

She learned to rebuild tools, bend iron, saw wood, and work with plumbing pipes. She learned how to chase and finish bronzes, and haunted the bronze foundry, studying the stages by which the craftsmen cast and finished the work. She worked so hard that she collapsed at one point and was sent to the country to rest.

In Paris Hoffman met Gertrude Stein, Matisse, Romaine Brooks, Frederick MacMonnies, and Mabel Dodge. Most important of all, she was introduced to Anna Pavlova, the great Russian ballerina, who became a generous friend to her. The dancer posed late into the night, even after a grueling theater performance, and her magnificent dancing inspired Hoffman's first important group of sculptures. Once, in an attempt to identify with the spirit of the dance, Hoffman studied ballet and worked herself into such a frenzy performing *Au-*

tumn Bacchanale in an empty theater for Pavlova that she "saw the lights go red and fade out into oblivion. . . ."[85] She had fainted.

Hoffman modeled a long frieze, showing fifty-two dancing figures, and sculpted a bronze *Gavotte* (1915) and a two-figure composition showing Pavlova and Mordkine doing a Bacchanale. When she returned to New York, one of these dancing groups, cast in an edition (a number of castings made from the artist's original sculpture), launched her career.

Many important commissions followed: a war memorial, *The Sacrifice* (1920); a bust of John Keats; and a portrait of her friend Ignace Paderewski. In 1924 she was commissioned by Irving T. Bush, an American businessman, to make two stone figures, fifteen feet high, dedicated "To the Friendship of English Speaking Peoples" (1925). This work was carved in sections of limestone. After it was hoisted in place on the facade of Bush House, a nine-story office building in London, she spent five weeks, eighty feet in the air, on four boards slung alongside it, deepening the carving. The sun, it seems, never hit the work directly, and it had to be carved more deeply to show the form. Dramatic photographs show Hoffman at work, seated on the shoulder of her gargantuan figures.

By this time, Hoffman had achieved considerable success, but was seized by restlessness. She had not yet found what she really wanted to say in sculpture and decided to seek inspiration in Africa. There, greatly moved by the beautiful forms of the Senegalese people, the sculptor created a series of fine portrait heads in a powerfully geometrized and simplified style. *Senegalese Man* (1927) and *Martinique Woman* (1928), in black Belgian marble, are two of her finest works.

These sculptures brought her the major commission of her career. The Marshall Field Museum of Natural History in Chicago hired her to search the world for all the major ethnic types and portray them in sculpture for the Hall of Man. Since the project was an enormous undertaking, the museum

directors expected to divide it among five sculptors. Although secretly terrified at the enormity of the work, Hoffman persuaded them to give her the whole job in the interest of unity in style. The initial contract only called for plaster figures, but she succeeded in convincing the museum people to cast all 105 of them in bronze.

Hoffman then started on an odyssey around the world in search of models, knowledge, and background materials. Her husband Samuel Grimson, a concert violinist (whom she married in 1924), became a skilled assistant, taking movies of the entire experience. She ended her quest in Taos, New Mexico, studying the American Indian at the home of her old friend Mabel Dodge (Luhan). (This was the same Mabel Dodge who had also urged Georgia O'Keeffe to visit New Mexico.) In her book *Heads and Tales,* Hoffman shares with the reader her frequent periods of nervous exhaustion and fear at the thought that she might never accomplish her task. But her monumental project was completed in time to be a central feature of the Chicago World's Fair in 1933.

In subsequent years Hoffman continued to work on architectural commissions, among them a 1948 World War II Memorial at Épinal in France and a sculpture for the facade of the Joslin Clinic at Boston. The latter was a history of medicine in low relief, in a stylized manner well suited to the simple lines of the building.

She was named Woman of the Year by the American Association of University Women in 1957. She also received a gold medal of honor in 1964 from the National Sculpture Society and many honorary degrees from colleges and universities.

Hoffman's sculptural style was essentially conservative. Yet she was part of the new movement of the early twentieth century that emphasized direct carving in stone. Along with modern sculptors, she showed great respect for the nature of materials. Particularly in her African heads, she simplified the forms, emphasizing their powerful geometry. She made a thorough study of the relationship between architecture and sculpture, and belongs with the time-honored architectural sculptor-craftspeople who trace their history all the way back to ancient Egypt.

Meta Vaux Warrick Fuller (1877–1968) was a black realist-impressionist sculptor whose style was influenced by Auguste Rodin. Most of her works express black aspiration and a warm concern for humanity. Two examples are *Water Boy* (1914), showing a black child struggling with a large water jar, and *The Wretched* (1903), whose seven figures represent forms of human suffering. *Awakening Ethiopia* (1914), now at the Schomburg collection of black art in the Harlem branch of the New York Public Library, suggests an Egyptian mummy in the headdress and the stylized wrapping of the lower part of the body. Ethiopia, awakening from a sleep of thousands of years symbolizes black awakening, with allusions to African roots.

Born in Philadelphia to middle-class parents who encouraged her interest in art, Warrick received a scholarship to the Pennsylvania School of Industrial Art in 1894. At graduation, her frieze of thirty-seven medieval figures and a prize-winning metal *Crucifixion of Christ in Agony* won her a scholarship for study in Paris. Arriving in 1899 the young artist discovered that she could not stay at the American Girls Club because of American race prejudice; the well-known black expatriate painter from Philadelphia, Henry O. Tanner, found her a small room in a hotel.

France, however, opened its arms to the young sculptor. She studied at the École des Beaux-Arts (1899) and at the Académie Colarossi with Injalbert and Rollard. The great Rodin met her and was greatly impressed with her sculpture *Secret Sorrow* (sometimes called *Man Eating His Heart*). Praised and encouraged by Rodin, Fuller exhibited *The Thief on the Cross, The Wretched, Man Carrying a Dead Comrade,* and other works at L'Art Nouveau,

a prestigious Paris gallery. These titles give some idea, of the powerful, emotional, romantic, and at the same time macabre quality that critics described in her early work.

After she returned to the United States in 1904, prejudiced art dealers ignored the black artist, despite her success in Paris, until she won a gold medal in 1907 for a tableau of over a hundred figures, *The Progress of the Negro in America,* shown at the Jamestown Tercentennial. In 1909,

after marrying Liberian-born Dr. Solomon Fuller, a Boston neurologist and psychologist, Fuller settled permanently with him in their home in Framingham, Massachusetts, and subsequently raised three sons.

In 1910 a Philadelphia warehouse fire destroyed practically all of her early sculpture. Nevertheless, for the next fifty years Fuller continued to work, now using Afro-American subjects, and was active in the Boston Arts Club and other Boston art groups.

Fig. 5-22. Meta Vaux Warrick Fuller, THE TALKING SKULL (1939), bronze, 42" × 30" × 18" (Photo shows this work in plaster before casting in bronze)

Her life-sized *Awakening Ethiopia* was shown in the 1922 New York Making of America Exposition. Her later, smaller pieces are more ingratiating and restrained than her early, somber, Rodinesque sculptures.

Fuller's work was not popular in its day. Her themes and the emotional way in which she expressed them were too grim for contemporary taste. She was known as a "sculptor of horrors," and *The Talking Skull* (1937), showing a black man kneeling before a skull (perhaps communing with his African ancestors), is in this vein. Fuller's interest in social problems and in the resurgence of black culture made her a forerunner of the Black Renaissance that followed the period of her major work. Like Edmonia Lewis before her, this extraordinary woman overcame the barriers of sex and race, and created strong statements far ahead of her time.

Laura Gardin Fraser (1889–1966) was born in Chicago. She studied with James Earle Fraser at the Art Students League between 1907 and 1911 and married him in 1913. They were, perhaps, the most successful husband-wife team in American sculpture. From their joint split-level studio at Westport, Connecticut, Laura Fraser designed animal sculptures for buildings and outdoor locations across the country. Her *Lee and Jackson Monument* (1948), a monumental double equestrian group, is in Wyman Park, Baltimore; her forty-foot relief, *Oklahoma Run* (c. 1950s) is at the Cowboy Hall of Fame in Oklahoma. She finished three bronze panels for the library of the United States Military Academy at West Point in her last year, and was at that time still working on four heroic-sized allegorical reliefs for the abutment of the Theodore Roosevelt Bridge.

Laura Fraser was also one of the finest American medalists. Among her coins are the Ulysses S. Grant gold dollar and half-dollar, the Lindbergh Congressional Medal, and the coinage for the Philippines (1947). The American Numismatic Society marked its centennial by issuing a medal designed by her.

She was a fellow of the National Sculpture Society, and a member of the National Institute of Arts and Letters and the National Academy of Design.

Sally James Farnham (1876–1943) came from a wealthy family in Ogdensburg, New York. Her father, Colonel Edward C. James, a prominent trial lawyer, took his daughter along with him when he traveled abroad. Although at the time she did not show any talent in art, she appreciated the great museum collections, especially the sculpture.

Her real interests as a child were riding and hunting on the family estate. These activities gave her an intimate knowledge of horses and other animals, which proved important to her later work. In 1896 she married Paulding Farnham, an artist who designed silverware for Tiffany and Company, and had three children.

During a long hospital recovery from illness in 1901, a friend gave her some plasticine to relieve her boredom, and she was soon absorbed in this new hobby. She showed a finished piece, *Spanish Dancer* (1901), to her friend and Ogdensburg neighbor, Frederick Remington, the renowned artist of Western cowboy themes. He urged her to pursue sculpture seriously, and she opened a studio and became a professional.

As she worked, she received criticism from sculptors Remington, Henry Schrady, and others. Her first commission, a garden fountain in Baltimore, was followed by a rollicking series of cowboys and horses inspired by Remington. In 1905 she created a soldiers and sailors monument for her hometown. It was a dramatic Victory atop a shaft, with a flag billowing out behind Farnham showed a theatrical flair in this and the two memorials that followed.

In 1910 she sculpted four long bas-relief panels depicting the early history of the New World for the boardroom of the new Pan-American Union Building in Washington, D.C. She was then asked to do two portraits of South American patriots for the same building. While working on them, Farnham

became immersed in the study of South American history, and in a short time won a competition for a statue of the Venezuelan liberator-hero, *Simon Bolivar* (1921), which the Venezuelan government wished to erect in Central Park, New York. The equestrian statue is a flamboyant work showing the Great Liberator as a proud and noble figure astride a fiery steed. For this achievement the Venezuelan government presented her with the Order of the Bust of Bolivar.

Farnham went on to execute many more commissions, among them the statue of the Franciscan missionary Father Serra with a young Indian, near the San Fernando Mission in California, and por-

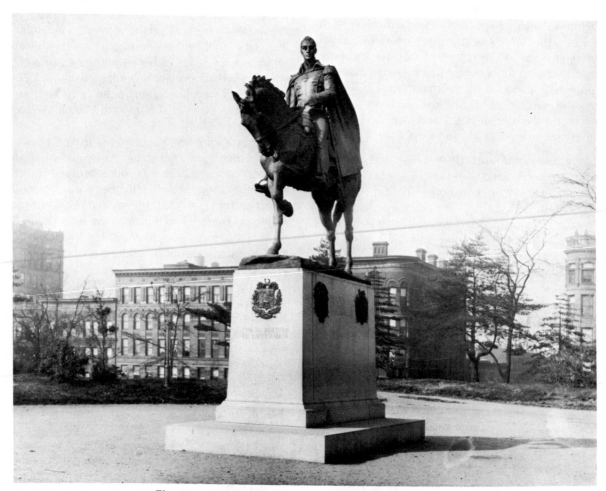

Fig. 5-23. Sally James Farnham, SIMON BOLIVAR (1921), bronze

traits of three presidents. Her career demonstrates the energy unlocked in the early twentieth century, a time when American women felt a new surge of power.

Other Traditional Sculptors

Other well-known traditional women sculptors in the 1920s were: Harriet Whitney Frishmuth (1880–1979), Anna Coleman Watts Ladd (1878–1938), Brenda Putnam (1890–1975), Louise Allen, Ruth Norton Ball, Hester Bancroft, Hester Bremer, Leila Usher, Sonia Gordon Brown, Ella Buchanan, Mary Elizabeth Cook, Mabel Conkling, Nancy Cox-McCormack, Gail Sherman Corbett, Maud Daggett, Jane Davenport, Sarah James Eddy, Joan Hartley, Edith Howland, Hazell Brill Jackson, Grace Mott Johnson, Gertrude Katherine Lathrop, Bashka Paeff, Edith Barretto Parsons, Grace Helen Talbot, Katharine Ward Lane Weems, Margaret French Cresson, and Annetta Saint-Gaudens.

Early Modern Sculptors

Ash can sculptors, Abastenia Eberle and Ethel Myers have been discussed earlier in this chapter.

Alice Morgan Wright (1881–1975) grew up in Albany, New York, and became one of the first American sculptors to use cubist forms, as in *Medea* (1920). She studied sculpture at the Art Students League (1905–1910) with Herman MacNeil, Gutzon Borglum, and James Earle Fraser. While in Paris at the Académie Colarossi (1910–1912), she was impressed by the Cubist movement and began to integrate its fractured planes and geometric forms with expressive themes. Her statue of Lady Macbeth is at the Folger Shakespeare Library, Washington, D.C.

Edith Woodman Burroughs (1871–1916) is described by Lorado Taft as one of the few American sculptors to develop an original style at the beginning of the century. She simplified the forms in her sculpture under the influence of Aristide Maillol, and would probably have gone further in that direction, but an early death abruptly ended her career.

Born in Riverdale, New York, Edith Woodman was already studying at the Art Students League with Augustus Saint-Gaudens and Kenyon Cox at the age of fifteen. At eighteen she was supporting herself working on figures for churches, and teaching.

Fig. 5-24. Alice Morgan Wright, study for MEDEA (1920), plaster, 11½″ × 4½″ × 4¼″

Fig. 5-25. Edith Woodman Burroughs, ON THE THRESHOLD (1912), limestone, height 62½"

In 1893, while in England, she married the painter Bryson Burroughs (later the curator of paintings at New York's Metropolitan Museum of Art). She studied sculpture with Injalbert and painting with Luc Olivier Merson in Paris for two years. During travels in France she was greatly moved by the Gothic sculpture on the cathedrals of Chartres and Amiens. Working in the richly detailed neobaroque style after her return, she won the Shaw Memorial Prize for *Circe* at the National Academy in 1907. It was during a return trip to Paris in 1909 that she came under the influence of Maillol, an important early figure in the modern movement.

Burrough's work is a departure from the lingering baroque style of most of her Beaux-Arts-trained contemporaries. *At the Threshold* (1912) has a grave, tender quality and compactness that was just beginning to be seen in American sculpture.

Burroughs was included in the Armory Show of 1913, won a silver medal for sculpture at the Panama-Pacific Exposition, and had a major exhibition of thirty-nine works in New York. The National Sculpture Society held a commemorative exhibition at her death.

Eugenie Shonnard (1886–1978), an early exponent of direct carving in chunky simplified forms, studied with the Art Nouveau designer Alphonse Mucha at the New York School of Applied Design for Women, at the Art Students League with James Earl Fraser, and in Paris with Auguste Rodin and Émile Bourdelle. She settled in Santa Fe and became a leading sculptor of the New Mexico Indians. She held her first exhibition of carvings at the Museum of New Mexico in 1927, including *Pueblo Indian Woman* (1926).

Eugenie Gershoy (1902–) born in Russia, trained at the Art Students League with A. Sterling Calder, Boardman Robinson, and Kenneth Hayes Miller. She later became a member of the Woodstock art colony, and a neighbor of sculptor John Flanagan. In 1925 she created her first wood carv-

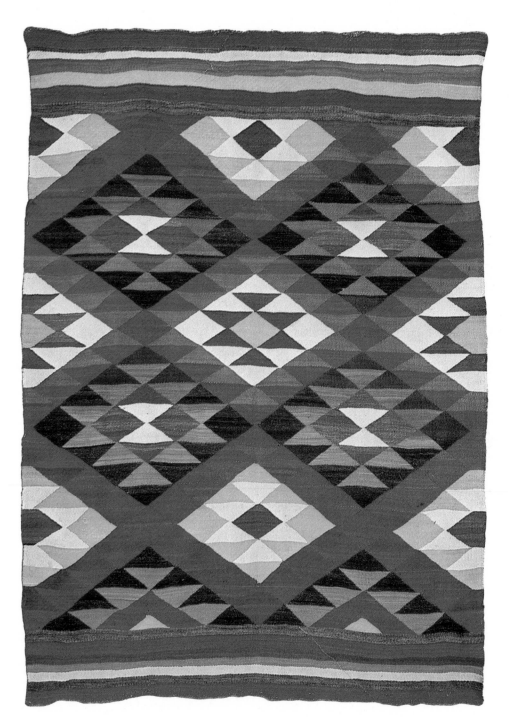

Plate 1. NAVAJO EYE-DAZZLER BLANKET (c. 1880– 90)
84¼″ × 59¼″
Collection of Anthony Berlant, Santa Monica, Calif.

Plate 2. BOWLS BY NAMPEYO AND HER DAUGHTER FANNIE NAMPEYO
Collection of Mr. and Mrs. Dennis Lyon. Photo: Jerry D. Jacka, Phoenix

Plate 3. Pablita Velarde, OLD FATHER THE STORY TELLER (1960)
Courtesy of the artist. Photo: Cradoc Bagshaw, Albuquerque

Plate 4. Helen Hardin, WINTER AWAKENING OF THE O-KHOO-WAH (1972)
Acrylic on masonite, 15″ × 30″
Courtesy of James T. Bialac. Photo: Cradoc Bagshaw, Albuquerque

Plate 5. Anonymous, BABY BLOCKS (c. 1860),
Springfield, Massachusetts area, pieced quilt top 102″ × 88″
Collection of David M. S. Pettigrew. Reproduced from A Calendar of American Folk Art 1976
by permission of the publishers, E. P. Dutton, Inc., New York

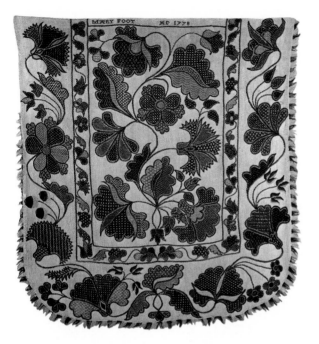

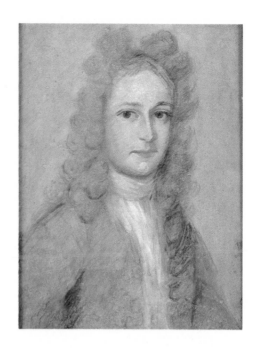

Plate 6. Mary Foot, BED
RUG (1778)
wool, 83½″ × 77½″
*Courtesy of The Henry
Francis du Pont Winterthur
Museum*

Plate 7. Henrietta
Johnston, COLONEL
SAMUEL PRIOLEAU
(1715)
pastel on paper, 12″ × 19″
*Courtesy of Museum of Early
Southern Decorative Arts,
Winston-Salem, N.C.*

Plate 8. Sarah Miriam Peale, PORTRAIT OF
HENRY A. WISE (1842)
Oil on canvas, 39½″ × 24½″
*Virginia Museum of Fine Arts. Gift of The Duchess
de Richelieu, 1963*

Plate 9. Fanny Palmer, THE ROCKY MOUNTAINS (1866)
Lithograph for Currier & Ives
From the Esmark Collection of Currier & Ives

Plate 10. Lilly Martin Spencer, FI! FO! FUM! (1858)
Oil on canvas, 35⅞″ × 28⅝″
Courtesy of Mrs. Joseph J. Betz

Plate 11. Sarah Paxton Ball Dodson, THE BACIDAE (1883)
Oil on canvas, 79½″ × 61¹¹/₁₆″
Courtesy of Indianapolis Museum of Art. Gift of Richard B. Dodson

Plate 12. Elizabeth Boott Duveneck,
HEAD OF A NEGRO BOY (JERRY) (1883),
Oil on canvas, 23¾″ × 19¾″
Collection of Mr. Melvin Holmes, San Francisco

Plate 13. Elizabeth Nourse, THE HUMBLE MENAGE (before 1911)
Oil on canvas, 39½″ × 39½″, *Courtesy of Grand Rapids Art Museum.*
Gift of Mrs. Cyrus E. Perkins Photo: W.D. Pieri III

Plate 14. Mary Cassatt, BABY REACHING FOR AN APPLE (1893)
Oil on canvas, 39½″ × 25¾″
Courtesy of Virginia Museum of Fine Arts. Gift of an anonymous donor, 1975

Plate 15. Susan Macdowell Eakins, TWO SISTERS (1879), Oil on canvas, 57¼″ × 45¾″ *Collection of Peggy Macdowell Thomas, Roanoke. Photo: Wayne Newcomb, Roanoke*

Plate 16. Lilla Cabot Perry, BRIDGE-WILLOW-EARLY SPRING (c. 1905) Pastel, 25¼″ × 31¼″ *Private Collection. Courtesy of Hirschl & Adler Galleries, New York*

Plate 17. Cecilia Beaux, MAN WITH THE CAT (HENRY STURGIS DRINKER) (1898)
Oil on canvas, 48″ × 34⅝″
National Museum of American Art (formerly National Collection of Fine Arts), Smithsonian
Institution. Bequest of Henry Ward Ranger through the National Academy of Design

Plate 18. Marguerite Zorach, MAN AMONG THE REDWOODS (1912), Oil on canvas, 25¾″ × 20¼″ *Collection of Roberta K. and James V. Tarbell, Hockessin, Del.*

Plate 19. Violet Oakley, ANNE ASKEW REFUSING TO RECANT (1902–06) Mural, 6′ × 11′ 10″. Governor's Reception Room, State Capitol Building, Harrisburg, Pa. Reproduced in: *The Holy Experiment* (plate size 7″ × 9″), *Collection of the Violet Oakley Memorial Foundation, Philadelphia, Pa. Photo: Victor Fried*

Plate 20. Georgia O'Keeffe, THE GREY HILLS (1942)
Oil on canvas, 20″ × 30″
Indianapolis Museum of Art. Gift of Mr. and Mrs. James W. Fesler

Plate 21. Florine Stettheimer, SPRING SALE AT BENDEL'S (1921)
Oil on canvas, 50″ × 40″
Philadelphia Museum of Art. Gift of Miss Ettie Stettheimer

Plate 22. Romaine Brooks, UNA, LADY TROUBRIDGE (1924)
Oil on canvas, 50⅛″ × 30½″
National Museum of American Art (formerly National Collection of Fine Arts),
Smithsonian Institution. Gift of the artist

Plate 23. Maxine Albro, detail of mural CALIFORNIA AGRICULTURE (1934). Fresco. Public Works of Art Project, Coit Tower, San Francisco.
Photograph © 1976 de Saisset Art Gallery, a division of the University of Santa Clara

Plate 24. Marion Greenwood, photo of study for PLANNED COMMUNITY LIFE (BLUEPRINT FOR LIVING) c. 1940. Fresco in Red Hook Houses, Community Center Lobby, Brooklyn (now destroyed except for section over doors to gym), WPA/FAP.
Vassar College Art Gallery, Poughkeepsie, N.Y.

Plate 25. Isabel Bishop, VIRGIL AND DANTE IN UNION SQUARE (1932)
Oil on canvas, 27″ × 52″ *Delaware Art Museum, Wilmington*

Plate 26. Isabel Bishop, MEN AND GIRLS WALKING (1969)
Oil and tempera on gesso panel, 29″ × 40″
Mt. Holyoke College Art Museum. Anonymous gift.

Plate 27. Irene Rice Pereira, BRIGHT DEPTH (1949)
Oil on canvas, 36″ × 29″
Courtesy Andre Zarre Gallery, New York City

Plate 28. Gertrude Greene, COMPOSITION (1937)
Wood construction, 20″ × 40″
Collection of The Berkshire Museum, Pittsfield, Massachusetts. Gift of A. E. Gallatin

Plate 30. Dorothea Tanning, GUARDIAN ANGELS (1946)
Oil on canvas, 48″ × 36″
New Orleans Museum of Art, New Orleans, La.

Plate 29. Kay Sage, SMALL PORTRAIT (1950)
Oil on canvas, 14½″ × 11½″
Vassar College Art Gallery, Poughkeepsie, N.Y.

Plate 31. Lee Krasner, ABSTRACT NO. 2 (1946–48)
Oil on canvas, 20½″ × 23½″
Courtesy of Robert Miller Gallery, New York

Plate 32. Joan Mitchell, CASINO (1956)
Oil on canvas, 61¾" × 68"
Courtesy of Xavier Fourcade, Inc., New York

Plate 33. Grace Hartigan, CITY LIFE (1956)
Oil on canvas, 6'9" × 8'2½"
National Trust for Historic Preservation. Bequest of Nelson A.
Rockefeller. Photo: Lee Boltin

Plate 34. Louise Nevelson, installation, Whitney Museum of American Art, 1967. (Left): AN AMERICAN TRIBUTE TO THE BRITISH PEOPLE (1960–65), painted wood, 10′2″ × 14′3″. *The Tate Gallery, London.* (Right): SUNGARDEN NO. 1 (1964), painted wood, height 72″. *Private collection, New York. Photo courtesy The Pace Gallery, New York.*

Plate 35. Jane Wilson, INDIA SILK (1970)
Oil on canvas, 60″ × 50″
Collection of Mrs. Alice Esty

Plate 36. Nell Blaine, GLOUCESTER NIGHT STILL LIFE (1975)
Oil on canvas, 20″ × 28″
Collection of Mr. and Mrs. Bruce C. Gottwald

Plate 37. Jane Freilicher, IN BROAD DAYLIGHT (1979)
Oil on canvas, 70″ × 80″
McNay Art Institute, San Antonio. Gift of the Semmes Foundation

Plate 38. Alma Thomas, WIND AND CREPE MYRTLE
CONCERTO (1973) Synthetic polymer on canvas,
35″ × 52″
National Museum of American Art
(formerly National Collection of Fine Arts),
Smithsonian Institution.
Gift of Vincent Melzac

Plate 39. Helen Lundeberg, AEGEAN LIGHT (1973)
Acrylic on canvas, 60″ × 60″
Courtesy of Tobey C. Moss Gallery, Los Angeles

Plate 40. Helen Frankenthaler, TANGERINE (1964)
Acrylic on canvas, 76″ × 66″
Private collection

Plate 41. Joan Brown, DANCERS IN THE CITY #3 (1973)
Enamel on canvas, 8′ × 10′
Collection of Dorothy Goldeen

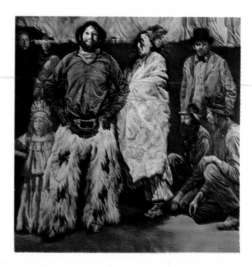

Plate 42. Joyce Treiman, DEAR FRIENDS (1972)
Oil on canvas, 70″ × 70″
Private Collection. Photo: Frank Thomas, Los Angeles

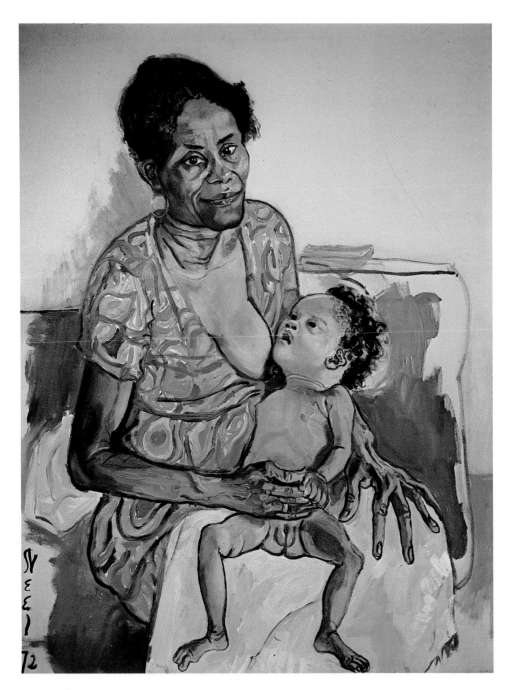

Plate 43. Alice Neel, CARMEN AND BABY (1972)
Oil on canvas, 40″ × 30″
Courtesy of the artist. Photo: Eric Pollitzer, New York

Plate 45. Catherine Murphy,
VIEW OF WORLD TRADE CENTER
FROM ROSE GARDEN (1976)
Oil on canvas, 37″ × 29″
Hirshhorn Museum and Sculpture Garden,
Smithsonian Institution

Plate 44. Janet Fish, WINE AND CHEESE GLASSES
(1975)
Collection of Indiana University Art Museum
Photo: Courtesy Robert Miller Gallery, New York

Plate 46. Audrey Flack, CHANEL (1974) Acrylic on canvas, 60″ × 84″
Collection of Mr. and Mrs. Morton G. Neumann, Chicago. Photo: Bruce C. Jones.
Courtesy of Louis K. Meisel Gallery, New York.

Plate 47. Idelle Weber, CHA-CHA: BROOKLYN TERMINAL MARKET (1979)
Oil on canvas, 36¼″ × 73″
Private Collection Courtesy of O. K. Harris Gallery, New York

Plate 48. Miriam Schapiro, COEUR DES FLEURS (1980)
Acrylic and collage on canvas, 69″ × 50″
Collection of Norma and William Roth

Plate 49. May Stevens, SOHO WOMEN ARTISTS (1978)
Acrylic on canvas, 78″ × 142″
Collection of the artist. Courtesy of Lerner-Heller Gallery, New York

ing, a primitivistic *Nude*, reminiscent of an Archaic Greek figure, in which the forms are flattened out on the four planes of a rectangular block of wood. Gershoy went on to become a sculptor of witty diverse forms, working in a wide range of styles and media—papier maché, stone, plaster, wood—and

was in the sculpture division of the Federal Art Project between 1935 and 1939.

Simone Brangier Boas (1895–), of Baltimore, was another early exponent of direct carving in simplified, massive forms.

Fig. 5-27. Eugenie Gershoy, FIGURE (1930), alabaster, 17¼″ × 7″ × 9½″

Fig. 5-26. Eugenie Shonnard, PUEBLO INDIAN WOMAN (1926), hardwood (satina), 17¼″ × 6½″ × 5⅛″

Chapter 6
The Thirties: Daughters of the Depression

The collapse that followed the stock market crash of 1929 put an end to the era of jazz, the flapper, and the hip flask, and shattered public confidence in what had seemed a foolproof economic system. With ten million unemployed, and wages for others driven far below the subsistence level, workers organized to fight for better conditions, creating new industrial unions affiliated with the militant C.I.O. Even artists began to organize. As their markets and patrons disappeared, they formed an Unemployed Artists Association to press for government relief, and then started their own Artists Union.

In response to emerging European fascism, the American Artists Congress, an organization formed to promote the economic and social interests of artists, actively worked to stem the rising tide of Nazism. Women artists were active in all phases of this agitation. For example, Bernarda Bryson, an artist who became the wife of Ben Shahn, was one of the founders of the Artists Union, and *Life* magazine photographer Margaret Bourke-White was a vice-chairwoman of the American Artists Congress.[1]

Fig. 6-1. Ellen Emmet Rand, PORTRAIT OF PRESIDENT FRANKLIN DELANO ROOSEVELT (1934)

The federal government responded to the emergency by distributing relief and creating jobs through various New Deal programs, and also by a campaign to rebuild public confidence in the system. While President Roosevelt told the nation that the only thing it had to fear was fear itself, artists on government art project were encouraged to create up-beat pictures of idealized American workers and farmers and U.S. history for the walls of post offices and other public buildings. Many of these murals depicting the abundance of American agriculture or the productivity of American industry can still be seen around the country today.

A large number of these murals were by women, for, as an indirect result of the economic crisis,

American women artists were given an unprecedented opportunity to work in their profession. Under the New Deal, the federal art programs that had been organized to create jobs for artists were required to follow an equal opportunity policy in hiring. Perhaps for the first time in world history, women artists were hired without discrimination, in proportions that bore some relation to their numbers in the population. In a 1935 survey, about 40 percent of the artists on relief were women.[2] Many leading American women artists—Alice Neel, Lee Krasner, June Wayne, Irene Rice Pereira, Louise Nevelson, and Loren MacIver, to name a few—were helped in their early careers by the Federal Art Project. Women created thousands of easel paintings, prints, and sculptures, taught classes in the community art centers set up by the government in different parts of the country, and felt a great sense of camaraderie and equality with their male colleagues.

Women were important administrators as well. Juliana Force was appointed New York regional director of the Public Works of Art Project, the earliest art relief plan. Audrey McMahon[3] followed as New York regional director of the Federal Art Project, a division of the Works Progress Administration (W.P.A.). From 1935 until the Project's liquidation in 1943, she exerted supreme authority over the careers of a large number of the artists in the nation, most of whom clustered around New York City. Two state directors of the Federal Art Project were Caroline Durieux in Louisiana and Nan Sheets[4] in Oklahoma, both fine artists.

Other women who held interesting administrative positions included: Berenice Abbott, supervisor of the Photographic Division in 1935; black artists Augusta Savage and Gwendolyn Bennett, directors of the Harlem Art Center; the gifted textile designer Ruth Reeves, initiator and the first director of the Index of American Design (a nationwide research project that created a permanent archive of American folk crafts);[5] Edris Eckhardt, supervisor

of the ambitious ceramic sculpture workshop and laboratory in Cleveland, Ohio (they made large scale ceramic decorations for public buildings). And there were more.

Unhappily, in the shambles of congressional budget cuts that ended the Project in the early 1940s, a great deal of the work produced by artists on the government projects was painted over, lost, or literally dumped. During the ensuing wave of abstract art that swept the American art scene, the federal art programs were denigrated and ignored. Today there is renewed interest in this work, and specifically in its impact on women artists. Eleanor Tufts' colloquium at the 1975 College Art Association conference[6] and the 1976 exhibition "Seven American Women: The Depression Decade" sparked a revival of the accomplishments of women in this earlier epoch. Of course, there were important women artists like Peggy Bacon, Georgia O'Keeffe, and others who worked outside of the federal art programs in the 1930s.

Stylistically, however, the thirties can be considered "the decisive decade."[7] American artists, searching for a genuinely American and yet genuinely modern style, began to explore some of the innovative forms that were to make the United States, in the 1950s, the world leader of art. Women artists played an active part in all the various trends, ranging from realism to abstraction, and the contribution of certain women as pioneers of modernist forms is just now being properly assessed.

Art Styles in the Thirties

Artists reacted to the social ferment of this period in various ways. In the face of mass unemployment and even starvation, the aesthetic preoccupations of the 1920s seemed effete and irrelevant to many of them. There was a great movement back to representational and realistic art for social propaganda and for the depiction of the American scene.

Some artists at this time, under the influence of

Marxist, socialist, or other leftist ideology, felt that the arts should actively promote the improvement of society. They painted utopian pictures of the future, attacked the present evils of society, and expressed compassion for the downtrodden worker and farmer. Most artists on the government projects, however, supported the New Deal programs and glorified American history and American society. Believing that art "is for the people," both groups were happiest when working in post offices and public places, in direct contact with their audiences.

For their stylistic models some of them looked back to the early Italian Renaissance, when art had addressed itself to the whole population. Many women artists made heroes of the Mexican muralists Diego Rivera, José Clemente Orozco, and David Alfaro Siqueiros, whose frescoes had educated an illiterate peasantry to the meaning of the Mexican national revolution. These three artists came to the United States often in the thirties and painted commissions in several major cities. Wherever they went they were the center of activity and admiration. They often hired young Americans to assist them—among them, many women. Artists Louise Nevelson, Caroline Durieux, Marion Greenwood, Lucienne Bloch, Henrietta Shore, Maxine Albro, Jean Ames, Dorothy Hood, and Emmy Lou Packard were a few whose careers were directly affected by Rivera, Orozco, and Siqueiros.

Following in the tradition of Honoré Daumier and Francisco Goya, women artists made quantities of prints and drew satirical cartoons and illustrations for *The New Masses* and *Art Front* (the magazine of the Artists Union), as well as for the Federal Art Project. A large group of artists chose to return to American roots and to portray life in the rural Midwest, New England, the South, and in small towns as a reaffirmation of American values in the teeth of the crisis. Others, in a kind of continuation of the earlier Ash Can School, preferred to show the hustle and bustle of people in the big cities. Typical of the American Scene painters who

worked in these two genres were Doris Lee, who portrayed both rural and urban America, and Isabel Bishop, who painted the crowds of New York City.

On the other hand, a small but determined group insisted that nonrealistic, abstract styles were the truly revolutionary twentieth century expression. In general, however, the art community and the public were hostile to them. Most commercial galleries refused to show their work. To exhibit and proselytize for their artistic position, they set up the American Abstract Artists (A.A.A.) association in 1936, and women in that group played leading roles as founding members and officers, as well as hard working artists. Among the 1937 charter members were Alice Trumbull Mason, Gertrude Greene, Rosalind Bengelsdorf, Mercedes Carles, Esphyr Slobodkina, and Ray Kaiser who later became the design partner and wife of Charles Eames. By 1938 membership included Anna Cohen, Margaret Peterson, Florence Swift, Dorothy Joralemon, Agnes Lyall, Janet Young, and Susie Frelinghuysen. Irene Rice Pereira and Lee Krasner soon joined them, too.

These women are now beginning to be properly recognized for their vanguard roles. Some of them wrote aesthetic position papers for the A.A.A. yearbooks, helped organize shows, picketed the museums to demand exhibitions for American abstractionists, and defended the viewpoint of abstract artists at the Artists Union and in other organizational settings.

On the whole, American abstract artists in the thirties were heavily influenced by Picasso and other European moderns whose work was beginning to be shown at the newly formed Museum of Modern Art in New York City. Some came under the charismatic sway of Hans Hofmann, the brilliant modernist teacher who had come to the United States from Munich and was electrifying a small, devoted coterie of students in his classes in Greenwich Village, at the Art Students League, and in Provincetown.

The forceful Baroness Hilla Rebay felt that

Picasso and Cubism did not go far enough. She was a passionate advocate of totally nonobjective art and became the driving force behind the creation of the Solomon Guggenheim Museum of nonobjective art in New York City.

Government art projects also played a role in the development of abstract art in America. Although administrators definitely favored American Scene painting, government guidelines called for democratic acceptance of all forms of expression. The Federal Art Project allowed artists to experiment with new forms, and to work full time at their professions. It became the seedbed for the careers of many abstractionists, who in the prosperous period after World War II, helped make the United States, for the first time in history, the great art center of the world. Holger Cahill, the visionary national director, was particularly aware of the importance of the Project as the forerunner of an American artistic renaissance.

The Position of Women

Although women artists flourished in the thirties, it was a time of peculiar ambivalence for American women in general. On the one hand, the New Deal gave lip service to equal opportunity. Frances Perkins, the first woman to become a cabinet member, was appointed Secretary of Labor, and she sponsored important legislation improving the lot of millions of women working in offices, department stores, and factories. On the other hand, Perkins and the media called upon married women to quit their jobs during the era of high unemployment, so that male breadwinners could have them. Thousands of married school teachers and women in other fields were thrown out of work, and thousands of others were forced to go to Reno to obtain temporary divorces so they could keep their positions.[8]

Movies catered to the repressed daydreams of women by showing Bette Davis, Katherine Hepburn, and Rosalind Russell playing the roles of career women, wisecracking in a comradely way with their male colleagues on the job. At the end of the movies, however, the heroines would invariably throw themselves into the arms of the Right Man (usually their coworkers) and live happily ever after in a cottage with children. Thus women were permitted to vent their fantasies and were given the illusion of equality, while at the same time they were being propagandized to remain in conventional roles.

Certain women pursued brilliant careers in the thirties as they had in the twenties. Martha Graham led in dance; Dorothy Thompson, Clare Booth Luce, and Lillian Hellman were literary and journalistic stars; psychiatrist Karen Horney challenged Sigmund Freud's theories with her new psychology; and Eleanor Roosevelt was ambassador-at-large to humanity. But for the most part, women subordinated their own needs to the needs of society as a whole at a time of economic disaster and threatening fascism. The women's movement as a separate entity faded. The unusual position of women artists in the Federal Art Project, however, was an interesting anomaly and is worthy of further study.

Women Painters of the Thirties

Social Realism and Social Satire

Of **Marion Greenwood (1909–1980)** the great Mexican muralist David Alfaro Siqueiros said, "She could have been the queen of Mexico."[9] In her early twenties, Greenwood was already a legend in that country, admired both for her powerful murals, painted in Morelia and Mexico City, and for her vibrant adventurous spirit. She became a government muralist, easel painter, and printmaker in the United States.

Born in Brooklyn, Marion Greenwood was a child prodigy who left high school at age fifteen to study on scholarship with John Sloan and George Bridgman at the Art Students League. At eighteen she

made the first of several visits to Yaddo, a foundation in Saratoga Springs, New York, that provides selected artists and writers with a retreat, free from the interruptions of daily living. She called Yaddo her "university," because while painting portraits of intellectuals-in-residence like composer Aaron Copland and writer Waldo Frank, she gained an unofficial higher education by sharing in the stimulating exchange of ideas.

Greenwood earned her way to Europe with proceeds from a portrait of a wealthy financier while still in her teens. In Paris she studied at the Académie Colarossi and returned to New York in 1930, where she sketched theatre people for the theater section of the New York Times. In 1931 she traveled to the Southwest to paint the Navajo Indians, the first of many trips to paint ethnic types in different parts of the world. From there she crossed the border into Mexico and was plunged into several extraordinary adventures.

In Taxco she met Pablo O'Higgins, the expatriate American artist, who encouraged her to try fresco painting. Greenwood painted a mural of native life on a wall of the Hotel Taxqueno, which resulted in a commission from the Mexican government. She was the first woman to receive such a commission.

In 1932, after a year of arduous study of the Tarascan Indians, she painted a seven-hundred-square-foot fresco of Indian life for the University of San Hidalgo in Morelia. (In a later era, during a wave of anti-"gringo" demonstrations, when Mexican students threatened to mutilate the frescoes because they were painted by an American, President Cardenas interceded, pointing out Greenwood's deep love of the Mexican people and the laborious study that had attended the creation of this work. The paintings were left unharmed.)

In 1934 Diego Rivera, head of the government mural program, was impressed by the authenticity of Greenwood's observation of the Mexican people and hired her and her sister, Grace Greenwood (also a distinguished artist), to work on one section of a group mural in the Mercado Rodriguez, the central market and civic center in Mexico City. A photograph taken at the time, shows Marion Greenwood, a slender young woman, standing before a huge mural crowded with dynamic peasant figures on the stairwell behind her. Her work of this period was revolutionary in theme and influenced by the stylized manner of Orozco and Rivera.

The American architect Oscar Stonorov admired Greenwood's Mexican murals and recommended that she and her sister be hired by the Treasury Relief Art Project[10] to create wall paintings for a housing project he was designing in Camden, New Jersey. Returning to the United States in 1936, she chose as her subject a labor theme, specifically the achievement of collective bargaining by the Camden shipyard workers under the New Deal program. This oil-on-canvas mural, like so many works of its type from this period, is covered over today. Greenwood was hired to teach fresco technique at Columbia University in 1937.

In 1937 Marion and Grace Greenwood joined the idealistic (and even utopian) Architect, Painters and Sculptors Collaborative, a group devoted, as were many such organizations in the thirties, to the idea of improving the lives of common people by providing them with a harmonious architectural environment. The group, which included Concetta Scaravaglione, José de Rivera, Isamu Noguchi, William Zorach, and others, designed a community center with sculpture and mural decorations, which they hoped to build for the 1939 New York World's Fair. Although the community center was never executed, it was widely praised as a very advanced environmental concept when the model was exhibited at museums.

In 1938 Marion Greenwood was commissioned by the Treasury Department Section of Fine Arts to paint an oil mural for the post office at Crossville, Tennessee. The work shows a father, mother, and baby under a tree enjoying the peace and prosperity brought to the Tennessee Valley by the darns and hydroelectric projects of the T.V.A. Government officials deadened the composition, however, by

insisting on changes in the design that took much of the vitality out of it. Artists were always battling censorship and interference from the government bureaucracy, and Greenwood in later years expressed hostility to the government programs on this account, saying that she much preferred working as an independent artist.

In 1940 she was commissioned by the Federal Art Project to paint frescoes entitled *Blueprint for Living* (1940) for the Red Hook housing project in Brooklyn. She was very committed to the idea of the benefits of low-cost, government-sponsored housing for low-income citizens. *Blueprint for Living* expressed the optimistic idealism of the period—hope for a future when the people's needs would be met through a harmoniously ordered society. Suffering the same fate as many government murals, this work was subsequently painted over, but

Fig. 6-2. Marion Greenwood, DETAIL OF MURAL ON THEME OF AMERICAN MUSIC (Memphis Jazz and Cottonfield Songs and Dances Section) (1954–55), oil on canvas, 6' × 35'

photographs of it show the impressive scope of her talents.

When World War II began, the adventurous Greenwood—with **Anne Poor** one of only two women appointed as artist war-correspondents—was hired by the U.S. Army Medical Corps to do a series of paintings depicting the reconditioning of wounded soldiers. After the war Greenwood was happy to concentrate on smaller easel paintings and prints, and enjoyed expressing her personal feelings without the supervision and censorship of a government agency. She had numerous solo shows at the American Contemporary Artists Gallery and won awards from the Pennsylvania Academy, the National Academy of Design, and the Carnegie Institute. She traveled to Hong Kong, the West Indies, North Africa, and India, painting and sketching ethnic types. Greenwood particularly identified with the oppressed people living in underdeveloped parts of the world.

In 1954, during an appointment as visiting professor at the University of Tennessee in Knoxville, she again received a large commission, this time for a mural spanning the width of the student center auditorium. Dealing with the theme of Tennessee music, she created a complex American regionalist work, somewhat in the manner of Thomas Benton, interweaving black jazz and spirituals, country mountain music, banjo, guitar, bull fiddle, and folk dance. The intertwining rhythms that resulted are more emotional than those in the murals created under federal supervision. Her last mural, in 1965 at Syracuse University, was dedicated to women all over the world and combined studies of different ethnic types taken from drawings and paintings made during her travels.

Greenwood's work is interesting because of the stylistic changes that occurred as it developed. Her early works in Mexico are imbued with revolutionary fervor and show the influence of Orozco and Rivera; her more restrained and classical murals commissioned by the Federal Art Project support New Deal Programs; and the murals carried out independently later on show more movement and are more expressionistic.[11]

Marion Greenwood was well loved in Woodstock, New York, where she lived and—with her husband Robert Plate—enjoyed the art colony. She is remembered as a full-spirited woman with a rich voice and hearty sense of humor. She died in 1970 after a long recovery from an automobile crash.

Lucienne Bloch (1909–)

Lucienne Bloch (1909–) was working as an assistant to Mexican fresco painter Diego Rivera in 1933 when she made history by slipping past the guards to photograph his censored murals at Rockefeller Center before they were destroyed. At that time she was part of the American mural movement that was directly inspired by Rivera.

The younger daughter of the famous composer Ernest Bloch, she was born in Geneva, Switzerland, and came to the United States with her family at the age of eight. She studied at the Cleveland School of Art (1924–25) and then trained in Paris with the sculptor Antoine Bourdelle and the painter André L'Hote.

In 1929, as a promising young sculptor for the Royal Leerdam Glassworks in Holland, she came to New York to exhibit her glass figures at an exhibition scheduled to open on the very day the stock market crashed. The market for such luxury items dried up almost overnight, and for two years Bloch's career was in a state of suspension.[12]

In 1931 she met Rivera when he was in New York for his exhibit at the Museum of Modern Art and expressed to him her great desire to try fresco painting. He hired her as a color grinder, and she traveled with him to the Detroit Institute of the Arts to assist him with his murals of the auto industry. During this time Bloch met her future husband, Stephen Dimitroff, also an assistant to Rivera, and they began a personal and professional collaboration that continues to this day.

Bloch returned to New York to help Rivera with his mural *Man at the Crossroads* (1933) for the new Rockefeller Center. This mural featured a central heroic worker choosing between an evil capitalist world of unemployment, war, and oppression, and a world of socialism, depicted as a worker's paradise, complete with a portrait of Lenin. The unabashed propaganda content caused the owners of Rockefeller Center to cover the mural and ultimately destroy it.

The decision to destroy Rivera's mural inspired Bloch to hide a tiny camera in her garments and photograph the fresco so that subsequent generations would have a record of this important work.[13] A storm of controversy swirled around this episode of censorship.

In 1935 she was hired by the Federal Art Project to design a mural for the black women prisoners' recreation room in the House of Detention for Women in New York. Her hope, shared by the Commissioner of Corrections, Austin MacCormick,

was that color and decoration could give a spiritual lift to the women prisoners. Many young artists shared the view of the Mexican painters that through art they could educate, rehabilitate, and benefit a mass audience.

On the blank wall of the drab institutional recreation room, she created a colorful and humane view of a potential constructive life and a better world, showing a picture of black and white mothers raising healthy children in an integrated community.[14] She consulted the women prisoners as she worked, and incorporated their ideas into the mural. At their suggestion, she included the flower vendor on the left side and the prison cat Coconita, who was painted nestling on a window sill.

The experience of working directly with her audience was rewarding. The completed mural was praised by critics for its coherent design and integration with the architecture of the room.

Her next fresco series for the music room at George Washington High School in New York

Fig. 6-3. Lucienne Bloch, panel, CHILDHOOD, from the fresco mural CYCLE OF A WOMAN'S LIFE, Federal Art Project (1935) (demolished)

(1937) shows the history of music. Bloch had by this time thrown off the influence of Rivera and was synthesizing her own style. Using a framework of dynamic symmetry, a mathematical system for dividing space into harmonious rectangles, she created semiabstract compositions on such themes as *Primitive Music* (1937), *Balinese Music* (1937), and the *Modern Symphony Orchestra* (1937).

In 1936 Bloch married Stephen Dimitroff. After designing a mural for the Swiss Pavilion at the 1939 New York World's Fair, she and her husband moved to the Midwest and then settled in Mill Valley, California. Working as a team in which she is the designer and he is the technical director, the Dimitroffs have carried out over seventeen murals in a wide range of media.

The kind of successful collaboration enjoyed by Lucienne Bloch and Stephen Dimitroff emerged in several cases among the women and men who worked on the Federal Art Project. The social purpose and cooperative atmosphere seem to have promoted a spirit different from the corrosive personal competition so often experienced by artist couples of the forties, fifties, and sixties, in which the women and their talents were frequently submerged.

Elizabeth Olds (1896–) was well known during the Great Depression for her hard-hitting lithographs and silk screen prints, which attacked the evils of society and sympathized with the plight of the working man. Born in Minneapolis, Olds trained at the Minneapolis School of Art (1918–20), won a scholarship to the Art Students League in 1920, and studied there for three years. Her teacher, George Luks, one of the original Ash Can painters, accompanied her on sketching trips in the streets and parks of New York City. His direct, even brutal, draftsmanship strongly influenced her style.

Wishing to find her own direction, Olds traveled and studied in Europe between 1925 and 1929, and was exposed to the modern aesthetic in Paris. In 1926 she won a Guggenheim Fellowship to study painting abroad, the first woman to receive this honor.

Olds returned to the United States just as the Depression was getting under way, having decided in Europe, like so many American artists at that time, to root her art in contemporary American life and experience. Seeking authentic American subject matter, she sketched a series of views of the stockyards in Omaha, Nebraska, resulting in a "Stockyard Series" of lithographs in 1934 that were praised by critics in the Midwest and New York. The artist won a silver medal at the Kansas City Art Institute. Art critic Emily Genauer noticed the strong abstract feeling in these works:

She attacks [the slaughterhouse scenes] as problems in design, seeking to achieve something of the violence and grossness and at the same time, matter-of-factness of the whole procedure through sheer pattern carried out in black and white.[15]

Olds went to New York and was a leading member of the graphics division of the Federal Art Project between 1935 and 1940. Believing that "art is for the people," she ardently advocated the idea that prints should be produced in large quantities and distributed at low prices, so that ordinary people could afford them. In a 1936 essay, "Prints for Mass Production,"[16] written for the Federal Art Project, Olds points out that this was the original intention of printmaking; in early times the old masters issued their prints in large editions and sold them for pennies. With this in mind, in 1938 she became a founding member of the Silk Screen Unit of the Federal Art Project, joining a group of artists who hoped to transform the commercial silk screen process into a new, inexpensive fine arts medium capable of producing very large editions. Olds made many silk screen prints and continued her lithography and painting.

Her work combines strong draftsmanship and

bold black-and-white design with a social message. In a lithograph entitled *1939 A.D.* (1939), for example, she shows the workers chasing the capitalists out of the Stock Exchange—a reworking of the theme of Christ and the moneychangers. In 1937, the first of many solo exhibitions at the American Contemporary Artists Gallery in New York consisted of drawings of life in the steel mills—studies for her "Steel Series" of lithographs.

Along with William Gropper, and other artists of the day, Olds drew illustrations with titles like *Unemployed Miners* and *New Woman of Spain* for the left-wing magazine *The New Masses*. She belonged to the American Artists Congress from 1936 to 1940, and her work was shown at the 1939 New York World's Fair. Since the forties she has been an illustrator for *Fortune* and *New Republic* magazines, and has written and illustrated six books for children, of which three were chosen as Literary Guild selections. Her prints are in the Brooklyn Museum, the Metropolitan Museum of Art, the Philadelphia Museum, and elsewhere.

Fig. 6-4. Elizabeth Olds, SCRAP IRON (c. 1935–39), lithograph, 30.1 × 42.1 cm

Mabel Dwight (1876–1955) has been called "the Master of the Comédie Humaine."[17] Like Peggy Bacon, Doris Lee, and the early Minna Citron, she saw the tragicomic side of people living in cities and captured that quality in her velvety lithographs.

Born in Cincinnati and raised in New Orleans, Dwight studied art in San Francisco at the Hopkins Art School before the turn of the century. Although she was a contemporary of the turn-of-the-century California decorative artist Lucia K. Matthews, the

bulk of Dwight's work belongs stylistically in a much later period.

While living in San Francisco, she became influenced by the socialist ideas of fellow art students. She later described in an essay, "Satire in Art,"[18] how her almost religious radical fervor shocked and upset her parents. Although her political ideas were tempered and modified later on, she never lost her feeling for the underdog, expressed in such prints as *Derelicts* (c. 1936) and *In the Crowd* (c. 1936). To

Fig. 6-5. Mabel Dwight, QUEER FISH (1936), lithograph, 10⅝" × 13"

her, poverty was the great disease—totally unnecessary in the age of science.

Dwight traveled extensively in Europe and Asia and did not discover her true métier until she was over fifty. In Paris in 1927 she made seventeen picturesque lithographs of the city in collaboration with the French printer Duchatel, and from that time forward devoted herself to lithography.

Returning to the United States in 1928, Dwight rapidly became well known for lithographs featuring the dark comedy of city life. *In the Subway* (c. 1928) was the first of over a hundred prints depicting the endless variety of urban characters and the absurd situations in which they found themselves. By the time Dwight began to do prints and watercolors for the Federal Art Project between 1935 and 1939, she was a well-established artist who had had a major exhibition at the Weyhe Gallery, New York, and whose work was bought by museums and private collections.

In an essay written for the Federal Art Project,[19] Dwight gives her views on the role of satire in art. She objects to arbitrary distortion or screaming political histrionics and points out that the great social and satirical artists, such as Goya and Honoré Daumier, seldom fell into those traps. For her, modern life itself was so absurd that one needed only to observe it profoundly for the result to seem twisted. She also points out that subject matter is not enough for a work of art to endure; the aesthetic properties—design and form—are essential. Even Daumier, she claims, turned out poor work when the speedy execution required for the daily newspaper did not permit the development of formal qualities to support the idea.

In *Queer Fish* (1936), a characteristic example of her oeuvre, Dwight reveals the droll and dreamlike quality of a crowd of people at the aquarium, silhouetted against lit-up tanks, their varied shapes twisted in odd configurations. In a dramatic confrontation, a fat grouper fish stares hypnotically at a fat man for a brief moment before each one swims off in a different direction. Both are queer fish.[20] In this composition she employs a counterpoint of curved forms, played against diagonals. The carefully controlled, velvety lithograph crayon technique, the unified white shape against the dark, reveal her great concern with technique and organization.

Dwight lived a life at times as poignant as the characters in her lithographs. As the victim of Federal Art Project red tape requiring all artists to punch a time clock at "work" in the morning, she was often up half the night in terror that she might not hear the alarm since she was hard of hearing. So every morning she dragged herself, exhausted, on the Staten Island ferry to Manhattan to punch that time clock, and then went right back home to work in her own studio.[21]

Caroline Durieux (1896–), of New Orleans, attended Sophia Newcomb College[22] in her hometown and the Pennsylvania Academy of the Fine Arts, and then worked with Diego Rivera in Mexico. During the 1930s and 1940s, Durieux became a well-known lithographer and social satirist (in the tradition of George Grosz and Honoré Daumier) whose sharp eye and graphic line punctured pomposity and exposed human foibles in scenes of Louisiana life. She served as director of the Federal Art Project for the state of Louisiana between 1938 and 1943 and then joined the faculty of Louisiana State University at Baton Rouge.

In the 1950s and 1960s, Durieux began to experiment with abstract art, and became an innovator of new technical methods in printmaking. Working with nuclear scientists at the university, she developed the technology of the electron print, created by drawing with radioactive ink. After this, Durieux started a one-woman renaissance of the *cliché verre* technique of printmaking on glass. She revived and enriched this nineteenth century method with her own new color print processes. Durieux has received international recognition for

her innovations, and her work is in many collections. After a long teaching career she is now Professor Emeritus of Fine Arts, and lives in Baton Rouge. The Women's Caucus for Art honored her with one of their 1980 awards for national outstanding achievement in the visual arts.

Lois Mailou Jones (1905–) has been called the first black female painter of importance and is today Professor Emeritus of art at Howard University after a long and distinguished career. On her way up, however, she suffered more than her share of discrimination. One such affront took place in 1927, when she graduated from the Boston Museum School of Fine Arts and asked the director for an assistantship. According to Jones, he stared at her "with his steely blue eyes" and told her to go to the South to help her "own people."[23]

Jones was born in Boston. Her father, a building superintendent, earned a law degree at the age of forty. Her mother ran a beauty shop and made hats. During summers at Martha's Vineyard, where the family had a home, she met the black sculptor Meta Warrick Fuller and other artists and began to paint seriously. Fuller's stories about working with Auguste Rodin filled Jones with a desire to study in Europe.

While in high school, she studied after school at the Boston Museum and in 1923 went there full-time on a scholarship. After graduating, unable to obtain the assistantship she wanted, she worked as a textile designer and took advanced courses at the Designers Art School at Harvard University and then at Howard and at Columbia Universities.

Jones made frequent trips to New York and met many of the leaders of Harlem's Black Renaissance—Countee Cullen, Claude McKay, and others. In 1930 she joined the staff of the art department at Howard University in Washington, D.C., and remained there until she retired forty-seven years later in 1977. Many leading black artists studied with her, including Elizabeth Catlett and Alma Thomas.

Fig. 6-6. Lois Mailou Jones, DANS UN CAFÉ À PARIS: LEIGH WHIPPER (1939), oil on canvas, 36" × 28¼"

In 1937 Jones was awarded a fellowship for study at the Académie Julian in Paris. The experience of at last entering a country relatively free of prejudice against blacks was exhilarating for her. After an early phase of watercolors and oils of New England landscapes, she now began, in Paris and on the Riviera, to paint impressionist landscapes and Cézanne-like portraits and still lifes such as *Place du Tertre* (1938), *Tête de Nègre* (1938), and *Les Pommes Vertes* (1938). She exhibited these in the Salon des Artistes and the Galerie Charpentier. When she met Émile Bernard, who had worked

with Van Gogh, he invited her to work in his studio and introduced her to his artistic circle.

Returning to the bigotry and prejudice of the United States in 1938 was shocking for Jones. Dr. Alain Locke of Howard University encouraged her to treat the black experience in her painting, and she did so in pictures like *Mob Victim* (1944). The model for the figure in *Mob Victim* had actually witnessed a lynching and imitated the pose of the victim. Jones originally had a noose around the neck, but painted it out.

In 1941, knowing that many museums excluded black artists, she asked a white friend to submit her painting *Indian Shops, Gay Head,* a cheerful impressionist landscape, to a competition at the Corcoran Gallery in Washington, D.C. When she won the Corcoran's Robert Woods Bliss Prize, her white friend picked up the award for her, and Jones did not claim the credit until over two years later.

In 1953 Jones married the distinguished Haitian artist Louis Vergniaud Pierre-Noel. The following year she was invited by President Malgloire of Haiti to do a series on Haitian life, and during frequent visits she painted *Bazar du Quai* (1961) and many other scenes of that country in an angular, cubistic style, more abstract than her earlier work. These were shown at the Pan-American Union in Washington, D.C., during President Malgloire's state visit to the United States.

The most recent phase of Jones's art has been inspired by trips to Africa. In 1970–71 she spent a sabbatical year in Africa, touring fourteen countries and making innumerable slides for a comprehensive international archive of black artists at Howard University. Her African pictures return to a theme she had touched on forty years earlier in *Ascent of Ethiopia* (1930), which had been inspired by Meta Warrick Fuller's *Ethiopia Awakening* (1914). Recent works like *Moon Masque* (1971), *Magic of Nigeria* (1971), and *Homage au President Leopold Cedar Senghor* (1976) combine powerful, flat design shapes and the stylized forms of indigenous African art into images of great force.

Jones has exhibited in over forty-five shows, including a 1972 retrospective at Howard University. Among her many honors, she was elected a fellow of the Royal Society of the Arts in London. Her acrylic *Ubi Girl from Tai Region* (1972) now hangs in the Boston Museum of Fine Arts, where over forty years earlier the Boston native was told to go South to help "her own people."

American Scene and Realist Painting

Isabel Bishop (1902–), one of America's leading humanist painters, has worked out of her studio on Union Square in New York City for the past fifty years. She has derived her subject matter during all these years from the inhabitants, workers, and passersby of the teeming square, including shoppers, waitresses, and derelicts. Along with Reginald Marsh and the Soyer brothers, she was recognized as an outstanding urban realist of the so-called "Fourteenth Street School" in the thirties. In recent years her style has changed slowly, until today, her walking figures move transparently through veils of tone and networks of lines and dots, taking on a haunting poetic aspect.

She was born in Cincinnati. Her father, Dr. J. Remsen Bishop, was a schoolmaster who had previously run his own school in Princeton, New Jersey, but had come to Cincinnati to try to make more money to support his five children. The year after Isabel was born, the family moved to a less than desirable neighborhood in Detroit where Dr. Bishop became principal of a high school and wrote textbooks in Greek and Latin.

Bishop had a lonely and isolated childhood, since she was forbidden to play with the neighborhood children, who were not considered good enough for her. She envied the warmer family lives of the poor children around her and said years later that she felt her love for the bustling life of Union Square had its root in her childhood deprivation and envy.

Bishop graduated from high school at age fifteen and began art studies at John Wicker's art school in Detroit. Through the generosity of a rich relative, she went to New York to study commercial art for two years at the School of Applied Design for Women, but after reading about the exciting developments in modern art she transferred in 1920 to the Art Students League. At that time the League was a seething battleground of ideas. Each teacher led a small regiment in a different direction—modernist or traditional. At first she was excited by the developments stimulated by the 1913 Armory Show. She studied with Max Weber, who was then in his post-Cubist period, but since she stubbornly continued to paint in a realist manner, Weber disliked her work. And so, she moved on to Kenneth Hayes Miller, who taught Renaissance representational techniques, adapted to contemporary subject matter. Miller's total commitment to painting was inspiring, and in his classes Bishop met Reginald Marsh and the Soyer brothers, later her friends and colleagues.

When Bishop left the League in 1923 and took a studio alone on 8th Street (she later moved to 9 West 14th Street), the sudden return to isolation threw her into a depression. The loss of warm camaraderie was debilitating, and she found herself sleeping during the day and wakeful at night. "I thought of just disappearing, just dropping out of the world. I thought of suicide. . . . Then it occurred to me that I should go back to the League. . . . I then would have some part of my day structured."[24] She worked with Miller in the mornings for several years until she could function on her own. By 1928 she

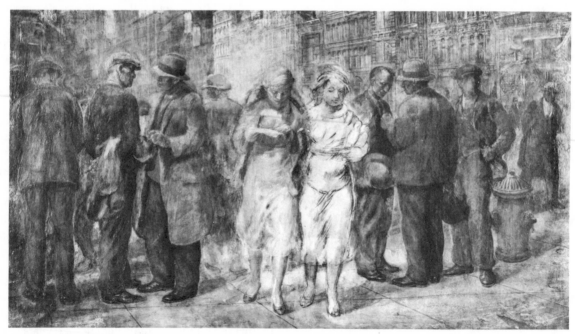

Fig. 6-7. Isabel Bishop, ON THE STREET (c. 1932), oil on canvas, 14½" × 26"

and her colleagues were all living and working near Union Square and beginning to create a distinctive Fourteenth Street School.

Bishop describes some of the hazards of being an American scene painter in a 1976 interview with Cindy Nemser in the *Feminist Art Journal*.[25] She tells of her daily sketching excursions to Union Square, which were rudely interrupted when a mob of derelicts who congregated in the park ganged up on her, threatened her, and shouted that she was a capitalist making money off their misery. The policeman on the square refused to protect her and suggested that she would be better off leaving. In a way, this incident echoed her earlier separation from ordinary people because of her class position.

In 1934, when Bishop was already an established artist with a well-structured working life, she married Harold G. Wolff, a neurologist and a creative man in his own field who regarded science and art as one continuum. With him she had a happy and enduring relationship, and raised a son.

After her marriage, Bishop moved to Riverdale, a suburb of New York. For forty years (until she recently had to move) she commuted every day to a studio on Union Square, arriving before 9 A.M. and returning at night like a business executive. From the big picture window in her studio, high up in an office building, she saw the restless stream of moving figures in the street below while she worked.

Bishop paints with a technique derived from European painters of the Baroque period, most notably Peter Paul Rubens. She chose to emulate Rubens because the technique and composition of his work expressed, more than any other painter, the quality of movement she sought. Fundamentally, this technique consists of applying uneven, transparent washes of underpainting on the white ground to create a sense of vibration in the picture, then adding the drawing and paint glazes, allowing the underpainting and the white ground to glow through in places. The result is that Bishop's pictures have a luminous, old-master quality. Her work has always had a characteristic high-key tonality of subtle tones, with glowing accents of orange, turquoise, and other colors.

Although her subject matter—shopgirls and shoppers, straphangers and bums—is similar to that of other American Scene painters of lower New York City, her treatment of this material is more evocative than theirs. In an early picture called *Dante and Virgil in Union Square* (1932), she shows a crowded square with what appear to be hundreds of people hurrying in every direction. In front of them, viewing the scene, are Virgil and Dante. The picture was suggested to her by the passage in the first canto of Dante's *Inferno* in which Virgil and Dante are in the vestibule of Hell looking at all of those who, in their lives, have been neither bad nor good, but simply indifferent. Dante is saying to Virgil, "I did not think Death had undone so many."[26] Nobody in the crowd seems to notice the peculiarly robed figures in the foreground of the picture, except possibly one man in a slouch hat. It is never made clear whether Union Square is supposed to be the outer circle of Hell (Bishop denies this), whether the people in the picture are transitory spirits, alienated humans, unaware of one another, or whether they are merely shoppers hurrying to pick up bargains in tawdry discount department stores. Because of these unanswered questions, the picture has a strange mystery to it.

Even Bishop's early paintings suggest movement and convey the notion that perhaps all of her people are moving up and down in the society that fills Union Square. In *Two Girls* (1935), at the Metropolitan Museum of Art, one girl turns aside momentarily to say something to the other. Obviously poor, they both look very intelligent. Bishop has emphasized that she thinks of her girls as upwardly mobile in society.

A trivial gesture like wiping lipstick off one's teeth becomes a larger metaphor for "putting a good face forward"; struggling into a coat, in a way, is "putting on one's armor."[27] Bishop also painted the nude, usually engaged in some awkward transitory gesture such as trimming a toenail. Bishop has said

Fig. 6-8. Isabel Bishop, TIDYING UP (c. 1938), oil on masonite, 15⅛″ × 11⅝″

that, like Rembrandt, she tries to invest the nude with the same quality of potential movement that raises it out of the stereotype and into the world of broad human values.

In her more recent paintings, Bishop has shown less interest in the realistic portrayal of life and increased concentration on the abstract quality in her work. In *Under Union Square* (1957), the high columns of the subway station under the square combine with the floors and roof to create a cubist pattern. In *Men and Girls Walking* (1970) there is interplay between the pattern formed by vertical and horizontal areas of color and the shadowy moving figures. Unlike the solid figures in her paintings of the 1930s, the figures in these recent works are almost transparent, giving the effect of rapidly moving wraiths peering at one another or out at the viewer through a kind of mist. They almost disappear into the abstract pattern of the pictures.

Bishop's object now seems to be to achieve certain spatial and formal qualities. She is trying to keep the image locked to the two-dimensional surface, while simultaneously suggesting backward and forward movements in space, as well as an interpenetration of figures and environment. The surface richness of complex dots and dashes of paint creates a personal handwriting—her own unique and highly controlled incorporation of some of the qualities of Abstract Expressionism.

Over the years, Isabel Bishop has exhibited steadily at the Midtown Galleries and has won many honors and prizes. She was elected vice-president of the National Institute of Arts and Letters (the first woman officer since its founding in 1898); she has been a visiting artist at Yale University and had a 1975 retrospective at the University of Arizona Museum of Art and a solo exhibition at the Whitney Museum. Her paintings, drawings, and etchings are in all the major museums in the country. According to Ralph Pomeroy in *Art News* (1967), Isabel Bishop's flickering figures are part of the history of American painting. They have become broad symbols of American life, with its constant flux, change, movement—and its lonely crowds.

Minna Wright Citron (1896–), known today as an abstract painter and printmaker, belonged for years to the "Fourteenth Street Gang" of urban realists, many of whom were inspired by Kenneth Hayes Miller at the Art Students League. Citron's continuing vitality is indicated by the fact that she was a delegate to the 1972 National Conference of Women in the Arts held at the Corcoran Gallery in Washington, D.C. In her eighties, she identifies strongly with the current women's movement.

Minna Wright grew up in Newark, New Jersey, the adored and adoring object of all her mother's affection after her father died when she was a small child. She did not begin to study art until she was twenty-eight and a middle-class mother of two children in Brooklyn. She first enrolled at the New York School of Applied Design for Women, intending to become a commercial artist. But after graduating with honors, she began to study fine arts seriously at the Art Students League with Kenneth Hayes Miller, Harry Sternberg (a social realist), and Kimon Nicolaïdes, the famous drawing instructor.

Her new career sharpened the role conflicts already present in her marriage, and in 1934 she divorced her husband, whom she described as loving "money, gold and cigars"[28]—values completely different from her own. It was the middle of the Depression, and raising two children alone was not easy, but Citron never regretted her newfound freedom. Leaving behind her middle-class suburban existence, she moved to Union Square in Manhattan and became part of the supportive group of professional artists who congregated there. Among her new friends were Isabel Bishop, Edward Laning (the muralist), and Reginald Marsh.

Citron greatly admired the work of Honoré Daumier, and early in her career she used her brush to probe the various corners of society, as he had done. Her first solo show, at the Midtown Galleries

Cooperative, was a biting series of paintings, *Feminanities* (1935), which ridiculed the shallow activities of the stereotypical female. She now views these works as an expression of her need to resolve her own conflicts about sex roles.[29]

In 1937 a trip to Reno, Nevada, to finalize her divorce resulted in a series of pictures showing dealers and players in the gambling casinos of the West. Similarly, time spent on jury duty stimulated Daumier-like observations of the courts.

From 1935 to 1937 Citron was an art teacher, surviving like so many of her peers, with the aid of the Federal Art Project. She was also a member of the American Artists Congress between 1936 and 1940, serving as chairman of the graphics committee.

Between 1938 and 1942 Citron was awarded government mural commissions. While making studies for a T.V.A. mural for Newport, Tennessee, and one of a *Horse Fair* (1941–42) for the Manchester, Tennessee, post office, she traveled around the Tennessee Valley and completed a series of regional paintings, which were shown at the Midtown Galleries.

In 1942 her work began to move in the direction of abstraction. At Stanley Hayter's Atelier 17, the world-famous Paris graphics workshop that relocated temporarily in New York during the war, Citron worked alongside of brilliant refugee artists (such as Marc Chagall, André Masson, and Jacques Lipchitz) who were living at that time in New York, and she began to explore innovative techniques. Hayter taught new methods of viscosity color printing and other techniques barely known in the United States at the time.

Citron pioneered in creating a three-dimensional, raised surface in printmaking and painting. She piled up paint in thick calligraphic lines on etching plate and canvas and then "cut into" them. In an exhibition called "The Uncharted Course," she showed the progression by which, in a series of prints, she was carried from one stage to the next, incorporating into the compositions acciden-

tal designs and textures (such as the pattern created by a cellophane wrapper by which the plate was originally covered).

Citron taught at the Brooklyn Museum School (1940–1944) and at Pratt Institute. She represented the U.S. government at an international art education congress in Paris. She has also been a Yaddo Fellow and has won several graphics awards. Her work is in the Museum of Modern Art, the National Gallery, the Tate Gallery in London, and other museums.

Doris Emrick Lee (1905–), of Aledo, Illinois, is an American Scene painter whose rural subjects spring naturally from her roots in the Midwest. The fourth of six children of Edward Everett Emrick, a merchant and banker, and Nancy May (Love) Emrick, a country school teacher, she descends from Irish, English, and German pioneers in Illinois. Her great-grandfather was an English engineer who came to Illinois to build a bridge across the Mississippi, and she remembers her grandfather painting a picture of that same bridge. Emrick grew up watching her great aunts and grandmothers embroider, quilt, and carve picture frames and bedposts. Her wry narrative canvases, with subject matter ranging from a farm kitchen to a New York disaster scene, reflect the search for national identity through American subjects that characterized the art of the thirties.

Lee shot into prominence in 1935 when a controversy raged around her painting *Thanksgiving* (1935). She won the Logan prize at the Art Institute of Chicago for this lively scene of rural women preparing a Thanksgiving dinner in an old fashioned farm kitchen. Josephine Hancock Logan, however, wife of the museum benefactor who had sponsored the award, called the painting "atrocious" and started a brief "Sanity in Art" movement, which sought a return to older and sweeter concepts of beauty. The bright colors and neoprimitive forms seemed to Logan to be part of a new wave of ugly modernism. The critics and public, however, en-

Fig. 6-9. Doris Lee, THANKSGIVING (1935), oil on canvas, 28⅛″ × 40″

joyed the painting and rallied in support of the artist. The Art Institute ended up buying *Thanksgiving* for its permanent collection.

The "primitive" quality that critics found in her work in the mid-1930s was deceptive. In *Thanksgiving*, which has been mistakenly labeled "naive," the forms are carefully modeled in chiaroscuro tones, unlike the flat figures of primitive artists. The composition is worked out in scientific perspective, and the eye is carried in organized movements that draw the viewer's attention back into the distant dining room and forward again.[30] It is true that folk art was a great influence on artists in that period, and certainly on Lee, but her attempt to capture a folk quality in her genre scenes was sophisticated stylization, the result of extensive training.

After graduating from Rockford College, Illinois, in 1927, Lee studied at the Kansas City Art Institute with impressionist Ernest Lawson in 1928–29, in Paris with the cubist André L'Hote, and at the California School of Fine Arts in San Francisco in 1930 with Arnold Blanch, whom she married in 1939. She was discontentedly painting abstractions, influenced by her studies in Paris, when she entered Blanch's classes. He encouraged her to work from nature and choose real-life subjects she enjoyed.

Around 1931 she moved permanently to Wood-

stock, the art colony near New York. There she enjoyed the companionship of fellow artists, served as an officer in the Woodstock Art Association, and found inspiration for many of her rural paintings in the beautiful countryside nearby.

In 1935 Lee won two mural commissions in the very first competition sponsored by the Treasury Department Section of Painting and Sculpture for the Post Office Department building in Washington, D.C. The fact that she won this plum in an anonymous competition with men from all over the country was due to her technical polish. Also, her approach to American subjects was in harmony with the general approach of the Section, which favored American Scene painting.

Lee drew on childhood memories of life in the Mississippi Valley in *Country Post* (1935)—a mural of a country farm family eagerly receiving the mail—*Illinois River Town* (1938), and many other works. But her range of subject matter also extends to urban scenes. *Catastrophe* (1936), now at the Metropolitan Museum of Art, shows victims parachuting from a flaming zeppelin over the New York skyline, while frantic rescuers rush about below. The artist has said, "What I feel is a sort of violence"[31] underlying modern life, and in many of her paintings she takes an amused look at the frenzy underlying the daily activities of ordinary people. Like Pieter Brueghel, she finds a tougher and more universal meaning behind the humor of her animated crowd scenes.

Lee was one of the original signers of the petition to form the American Artists Congress and lectured to this group on the subject of "Art Colonies." Artists of all aesthetic camps in the 1930s saw no conflict between the demands of their art and active participation in organizational life. Her work was shown at the New York World's Fair and the San Francisco Golden Gate Exposition in 1939.

In the 1940s Lee executed illustrations for *Life* magazine, including four paintings of the musical play *Oklahoma* and a "Hollywood Gallery" (im-pressions of the movie colony). She won the Carnegie Prize in 1944 and the gold medal of the Art Directors Club in 1957, has been guest artist at several universities, and coauthored a book, *It's Fun to Paint,* with her husband Arnold Blanch.

The work of both **Jenne Magafan (1916–1952)** and **Ethel Magafan (1916–)**, twins from Colorado, has a strong Western regional flavor. They achieved success early in their careers as a result of the federal mural projects of the 1930s. Models for other women, in a sense, they helped one another and enjoyed their mutual opportunities and successes in remarkable, noncompetitive careers until the untimely death of Jenne in 1952. Ethel continues to win mural commissions and to paint, although her work is now often semiabstract in style.

The Magafans were born in Chicago, Illinois. Their father, Petros Magafan, had come to this country from Greece in 1912 and soon moved to Colorado Springs to raise his family among the mountains there, which he said were "just like the Old Country."[32] Love of the mountains and a combined Western and Greek heritage permeated the art of the two sisters.

Both girls, encouraged by their grade school teachers, wanted to be painters when they were very young. When Jenne won the Carter Memorial Art Scholarship of ninety dollars, the sisters decided at once to share it and spend what seemed like a fortune in those days to study at the Colorado Springs Fine Arts Center. Frank Mechau, Boardman Robinson, and Peppino Mangravite, their teachers, recognized the Magafans' ability at once. When the scholarship money ran out in two months, Mechau hired them as assistants to help him with his own murals. Mangravite later invited Ethel to assist him on murals that he was completing in Atlantic City.

This intensive early practical training enabled both twins to enter the open juried competitions sponsored by the Treasury Department Section of Fine Arts. Ethel was in her early twenties when she won her first commission in open competition—

Fig. 6-10. Jenne Magafan, WESTERN TOWN (1940), post office mural, Helper, Utah

Wheat Threshing (1937), a mural for the post office in Auburn, Nebraska.

The fate of her study for *The Lawrence Massacre* (1937) is interesting as an example of government influence. After submitting the design in competition for the post office mural in Fort Scott, Kansas, she received a polite note from the Superintendent of the Section of Painting and Sculpture of the Treasury Department. He informed her that her design was outstanding, but the subject matter was too disturbing. Kansas did not seem to want to be reminded of its past racial problems in the border clashes that preceded the Civil War. Magafan still hopes to paint this mural some day.

Jenne's mural *Western Town* (c. 1939–44) for the post office in Helper, Utah, is a good example of the Magafans' mural style, influenced at that time by early Renaissance masters such as Giotto and Massaccio. The spirit of the American West is captured in broadly simplified forms held within a shallow stage space, maintaining a feeling of the flat wall.

The Magafan twins collaborated on one mural, *Mountains and Snow,* for the boardroom of the U.S.

Health, Education, and Welfare Building in Washington (originally the Social Security Building). They also shared seven two-woman exhibitions of their easel paintings.

When the twins traveled to Los Angeles for an assignment, they met Doris Lee and Arnold Blanch, who described Woodstock, New York, as the ultimate artist's community. In 1945 the Magafans crossed the country in their station wagon and settled permanently in Woodstock.

Jenne married artist Edward Chavez, Ethel married artist Bruce Currie, and the two couples enjoyed a companionable relationship of shared interests. The twins, now in separate studios for the first time, developed separate styles. *Art News* described this difference in a review of their 1950 Ganso Gallery exhibition in New York:

Ethel is the more rugged painter, interested primarily in horses. . . . Jenne, whose style is similar but more sensitive, more often makes people the center of interest. . . .[33]

Around 1951, both sisters won Tiffany Foundation awards and Fulbright fellowships. Ethel Maga-

fan's Fulbright travel in Greece had a lasting effect on her work. Returning to her Greek roots, she and her husband climbed into little mountain towns perched on the side of cliffs where the local peasants had never seen a traveler before. Once they had to be rescued from a curious crowd by the police. Since that time, Ethel Magafan's mountain landscapes have grown increasingly abstract; she tries to capture the feeling, rather than the literal detail, of a scene. One of her favorite motifs—the horse—shows the influence of ancient Archaic Greek forms.

Tragedy came in 1952. A few days after both couples had returned from separate Fulbright travels—Ethel to Greece and Jenne to Italy—Jenne died suddenly of a cerebral hemorrhage. Ethel has called her sister's death "a tragedy from which I have never fully recovered."[34]

Ethel Magafan has painted seven murals for the federal government, including ones in the Senate Chamber and the Recorder of Deeds Building in Washington. In 1971 she received a government grant to paint the mountains of the West and has recently completed a mural of the Civil War under an Edwin Austin Abbey Mural Award (1980). Magafan has won the Altman prize from the National Academy of Design, the Hallgarten Award, and the 1970 Childe Hassam Purchase award from the Academy of Arts and Letters.

Marjorie Acker Phillips (1895–) has combined two long and remarkable careers. A painter of lyrical scenes and still lifes, she has also been, since her marriage to Duncan Phillips in 1921, an administrator of the famed Phillips Collection in Washington, D.C.

As a young woman from a well-to-do family in Ossining, New York (her father was a chemical engineer and inventor), she commuted to the Art Students League to study with Boardman Robinson and Kenneth Hayes Miller between 1915 and 1918. Her uncle was the fine American painter Gifford Beal. Already advanced and discerning in her taste, she often visited Katherine Dreier's avant-garde Société Anonyme collection when it opened in New York in 1921.

Marjorie Acker met Duncan Phillips "in the most delightful way"[35] when she went to see the newly formed Phillips Memorial Collection in 1921 at the Century Club in New York. He happened to be there that day, and before long Acker and Phillips were deep in conversation about the art in the collection. They immediately discovered a harmony of viewpoint, which led to a long, shared life in art.

Marjorie Phillips moved to Washington after her marriage and helped her husband develop the uniquely personal museum of modern art housed in the Victorian family mansion on 21st Street, today one of the cultural jewels of the capital city. It began in 1918 as a memorial in honor of Duncan Phillips's beloved brother and father, who died a short time apart. Marjorie Phillips has described her adventures and experiences building the museum and meeting artists, curators, and art luminaries over the years, in her book *Duncan Phillips and His Collection* (1971). As Associate Director (1925–1966) and Director (1966–1972) of the Phillips Collection, she helped to arrange landmark exhibitions such as the Cézanne exhibition that travelled to Boston and Chicago in 1971. Her discerning artist's eye also played a role in selecting new acquisitions for the gallery. The Phillipses particularly believed in giving support to living artists, such as Arthur Dove, whose work had not received proper recognition. They had two children; their son Laughlin is today director of the collection.

Despite this busy life, Marjorie Phillips continued to paint with the full support of her husband. Her work was in three major expositions of the thirties—the 1933 Chicago Century of Progress, the 1939 New York World's Fair, and the 1939 San Francisco Golden Gate Exposition. A one-woman exhibition at the New York Durand-Ruel Gallery in

1941 was followed by others at the California Palace of the Legion of Honor (1950) and the Corcoran Gallery (1955), and by retrospectives at Hamilton College (1965) and at the Marlborough Gallery, London (1973).

Phillips's work can perhaps best be related in approach to that of Pierre Bonnard, an artist whose paintings she very much admires. ''I love nature—the world around me—so much that I continue to paint realistically, sometimes a lyric realism, and I hope sometimes a touch of the classic.''[36]

Intimate interiors, still lifes, and landscapes shown in their idyllic aspects using glowing post-impressionist colors, reflect the world of a culti-

vated person who has always lived in gracious surroundings and enjoyed the company of people who have appreciated beauty as she has. Joseph S. Trovato, in the catalogue of Phillips's Hamilton College retrospective, wrote of

her instinct for rendering what she sees and feels in terms of clearly designed shapes and richly varied tones and color intensities that give a unifying effect of light. . . . These paintings are imbued with . . . poetic charm and feeling of quietude. . . .[37]

Marjorie Phillips often attended baseball games with her husband and sketched the players. *Night Baseball* (1951) captures the excitement and tension between pitcher, catcher, and man at bat in the

Fig. 6-11. Marjorie Phillips, NIGHT BASEBALL (1951), oil on canvas, 24″ × 36″

Fig. 6-12. Constance C. Richardson, FREIGHT YARDS, DULUTH (1954), 16″ × 30″

night-lit green setting—a characteristic, but seldom painted, American scene. Her paintings are in the Whitney Museum, Yale University, the Boston Museum of Fine Arts, and occupy a room at the Phillips Collection.

Constance Coleman Richardson (1905–) is a realist painter of the American landscape who works painstakingly, using classic fifteenth century technical methods learned from museum conservationists:

As the daughter of a historian and the wife of a museum director, I am accustomed to thinking in terms of centuries. Time is long and art and fashion are fleeting.[38]

Her father was head of the history department at Butler College and director of the Indiana State Historical Commission; her great-grandfather, Judge Logan, was a law partner of Abraham Lincoln. With this background it is not surprising that Richardson's paintings are filled with deep feelings for the American scene. An early painting shows the grandly looming Indiana state capitol dome. She has painted a whole series of the Detroit River, where boats carry grain and ore from the Great Lakes. Another series is of distant views of the city and freightyards of Duluth (*Freight Yards, Duluth* [1954] and *Duluth Hillside* [1956]).

She attended Vassar College and then spent three years at the Pennsylvania Academy of Art. There she met Edgar Preston Richardson, a fellow art student, whom she married. Edgar Richardson became one of America's important American art historians and museum directors, and Constance Richardson freely admits the benefit of living surrounded by the works of the old masters.

In the 1930s Richardson exhibited at the Detroit Institute of the Arts, the Chicago Art Institute, and the Schaefer Gallery in New York. *Street Light* (1930) captures the mood of a lamplit, hot summer night on a suburban street, in a starkly simplified architectonic composition reminiscent of Edward Hopper. She has had solo exhibitions at New York's Macbeth Gallery in the 1940s, at the San Francisco Palace of the Legion of Honor (1947), the Kennedy Galleries (1970), and elsewhere.

The Richardsons have spent their summers working in quiet seclusion in different parts of rural America, such as Hastings, Minnesota; Lusk, Wyoming; and the upper Mississippi River. They have assiduously avoided picturesque spots and art colonies. In these places, Constance Richardson often starts painting at dawn to capture the early light in her work, and makes full-color oil sketches on the site before working out her compositions slowly in the studio. She occasionally takes photographs to jog her memory about details, but unlike the photo-realists, she finds it essential to experience directly the vivid sensations of early morning dew and midday heat, the smells, sights, and sounds of the real world. She changes compositional elements, alters the colors, simplifies the forms, and adds figures to develop the structure and emphasize a mood.

Her technical procedures are meticulous; she even cooks her own *gesso ground* (a chalky liquid that gives a brilliant white surface to the painting support), using an ancient rabbit's skin glue recipe supplied by William Sur, the conservator of the Frick Museum. Five coats of gesso are applied to masonite with slow drying between. Finished paintings are dried for a year, rubbed with bread to remove shiny spots, then carefully varnished and polished with a silk cloth.[39] Like the old Flemish paintings, her soundly crafted work will last.

Richardson often uses a muted, gray-green palette—with greens that are mixed from black and yellow. Her paintings frequently use a wide horizontal format, expressive of calm and solidity. One cannot help noticing that telephone poles and wires seldom appear in her compositions—a clue to the fact that Richardson's vision of America, underneath its deadpan realism and despite the presence of freight yards and industrial sites in some of her panoramas, emphasizes the nobility and grandeur of her subjects. She carries the great tradition of the Hudson River School into the twentieth century. Her paintings are at the Whitney Museum, the Detroit Institute of the Arts, the Pennsylvania Academy of the Fine Arts, and elsewhere.

Laura Wheeler Waring (1887–1948) was a noted black portrait painter whose sitters include such famous black figures as historian W.E.B. Du Bois (1945) and artist Alma Thomas (1945). She painted in a realistic and approachable way, with intimacy of characterization and a warm regard for her subject. Typical of her broadly brushed style is *Anne Washington Derry*.

Born in Hartford, Connecticut, Waring studied at the Pennsylvania Academy of the Fine Arts and won a Cresson Traveling scholarship at graduation. After studying at the Académie de la Grande Chaumière in Paris (1924–25), she returned and taught art at Cheyney State Teachers College in Pennsylvania.

Waring won a Harmon Gold Award in Fine Arts in 1927 and exhibited in the Harmon shows, which showcased black talent, in 1928 and 1931. Her work has been widely exhibited at the Art Institute of Chicago, the Smithsonian and Corcoran museums, the Pennsylvania Academy, and elsewhere.

Other Regionalists and Realists

Some other regionalists and realists of the 1930s are: André Ruellan (1905–), Woodstock artist, muralist, regional painter of New York and the South, and Guggenheim winner; Lauren Ford (1891–), painter of whimsical Connecticut country scenes; Agnes Tait (1897–), muralist and illustrator; Henriette Wyeth Hurd (1907–), painter of Mexican and Indian types in New Mexico landscape settings (the daughter of illustrator N. C. Wyeth and sister of painter Andrew Wyeth); Doris Rosenthal, painter of American genre scenes and scenes of Mexican life; Katherine Schmidt; and Molly Luce.

Two outstanding figure painters of the 1930s are: Gladys Rockmore Davis (born 1901) and Ann Brockman (born 1898).

Georgina Klitgaard (1893–), a well-known Woodstock landscape painter (see chapter 5), painted murals for the federal projects and traveled in Europe on a Guggenheim Fellowship.

Modern and Abstract Painting

The Solomon R. Guggenheim Museum, a dramatic spiral-shaped structure on Fifth Avenue and 88th Street in New York, owes its existence largely to a dynamic German-American woman artist, the **Baroness Hilla Rebay von Ehrenweisen (1890–1967).** She met Solomon Guggenheim, the mining tycoon, opened his eyes to the significance of modern art, and became the moving spirit behind the new museum that grew out of his collection. Her passionate devotion to nonobjective painting had an important influence on an entire generation of American artists.

The Baroness Hildegard Anna Augusta Elisabeth Rebay, daughter of Baron Franz Joseph Rebay, a career army officer from Bavaria, was born in Strasbourg, Alsace. She received her early training in the Düsseldorf Academy and in Paris and Munich. But by 1914 she had already left traditional art behind her and was exhibiting with such avant-garde groups as the Secession in Munich, the Salon des Indépendants in Paris, the November Gruppe in Berlin (1918), and the Krater (1920). In 1917 she exhibited in Berlin at Herwarth Walden's gallery, Der Sturm, where she encountered many modern artists who were also showing there—Vasily Kandinsky, Marc Chagall, Robert Delaunay, Paul Klee, and Rudolf Bauer. Rebay regarded Bauer as a genius and supported him for many years.[40]

In 1927 Rebay came to the United States and was soon introduced to Solomon R. Guggenheim of the Swiss-American mining dynasty, who commissioned her to paint his portrait. Up to this point, Guggenheim and his wife Irene had been conventional collectors of old-master art in the tradition of other tycoon collectors like Henry Clay Frick and J. P. Morgan. It is easy to imagine the energetic Rebay dabbing the canvas while enthusiastically describing to her millionaire sitter, in German-accented English, the wonders of the modern art movements in which she had been so active in Germany. Before long, she was bringing him to the studios of nonobjective painters, eagerly discussing with him the significance of the works of Kandinsky and others, and encouraging Guggenheim to become a collector of avant-garde art.

Guggenheim's apartment in the Plaza Hotel was soon filled with these works, and Rebay rented an office in Carnegie Hall to supervise them. The collection grew until, in 1937, a foundation was incorporated with the intention of creating a new museum of nonobjective art.

In 1939 the Solomon R. Guggenheim Museum of Nonobjective Painting (also called Art of Tomorrow) opened in rented gallery space on 54th Street. From the beginning, Rebay demonstrated distinctive showmanship in the way she presented the works. They were spaced with fanatical care against chaste, modern backgrounds.

Rebay had strong opinions and prejudices about

modern art. She was passionately devoted to the totally nonobjective works of the Dutch De Stijl Group—Piet Mondrian, Theo van Doesburg, Georges Vantongerloo, and the Bauhaus artists such as Laszló Moholy-Nagy, Klee, and Kandinsky. Although she advocated totally nonobjective art, under her aegis the collection acquired works by Georges Seurat, Henri Matisse, Henri Rousseau, Franz Marc, Lyonel Feininger, Pablo Picasso, Fernand Léger, and others.

By 1948 the foundation had bought land on Fifth Avenue between 88th and 89th Streets, and Frank Lloyd Wright was commissioned to design a building that, it was hoped, would match the collection in the daring modernity of its design. Meanwhile, the art works were temporarily displayed in a six-story mansion located on the grounds.

Rebay created an unforgettable, hushed, otherworldly atmosphere at this interim museum. An all-gray background—gray fabric walls and gray velvety rugs—provided a subdued atmosphere against which the paintings, in specially designed flat gold or silver frames, gave an effect of quiet richness. Bach recordings were played while visitors looked at the work, and clusters of calla lilies were placed at intervals in the rooms to add to the slightly funereal atmosphere. People coming in from the noise and bustle of the streets found themselves transported into a seemingly higher spiritual dimension.

In addition to her role as director of the Guggenheim museum, Rebay became the mentor of a group of young American artists. She gave money for supplies to starving young abstractionists who came twice a month to show her their nonobjective paintings, and she exhibited their work in shows of new talent. Perle Fine, for example, was an early woman protégée, and the struggling Jackson Pollock was able at one point to eke out an existence as a museum carpenter and janitor.

Rebay, "the stormy petrel of nonobjective art,"[41] was often the target of attacks. She was called "reactionary" because of her high-handed autocratic manner and mystical philosophy. Her view of nonobjective art as a pure form that reached into a nonmaterial, metaphysical realm, brought down the wrath of realists and of socially conscious left-wing artists, as well as that group of painters who saw abstract forms as a new kind of investigation of nature—not as supernatural experiences.

Rebay also suffered from anti-German sentiment during World War II. She endured an ordeal when she was denounced as a German spy, but soon cleared herself after an investigation. According to her biographer, Rebay's pain over this episode was aggravated when she discovered that the ungrateful Bauer, whom she had subsidized and promoted in United States, had spread the false rumors because he was jealous of her position.[42]

Two years after Guggenheim's death in 1949, the Baroness stepped down from the directorship of the

Fig. 6-13. Hilla von Rebay, ANIMATO (1941–42), oil on canvas, 37" × 50¼"

museum, but remained a trustee. She had, throughout her tenure, continued to paint and exhibit in the United States, from her first 1927 show at the Worcester Museum until her last 1962 show at French and Company. Using a wide range of geometric shapes, the artist created nonobjective compositions that often derive their rhythms, colors, and "sonorities" from musical themes, as in *Animato* (1941). She also made nonobjective collages like *Receding* (1917), beginning as early as 1916—a very early date, indeed.

Yet, it is undoubtedly as an influence on American taste and as the creator of a great American collection that Rebay will be most remembered. Many Americans first saw the works of Kandinsky and other nonobjective painters at the important exhibitions held under her direction at the Guggenheim Collection, or in traveling modern art loan shows she organized and sent across the country.

Gertrude Glass Greene (1904–1956), a charter member of the American Abstract Artists, was a pioneer abstract painter-sculptor whose wood constructions have only recently, over twenty years after her death, begun to receive appropriate recognition. In the *College Art Journal*, Peter Walch, reviewing a revival exhibition of the work of the American Abstract Artists at the University of New Mexico, said:

With certain works one feels confronted with an odd time-warp sensation of ideas taken up by even more recent artists. Gertrude Greene's *Construction Grey* of 1939 . . . is a . . . wood relief whose odd, clunky rhythms amazingly enough predict (however fortuitously) Frank Stella's most recent pieces.[43]

Known inexplicably to her friends as "Peter," Gertrude Glass was born in Brooklyn and studied sculpture at the Leonardo da Vinci Art School in New York City between 1924 and 1926. In 1926 she married painter Balcomb Greene, and between

Fig. 6-14. Gertrude Greene, CONSTRUCTION IN BLUE (1937), mixed media, painted wood

1926 and 1931 they zig-zagged back and forth between New York, Vienna, and Paris, studying the latest art movements. In 1931 the Greenes returned to New York City, where Gertrude maintained a studio in Greenwich Village until her death.

Greene was an early constructivist of the clean, hard-angled variety. A founding member of the American Abstract Artists, she was present at the group's first informal gathering in Ibram Lassaw's studio and continued to exhibit steadily with it

through the years. Photographs show her staffing the desk at the first exhibition in the Squibb Gallery in New York in 1937, distributing a questionnaire to visitors to record their reactions to the art on display. She was also a founding member of the Federation of Modern Painters and Sculptors, the Sculptors Guild, and the Artists Union.

Before 1935 Greene created free-standing sculptures. Beginning in that year, however, she began to construct wood reliefs, often painted in color, which combine the elements of both painting and sculpture, and are balanced arrangements of organic and geometric forms. Today *White Anxiety* (1943–44) *Construction in Blue* (1937), and *Space Construction* (1942) seem to forecast remarkably the art of the 1960s. In 1935, with fellow sculptor Ibram Lassaw, she bought a steel forge and experimented with sheet-metal sculpture.

In the 1940s the Greenes bought a hundred-foot stretch of ocean-front land on a deserted cliff near Montauk, Long Island. There, in sight of the gulls and the sea, but far from telephone lines and electricity, they built a summer home with their own hands, a task that took many years. The first summer they slept in a 6 × 8 foot dugout, pulling in their tools and bags of cement with them at night to protect them from the wet night air. They completed one room that first summer, and in subsequent years, enlisting the help of their visiting friends—artists, writers, and psychoanalysts—they finished the house. Stark and simple, with large windows facing the sea, it was an unconventional home for unconventional people. Gertrude Greene is described by friends as a vivacious, talkative person with "advanced views" on everything, who loved to cook for large groups.

Greene taught herself to paint and do collages. In fact, her painting was in the 1951 exhibition "Abstract Painting and Sculpture in America" at New York's Museum of Modern Art. Her first solo show at the Grace Borgenicht Gallery, in 1951, was followed by another at the Bertha Schaefer Gallery

in 1955. In this exhibition her textured palette-knife paintings were described in the *New York Times* as achieving a "soft inner glow and a feeling of landscape . . . her colors, the terra cottas, dove grays, mauves and greens of the forest."[44]

Greene's untimely death of cancer was deeply mourned in the art community. She is recognized today as a bold pioneer of constructivist, nonobjective sculpture. The Whitney Museum included one of her reliefs in its bicentennial survey *Two Hundred Years of American Sculpture* (1976).

Alice Trumbull Mason (1904–1971) was a charter member and at times an officer of the American Abstract Artists. A pioneer of American nonobjective art, her subtle geometric paintings are only now beginning to achieve wide recognition.

Born in Litchfield, Connecticut, Alice Trumbull was a direct descendant of John Trumbull, one of America's great painters of the American revolutionary period. Another ancestor was the first governor to rally behind George Washington.

Her father was independently wealthy, and although trained as a lawyer, he never practiced, but spent long periods traveling abroad with his family. During a stay in Italy in 1921, at age seventeen, Trumbull studied at the British Academy in Rome. She convinced her parents to return to New York so that she might study at the National Academy of Design with Charles Hawthorne, a follower of William Merritt Chase.

In 1927 Trumbull transferred to the Grand Central Art Galleries School and studied with Arshile Gorky. Gorky, a vociferous Armenian immigrant who later committed suicide, was a legendary romantic of the American modern movement, credited by many with being the father of the Abstract Expressionist movement of the 1940s. A modernist to the core, he said of social realism that it was "poor painting for poor people." Gorky was the first to open Alice Trumbull's eyes to cubism and modern art.

In 1928, during a trip to Italy and Greece, Trumbull became keenly aware of the geometric abstract design in Byzantine mosaics and archaic Greek sculpture, and after returning, painted her first geometric abstractions in 1929.

She stopped painting altogether for several years after her marriage in 1930 to Warwood Mason, an officer of the American Export Line whom she met on the sea voyage to Greece. While her two children were small, and her husband was frequently away at sea, she restricted herself to writing poetry. "Kalamabakka," a poem in which she showed her interest in words as abstract *sounds,* was published in the *American Poetry Journal* in 1934. In 1935 she returned to painting and was the sole abstractionist in the Washington Square art show that same year.

Mason was present at the creation of the American Abstract Artists in 1936, and served as treasurer, secretary, and president at various times through the years. In the U.S. in the 1930s, abstract painters were a small group, attacked by hostile citizens and critics. In an attempt to thaw the freeze-out by museum curators, they picketed the Museum of Modern Art to demand that the works of living American abstractionists be shown.

Mason wrote a statement for the 1938 American Abstract Artists Yearbook, entitled "Concerning Plastic Significance," in which she traced the formal elements in great ancient art, but added that artists today "are free of the limitations these artists knew. . . . The field of painting is too great to be bound to any literary content and this is why he breaks with the past and looks into a new experimental world."[45]

In paintings of the 1930s, such as *Free White Spacing* (1934), Mason essayed biomorphic forms, somewhat resembling the work of Joan Miró. But after meeting Piet Mondrian in 1942, she was strongly influenced by the latter's vertical and horizontal rectangular schemes. Her subtle color schemes are, however, clearly distinguishable from Mondrian's bright, primary colors. That same year

Fig. 6-15. Alice Trumbull Mason, MEMORIAL (1958–59), oil on composition board, 36" × 28"

her first solo exhibition was held at the Museum of Living Art (New York University), followed by another at the Rose Fried Gallery in 1948. She also studied etching at Stanley Hayter's Atelier 17.

In the late fifties and sixties her work became simpler and stronger, with fewer shapes, in paintings like *Magnetic Field* (1951) and *Magnitude of Memory* (1962). Increasingly, she perfected a sense of architecture in her deceptively simple, pared-down compositions. Mason organized them so they could be seen in balance from all four directions, aiming, as she said, for "the sense of every part bearing its proper stress."[46] With true respect for craftsmanship, she even made her own oil paints to achieve certain refined distinctions of color.

Alice Mason received little critical attention during her lifetime, and her later years were saddened by her son's mysterious death at sea in 1958. The artist expressed her grief in a painting, *Memorial* (1958–59), based on the trinity motif. Three shapes rise up in monumental vertical pillars that suggest hope and aspiration, while the crossed triangles imply the irrevocable finality of death. The cold, dark blue and black colors emphasize the sense of tragedy.

Oppressed by lack of recognition after a lifetime of dedicated work, she reportedly became increasingly isolated and reliant on alcohol toward the end of her life.[47] In 1973 the Whitney Museum of American Art held a posthumous retrospective exhibition of her work, for which Robert Pincus-Witten wrote the first major estimate of her oeuvre. Since then there have been exhibitions at the University of Nebraska, the Montgomery (Alabama) Museum of Art, the University of Georgia at Athens, and the Washburn Gallery in New York.

Rosalind Bengelsdorf (Browne) (1916–1979), another founding member of the American Abstract Artists, painted one of the first abstract murals in the United States for the Federal Art Project. Looking at the high-powered explosion of abstract art in the 1960s and '70s, Bengelsdorf wrote: "Frankly, the majority of current styles amount to a repetition of what was done then—only now production is done on a larger, costlier scale. . . . The real difference is that we didn't become prosperous doing it."[48] She contended that the ground-breaking work of the American Abstract Artists is still not properly understood.

Born in New York City, she studied at first with Anne Goldthwaite, George Bridgman, John Steuart Curry, and Raphael Soyer—all realist teachers at the Art Students League. At the League she met Arshile Gorky, the precursor of Abstract Expressionism, who visited from time to time from the Grand Central School where he was teaching. He took her to the Museum of Modern Art, where she saw (but did not understand) her first green-haired Picasso. Bengelsdorf much preferred a charming painting of a titian-haired woman by Renoir.

A year of study at the Annot School in 1934–35 taught her to analyze abstract form, and after that she enrolled in Hans Hofmann's first private school on 57th Street. Hofmann had a profound effect on her. Bengelsdorf began to see the analogy between modern painting and the new understanding of the scientific world in physics.

Hofmann taught his famous "push-pull" theory of the interaction of all forms on the canvas, the role of negative as well as positive shapes, and the forward-backward movements created by color. "Nothing is static or empty in nature,"[49] he said, and likewise no form on a canvas should be. The problem in painting, he explained, is to maintain the integrity of the flat picture surface, to avoid making "holes" in the picture, while at the same time creating many depth levels that move back and forth, expand, contract, and merge in vital complexities.

Bengelsdorf, Gertrude Greene, and Alice Mason were in the small group of artists who met informally at Ibram Lassaw's studio to form the American Abstract Artists in 1936. In their first exhibition in 1937 at the Squibb Building, each member contributed a lithograph to a print folio containing thirty-nine prints, which sold for fifty cents (!) to raise money to defray the expenses of the exhibition. Abstract art had little acceptance at that time, and several of the artists literally went hungry.

In 1938 Bengelsdorf and Mason were chosen to write position papers for the catalogue yearbook of the organization. In an essay called "The New Realism," Bengelsdorf took the position that abstract artists are not remote from the material world, but are expressing a new and profounder understanding of reality. They are showing more than the simple external appearance to the eye; they are revealing what they understand about the

Fig. 6-16. Rosalind Bengelsdorf (Browne), UNTITLED STUDY FOR MURAL FOR CENTRAL NURSES HOME, WELFARE ISLAND, N.Y.C. (c. 1937–38), oil on canvas, 20″ × 54½″

interacting forces between the object and its environment.[50]

Bengelsdorf felt that abstract artists were not escaping from their obligations to society, but instead were helping to build a better social order. In answer to attacks from social realists, she said:

Our present civilization is caught in the maelstrom of economic disorder and changing standards. An intense need for constructive thought predominates. The message of abstract painting, when utilized to serve this need will be found to ring in accord with the life concerns of those great economists whose prophesies and plans are being notably fulfilled.[51]

Bengelsdorf and a group of her colleagues were opposed to the mystical position taken by Hilla Rebay, of the Guggenheim Foundation, and certain other nonobjective painters who were seeking a religious other-world, hidden behind the facade of reality.

In 1938 Bengelsdorf painted a large abstract mural at the Central Nurses Home on Welfare Island in New York City for the Federal Art Project, which rarely commissioned abstract art. Although Arshile Gorky's Newark Airport mural is always mentioned as a milestone, hers was equally innova-

tive. Bengelsdorf's mural, combining straight-edged and biomorphic forms in a manner that relates to Picasso's Cubism, was subsequently destroyed. But her *Study for Mural, Central Nurse's Home* (1937–38) is in the University Art Museum at the University of New Mexico.

In 1940 Bengelsdorf married abstract artist Byron Browne. After her son was born she took up criticism, writing, and teaching, while continuing to paint on a part-time basis. Like many women of that era, she felt that her husband's career as a painter was more important than her own. A spokeswoman for abstract art in the United States, her articles appeared in a variety of art publications, and she served as an editorial associate for *Art News* until late 1972 and taught classes in creativity at the New School for Social Research until her death.

Anni Albers (1899–), the famous weaver, brought the Bauhaus tradition of geometric and functional design to the United States in the 1930s. She was born in Berlin, and for seven years (1922–1930) attended the Bauhaus, a pioneering school of modern design in Germany. She married her profes-

sor, painter Josef Albers, in 1925 and was already well known for her "pictorial weavings" in severe vertical-horizontal constructivist forms (*Tapestry* [1927]) when Hitler shut down the Bauhaus in 1933. The Alberses fled to the United States and became U.S. citizens.

They were immediately invited to join the faculty of Black Mountain College in North Carolina, an innovative school that was the breeding ground for many creative artists after World War II. As assistant professor of art, Anni Albers set up the weaving workshop and during the next sixteen years encouraged several generations of students to experiment freely with materials and explore the potentialities of the handloom and the machine process. She urged artists to create anonymous, timeless, functional designs for mass production: "Not only the materials themselves, which we come to know in a craft, are our teachers. The tools, or the more mechanized tools, our machines, are our guides too."[52] Anni Albers influenced Ruth Asawa, Sue Fuller, Sheila Hicks, and many other artists, and helped to revolutionize art education and industrial design in America.

In 1949 the Museum of Modern Art, recognizing that her compositions in thread were fine art, sponsored a one-woman show of her weavings—the first such exhibition ever held there. Her books *On Designing* (1959) and *On Weaving* (1965) are classics, and her writings have the same pristine clarity as her designs.

After Josef Albers became director of the Yale University School of Fine Arts in 1950, the couple moved to Connecticut, and Anni Albers continued to design textiles for industry, and created handloomed works of art (which she framed under glass). Her work became more informal, incorporating irregular weaves, knots, and designs influenced by her researches into Peruvian and other ancient methods of weaving, as evidenced by *Pasture* (1958) and *Variations on a Theme* (1958). In 1961 the American Institute of Architects awarded

her a gold medal in the field of craftsmanship. In 1965 she wrote the entry on hand weaving for the Encyclopedia Brittanica.

Albers began to make prints for the first time when her husband was invited to be an artist-in-residence at June Wayne's Tamarind Lithography Workshop in California. "As a useless wife, I was just hanging around,"[53] the famous designer said laughingly, when June Wayne invited Albers to try lithography with her husband. Her abstractions of intertwined thread motifs were so exciting that she was invited back as artist-in-residence, an offer that resulted in a suite of lithographs, *Line Involvements* (1964).

Since then she has made lithographs, etchings, and silk-screen and photo-offset prints. Like a true Bauhaus disciple, Albers allows the machine process to lead her into new techniques of embossing, overprinting, and so forth. Using repetitions of pristine geometric elements, such as triangles or maze-like rectangles, she maps out gridlike compositions on graph paper, carefully organizing them as "internal irregularities-within-regularities." They have a quiet, mysterious vitality and variety based on intuition, and are not mathematically systematized. Examples are *TR III* (1970) and *Red Meander* (1969).

Albers has been a key figure in breaking down the artificial boundaries between "art" and "craft" in America. A stringent critic of poor industrial design, she has promoted a "cerebral art predicated on a beauty existing within the discipline of hard, clean thought."[54]

Irene Rice Pereira (1907–1971), another pioneer of American nonobjective painting, could be called a "metaphysical constructivist." On a trip to the Sahara Desert in the early 1930s, she looked out over the endless stretches of sand in the blazing sunlight and had a sudden vision of infinity—which, in the following years, she tried to express in some of the most innovative paintings of the decade.

She was born in Chelsea, near Boston, the oldest of four children of Emanuel Rice, a Polish immigrant who moved the family many times and changed businesses frequently, finally settling in Brooklyn, New York. Her father called her "Gypsy." An intense, imaginative, and introspective child with mystical visions (one was of the sun as a god), she was a voracious reader and once tried to write a book about Joan of Arc.

When Rice was fifteen her father died. Her mother was ill, and because she bore the full responsibility of supporting two sisters and a brother, she was forced to abandon academic high school courses and study stenography. Under this pressure she completed three years of school in six months and went to work in an accountant's office.

Even with this inauspicious early life, Irene Rice had developed a thirst for knowledge. In the next four years she took night classes in literature, clothing design, and art. The art classes at Washington Irving High School were so stimulating that she enrolled in the evening session at the Art Students League in 1927, where teachers Jan Matulka (a Czech cubist) and Richard Lahey introduced her to the world of modern art. In her classes she became friends with a group of students who were to become leaders of the American abstract art movement—David Smith, the sculptor; his wife, sculptor Dorothy Dehner; and Burgoyne Diller, an abstract painter in the manner of Piet Mondrian.

In 1929 Irene married her first of three husbands—Humberto Pereira, a commercial artist, and by 1931 she had saved up for a trip to Europe, alone. She hoped to study with purist Amadée Ozenfant at the Académie Moderne in Paris. But when the curriculum turned out to be the stale traditional one of drawing from the model, she quit after a month and went on an odyssey through Italy and down to North Africa—a crucial journey.

In the Sahara desert she was moved by an almost transcendental experience, which she later described as a turning point in her life. From then on she tried to express the quality of infinity and light in her work.

Back in New York in 1932, her first solo show at the American Contemporary Artists Gallery consisted of paintings of anchors, ventilators, and other machine parts of the S.S. *Pennland* (sketched during her transatlantic voyage). This was followed the next year by abstract images of humans pitted against giant machines, somewhat in the manner of Fernand Léger.

In 1935 the government art program entered her life. She became a founder and teacher in the Federal Art Project Design Laboratory in New York, an experimental workshop which emulated the Bauhaus. (The Bauhaus was a renowned design school in pre-Hitler Germany where artists in all fields came together to create a new aesthetic for the machine age.) At the Design Laboratory, Pereira felt free to try materials like glass, plastic, and parchment, and all kinds of textures; she also began to use pure geometric forms such as rectangles, trapezoids, and triangles. To these innovative works she added spatter, stain, thick-combed paint, sand, gold leaf, and incised lines, and she also pressed netting into the paint.

In 1939 she made her first paintings on glass and translucent parchment. By 1947 she was superimposing several layers of painted corrugated glass, one over the other, to create multiple reflections, as in *Undulating Arrangement* (1947). In all her work she evoked a primeval sense of light emanating from the heart of her painting, often achieved by leaving a glowing white space somewhere near the center, which she called "the plane of infinity."

John I. H. Baur of the Whitney Museum, who knew Pereira personally, saw her as an almost schizoid combination of logic and passion. Despite the logical geometry of her abstractions, when she worked she was "seized by a kind of creative hysteria; she weeps and sings and draws—violently and with both hands. . . . The two Pereiras become, by some alchemy, a single artistic personality, so

Fig. 6-17. I. Rice Pereira, UNDULATING ARRANGEMENT (1947), oil on masonite and glass, 23⅝″ × 17¼″

that the passion of the one enters into and illuminates what might easily be the rather chilly geometry of the other."[55] She was at times completely taken over by an inner rhythm that so possessed her that at her peak, she would work sometimes on twenty paintings during a single day.

In 1950 she married her third husband, George Reavey, a poet and teacher and spent the following year with him in Manchester, England. The dreary climate cast a pall on her spirit, and caused her to return to the United States early, acutely aware of her craving for light and sun, both in her art and in her environment.

Her experiments in painting began to be accompanied by complicated metaphysical theories about the nature of the universe, the fourth dimension, and the new era in physics. In a curious mélange of mysticism and science, she developed ideas that she expounded in lectures and in books such as *Light and the New Reality* (1951) and *The Paradox of Space and the Simultaneous Ever-Coming to Be* (1955). Pereira corresponded with museums, universities, and intellectuals around the world and was awarded an honorary doctor of philosophy degree by the Free University of Asia. She believed that through geometric forms the artist can "find plastic equivalents for the revolutionary discoveries in mathematics, biochemistry, and radioactivity."[56] In her work she tried to evoke a cosmic sense of "the reality of space and light; an ever-flowing . . . continuity . . . infinite possibilities of change."[57]

Pereira was in the Fourteen Americans exhibition at the Museum of Modern Art in 1946 and was given a joint retrospective with Loren MacIver at the Whitney Museum in 1953. After more than fifty one-woman shows and forty years of experimentation, her health began to suffer. She moved to Marbella, a vacation resort on the Spanish Costa Del Sol, and spent her last years painting in the blazing sunlight of the Mediterranean coast. Her last series of paintings suggests a luminous sea and sky, over which hover transparent planes that look something like "music clefs."[58]

Pereira's paintings on layered glass are unique. Yet her idiosyncratic work was oddly neglected in recent years and is only now being properly reassessed for its vanguard role.

Surrealism and Fantasy

Loren MacIver (1909–) transforms the ordinary things around her—rain on a taxi window, oil slicks on the street, a torn windowshade—into poetic, semiabstract paintings. Critic James Thrall Soby has described her work as "shy, tiptoe art,"[59] and MacIver herself seems to come from another world. She speaks in a whisper—quiet and elusive—like someone who has spent her life in contemplation. She has never been under the sway of any teacher, artist, or movement. In fact, she is almost entirely self-taught; yet she has earned a unique place in modern American art.

MacIver was born in New York City to Charles Augustus Newman and Julia MacIver. Her mother kept her own Scots-Irish name and her daughter also adopted it. MacIver began painting as a child, and by the age of ten was enrolled in Saturday classes at the Art Students League. She studied there for a year—her entire formal training—and even during that year spent the time wandering in and out of the different studios.[60]

She continued to paint during her spare time throughout high school, in a natural un-self-conscious way, without any thought of a career. At twenty she married a high school chum—the poet Lloyd Frankenberg. They lived over a bakery on MacDougal Street and in different Greenwich Village locations in the following years.

The couple spent summers on Cape Cod in a shack they built themselves out of driftwood. Some of MacIver's earliest works were inspired by observations of beach debris and sand dunes on the

Cape. *Tern Eggs* (1933), in which the ordinary natural forms glow like jewels, shows her characteristic meditative wonder at simple things.

Between 1936 and 1939 MacIver worked on the Federal Art Project, another example of rare talent developed with the help of government sponsorship. Alfred Barr began to buy her work, and in 1935 the Museum of Modern Art purchased *Shack* (1934). In 1938 Marian Willard sponsored her first one-woman exhibition at the East River Gallery in New York City.

In the 1940s MacIver's city paintings reached full development. *Hopscotch* (1940) is typical of her approach. At first, the image suggests some strange abstract insect or creature. The fragile chalk marks of a child's hopscotch game at the right make one peer closer. Slowly the viewer realizes that this "design" or "insect" is actually a piece of cracked, broken, swollen asphalt pavement. Further metaphoric implications emerge—the fresh, but fleeting imagination of the child's game is contrasted with the stale erosion of time.

Paintings of other city subjects include *Pushcart* (1944), *Window Shade* (1948), and *The Violet Hour* (1943). To obtain certain glowing, mysterious color effects, MacIver frequently stains, or "bleeds," her colors into areas and then uses pictographic accents or patterns for contrast.

In 1948, after considerable success with her shows at the Pierre Matisse Gallery in New York, she and Frankenberg traveled to France, Italy, England, and Ireland. All over Europe MacIver made "scrawls" in her notebooks, jotting down the essence of certain scenes. These observations resulted in works like *Cathedral* (1949), which captures the jewel tones of stained glass at Chartres, *Venice* (1949), and *Dublin and Environs* (1950).

Resuming scenes of city life and nature, MacIver became less interested in the decayed poignancy of torn shades and broken sidewalks. She preferred instead the sparkle and iridescence of an *Oil Slick* (1940), or as in *Taxi* (1952), the explosions of color

Fig. 6-18. Loren MacIver, PUDDLE (1945), oil on canvas, 40" × 29"

in rain on a taxi window reflecting the neon of the city.

MacIver has been compared with Paul Klee and Odilon Redon in attempts to describe the curious quality of her work. She has sometimes been called a romantic, at other times a surrealist because of her ability to evoke subconscious responses to forms in nature and "project them as abstract gossamer."[61]

Although her work generally can be described as poetic and dreamlike, she varies the approach. Sometimes she uses a cutaway X-ray view into the interior of a house, or shows a city scene in horizontal bands of pictographic figures, one below the

other, in the manner of a very knowing child. On the other hand, she may focus on a close-up of a puddle of water with a ginko leaf floating in it (*Puddle* [1945]). This variety results because Mac-Iver has never followed a "style" or "school," but allows each subject to call up its own response or treatment.

Gertrude Abercrombie (1908–1977) was a Chicago surrealist with a droll, off-beat personality. Her paintings relate vaguely to René Magritte and Giorgio de Chirico, but they are more primitive and very personal in their strange imagery.

Abercrombie came from a well-to-do Chicago North Shore family, married and divorced a successful lawyer, and remarried a jazz impresario, Frank Sandiford (at a be-bop ceremony with Dizzy Gillespie officiating). For many years she was deeply involved with jazz and music, as well as art. She held Saturday night sessions at her three-story brick town house in Hyde Park, where Billie Holliday, Dizzy Gillespie, Sarah Vaughan, and others held forth. She was also a good friend of authors Thornton Wilder, James Purdy, and Michael Wilcox.

Abercrombie studied commercial art for a time at the University of Illinois, but was largely self-taught. She was on the Federal Art Project in the 1930s and was associated for a long time with a group of Chicago artists—Julio De Diego, Julia Thecla, and others—who used fantasy imagery. Chicago has been the home of a steady stream of surrealists and fantasists, leading directly and without interruption from Ivan Albright to contemporary Chicago artists like Ellen Lanyon, or the "Hairy Who," a group of present-day Chicago imagists who employ brutal and grotesque forms.

Helen Lundeberg (1908–), known today as a hard-edge painter, cofounded one of the few independent avant-garde movements of the thirties—California postsurrealism. Lundeberg was born in Chicago and came to California at the age of four. In

1930, at twenty-two, she registered at the Stickney Memorial School of Art in Pasadena, where Lorser Feitelson, a new instructor, immediately noticed and began to influence her. She described her three years of training as "an analytical approach to art structure and art history with Lorser Feitelson."[62]

She and Feitelson (an early modernist who had known Giorgio de Chirico and others in Europe), became a well-known artist couple in Southern California. Lundeberg was a precocious draftswoman, and after only a year of study, while still in school, her work was accepted in the Southern California Annual Exhibition at the San Diego Fine Arts Gallery. The following year her *Landscape with Figure* won honorable mention at the annual exhibition of the Los Angeles County Museum.

In the late 1920s the European surrealists, drawing on the discoveries of Sigmund Freud, had begun to paint the world of dreams, often using automatic, intuitive imagery that welled up from the subconscious, and attempting to avoid any interference from the rational intellect. Helen Lundeberg and Lorser Feitelson accepted imaginative, dreamlike imagery, but went a step further. Beginning in 1933 they attempted to reconcile subjective, introspective material with the logical and rational conscious mind. Lundeberg wrote the theoretical manifesto to accompany their first Post-surrealist exhibition in California.

In 1935 Lundeberg was acclaimed for her painting *Double Portrait in Time,* which shows a child casting the shadow of an adult on a wall. Lorser Feitelson organized an exhibit of the California Post-surrealists at the Brooklyn Museum in New York in 1936, and in a *New York Times* review illustrated with her painting, art critic Edward Alden Jewell described her as "handling a brush with cosmic authority."[63] She was in the Museum of Modern Art's "Fantastic Art, Dada, and Surrealism" exhibit in 1936. There she was grouped with those who were related to, but not actually part of, the Dada and Surrealist movements.

Fig. 6-19. Helen Lundeberg, DOUBLE PORTRAIT OF THE ARTIST IN TIME (1935), oil on fiberboard, 48" × 40"

Lundeberg has been called a "poet among painters." Personally, she has been described as "very private," and her work has an uncanny quietude combined with enigmatic metaphysical overtones. In *The Red Planet* (1939), for instance, she creates mysterious ambiguities between limited space and infinity. A red doorknob on a door suddenly reverses itself and can also be read as Mars, the red planet, moving in deep space. Unlike the surrealists, however, her lyrical shapes, colors, and forms, have an ordered classicism totally different from the chaos of the dream, and her themes are clearly readable.

Lundeberg became an easel painter and muralist for the Southern California Federal Art Project between 1933 and 1941. Her mosaic wall for Cen-

tinela Park in Inglewood, California, is perhaps the longest work executed for the New Deal. The artist decorated the 245-foot curved outdoor wall with *The History of Transportation* (1940) in petra-chrome, a kind of inexpensive mosaic made of colored cement embedded with marble chips. She also painted various historical murals and collaborated on a school mural with Grace Clements, another early California modernist. Lundeberg is described by Southern California artists on the Federal Art Project as an efficient leader and organizer in her own quiet way, supervising groups of skilled workmen.

In her opinion, the value of federal art patronage was that it

made it possible for me to work full time as a professional artist at a time when the 'art market' was extremely depressed. It also . . . gave my general self confidence a boost . . . obliged me to undertake things I might not otherwise have dreamed of doing. It was a good experience, but I don't think that what I did for the Project had much, if any, influence on my later work. I had continued to paint 'for myself' on my own time, and as soon as the art project ended I began a series of very *small* and personal paintings—a reaction to the impersonal and public aspects of mural painting.[64]

In the 1940s Lundeberg continued Post-surrealist explorations; *The Veil* (1946) shows the daytime world as a kind of veil being pulled aside to reveal a dark, endless night. In the early 1950s she began to paint poetic still lifes and landscapes, or perhaps "mindscapes," in muted colors using very few flat shapes with clean edges.

In 1959 Jules Langsner coined the term "hard-edge" to describe the work of the avant-garde California group that had been working throughout the fifties in flat abstract shapes of unmodulated color areas. Lorser Feitelson, John McLaughlin, Karl Benjamin, Frederick Hammersley, and, later, Florence Arnold, of Fullerton, California, were in this group. Lundeberg also exhibited with them but she always maintained a separate identity. The others painted nonobjective canvases, but Lundeberg never

wished to let go completely of subject matter or of three-dimensional space. The artist set herself the complex task of suggesting a landscape, interior, or still life, and at the same time reducing it to a satisfying hard-edge abstraction. Although she has never painted a landscape from nature, the Southern California ambience of sea, sky, and desert is strongly felt in works like *Desert Coast* (1963) and *Waterways* (1962).

Lundeberg had a 1971 retrospective at the La Jolla Museum of Modern Art and another in 1979 at the Los Angeles Municipal Art Gallery. When Lorser Feitelson died after fifty years of work alongside her in the same studio, a 1980 double retrospective at the San Francisco Museum of Modern Art pointed up their sharply individual and separate characteristics.

Lundeberg's 1935 painting *Double Portrait in Time* shows a child with a flower and a clock set at a quarter past two, symbolizing her age. The little girl is casting a shadow of an adult who also appears in a portrait on the wall. The adult in the portrait is staring at the miraculous form of a flower.

Over forty-five years ago Lundeberg forecast her wonder at the miraculous forms in the natural universe, a wonder that continues to this day. Other qualities that appear in her first paintings, such as classicism, lyricism, subtle color, and a sense of inner calm are still present in such recent works as *Aegean Light* (1973)—a hard-edge painting that suggests brilliant sunlight on white buildings and blue sea. Lundeberg is increasingly recognized as a major American artist of the last four decades.

Women Sculptors of the Thirties

In the 1930s a progressive group of American sculptors, influenced by modern movements abroad, began to simplify and stylize forms and carve directly in stone and wood. For their models they sometimes turned for inspiration to primitive art—African, Pre-Columbian, as well as American folk art—finding in that work a formal sense of design, truth to materials, and an elemental kind of power and feeling. These sculptors were no longer interested in the detailed bronze realism or marble neoclassicism of the nineteenth century.

Traditional sculptors in the National Sculpture Society, however, continued to obtain most of the commissions for large buildings or for the estates of wealthy patrons. To "stimulate and uphold new artistic values and combat all reactionary tendencies," a group of modern sculptors banded together in the Sculptors Guild in 1938. Along with such well-known artists as William Zorach, John Flanagan, and Chaim Gross, there were many outstanding women charter members. On the executive board of the new organization were Sonia Gordon Brown, Minna R. Harkavy, Berta Margoulies, and Concetta Scaravaglione; Berta Margoulies and Dorothea S. Greenbaum served as secretaries of the organization; and Anita Weschler was treasurer. Others in their first exhibition were: Simone Brangier Boas, Cornelia Van A. Chapin, Louise Cross, Alice Decker, Eugenie Gershoy, Margaret Brassler Kane, Helene Sardeau, Mary Tarleton, Marion Walton, Genevieve Karr Hamlin, and Dina Melicov.

The Sculptors Guild organized a well-publicized, landmark show in 1938 in an outdoor space on Amsterdam Avenue near Grand Central Station. The exhibition was attended by thousands, including the First Lady, Eleanor Roosevelt. The new sculptors believed that the form should grow out of the material, and were very much concerned with the grain of wood and the veining of stone. They often allowed the natural shape of a stone to influence the design. Still, they continued to use recognizable subject matter and humanistic themes. Some, like the painters of the 1930s, introduced political and social themes. Minna Harkavy

in *American Miner's Family* (1931) and Berta Margoulies in *Mine Disaster* (1942) express sympathy with a particularly oppressed segment of the working class that was organizing under John L. Lewis in the United Mine Workers union.

Even more expressionistic were some, like Doris Caesar, who heightened emotion and feeling by exaggerating forms, stretching them out of shape, and leaving finger marks in the clay.

A small group of avant-garde sculptors, mostly in the American Abstract Artists Group, were beginning to experiment with totally nonobjective works and welded metal forms. Gertrude Greene, discussed earlier with the painters in this chapter, was one of these pioneers.

Concetta Scaravaglione (1900–1975), the child of poor Italian immigrants from Calabria, loved to make things with her hands from her earliest years. Her first "sculpture" was an "expresswagon which I raced up and down the crowded sidewalk in the Italian quarter of New York City where I was born."[65] She went on to carry out large-scale public sculpture expressive of a warm humanism.

She attributed much of her feeling for the human form to her early life in the teeming ghetto. She remembered peddlers shouting behind their pushcarts, stores crowded with bargaining women, children dancing to the sounds of hurdygurdy men: "My eyes were feasted all day. I sincerely believe that this constant rubbing of elbows with a moving army of people gave me a knowledge of the figure and of the movements of the body."[66]

She was first encouraged in her love of drawing in elementary school by Cecilia Holman, an inspiring teacher. When a family friend urged the Scaravagliones to send their daughter to art school, her parents were at first shocked—a stenography course seemed more sensible—but unwilling to deny anything to their youngest of nine children,

they held a big family conference and at last agreed. Scaravaglione looked back later and realized that such an opportunity would have been unthinkable if she had been raised in her ancestral Calabrían village.

At the National Academy of Design she attended a special free sculpture class for young women taught by Frederick Roth, a rigorous instructor. One by one the girls in this class dropped out, leaving Scaravaglione, who was winning bronze and silver medals in 1917 and 1918, the last student.

The Academy decided it was too much of a luxury to support the class for one student and cancelled it. Since the Art Students League charged tuition, Scaravaglione had to go to work in a factory to earn money. She got a job filling perfume bottles and later reminisced[67] that the reek of cheap perfume entered the pores of her body so completely that bathing would not rid her of it; she was embarrassed by the smell when riding on the subway. She never forgot the horrors of this factory job, which made her appreciate her chosen profession all the more.

Having saved up tuition money, Scaravaglione studied at the Art Students League with Boardman Robinson and John Sloan and took direct carving from Robert Laurent at the Masters Institute. By 1925 she was exhibiting at the Whitney Studio Club and then at the Whitney Museum, the Museum of Modern Art, and the Pennsylvania Academy, where she won the Widener gold medal in 1934.

From 1935 to 1939 the artist carried out important commissions for the Treasury Department Section of Painting and Sculpture, including *Railway Mail Carrier* (1935), a cast aluminum figure for the federal post office building in Washington, D.C., and *Agriculture* (1937), a two-figure limestone bas-relief on the Federal Trade Commission building, also in the nation's capital. In *Agriculture*, Scaravaglione took a traditional public symbol and managed to imbue it with a sense of vitality, while

Fig. 6-20. Concetta Scaravaglione, HARVEST (1937), limestone bas relief, Federal Trade Commission Building, Washington, D.C.

working within the time-honored classical and Renaissance tradition. Her largest government commission was the fourteen-foot-high *Woman with Mountain Sheep* (1939) for the garden court of the Federal Building at the 1939 New York World's Fair (only a small plaster model remains). In 1937 she joined the utopian Architect, Painters and Sculptors Collaborative. That same year she designed *Dawn* as part of a community center project for the New York World's Fair, which was proposed but never executed.

In 1938 the new Sculptors Guild held a huge outdoor show, attended by 39,000 people. Scaravaglione's *Girl with Gazelle* (1936) won widespread critical praise and appeared on the covers of *Art Digest* and *Newsweek*. *Girl with Gazelle* is composed of balanced, curving rhythms; the forms have a tactile, yet tense quality; one can almost feel the sculptor's hand caressing the forms.

The Virginia Museum of Fine Arts gave Scaravaglione her first solo show in 1941. She worked with Theodore Roszak in welded metals in 1946 and received the Prix de Rome to study at the American Academy in Rome from 1947 to 1950. Her sculptures became more experimental, simplified and abstract.

Parallel with her artistic achievements, Scaravaglione enjoyed a long, successful teaching career, starting at the Educational Alliance in 1925 and continuing at New York University, Sarah Lawrence College, Black Mountain College, and Vassar College (1952–1967). Her work is at the Museum of

Fig. 6-21. Concetta Scaravaglione working on GIRL WITH FAWN (1936)

Modern Art, the Whitney Museum, and the National Collection of Fine Arts.

Scaravaglione's career reflects the new opportunities opening up to people of all ethnic backgrounds in the United States. No longer were the arts primarily the private domain of Boston Brahmins and New York upper-class women and men. Artists of all origins and classes began to enter the mainstream. Back in 1910, Abastenia St. Leger Eberle had done sculptures of ghetto life, but came from a cultured, upper-middle-class home. Concetta Scaravaglione actually *came* from the ghetto. Throughout her life, she remained proud of her Italian heritage.

Dorothea Schwarcz Greenbaum (1893–) is a sculptor of bronzes, carvings, and hammered lead figures that convey her belief in the dignity of human life—a belief also reflected in her leading roles in the Sculptors Guild, Artist's Equity, and other organizations of artists.

She was born in Brooklyn, New York, the daughter of Maximilian Schwarcz, an importer who drowned in the Lusitania disaster in 1915. She attended the New York School of Design for Women, and in the twenties studied with Kenneth Hayes Miller at the Art Students League in the lively class that included Peggy Bacon, Alexander Brook, Reginald Marsh, Yasuo Kuniyoshi, and others. "Dots" shared a Union Square studio with Peggy Bacon, showed paintings at the Whitney Studio Club, and was a Fourteenth Street School painter, influenced by Miller.

It was not until after her marriage to lawyer Edward Greenbaum in 1925 and the birth of two sons that she tried clay modeling, found it to be her natural métier, and abandoned painting for sculpture.

Greenbaum's first one-woman exhibition at the Weyhe Gallery included bronzes with political undertones like *Tired Shopper* (c. 1938) and *Fascist* (c. 1938), an oversized, brutal-looking head in which she tried to communicate the fascist mentality. Her sculpture *Sleeping Girl* (1928) was in the 1933 Chicago Century of Progress Exposition.

She was not on the Federal Art Project because of her comfortable circumstances, but from the beginning took on heavy responsibilities in artists' organizations. Greenbaum helped William Zorach organize the outdoor exhibition organized by the Sculptors Guild in 1938. The Guild, founded in opposition to the traditional National Sculpture Society, contained a highly individualistic group of artists who had difficulty agreeing on policy or conforming to bureaucratic restrictions of any kind. In a 1940 interview in the (Martha's) *Vineyard Gazette*, Greenbaum laughed about her role as sec-

retary and peacemaker among the opinionated artists, describing the Guild joshingly as "an organization so radical . . . that it even refuses to have a president. That means I'm the boss."[68]

During World War II, when Greenbaum's husband was a brigadier general in Washington, D.C., she helped to build the Sculptors Guild there and won sculpture awards, such as the Pennsylvania Academy's Widener Medal. The *Washington Post* announced one of her solo shows in typical forties fashion: "General's Wife To Have One Man Art Exhibit."[69]

Returning to New York after the war, she was a founder of Artists Equity, and worked for improved rights and economic opportunities for artists. Her concern for human rights caused her and her husband to come to the aid of sculptor William Zorach when he was threatened with deportation during the McCarthy Era.[70] In 1952 she was one of a seven-person delegation to the United Nations UNESCO conference in Venice, Italy, where representatives from all over the world discussed the future of the arts. In 1947 she was honored by the American Academy of Arts and Letters with a $1,000 grant "in recognition of sculpture of a high order replete with a warm and sensitive appreciation of the human spirit."

During summers at Martha's Vineyard, she and her family enjoyed sailing, and there, on Menemsha Beach, she found some of the rocks she used in direct carving. Greenbaum works in a modified traditional mode, and has gradually expanded her range of media from clay modeling to stone carving and finally to hammered lead, a medium she finds very alive and responsive. In *Drowned Girl* (1950), a head in Tennessee marble, the form grows out of the natural shape of the stone. The sensitively modeled head is caught up in the flowing rhythms of hair; the textural contrasts created by tool marks are effectively played off against the smooth surfaces.

Fig. 6-22. Dorothea Greenbaum, DROWNED GIRL (1950), Tennessee marble, 9" × 10½" × 11"

When Greenbaum was in a two-person exhibition with Isabel Bishop at the New Jersey State Museum in 1970, the catalogue described her as a "romantic realist"[71] whose works "radiate serenity." In contrast with the stereotypical picture of the artist as a withdrawn and difficult loner, Dorothea Greenbaum's career demonstrates the increasing ability of women in the twentieth century to combine sustained careers as working artists with public service and roles in the larger world.

Augusta Savage (1900–1962) is important both as a sculptor and as an influential figure in the advancement of black art in the United States. her portrait head of W.E.B. DuBois in the 135th Street branch of the New York Public Library is considered the finest portrait ever done of him. She was the moving spirit behind the Harlem Art Center of the

Federal Art Project and used this position to further the careers of many younger black artists who attended the center's school, including Jacob Lawrence, Rex Goreleigh, and Roy de Carva.

Born in Green Cove, Florida, the seventh in a family of fourteen children of a poor Methodist minister, Savage became interested in sculpture as a small child (despite strenuous objections from her strict father). She was so talented that she taught clay modeling in her high school before she herself graduated. After preparing for a teaching career at Tallahassee State Normal School, she decided to study sculpture at New York's Cooper Union in 1921. She was almost forced to drop out because she was penniless (in fact, she was being evicted from her room), but her teachers were so impressed with her talent that they convinced the board of trustees to give her a scholarship.

In 1922 Savage applied for admission to the summer art school at the Palace of Fontainebleau outside of Paris, but was rejected even before her application was complete. Evidently, the school felt that white parents would not want their daughters to be in class with a black student. Savage fought back in newspaper interviews and letters, with the support of such white community leaders as Alfred Martin of the Ethical Culture Society and anthropologist Franz Boas. The issue was argued on the pages of the *New York Times* and *The Nation*. As a result of the hostility of white dealers and museums following this struggle, Savage had a hard time making a living with her sculpture and had to work for years in factories and laundries to support herself.

In 1930, however, she received a Julius Rosenwald Fellowship enabling her to study with sculptor Félix Bueneteaux at the Académie de la Grande Chaumière in Paris. Returning in 1932, she opened the Savage School of Arts and Crafts in Harlem and obtained a Carnegie Foundation grant providing tuition for young children. She was the first teacher

of such important black artists as William Artis, Norman Lewis, and Ernest Crichlow.

Savage was the founder and first director of the Harlem Art Center, a black showcase school for the Federal Art Project. She boldly fought with the bureaucracy to accept black artists on the project and helped them get positions as supervisors. Savage also exhibited in the first shows of the Harmon Foundation (1926, 1928, 1930, and 1931), organized by William E. Harmon, a white businessman-philanthropist, to promote black art.

Commissioned to do a sculpture for the 1939 New York World's Fair, Savage celebrated black American music in *Lift Every Voice and Sing* (1939),

Fig. 6-23. Augusta Savage, LIFT EVERY VOICE AND SING (1939) (destroyed), cast sculpture

a large grouping of choir singers in the form of a harp, with a muscular figure in the foreground offering a bar of musical notes to the viewer. Unfortunately, there was no money to cast the plaster sculpture in bronze, and after the fair it was destroyed. Art historian Samella Lewis suggests that the effort Savage put into helping up-and-coming black artists undoubtedly worked to limit her own artistic achievement.

Doris Porter Caesar (1892–1971), a sculptor of bronze figures, was once described by John I. H. Bauer as "an expressionist in the northern tradition. She owes an obvious debt to Lehmbruch and Barlach, and like them traces her sculptural ancestry back to the romantic elongations of . . . north Gothic art."[72]

Porter was born in a fashionable neighborhood in Brooklyn. Her mother died when she was twelve, but she was very close to her successful and brilliant father, a lawyer with wide-ranging interests who took her with him on leisurely trips to Europe. He strongly supported her desire to be an artist, and by the age of sixteen she was already dividing her time between mornings at the proper Spence School for girls and afternoons in the bohemian atmosphere of the Art Students League. In the cafeteria of the League she engaged in heated, "liberated" discussions of art and politics under the impetus of the Ash Can movement. In 1913, after four years of drawing (with George Bridgman) and painting, she married.

For twelve years, like so many women before and since, Doris Porter Caesar's time was completely taken up by the care of her two sons and daughter, and the responsibilities of a well-to-do housewife. After 1925, she slowly began to reemerge as a sculptor. In the late twenties and early thirties she worked very hard, struggling to find her own personal statement by doing many studies from the model. Her inspiring teacher at this time was Alex-

ander Archipenko, the pioneering cubist who had recently arrived from Paris.

In 1927 Caesar cast her first bronze piece and carried it timidly to the Weyhe Gallery on Lexington Avenue in New York. E. Weyhe, a perceptive dealer who ran a combined bookstore–art gallery, was sensitive to the work of talented but unknown artists. This visit proved to be the beginning of a long relationship, which resulted in a series of solo shows beginning in 1935.

Caesar's development was very much affected by Weyhe, who was an enthusiast about German expressionist art. Caesar was greatly moved by the works of Wilhelm Barlach, Ernst Lehmbruck, and Käthe Kollwitz in his collection. From the start, she intuitively turned away from serene classical forms, such as those of Aristide Maillol, and distorted her figure pieces until they were extremely attenuated—almost "stick-like."[73]

Starting in the forties, Caesar worked on sculpture groups like *Mother and Child* (1947) and *Descent from the Cross* (1950), using expressionist distortion and an emotional, loose style in which the unsmoothed thumb marks in the clay remain as a textural element in the finished bronzes. She often worked right through the night at her studio in the Sherwood Building in New York. Simultaneously, she was very active in artists' organizations.

In the fifties Caesar arrived at a fully developed personal style. She now restricted herself entirely to single, naked female figures in tense and tactile forms, elongated but smoother-surfaced, as in *Torso* (1953).

In the Litchfield, Connecticut, studio to which she moved in 1957, she completed works of stripped-down, formal excitement and poignancy that culminated years of searching. Forty of her pieces were shown at the Whitney Museum in a four-person show entitled *Four American Expressionists* in 1959. Caesar died in Litchfield at the age of seventy-eight.

Fig. 6-24. Doris Caesar, DESCENT FROM THE CROSS (1950), bronze, height 22½"

Selma Burke (1901–), for whom the Selma Burke Art Center in Pittsburgh is named, is a distinguished black woman sculptor who lives in that city and has been an influential teacher and moving force in the development of black art in America. Her work is reminiscent of Aristide Maillol, with whom she studied.

The Influence of the New Deal: Some California Murals by Women

Women carried out an unprecedented amount and variety of art for the federal art programs in the 1930s, but most of this work still remains buried. Researchers have concentrated on the New York area, where 40 percent of the artists in the United States lived at the time. Artists who worked elsewhere have been relatively neglected. Although far from complete, the following discussion of a few of the mural commissions executed by California women artists should indicate the wealth of work waiting to be exhumed and studied in other parts of the country.

Maxine Albro (1903–) painted one of the earliest murals carried out under the federal relief programs of the thirties. She had just finished assisting Diego Rivera on his San Francisco murals when she received a commission from the Public Works of Art Project to paint a fresco, *California Agriculture* (1934), in the newly completed Coit Tower, a landmark on Telegraph Hill in San Francisco.

Her cheerful scene of farmworkers harvesting oranges, with their stubby figures and simplified, massive forms, shows the influence of Rivera. Albro's fresco is a glowing picture of improved life for farmers under the New Deal. The National Recovery Agency (N.R.A.) blue eagle, a symbol of the New Deal, is stamped on the orange crates. Her pastoral idyll is in marked contrast to Dorothea

Lange's grim photographs taken at the same time, which show the actual hideous conditions of migrant workers slaving in California's "factories in the fields."[74] In general, the federally sponsored murals reflect optimism about the possibility of creating a new and better social order.

In contrast with Maxine Albro's "Social Unrealism," **Jane Berlandina (1898–)** painted a Dufy-like semiabstraction, *Home Life* (1934), in Coit Tower. Although the government strongly favored American Scene painting, it tolerated a wide spectrum of styles, and many abstract artists got their start on the Federal Art Project. Sculptor Claire Falkenstein (see chapter 7) painted an abstract fresco, *Poppy* (1934), at Piedmont High School in Oakland at the beginning of her career. It was prophetic of the thorny, spiked forms of her later, welded work.

Henrietta Shore (1880–1963), an early modernist of the 1920s, painted some of the finest federally sponsored murals of the 1930s in the post offices at Santa Cruz and Monterey, California. Her work had a pivotal influence on the great photographer Edward Weston, who helped put together a small book about her, published by E. Weyhe in 1933. Reginald Poland, director of the San Diego Museum of Fine Arts wrote in 1932, "She is a profound artist—as strong as any on the Pacific Coast for a synthesis of intellectual, technical, and aesthetic qualities."[75]

Born in Toronto, Canada, Shore moved to New York to study with W. M. Chase and Robert Henri and at the Art Students League with Kenneth Hayes Miller. She also attended the Heatherley Art School in London and was a friend of John Singer Sargent. In 1913 she moved to Los Angeles, became a founder of the Los Angeles Society of Modern Artists, won a silver medal at the 1915 San Diego Pan-American Exposition, and had a joint exhibition with Helena Dunlap at the Los Angeles County Museum in 1918.

Shore returned to New York and became an American citizen in 1921. There she went through a nonobjective phase before emerging with a precisionist style of abstracted realism. After a 1923 retrospective at the Worcester (Massachusetts) Art Museum, *Arts* magazine described her work at Ehrich Galleries as somewhat reminiscent of Georgia O'Keeffe's. In 1924 she was one of twenty-five artists selected by Marie Sterner to represent American art in Paris, and in 1925 she was a founding member of the avant-garde New York Society of Women Artists (Marguerite Zorach was president).

Shore went to Mexico and painted portraits of José Orozco, and Jean Charlot, who later became a supporter of her work. In 1927 in Los Angeles she became a close friend of Edward Weston, who was inspired by the sight of her precisionist blown-up views of shells and began to make photographs of the same subject. Weston's famous series had a crucial influence on American photography. He later wrote:

Ushered directly into a room hung with Shore's canvases I stopped short in my tracks. . . . Here was something outstanding. . . . The response was immediate. . . . That work held the amazement of discovery, had all the force released by an artist who in a period of transition reaches toward new horizons; my introduction was to a group of Shore's 'Semi-Abstractions.' . . .[76]

Shore moved to the Carmel area and in 1936–37 carried out six murals commissioned by the Treasury Relief Art Project (T.R.A.P.), a short-lived, elite federal agency especially created to demonstrate excellence in government art.

Her powerfully simplified *Artichoke Pickers* (1936–37) and *Cabbage Pickers* (1936–37) at the Santa Cruz post office combine an abstract approach with an American Scene theme in a unique synthesis, somewhat reminiscent of the work of Fernand Léger. The curves of figures and plants, counterbalanced by strong architectonic horizontal, vertical, and diagonal rhythms, admirably relate to the hemispherical lunette forms of the archi-

Fig. 6-25. Henrietta Shore, CABBAGE CULTURE (1936), oil on canvas, 4' × 8', one of four lunette murals for Santa Cruz Post Office, California

tectural setting. The four panels at Santa Cruz are intact, but her mural at the Monterey Post Office was covered up in 1966 and is still under wraps. Shore lived reclusively near Carmel and was given a posthumous exhibition by the Carmel Art Association.

Edith Hamlin (1902–) painted *The History of the Mission of San Francisco* (1937) in the library of Mission High School—an ambitious work in egg tempera that took two years to complete. She chose this theme because the Mission Dolores was in the neighborhood, and many of the children at the school were of Mexican and Indian heritage. They watched with delight as she worked on the two thirty-foot-wide panels, and frequently served as her models. The paintings show the building of the mission and its activities—pottery, weaving, blacksmithing, and so forth.

The murals were unveiled amidst fanfare at a ceremony attended by the mayor, the board of education, and the press. *Art News* (1937) described

them as a prime example of the new "art for the people" that was emerging from the Federal Art Project. Hamlin's "Giottesque" compositions fit well into the architecture and portray the docile Indians learning the arts of civilization from the Franciscan fathers; the Indians are not shown as oppressed victims of Spanish conquerors. Although New Deal art was violently attacked as "radical" by the conservatives of the thirties, most of the public art was actually quite noncontroversial, as Professor Steven Gelber points out in *New Deal Art: California*.

Hamlin, the daughter of a distinguished San Francisco musician, was trained by muralist Ray Boynton at the California School of Fine Arts (1920–24) and carried out her first small commission for the federal government in Coit Tower. She remembers the wonderful camaraderie, as twenty-five San Francisco artists decorated the picturesque landmark in 1933, assisted by technical advisors who had just helped Diego Rivera with his murals in that city. In the San Francisco Society of Muralists, Hamlin met Maynard Dixon, an important painter

of the West, and married him in 1937. She has continued to paint murals in various media and more abstract styles.

New Deal Mosaic Murals by California Women

One of the interesting features of California New Deal art was the widespread revival of outdoor mosaic decoration on public buildings, inspired perhaps by the California light and climate, which is so reminiscent of the Mediterranean. Women created a startling number of these mosaic murals. Helen Bruton's *St. Francis* (1934) for the Fleishhacker Zoo in San Francisco, commissioned by the Public Works of Art Project, was one of the earliest ones. Helen Bruton (1898–) and Florence Swift (1890–) decorated the east facade of the old art gallery at the University of California at Berkeley (*Music* and *Art*) for the Federal Art Project in 1936. The two women were assisted by a crew of six male technicians and used scrap tile left over from a San Jose tile factory.

Maxine Albro's Byzantine-looking mosaic of floral and animal motifs in marble pieces for the Federal Art Project adorns the entrance to the Hall of Natural Science at San Francisco State University. Marion Simpson, who trained with Diego Rivera, executed a handsome set of stylized, contemporary-looking panels, *The Exploration and Settling of California* (1937), which flank the entrance to the lobby of the Alameda County courthouse in Oakland. These panels were carried out for the Federal Art Project in *opus sectile,* an elegant technique dating back to classical times. Flat, polished pieces of colored marble were cut into shapes and fitted together like a jigsaw puzzle.

Jean Goodwin Ames (1903–) recalls that a W.P.A. mosaic assignment was the springboard to a long successful career. Ames was subsequently nationally known as an enamelist and tapestry de-

Fig. 6-26. Jean Goodwin (Ames) working on mosaic mural, FISHER GIRLS (1937)

signer, and became the chairperson of the Graduate School of Art of the Claremont Colleges in Claremont, California—an exalted academic position that is extremely rare for a woman.

Goodwin was raised on an orange ranch in Santa Ana and received a thorough art education at the Art Institute of Chicago. At the start of the Depression she and her fiancé, artist Arthur Ames, were wondering how they would survive, when the Federal Art Project opened up opportunities to them. Inspired by Maxine Albro's mosaics, which they had seen in San Francisco, they each designed a mosaic panel for the patio of Newport Harbor Union High School. Goodwin chose the theme of *Fisher Girls* (1937) and fishing nets, because of the seacoast location of the school. The financial support from this and other assignments made it possible for Goodwin to obtain a Master's degree at the University of Southern California and become a college professor.

She married Ames in 1940,[77] and in subsequent years they collaborated on murals and public decorations in Southern California. The practical experience gained on the Federal Art Project made it possible for her to tackle large scale assignments in churches, department stores, and public buildings. Ames is Professor Emeritus at Claremont and continues to paint and work in that community today.

The Three World's Fairs

The handbooks of the three World's Fairs of the thirties show women participating on a grand scale. At Treasure Island in San Francisco Bay, the location of the 1939 Golden Gate Exposition, Helen Bruton and her two sisters carried out a dramatically lit wall-relief for the Court of the Pacifica, entitled *The Peacemakers*. Ruth Cravath and Adaline Kent made sculptures for the Exposition, and Katherine Forbes and Dorothy Pucinelli painted murals. At the 1939 New York World's Fair, Concetta Scaravaglione showed her nineteen-foot-high plaster, *Girl with Mountain Sheep,* and Brenda Putnam, Malvina Hoffman, Marion Walton, Gertrude Vanderbilt Whitney, and Augusta Savage also had commissions. Interestingly, the number of large commissioned works awarded to women does not appear to be as great as in the 1915 Panama-Pacific Exposition, when the suffrage movement was at its peak.

The appendix at the back of this book includes a list of women in the juried exhibitions of contemporary American art at the New York (1939) and Chicago (1933) fairs. Selected from the nation's artists, this list reflects the taste of the period.

Conclusions about the Thirties

The experience of the American thirties is without precedent in the history of women artists. Never had women in such large numbers undertaken and completed projects of such magnitude. The scale, amount, and breadth of subject matter collectively surpassed any achievements that had come before.

The scope of the art carried out for the Federal Art Project included vigorous American scenes of muscular workers, cowboys on horseback, and wide spacious landscapes, as well as abstract paintings. A comparison of the murals with the earlier ones shows the expanding range and increased dynamic rhythm in the work of women artists in the thirties.

Many artists not included in this chapter, such as Lee Krasner and Louise Nevelson, worked on federal art programs in this decade. But since their art flowered later, they are discussed in later chapters.

Chapter 7
The Forties and Fifties: Women of the New York School

In the late 1940s and 1950s the United States, which had emerged as the great world power after World War II, at long last also became the world leader in art, with New York replacing Paris as the new center. In 1959 the Museum of Modern Art proudly sent abroad an exhibition entitled "The New American Painting," and artists in foreign capitals began to imitate the Abstract Expressionist works of the so-called "New York School."

Critics and art historians have nostalgically reviewed this period as a kind of heroic age of American art. They have fixed on the images of Jackson Pollock spilling paint from cans onto huge canvases stretched out on the floor and Willem de Kooning fracturing the figure of a woman into flying shards of brushwork with his "action painting." Mark Rothko, Adolph Gottlieb, Robert Motherwell, and Clyfford Still are also artists whose works loom large in surveys of the period.

The general impression is that there were plenty of heroes in this era, but no heroines. But the heroines, in fact, were also there, painting, sculpt-

ing, exhibiting, and pioneering. Lee Krasner was active in the "first generation" of Abstract Expressionism, followed by Helen Frankenthaler, Grace Hartigan, Joan Mitchell, and others in the "second generation." Louise Nevelson and Louise Bourgeois in the East, and Claire Falkenstein on the West Coast created new forms of sculpture. Nell Blaine, Jane Wilson, and others were very active in the new, artist-run cooperative galleries that sprang up in the fifties to provide a showcase for the new art and circumvent the conservative commercial galleries.

As always, however, in addition to those who plunged into the new abstract modes, there were many women artists who continued to work in a variety of different styles ranging from surrealism (Dorothea Tanning and Kay Sage) to various forms of expressionism and realism. There were still others who do not fit into any rigid category. It is important to look at more than the male figures of the mainstream (by now larger than life) and examine the work of different artists working in different ways during this period.

The New American Painting

There was more than one reason for the dramatic shift in the early 1940s away from social realism and American Scene painting and toward a new abstract art. Social realism was associated with radical and reformist attitudes to American social problems during the Great Depression. Toward the end of the thirties and in the forties, however, most intellectuals had become disillusioned with Marxism, or with the possibility of socio-economic or political solutions to society's evils. The Nazi-Soviet nonaggression pact, the rising tide of fascism and war, and later the threat of the atom bomb, all contributed to a new sense that the problems of humanity lay deeper, perhaps in human nature itself. Many artists turned to the works of Sigmund Freud and Carl Jung, and inward to their own sub-

consciousness, searching for universal archetypal symbols of the dark forces that have stirred in the human soul in all societies and in all ages. Some studied Oceanic, Native American, and pre-Columbian cultures, looking for images that seemed to express this universal spirit.

As the United States entered World War II, American Scene painting and regionalism began to seem isolationist, stale, and narrow-mindedly chauvinistic. New York had become a melting pot of great European artists who had fled there as refugees. American artists now felt themselves to be part of the grand continuum of international modern art.

Expatriate artists Matta Echaurren, Yves Tanguy, Max Ernst, André Masson, and the poet André Breton, resurrected Paris in a New York surrealist community—complete with "games," happenings, techniques of "automatic painting," and imagery derived from dreams and the uncensored irrational psyche. They "dripped" paint or made rubbings from textured surfaces and then saw images in them; they permitted the brush and pencil to wander freely over the page, unhampered by control from the conscious mind. These methods profoundly influenced American artists.

European abstractionists, such as Fernand Léger, Jean Hélion, Marc Chagall, Laszló Moholy-Nagy, and Naum Gabo also took refuge here. Stanley Hayter transferred his famous etching workshop, the Atelier 17, to New York. Piet Mondrian was brought over by Americans in 1940 to save him from the bombings in Britain. Charmion von Wiegand has described the enormous impression Mondrian's paintings and personality made on her when she went to interview him—claiming that "the whole city looked different" when she left his studio.

Although American artists were greatly stimulated by this influx of genius from abroad, they were no longer content to be followers. The time had come, they felt, to pioneer a great new American form of abstract art and outstrip the Europeans, particularly Picasso, who seemed to dominate the modern movement so completely.

One way in which the Americans expressed their aspirations was by working on a heroic scale. They used enormous canvases—much larger than those of earlier modernists. The viewer was almost surrounded by an environment when looking at the new work. Some painters consciously tried to express the speed, energy, and raw power of American life. The paint stroke itself became important for some artists; others sought large universal symbols that embodied for them the nature of the cosmos.

Peggy Guggenheim and the New York School

During this period, Peggy Guggenheim, one of the most important patrons in the history of American art, played a crucial role. A wealthy heiress and the niece of Solomon R. Guggenheim, she married (1922) and divorced (1930) the artist-writer Laurence Vail, became part of the European bohemian community, and was introduced to modern art by her friend, the artist Marcel Duchamp. She opened a gallery in London in 1938 and then planned to create a museum of modern art on the continent.

With the advice of the critic Sir Herbert Read, Marcel Duchamp, and Nellie van Doesburg (wife of the Dutch purist painter), Guggenheim was feverishly buying paintings at the rate of one a day, as France fell to the Nazis. She rescued her collection by shipping it to the United States on a boat, disguised as "household objects," and then flew home with the refugee surrealist painter Max Ernst, whom she married soon after arriving in New York in 1941. Their Beekman Place home became the scene of huge parties where she introduced the surrealists and other artists-in-exile to the Americans.

In 1942 Guggenheim opened a New York gallery-museum, Art of This Century, where she

showed the work of leading European modernists, and sponsored lectures by them amidst a wildly improbable setting designed by architect Frederick Kiesler. Paintings projected out from curved walls and were suspended from the ceiling.

Guggenheim championed the new American artists. She gave Jackson Pollock, Clyfford Still, Mark Rothko, Robert Motherwell, William Baziotes, Hans Hofmann, and others their first one-man exhibitions. She launched Pollock's career with a mural commission for her home. It is generally agreed that her gallery was the birthplace of the New York School.

Guggenheim also sponsored certain women artists. She gave Irene Pereira a solo show. She held a juried exhibition called "31 Women" in 1943 and a second women's show in 1945. "31 Women" was a glittering array of international female talent (Frida Kahlo, Leonora Carrington, Meret Oppenheim, and others were included). Many Americans were also selected, among them: Pereira, Djuna Barnes (author of the novel *Nightwood*), Susie Frelinghuysen, Buffie Johnson, Louise Nevelson, Kay Sage, Sonia Secula, Esphyr Slobodkina, Hedda Sterne, Dorothea Tanning, Julia Thecla (a Chicago fantasist), and others. Elsa von Freytag-Loringhoven, a wonderful eccentric Dadaist who wore ice cream spoons and sardine cans on her head, was also included. The 1945 show included Nell Blaine, Louise Bourgeois, Ronnie Elliot, Perle Fine, Fannie Hillsmith, Lee Krasner, Loren MacIver, Charmion von Wiegand, Alice Trumbull Mason, Janet Sobel, and others.[1]

In 1946, at the end of the war, Peggy Guggenheim (by now divorced from Max Ernst) entrusted the careers of her artist-protégés to the gallery owner-artist Betty Parsons. She moved to Venice and installed her collection in the Palazzo Venier dei Leoni on the Grand Canal. It became one of the leading sights of Europe, and many Europeans saw the work of modern American artists there for the first time. At her death in 1979 she willed the museum to the Solomon R. Guggenheim Foundation (created by her uncle).[2]

As flamboyant in a gondola as on 57th Street, Peggy Guggenheim was made an honorary citizen of Venice before her death and is still referred to by the Venetians as "the Last Duchess." Her scandalous memoirs, *Out of This Century* (1946) and *Confessions of an Art Addict* (1960), give an inside glimpse of an unconventional life in the art world.

Women Artists in the Forties and Fifties

After the giant leap forward taken by women artists under the Federal Art Project in the 1930s, one might reasonably have expected them to come into their own in the 1940s and 1950s, as American art moved toward world leadership. But just the opposite proved to be the case. The forties, fifties, and sixties turned out to be a period of increased discrimination. The leading galleries carried few works by women, and very few women had solo shows in major museums in this period. When the famous exhibition "The New American Painting" went abroad to tour the capitals of Europe in 1959, only one woman out of seventeen artists—Grace Hartigan—was included.

The Federal Art Project, with its antidiscriminatory rules, was gone. Male artists, beginning to smell high stakes in the offing as American collections and museums began to come of age, formed an unofficial old boy's club in which the work of their female colleagues was not taken seriously. As author Eleanor Munro aptly states, "Machismo was part and parcel of a psycho-esthetic that cast male artists as sublime-tongued-and-fingered prophets in touch with 'the chaos of ecstasy.'"[3] Artist Dorothy Dehner, who lived for years in the shadow of her famous sculptor-husband David Smith, put it more bluntly: "There had never been a great American art before: in fact art had always been

regarded as somewhat sissified in this country. By God, these men were not going to be sissies."[4]

Typical of the male rhetoric of the times was Barnett Newman's defense of his huge painting bearing the patriarchal title *Vir Heroicus Sublimus* ("Heroic Sublime Man"):

What is to be pitied is love of impotence . . . fear of the creative man . . . man spelled masculine. . . . Someday Mr. Crehan the critic may learn that no matter how many it takes to tango it takes only *one real man* to create a work of art.[5]

This was the period when a leading male artist informed Louise Nevelson, "You know, Louise, you've got to have *balls* to be a sculptor."[6] Lila Katzen winced in pain when her revered teacher Hans Hofmann, at a dinner party in her home, raised his glass in a toast "to art. . . . Only the men have wings."[7]

Such attitudes toward creativity in women were by no means confined to the field of art in the fifties. Norman Mailer described the work of leading women writers as follows:

I can only say that the sniffs I get from the ink of the women are always fey, old-hat, Quaintsy, Goysy, tiny, too dykily psychotic, crippled, creepish, fashionable, frigid, outer-Baroque, *maquille* in mannikin's whimsy, or else bright and still born. . . . A good novelist can do without everything but the remnant of his balls.[8]

One very important factor was the absence of an active feminist movement in the thirties and forties. After women won the right to vote in 1920, and during the egalitarian Roosevelt years, they deluded themselves into thinking they had achieved equality. Therefore, there was no organizational structure or even awareness with which to resist the chauvinism of the period.[9]

As Betty Friedan has pointed out, when the G.I.s returned after World War II, the era of the flight to the suburbs and the Baby Boom began, and women were informed once more that true happiness for them lay in the kitchen and the bedroom rather than in factories or professions. Freudian analysts assured women that they would be best served by accepting their passive female roles. The fifties was a very conservative decade in American history—a time of conformity, the cold war, and the witch-hunts of Senator Joe McCarthy. A deafening silence settled over the country.

As the new American art movement became hugely successful in the late 1950s and the 1960s, opportunities for women artists deteriorated still further. Never before had American painters come even close to great wealth. Now the few at the top became marketable celebrities, even "stars." Dealers, taste-makers, and gurus were on hand to help the insecure new breed of American collector decide on his "investment"—which, indeed, art had become, since a "killing" could be made by buying the right newcomer and waiting for prices to skyrocket. In the big business of the art world, women were not good risks.

Despite the obstacles, a small number of amazons managed to climb into the center ring. But they often became very prickly, sensitive, and defensive, and adopted a super-tough, one-of-the-boys stance. Women artists were isolated from one another, and they reacted to the isolation and neglect from the art world.

Miriam Schapiro, who was a successful Abstract Expressionist in the fifties, before she became a feminist, has described how uncomfortable it felt to be a woman in the male art scene at the time:

There were several interested and dedicated women artists in New York but with them I had only 'girl talk.' The men would get together in studios to talk about their work. The women really didn't respect each other deeply. I don't think that another woman, at that time, really cared about my opinion of her work. She wanted a man's opinion.[10]

Abstract Expressionism

The First Generation

Abstract Expressionism was the first totally original avant-garde artistic movement in the United States. It began, in a sense, when Robert Motherwell and Jackson Pollock tried automatic painting with the Surrealist Matta Echaurren. The idea behind automatic painting was to let go of the conscious hold on tools and permit the primordial forces of the unconscious mind to release themselves into the art form. In this way the artist hoped to come in contact with the energy of the cosmos, the primeval timeless elements of nature, and the collective symbols of good and evil, light and dark. Soon this technique was transformed into a method of expressing each artist's authentic feelings.

Abstract Expressionism was not concerned with pretty decoration or good design. It had an almost mystical quality through which the artists could also express their independence from bourgeois society, their willingness to be alienated. Making their unique expression thus asserted the powerful ability of the creator to stand alone. Although they considered themselves part of the worldwide avant-garde movement, some of these artists wanted to incorporate the qualities of raw vigor and power they felt particularly expressed American life.

Lee Krasner (Lenore Krassner) (1908–) is a leading member of the first generation of Abstract Expressionists who moved the center of the art world from Paris to New York during the early 1940s. Although her reputation was submerged for many years under the shadow of her famous husband Jackson Pollock, she is recognized today not only as one of the earliest pioneers of the New York school, but also for her continually expanding repertoire of innovative forms.

Krasner grew up in Brooklyn in an orthodox Jewish family of first generation Russian immigrants. Her parents had met while working for a rabbi in Odessa, and ran a small vegetable store when they came to this country. She was the first in the large family to be born in the United States and lived as a child in a polyglot world of Russian, Yiddish, and Hebrew. While she was growing up she read fairy tales, Maeterlinck, and the Russian classics.

Krasner showed a determined spirit from an early age. At school she caused a commotion by standing up in music class to tell the teacher that she could not sing the words of the Christmas hymn because "Jesus Christ is not my lord."[11] In her self-portrait of 1930, painted as a student at the National Academy of Design, an intense, stubborn face stares out from the canvas.

Even as a kid, I knew I was an artist. I have stayed with that conviction. I have worked all my life—before and during my marriage. I can't imagine staying with a man who wouldn't let me do my work.[12]

Her parents neither discouraged nor supported her career goals as they were too busy struggling to survive to pay much attention:

At thirteen I made no economic demands on my parents so they in turn let me be. . . . I earned my own carfare and lunch money. I had all kinds of jobs. I painted flowers on lampshades and vertical stripes on felt hats. . . .[13]

Despite obstacles and lack of support from her teachers in her early years, Krasner pursued her art training with singleminded obstinacy. When she applied to Washington Irving High School in New York, the only secondary school that gave professional art training to women at that time, she was rejected, but with characteristic tenacity she applied again and was admitted. In her senior year her art teacher patronizingly told her that he was passing her in art only because she had done so well in her other subjects. Such treatment would have discouraged most aspiring artists, but Krasner showed an unshakable will.

Fig. 7-1. Lee Krasner, THE EYE IS THE FIRST CIRCLE (1960), oil on canvas, 92¾" × 191⅞"

From 1926 to 1929 she studied at the Women's Art School at Cooper Union and then enrolled at the conservative National Academy of Design. She had a revelation when she first saw an exhibition of Matisse and Picasso at the new Museum of Modern Art, which had opened in 1929. "I flipped my lid,"[14] she told an interviewer from *Newsday*, adding that she and her fellow students "staged a revolution" at the staid National Academy after that. When she painted a composition in brilliant Fauve colors, her instructor, Leon Kroll, told her to "go home and take a mental bath."[15] In the following years, Matisse and Picasso were her idols and greatly influenced her work.

After three years at the National Academy, Krasner, in lockstep with many women from her background at the time, went almost automatically to City College to get a high school teaching credential. She supported herself by working as a waitress at Sam Johnson's, a Greenwich Village cafe where artists and art critics like Harold Rosenberg and Parker Tyler congregated to discuss art and life. She

became part of this milieu and soon recognized that she really did not want to teach.

The Federal Art Project made it possible for Krasner to pursue a full-time career as an artist from 1934 to 1943. She worked as an assistant to muralist Max Spivak. During those years, because the project was continually under attack from politicians, she became a leader in the Artists Union and was fired from her job twice.

Between 1937 and 1940, Krasner studied with Hans Hofmann, partly because she could not afford a model or studio of her own. She absorbed the cubist concepts Hofmann was developing, and he paid her the supreme male chauvinist compliment: "This is so good you would not know it was done by a woman."[16]

Although no one knew it at the time (Hofmann had not exhibited his work yet or shown it to his students), Krasner's drawings were more advanced than her teacher's own work. Her charcoal sketches from the figure, done in his class as early as 1938, contain the dynamic gestural qualities that forecast

the Abstract Expressionist movement.[17]

One of the sources for Krasner's advanced approach was her friend John Graham, the eccentric Russian emigré, now considered one of the gurus of Abstract Expressionism. By 1937 she had already studied closely Graham's book *System and Dialectics of Art,* which opens with the important phrase "Art opens access to the unconscious mind," and goes on to state that such qualities as "the brush pressure, saturation, velocity, caress or repulsion, anger or desire which changes and varies in unison with the flow of feeling constitutes a work of art."[18] This is actually an early definition of "action painting."

In this period Krasner introduced the trend-setting critic Clement Greenberg to Hofmann's ideas by inviting him to Hofmann's weekly public lectures. In 1940 she began to exhibit with the American Abstract Artists and through them met Piet Mondrian, the first person to give her a strong expression of support and encouragement, which she never forgot. He stood in front of her painting and said, "You have a very strong inner rhythm; you must never lose it."[19]

In 1942 John Graham invited Krasner and Jackson Pollock to exhibit in a landmark show called "French and American Painting" at the McMillen Gallery in New York City. (Graham was brash enough to compare the work of young Americans with such European masters as Braque and Matisse.) Curious about the artist who was going to be in the exhibit with her, Krasner went to visit his studio around the corner from her in Greenwich Village. She was "totally bowled over" by his work and was the first to recognize the giant leap Pollock had taken. He had united drawing and painting in one act, using the spontaneous, unpremeditated gesture of surrealism to tap into his own feelings and create a new abstract form. As Barbara Rose has pointed out, Krasner recognized this break so clearly because she was on the verge of doing the same

thing herself, but had not quite made the transition from her drawings into the act of painting.[20]

Soon Krasner and Pollock were living together and searching simultaneously for new forms derived from automatic painting gestures. Although Pollock was breaking through, for three years Krasner endured the terrifying emptiness of working over and over her canvases until they became pasty crusts of gray, with no new image emerging.[21]

In 1945 the two artists were married. They bought (for $5,000) an old, unheated farmhouse in the Springs near East Hampton on Long Island and moved in during a freezing northeaster. Pollock worked in the barn, spilling paint from cans onto huge canvases stretched out on the ground, while Krasner struggled to find her own imagery in a small bedroom in the house.

Krasner has described their shared life during these early years. They critiqued each other's paintings and divided up the household chores:

He always slept very late. . . . Morning was my best time for work, so I would be in my studio when I heard him stirring around. . . . Neither of us would go into the other's studio without being asked. . . . Something like once a week he would say, "I have something to show you." . . . He would ask, "Does it work?" or . . . in looking at mine he would comment, "It works" or "It doesn't work." I did the cooking but he did the baking. . . . We made an agreement about the garden. He said, "I'll dig it and set it out if you'll water and weed.[22]

Finally, between 1945 and 1950, her series of "Little Image" paintings slowly emerged. *Abstract #2* (1946–48), *Shell Flower* (1947), and other works, were created partly by spilling thinned oil paint from a small can onto a horizontal canvas. Some of them are composed of many self-contained units, each resembling a hieroglyphic or cuneiform in which tangled skeins of rich rolor (red, red-orange, yellow, green) emerge from a gray background. With the completion of the "Little Image" paintings, Krasner had tenaciously and successfully weathered a stormy artistic journey. (The impor-

tance of these early works was not recognized until the 1970s).

Krasner also devoted a good deal of energy to advancing her husband's career. Better known than Pollock when they met, she introduced him to many influential people and ran interference for him in many ways—so much so that people had the mistaken impression that she was no longer painting. Peggy Guggenheim wrote in her memoirs:

He [Pollock] was very fortunate, because his wife Lee Krassner, a painter, . . . even gave up painting at one period, as he required her complete devotion. My relationship with Pollock was purely that of artist and patron, and Lee was the intermediary. Pollock himself was rather difficult; he drank too much and became so unpleasant, one might say devilish, on these occasions. But as Lee pointed out when I complained, "He also has an angelic side."[23]

As Pollock became famous, Krasner was more and more eclipsed. In 1950 she was deeply hurt when a leading group of artists, The Irascible Eighteen, organized a protest against the Metropolitan Museum's conservative jurying policies and invited Pollock to join them, but left her out.

In 1951 she had a solo show at the Betty Parsons Gallery, but when Pollock broke his contract and left the gallery, Krasner was also dropped. Depressed, she realized that she was regarded as "the artist's wife." Recently, when asked why she never promoted herself more aggressively, she answered with some truculence:

I couldn't run out and do a one-woman job on the sexist aspects of the art world. . . . I was able to work and other things would have to take their turn.[24]

Continuing to work despite near-invisibility, Krasner had an important show of collages in 1955 at Eleanor Ward's Stable Gallery in New York City. The manner in which she began to do these collages gives an insight into her work method and her fiercely self-critical attitude. In a mood of discour-

Fig. 7-2. Lee Krasner, MILKWEED (1955), oil, paper, canvas collage on canvas, 82⅜″ × 57¾″

agement one day, she ripped a whole set of black-and-white drawings off the walls, tore them up, and threw them on the floor. The next day she saw interesting shapes in them and began to cut them up and glue them together in new ways. Soon she was slashing up the paintings she had done for the Parsons show and incorporating them with black paper and scraps of Pollock's cast-off paintings. She ruthlessly destroyed an entire series of early works to create collages like *Bird Talk* (1955), which forecast the nature themes and swinging rhythms of her later paintings. She sometimes uses this method today.

At the same time that Krasner's collages were taking shape, her husband was suffering from the

increasing effects of alcoholism and was in psychoanalysis. Krasner began to produce frightening images that seemed to well up from some deep source. It was a time of trouble and personal difficulty for her. Pollock was killed in an auto accident in 1956 while she was in Europe, and after his death she painted a whole group of stormy canvases in which the frightening image of an eye sometimes reappears (*The Eye is the First Circle* [1960]). It took many years for her to work through the pain of his death.

Krasner understood that Pollock's difficult behavior had come from some inner torment and self-doubt. "As Jackson's fame grew, he became more and more tortured. My help, assistance and encouragement seemed insufficient."[25] In many ways the stronger of the two, she accepted a subordinate position because she knew the insecurity that lay underneath the posturing of this cowboy genius from Cody, Wyoming. Yet she ascribes the sexist attitudes that for so long kept her from achieving her proper position in art history to critics, dealers, and other influential people—not to Pollock.

The following period was difficult. Her health was poor; her time was consumed with endless litigation and the details of being an "art widow." She endured the wrath of many powerful people in the art world because of her insistence on handling the Pollock estate in her own way. They wanted to administer it, and accused her of releasing the paintings slowly in order to drive up the prices:

I had to make decisions, and I stepped on a lot of toes. . . . So there were a lot of vendettas against Mrs. Pollock, the widow, that had to be paid back to Lee Krasner, the artist.[26]

In a later interview she reiterated: "My acceptance today was made as difficult by that position as by being a woman artist. . . . Because of it my own path has been fierce."[27]

By the time of her major retrospective in 1965 at the Whitechapel Art Gallery in London, her paintings revealed a new soaring, lyrical mood. Abandoning the moody umber and off-white colors of the period after Pollock's death, she created huge, brilliantly colored paintings such as *Bird's Parasol* (1964) and *Right Bird Left* (1965). In these works the impetuous brushwork splatters with energetic force, and the swinging rhythms suggest birds, flowers, genitalia, and growing plant forms, bursting and spilling out of the canvas.

This very successful show was followed by a series of large, majestic paintings in flat, hard-edged shapes and jewel colors (reminiscent of Matisse's cut-paper collages), such as *Majuscule* (1971), *Sun Dial* (1972), and *Lotos* (1972). Recently, she cut up old charcoal drawings from her student days with Hofmann and combined their fractured forms with the large flat shapes of her recent work. They are a kind of recapitulation of her entire life in art—from the early turmoil of her first gestural abstractions to such grand and monumental forms as *Present Perfect* (1976) and *Past Continuous* (1976).

Although she has shown regularly in galleries all along, only in the past few years has Krasner finally been properly recognized as a founder of one of America's great original art movements. Until very recently she was left out of the major histories of the New York School.[28]

Art critic Barbara Rose pointed out her historic role in 1972,[29] and Marcia Tucker reiterated it in the catalogue of a 1973 show of eighteen paintings by Krasner at the Whitney Museum. Finally, in 1978 she was accorded her rightful place alongside of Pollock, Mark Rothko, Adolph Gottlieb, and company, in an exhibition entitled "Abstract Expressionism: The Formative Years."

Hilton Kramer wrote in the *New York Times*, with some amazement:

There are seven pictures of Lee Krasner, who until recently was denied any sort of serious place in this history except as the wife of Jackson Pollock. Is this a case of an historical injustice finally being set right—both the quality and the dates of the picture would suggest that it is—or

does it represent a surrender to the feminist politics that are now influencing the writing of art history, or both?[30]

Today, the successful artist continues to paint at her large apartment in New York City and at the East Hampton farmhouse that she once shared with Jackson Pollock. Art historian Elsa Fine has described her method:

Krasner has a non-intellectual approach to her art. When she stands in front of a canvas she has no idea what will emerge. One gesture suggests another; a form is created which demands another form. . . . the Abstract Expressionist use of the spontaneous gesture remains with her but it is the spontaneity of a well trained sensibility.[31]

"I'm often astonished," says the artist, "at what I'm confronted with when the major part comes through. . . . In that sense, it's archetypal."[32] She wants her canvases to "breathe"—to "soar into space," and is very irritated when they seem "earthbound."

Krasner periodically goes through new cycles in her work, and each new cycle provokes great anxiety. But she says:

I don't force myself. I have regard for the inner rhythm; I listen to that. I don't know if the inner rhythm is Eastern or Western; it is essential for me.[33]

That "inner rhythm"—first noticed by Piet Mondrian over forty years ago—is carrying Lee Krasner forward, in her later years, to new heights in the art world.

Hedda Sterne (1916–) was one of the artist-refugees who came to the United States in the 1940s bringing with them the European avant-garde artistic vision. She became a well-known surrealist and Abstract Expressionist in New York. In fact, in a 1950 *Life* magazine photograph, she appears as the only woman in a group of fifteen famous New York School artists. They were dubbed "The Irascibles" by the press because they were protesting against the Metropolitan Museum's conservative policies.

She was born Hedda Lindenberg in Bucharest, Romania, into a family steeped in old world culture.

Fig. 7-3. Hedda Sterne, BARROCCO #14 (1954), oil on canvas, 72" × 42"

Her brother became a prominent orchestra conductor in Paris, and she began to draw at an early age, copying the masters from art books. She majored in philosophy at the University of Bucharest and then studied art in Vienna and Paris.

Driven by the storms of war, she arrived in the United States in 1941 and became a citizen in 1944. Sterne was at first a surrealist and particularly admired the work of Victor Brauner, a fellow Romanian she had known in Bucharest and Paris who painted darkly haunting fantasies of metamorphosing figures. She was one of the surrealist group that exhibited at Peggy Guggenheim's gallery, Art of This Century.

Sterne's partly surreal, partly abstract paintings depict her reaction to the "terrifying grandeur"[34] of America's urban and industrial civilization. She explained, "I had to paint these machines in order to exorcise them."[35]

In *Barrocco #14* (1954) and other works, Sterne evoked the hurtling trains, cranes, derricks, and bridges of the city in machine-monster images she called "Anthropographs." Her semiabstract cityscapes of the fifties, such as *Manhattan #1* (1958), capture the spirit of speed and light of America's roads and highways.

In 1943, Sterne married the artist Saul Steinberg, another refugee who had originally come from Romania. He introduced her to Betty Parsons, and she has been exhibiting at the Betty Parsons Gallery since 1947. (Sterne and Steinberg separated amicably in the sixties.)

In 1950 she was singled out in *Life* magazine as a promising young American painter, and again in 1951 was featured with her husband in a *Life* article, "Steinberg and Sterne."[36] Her work became more and more nonobjective, as she developed a series of experimental circular *tondos,* canvases spun on ball bearings like roulette wheels, to be viewed from different directions.

In recent years she has been painting nonobjective canvases of horizontal bands and striations of color, which have suggested, in the words of one critic, "open clear landscape—most particularly the landscape of sea, pale sand and sky."[37] She has also, throughout her career, continued to do highly personal "feather light" portrait sketches and strange, evocative, oversized portrait paintings of people she knows well, such as the late critic Harold Rosenberg and artist Elaine de Kooning.

Sterne received a Fulbright Fellowship to study in Venice in 1973, and a retrospective at Montclair (New Jersey) Art Museum in 1977. Her work is in many museums around the country, including the Art Institute of Chicago, and the Museum of Modern Art.

Betty Parsons (1900–)

When the music flows
and no voice is heard
like a plant that grows
like a soundless bird
 poem by Betty Parsons[38]

The elegant, mercurial Betty Parsons is another American woman artist who, like Katherine Dreier, Marjorie Phillips, Hilla Rebay, and Gertrude Whitney before her, played the quadruple role of artist, sponsor, impresario, and collector. So important was her gallery to the emerging artists of the 1940s that she has been called the "midwife"[39] of the New York School.

Starting in 1946 in her 57th Street gallery, Jackson Pollock, Clyfford Still, Mark Rothko, Barnett Newman, and other leaders of Abstract Expressionism were recognized. These artists were at the start of their careers when Parsons first showed their work, and she drew the interest of museums, critics, and collectors, although sales were at that time very few.

Women whom she sponsored include Agnes Martin, Anne Ryan, Hedda Sterne, Jeanne Miles, Sonia Secula, Perle Fine, Sari Dienes, Barbara Chase–Riboud, and others. Her special antenna for sensing talent ahead of others is undoubtedly related to the fact that she is herself an established

painter and sculptor with years of training behind her.

Betty Pierson came from an old, wealthy, conservative New York family. With her fine-boned face, high forehead, and pageboy haircut, she has often been said to resemble Greta Garbo. She was so proficient at tennis in her youth that she was asked to join the U.S. Olympic tennis team, but turned it down because it interfered too much with her art.

She was interested in sculpture at a young age, and after an early marriage to Schuyler Parsons she apprenticed to Renée Praha, a Beaux-Arts sculptor in New York. The couple went to Paris for a divorce two years after their marriage, and she remained in France for ten more years.

In Paris, Parsons studied with sculptor Émile-Antoine Bourdelle and Ossip Zadkine, and in the summers she painted watercolors of villages and landscapes in Brittany with the English artist Arthur Lindsey. She lived in the Rue Boulard in Paris, behind the Montparnasse cemetery, and associated with such leading intellectuals as Man Ray, Tristan Tzara, Gertrude Stein, Alexander Calder, and Isamu Noguchi. Her first one-woman show was at the Galerie des Quatres Chemins in 1927.

"There were no money problems then, but I was wiped out in the crash in 1929,"[40] she later recalled. Upon her return to the U.S. in 1933, Parsons supported herself by teaching in Santa Barbara, California, and in 1936 settled again in New York. There she had many shows of watercolors at the Midtown Gallery. During this time she worked in Mrs. Cornelius Sullivan's gallery, where she learned the art business. It is an index of Parsons's early and deep awareness of the Abstract Expressionist movement that Arshile Gorky and John Graham, now recognized as the early gurus of that school, taught classes in her studio while she watched and served as hostess. Between 1941 and 1944 she ran an art gallery in the Wakefield Bookstore; during 1944 and 1945 she handled the modern wing of the Mortimer Brandt Gallery; and in 1946 she opened the Betty Parsons Gallery.

In her gallery artists received very special treatment. They were permitted to hang the paintings for their own shows, and thus were able to create what they thought was the best environment for their work. She gave them total freedom. "Each one of my painters is an individual. Once I have made my selection, I have complete trust in the artist's creative work. . . . I would never dream of imposing my will for the sake of recognition or applause. . . ."[41]

She functioned in a way altogether different from the burgeoning commercialism of the art marketplace. Her two-sided nature—artist and aristocrat—made her a perfect intermediary between the world of the collector and the temperaments of many of the artists, who might, as in the case of Jackson Pollock, choose to be insulting to prospective patrons.

The role of gallery owner has its vicissitudes. "My relationships with artists are very friendly . . . so when they leave it is extremely painful. It always happens when they get a better deal from someone who can support them."[42]

Parsons continued to work at her own art, showing it with great modesty at other galleries, and with the American Abstract Artists. She started out as a traditional watercolorist and then moved closer to the style of Raoul Dufy in the thirties.

In the 1940s she moved into abstraction. Paintings of the 1950s, such as *Orange* (1956) and *Blue Space* (1957), are thick with impasto texture, dragged paint, and tipped broken shapes. In the 1960s smoother patches or islands of color appear in large fields. Parson's approach to painting is characteristic of the Abstract Expressionists:

When I start painting I try to become a blank and only let an emotion come into me. . . . One color introduces an idea for another color. . . . Sometimes I start off in a very abstract way and subconsciously get back into nature. . . . Nature somehow gets in.[43]

Parsons has in recent years been influenced by her move to a studio on a cliff overlooking the sea on

Long Island. There, in a large room designed by Tony Smith, with high ceilings and light from many sources, she has begun to create sculptures that come, in a sense, from the sea. She began to collect driftwood and stones, paint them with bands, zig-zags, stripes, and dots, and put the weathered wood pieces together to create totem-like forms such as *Between the Verticals* (1974) and *Sentinel* (1976). This distinctive new sculpture combines her love of painted acrylic abstract shapes with her feeling for nature and her original love of sculpture. The same bright bands and dots have been carried over into canvases like *The Queen of Crete* (1972). Among the many exhibitions Parsons has been given throughout her busy career was a retrospective at the Montclair Art Museum in 1974.

Parsons's little black notebooks are famous among her friends. A continuing record of her impulsive sensibility, they include quotations ("The truth must dazzle gradually"—Emily Dickinson),[44] dried flowers from many countries, sketches, snatches of her own poetry, and notations of weather, landscape, and mood, gleaned from a fast-moving life.

The Second Generation

From small towns and college campuses, young artists descended on New York in the fifties to be near their new heroes—not Picasso and Matisse, but de Kooning and Pollock. No longer was the pilgrimage to Paris a necessary stage in the development and training of the artist. On the contrary, young painters felt that this country, as Grace Hartigan put it, "is the only place that lives in the present."[45]

A favorite meeting place on Wednesday and Friday evenings was "the Club," an organization founded in 1949 by a group of leading "first generation" painters and sculptors. At their 10th Street headquarters, noisy round table discussions and panels on art were followed by dancing and socializing. The Club was male-dominated, but cer-

Fig. 7-4. Betty Parsons, SENTINEL (1976), painted wood sculpture, 63¼" × 44¼"

tain favored women—Jeanne Miles, Elaine de Kooning, Mercedes Matter, Helen Frankenthaler, Nell Blaine, Joan Mitchell, and others were invited to attend.

Life magazine began to feature articles about the New York School. Art openings were jammed and so was the Cedar Bar, a drab hangout in Greenwich Village where de Kooning, Franz Kline, and Pollock congregated and engaged in aesthetic debates and even occasional physical brawls.

A second generation of Abstract Expressionists arose, hard on the heels of the first. The work of these artists had a different quality. It was, perhaps, more lyrical and not as dominated by a sense of angst and tragedy as the first group. After a while a group of painters began to return to recognizable subject matter—landscape, figure, and still life—while still retaining the spontaneous painterliness of Abstract Expressionism. These artists are often referred to as "painterly realists" or "gestural realists."

Because few commercial galleries were willing to show their avant-garde work, a certain number of artists decided to create cooperatives. The Jane Street, Tanager, Hansa, March, and other artist-run galleries began to cluster around East 10th Street, near The Club, making this a lively district where people mixed and met. A third of the artists in those galleries were women, a much higher percentage than in the prestige commercial galleries.[46]

In addition to the women discussed in this chapter, some outstanding painters of the period were Eugenie Baizerman, Leatrice Rose, Gretna Campbell, Lois Dodd, Rosemarie Beck, Sonia Gechtoff, Fay Lansner, Fannie Hillsmith, and Louisa Matthiasdottir. All continued outstanding careers. Helen Frankenthaler, one of the stars of the "second generation," is discussed in chapter 8.

Grace Hartigan (1922–) was internationally recognized in the fifties as a leading second generation Abstract Expressionist painter. Her gutsy, slash-ing compositions incorporated fragments of city imagery—store windows, pushcarts, glimpses of figures—with bold brushstrokes. They were bought by the Museum of Modern Art, the Metropolitan Museum of Art, and the Whitney. She was accepted into the inner group of predominantly male artists such as Willem de Kooning, Franz Kline, and Jackson Pollock, who dominated the Cedar Bar and the Artists' Club during that exciting era. With her paintings and her lifestyle, she earned their respect at a time when most women artists did not.

Hartigan was born in Newark, New Jersey, in an English-Irish family. She describes herself as feeling like a "changeling"[47]—a difficult child whose parents, soon realizing that she would not follow a conventional path, expected something unusual from her. They could not afford to send her to college, and at seventeen, barely out of high school, she married and immediately became pregnant.

Fortunately, her young husband, like her parents, recognized her creativity and urged her to take art classes at night. She had no skills—she had never drawn before, and later described herself as "crying and sweating"[48] with frustration when she picked up a pencil and tried to do a still life. Nevertheless, she became involved, and during the rest of her pregnancy and after her child was born, she drew whenever she could find the time.

Her husband was drafted in World War II, and Hartigan supported herself as a mechanical draftswoman in an airplane factory. A fellow draftsman told her about Isaac Lane Muse, an avant-garde painting teacher in Newark. Hartigan studied with Muse for four years, and with him she moved to New York to be closer to the center of activity in the art world.

During this period she often felt she had absolutely no talent. It was only Muse's encouragement, his stress on creativity over polished execution, that gave her the courage to continue struggling. She signed her work "George" and did not feel that she had arrived at a genuine personal artistic statement until 1949.

Hartigan was very poor, and suffered from the conflicts inherent in her situation. She realized that the bohemian life she was living would be destructive for her little boy. So she decided it would be better for him to live with his father, who had moved to California.[49]

When she first hitchhiked out to see Jackson Pollock's paintings in the barn-studio at East Hampton in 1948, Hartigan was overwhelmed and felt that a new world was opening up to her. Pollock at the time was just beginning his major phase and was not yet internationally recognized. He appreciated the support of young painters such as Hartigan, and she became friends with him and his wife Lee Krasner. Through them she met de Kooning and Kline, who also exerted a great influence on her work. At this time she painted abstractions such as *Rough Ain't It!* (1949) and *Months and Moons* (1951) in energetic swaths of dripping housepaint and collage.

In 1950 art critics Meyer Schapiro and Clement Greenberg discovered her and selected her work for a show called "New Talent" at the Kootz Gallery. In 1951 she was acclaimed at her first solo show at the Tibor de Nagy Gallery.

At this time Hartigan began to "get guilty for walking in and . . . taking their [Pollock and de Kooning's] form without having gone through their struggle. I decided to . . . paint my way through art history."[50] She copied reproductions of Rubens, Velasquez, and Goya, in a very free manner, with the idea of learning their secrets and incorporating them in her own work.

For this apostasy from the abstract movement, slight and private as it was, the totally committed Pollock, Kline, and Rothko regarded her as a kind of defector. Nevertheless, Hartigan continued to probe and to study and discovered that her temperament required the use of fragmentary elements from the real world around her to draw forth the full emotional response in painting. From this period came some of her best-known works—*Grand Street*

Brides (1954), *Shop Window* (1955), *City Life* (1956), *Persian Jacket* (1952; bought by the Museum of Modern Art). "I have found my subject," she wrote. "It concerns that which is vulgar and vital in American life. . . ."[51]

In 1958 she was the only woman chosen by the Museum of Modern Art for its show "The New American Painting," which traveled to eight European countries. She sold almost every painting from this period, leaving almost none for her own collection. In 1962 *Current Biography* called her "the most celebrated woman painter in the United States today."[52]

In 1960 Hartigan married a research scientist and moved to Baltimore. Today she lives in a comfortable suburb nearby, but maintains a studio in the inner city area. When she first moved to Baltimore she felt cut off from the intellectual stimulation of New York and was disillusioned by the narrowness and lack of communication between people outside the art world. To counteract this culture shock and isolation, she began to teach painting to graduate students at the Maryland Institute, and now reaps much satisfaction from this involvement with young people. Many of her good friends today are former students.

Hartigan now works in a free-swinging calligraphy of brilliant colors, using images that are a kind of personal mythology. Elements of figures, plants, animals, or motifs from her travels, are thrown together in a seemingly casual, but carefully calculated, mélange that often suggests some deeper theme. For instance, in *Another Birthday,* the passing of time, old age, is suggested by fragments of bodies, fish, and other elements. Mythic and mystical motifs—based on Celtic manuscripts and Lascaux cave paintings, as in *Celtic Painting* (1979)—emerged in a 1981 traveling retrospective. Arranged by the Fort Wayne Museum of Art, it marked her resurgence as an important figure.

Hartigan almost dropped out of sight for a while and endured the vicissitudes of art fashion during

Fig. 7-5. Grace Hartigan, CITY LIFE (1956), oil on canvas, 81″ × 98½″

the waves of Op and Minimal art in the sixties and seventies. Nevertheless, today she says, "I continue with the formal painting concepts of all-over space, a projecting surface and the challenge of vibrant color."[53]

Joan Mitchell (1926–), a leading member of the second generation of Abstract Expressionists, has chosen to remove herself from the competitive New York art scene. She lives in relative isolation with the Canadian painter Jean-Paul Riopelle in Vétheuil, a village near Paris where Claude Monet lived. Although abstract, Mitchell's huge canvases convey a sense of light, fields, and nature. "My paintings are about a feeling that comes to me from the outside, from landscape."[54]

As a child growing up in Chicago, Mitchell felt that her not being a boy was perhaps a disappointment to her father, and competed hard at sports and intellectual achievements to try to please her family.[55] Both her father, a cultivated and well-to-do doctor, and her mother, a poet, encouraged and supported her accomplishments.

Mitchell attended Frances Parker School, a progressive private high school where the teachers encouraged her art and her rebellion against her social register background. After two restless years at Smith College, she transferred to the Art Institute of Chicago (1944–1947), was influenced by Cézanne and cubism, earned a Master's degree, and won a traveling fellowship to study in France (1948–49). This was a painful time, living in a rat infested, unheated flat, struggling to find her own expression.[56]

In the early fifties, Mitchell settled in a cold-water studio in Greenwich Village. Briefly married to Barney Rossett (founder of Grove Press), she became part of the younger group of the New York School, socializing at the Cedar Bar and attending lectures at the Artists' Club. Arshile Gorky and Willem de Kooning became her influences, and when she visited Franz Kline's studio in 1950 "those

black and white paintings on a brick wall . . . blew my mind."[57] "Well, it was exciting. You had this feeling of a group against the world."[58]

In 1951 when her work was selected for the "Ninth Street Show" by the charter members of The Club, she emerged quickly as a major figure. Her first solo show in New York in 1952 at the New Gallery was described as "heroic-sized cataclysms of aggressive color-lines" in a "savage debut that shows her moving further and further from . . . Cubist order."[59]

Mitchell's paintings of the fifties—such as *Hemlock* (1956) and *Ladybug* (1957)—have a characteristic and recognizable calligraphy. On frozen whitish backgrounds, she painted swiftly curving whiplash lines—thorny arcs of green, purple, and blue that have been likened to the movements of an ice skater. (As a child in Chicago she was a champion ice skater.)

Although there are no actual objects in her paintings, she has admitted that they are suggested by such memories as summers in the northern woods of Michigan or the frozen Chicago lakefront seen from her family's apartment as a child. "I'm trying to remember what I felt about a certain cypress tree,"[60] she once mused about a painting. In *Hudson River Dayline* (1956), a shimmering web of lines and painterly areas of blues and yellows float on the white ground, suggesting sun on the water, but there is never any realistic image or specific form.

Unlike the other Abstract Expressionists, she calls herself a "traditionalist" because she works consciously toward a design structure, instead of abandoning herself to the promptings of the automatic gesture and the subconscious. "I want (my paintings) to hold one image, despite all the activity. It's a kind of plumb line that dancers have; they have to be perfectly balanced, the more frenetic the activity is."[61]

After enormous success in the fifties, Mitchell, like other members of the New York School, was ignored by critics in the sixties during the days of

Fig. 7-6. Joan Mitchell, LADYBUG (1957), oil on canvas, 6′5⅞″ × 9′

Pop and Minimal Art. By 1959 she had moved to France permanently. She prefers to work far from the stylistic somersaults of the New York art scene.

Mitchell's stone house in Vétheuil is set high on a hill, looking out over fields, rivers, and boats—familiar features of Monet's paintings. Now her paintings have fiery passages of orange, pale pink, gold, and alizarin, set against the green-browns and deep blues, inspired by the light of France and the trees and sunflowers in her garden.

The moody artist (her mate Riopelle joshingly calls her "Rosa Malheur")[62] begins to work in the late afternoon and continues through the night until daybreak. Curator Marcia Tucker describes her as follows:

Her intellectual and physical energy are overwhelming. . . . She is a very intense person of blunt and disconcerting honesty. . . . She listens to music of every kind while she is painting and paces restlessly when she isn't. . . .[63]

Mitchell has said, "Painting is what allows me to survive."[64]

Despite their energetic, action-painting look, Mitchell's pictures are created slowly, with much thought and planning, and preliminary drawings on the canvas in charcoal. She produces only about twenty pictures a year, and has destroyed many of them. "I don't close my eyes and hope for the best. If I can get into the act of painting, and be free in the act, then I want to know what my brush is doing."[65]

Her canvases are very large and are meant to be viewed from a distance. Often she works out her concepts in diptychs, triptychs, or four-panel compositions that suggest the passage of time as one moves from one panel to the next.

It has been suggested that her recent paintings are landscapes—metaphors for aspects of psychic life. *Mooring* (1971) perhaps suggests the safety of harbor and land against the open fluctuating space of the sea. *Plowed Field* (1971), in more earthy colors, perhaps symbolizes in a broad way the "modification or ordering of nature by man."[66] In some of the "Territory" paintings done around 1972, the shapes are separate, self-enclosed, and discrete, suggesting privacy, uniqueness, and isolation.[67] These floating shapes, glittering cascades, and fields of stiff green strokes have brought Mitchell a renewed reputation in recent years, with major one-woman shows at the Everson Museum in Syracuse, New York, in 1973 and at the Whitney Museum in 1974.

Elaine Fried de Kooning (1920–) has figured importantly as a member of the Abstract Expressionist group since the late forties. Witty and intellectual, she wrote some of the first articles for *Art News* about Hans Hofmann, Josef Albers, Arshile Gorky, and David Smith, while at the same time developing her own version of "action painting." She is unique among the Abstract Expressionists in that she has simultaneously pursued a distinguished career as a portrait painter. Her serious commitment to painting and her rapid-fire repartee made her a natural and welcome part of the gatherings of Abstract Expressionists at the Cedar Bar and the Artists' Club in New York City.

Elaine Fried grew up in Brooklyn in a middle-class family of German-Irish ancestry. She was frequently taken to the Metropolitan Museum (she remembers the "hush and glamour of the place").[68] At the age of six she watched her mother draw a sketch of her and decided she could do as well or better. Fried began to draw constantly, and by the age of ten her peers referred to her as "the artist." She was so talented a draftswoman and so conscious of her identity that she compared herself to Raphael and worried because she had yet to produce a masterpiece, as he had by the age of twelve.

Although Fried's mother introduced her to literature, theater, and opera, and showed her paintings by Rosa Bonheur and Elizabeth Vigée LeBrun, she also indicated that "little girls were smarter than little boys, but that men were smarter than women."[69] Her daughter responded to this challenge by becoming competitive and a tomboy, and spent most of her spare time as a child playing ball with boys on the block. Her unusual preoccupation with the vigorous male athletic image in her paintings may stem from this early period.[70]

At age seventeen, Fried was propelled into the middle of the New York art scene when she attended the American Artists School and also the Leonardo da Vinci School in New York, where Conrad Marca-Relli taught and Robert Jonas was an administrator. These men were good friends of Willem de Kooning and the other artists who pioneered the new American abstraction in the early forties. Jonas introuced Fried to de Kooning, who became her private teacher; she still remembers the rigorous training in modern spatial concepts she received from her future husband. While Fried worked for three months on a still life, "he'd talk about the space between the objects. 'See this curve here, and how it relates to this . . . and the space between them. . . .' Everything was a matter of tension between objects or edges, the tension extended to every part of the canvas."[71] In 1943 they were married.

Elaine de Kooning has described the dodges and maneuvers the struggling American abstract artists resorted to in order to survive. "Sugar bowls from the Automat began to appear in artists' studios . . . a major source of energy in diets that were skimpy. A Viennese analyst and his wife would invite us to lunch every Tuesday. Our week began to center around that one really good meal. . . . Second helpings, needless to say, were outrageous."[72] Sometimes, unable to afford new canvas, they would paint over old works.

Despite these hardships, Elaine de Kooning was working out her own particular version of action painting. Bold, slashing strokes at first encompassed a series of faceless male figures; a sports series followed in images such as *Basketball Players* (1950) and *Scrimmage* (1953), inspired by news photos. She and her husband had very different working styles. She worked rapidly and continuously, while he anguished over every stroke. "Bill said my pace was like Gorky's—hacking away at the canvas."[73]

By this time Elaine de Kooning was a well-known art critic, part of a lively coterie that included poet Frank O'Hara and dance critic Edwin Denby. Clement Greenberg and Meyer Schapiro included her in the 1950 "New Talent" exhibition at the Kootz Gallery. Her first solo show was at the Stable Gal-

lery in 1952, and *Art News* selected her for its list of "Ten Best" exhibitions in 1956, 1957, and 1960.

Art critic John Gruen has described the change in atmosphere among the artists in the New York School as they became famous and successful.[74] In the lean forties, as artists struggled to forge new styles, they were a fellowship. They visited one another's studios, drank tea at one another's homes, and brought out their works one at a time for their peers to discuss and criticize. Certain all-night cafeterias like the Waldorf were hangouts where the artists gathered to talk and argue until the morning hours.

In the late fifties, when success began to make its inroads, the atmosphere became wild, ebullient, and circus-like. Liquor drowned the participants at a heady round of parties, exhibition openings, and gatherings in East Hampton during the summer. "Groupies," not unlike those who attach themselves to rock stars today, hung around the Cedar Bar hoping to infiltrate the exciting new scene. Elaine de Kooning saw this as a self-destructive era and Clement Greenberg said, "The Scene eats artists."[75] By 1957 her paintings, in heavy colors, bore titles such as *Death of Johnny A, Man in Hiding,* and *Suicide.*

Perhaps looking for a change of atmosphere, Elaine de Kooning went to Albuquerque as a visiting professor at the University of New Mexico and found the western landscape a relief from the dense claustrophobic verticality of New York. "When I went West, the color experiences of New Mexico convinced me that 'feeling' was the thing."[76] She visited Juarez, Mexico, and was inspired by the bullfights, which led her into a series of huge, dynamic paintings of that subject.

After she returned to New York in 1959, she rented a colossal studio to paint twenty-foot-wide horizontal canvases in slashing strokes of magenta, chartreuse, orange, blue—colors reminiscent of the light and color of the Southwest. This series (*Arena* [1959], *Redondo* [1960], etc.) based on sketches

made at the bullfights, was painted with a brush set into the end of a long aluminum tube so that she could make strokes as long as eleven feet. The subject is literally obliterated in these works, but the energy and conflict of the bullfight are maintained.[77]

By the early 1960s de Kooning was well known for her portraits, painted in a distinctive, vigorously brushed style. In 1962 she was commissioned to paint President John F. Kennedy at his winter White House in Palm Beach, a portrait that resulted in a series of studies that were widely publicized in *Life* and *Art News*. One of these portraits is now in the Truman Library in Missouri and another is at the John F. Kennedy Library in Boston.

De Kooning struggled to capture the spirit of the young president—"He was incandescent, golden

Fig. 7-7. Elaine de Kooning, PORTRAIT OF JOHN F. KENNEDY (1962–63), oil on canvas, 61" × 49"

and bigger than life."[78] She had as many as thirty-six studies going at one time, and was working at fever pitch when Kennedy was assassinated.[79] After this, unable to paint for a while, she turned to bronze sculpture with crucifixion themes.

De Kooning is best known for her portraits and receives increasing recognition through exhibitions such as the Museum of Modern Art's "Recent Paintings U.S.A.: The Figure" (1963) and "Portraits by Elaine de Kooning" (1973) at the Montclair Art Museum. She catches the essence and character of the subject and concerns herself with the structure and composition of the canvas, but strives for a "spontaneous image that looks unstructured . . . one that might seem 'blown on.'"[80] She says "one subject . . . has a silvery light that just isn't the same light that falls on others; another has a kind of lavendar light."[81]

After some years of going their separate ways, Elaine and Willem de Kooning are living and working in East Hampton. She held a 1981 exhibition of new and old paintings called "Hoops and Homers" at New York's Spectrum Gallery. Over thirty years ago she first noticed that "sports photos on newsstands looked like exciting abstractions."[82] Today she still enthuses "it's the gesture and the nervous kaleidoscope of color . . . it's the stance. . . ."[83]

Nell Blaine (1922–) paints brilliantly colored landscapes and still lifes in sensuous brushstrokes. She has been called "the priestess of light"[84] and the "Queen of Unpolluted Color."[85]

The carefree, decorative look is based on years of disciplined study of abstract design and is also a triumph over personal disaster. At the height of her career she was almost killed by polio and later retrained herself to paint with her left hand. "Don't make much of it," she says, "I don't."[86]

Her art started with an intense experience at a very young age. She was born with bad eyesight, which her parents did not discover until she was

two years old. After corrective surgery, she recalls, "I ran around touching things and looking at them."[87] This early wonder at light and color has never left her.

Blaine never felt at home in the conservative South where she was brought up. As a young child in Richmond, Virginia, she remembers playing in the dirt with a black child and being snatched away by shocked white adults. She rebelled and left at a young age.

After beginning to draw in early childhood, Blaine was already earning money with posters and portraits in high school. She trained in an academic realist style at the Richmond School of Art (now Virginia Commonwealth University) between 1939 and 1942, until a woman instructor named Wörden Day[88] opened her eyes to modern art. Day told her that Hans Hofmann in his Eighth Street School in New York was the greatest teacher of abstract art in America. Blaine saved up enough money working in an advertising agency (she has always been a very skilled commercial artist) to head for New York and Hofmann's classes.

Blaine later said, "Rebellion came when I hit New York in 1942. . . . Everything exploded for me. I rushed from one revelation to another, full of wild enthusiasm for art in all its forms."[89] Between 1942 and 1944 she was a scholarship student, classroom monitor, and disciple of Hofmann, while absorbing his organic push-pull theories of composition and reconciling the two- and three-dimensional aspects of design.

Soon after arriving in New York, she married a French–horn player and for a few years became immersed in the world of jazz. At their 21st Street studio-loft, she beat drums and improvised wild dance steps during all-night sessions, listening to records of Charlie Parker, Dizzie Gillespie, and Lester Young. Musicians, artists, poets like Edwin Denby, and beat writers like Jack Kerouac drifted in and out to listen, eat, and discuss. She felt a close relationship between the improvisations of jazz and abstract art.

In 1944 Blaine became the youngest member (at age twenty-two) of the American Abstract Artists. She began to exhibit disciplined works influenced by Piet Mondrian, Jean Hélion, and Jean Arp, such as *Great White Creature* (1945) and *White Figures on Blue* (1946)—hard-edged, severe abstractions of geometric and organic shapes in flat, unmodulated color. They were mainly in black, white, and gray, with accents of pure primary colors. *Lester Leaps* (1944) was named after a jazz record. "I was consciously trying to give the forms little impacts on the surface almost the way drum breaks marked the time. . . ."[90]

Also in 1944, Blaine joined the Jane Street Gallery, one of the first serious artists cooperatives in New York City, where she exhibited with Leland Bell, Louisa Matthiasdottir, and Hyde Solomon. Bursting with energy, she organized shows and ran so many activities that some people began to refer laughingly to the co-op as "The Blaine Street Gallery." Art critic Clement Greenberg referred to it as one of the most important galleries in New York in that period.

Blaine was a powerhouse, a leader with vociferous opinions who had a lasting influence on the people around her—among them, Larry Rivers and Jane Freilicher, two artists who studied with her. Rivers was a young jazz musician who came to hear records in Blaine's studio and was astounded at her paintings. "Man, this is like real art,"[91] he said, and began to bring her his drawings. Rivers became a sophisticated painter with a profound knowledge of art history. He said of Blaine's influence on his career, "Nell—somehow everything is through Nell."[92]

Around 1949, Blaine decided that the noise, the alcohol, and the wild lifestyle around her were becoming destructive. She fled New York and was incommunicado for a few weeks. Soon after, she took an important trip to France, where she studied and admired the work of Jean Antoine Watteau, Eugene Delacroix, Nicholas Poussin, Gustave Courbet, and other masters, and became more in-terested in figurative art. She wanted to respond to nature, landscape, figure, and flowers in a spontaneous, fluid way, while still incorporating her knowledge about plastic space relationships.

In 1959, after exhibitions at the Stable Gallery and solo exhibits at the Tibor de Nagy Gallery, she was included by Thomas B. Hess in the exhibition "U.S. Painting: Some Recent Directions." She also received fellowships to Yaddo and the MacDowell Colony and was recognized as one of the leading new "painterly realists."

By the late 1950s Blaine's art depended on a kind of instinctive, rhythmic use of the brush stroke; she had abandoned geometric forms and was painting landscapes and interiors, such as *Dark Window* (1955) and *Harbor and Green Cloth II* (1958), at Gloucester, Massachusetts (where she still spends more than half the year). A trip to Mexico in 1957 raised her color sense to a higher-pitched, more brilliant key.

During a painting trip to Greece in 1959, she was struck down by bulbar-spinal polio on the island of Mykonos. Friends rescued her, flew her to Athens, and then to Mount Sinai Hospital in New York. The art community expressed its affection in an exhibition, "To Nell Blaine," where over seventy-nine artists (including Willem de Kooning, Milton Avery, and Philip Guston) exhibited works to help support the extensive physical therapy needed for her recovery.

Today Nell Blaine lives in a studio on Riverside Drive, spends summers in Gloucester, and works from a wheelchair. The polio partially paralyzed her right arm, "I used to love to draw with a big brush . . . zip around."[93] Using mainly her left hand, however, has produced a greater simplification in her art, and she feels that the tragic experience has also brought a deeper spirituality to it.

Blaine has described her work method. Like Matisse, she takes great pains to get effects of spontaneity. She goes out on the site, spends a lot of time setting up, putting out as many as fifty colors. Then, in the magic hour when the light is fading and the

colors take on a peculiar intensity, she begins to paint furiously all over the canvas or watercolor paper. "Painting is like a spider's web. It comes out of the body of the artist, is pulled out of the body."[94]

She says of works like *Gloucester Night Still Life* (1976) and *Old Lyme Bouquet* (1973), "The whole canvas must be broken up by color so that there are intervals of color, like intervals in music."[95] "My work has always had light in it, even the early geometric abstractions have a sense of airy space in them."[96]

Artist-critic Lawrence Campbell has described her paintings as follows:

The hills or the trees or the flowers or the human faces . . . are dots, streaks, or small wriggling lines or tiny splashes of color . . . but everything pulls together, touch by touch, to make a hovering image. She raises the veil of Maya to produce a second Maya's veil, more glittering, more phosphoric . . . than the first. . . . The yellows, greens and blues turn on the light as they act against the mauves, the purples and the amethysts. . . . Her paintings look as though they had poured out together at one time, a summer show of luminosity.[97]

Well known today as a lyrical landscape and still life painter, **Jane Wilson (1922–)** was very much a part of the art scene in New York in the 1950s during the heyday of action painting. Her husband, critic John Gruen, has described their lives as part of the New York School aesthetic and social explosion in his book *The Party's Over Now* (1967).[98]

Wilson was raised on a farm in Seymour, Iowa, whose big sky, wide spaces, and golden afternoon light have played a crucial role in her work:

The landscape was enormously meaningful to me. I used to roam around a lot by myself as a child, and when I think of a landscape, I think of the great weight of the sky and how it rests on the earth. And I remember the light. Light is specific to certain places. . . . (It) is immensely influential to what you do later on.[99]

Wilson studied painting and art history at Iowa State University, received a Master's degree in 1947,

and became an art history instructor at the university. She seemed on her way to an orderly life when she met and married John Gruen, a G.I. Bill student in one of her classes. Over the objections of relatives and colleagues, she headed with him for New York and the uncertain life of a painter.

In New York, Wilson was stimulated by the capers of the art scene, but she and her husband struggled financially. At one point she supported herself during the day with lucrative modeling jobs (to the horror of her fellow artists, who considered this work offensively "establishment"), but continued to paint with serious concentration at night.

In the late forties and early fifties she painted total abstractions, as in *Orbit* (1953), responding to the prevailing mode. But gradually, she found that her horizontal format was leading her by a natural process to painterly landscapes—to her memories of the light and sky of the Midwest.

Wilson's career clearly demonstrates the crucial role of the cooperative galleries in the fifties. She was producing a consistent body of "memory-scapes," but had no outlet for them until 1953, when she was invited to be a founding member of the Hansa Gallery. A cooperative owned and run by artists and named after Hans Hofmann, the Hansa was a springboard for many artistic careers, including that of Alan Kaprow. Not surprisingly, this offer took place at the Cedar Bar in Greenwich Village, the meeting place of Pollock, de Kooning, Kline, and many other activists of the first and second generation New York School.

At the Hansa Gallery, her Abstract Expressionist landscapes (*Into Evening* [1961], *Basket Lake* [1955]) were immediately well received. Soon some were purchased by the Museum of Modern Art and the Whitney Museum. As a result, she was able to move on to the more prestigious Tibor de Nagy Gallery, which also carried the work of Grace Hartigan, Helen Frankenthaler, and Jane Freilicher.

By 1965 Wilson had exhausted the theme of the memory landscape and began a series of cityscapes

inspired by the view out of her large apartment windows facing Tompkins Square in New York City. More recently, she has focused on still life. When she began to teach private painting classes, she set up exotic, patterned still lifes with richly textured fabrics, flowers, fruits, and vegetables. She decided that too many modern paintings look great from a distance, but become formless as the viewer comes closer. Striving to restore the richness of Dutch and Flemish art, she provided herself with huge set-ups crammed with more detail than she could possibly use and forced herself to simplify and select from the mass. This effort resulted in lush, exotic paintings like *India Silk* (1970) and *Gloxinia, Begonia, Petunia* (1970). Then she turned to more austere forms in subtle arrangements like *Tottering Boxes* (1972). Throughout all these phases she has kept the loose, gestural brush stroke derived from Abstract Expressionism. Recently she has veered into a new image that almost resembles hieroglyphics.

Wilson's long study and teaching of art history have given weight and substance to the seemingly effortless sensuality of her art. She has taught at Pratt Institute and Parsons School of Design, and in 1974 was visiting professor at the University of Iowa. She received the Merrill Foundation Award in 1963, the Tiffany Foundation Award in 1967 and 1969, and the Childe Hassam Award in 1972 and 1973.

Jane Freilicher (1924–) paints landscapes of Long Island, and cityscapes of New York in a fluid, lyrical style that owes at least some of its vitality to her background in Abstract Expressionism. She is an artist who cut her teeth on action painting, but moved on to "gestural realism."

Freilicher received a B.A. in art at Brooklyn College and an M.A. from Teachers College at Columbia University, then studied with Meyer Schapiro and with Hans Hofmann at his Eighth Street School. She married a jazz musician and in 1944 met Nell Blaine at jazz sessions. Soon Freilicher was drawing

Fig. 7-8. Jane Wilson, INDIA SILK (1970), oil on canvas, 60″ × 50″

at informal classes at "Nellie's Pad," and became part of the lively circle of young New York School artists and poets in the 1950s that included Jane Wilson and Larry Rivers. In fact, she is known as a painter of poets (*Frank O'Hara* [1951], *John Ashbery* [1954]), and the poets, in turn, have written about her paintings.

Freilicher decided early on that pure abstraction led to monotony and stereotyped composition. In a 1956 interview in *Art News* she said, "People who 'expose their subconscious' often expose dull material."[100] "Too many paintings with the 'modern look' have compositions arranged like electrocardiograms with linear radiations. . . . It seems to me that 'realism' affords more opportunities for unique organization."[101] She had fourteen solo shows at the Tibor de Nagy Gallery.

For her joyous celebrations of everyday subjects, Freilicher has been viewed as a kind of Pierre Bonnard of gestural realists. Indeed, Bonnard, Vuillard, and Monet are three of her favorite painters. She does not make a photographic transcription of what she sees, but tries to seize the vital movement of the objects she looks at. She sometimes distorts a shape slightly, softens an edge, or "pushes" the colors to evoke a ripe, rich, sensuous visual experience.

From her early *Mallow Gatherers* (1958) to *Plowed Field and Seagulls* (1971), she has painted, in a shorthand of varied calligraphic brushstrokes, the potato fields and ponds near her summer home at Watermill. Her colors capture the "milky Eastern Long Island light"[102] and the greens and browns of the meadows. She has also painted many views of the "awkward geometry"[103] of the New York skyline seen from studio windows, as in *12th Street and Beyond* (1976) or *World Trade Center* (1971). Her luscious still lifes in creamy whites, oranges, red-purples, and silvery grays, range from her early *Still Life with Calendulas* (1955) to *Still Life with Two Fish* (1973).

Freilicher has been visiting critic and lecturer at the University of Pennsylvania and Carnegie-Mellon Institute. Her work has appeared in such recent shows as Vassar College's "Figurative Painting" (1968) and the American Federation of Art's "Painterly Realism" (1970).

Surrealism, Fantasy, and Various Forms of Abstraction

Underneath the poetic forms and seductively satisfying aesthetic order, the haunting surrealist landscapes of **Katherine (Kay) Linn Sage (Tanguy) (1893–1963)** suggest an existential emptiness. Her dreamscapes have long been recognized by critics and connoisseurs, but the full power of her work is perhaps still not full appreciated.

Kay Sage was born in Albany, the second daughter of Henry Manning Sage, a New York state senator. Her close friend Régine Tessier Krieger de-scribed her as coming from a background in which her father's family was wealthy and conservative and her mother was "unconventional and restless."[104] Kay's mother adored the gaiety of Paris and took her daughter there every year. After her parents' divorce, Mrs. Sage's allowance still permitted them to continue their travels. Kay was often taken out of school, but received perhaps a better education from extensive travel throughout Europe and the Middle East, and passed her college boards at fourteen.

One stabilizing factor for Sage was an annual visit to Italy, where her mother rented the same villa every year. Sage loved the natural, rustic existence among the Italian peasants, who taught her how to cook "while nibbling at raw garlic."[105] She also imbibed their superstitions, which she retained throughout her life, although she considered herself a rational intellectual. Her brief visits to her father's well-run home, by contrast, made her feel constrained.

Sage was an unconventional and beautiful young woman who found the routines of finishing school and college confining (she attended the exclusive Brearley and Foxcroft Schools). While living in Washington, D.C., she took a brief winter course at the Corcoran Art School (c. 1915), but was not yet serious or disciplined.

In 1917, during World War I, Sage was a translator in the government censorship bureau in New York. It was a natural and enjoyable spot for her, since she was brilliantly fluent in languages, including French, Italian, Spanish, and Portuguese. In 1919 she fell in love with a much older married man, and her family thought it wise for her to return, heartbroken, to Italy.

Living in a moldy run-down villa in Rome, Sage began to draw from life at the academies, characteristically avoiding the days when teachers came to give criticism. She preferred to learn freely on her own. At this time she met Onorato Carlandi, an aging artist, liberal, and veteran of the Garibaldi campaigns for Italian national liberation. Carlandi

took her under his fatherly wing, escorting her on painting trips into the Roman countryside with his friends, while lecturing to her, with frequent quotations from Leonardo, on the value of individualism and liberty. The years spent with Carlandi were happy ones for her, and slowly, she recovered from her earlier love affair.

At a society tea dance in Rome she met the handsome Prince Ranieri de San Faustino. They married in 1925, but after ten years of an idle, upper-class Italian life, she was divorced and moved to Paris. Sage immediately felt comfortable in this city, where she had been happiest as a child. Soon she became part of the surrealist group of artists, who were very active at that time. Incorporating the concepts of the surrealist movement, she brought visions of dreams to life on her canvas, in simplified geometric compositions painted in a tightly rendered and smooth technique. André Breton admired her work. She met and fell in love with Yves Tanguy, the surrealist painter, and formed a lasting relationship with him.

Sage returned to New York when World War II broke out, married Tanguy in 1940, and settled with

Fig. 7-9. Kay Sage, ON THE FIRST OF MARCH CROWS BEGIN TO SEARCH (1947), oil on canvas, 18" × 24"

him in Woodbury, Connecticut, in a nineteenth century yellow clapboard farmhouse with a white picket fence. Together, they helped many French painters escape the traumas of World War II and arranged exhibitions for them in the United States.

Sage was a discriminating person who enjoyed a small, select group of friends—gallery owner Julien Levy and his wife; the constructivist sculptor Naum Gabo; the critic James Thrall Soby (who greatly admired her work); Alexander Calder, the sculptor of mobiles; and others connected with the Surrealist art world. She delighted them with her wit, her poetry (like many other women artists she wrote very well), her cooking, and the charming order of her country house, which was adorned with a fine collection of surrealist paintings by René Magritte, Paul Delvaux, Giorgio de Chirico, and others.

For Sage, the forties and fifties were a period of disciplined painting and frequent exhibitions. She showed at the Pierre Matisse Gallery and then at the Julien Levy Gallery. In 1950 she began a fruitful and enduring relationship with a supportive art dealer, Catherine Viviano. In 1955, however, her superstitiousness rose up to haunt her. A wild bird flew into the house, which, according to folk legend, was a warning of imminent death in the family. A few days later, Tanguy suddenly became ill and died.

Sage became reclusive after the loss of her husband. Around this time she wrote:

I walk very quickly over a thin layer of ice. Below, the lake is deep. I am alone. There is nothing on the horizon. If I stop, even for a second the ice breaks, and down I go. . . . There is no other side.[106]

In 1958 she lost part of her vision after a double cataract operation. She first attempted suicide in 1959 and after being resuscitated busied herself with cataloguing Tanguy's work and doing collages. But after an illness in the middle of a long winter four years later, she killed herself with a bullet to the heart.

Sage cared little for publicity and commercial huckstering. Few people in her little Connecticut town knew who she was. Devoted to high standards of craftsmanship, she refused to paint when her damaged eyesight meant accepting less than perfection in technique. She remained taciturn about the symbolism in her art.

Her paintings suggest a lonely and empty world of shattered architectural forms and tattered draperies, after some kind of a holocaust. She often used scaffoldings and rigging in her compositions, through which one can see an endless horizon. In one painting a woman whose back faces the viewer looks out over an infinity of nothingness.

Small Portrait (1950) shows the form of a head, muffled and wrapped by bands and drapes, a powerful symbol of the human spirit trapped and locked by confining forces. The metamorphic forms variously suggest the head and beak of a bird, a lock, a piece of drapery. Behind the head in a gloomy, threatening light, in characteristic dull colors of earthy greens and rusts, the edge of a cliff seems to fall off into infinite space.

The forms in *The Instant* (1949) suggest the weathering of time, eroding all substance. A hill-like shape—resembling at once a shipwreck, a pile of old bones, shells, and sea debris, and an assemblage of ghostly cowled and hooded forms—appears to be melting into the infinite misty distance of the sea. Sage used a smooth paint surface and clearly defined forms to depict these threatening dreamlike vistas.

Sage's work has been overshadowed by that of her husband, Tanguy. Books of art history usually mention her, if at all, with a chance remark that she was also a surrealist painter. A major retrospective of her work in 1977 at the Herbert Johnson Museum of Art at Cornell, showed her full range as an artist.

Throughout her career, Sage was also a prolific and distinguished poet. In one of her four published volumes are the following lines from the poem "Tower":

Fig. 7-10. Kay Sage, THE INSTANT (1949), oil on canvas, 38″ × 54″

I have built a tower on despair,
You hear nothing in it, there is nothing to see. . . .[107]

Dorothea Tanning (Ernst) (1910–) was one of three daughters brought up by Swedish parents in Galesburg, Illinois—an unlikely start for someone destined to become an internationally recognized surrealist painter living in France. Her father had left Sweden in rebellion against his bourgeois father, and came to the United States searching for adventure. Her mother had dreamed of being a professional singer. Projecting this ambition on her daughter, she gave Dorothea elocution lessons, and

at age five, dressed in ribbons and taffeta, Tanning entertained audiences with real tears while reciting sad poems. But by the age of seven she had discovered her true métier in a watercolor box, and decided at that time to be a painter. From then on she drew and painted continuously.

School bored her, and the monotonous, straitlaced Midwestern environment was relieved by a secret fantasy life nourished by voracious reading in the public library. Tanning began in the children's section, with Lewis Carroll, Hans Christian Andersen, and the illustrations of Arthur Rackham, Max-

293

field Parrish, and Sir John Tenniel. When she promoted herself to the adult section, the provincial mores of her strict Lutheran environment were further subverted by daily, imaginary escapes to Paris, London, and a world of decadent delights by means of books such as Oscar Wilde's *The Portrait of Dorian Gray* (1891), Gustave Flaubert's *Salammbo* (1862), and the gothic novels of Ann Radcliffe and Mary Shelley. Her mind was furnished with images she drew on for the rest of her life.

After two years at Knox College Tanning left to study at the Art Institute of Chicago. But in two weeks she decided she could learn more by studying on her own. To the dismay of her parents, she went to New York and began to live a bohemian life. She shared an apartment with another young woman artist, read William Faulkner, Emily Dickinson, and the Bhagavad Gita, studied Hindu dance and philosophy, worked at odd jobs (she was an extra at the Metropolitan Opera among other things), and continued to paint. Julien Levy, the art dealer, soon recognized the fantasy imagery in Tanning's work, which already incorporated the double meanings of surrealism.

In 1936 she was profoundly affected by a landmark exhibition at the Museum of Modern Art, "Fantastic Art, Dada, and Surrealism." This experience affirmed the tendencies already present in her work, and she left for Paris in 1939 with letters of introduction to Picasso, Max Ernst, and others, eager to join the surrealist art scene in France. But France was on the brink of war, and Paris was a ghost town from which frightened people were fleeing. None of the artists were there, and when the war broke out she returned, dejected, to New York.

Tanning had managed to become a skillful draftswoman and supported herself successfully at advertising jobs. She took a large apartment on 58th Street and soon discovered to her delight that the surrealist world she had been seeking had actually moved to New York. Most of the leading intel-

lectuals of the surrealist movement were re-creating the surrealist community, complete with "happenings," games, and publications. Tanning became part of this group and acted in a Surrealist film, *Dreams That Money Can Buy* (1944–46), directed by Hans Richter.

When Peggy Guggenheim held the 1943 exhibition "31 Women" at Art of this Century she sent her husband Max Ernst to pick up Tanning's painting. Ernst was very much impressed with this picture of a woman with weeds and roots growing out of her, who opens a door that reveals an endless succession of other doors. He was also impressed with Tanning. Peggy Guggenheim later wrote in her memoirs:

They now became very friendly and played chess together while I was in the gallery. . . . Soon they were more than friendly and I realized that I should only have had thirty women in the show.[108]

Ernst was divorced from Guggenheim, married Tanning in 1946, and moved with her to the small village of Sedona, Arizona, where they continued to paint, amidst a coterie of other surrealists.

In 1952 they moved permanently to France, where, like Mary Cassatt, Dorothea Tanning is more renowned than in her own country. In 1974 she was given an important retrospective exhibition at the Centre National d'Art Contemporain.

During the 1940s Tanning did some of the most meticulously rendered images of the surrealist movement, but her later works are more amorphous and abstract, sometimes fractured into facets. She has said that her earlier work was painted "on this side of the looking glass," looking directly at the subject, but that the later work is "*through* the looking glass"[109]—the subject is observed more obliquely and is harder to read, but has more overtones.

Guardian Angels (1946) contains a kind of apocalyptic vision in which female figures are swept up from their beds and carried into the sky by creatures, perhaps representing forces of the un-

Fig. 7-11. Dorothea Tanning, GUARDIAN ANGELS (1946), oil on canvas, 48" × 36"

she gives herself up to chaos, dreams, and the liberating world of the imagination. In recent years she has made a group of soft sculptures, writhing body forms covered with cloth and felt, sometimes growing out of a piece of furniture, such as a table.

Tanning has admitted that her relationship with the grand master of surrealism, Max Ernst, has hampered her career in the predictable ways. André Breton left her out of his big book on surrealism because he viewed her solely as an appendage of her husband. Tanning claims that none of this prejudice came from Ernst himself, with whom she had until his death in 1976, a harmonious relationship. She once wrote: "We live without shadows . . . fascinated by what the other is doing."[111]

Ynez Johnston (1920–) is a Los Angeles artist whose prints, paintings, and sculpture are reminiscent of Paul Klee and Persian miniatures, and yet are uniquely her own. Mythic figures, castles, boats, and beasts combine and metamorphose into strange new forms in angular patterns and jewel colors. Her work is an unusual blend of modern art and ancient Oriental influences.

Johnston was born in Berkeley and studied art there at the University of California. Some of the exotic influences in her art can be traced to the environment of San Francisco, where she spent her formative years. She recalls that

the atmosphere of that city had a very romantic quality for me as a child. The changing moods of the landscapes . . . the way the city's constructed on hills . . . the museum which had so many Chinese artifacts . . . the little boats on the bay. . . . "foghorns, ferry boats, Chinese pagodas."[112]

While still an undergraduate at Berkeley, she painted a series of Persian-style miniatures, influenced by the Rajput, Mogul, and Persian art in the San Francisco museums. Upon graduation in 1941, she received a University of California scholarship grant to study and paint in Mexico. Her travels resulted in her first solo show at the San Francisco

conscious. *Family Portrait* (1954) is a monstrous version of a male-dominated family. Many of her paintings show a child being initiated into a secret erotic world that is both tantalizing and sinister. A mysterious Pekingese dog, often present in her paintings, appears sometimes to be playing with a young woman, and sometimes seems about to overwhelm her.

Tanning has been annoyed by critical interpretations that find coy feminine eroticism in her work. According to her, it is death, which she fears, that often looks out at her from the canvas.[110] Like a true surrealist, she has said that she creates each of her paintings in a kind of ecstatic convulsion in which

Museum of Art in 1943 of paintings made in Oaxaca, Yucatan, and Chiapas. Johnston was fortunate enough to settle on a basic imagery and find her artistic identity at the very beginning of her career. She received an M.A. from Berkeley in 1946 and was selected in 1951 for the "New Talent" show at the Museum of Modern Art.

Her early paintings *Advancing Mist* (1953) and *Winter Voyage* (1955) resemble bird's eye views or maps of strange cities of the mind that, like San Francisco, are bordered by water and boats. The general effect is one of jagged masses of calligraphic tracery.

Johnston received a first award for her watercolor *Black Palace with Courtyard* (1952) at the Metropolitan Museum of Art, followed by a Guggenheim grant in 1952 for six months of travel and painting in Italy. Roman and medieval motifs entered her work at this time.

In 1952, while she was artist-in-residence at the Huntington Hartford Foundation in California, she met the poet and novelist John Berry, author of *Krishna Fluting* (1959), and married him the following year. Berry has worked with Johnston in a unique collaboration. He sometimes writes catalogue essays for her exhibitions and enjoys helping her with the carpentry of her wooden sculptures. These "unspeakable animals" are mythic beasts and abstract constructions of flat pieces cut into bizarre shapes and painted with her characteristic motifs. Johnston has also decorated ceramic objects and ceramic murals.

Johnston and Berry traveled in India together when he received a Fulbright research grant in 1964. She said later that when she arrived in India, she felt she had been there many times before in her imagination and was merely returning. Tibetan *thankas,* or wall hangings, with their centered geometric images and heavy borders, influenced *The Green Safari* (1975), *The Cosmic Mountain* (1975), and other paintings in chemical dyes on silk. A very experimental etcher, she likes to cut out

etched metal shapes in free forms and place them together in different compositions.

Johnston is clearly part of the art movement in the late forties and fifties in which the idea of archetypal forms from the collective unconscious figured prominently. She has said:

Painting is for me like a voyage into oceans known and unknown . . . depths and distances ultimately unfathomable. The end of the voyage is never what one might have anticipated. Some images, themes . . . seem to recur almost obsessively. . . . These appear to be composite shapes: the running together of architectural, landscape and animal and human forms. Something different from the originals is then created which may refer to them obliquely, but does not repeat them.[113]

The artist has won Yaddo and Tiffany grants, taught at colleges, and among her long list of exhibitions, had a graphics retrospective at the San Francisco Museum of Art in 1967.

Charmion von Wiegand (1899–) has had a long, colorful career as a geometric abstract artist, a journalist, and a scholar of Buddhist art. Born in Chicago, she grew up in San Francisco, and her early memories of that city remain important to her: "I always liked color. I got it early from the Chinese in the streets . . . dragon parades and firecrackers."[114] She remembers being jealous because her brother had been baptized in the Vedanta church, whereas she had to attend the Methodist church when she was growing up.

Her father Karl von Wiegand was a theosophist and a friend of Jack London. She recalls:

Father was a brilliant journalist . . . at one point general manager for the Hearst papers in Europe. My father was the first to announce World War I. He was always trying to make me more modern; Mother was more conservative and Victorian, one of the society girls of the American colony in Europe.[115]

Her parents separated in the late 1920s.

Von Wiegand attended high school in Berlin when her father was stationed there as foreign correspondent, and then went to Barnard College. Be-

cause her father wanted her to be a journalist she registered in the Columbia School of Journalism, but transferred to art history and archaeology at Columbia and New York University.

In accordance with family expectations, von Wiegand married a wealthy man, but soon became totally dissatisfied with her life: "I had to entertain all these merchants and millionaires. It was very boring."[116]

She began to paint in 1926 as an outgrowth of psychoanalysis. When her analyst asked what she would do if she could do anything she wanted, von Wiegand replied, "Why I'd paint, of course."[117] Realizing that she had always wanted to, but thought it impossible, she began to paint the apple tree in her yard in Darien, Connecticut, naively rendering every leaf. She divorced her husband, refusing to take any money from him. "Then," she recalls,

I put my picture in the Independents' show and there at the opening were people like Burliuk with a turquoise earring in one ear and a Chinese robe. After my analysis I became a radical. I went down to Greenwich Village in a batik blouse and took a studio in MacDougal Alley. . . . I knew Theodore Dreiser, Frank Harris, Max Eastman. I knew all the writers and poets. Hart Crane got the idea for his poem about the bridge when I introduced him to Joseph Stella.[118]

After receiving art criticism for a while from her friend, the painter Joseph Stella, she went to Moscow as a journalist in 1929, continuing to paint Russian churches on the weekends. Returning to New York in 1932, she married Joseph Freeman, a founder of *The New Masses* magazine and later of the *Partisan Review*.

During the thirties, von Wiegand was an editor of *Art Front,* the magazine of the Artists Union, and wrote publicity for the Federal Art Project. Her interest in abstract art was first aroused when she wrote a discerning review of the first exhibition of the American Abstract Artists for *The New Masses,* adopting a viewpoint far ahead of the times.

The turning point of Von Wiegand's career came in 1941, when she interviewed Piet Mondrian, the Dutch painter of rectilinear nonobjective canvases, for an article she was writing about the European artists in exile who had come to New York to escape fascism. She has described her first meeting with him:

Mondrian wasn't tall and impressive looking. He was wearing a white smock like a dentist . . . but he had eyes, what eyes . . . my God what a man. . . . Suddenly the room seemed to be full of light with all these pictures. I felt as if I had two drinks. When I went out, the city looked different. . . .[119]

Mondrian's mystical view that art searched for a hidden order and harmony in the universe stirred memories of her father's theosophism. The two artists became good friends, and she worked with him on the first translations of his writings into English. Also, at Mondrian's suggestion, she joined the American Abstract Artists in 1942. Von Wiegand has had a long association with that organization, exhibiting since 1947 and serving as president from 1951 to 1953.

Guided by Mondrian, she created biomorphic and geometric nonobjective paintings, such as *Individual Worlds* (1947), influenced by his orthogonal and rectilinear compositions. She was in Peggy Guggenheim's 1945 women's show at Art of This Century.

Around 1946, however, she began to create more playful and relaxed collages using the signs of the zodiac, strips of paper lace, tarot cards, brightly painted papers, and other materials (*Map of the Heavens* [1947], *Tarot* [1947]). According to art historian Herta Wescher, "Her first exhibitions, held in 1947 at the museums in Masillon and Akron, Ohio stimulated a new wave of interest in collage in the United States."[120] The following year, along with Katherine Dreier and Naum Gabo, she organized an important show of Kurt Schwitters's collages.

One of von Wiegand's earliest collages was made of travel labels from her father's suitcase when he was held prisoner for two and a half years in Shanghai during World War II. As she grew more interested in Oriental art and philosophy, she began to include Chinese characters, cut from texts or painted by her, lending a mysterious vitality to her collages. The playful brushwork elements were subdued by subtle arrangements of rectangles and strips in works like *Transfer to Cathay #93* (1948) and *Journey into Fear* (1958).

Around 1949 von Wiegand began to immerse herself in Tibetan Buddhist art, stimulated partly by the Zen spiritualism of her friend, the artist Mark Tobey. This resulted in new and original forms in her painting based on Eastern religious symbolism. She created a series based on the triangle, another using the mandala form. Still later, in such works as *Invocation to the Winter Goddess* and *The Diamond Scepter* (1969), she created geometric goddess images in long, vertical, symmetrical panels, using clear and brilliant colors. These goddess images are prophetic of the feminist involvement with female deities in the 1970s.

Von Wiegand traveled to India for the first time in 1970. She continues to paint, write, and lecture, principally on Buddhist art. In such essays as "The Oriental Tradition and Abstract Art"[121] and "The Adamantine Way,"[122] von Wiegand expresses hope that the world will integrate the eastern philosophical idea of man's harmony with the universe in a new synthesis with western notions of individual freedom and scientific logic.

A retrospective of her work was shown at the Noah Goldowsky Gallery, New York, in 1974. Her paintings are also in many museum collections.

Jeanne Miles (1908–) is a "purist" painter whose simplified geometric forms, enriched by gold and platinum leaf, reflect a search for a mystical order underlying the material world. Her daring spirit led her into the modern movement in Paris in the 1930s.

Fig. 7-12. Charmion von Wiegand, DARK JOURNEY: COLLAGE #207 (1958), 19¼″ × 15½″

Born in Baltimore, she studied art at George Washington University and first discovered Van Gogh and Picasso as she wandered through the rooms of the Phillips Memorial Gallery in Washington, D.C. The Phillips Gallery summer school on Cape Cod gave her a scholarship for a brief exciting survey course on modern art.

In Washington Miles was hired to paint a mural at the socialite Café Ramon (the painting included more than a hundred caricatures of the cafe's young clientele). A wealthy New Yorker who was intrigued by the mural offered her a travel scholarship; she could go anywhere if she would live on a dollar a day. In 1937 Miles went to Tahiti, still a primitive place at that time. She lived with a native family, swam, and painted, and was initiated into the spirit world of the Tahitians.

With only seventy-five dollars left, she decided to stow away on a cargo ship going to France, much to the chagrin of the captain when he discovered it. Living in dire circumstances in Paris, she studied with Marcel Gromaire (as the only woman student in his class), developed a brightly colored fauvist style, and exhibited at the Salon des Indépendants in 1938. That same year a surrealist show organized by André Breton and others made a strong impression on her.

Miles married the French painter Johannes Schiefer and had a daughter, Joanna Miles, who is today a well-known actress. After France fell, they hid in an abandoned monastery and then fled to the United States. They were part of the large group of artistic refugees from Europe who brought such color and excitement to New York in the early forties. Miles separated from her husband soon after they arrived in New York, and raised her daughter alone. She earned money by working at the Guggenheim Museum for Baroness Hilla Rebay, lecturing, and teaching at Oberlin College and elsewhere. Miles gave classes jointly with Theodore Stamos, one of the founders of the New York School, in her large studio apartment in the historic Stuyvesant Building (since destroyed, but at that time an enclave of artists and theater people).

In the forties Miles was associated stylistically and socially with the leading Abstract Expressionists in New York, and was one of very few women in the original group that formed the Artists' Club. Betty Parsons sponsored her first one-woman show, at the Wakefield Gallery, and later carried her work at the Betty Parsons Gallery.

Miles, however, did not long rest content with the loose, gestural, quasi-surrealist painting style she worked in at that time (*Fire* [1946]). Her increasing interest in spiritualism, especially the mystical theories of P. Ouspensky and eastern philosophy, led her in the opposite direction from Abstract Expressionism, then exploding with popularity. She moved toward increasingly purist geometric forms—rectangles and later circles in squares,

mandalas, and triangles, as in *Movement Geometrique* (1952–62).

One of the distinctive elements of her work has been the use of gold and platinum leaf in paintings like *Three Symbols,* (1963) and *Mandala #3* (1970), glazed over with thin washes of paint. This arduous technique gives richness to her geometric forms. Miles branched out into cast polyester spherical sculpture during the sixties, but was stopped by muscle paralysis resulting from the poisoning effects of this medium. She has since recovered.

In 1959, she joined and exhibited with the American Abstract Artists. She was given an exhibition of her paintings and sculpture at the Grand Central Moderns Gallery in 1968 and was in "Three American Purists" at the Museum of Fine Arts in Springfield, Massachusetts, in 1975. Like Alice Mason and Charmion von Wiegand, her work has appeared in many exhibitions devoted to abstract classicist or purist works.

Perle Fine (1908–) was one of the young talents promoted by the Baroness Rebay and the Guggenheim Museum in the 1940s. Her geometric, nonobjective paintings were shown there in group shows and she went on to a productive and stylistically varied career, always in the nonobjective tradition. She has said that "only through the discipline of painting in the abstract vein . . . could I express . . . the Universal as an ideal."[123]

Fine grew up on a dairy farm in Boston and knew as a child that she wanted to be an artist. She came to New York in the 1920s and enrolled at the Art Students League with her first inspiring teacher, the drawing instructor Kimon Nicolaïdes. There she met her future husband, Maurice Berezov. Both abstractionists, they exhibit separately; maintaining distinct identities.

Fine gained a great deal from studying with Hans Hofmann at his Eighth Street School in New York in the late thirties. She did not agree with all of Hofmann's ideas, however, and would often retreat to her cold-water flat across the street to sort things out

and work on her own. "Hofmann," she has said, "kept relating abstraction to the figure and to nature, and I knew there was much more."[124]

Not until she visited the Guggenheim Museum and saw the works of Vasily Kandinsky, and other nonobjective masters, did she suddenly feel completely at home with an artistic mode. She became one of a group of young artists who were subsidized by small stipends from the Guggenheim Foundation, administered by its fiery director, Hilla Rebay. In return for enough money to pay for materials, they were required to bring in work once a month, which Rebay in turn showed to Solomon Guggenheim. One of her fond memories is of the time Frank Lloyd Wright, the architect of the museum, bought one of her paintings, although he hated almost all painting.

In her first solo show at the Willard Gallery in 1945, her painting *Polyphonic* was described as looking like "an immobilized Calder mobile . . . using bright clear hues and a wiry black line."[125] In subsequent shows at the Nierendorf Gallery (1946 and 1947), and elsewhere, she used a wide range of forms—rectangles, triangles, and other kinds of geometric and biomorphic (organic) elements. These paintings included *Form and Line* (1946), *Juxtaposition of Soft Black Form* (1946), and *Midnight* (1947).

Fine joined the American Abstract Artists in the 1940s and remembers the fierce arguments and debates over aesthetic issues that raged in the organization. She had become friends with Jackson Pollock at the Guggenheim (he was working as a guard there at the time), and as soon as she was admitted as a member of American Abstract Artists she proposed him as a member. At which time, she recalls, "they practically threw me out!"[126] Most of the members were geometric abstractionists devoted to the tradition of cubism, and they considered the works of Pollock and Willem de Kooning "impure"—lacking in plastic principles.

In shows at the Betty Parsons Gallery in the early

fifties, Fine's canvases grew larger, looser, and almost cloud-like in imagery. She found the Abstract Expressionist movement a healthy "loosening up" influence. In the mid-1950s she was elected to the Tanager cooperative. Fine was working in an oversized, but decaying loft, and rented the front part of it to the Tanager group as an exhibition space, while continuing to use the back part as a studio.

In 1954 Fine moved to the Springs, near East Hampton, Long Island, the art colony that became the country outpost of the New York School. At age forty-six she became an associate professor of art at Hofstra University and taught for twelve years until 1966. She has described her feelings about teaching as follows:

Fig. 7-13. Perle Fine, TAURUS (c. 1946), oil on canvas, 28" × 24"

I had always been an anti-person person. I kept away from too much social involvement because I felt that I needed the time to be alone to work out my ideas, but when I began to teach I discovered to my surprise that I enjoyed people. I took teaching very seriously but found that it drained most of my energy. Teaching is a creative commitment.[127]

During a period of illness in the late 1960s, Fine went through another stylistic change. Unable to work on large canvases, she did a series of collages that combined wood pieces with painted grids. Later, graph paper designs led into her recent series of serene and calm gridlike paintings, which she has called her "Accordment" series. Using very minimal means (somewhat in the manner of Agnes Martin)—vertical lines of color balanced against horizontal ones, she plays colors against one another, exploring the effects of color interrelationships on the overall field. Her paintings emit a kind of subtle, inner luminosity.

In a way, paintings like *Accordment Series #2, #3, #6, #55,* and so on, painted in 1977 and 1978 (also called *The Dawn's Wind, A Woven Warmth, Gently Cascading,* and other fanciful names) hark back to Fine's early close association with Mondrian in the forties in the American Abstract Artists. At that time she did erudite analytical charts interpreting Mondrian's *Victory Boogie Woogie* (1944).

Fine is still working in her country studio at East Hampton. She retains an abiding belief in "works which will express life-affirming idealistic feelings through the constructive of ordered color spaces."[128]

Anne Ryan (1889–1954) fashioned sensitive abstract collages of paper and fabric that were not fully appreciated until long after her death, when the National Collection of Fine Arts and the Brooklyn Museum gave them a major exhibition. Ryan's art career was short, but intense—about fifteen years from start to finish. She was born in Hoboken,

New Jersey, to a wealthy Irish Catholic family, studied at a convent school and at Saint Elizabeth's college near Morristown, married a lawyer, and had three children.

Her conventional existence ended several years later when she began to write poetry (*Lost Hills* was published in 1925) and her marriage failed. By 1928 she had written in the margin of her notebook, "Bound by no rules, and for myself alone."[129] For two years she lived on the island of Mallorca, writing poetry, stories, and articles. In 1933 she returned to Greenwich Village, becoming a part of the intellectual community there.

She was almost fifty years old when her friends Hans Hofmann and sculptor Tony Smith, encouraged her to paint. In 1941, at the age of fifty-two, she had her first one-woman show of oil paintings. She studied printmaking at Stanley Hayter's influential Atelier 17 and also designed ballet costumes and stage backdrops.

An exhibition of collages by Kurt Schwitters at Rose Fried's Pinacotheca Gallery in 1948 inspired Ryan to work in the mode for which she became famous. For the following five years, until her death, she constructed some of the most lyrical collages ever created in the United States. Their calm, spiritual quality stems from her early contact with the Catholic mystics and her familiarity with the poetry of Rainier Maria Rilke and Gerard Manley Hopkins, among others. Betty Parsons's gallery brought Ryan's collages to the attention of the public in 1950, and she was included in the 1951 exhibition "Abstract Painting and Sculpture in America" at the Museum of Modern Art. Her rare sensibility was beginning to be generally recognized shortly before her death.

The material in Ryan's collages is an odd mélange of papers, fabrics, and threads. The papers range from scraps of candy wrapping to handmade special papers designed and produced by Douglas Howell, a genius in this field, whose papers were also used by Lee Krasner and Jackson Pollock. The

fabrics are bits of old handkerchiefs, scraps of toweling, torn pieces of hand-me-down, thrift shop dresses that turned up in her sewing bags. In collages like *Untitled, #424* (1953), *#426* (1952), and *#625* (1953), she used these materials in basically cubist compositions of rectilinear shapes softened by ragged edges. An occasional orange or turquoise accent sings out amidst a close harmony of near-neutral colors.

Ryan waited patiently for certain materials to be "ripe"—to have a sufficiently faded and worn quality. Out of these odds and ends, she created works in which an "atmosphere of otherworldliness, even transcendence . . . seems foremost."[130] Her work is at the Museum of Modern Art, the Whitney Museum, and elsewhere.

Realism-Expressionism

Honoré Sharrer (1920–) became celebrated as a prodigy of realism in 1944 at age twenty-four, when the Museum of Modern Art bought her study for a federal mural, *Workers and Paintings* (1943). At a time when most artists were moving into abstraction, she chose to paint small, meticulous panels, expressing her sympathy with the common people of this country.

Sharrer was born in West Point, New York. Her father was an army colonel, and her mother was an artist who had studied with Robert Henri. From her earliest years, Sharrer and her mother shared a companionable interest in art and spent weekends in the country painting and picnicking together. When she was fourteen, her father was stationed in Paris on the Île St. Louis, and she attended her first life-drawing class at the Académie Colarossi with her mother. Much younger than the other students, she remembers being embarrassed by the nude model. Unlike the French girls at the *lycée*, Sharrer was free to roam the city unchaperoned, visiting the museums and absorbing the old masters at the Louvre.

Fig. 7-14. Anne Ryan, UNTITLED (#461) (1952), paper and fabric on paper, 6¹³/₁₆″ × 5⅛″

When her father was transferred to San Diego, California, she attended the Bishop's School, a private school in La Jolla. In her senior year there she won a $1,000 prize from *American Magazine* in a national competition. Sharrer vividly remembers the powerful impression made on her by a fifteenth century painting by Hieronymus Bosch, *Christ Crowned With Thorns,* at the San Diego Gallery of Fine Arts. She identified with this traditional mode and decided to study at the Yale University art school, a stronghold of rigorous traditional training before the arrival of Josef Albers and his Bauhaus-modern curriculum. After a year there, Sharrer spent an additional year at the more free-wheeling California School of Fine Arts.

During World War II, she worked as a welder in a shipyard in Hoboken, New Jersey. There she closely observed the working-class types she began to depict in her paintings. Oddly, at a time when most artists were turning toward abstraction, Sharrer looked back to the realistic public art of the Federal Art Project of the 1930s, identifying strongly with its "human content and monumental form."[131] She entered competitions for government post offices, and her mural study for the Worcester, Massachusetts, post office brought her to the attention of Lincoln Kirsten, who bought the study for the Museum of Modern Art.

After several small paintings, rendered like the works of Flemish and early Renaissance masters (*Man at the Fountain* [1948]), Sharrer embarked on an ambitious polyptych made up of five panels, entitled *A Tribute to the American Working People* (1951). Shown at Knoedler's Gallery in 1951, this work is now in the Sara Roby Foundation collection in New York. Although small in size, it is monumental in conception. Organized like a Renaissance altarpiece, *A Tribute* presents pictures of everyday America—a worker in front of a factory, a schoolteacher and her class, a country fair. Sharrer has explained,

I conceive of the people of this painting as individuals with petty pretensions and commercial vulgarities, but despite this crust of stereotype, they are the vital determining majority in which the cycle of birth, marriage, struggle and death always seem to be pared down to elemental energy and simplicity of purpose.[132]

Four and a half years of arduous effort and over four hundred photographs and sketches went into the research and execution of this work. She spent an entire day in an elementary school classroom just to study a particular kind of gesture of friendly play between a white child and a black child. The complex drawings were traced onto gesso panels and rendered in a technique so meticulous that painting one eye took an entire day.

In addition to receiving major articles in *Life* and *Art News,* Sharrer exhibited in "Fourteen Americans" at the Museum of Modern Art and won various awards. Between 1951 and 1969, during the wave of abstract art, she retreated into comparative isolation on her farm in Rochester, New York, where she still lives and works in seclusion. She has been married since 1947 to Perez Zagorin, a history professor, and has one son.

Emerging after a hiatus, Sharrer showed larger satirical works, which were described in *Arts* (April 1969) as "devastating examples of social, political and religious satire. . . . The Last Supper is shown as the Mad-Hatter's tea party." Lecherous old men, fully dressed monkeys, and fornicating dogs were part of the mélange, painted in a looser style.

In 1972 her painting *Leda and the Dwarf* won the Childe Hassam purchase prize from the American Academy of Arts and Letters. In 1978 *A Tribute to the American Working People* was sent to the U.S.S.R. in a major exhibition of American painting selected by the Metropolitan Museum of Art.

Ruth Gikow (1915–1982) first painted social realist themes for the Federal Art Project in the 1930s and then again in the 1960s, when the antiwar movement and other burning issues elicited paintings of social comment, this time in a fluid, expressionist style. Author Matthew Josephson has said that her paintings are "filled with the consciousness of our apocalpytic times and their terrifying history."[133]

Gikow was born in the Russian Ukraine during World War I, but her family fled when she was five to escape from civil war and pogroms against the Jews. One night, during a terrifying two-year journey across the borders to freedom, she was lost by peasant guides while going through a forest swamp. The Gikows finally settled in New York in a tenement on the Lower East Side. Her parents felt culturally superior to the immigrants around them (her father had been a photographer). Ruth, however,

Fig. 7-15. Honore Sharrer, TRIBUTE TO THE AMERICAN WORKING PEOPLE (1951), oil on composition board, 33¼″ × 27″ (center panel), 11⅜″ × 16⅜″ (smaller panels)

Fig. 7-16. Honore Sharrer, center panel, TRIBUTE TO THE AMERICAN WORKING PEOPLE (1951), oil on composition board, 33¼″ × 27″

learned English and eagerly joined the neighborhood children. She set her sights on a well-to-do life as a fashion artist, and distinguished herself at Washington Irving High School's art department, while working at night at Woolworth's to earn spending money.

When she graduated from high school in 1932, the Depression was in full force, and there were no fashion illustration jobs to be found. Continuing to work at Woolworth's for seven dollars a week, she enrolled at Cooper Union Art School with John Steuart Curry and also took private classes with Raphael Soyer.

Her first modest exhibit, in the lobby of the Eighth Street Playhouse in Greenwich Villiage, was described by Soyer as a sympathetic portrayal "with youthful crudeness and strength" of the "worker, his wife and children and his neighborhood."[134] On the Federal Art Project she painted for $23.86 a week and socialized with other young social realists who hoped to change the world. Inspired by the Mexican muralists, she painted a 1939 mural for the children's ward of the Bronx Hospital. At the World's Fair in Flushing Meadows, she demonstrated mural painting to a friendly crowd from atop a high scaffold.

When the Federal Art Project disbanded, Gikow became art director of an advertising agency. The strain of this work, combined with her attempt to continue her own painting, drove her into a depression. She had already decided to take the leap and devote herself entirely to painting when she met, and in 1946, married Jack Levine, the distinguished expressionist painter. That year she had a solo show at the Weyhe Gallery and another in 1948 at the Grand Central Galleries.

In 1947–48, Gikow traveled in Europe with her husband, spending twelve months in Italy. Her work was influenced by early Italian Renaissance masters like Piero della Francesca and Massaccio, and in France by Jules Pascin, Chaim Soutine, and the moody Belgian expressionist James Ensor. Her paintings of Italy, such as *Blind Musician* (1952),

show strolling musicians, carnivals, and beggars in settings of war-bombed ruins.

Back in New York with a teenage daughter in the fifties, Gikow painted themes of youth. *Apotheosis* (1956), showing a near-religious procession of teenagers carrying a rock-musician idol on their shoulders, was done from sketches made in the street of Greenwich Village.

During the sixties, Gikow painted the antiwar and civil rights movements in scenes of crowds swayed by emotion. *Moratorium—October 15* (1959), *Freak-Outs* (1969), and *Pot* (1967) depict the troubled youth of the time.

She aimed her brush at the older generation in such satirical works as *Drip Dry Invasion* (1969) and *Adoration of the Gadget* (1969). In the latter a crowd of people holding cameras and television sets is obsessed by a craving for machines. The women wear metal hair rollers or sit under hairdryers that make them look like space voyagers, and the background is crowded with space vehicles and scaffoldings that crowd out grass, sky, and land.

Gikow works in loose, drippy washes of pearly color, accented with line, something like the technique of Jules Pascin. Her broadly generalized, sketchy figures show an edge of caricature.

Sculpture of the Forties and Fifties

In the 1940s and 1950s, American sculptors turned toward total abstraction, open forms, and the spontaneous, intuitive process of welding in metal. Mary Callery's attenuated linear figures and Claire Falkenstein's welded thickets emphasize the significance of the open spaces between the forms. Assemblage and junk sculpture, created from debris and cast-off objects, also became important new media. Louise Nevelson and Jean Follett were pioneers in this field.

Louise Nevelson (1899–) is one of the major sculptors of the twentieth century, and today receives more public commissions than any living

American sculptor. She is best known for her monumental cubist wood assemblages—stacked boxes that contain pieces of cast-off objects—moldings, jagged scraps of crates, furniture legs—painted all black, white, or gold.

Nevelson struggled, unrecognized for three decades. She was prepared to sacrifice marriage, family, financial security, and all the comforts of an ordinary life for the freedom to devote herself totally to the search for a personal vision in art. "I felt rich enough to pay the price" is her famous explanation.[135]

Louise Berliawsky was born into a Jewish family in Kiev, Russia. Like many other immigrants at the turn of the century, her family came to America in 1905 seeking a better life, and settled in Rockland, Maine. There her father established a successful lumber and construction business.

Growing up was painful for Nevelson. There were only thirty Jewish families in her community. She has said:

Rockland was a WASP Yankee town. . . . An immigrant family pays a price. Now it's better, but think of 1905 when you have a name like BER-LI-AWSKY and you come to Maine. . . . I was an outsider.[136]

Louise felt like an alien in the community and was shy in school, but in the bosom of her indulgent family she led an intense, imaginative life. She fantasized that she was destined to act on a much larger stage than Rockland:

Since I did not find a reality . . . on the outside. . . , I built a whole reality for myself. . . . My life had a blueprint from the beginning. . . . I was an artist. . . . I wanted to build a universe.[137]

From the age of five she painted and drew incessantly, and all her teachers gave her perfect marks in art. She remembers that she felt cold all the time in school except in art class, where she felt warm. At age nine, when the Rockland librarian asked her what she wanted to be when she grew up, she suddenly spluttered: "An artist, no a sculptor; I don't want color to help me."[138] This reply, coming unexpectedly from deep inside of her, frightened her so much that she ran home crying.

The upward-mobile Berliawskys, eager to educate their children and give them every advantage, were firm believers in equality for women. They supported Louise's image of herself as a creative person:

Being a female was never a handicap for me. . . . I felt . . . I knew . . . that I could do anything I wanted to . . . so I did it.[139]

Dancing, piano, voice, and painting lessons filled her free time, and her sister remembers that "she was always moving furniture around, dabbing paint on things or dressing up and acting. . . ."[140]

Louise dreamed of going to New York City to study. In 1920 she did go to New York, by marrying Charles Nevelson, a wealthy cargo ship owner, and two years later her son Mike was born. But the marriage soon proved to be a mistake.

My husband's family was terribly refined. Within their circle you could know Beethoven, but God forbid if you *were* Beethoven.[141]

Depressed and searching for an identity, Nevelson plunged into study of all the arts. She took dance to free her body, voice lessons from a Metropolitan Opera coach, drama with Princess Matchabelli, and painting from Theresa Bernstein and William Meyerowitz. She attended the lectures of the Eastern mystic Krishnamurti, and has continued to study metaphysics through the years in an ongoing search for self-realization.

In 1929 she enrolled at the Art Students League, where students were talking about Cubism, a new vision in art, and about Hans Hofmann, the legendary teacher in Munich. In 1931 she took a drastic step—the turning point of her career. She left her husband, entrusted her son to her family in Maine, and went to Germany to study with Hofmann:

The restriction of a family situation strangled me, and I ended my marriage. . . . And so I gave myself the greatest gift I could have, my own life.[142]

Nevelson was one of the first Americans to study with the teacher who later had such a profound influence on American artists. Although he left for the United States soon after her arrival (to escape fascism), she was greatly affected by his cubist teachings, and still conceives of sculpture as "a block of space for light, a block for shadow."[143] Nevelson became, however briefly, a part of the Munich cafe community of artists and writers (entertaining them with the latest American jazz songs), and was invited to Vienna to act in some bit parts in films.

During this brief encounter, the frontal illusionary world of the set, the lighting, the collage of the film itself—permanently affected her artistic vision. Even today, her shallow sculptures give an illusion of boundless depth, emphasized in the gallery by side lighting, so that in a sense they resemble the facades in a movie set. In exhibitions she combines many pieces and thereby puts her "sets" together. Although they are subsequently dismounted, and the parts are dispersed to collectors and museums, the "theatrical" moment remains in the public consciousness in photographs taken at the installations.

On her way home Nevelson stopped in Paris. Alone and directionless, she was overwhelmed by an almost suicidal depression. In a poem, "Paris, 1931," she wrote of being lost, of the guilt she felt at leaving her son. (After returning, she raised Mike. Today he is a sculptor, and she is a great-grandmother.)

Nevertheless, she separated permanently from her husband, pawned her jewelry for fare, and returned to Paris to study. This time she was stunned by the work of Picasso and by the raw power of the African sculpture in the Musée de L'Homme. She came home determined to be a sculptor.

In 1933, like so many women artists of the 1930s, Nevelson worked as an assistant to muralist Diego Rivera. She found his style of social realism tedious, but the magnetic personalities of Rivera and his wife, the surrealist painter Frida Kahlo, were very stimulating for Nevelson. Every evening the Riveras held court for visiting diplomats and artists; she listened to their conversations and was introduced to the ancient art of pre-Columbian Mexico, with which she immediately identified.

In the thirties, Nevelson was very poor and entered a nomadic phase, in which she moved from studio to studio, struggling to find her own statement in sculpture. She made blocky figures of plaster and tattistone (a self-hardening material) and painted them in colored planes. They show the influence of pre-Columbian art and cubism. With a ceaseless compulsion she piled up mountains of sculpture, and then, crowded out by her own work, moved to another location. She has said of these struggling years, "I've been so lonely for long periods of my life that if a rat walked in I would have welcomed it."[144]

A turning point came when a wealthy friend came to town and squandered a thousand dollars on dinners and a vacation with her in a day. The contrast between this profligate waste and her own impoverished and denigrated situation filled her with rage. Determining that the Nierendorf Gallery was the most prestigious in New York City, she stormed the director's office and insisted that he look at her work. Karl Nierendorf visited her studio, recognized a certain power in her sculpture, and scheduled an exhibition. Her first solo show at the Nierendorf in 1941 was reviewed by Cue magazine:

We learned the artist is a woman, in time to check our enthusiasm. Had it been otherwise, we might have hailed these sculptural expressions as by surely a great figure among moderns.[145]

At this time Nevelson began to pick up "found objects" of wood and assemble them. She was beginning to receive considerable recognition, and critic Emily Genauer wrote enthusiastically about these "junk sculptures" shown at the Nierendorf Gallery in 1944, almost a decade ahead of the assemblage movement of the fifties:

She has taken existing objects, a wooden duck decoy, a hatter's block, a chair rail . . . and assembled them into

complex constructions of astonishing interest and variety. . . .[146]

The sudden death of her mentor Nierendorf in 1948 was a severe personal and professional loss to her. Nierendorf had taken her into his gallery alongside of Picasso and Klee, and for seven years had been a warm friend and advocate. For years afterwards Nevelson struggled, unrecognized.

A trip to Mexico with her sister at this difficult time reinforced her identification with Mayan art and architecture. In the middle of the Yucatan jungle, climbing a sacred ruin, she felt a deep spiritual harmony between art and nature. This influence has remained subtly pervasive in her work.

A small inheritance enabled her to buy a house on East 30th Street in Manhattan, where she was finally able to live and work in one place. In 1952 she opened her home to the "Four O'Clock Forum," a discussion group that included Will Barnett, Max Weber, Mark Rothko, Ad Reinhardt, Richard Lippold, and other artists seeking a new abstract form, different from the dominant, gestural Abstract Expressionist mode. For Nevelson this was a period of growth and reflection.

In 1955 she began to exhibit again at the Grand Central Moderns Gallery, with the friendship and support of the gallery director, Colette Roberts. She used orange crates as bases for her sculptures and painted them black; she collected vast amounts of cast-off wooden debris of all kinds, from which to construct her pieces.

In 1957 the artist was given a case of liquor as a Christmas present, and looking at it with a sculptor's eye, suddenly noticed the cellular structure of the box. In a kind of aesthetic *gestalt,* or breakthrough, she began to put her assemblages inside of boxes and crates.[147] Because she was churning out so many pieces and had no more room for them on the floor, she began to stack these assemblages one on top of the other to make room to work in her studio. Allowing her intuition to lead her from one point to the next, she wandered into a totally new form. She began to notice that her stacking was creating a rich, encrusted wall.

In her third exhibition, "Moon Garden Plus One" (1958), Nevelson came fully into her own style. She created a mysterious environment, blocking off all the light in the gallery except for a few dim, blue lights that illuminated landscape gardens of encrusted columns and her sculpture wall, *Sky Cathedral* (1958). The artist painted all her cast-off materials a matte black, so that they read as new forms, totally purged of their previous mundane origins. Art critic Hilton Kramer wrote of these pieces:

They are appalling and marvelous; utterly shocking in the way they violate our received ideas on the limits of sculpture, yet profoundly exhilarating in the way they open an entire realm of possibility . . . a sculptural architecture.[148]

Nevelson's columns and walls have a commanding presence and ritual solemnity that are linked to their multilayered symbolic and metaphorical meanings. She has repeatedly said that her work exists in the "fourth dimension" of illusion, mind, and spirit. The columns suggest towers, skyscrapers, primitive totems and mysterious archetypal "personages." The walls remind one of ancient Mayan ruins, altars, and at the same time echo the cubist rhythms of New York City. She has admitted that there is a strong female content in her work. The "boxes" can be viewed as icons representing aspects of the intimate self. Some of the secret, dark interiors are protected by jagged or boarded-up openings; others are more penetrable and vulnerable.

Although the assemblages are basically cubist constructions of carefully composed, overlapping planes, when they are massed together on whole walls, they have some of the qualities of Abstract Expressionist paintings:

Like the churning labyrinths of Pollock, her shadowy facades are inexhaustibly complex, affording endless explorations to the eye. . . . Her walls, like Pollock's mural spaces, are boundless for what we see is only a fragment of elements that are infinitely extendible.[149]

Fig. 7-17. Louise Nevelson, SKY CATHEDRAL (1958), assemblage (wood construction painted black), 11'3½" × 10'¼" × 18"

After the "Moon Garden" exhibition, when she was nearly sixty years old, Nevelson finally began to achieve important recognition. Curator Dorothy Miller of the Museum of Modern Art invited her to exhibit with "Sixteen Americans" in 1959. The critic Dore Ashton experienced her all-white environment, *Dawn's Wedding Feast* (1959), as reminiscent of a sunlit New England or American Victorian town, re-created in fantasy forms. The artist called it "a marriage with the world." And indeed, two totemic figures appear to be arriving on some unknown shore, where columns of guests await them with *Dawn's Wedding Cake* and *Dawn's Wedding Pillow*.

Although Nevelson was already well known, no collector came forward to rescue the whole environment and keep it together. Bitterly disappointed, she has said that if a museum had been willing to take it, she would have donated it without charge. As it was, the pieces were sold off, scattered, and used in other works—an incident typical of the repeated disappointments and setbacks she has endured throughout her life.

In 1963, when she was selected to represent the United States at the Venice Biennale, the artist designed a black, a white, and an all-gold room. Finally, the Whitney Museum gave her a major retrospective in 1967.

When Nevelson saw that she was at last established, she sold her furniture, her paintings, and her ethnic collections. In so doing, she was saying goodbye to the last distractions and encumbrances of the past. Her five-story studio-home in lower Manhattan is today more like a factory, filled with works-in-progress.

Except for her recent large-scale steel works, which sometimes require a preliminary model, she has been, on the whole, an intuitive and romantic expressionist in her method. She seldom draws plans in advance, but reaches out in a kind of moving dance, selecting pieces from her stockpiles of debris, and putting them together in instant aesthetic judgments, altering and adjusting as she works.

She has said: "I *hate* the word *intellectual*—that offends me. And I'll tell you another word that is poison for me, and that is *logic*."[150]

Branching out into huge constructions of Corten steel, she directs skilled workmen as they cut, bend, lift the sections, and weld them at the Lippincott factory in Connecticut. Recent commissions, designed with openings through which the landscape can be seen, include *Transparent Horizon* (1975) at the Massachusetts Institute of Technology and the fifty-three-foot-high *Sky Tree*, at San Francisco's Embarcadero Center.

Nevelson's mythic personality and outrageous wit match her achievements. Often called "The Martha Graham of American Art" (she studied modern dance for twenty years), her face is a dramatic mask, fringed with three layers of thick, black, artificial eyelashes. She is tall and thin, costumed in unexpected aggregations of the elaborate and the simple. For example, with a Chinese embroidered robe on top of a denim workshirt and long Mexican skirt, a jockey cap on her head, and a small tiparillo cigar dangling from her mouth, she resembles nothing so much as a player in a Kabuki drama.

When she turned eighty, New York had a kind of unofficial Nevelson "festival." The Whitney Museum staged a retrospective of her environmental pieces, and the city named Louise Nevelson Plaza after her. In a five-page *Time* magazine cover story, art critic Robert Hughes wrote:

In getting to this pitch of achievement, she, like Georgia O'Keeffe, has also redrawn the assumptions that surround the role of women in art. In that respect she belongs to the culture as a whole, not just to the art world and its concerns.[151]

Nevelson herself has said:

It's a hell of a thing to be born, and if you're born you're at least entitled to your own self.[152]

Mary Callery (1903–1977) is known for her linear, open sculptures that are like drawings in metal. Her stick-figure acrobats and figures ("a ballet in bronze") poised in hair-edge equilibrium or arranged in frieze-like bands, move in space and in-

vite air to flow between their outlines.

Callery came from a wealthy background. Born in New York City and raised in Pittsburgh, she was the daughter of James Callery, president of the Diamond National Bank and chairman of the board of the Pittsburgh Railways Company. She became interested in sculpture at age twelve. After graduating from Miss Spence's School in New York in 1921, she studied sculpture for four years with Edward McCartan at the Art Students League in New York. She married in 1923, and subsequently had a daughter, with Frederic Coudert, Jr. (later Congressman Coudert), from whom she was later divorced.

Between 1930 and 1940 Callery lived in Paris. After two years of study with the sculptor Jacques Loutchansky, working in an almost classical style something like Aristide Maillol's, she was swept up into the modern movement and became part of the devoted circle around Picasso. In her 1942 essay "The Last Time I Saw Picasso," she wrote: "The more one saw, the greater he became. I find myself even now repeating the things I became aware of through him."[153]

Picasso teased her by asking her if she had done a "seascape" and then, more seriously, urged her to work from imagination. "What do you need a model for? You know that the human body has a head . . . and two legs. . . ."[154]

She visited Picasso's flat in the Rue La Boétie with fellow artists and friends ("You wondered how it was actually possible to get through all the mail strewn upon the floor"), where he pulled out painting after painting with a running commentary. She also visited his sculpture atelier at the small chateau at Bois-Geloup, north of Paris, where his works stood in the stable and about the grounds. Some of her other associates at this time were the purist painter Amédée Ozenfant, sculptor Henri Laurens, and critic Christian Zervos. Between 1934 and 1936 she was married to Carlo Frua de Angeli of Milan.

Callery returned to New York in 1940 to escape the ravages of World War II. In the forties she developed her distinctive, attenuated, interweaving figures in such works as *Amity* (1947) and *The Curve* (1947). She had shown in Paris, and after an opening solo show at the Curt Valentin Gallery, exhibited many times at the Buchholz Gallery in the forties and fifties, and at Knoedler's in the sixties.

Callery believed that color should be used on sculpture, an ancient tradition shared by the Egyptians and the Greeks, and she sometimes painted her works. During the 1940s she collaborated with Fernand Léger in an innovative conjunction of sculpture and painting. "Against Léger's patterned backgrounds of primary colors her figures weave their arabesques," wrote critic Philip Adams.[155]

Callery executed several architectural commissions. *The Fables of La Fontaine* (1954), for Public School 34 on East 12th Street, New York City, is a frieze designed for school children to climb and crawl through, and uses forms reminiscent of industrial I-beams. In 1953 she designed three aluminum sculptures for the Aluminum Company of America's headquarters in Pittsburgh: *Constellation I, Constellation II,* and *Three Birds in Flight,* a twelve-foot aluminum abstraction suspended in the glass entrance space of the Alcoa building. *Acrobats, Monument* (1955) was designed for Wingate Public School in Brooklyn.

Art critic Judith Kaye Reed described Callery and her work *Amity,* a procession of five figures with a calm, classical feeling, as "a modern who can pare substance down to slender, pencil-like forms without substituting sterile symbols for the fluid grace of living matter. . . ."[156] Aline Louchheim in *Art News* called *Amity* "among the most successful of contemporary out-of-doors sculptures."[157] Callery's work is in the collection of Nelson D. Rockefeller and the Museum of Modern Art.

Louise Bourgeois (1911–) creates highly acclaimed sculptures that, although abstract in form, suggest the soft, sexual center of living organisms—the confused and threatened feelings

Fig. 7-18. Mary Callery, AMITY (1947), bronze, 5' × 16'

of men and women, their mixture of love, hate, pain, and rage.

Bourgeois was born in France into a family of tapestry weavers. Her father was also a landscape architect who had a passion for lead sculptures. When he found broken ones, he would dump them in the backyard, where his small daughter found them and was fascinated by them. She helped her mother repair ancient tapestries and, starting at fifteen, made working drawings for her parents. Bourgeois grew up feeling that art was useful, real work, not an elitist hobby unrelated to life.

At the Sorbonne in Paris she majored and excelled in mathematics, loving the "precise and irreversible—secure"[158] qualities of solid geometry. Even today, she regards her art as a combination of the emotional and the geometric. When she was twenty-five, she switched to art, and from 1936 to 1938 she studied at the École des Beaux-Arts, the Académie de la Grande Chaumière, and at the atelier of the cubist painter Fernand Léger.

In 1938 Bourgeois married a young American art historian, Robert Goldwater, who was in Paris finishing a book on primitivism, and returned with him to the United States. (She has three sons.) In New York she studied at the Art Students League and was soon exhibiting surrealist paintings and engravings in the Whitney annuals. She knew many of the Surrealists who clustered as exiles in New York at that time, including Marcel Duchamp who became a close personal friend and critic of her work. The Surrealist influence is still felt in her

sculpture, which deals so much with emotions at the subconscious level.

Her early paintings and engravings at this time show such motifs as a woman's body trapped in a house (*Femme/Maison* [1947]); a balloon floating mournfully in a room, unable to escape through a small door; and other subjects that convey uneasiness, malaise, and confinement. So aptly do they suggest female anxiety and frustration that art critic Lucy Lippard used one of them thirty years later for the cover of her book about feminism and art, *From The Center* (1976).

In the harsh and alien urban culture of New York, Bourgeois missed the family and country she had left behind. Her first sculptures grew out of loneliness for France and for the family that was no longer with her. Working alone on the roof of her apartment house, she carved a series of tall, thin, pole-like wooden shapes, painted in black, white, and red, which to her represented a reconstruction of her lost family. One was even a portable brother she could carry around.[159]

In 1949 her first all-sculpture solo show at the Peridot Gallery, New York, consisted largely of these tall, post-like wooden forms, suspended or standing around the gallery alone or in couples. The Museum of Modern Art bought one of her works, and Bourgeois was at that time recognized as a major sculptor in the New York School. In the next period, however, she suffered some neglect (like so many outstanding women artists), but continued to be productive.

In 1964, at the Stable Gallery, she exhibited her first "lairs"—plaster and latex forms that looked like caves or hiding places, inside of which visceral body forms could be seen. Lippard, recognizing the peculiar sensibility of her work, included her in the "Eccentric Abstraction" show at the Fischbach Gallery in 1966. There, with the young Eva Hesse, Bourgeois was part of a group that introduced an emotional, visceral quality into the world of abstraction—at its most rigid and mechanical moment.

Each of her pieces has some private myth or strong personal feeling connected with it, and each responds to a driving inner need or compulsion. Some pieces are pitiful female forms reminding one of the prehistoric Venus of Willendorf—bulbous, pregnant bodies tapering off into stake-like points at the ends, without arms or feet. A "woman-knife" (*Femme Couteau* [1969–70]), a blade-like marble form in which the vulnerable private parts are wrapped by folds, and both ends are pointed, represents the transformation of woman into a destructive force—a blade or knife—because she is fearful and tries to defend herself. In one sculpture, *Femme Pieu* (1970), a wax form lies helpless with needles and pins sticking into it like a fetish. Bourgeois has referred to her work *The Quartered One*, as "a woman's body which can be mistreated."[160] She has said that she suffered as a child from the double standard she saw around her in France—neglect and bad treatment of women by men.

Some of Bourgeois's work is a response to political events. *The Blind Leading the Blind* (1949)—six pairs of vertical, spiked wooden posts in a row, joined by a horizontal roof—has been interpreted as a comment on the McCarthy Era.[161] In certain pieces of the 1960s, crowd-like masses of marble cylinders represent marchers or confrontations between groups at antiwar demonstrations.

In addition to her involvement with emotional, personal, and mythic content, Bourgeois is a tough-minded intellectual who can solve logical problems. Her love of solid geometry is still with her. This is reflected in her recent commission, a steel sculpture for a federal building in Manchester, New Hampshire. Dealing with the theme of solar energy, it is a cluster of forms, sliced off at different beveled angles to reflect the sun. At the same time, it is a metaphor for a crowd of people looking up at the sun.

Bourgeois continues to move back and forth freely in a variety of media—marble, wax, or wood. She continues to build environments out of latex, such as *Destruction of the Father*, which was shown at the 112 Greene Street Gallery in 1974. Inside a tent-like enclosure, bulbous shapes hang down from above and grow from the ground. The space is claustrophobic; the suffocating anxieties of family life are suggested; pieces of animal parts strewn on the floor suggest some hideous Oedipal revenge. *Confrontation* (1978), a room with an altar heaped with breast-like forms, was the scene of a wild surrealist "fashion show" designed by Bourgeois.

A theme that Bourgeois has worked on obsessively is her *Cumul* series. The idea for these works came to her when she flew over the Sahara years ago and saw "little huts nestling together near water—a metaphor of loneliness and togetherness."[162] Over and over again she has carved, cast, and molded these images (the name comes from the cumulus clouds). To her, they are generalized symbols of life—their eroticism is understated and ambivalent, incorporating both male and female components. Sometimes they are hard and shining like buds, breasts, or penises, as in her marble *Cumul 1* (1968); sometimes they are made out of wrinkled latex, suggesting dessication and withering.

In 1977 Yale University conferred on Bourgeois an honorary doctoral degree, saying: "You have reminded us through your sculpture that art speaks to the human condition. You have offered us powerful symbols of our experience and of the relations between men and women. You have not been afraid to disturb our complacency."[163] She is increasingly recognized as a major figure—one who gets to the core and center of human feelings.

Fig. 7-19. Louise Bourgeois, CUMUL I (1968), white carrara marble, 3′6″ × 3′6″ × 3′

Claire Falkenstein (1908–) is internationally recognized for her innovative Abstract Expressionist sculptures, made of thorny thickets of welded metal fused with melted glass. Since the early 1930s she has been inventing abstract forms that reflect the new scientific and philosophical concepts of the twentieth century.

She grew up in a tiny isolated community on Coos Bay in Oregon. The town had one industry—the lumber mill in which her father was a manager. Falkenstein recalls her initiation into a life of art:

The only art in Coos Bay was the funny papers . . . with one exception. The wealthy owner of the mill, L. J. Simpson was a collector. He built a mansion called Shore Acres, above the ocean, which he made into a work of art. From six years old to the age of twelve we used to go there as guests. I was stimulated because I saw a real honest-to-God oil painting. It was a mythological painting of somebody chasing somebody else. . . . I remember looking at it coming down the stairway. There was a bronze tiger on the piano and wonderful Oriental rugs. . . .[164]

As a child, she would ride her horse in the dark on the beach to see the sun come up and spend time looking at shells, rocks, seaweed, and driftwood. These nature forms still inspire her sculpture today.

At the University of California at Berkeley, Falkenstein majored in art and minored in philosophy and anthropology, but was unmotivated until her junior year. The academic art classes were tedious, but one teacher, George Lusk, had studied with

André L'Hote in Paris and was an independent and a modernist. Falkenstein says that Lusk

opened up my own interior for me to be myself. It was in a life class. The model was there, but I could do anything with it. Those figure drawings were an absolute volcano—they exploded the figure into a freedom which I felt—somehow using the figure as a total environment.[165]

Even before she graduated from Berkeley in 1930, she had a one-woman show at the East-West Gallery in San Francisco.

From 1930 to 1939, while teaching to support herself, Falkenstein created nonobjective, textured ceramic sculptures from ribbons of clay bent into interwoven Möbius strips. These forms, undulating in hollow and round curves, show her early interest in scientific concepts. From their dates they would appear to be some of the early nonobjective sculptures in America.

Between 1940 and 1944 she produced a series of wood pieces called "exploded volumes," made of interlocking parts that could be moved and separated into different combinations by the viewer: "This concept of the importance of the interval—the spaces between—has always been important to me."

Falkenstein learned to weld at an industrial welding shop, and after winning recognition for her wire sculpture and jewelry, was hired to teach at the California School of Fine Arts. At that time the school was a hotbed of innovation, with Clyfford Still, Richard Diebenkorn, and other Abstract Expressionists on the faculty. She became a close friend of Still and was greatly influenced by his ideas.

Falkenstein went to Paris in 1950 and met Jean Arp, Alberto Giacometti, and many other European artists. She also associated with a talented group of Americans, including Sam Francis and Paul Jenkins. The Americans came under the protective wing of a mentor, Michel Tapié, an art connoisseur and intellectual who promoted their work and their ideas.

He also discussed with them the relationship between the new art and Einsteinian concepts in physics and mathematics that were replacing the old Newtonian and Euclidean logic.

Falkenstein was working toward an artistic expression she calls "topology"—a form that connects matter and space, conveying the idea of the continuous void in nature. The abstractionists in Paris in the 1950s, like their colleagues in New York, were trying to break away from the rigid geometric forms of cubism into a newer, freer kind of expression. This French counterpart of America's Abstract Expressionism was called "L'Art Informel."

Because she was poor, Falkenstein began to weld with the cheapest material she could find—stovepipe wire. Out of this necessity and adversity came open structures, built up into larger and larger forms, with airy openings breathing between them, such as *Sun #5* (1954). This was the beginning of the style for which she became famous.

In 1958 Tapié arranged a show at the new Galleria Spazio in Rome. The architect Luigi Moretti asked Falkenstein to design a welded stair railing for the gallery. Since the sun came down into the gallery from the street, Moretti suggested that she use colored glass, which would cast colored light on the floor. But Falkenstein had advanced from cubism to topology, and refused to do anything that used flat planes of glass. Instead, she experimented and discovered how to fuse chunks of colored glass with copper tubing by heating them together in a kiln. This type of tubing, bent and welded and hammered flat in places, with pieces of colored glass melting in the interstices, became her uniquely invented medium.

Falkenstein was also commissioned to create welded gates for the sea villa of the Princess Pignatelli. In 1960 Peggy Guggenheim commissioned her to weld gates of metal webbing, accented with chunks of shimmering glass, for her villa-museum on the grand Canal in Venice. Guggenheim dubbed

them "The New Gates of Paradise." In these works, for the first time, Falkenstein used the concept of *the never-ending screen*—a single module is repeated, attaching in all directions, to form a continuous field, which looks as if it could go on infinitely. This idea of *the moving point* is a recurring theme in her work.

After thirteen years abroad, during which she had become well known in Europe, Falkenstein returned to the United States in 1962 and built a modern house-studio on the sea in Venice, California. In the following years she carried out her most ambitious, large-scale public commissions. These include *Structure and Flow #2* (1963–65), a fountain for California Federal Savings and Loan in Los Angeles; fountains and sculptures for the Fresno and Coos Bay shopping malls; a fountain for the San Diego Art Museum; a screen for the Seattle Art Museum; and other works.

In 1960 the artist completed her monumental commission for St. Basil's Cathedral on Wilshire Boulevard in Los Angeles. In the doors, Falkenstein reiterated her concept of the never-ending screen. The fifteen stained glass windows (some are 144 feet high) are not flat, but rather, move in and out in three dimensions.

U as a Set, built on the campus of Long Beach State University, is typical of her mature style. Its spiky look suggests brambles or seaweed—her work has been described as "frozen thorns." The free, intuitive, ever-growing forms look as if they could expand forever—much as Jackson Pollock's paintings suggest that they could continue indefinitely beyond the canvas. They imply in a small model, the infinite continuum of the universe.

Sue Fuller (1914–) is a constructivist sculptor who creates crystalline geometric compositions of filaments embedded in translucent plastic forms. Fuller was raised in Pittsburgh, where her father was an engineer of bridges. Since her mother crocheted and knitted, the house was always filled with baskets of thread. She feels that she was programmed from childhood to work with threads

under tension, but it took many years for her to arrive at her art form.

When Fuller entered Carnegie Institute of Technology in 1932 as an eighteen-year-old student, she studied with Joe Jones, a painter of corn fields, and won prizes in Pittsburgh for American Scene watercolors. A summer class with Hans Hofmann in 1934 at the Thurn School of Art in Gloucester, Massachusetts, moved her toward modernism. But her true revelation came on a trip to Europe in 1937 at the end of a year at Teachers College of Columbia University, when she saw an exhibition in Munich called "German Degenerate Art":

In that exhibition all the great German Expressionists and other modernist artists were derided for their work. A companion exhibition approved by the Nazis was embarrassingly bad academic work. With clarity, I realized just how much *freedom of expression* meant to me.[166]

Back in New York, in 1943, she enrolled in Stanley William Hayter's stimulating printmaking workshop, Atelier 17. There she met refugee geniuses such as Joan Miró, André Masson, Jacques Lipchitz, and Marc Chagall, and the American Alexander Calder.

During this period Fuller taught children's classes at the Museum of Modern Art. A workshop for teachers conducted by Josef and Anni Albers at the Museum of Modern Art introduced her to Bauhaus techniques, to collage in printmaking, and to the experimental weaving of Anni Albers. These studies reawakened her needlework heritage (she had actually inherited a basket of threads and laces from her mother). They also led her into a series of etchings such as *Hen* (1949), which includes textures derived by pressing one of her mother's lace collars into the etching ground. Soon Fuller was stretching and pulling individual threads into designs for her etching compositions. Finally, she abandoned the etchings and stretched her string composition on a pegged frame in *String Composition #1* (1946). An exhibition of the pure, mathematical constructions

Fig. 7-20. Claire Falkenstein, "U" AS A SET (1965)

of Naum Gabo and Antoine Pevsner at the Museum of Modern Art reinforced this direction. One of her string compositions was in the museum's exhibition "Abstract Art in America" (1950), and the Bertha Schaefer Gallery showed her work from 1941 to 1969.

During the fifties Fuller created hundreds of string compositions (e.g., *String Composition #52* [1953]), but began to encounter technical problems: colored threads faded and sagged, and wooden frames warped when threads pulled them under tension. She has spent twenty years experimenting with solutions to these problems, partially financed in her research by Guggenheim and Tiffany fellowships and by a grant from the Institute of Arts and Letters. Around 1960, Fuller began to use the polypropalene thread and the technique of embedding her designs "like bananas in jello"[167] by pouring translucent plastic around them. She is a pioneer in this field and has patented some of her methods.

Fuller's immaculate workshop, filled with stacks of color tests, testifies to her perfectionism. Yet her compositions of parabolic curves, such as *String Composition 901* (1970), which refract the light in marvelous ways, are intuitive and based on her own sensibility. In Fuller's own words:

Light, transparency, and balance is the aesthetic of our day. . . . My work in terms of linear geometric progressions is visual poetry of infinity in the space age.[168]

Adaline Kent (1900–1957), the first modern West Coast sculptor to achieve a national reputation, was a pioneer of abstract form in the Bay Area when that region was still dominated by figurative and realistic traditions.

Born in Kentfield, California, Kent graduated from Vassar College in 1923, and returned to the Bay Area to study sculpture at the California School of Fine Arts with Ralph Stackpole. She also studied in Paris with the famous sculptor Émile Bourdelle between 1924 and 1929.

In the 1930s, paralleling such East Coast sculptors as William Zorach and Concetta Scaravaglione, Kent explored the direct-carving mode, still using figurative images. In 1939, already well known in the Bay Area, she was one of the artists who designed sculptures for the San Francisco Golden Gate Exposition at Treasure Island. Eugen Neuhaus, in his book on the fair, commented that "the problem of an objective critical estimate is further complicated by the unusual circumstances that the twelve figures . . . are the work of four women sculptors." But he went on to admit that "Miss Kent's statue, *Young Man Improvising Music* . . . is one of the finest pieces of plastic art which the Exposition offers out of doors. . . . It possesses both outer form and inner life. It is more than decorative."[169]

In the 1940s Kent began to incorporate the concepts of pierced, abstract forms innovated by Henry Moore, as well as Picasso-like bone and metamorphic shapes, in large sculptures made of *magnesite* and *hydrocal* (durable plaster-like substances). Sometimes these were polychromed.

At the time of her sudden death in an automobile accident in 1957 she was developing a body of terra cotta work that reflected an interest in archaic and primitive forms, inspired by her wide travels in Europe and Mexico. Kent was unique among West Coast sculptors in the 1950s because she exhibited at the Betty Parsons Gallery in New York, where she received widespread praise, and recognition from the influential New York critic Clement Greenberg.

Ruth Asawa (1926–) is a remarkable woman who has combined a high level of artistic creativity with a total involvement in community and family life. She is the creator of major sculpture commissions—five large fountains in San Francisco alone. Her woven wire sculptures are in major collections such as the Whitney Museum. She is a leading art educator and inventor of a new sculptural medium, *baker's dough,* which even kindergarten children can use. And Asawa has been a member of the San Francisco Art Commission, the Bart Art Council, the National Endowment for the Arts Education Panel, and the California Arts Council. Even in creating her murals and major sculptures, she has found ways to involve not only other artists, but ordinary school children.

Yet the circumstances of Ruth Asawa's background were less than auspicious. She was born in Southern California of Japanese-American parents, small farmers who worked long hours and barely made a living during the Depression. From a very early age she liked to draw and wanted to be an artist—an ambition that everyone but her Zen Buddhist parents discouraged as impractical. When World War II came, the family was uprooted and interned in a camp in Arkansas.

In the camp were several Japanese artists who had worked at Disney Studios. With lots of time on their hands, they taught drawing all day and into the night, and so Asawa received a unique art education when she was still of high school age. After finishing high school, she was permitted to leave the internment camp to attend Milwaukee State Teachers College in Wisconsin and obtain a teaching credential in art. But after three years of study, she was told that school districts would refuse to hire her because she was Japanese and the U.S. was still at war with Japan.

As a result, Asawa abandoned the idea of teaching and decided to study art at Black Mountain College in North Carolina, under such inspiring teachers as Josef and Anni Albers and Buckminster Fuller. Her later interest in pure structural form may

Fig. 7-21. Sue Fuller, STRING COMPOSITION #901 (1970), plastic embedment, 30″ × 52″

be attributed to the Bauhaus influence of her three years with these teachers. At Black Mountain, she met Albert Lanier, an architect, and married him in 1949. Asawa left Black Mountain after her marriage and has lived and worked in San Francisco ever since. The Laniers have six children.

In the 1950s she achieved notable recognition for her woven wire sculptures, airy constructivist forms that resemble dandelions and other forms in nature and are often suspended, casting beautiful filigree shadows on the wall behind them. These tubular knit, or mesh, works were pioneering efforts, ahead of the present wave of woven forms, and were acclaimed when they were exhibited at the Whitney Museum (1958), the Museum of Modern Art (1959), at New York's Peridot Gallery (1954, 1956, and 1958), and at the San Francisco Museum of Art.

Asawa's involvement in the San Francisco community—in the state from which she had been forcibly expatriated eighteen years before—was total and enthusiastic. Her *Mermaid Fountain* (1968) is the focal point of the city's Ghirardelli Square, and her giant, round cityscape-in-bronze encases the 1973 fountain in front of the Hyatt Regency Hotel on Union Square. Sculpted by Asawa with the help of artist friends, relatives (her mother and daughter), and school children, it shows the key attractions of the city in imaginative fantasy reliefs. Her newest fountain in Japan Town is based on the forms of Japanese *origami* (paper folding).

A major focus of Asawa's life has been on art education. She has fought for larger budgets for teaching art to school children, and she has created

mural projects and sculptural projects in which school children can participate.

When the San Francisco Museum of Art held a Ruth Asawa retrospective in 1973, she introduced the idea of a "dough-in," and one thousand youngsters took up her invitation to do baker's clay sculpture at the museum. In 1976, the San Francisco Art Commission bestowed its honor award exhibition on her for her contribution to the city as artist, educator, and civic leader. Recently, with glass artist Bruce Sherman, she has created a glass-and-wire sculpture. She is enthusiastic about collaborating and wants especially to work with graphic artists. "That's the really exciting thing," she has said, "collaborating. It is enriching for all of us."[170]

Elizabeth Catlett (1915–) is considered by many to be the greatest American black sculptor (although she has spent the last thirty-five years in Mexico). She regards her work as art of communication, art with a purpose. Catlett wrote in 1971: "I have gradually reached the conclusion that art is important only to the extent that it aids in the libera-

Fig. 7-22. Adaline Kent, CITADEL (1955), terra cotta, 13" × 18¾" × 5½"

tion of our people. . . . I have now rejected 'International Art' except to use those of its techniques that may help me make the message clearer to my folks."[171] And in 1978 she remarked: "Art must be realistic for me whether sculpture or printmaking. I have always wanted my art to service Black people—to reflect us, to relate to us, to stimulate us, to make us aware of our potential."[172] While fundamentally realistic, Catlett's sculptures and prints have, in fact, always had a strong formal element and show the influence of her extensive training in the modern tradition and also in African art.

Catlett was born in Washington, D.C. Her father, who had taught math at Tuskegee Institute and later in public schools in Washington, died before she was born. Her mother worked, and she and the children lived in relative comfort in a middle-class home built by her father's family.

Catlett was bright and excelled in carving and drawing in high school. Since she had a cousin living in Pittsburgh, she decided to go to the Carnegie Institute of Technology in that city. Carnegie Tech had never admitted a black student to the art school, but Catlett did so well on the entrance exam that she was sure she would get in. In North Carolina (her grandparents' home state) and in Washington she knew there was discrimination against blacks, but she thought things would be different in the North. It was an embittering experience for her when she was turned down.[173]

She studied instead at Howard University with James Wells, Howard Porter, and Lois Mailou Jones. She worked briefly on the Federal Art Project, and after earning her B.A. in 1936, got a job teaching elementary and high school for $59 a month in Durham, North Carolina. In Durham she participated with an NAACP attorney, Thurgood Marshall (later a U.S. Supreme Court justice), in a campaign conducted by the state teachers association to equalize wages for black and white teachers.

Catlett enrolled for a graduate degree at the University of Iowa's art department. She had chosen Iowa because Grant Wood taught there, and be-

Fig. 7-23. Ruth Asawa, NUMBER 1-1955, brass and iron wire, 60″ × 67½″ × 15″

cause it was one of the few state universities that did not charge out-of-state students tuition. She remembers Grant Wood as a fine teacher with high standards and a deep concern for his students.

At Iowa, however, the university did not allow blacks to live in the dormitory, and she had to find a place in the black ghetto in Iowa City. She was the first student ever to earn an M.F.A. in sculpture at Iowa (1940).

Following graduation, Catlett was chairwoman of the art department at Dillard University in New Orleans. There she won a fight to establish life classes with nude models in the school, got black students admitted to a local (previously off-limits) museum to see a Picasso show, and fought for higher wages for the teaching staff.

Disappointed with a new administration at Dillard, Catlett next went to New York, where she spent a stimulating year meeting black performers like Josh White and Leadbelly and getting to know many of the creative people of Manhattan. She studied in Greenwich Village under the sculptor Ossip Zadkine, who had a strong influence on her subsequent work.

When she received a Rosenwald Fellowship in 1946, she and her husband, the famous black artist Charles White, used the money to go to Mexico. Since the 1920s Mexican artists had been documenting their country's struggle against oppression. In Mexico, Catlett worked with a group of artists in the famous *Taller de Grafica Popular* print workshop on a volume of prints depicting life all over the Mexican republic. In this period she also executed a series of paintings and prints on the theme *The Negro Woman* (1946–47). Her powerful linoleum-cut prints present images of black women as laborers, artists, farmworkers, and in many other roles. This suite was shown at the Barnett-Aden Gallery, Washington, D.C., in 1948.

Catlett decided to remain in Mexico, but her husband returned to the United States. After their divorce she married Francisco Mora, a well known Mexican artist.

In 1959 Catlett became the first woman professor of sculpture at Mexico's National University. As chairwoman of the department she proved to be so objective, fair, and agreeable that she soon overcame any objections by her male colleagues. She has continued to exhibit and win prizes in the United States and all over the world, including four in Mexico.

Her *Olmec Bather* (1966), a nine-foot-tall cast bronze statue, stands in the cultural center of Mexico's National Polytechnic Institute. *Reclining Woman* was shown in the Olympic Village in 1968. *Black Unity* (1968), seen from one side, consists of two walnut black heads reminiscent of African masks; seen from the other side, the sculpture is a large clenched fist. *Malcolm Speaks for Us* (1969) is a linocut made of three blocks, showing faces of black people. Each is printed several times in different arrangements in the composition; there is a fourth block printed once, with a picture of Malcolm X on it. In the bronze sculpture *Target Practice* (1970), a very powerful effect is achieved by having the viewer see the sculpture of a black man through the sights of a rifle.

Catlett feels, and expresses in her art, a dual devotion to black people, and to the people of Mexico. She and Mora have three grown children. She recently retired from her professorship at the National University. Now, with her children grown, and with a lifetime of struggle behind her, "La Maestra," as her students call her, looks forward to devoting her time entirely to printmaking and sculpture. The Women's Caucus For Art honored Catlett with one of their coveted prizes in 1981.

Other Sculptors

Other outstanding women sculptors worked in the 1940s and 1950s.

Luise Kaish (1925–) is an expressionist sculptor, particularly noted for her biblical subjects in bronze, as in *The Great Blessing of Abraham*

Fig. 7-24. Dorothy Dehner, LOOKING NORTH E. (1964), cast bronze, height 31½"

(1961) and her monumental bronze ark for Temple B'rith Kodesh, in Rochester, New York. Born in Atlanta, Georgia, the artist earned the B.A. and M.F.A. in sculpture at Syracuse University and studied with Ivan Mestrovic and at the *Taller de Grafica* print workshop in Mexico. In 1981 she was appointed chairwoman of the department of painting and sculpture at Columbia University. She has won the Tiffany Grant, Guggenheim Fellowship, and the Rome Prize Fellowship.

Dorothy Dehner (1901–) emerged as a distinguished sculptor in her own right after many years of obscurity in the shadow of her famous husband, sculptor David Smith. Since her divorce in 1950 her Abstract Expressionist wood and bronze totemic forms, somewhat ritualistic in feeling, have won increasing recognition from the critics.

Jean Follett (1917–) was one of the earliest to use "junk sculpture" in the fifties. A student of Hans Hofmann, she began to apply paint so thickly that her pictures look like reliefs. She embedded "found" objects—pieces of wood, metal, string, and heavier objects—into black-and-white reliefs. With these she creates surrealistic figure fetishes and machine-people such as *Lady With the*

Fig. 7-25. Elizabeth Catlett, TARGET PRACTICE (1970), bronze, height 13½"

Open-Door Stomach (1956) and *Many Headed Creature* (1958). She is closely associated with Richard Stankiewicz, her fellow student at Hofmann's school, and is credited with influencing him in the direction of junk sculpture.

Rhys Caparn (1909–) has worked in various styles since the thirties. More recently, she creates flattened relief forms directly in plaster (sometimes cast in bronze) that suggest weathered, natural, and architectural forms.

Stylized Realists

Marianna Pineda (1925–) trained at Cranbrook Academy in Michigan, at Bennington College, and at the Zadkine School of Sculpture in Paris. She creates flowing rhythmic figures in bronze that have a unique sonority, although they do not fit into any avant-garde trends.

Helena Simkhovitch creates sensitive terra cotta heads.

Laura Ziegler (1927–), another figurative sculptor who works in a modified, expressive figurative style, lives in Italy and has carried out large commissions from there.

A number of fine sculptors continue the tradition of sensitive direct carving in stone, with careful regard for the grain, texture, and polish of the materials—among them are **Cleo Hartwig** and **Jane Wasey.**

Chapter 8
The Sixties:
Pop Art and Hard Edge

In the 1960s American art continued to rise in importance becoming increasingly symbolic of our world position and increasingly valuable as a commercial commodity. American culture, no longer the provincial stepchild of Europe, dominated the western world.

The period of the sixties is often called "the decade of the trend." As the leaders of the New York School of the forties and fifties came to be regarded as "old masters," young American painters and sculptors had behind them a tradition of modernist innovation. Dealers and collectors waited eagerly for each new avant-garde movement to be identified and labeled by critics and curators, so they could buy early when the prices were low and resell as the values skyrocketed. Hard on the heels of Abstract Expressionism, repudiating it with new forms, came Pop Art, Color Field Painting, Hard Edge, and Minimal Art in vertiginous succession.

America reached a zenith of prosperity, power, and technological development in the early 1960s during the Kennedy administration. Computers, television, atomic power, mega-universities, were all part of the technical know-how that Japan, Germany, France, and other countries were trying to emulate. Although the United States found itself temporarily challenged when the Soviet Union launched *Sputnik,* the American scientific community immediately rose to the challenge and regained the ascendancy with a space program that placed a man on the moon in 1969.

The art expression of the sixties had a bold, heraldic sophistication that suited the times. Big, strong, elegant, tightly organized, it matched the burgeoning new American technology. It is not surprising that this became an era in which a partnership between art and technology took place—an era of marvelous experimentation with plastics, steel, kinetic sculpture, and neon light. Humanistic meaning and content were often expunged from the art of the sixties, as artists turned from the "warm" emotionalism and the search for "meaning" in Abstract Expressionism, to a new "cool" aesthetic.

Many painters proudly asserted that a painting was merely a painted surface and not an illusion or an illustration or a vehicle for ideology or feeling; they tried to make their pictures look flatter than flat, eliminating as much as possible all sense of three-dimensional depth. Many turned away from the human touch of thick impasto and brushy painting, going instead to a smooth, untextured surface that did not show the mark of the human hand. Minimal and Hard Edge art came in this period. Stripes, bands, chevrons—flatly painted abstract color spaces reduced to a minimum—locked the shapes to the canvas edge. The goal for many sculptors and painters was to reduce the image to one unitary form that could be perceived as an indissoluble, total abstract structure, instead of a balancing act between parts. These works were often huge, cold, and impressive; they made magnificent corporate emblems on the walls of banks and had the impact of giant road signs.

Post-Painterly Abstraction, as the formidable New York art critic Clement Greenberg called it, was a lyrical, sophisticated extension of the field

painting of Mark Rothko and Barnett Newman. Abandoning surface texture and the brushwork that had been so important before, the artist emphasized high-keying (instead of dark and light, which created illusions of depth), openness, clarity of form, and lucidity of color. Helen Frankenthaler was the prophet of this movement with her painting *Mountains and Sea* (1952), in which she poured and spilled flowing open shapes of jewel-like purity of hue with areas of raw canvas left to breathe between them. Although she was a major artist in the fifties and a contemporary of Joan Mitchell and Grace Hartigan, she is included in this chapter because of her influence on a movement that crested in the sixties.

This was the period when sculptors stood a giant cube on one point, or poised stainless steel geometric volumes in gravity-defying suspension, asserting the self-supporting strength of new industrial materials. These sculptures often looked like machine objects. Indeed, the sculptors sometimes ordered their work fabricated in industrial plants, avoiding all sense of the human touch on clay, or of the hand-directed chisel on stone. Industrial lacquers, lustrous plastics, and machined metal replaced the hand-crafted surface. Sculptural size was very important. Many of the pieces were big enough to walk into and through, becoming almost environmental.

Pop Art, which swept the scene at the beginning of the 1960s, seemingly so different from Hard Edge and Minimal Art, was in a way another side of the same coin. Pop Art brought back the image, but it also expressed the overwhelming domination of the commercial and industrial society by taking its images from commercial art—advertisements, billboards, comic strips, and news photos.

Whereas Jackson Pollock had said "I am nature," the Pop artists now maintained that the birds and the bees no longer had anything to do with modern life or the world of art. When Andy Warhol painted a Campbell's Soup can and Claes Oldenburg made

giant sculptures resembling a toilet, a light switch, and a hamburger, they were proclaiming the fact that contemporary American lives are totally inundated by the machine-made, mass-produced environment.

Of course, there were women artists connected with all of these movements. Agnes Martin's quiet grids are certainly a part of the reductive-minimal trend in painting—albeit with her own spiritual twist; Anne Truitt's large painted wooden boxes are considered forerunners of minimal sculpture; Beverly Pepper carried out large-scale steel commissions for public buildings; Chryssa's neon light sculptures reflect the art-and-technology marriage of the sixties. A few women became Pop artists (surprisingly few adopted the commercial art techniques of airbrush and billboard painting). Marisol is associated with Pop Art, although her assemblages never went all the way with the commercial-industrial image. But, as in the forties and fifties, these women made up a small band of Amazons—token figures who made it into the mainstream of an art scene that was overwhelmingly dominated by men.

The Civil Rights Movement, The Vietnam War and Art

By the mid-sixties, the civil rights movement and the Free Speech movement were flourishing. The Kennedy assassination, the shooting of Martin Luther King, and protests against the Vietnam War sent a shudder through American society that proved to be the first tremor of an earthquake. Young Americans began to create a counterculture to express their outrage at what they felt to be a crass and unfeeling civilization. Like the Dadaists during World War I, certain sections of youth expressed their opposition to the so-called rational and civilized society by "turning on and dropping out."

Art movements of the late 1960s began to reflect the disintegration of a monolithic mainstream in

American art. Artists began to develop an *antiart* and *antiform* position. Sculptor Eva Hesse, with her limp, non-art materials and "eccentric abstraction,"[1] renewed the idea of gut-level feeling and a sense of the tragic, the absurd. Other artists began to turn back to various forms of realism. Some, like Audrey Flack and May Stevens, began to use political themes relating to Civil Rights and the Vietnam War.

Still others, disgusted with the museum world and the world of "investment" objects, began to move into conceptual art, earthworks, performance, and so forth. They did not want their art works to become commodities to be bought and sold like so many shares of blue chip stock.

Painters

Abstract Painters

Helen Frankenthaler (1928–) is recognized today as the originator of a lyrical kind of abstraction of the sixties, sometimes called *stain painting*. Critic Barbara Rose has referred to her paintings as some of the most historically important work of recent decades and says, "There is no doubt that the bursting, seeping, expanding and unfolding image she creates is distinctly her own."[2] She is another example, like Georgia O'Keeffe and Louise Nevelson, of a woman artist who pioneered new forms.

Art critics have called her paintings "pastoral" and "arcadian" because they often imply idealized landscapes[3]—although they are not literal depictions of anything. Sometimes as enormous as ten feet high, they suggest dizzying spaces, yet at the same time keep a remarkable sense of the flat image on the surface of the picture plane.

Perhaps the privileged and supportive background in which Frankenthaler grew up prepared her to take risks, to try daring new forms, and to believe in them before they gained general critical acceptance. Like Harriet Hosmer in the nineteenth

Fig. 8-1. Helen Frankenthaler, LAS MAYAS (1958), oil on canvas, 8'4" × 43¼"

326

century, she had the advantages of a permissive and encouraging father and an enlightened, progressive education.

The youngest of three daughters of New York Supreme Court Justice Alfred Frankenthaler, she remembers her father as a doting parent, indulgent of her wilful nature and has said that he thought she was "special"[4] from the day she was born.

Frankenthaler was educated at some of New York City's finest private schools, Horace Mann and the Brearley School (Malvina Hoffman and Gertrude Whitney also studied there), and later at the progressive Dalton School. At Dalton she became the favored disciple of her distinguished teacher, the Mexican painter, Rufino Tamayo, who gave her a solid grounding in the technique of oil painting. Near her home were the old Guggenheim Museum, the Museum of Modern Art, and the galleries on 57th Street. Particularly influential in her later development were the Vasily Kandinsky improvisations, with which she was very familiar.

Frankenthaler has said that her world seemed to come to an end when her father died in 1940, but adds that Bennington College, where she went five years later, "saved her life."[5] At Bennington, famous for its avant-garde curriculum in the arts, she once again experienced the kind of freedom and support she had known at home.

There she studied with the cubist painter Paul Feeley, an early supporter of her work and a good friend. Later he was influenced by his precocious student, but in his seminars in this period Frankenthaler enjoyed his rigorous analysis of the work of Cézanne, Matisse, and Picasso, and soon developed into a competent cubist painter herself. Like so many outstanding women artists, she also had strong literary interests and mixed with the brilliant faculty at Bennington, which included W. H. Auden, Kenneth Burke, and Erich Fromm.

After graduation in 1949, Frankenthaler enrolled as a graduate student in art history at Columbia University to please her family. But finding herself drawn more and more to her studio in lower Manhattan, she soon dedicated herself totally to painting.

She met the prestigious art critic Clement Greenberg at a benefit exhibition, "Bennington Alumnae," which she had been asked to organize for her alma mater at the Seligmann Galleries. Her painting *Woman on a Horse* (1950) did not impress Greenberg—in fact, he disliked it. Frankenthaler was still a follower of Picasso, whereas Greenberg was already the knowledgeable guru of the new Abstract Expressionism. But he soon became her friend and mentor. He introduced her to the leaders of the New York School, took her to the Artists Club and the Cedar Bar, and encouraged her to study briefly with Hans Hofmann in Provincetown, Massachusetts. She had entered the explosive world of the younger New York School artists— Grace Hartigan, Joan Mitchell, Alfred Leslie, Larry Rivers, and their poet friends such as Kenneth Koch, John Ashbery, and Frank O'Hara.

She began to move out of cubism into freer forms, inspired at first by Vasily Kandinsky, Joan Miró, and Arshile Gorky (*Abstract Landscape* [1951], *Ed Winston's Tropical Gardens* [1951–52]), and then by Willem de Kooning. In 1951 she was the youngest artist in the "Ninth Street Show" (an exhibition set up by the older Abstract Expressionists in a store-front space), and John Myers gave her a solo show at the Tibor de Nagy Gallery.

That same year, Greenberg took her to see an exhibition of Jackson Pollock's paintings at the Betty Parsons Gallery. She was hit so hard by the physical impact that she felt as though she were "in the center ring of Madison Square Garden."[6] When they went out to visit the Pollocks at The Springs on Long Island, she was tremendously excited by Jackson's method:

Jackson's "spread" appealed to me enormously. . . . The dance-like use of arms and legs in painting, being in the center, relating to the floor.[7]

Frankenthaler decided she could "stretch more in the Pollock framework"[8]—use it as a jumping off point. She began to work with her canvas on the floor.

In 1952 she took the important first step beyond her master Pollock. After a visit to Nova Scotia, where she had sketched and painted watercolors of wooded mountains coming down to the blue sea, she created the landmark painting *Mountains and Sea* (1952). Instead of using viscous, thick paint, as most members of the New York School did at that time, she flooded pale tangles of diluted color onto raw unprimed canvas, permitting the delicate pale corals, blues, and gray-greens to stain and soak into the weave of the canvas, somewhat in the manner of watercolor painting. All sense of the loaded brush or a film of paint on top of canvas disappeared. The paint was now *in* the canvas. A curious ambivalence resulted. At the same time that shapes and colors suggested spatial movements and tensions, the weave of the canvas, showing up prominently through the thin soaked-in paint, reminded the viewer of the fact that the image was, after all, *on* or impregnated *in* a flat, two-dimensional support. Much of the drama of Frankenthaler's subsequent work comes from this ambivalence.

When Morris Louis and Kenneth Noland, who later became leaders of the Color Field school of the sixties, first saw *Mountains and Sea* in Frankenthaler's studio, they knew at once that it had opened up a new concept in painting. They also began to stain and flood color on unprimed canvas in a brushless technique, leading to a new movement that became known as stain painting. Frankenthaler, Louis, and Noland continued to exchange visits and ideas in the following years.

Most critics, however, were not ready for Frankenthaler's new departure. Accustomed to thick brushwork and turgid color, they viewed this transparent technique as insubstantial and the color as "sweet." The poet James Schuyler later pointed out that "her special courage was in going against

the think-tough and paint-tough grain of the New York abstract school. . . . She . . . chanced beauty in the simplest and most forthright way."[9]

The critics began to accept Frankenthaler as an important figure when her painting *Jacob's Ladder* (1957) won first prize at the 1959 Paris Biennale. By 1960 Frank O'Hara had organized her first retrospective at New York's Jewish Museum; in 1966 she was selected as one of four artists representing the United States at the Venice Biennale; and finally, at her 1969 Whitney Museum retrospective, it was evident that she had been the forerunner of an important movement.

In 1958 Frankenthaler married Robert Motherwell. During the thirteen years of their marriage they became a kind of "royal family" of modern American art. He was a major figure, a distinguished painter, critic, theoretician, and one of the founders of the New York School; she was a star of the "second generation" of Abstract Expressionism. Both came from wealthy families and were sophisticated intellectuals. They traveled in Spain and France, sharing a love of Basque culture. *Vogue* described the Spanish ambience they created in their one hundred-year-old brownstone on the Upper East Side of New York City, with white walls, Mediterranean blue ceilings, tile floors, and natural-wood doors—a background for bronzes by Auguste Rodin, African masks, and paintings by de Kooning and Rothko.[10] Departing from her habits in early years in the Village, Frankenthaler now avoided "the scene" and moved in a small circle of close friends.

Frankenthaler's method of painting requires strong nerves. She works like a Japanese calligrapher, without preliminary drawings, from intuition based on long training and knowledge. Circling the large, unprimed cotton-duck canvas (the same kind used for boat sails) thrown on the floor, she pours or spreads a shape, looks at it, and sees where the next shape is needed ("It answers back," she says). Then, led from point to point, she paints,

pours, drips, or uses a squeegee to spread great veils of tone, bends down to smear or flick an accent with her finger, and draws a thin tense line with the brush (she has even been known to use her foot or a palm of the hand). Finally, some strange new balance, some unexpected harmony of color, some tension between shapes that works when viewed from all four sides seems somehow "right" to her.

She may pin the work on the wall to look at it. Sometimes she has to crop the painting to make it work. Often the picture does not "come off" and has to be thrown away. Like Matisse, she finds that working over a picture can muddy the radiance of the color or destroy the look of effortlessness. A tremendous amount of labor, thought, and editing goes into the production of these "spontaneous" works. She says:

A really good picture looks as if it's happened at once. It's an immediate image. For my own work, when a picture looks labored and overworked . . . there is something in it that has not got to do with beautiful art to me. And I usually throw those out, though I think very often it takes ten of those over-labored efforts to produce one really beautiful wrist motion that is synchronized with your head and heart, and you have it, and therefore it looks as if it were born in a minute.[11]

Frankenthaler's work has gone through a change of technique and style. In her early paintings she used thin, diluted oil paint that left "halos," or stains of turpentine, around the edges of the forms. This early work often has a wildly calligraphic quality, something like Arshile Gorky's, or Kandinsky's improvisations—tangles, skeins, drips, and loosely formed shapes. In response to the minimalist trends of the sixties, her work became more controlled and even, at one point, symmetrical. She began to use acrylics and her paintings of the late sixties and early seventies have larger, simpler areas—islands or planes of more opaque color—often with raw canvas exposed between them.

It is never Frankenthaler's intention to paint a picture of any literal subject—her main concern is

with new kinds of spatial dynamics—yet after the work is finished, it may suggest landscape, figure, or other elements that lead to titles like *Flood* (1967), *Eden* (1957), and *Mount Sinai* (1956). These forms can sometimes suddenly be "read" in the manner of a Rorschach ink blot. For instance, as Barbara Rose points out, the birds in *Swan Lake* (1961) appear unexpectedly in the leftover "empty" spaces between painted forms. The glowing edges of certain shapes remind the viewer of clouds with the sun behind them, as in *Interior Landscape* (1964). Openings between great shapes of color that have been laid down on either side of the painting can suggest canyons between rocks; a thin horizontal strip of color can imply miles of sand or sea, while at the same time it seems flat on the surface of the canvas. Frankenthaler's work clearly derives from nature rather than from industrial-geometric sources. Many of her images, for example, were inspired by the vistas around her summer studio at Provincetown on Cape Cod.

Constantly experimenting and moving on, she says, "I'd rather risk an ugly surprise than rely on things I know I can do."[12] In one series of paintings she left large empty spaces in the center and concentrated her painted shapes at the very edges, suggesting that they are just the rim of vast forms that are implied to be going beyond the picture (*Four O'Clock Space* [1966], *One O'Clock* [1966]). This was a departure from the previous history of western painting, in which attention was directed toward objects in the middle of the work, while the edges received relatively less attention. In paintings like *Buddha's Court* (1964) she played with variations on the theme of a rectangle within the rectangle of the picture shape. Recently, she has used thin sharp lines in strange ways to "span" the soft islands of color, or suggest lines of force, or receding planes, and simultaneously, incisions in the surface.

Frankenthaler is a Color Field painter. Color spaces acting on one another are what make her

pictures work. Gorgeous rich reds and oranges and greens in *Tangerine* (1964) give way in other works to sonorous purples and blues, or rich golds and browns—always sensuous and often strange.

Her paintings are full of daring balance. She wants them to be surprising, "puzzled," and even a little "clumsy."[13] Above all, Frankenthaler avoids the expected or the predictable. She tries to keep the fresh eye and liberated spirit of a child, as in *Tangerine*, where the horizontal bands of color expand and flow upward like a "genie escaping from the bottle."[14]

Frankenthaler's work carries forward into new forms a tradition begun with Kandinsky and continued by the Surrealists and Jackson Pollock—of "letting go," letting things happen, permitting the unconscious forces to exert their influence. The artist is in a sense liberating herself (and, by implication, the viewer) from the restricting confines of a mechanistic and stifling industrial civilization, thus drawing out deeper and more basic feelings. The process sounds as if it might lead to a chaotic jumble, and in untrained hands it would, but with Frankenthaler's rigorous training and gifted eye, the unconscious perceptions liberated in creation turn chaos into order.

In 1975 the catalogue of her exhibition at the Corcoran Gallery of Art referred to Frankenthaler as "one of the great living American artists."[15] Her canvases have shown an increasing expansiveness and grandeur that relate them to the American landscape tradition. Recent works, inspired by several trips west (*Into the West* [1977]), are painted with a thicker, more textured paste of paint, pulled across with rollers or accented with drips or lines that sometimes suggest clefts in rocks. They have the imposing feel of grand canyons, waterfalls, glaciers (*Ice Age* 1978).

Reviewing her work of recent years, critic Gene Baro has written:

I should say that her basic insight is of scale. She has been able to paint in the grand manner because she has felt the grandeur of visual life in natural and ordinary perceptions. She sees what is big in feeling, what is spacious and vital in relationships. Her paintings . . . convey this message of space, light and energy. . . . She has truly made an American art . . . ample and forceful as the land itself . . . but also . . . intensely personal.[16]

Alma Thomas (1892–1978) was a Color Field painter known for her mosaic-like compositions of patches of luminous color. One of the few black artists to achieve prominence in the mainstream (white) art community, she chose to work in the modernist tradition of New York and Paris, rather than use black themes or base her work on her Afro-American heritage.

Thomas grew up in a loving family and called her father "the most respected Negro in Columbus [Georgia]."[17] The Thomases lived in a Victorian house on the top of a hill, and she remembers her mother, a dressmaker, singing as she made clothes in beautiful colors on the sewing machine.

Although at that time no black person could enter the Columbus library except "with a mop and bucket,"[18] Thomas's aunts were schoolteachers of black children, and she decided at an early age that education was her passport to a decent life. The family moved to Washington, D.C., in 1907, and in 1924 she was the first graduate of the newly formed art department at Howard University. There she found a mentor in art chairman James Vernon Herring. At his home she enjoyed his art library, and he talked to her for hours on end about art history.

Alma Thomas taught art to children for thirty-five years in the same schoolroom in Washington. Along the way she earned an M.A. at Teachers College of Columbia University (1934), and did her dissertation on marionettes with Tony Sarg. For many years she exhibited realistic pictures in shows of black artists, and was respected, but not acclaimed. In the fifties, she took painting classes at American University and began to be interested in color and abstract art.

Thomas was already seventy-four years old and had retired after a lifetime of teaching (in fact, she was suffering from severe arthritis and thought she might have to give up painting) when an unusual event changed her life. Howard University, in recognition of her long years as artist and teacher, offered her a 1966 retrospective exhibition. Inspired to add some marvelous new paintings to her earlier work, she

decided to try to paint something different from anything I'd ever done. Different from anything I'd ever seen. I thought to myself, that must be accomplished.[19]

Thomas looked out her window at the tree growing outside and saw in the leaves and the changing light, a limitless source of patterns. She painted pure abstractions for the first time and was soon asked to exhibit them in many places. In a short time she was widely recognized as an important Washington Color School painter.

In the 1970s she exhibited at the Whitney Museum, the Boston Museum of Fine Arts (1970), and the National Collection of Fine Arts. The Metropolitan Museum bought a painting, and New York's prestigious Martha Jackson Gallery carried her work. "Color is life," she wrote. "Light reveals to us the spirit and living soul of the world through colors."[20]

Thomas's glowing paintings are mosaics of patches of color that interact with one another and with the background. In *New Galaxy* (1970), vertical rows of rectangular patches in various shades of blue suggest the changing colors of the heavens. In *Flowers at Jefferson Memorial* (1970), the colored rectangles arranged in a mosaic of concentric circles are reminiscent of a floral display.

In *Autumn Leaves Fluttering in the Wind* (1973), the rust-colored patches of paint move in rhythms like those of swirling autumn leaves. The crevices between them reveal glimpses of blue, yellow, light green, suggesting sky and landscape. In 1976, at age eighty, Thomas wrote:

Based on the modern theory that color is the sole architect of space, my paintings reflect my communion with nature, man's highest source of inspiration. Intrigued with the changing colors of nature as the seasons progress, and the colossal scientific achievements in the rapidly changing world in which we live, I always seek new styles of expression.[21]

One of the paintings of **Agnes Martin (1912–)** is aptly called *Whispering* (1963). In reality, all of her paintings whisper barely audible secrets very quietly at the viewer. Since 1957 she has been painting and drawing self-effacing grids of faintly wavering pencil and paint lines, with which her name has become associated. In this way of working, she is generally considered a forerunner of the minimal art movement.

Born in Macklin, Saskatchewan, Canada, Martin came to the U.S. in 1932 and became a U.S. citizen in 1940. In 1941 she received a B.A., and in 1954 an M.F.A., from Columbia University. Intermittently during the forties and fifties, Martin taught painting at the University of New Mexico. She also spent time in New York, where in the early fifties she taught children in Harlem.

But all along, Martin was painting, first watercolors of the human figure and landscapes; then during the forties and fifties, Surrealist paintings.

It was not until 1957, however, when she returned to New York for a ten-year stay, that Martin found her artistic statement. She settled into the Coentes Slip section of New York City, where her artistic neighbors were all caught up in the break from Abstract Expressionism of the late fifties. Among them were Ellsworth Kelly, who was painting pictures of large bands or simple geometric shapes of bright color; Robert Indiana, who painted brilliant, hard-edge, geometrical patterns; and Jack Youngerman, who painted large, clean minimal abstractions based on organic forms.

At first, under the influence of her neighbors, Martin painted rectangles within the picture frame,

vaguely suggestive of the work of Mark Rothko or Kelly. In *White Study* (1958) there are two such rectangles. Soon she began to fill them with grids of various kinds.

In her picture *Islands No. 1* (1960), there is a rectangle within the picture frame. Within this rectangle there is a grid with a border all around it about an inch wide. The grid consists of columns of short horizontal dashes arranged in pairs. Since there is so little other variation within the picture, the slight changes of spacing seem to shift around giving the picture a surprising vitality and movement. Martin sometimes glued on small pieces of colored canvas or used nails and other elements in her grids, but they were always surrounded by a border.

Gradually, she pushed the edges of the inner rectangle out until it filled the entire picture. After 1964 most of her pictures have consisted of a canvas or paper totally covered by a grid; for example, *The Ages* (1960), *Little Sister* (1962), and *Desert* (1966).

Sometimes the grids have some obvious reference to nature. For example, in *Orange Grove* (1965) every fourth line is orange; in *Blue Flower* (1962), every small square in the grid is blue and has a nail head at its center. As time went by, these "naturalistic" details began to disappear. The grids became more monochromatic as in *Play, Hill,* and *Adventure* of 1966 and 1967. Variations became the subtlest changes of line—sharp to fuzzy, or slight changes in spacing—and the faintest irregularities of the tone of the background, or even the weave of the canvas.

Agnes Martin's success is indisputable. Her work was exhibited in one-woman shows every year (starting with Betty Parsons) from 1958 until 1967, the year she left New York. In addition, since 1957 she has also exhibited in fifty prestigious group shows in the U.S. and Europe.

From the time Martin settled in New York, she shared with her neighbors Ellsworth Kelly and Ad

Fig. 8-2. Agnes Martin, UNTITLED #6 (1977), india ink, graphite and gesso on canvas, 6' × 6'

Reinhardt a conscious revolt against 1950s Abstract Expressionism. She viewed the painters of that movement as egotistic romantics and viewed herself, rather self-consciously, as a classicist: "I would like my work to be recognized as being in the classic tradition."[22] Compared to the painters she was revolting against, her work certainly does seem classical. Where the Abstract Expressionists slapped thick paint on the canvas in a way dictated by the aestheic impulse of the moment, Martin placed her lines in a carefully premeditated plan. Where their compositions might develop in any direction, her grids were always horizontal and vertical, with an obvious suggestion of classical architecture and formal composition. Where their work was clearly the expression of personality, hers appears cooly detached and self-effacing. Where theirs is violently emotional, hers is quiet and calm.

In addition to classicism, Martin has at various times proclaimed a quasi-religious content, motivation, and even mystical efficacy for her grids. She

has implied that there may be Christian and Buddhist symbolism in them; in her poetry and lectures she refers frequently to the need to overthrow or "defeat" pride to attain humility.

I can see humility
Delicate and white
It is satisfying
Just by itself
I would rather think of humility
Than anything else.[23]

Indeed, there is a certain humility in abandoning all attempts at painterly virtuosity by reducing one's art to thin, wavering horizontal and vertical pencil lines. "When pride is lost," Martin has written, "we feel a moment of perfection."[24]

These essentially Christian ideas about the suppression of pride, and humility, and the consequent striving for perfection are combined in Martin's thinking with Buddhist ideas. She claims that her paintings are somehow related to the Buddhist progression. The first stage in this progression is the ritualistic; the second is the "classic," or "the underlying purity." The highest stage in this attempt to reach "true Dharma" is the void, or pure mind, the realm of the perfect—which, perhaps, Martin attempted to depict in the faint floating veils of her most minimal, most pure work in 1966 and 1967.

Although Agnes Martin spoke of herself as a classicist—as one who had left Abstract Expressionist Romanticism to return to an earlier mode—in reality, she was one of the creators of a new art form outside of both classicism and romanticism. It has been called, variously, *continuous surface art, minimal art, boundless field art,* and *systemic art.*

To understand this new art expression, one must consider the nature of traditional art, whether abstract or representational. Traditional art is compositionally a balance among objects located in a field (or bounded in a frame). The objects being balanced in the field are different in size, shape, and color. The interplay of these objects within the pic-ture frame constitutes the world of the picture and makes up a complete aesthetic whole that is independent of things outside the picture.

Obviously the grids of Agnes Martin are not such compositions. There are no separate objects of different shapes and sizes in the picture. The field in her pictures is indistinguishable from the objects in it—it is a continuous pattern, and because it is continuous, it suggests in Lawrence Alloway's phrase, "the continuous space of the world."[25] Looking at her pictures, she has suggested, is like looking at a waterfall or at the continuous, formless vastness of the sea. Martin herself has said, "You wouldn't think of forms by the ocean. . . ."[26] meaning that the ocean's surface is a boundless expanse of repeated forms of uniform size and shape. "Nature is like parting a curtain. You go into it."[27]

In 1967, Martin left New York abruptly to settle in an adobe hut on a tract of land in Cuba, New Mexico, in the middle of the vast, featureless desert. For the next six years she lived peacefully, devoting herself to work on a small adobe house and concentrating on writing rather than painting.

Writing in *Art News,* Carter Ratcliff observed in 1973, "Though six years is a long time to be away from the New York art scene . . . Agnes Martin has continued to be a presiding figure here. . . . One is tempted to see her influence whenever one sees a grid, especially if it is pencilled."[28]

Nearly a year later, Linda Morris wrote in the British art journal *Studio* in a review of a show of American painters in London, "Martin has recently emerged as a seminal figure."[29] Lawrence Alloway has assigned her a historic role and said that her square canvases, beginning "in the late '50s, not only anticipate Ad Reinhardt's series of black squares from 1960 to 1966, but rival him in the pursuit of a subversive equilibrium."[30]

Deborah Remington (1935–) paints luminous, Hard Edge abstractions that suggest subject matter ranging from the insides of automobile en-

gines, to human bones, to Japanese calligrams. This is not surprising, since her work grows out of conflicting influences—a background in American action painting and two and a half years spent in the Orient studying calligraphy.

Remington was born in Haddonfield, New Jersey. Her father was a stockbroker, her mother an intellectual who associated with illustrators. Remington was sent to art school as a child.

After her father died, the family moved to California, where she attended the California School of Fine Arts in San Francisco (1953–1957). The school was an exciting place, the West Coast center of Abstract Expressionism, with stimulating teachers such as Clyfford Still and Bay Area figurative artists David Park and Elmer Bischoff. Action painting—thick impasto—was the prevalent mode, and Remington worked in that style.

Remington was part of the San Francisco "beat" scene. Along with artists Wally Hedrick, David Simpson, Rayward Kind, and several poets, she ran the cooperative Six Gallery, the setting for Allen Ginsberg's first reading of *Howl* and many other events.

Like Joan Brown,[31] Remington became dissatisfied with Abstract Expressionism after a while, when all the work began to look alike to her. She traveled to Japan seeking inspiration and remained in the Far East from 1957 to 1959. She learned the language fluently, lived with Japanese families, explored the culture in depth, and studied calligraphy with Toyoda Sensei. These years of calligraphic training gave her work a new refinement and control, a new facility and finish. She learned to be sharply perceptive of shapes in the environment—a man's elbow, a tea-kettle spout, a voting lever—which, in her more recent work became the origins of abstract form.

To support herself, Remington acted in movies (as the occidental villainess) and as a television comedienne in Taipan, and worked as a cook for a Swiss technological advisory team in Nepal. Her exotic adventures came to an abrupt end when she nearly drowned in the Ganges River in 1959. After facing death, Remington realized it was time to stop playing and return home to a serious career. In her own words, it was "time to go back and face it again."[32]

Back in San Francisco between 1959 and 1965, she was forced to work as a waitress because men were given all the teaching jobs, but gradually developed her mature artistic style. It evolved out of a struggle between her love for thick, luscious paint and her interest in controlled images. A painting like *Statement* (1963) shows this conflict. A large, vaguely defined figure looms above two light areas. Neither the image nor the light areas are crisply defined.

Later, possibly under the influence of Hard Edge painting, Remington began to produce her characteristic work—paintings consisting of a dark field with a light image clearly defined, usually centered on the canvas. Unlike other Hard Edge painters, Remington does not simply fill her color areas with bright, unmodulated tones. There is a tonal variation from dark to light and vice versa that is so gradual that it appears to have been achieved with an airbrush. Actually, she builds up the variation gradually, using small hair brushes in two thin coats. An early painting in this manner is *Doxie* (1963) in which the forms have an effect of luminosity achieved by edge lighting; by the suppression of her earlier impasto for a flatter, subtly modulated tonality, and by the contrast of the dark field and the lighted objects.

Remington uses a limited palette. Against silvery tones, graded from white to deep gray, she plays a few deep, rich colors, mainly deep blue and red. Her mysterious paintings can best be described as having a *porthole effect*—one seems to be looking through a central opening at mysterious light spaces that suggest sea, sky, and infinity, and yet seem to reverse themselves and become a flat mirror, as in *Gallatin* (1976) and *Exeter* (1974).

All of Remington's artistic tendencies come to-

Fig. 8-3. Deborah Remington, ESSEX, 1972, oil on canvas, 96″ × 67″

gether in works like *Saxon* (1966–67). In a dark field, an image—possibly an engine, some kind of crystal, or an organic form—glows softly. Its edges are crisply defined, and it shines with subtly varied luminous color. There is something gemlike about it.

Out of all the influences to which Remington has exposed herself, she has developed a form that fits into no comfortable niche—it is uniquely her own. The artist now lives in New York and has taught at the San Francisco Art Institute, the University of California at Davis, and at Cooper Union.

Ida Kohlmeyer (1912–), of New Orleans, one of the best-known abstract artists of the South, started her career late. She earned a Master's degree in painting from Newcomb College in New Orleans at age forty-four. After becoming interested in abstract art at Hans Hofmann's Provincetown summer school, she returned to teach at Newcomb in 1957 and was profoundly influenced by Mark Rothko, then artist-in-residence at the school.

She began to blur bands and striations of color into larger geometric configurations such as a cross, a circle, a diamond (*Slatted* [1968]). She also arranged a kind of symbolic alphabet of forms on one canvas, creating a composite picture gallery in one image. The Women's Caucus for Art gave her one of its coveted awards for distinction in the arts in 1980.

Alice Baber (1928–) paints clusters of glowing, transparent ovals, discs, and streamers of color, that fly outward from a light-filled center.

Elise Asher wrote poetry until around 1947 and then began to paint in a kind of mysterious illegible script that weaves a gestural pattern through the painting. Today she paints this script on transparent plexiglass panels, along with curious amphibious and birdlike forms, giving her work a fantasy quality halfway between the gesture of Abstract Expressionism and Surrealism. She is the wife of poet Stanley Kunitz.

Some Hard Edge, Minimal, and Constructivist Painters of the Sixties and Seventies

Jo Baer (1929–) plays subtle games with shapes at the very edge of horizontal or vertical canvases. She runs elegant geometric and curved shapes across the upper front and wraps them around the top and sides as in *Arcuata* (1971). **Helen Lundeberg** (see chapter 6) and **Florence Arnold (1900–)** are associated with the California Hard Edge School, first identified by critic Jules Langsner in Los Angeles in the 1950s. **Elaine Lustig Cohen (1927–)** is a well-known New York painter of constructivist and geometric abstractions. **Edna Andrade (1917–),** a leading Philadelphia teacher and artist, has been associated with the Op Art movement. She creates space-filling patterns that reverse themselves and play other illusionary games with the viewer. **Dorothea Rockburne** creates tense minimal compositions of rare beauty by folding canvas into subtle parallelograms and triangles, enlivened with slight variations of surface texture.

Fig. 8-4. Edna Andrade, HOT BLOCKS (1966), acrylic on canvas, 60″ × 60″

Figurative Painters

Joan Brown (1938–) was only twenty-one and fresh out of school in the early sixties when she suddenly became the *wunderkind* of San Francisco Abstract Expressionist painters. Her total abandon with impasto paint—canvases that were built up thick and juicy with four-inch-thick layers—seemed the epitome of freedom in a mode that was very popular at the time. She was written about in art publications, given the 1962 *Mademoiselle* award for excellence, and was hailed in the heading of an article in *Artforum* as "everybody's darling."[33] Her work sold well and dealers and critics were happy.

But Brown turned away from this early, easy success. She felt there were depths she was not exploring. Today, her bold shiny canvases of silhouetted figures dancing crazily to jazz bands or a wild wolf walking the streets of San Francisco, sometimes set the critics' teeth on edge. The direct flatness of the images, the shiny enamel paint and bright colors have caused her to be labeled variously as "cartoony," "funky," and "naive." Her use of daily household subjects has earned her the designation of a "feminist" painter. Actually, she is trying in these curious works to capture the absurd and lonely quality of contemporary life.

Brown's childhood gave no indication of the rebel and artist she would become. A shy only child raised in a conservative Catholic home in San Francisco, she attended a parochial high school for girls and was expected to go on to Lone Mountain College, a women's college in the Bay Area, and then, by an inevitable progression, to be married.

Unaccountably, the night before her college registration she became panicked. The life ahead of her seemed bland, flavorless, and constricting. She looked through the papers and, attracted by an ad from the California School of Fine Arts (later the San Francisco Art Institute), impulsively registered the next day in the painting program. Her art education up to that point had consisted solely of copying pictures of movie stars or calendar illustrations, but her willingness to follow an intuition boldly was precisely what has characterized her career as an artist.

At the California School of Fine Arts, after a discouraging first year during which she seemed to lack any talent and almost quit, Brown entered the painting classes of David Park and Elmer Bischoff, two leaders of the Bay Area figurative school of painting. Bischoff became her role model—enthusiastic, totally devoted to art, and unbendingly honest in his search for a personal form of expression without regard for financial rewards. In her second year Brown made a total commitment to painting. Bischoff's teaching released her energy, and he counseled her to stop worrying, trust her feelings and "let go." Brown was soon painting abstractions in the juiciest of styles—gutsy, bold, and spontaneous.

She was still in school when George Staempfli, Bischoff's New York dealer, happened to see her work, was impressed, and bought several paintings. When Brown graduated with an M.F.A. degree in 1960, she was immediately put on a contract with the Staempfli Gallery, which provided her with a monthly stipend in exchange for works like *Large Laced Stocking and Things in Small Sea* (1960) and *Girl Sitting* (1962). During these years Brown married and divorced painter William Brown, then married painter Manuel Neri and had a son.

In 1965, dissatisfied with her overnight success, Brown went through a year of self-doubt during which she turned out only one important painting—a small, carefully painted still life in muted green and gray tones. By the following year she had started in a new direction. Since that time, she has been totally uninterested in the vagaries of the art scene, deliberately avoiding publicity and refusing to be under contract with any gallery.

Brenda Richardson, in her excellent catalogue essay for Brown's 1974 retrospective show at the

University Art Museum in Berkeley, has discussed the artist's new goals and methods. Richardson believes that at the deepest level Brown is interested in showing the human condition—the frail vulnerability of human beings in modern city life. In boldly simplified forms drawn from her environment, her family, and her own life, she is reaching for metaphors about human relationships.

Brown views "ritual activities"—cocktail parties, formal dining, dances—as the means by which people reach out pathetically to one another and

disguise their needs and fears. . . . She . . . believes and still participates in the social maneuvers that to most of us characterize another generation of fifties suburbia—dressing up in satin and chiffon, cocktail parties . . . dancing the waltz and foxtrot.[34]

She often depicts these social rituals, seeing them as the tools and instruments by which people try to communicate with one another. She has painted couples, for example, dancing to the big jazz bands in the ballrooms of San Francisco. In *The Last Dance* (1973) large rats unaccountably turn up and begin to eat the dancers.

Brown sometimes uses animals as metaphors. Her paintings *Wolf Walking Along S. F. Street at Night* (1972) and *Wolf in Studio* (1972) are symbols of how dislocated one can feel in the lonely, artificial world of big cities. Another series has resulted from her passionate hobby of recent years, long-distance competitive swimming with the Bay Area Swimmers Club. She swam San Francisco Bay to Alcatraz Island and incorporated this experience into a series of paintings that are metaphors, perhaps, for dreams of striving and achievement, as in *The Night Before the Alcatraz Swim* (1975).

The artist has moved away from the painterly gestural impasto of her early career and now uses shiny enamel in silhouetted flat areas of bold, raw color and decorative pattern. Ghosts of layers of paint underneath the enamel lend richness to the flat surfaces. She will do anything, no matter how unorthodox to effect the necessary result—throw

glitter into the paint or stick a piece of fabric into the picture to make it work. From the beginning, however, Brown's painting has consistently maintained a characteristic quality of spontaneity—it looks effortless, and has an almost garish vitality.

Joyce Wahl Treiman (1922–) increasingly recognized as one of the outstanding humanist painters in the United States, presents a paradox in both her life and her art. She lives in a comfortable suburban house in West Los Angeles. She has no studio or loft, and paints in half of a two-car garage, leaving room for the family car. For an artist, her lifestyle is so unbohemian as to be almost eccentric.

And yet, out of her garage have come powerful paintings with an eerie, haunting character, that embody the sense of uprootedness and angst that are so much a part of our time. Treiman's work is characterized by old-master draftsmanship and virtuosity that, until recently, because of the fashions of the art world, did not always get their due recognition. She uses this technique to treat the broad human issues of violence and isolation with which she has been concerned since the beginning of her career.

Joyce Wahl was born in Chicago, and her great native talent was evident early on. She was drawing by the age of eight, so her mother took her to a children's art class. The teacher instantly recognized her ability and phoned to tell the family that she belonged in an adult life class. Fearing she would be corrupted there, her father accompanied her to the class and waited for her all day Saturdays to take her home again.

Treiman drew after school at the Art Institute of Chicago throughout her high school years and was already a virtuoso draftswoman by the time she enrolled at the University of Iowa. At Iowa, her talent was immediately recognized by her painting instructor, Philip Guston. Lester Longman, her art history professor, not only encouraged her admiration for the great masters, ancient and modern, but

he also became a lifelong friend.

After graduating in 1943 she worked for a while as a commercial artist and married Kenneth Treiman, a businessman. In 1947 a Tiffany Foundation grant enabled her to devote herself entirely to painting, and since that time she has won a staggering number of awards and prizes in national exhibitions. Treiman was already an outstanding Chicago artist by the time she and her husband and young son decided to move to Los Angeles in 1960.

Treiman's early work, as is to be expected, was influenced by her teacher Philip Guston and featured stylized figures in an American expressionism vaguely suggestive of Ben Shahn. In her words:

In Chicago I used to walk around a kind of skid row neighborhood, near the hospital where my brother was an intern. When I got the Tiffany grant I did a series of paintings of these down-and-outers. I've always had an anxiety about the human condition.[35]

Figures of the losers and lost souls of the city float back and forth into rectangular shapes that suggest doorways and buildings, as in *Street in Motion* (1948).

In the fifties, I took my concern about people to a broader plane. I did a series based on mythology—Prometheus, Icarus—the archetypal stories about man's struggle with himself.[36]

By this time, Treiman was influenced by Abstract Expressionism and used ambiguous semiabstract forms caught up in a web of scumbled and loosely painted gestural impasto. Then as now, however, her themes dealt with man's inhumanity to man. Typical works from this period are *The Absalom Triptych* (1955), and *Arguing Angels* (1952), in which she suggests that even the angels can't get along with one another.

For a short while Treiman experimented with total gestural abstraction in a series leading up to *Homage to Rodin* (1959). She was very successful as an abstract artist and won many awards, but soon found this type of painting too easy and unchallenging. Several trips to Europe where she saw the work of Monet, Michelangelo, Donatello, and Tiepolo, convinced her that self-expression was trivial and self-indulgent.

In the 1960s, Treiman began to return to figurative art, moving gradually out of abstraction in a series of gloomy dream sequences, strange hallucinatory paintings in which the figures emerge out of "initially abstract configurations on the canvas . . . magically materialized as in dreams . . . radically transformed in scale and enigmatically related to one another."[37]

In these tormented paintings, distorted figures float through walls. *The Secret* (1965–66) shows sprawled figures in a room filled with a sense of impending disaster, about to be engulfed by a flood tide creeping into the room. *The Birthday Party* (1966) shows leering, mindless people at a weird party. On the floor is a space helmet and lit candle, hallucinatory symbolism that suggests some imminent catastrophe, probably the consequence of the sin symbolized by the apple in the picture.

Treiman's visits to Europe in 1967, 1968, and 1969 to study Velasquez, Goya, and Rembrandt were gradually leading her to attempt to emulate what she calls the "fullest" and "highest" expression. Rembrandt, above all, seemed to her the prototype of the great artist, one who combines a profound feeling for humanity with the fullest understanding of aesthetic content and painterly technique. For many years she kept next to her easel a poster of a self-portrait by Rembrandt from the Rijksmuseum. She also became interested in the work of a group of Americans: Thomas Eakins, John Singer Sargent and William Merritt Chase.

These influences of the European and American masters led up to a major phase of Treiman's mature work in the period 1967–1972. Starting with double portraits like *The Couple* (1968–69) and *The Yellow Lampshade* (1968–69), it culminates in *Anomie* (1969–70), a large group portrait of eight oddly dressed people, all of whom are portrayed as iso-

Fig. 8-5. Joyce Treiman, THE YELLOW LAMP-
SHADE (1968–69), oil on canvas, 40″ × 36″

lated from themselves and one another. These pictures are painted in a Rembrandtesque manner, with shadowy lighted figures emerging from a dark ground, and exotic period props. Los Angeles critic William Wilson, has described the curious existential atmosphere in Treiman's work of this period:

Shoe toes curl and people threaten to levitate. A chance expression of sly viciousness or stupidity turns a domesticated professor into a dangerous animal. A damask chair could pounce like a leopard from behind a potted fern. . . . The whole hints at insights from Ionesco's *Rhinoceros*, the screaming victims of Francis Bacon, the hiccuping absurdity of Samuel Beckett.[38]

In the next phases of Treiman's work canvases became progressively lighter. In a series of paintings done between 1969 and 1973, she depicted herself and her friends as horseback riders or cowboys in a kind of playful western charade. Sometimes she is an equestrian in these pictures; sometimes an Indian or a red-headed child. (Treiman has short, curly, red hair and frequently turns up in various transformations as a character or a witness in her work.) This is a kind of Americana period both in style and content, and is influenced by the work of Eakins.

In the late 1970s, Treiman produced a group of tributes to famous artists of the past, tributes in which she asserts her right to be considered one of them. Although sometimes rendered with almost photographic accuracy, these pictures, with their high key colors and imaginary settings and juxtapositions, are fantasies. For example, in *Thomas Eakins Modeling in California* (1974), Eakins is posing for her on the model stand with his nude back to the audience, and Treiman is sitting in an Indian feather headdress facing front, while her art-world friends sit around.

Treiman has always held very high standards both for herself and for other artists. In one interview she kept referring to this relentless striving for excellence with phrases like "I like the very best . . ." and "I like the highest development of an art

field. . . ."[39] In her tributes to the famous artists of the past, there is a sense that she has rivaled them and now feels entitled to be in their company. In *The Big Sargent* (1975), for example, two of Sargent's subjects and the artist himself are sitting in the room with her. Eakins, stripped bare, is her model, and Treiman sits in the garden with Pierre Bonnard, painting alongside of him.

Joyce Treiman has had over thirty solo shows (at the Art Institute of Chicago, the La Jolla Museum of Contemporary Art, and elsewhere), has been in over a hundred group shows, and has won over two dozen major awards. Her work is in the Whitney Museum, the Los Angeles County Museum of Art, and the Art Institute of Chicago. Too busy working to take any time for "hyping" herself in the media and contemptuous of any huckstering or bohemian stance, she is finally receiving the full recognition that she deserves.

Graphics

June Wayne (1918–), founder of the Tamarind Lithography Workshop, was largely responsible for a renaissance in the art of lithography in America. She is equally famous as an artist and as a leader and intellectual who has spoken out on issues from the days of the Federal Art Project to the present women's movement.

She grew up in a Chicago neighborhood of first-generation immigrants struggling to make a new life for themselves. Her parents were divorced when she was a baby, and her mother, Dorothy Kline, sold corsets and lingerie to support her. From an early age, June felt that women could take care of themselves.

Mother and daughter were voracious readers and intellectually curious. June taught herself to play the piano and at age nine began work on an illuminated manuscript of the *Rubáiyát of Omar Khayyám*. A bright student who skipped several grades, she

found high school boring and began to cut classes, preferring to read in the public library. She dropped out of high school in her third year to work in a factory, but at age sixteen she passed the entrance exams to the University of Chicago just to convince her mother she was educated.

She never went to college; nevertheless, in the following years she became part of the University of Chicago intellectual community of scientists, artists, and writers such as James T. Farrell, Saul Bellow, and Richard Wright. She read Kafka, listened to Beethoven, speculated on the nature of the universe, and painted.

At age seventeen, she had her first one-woman show at the Boulevard Gallery in Chicago, after which the Department of Public Education of the Mexican government invited her to paint in Mexico and exhibit her work at the Palacio de Belles Artes.

After this, June Claire (she used her middle name) joined the easel painting division of the Illinois Federal Art Project and painted expressionistic social statements with a thick palette-knife technique. Before the age of twenty, she was already lobbying for the Artists Union in Washington against bills that threatened to lay off project artists at sixteen-week intervals. To this day, through Artists Equity and other organizations, she continues to champion the economic rights of artists.

She moved to New York City in 1939, where she designed costume jewelry for mass production. As her biographer Mary Baskett points out, this job involved traveling to New England factories, making fast decisions and estimating production costs—experience that was invaluable later when she set up the Tamarind Workshop.[40]

In 1941 she married a doctor and after the war settled with her family (she has one daughter) in Los Angeles. There she became friends with the critic Jules Langsner, and their frequent discussions about the relationship between art and science led to a series of paintings and prints exploring various optical effects. Throughout her career Wayne has been fascinated by scientific phenomena.

In 1947 she became engrossed in lithography at Lynton Kisler's Los Angeles graphics workshop. "I took a small stone home from his studio and started fooling around. . . . It was like a first shot of heroin. I was hooked right off, and even after all these years I feel I've hardly touched the potential."[41]

Wayne had a successful one-woman show of prints, paintings, and experimental constructions at the Santa Barbara Museum of Art in 1950, and was chosen Woman of the Year in the arts by the *Los Angeles Times* in 1952. That same year, at the height of the McCarthy era, she joined with a group of leading Los Angeles artists to protest an outrageous Los Angeles City Council resolution condemning modern artists as "agents of the Kremlin."

In the next decade, Wayne's lithographs dealt largely with philosophical and metaphysical themes. Fascinated by the writings of Franz Kafka, who seemed to capture most accurately the ambiguous and anxious quality of modern life, she developed a set of Kafka-symbols. In *The Hero* (1949), for example, a metamorphic image is taken through a series of narrative adventures and is eventually left hanging by his own flag over an abyss. In *The Witness* (1952), shadowy figures are entrapped in tubular forms, suggesting that all people are prisoners caught within the confines of their narrow perceptions of the world.

Always interested in optics and science, Wayne experimented with crystalline images in which the figures or forms grew out of a diamond-faceted background, as in *The Bride* (1951) and *Adam and Eve* (1958). The artist went to Paris in 1957 to work at the ateliers of master printers who were much more advanced technically than those in the United States, and there produced a widely acclaimed illustrated edition of John Donne's poems.

Appalled at the inferior state of lithography in America, Wayne wrote an innovative proposal, adopted by the Ford Foundation in 1960, for a plan to set up an American workshop to train master

printers and to experiment with advanced techniques in lithography. This workshop, the Tamarind Lithography Workshop, named after the Los Angeles street on which her studio was located, became a national center to which America's finest artists were invited to work as artists-in-residence. Young master printers trained there and then fanned out across the country setting up other workshops and university departments. The Tamarind Workshop was honored in 1969 when the New York Museum of Modern Art exhibited its prints, made on Ford Foundation grants.

Wayne was too busy directing the Tamarind Workshop, now funded with two million dollars worth of Ford Foundation grants, to do much of her own work. In 1970, deciding to devote the rest of her life to her own art, she established the Tamarind Institute as a permanent training center at the University of New Mexico, and then detached herself from it. Since then she has been creating an ever-expanding output of lithographs, paintings, and monumental tapestries woven in France.

It was natural for June Wayne to become part of the women's movement in the 1970s. She was an outstanding role model for young artists—a woman who functioned simultaneously as a creative artist and as a vocal public figure and executive. She conducted "Joan of Art" seminars to teach young women artists the practical business of making a living in art; she served on national boards, appeared on television programs, and wrote an important article, "The Male Artist as Stereotypical Female" (*Arts in Society* [Spring-Summer 1974], University of Wisconsin.)

The themes in her own work continue to be philosophical musings on man, nature, and the universe. The discovery of DNA triggered off prints such as *Burning Helix* (1978), a visual speculation on the awesome and miraculous power of the genes. Her "Tidal Wave" series hints at the disasters, ecological and military, which the human race can unleash upon itself, for example, *Tenth Wave*

Fig. 8-6. June Wayne, THE TENTH WAVE (1973), lithograph, 40″ × 30″

(1976). Between 1975 and 1980 she completed the "Dorothy" series, based on photographs and images drawn from her mother's life.

Wayne's technical virtuosity has grown with each succeeding group of works. Through the Tamarind Workshop, working with master printers, she has explored every conceivable technical device, including spraying, dripping, pouring, scratching, and special techniques of color registration. She uses all the sensuous potential of the lithographic stone, from the tight velvety grease pencil, to loose fluid tones, to effects that appear to be three dimensional.

Her latest work-in-progress is *Stellar Winds of Space,* a suite of lithographs to be accompanied by an audiocassette of the actual sounds of space, researched in collaboration with an astrophysicist.

Corita Kent (1918–), or "Sister Corita," was a nun for thirty years, and while serving as head of the art department of Immaculate Heart College in Los Angeles became famous as a kind of Pop artist of silk screen printing. Ben Shahn called her a "joyful revolutionary" because of the way in which she changed typographic design—blithely incorporating free-form words into her brightly colored silk screen prints from such diverse and incongruous sources as the comic strip Peanuts, Beatles lyrics, advertisements, poems by e. e. cummings, and passages from the Bible.

In the sixties, these prints, with their slogans, became a voice of the liberal vanguard of the Catholic Church, calling for social change and an end to the Vietnam War. All her work is done in a spirit of joy, celebration, and even humor, which is her special trademark.

Frances Kent was born in Fort Dodge, Iowa, to a hard-working family with six children. They moved to Vancouver and then to Los Angeles, where she was educated in elementary school by the Immaculate Heart sisters. At Bishop Conaty High School, the sisters encouraged her love of art and she designed posters—a harbinger of her future creative formats. The summer before she joined a teaching order (The Institute of the Most Holy and Immaculate Heart of the Blessed Virgin Mary) she took two art courses at Otis Art Institute in Los Angeles—drawing and still life.

She entered the convent in 1936 at age eighteen, graduated from Immaculate Heart College in 1941, and after five years of teaching Indian elementary school children in British Columbia, was assigned to the art faculty of Immaculate Heart College. She enrolled in a Master's degree program at the University of Southern California and chose to study art history because she believed that most studio courses were taught in a stifling way. Her interest in silk screen printing started quite by accident when she found an old screen lying around the art department at Immaculate Heart College. When she

had trouble cleaning the screen, she was given informal instruction by Mrs. Alfredo Martinez, the wife of a Mexican muralist, who had mastered silk screen techniques in order to reproduce her husband's paintings.

Charles Eames, the world famous industrial designer living in Los Angeles, was also a major influence on Kent. Accepting no boundaries between so-called "fine arts" and chair design, filmmaking, advertising layout, or display, Eames gave her a vision of an artist as a worldly person, connected to life, not sequestered from it. To this day she feels that some of the best art and writing is done for television commercials, and that one need not succumb to the pressures to buy soap to recognize that the ad itself is a visual and verbal feast. Corita Kent believes that the artist has a responsibility to work with the mass media in an enlightened way instead of retreating to the ivory tower of high art.

She also admired her good friend Ben Shahn for his use of words in pictures and for the social and political stands his art embodies. "I'm not a picket woman, though I admire people who are," she said, "I'm not brave enough not to pay my income tax and risk going to jail. But I can say rather freely what I want to say in my art."[42]

Sister Corita was so busy teaching at Immaculate Heart College that she had to do her entire personal output of silk screen prints for the year (about twenty) during her three-week annual vacation—sometimes working day and night without stopping. In her early prints, starting in 1950, Sister Corita used figurative religious subjects, in a semiabstract style, reminiscent of Byzantine art, as in *The Lord is With Thee* (1952) and *At Cana of Galilee* (1952). Many layers of printing resulted in a richly colored image from the overlapping of transparent inks. Letters and words first appeared in *Christ and Mary* (1954).

The words became looser scrawls moving freely in the design. In the mid-sixties, the prints became more hard-edged, in bright primary colors, with a

Fig. 8-7. Corita Kent, THE LORD IS WITH THEE
(1952), serigraph, 22½″ × 15½″

strong social and religious message, for example, *The Rights of All Men* (1964) and *That They May Have Life* (1964). She has said that her pictures are a continuation of a centuries-old-tradition—the God-Bless-Our-Home samplers. By her juxtaposition of forms and ideas she "illuminates" old words. For example, a phrase from a commercial advertisement, "enriched bread," is given new life by relating it to the idea of the bread and wine of communion, and given a social meaning by adding Mahatma Ghandi's quotation, "There are so many hungry people that God cannot appear to them except in the form of bread."

But the shapes and colors of the letter forms are as important to her as the meaning. She says:

I think my words gentle people who are afraid of art. People look for content in a work but the artist is concerned with form. When they look at my prints, people are satisfied with the content, but then they're tricked into looking at them as pictures.[43]

Under her leadership, the art department at Immaculate Heart College became another one of her art works. "My students are the greatest thing I've done," she has said. Professional artists of all faiths flocked to her classes knowing they would be shaken up by new ideas. In the dingy basement area that housed the art department, students encrusted the steampipes and supporting columns with bits of tile and broken shards of mosaic and colored glass, turning it into an environment like a tomb in Ravenna. Sister Corita would take students to study a car wash instead of going to a museum; or she might call on them to design a huge display on the side of an IBM building or ask them to bring in one hundred quotations by famous leaders on the subject of peace. Her classes were events, happenings.

It is not surprising that a leading woman artist should also be a nun, because it is a continuation of an old tradition. Some of the great women intellectuals of the Middle Ages came out of the nunneries, at that time the only place where a woman could follow intellectual pursuits and rise to power, freed from the ordinary restrictions of family life. Even today (at least until recently) 90 percent of the women college presidents in the United States are nuns.[44]

The order of the Sisters of the Immaculate Heart in Los Angeles in particular encouraged their members to "do their own thing." They often clashed with the head of the archdiocese, Francis Cardinal McIntyre, in the sixties.[45] Sister Corita worked for reform and renewal in the Church after the Second Vatican Council (1962–1965); she opted for street clothing in 1967, and designed prints for various causes, including the defense of Daniel and Philip Berrigan.[46]

Sister Corita's fame spread. In 1964 she created a forty-foot mural—the *Beatitude Wall* for the Vatican Pavilion of the New York World's Fair. Her commissions ranged from wrapping paper for Neiman-Marcus, to books, record jackets, and Container Corporation ads. Her three-screen film, *We Have No Art* (the phrase comes from the Balinese saying, "We have no art, we do everything as well as possible") demonstrates her belief that people should make daily living into an art and find wonder in the ordinary things around them. With teams of students she created enormous "disposable exhibits," and in 1967 she had over 150 shows at museums, galleries, and universities in the United States.

Visitors flocked to Immaculate Heart College from around the world. Fame brought tensions with it and affected Sister Corita's normal relations with her students. She suffered from insomnia because of the continual pressure of deadlines. After thirty years, for a variety of personal reasons, she felt that she had reached a stage where she wanted to do something new, and publicly announced in 1968 that she was leaving the order and returning to private life.

Corita Kent now lives quietly in Boston and has more time for reflection and observation. Her apartment is decorated with modern Eames

furniture—bright orange against a white wall. She carries out commissions such as the mural for the autopsy room at U.C.L.A., a life-affirming image to relieve the grim nature of the setting. But she turns down advertising commissions for products she does not support.

Continuing to "think big," she painted a giant mural of rainbow stripes on a gas tank for the Boston Gas Company in 1970, making it a striking landmark seen for miles in either direction. In 1978, she designed rainbow-patterned panels for the sides of Digital Equipment Corporation business machines, bringing a cheerful human touch to the robot world of computers.

After 700 prints—increasingly bold, bright, and simple—Corita Kent hopes she is arriving at that quintessential point of mastery when she will be able to create a beautiful print with just one screening. The De Cordova Museum in Lincoln, Massachusetts, held a thirty-year retrospective of her work in 1980.

Sculptors

Marisol (Escobar) (1930–) is internationally famous for her satirical assemblages of figures in tableaux that combine carving, painting, casting, and pop objects in daring new ways. She has probed American institutions in works like *The Party* (1966), *The Wedding* (1963), and *The Family* (1962). Neither heads of state nor movie stars are immune to her satire—Lyndon B. Johnson and John Wayne have both come under her sculptor's knife.

Her dark, exotic beauty and withdrawn personality have become legendary. She has been known to sit so still during a party that a spider literally built a web in her armpit.[47] She was at one point part of the chic "beautiful people" of the sixties, but finding modern life increasingly disturbing, has spent a considerable amount of time in recent years traveling in the Orient and scuba-diving off remote islands.

Marisol's childhood was a peripatetic one in which her wealthy Venezuelan parents moved around from one glittering world capital to the next. She was born in Paris, and her mother died when she was eleven, but her father was always supportive of her work and provided her with an independent income. A quality of floating detachment seems to have remained with Marisol, and she has been described as a basically inward person to whom the world often seems unreal. A compulsive worker, she gives substance and stability to reality by solidifying it in her sculptural images.

When she was living in Los Angeles, attending the fashionable Westlake School for Girls, she studied art at the Jepson School with Howard Warshaw and Rico Lebrun, two humanist painters whose brooding, Goya-like influence can perhaps still be discerned if one looks carefully under the cool facade of humor and Pop Art in her work.

In the early fifties, Marisol came to New York and became a member of the rebellious "beat generation" of Greenwich Village. She has said she felt that "the beats were the only ones protesting" during that era of conformity: "Everyone thought [we] were a bunch of kooks."[48] Punctuating extreme shyness with wild bouts of "letting go,"[49] Marisol drew some comfort from the nonmaterialistic life with her beat friends.[50]

Meanwhile, she was searching for her own artistic expression. The Art Students League, where she studied with Yasuo Kuniyoshi, seemed to her somehow tired, but in Hans Hofmann's classes in Provincetown, Massachusetts, she found an exciting challenge, and explored some of the structural concepts he taught. Marisol has said, however, that her "main influence has been the street and bars, and not school and books."[51]

After three years of study with Hofmann, she began to play around with sculpture

as a kind of rebellion. . . . Everything was so serious. I was very sad myself and the people I met were so depressing. I started doing something funny so that I would become

Fig. 8-8. Marisol, THE FAMILY (1969), mixed media
(neon, glass, plastic, wood), 88″ × 56″ × 65″

happier. . . . I was also convinced that everyone would like my work because I had so much fun doing it . . . and they did.[52]

Early American folk art and Pre-Columbian pottery had a strong influence on Marisol, and her art has sometimes been compared with folk art, although it is actually highly sophisticated. Her first works were playful, erotic terra cottas, showing those influences. Admiring the work of William King, who makes sculptures by cutting out silhouettes of figures, she began to construct her sculptures out of blocky pieces of lumber, adding parts of objects, cast sections of hands and faces (often her own face) to them, and drawing and painting images on the sides of the blocks. Sometimes, several figures are combined with backgrounds to make three-dimensional tableaux. A woman's handbag, a Coca-Cola bottle, a stuffed dog's head, or sunglasses may be freely combined with carved and painted images.

After showing with groups at the Tanager and other cooperatives on 10th Street in the fifties, she discarded her last name so that she would "stand out from the crowd." Dealer Leo Castelli gave her a well-received uptown show in 1957, but the publicity frightened her so much that she fled to Rome for three years.

After her solo show at the Stable Gallery in 1962, she became famous; her work was reproduced on the cover of *Time*, and she became part of the glamorous Pop Art scene. She felt it was a temporary period of great enthusiasm about the arts, primarily because of the influence of President Kennedy and his cultivated wife. During this time, Marisol dressed in glamorous costumes, attended chic jet-set parties with Andy Warhol, and starred in one of his underground movies, *The Kiss*. By the late sixties, she felt that American life had turned menacing. Although Marisol was a well-known society figure, she has said that there was little real warmth underneath these huge affairs; growing fame produced greater alienation.

In the late sixties she left for the Far East, an experience that proved soul-satisfying for her. The people of India, Cambodia, and Thailand seemed genuine in contrast with the brittle character of life in western countries. For a while she no longer wanted to portray American life, and no longer cared about communicating in her work with the general public. Instead, she drew on her experiences with nature—expressing the peacefulness she felt while scuba-diving at the bottom of the sea. In some of these works she joined the mask of her own face with sleek and rhythmic carvings of mahogany sharks and tigerfish, or combined the body of a man with a fish head, suggesting perhaps that she was more in harmony with the world of nature than with industrial urban civilization. In 1981 she returned to her former urbane wit in a series of portraits of Georgia O'Keeffe, Pablo Picasso, Marcel Duchamp, and dancer Martha Graham—four great figures in modern art—exhibited at the Sidney Janis Gallery.

Like Louise Nevelson, Marisol has created a unique style and form. She leads the viewer around her tableaux in surprising skips and jumps, from a blocky form, to a flat drawing on a side of the object, to a real prop. A fabric-covered trouser leg may alternate with carved wood or a plaster cast of her own face or hand. Her design sense manages to unify these disparate elements with rhythmic repetitions of curves, right angles, or diagonals. Her style has been described as one of "carefully measured jumps; from one side to another, from one surface to another, to a missing space, to a hint at a shape. . . . She juggles with realities; the reality of illusion, the reality of tangible substance, the reality of the symbol."[53] Hofmann's "push-pull" tensions can be felt in these three-dimensional works.

But Marisol communicates a surreal power that is more than formal. In works like *The Party* (1965–66), artificial women (all having Marisol's face) in fantastic gowns and artificial headdresses, engage in the empty ritual of party-going; a real miniature

TV set in one head blares platitudes, while a three-headed butler carries a tray of real glasses. A portrait of LBJ contrasts his huge figure with three tiny images of wife and daughters held on the palm of his hand—a striking, unforgettable image of patriarchal power.

A self-taught sculptor, Marisol is a superb craftswoman: "If I wanted to know something, I asked someone how to do it. . . . Sometimes I telephoned other sculptors or a factory."[54] She uses power tools, axes, carpenter's tools, and even does her own electrical installations.

Because she repeatedly uses casts of her own face in her work, the artist has been accused of narcissism. She originally took the idea, however, from Jasper Johns's *Target With Four Faces* (1955) and has said that "a work of art is like a dream where all the characters, no matter in what disguise, are part of the dreamer." Besides, "When I want to make a face or hands for one of my figures, I'm usually the only person around to use as a model."[55]

Marisol has always been a loner and an original. She has admitted that she was playing roles during the tinselly sixties and was really working hard in her studio most of the time. When art historian Elsa Fine asked about her difficulties as a woman artist, she responded:

I always knew I would have [difficulties] whoever I was, because of the way I have always lived outside society. I never expected to be treated nicely by people and their customs I was rebelling against.[56]

Varda Chryssa (1933–) said in 1968, "America is very stimulating, intoxicating for me. Believe me when I say there is wisdom indeed, in the flashing lights of Times Square."[57] She was the first artist to use neon light tubing and commercial signs as the forms of sculpture.

Chryssa was born in Athens, Greece. After receiving a B.A. in social studies, she studied art in Paris in 1953 at the Salon de la Grande Chaumière, and met surrealists André Breton, Max Ernst, and others. She was not particularly inspired by the art being created in Europe; so she came to California. While she was at the California School of Fine Arts in 1954–55, she first saw the work of Jackson Pollock and had the experience of feeling liberated by it that so many other artists had had in the early fifties. Although her own experiments with drip painting did not satisfy her, they opened her eyes to the possibilities of pure form.

In 1955, at the age of twenty-two, she moved to New York and almost immediately began her career as an artist. One of the sources for her work was her Greek background. She saw inside the bottom of a cardboard packing crate the same forms as are on early Greek Cycladic sculpture, and her *Cycladic Books* (1955), are castings from these crates. These minimal bas-reliefs with virtually nothing on them except the slightest suggestion of shallow *T*s, anticipated the sculpture of Donald Judd and other minimalists of the sixties.

The following year Chryssa anticipated Jasper Johns's use of letters of the alphabet when she made sculptures out of plastic letters arranged in shallow boxes, and also bronze bas-reliefs cast from typefaces and newspaper molds.

Fascinated by the commonplace objects of contemporary American life, she did repeated pictures of *Automobile Tires* and *Cigarette Lighter* (1959–62) using Pop images of the kind soon to be exploited by Andy Warhol and Robert Rauschenberg. In 1961 she had solo shows at the Betty Parsons Gallery and the Solomon R. Guggenheim Museum.

Chryssa was overwhelmed by the sight of Times Square when she first came to New York: "I was naturally drawn to Times Square. Times Square I know had this great wisdom—it was Homeric."[58] She saw in the lights of Times Square against the sky, imagery reminiscent of her Byzantine heritage. "The sky was like the gold in a mosaic or icon."[59] Americans, she felt, were influenced by the visual excitement of Times Square without being aware of it, but she, a foreigner, was very aware and excited by it.

The signs of Times Square so enthralled her that she tried to get a job as a sign-maker, but the union kept her out. Finally, a sign painter let her into his shop, even though union rules did not allow it, and taught her how to make commercial signs.

She began to experiment with pieces of commercial signs and first used neon on an interwoven assemblage of curved script letters. This work, *Times Square Sky* (1962), was so crowded that it seemed to her to be suffocating; so she decided to open up the form and let it breathe by inserting a neon tube into the word *AIR*.

Suddenly she saw the potentialities of neon. Others had used electric lights in art before her, but in their work the light illuminated sculptural forms, whereas in hers the neon light for the first time *became* the sculpture, so that the sculpture itself emitted light rather than simply reflecting or diffusing it.

The works followed in rapid succession. She made variations on the letters *W* and *A* in banks of parallel neon lights; timers turned the lights on and off in long, tension-creating intervals; she used intense light to compensate for the fragility of the medium, and black glass cases to give the effect of night and to recapture her original inspiration. She feels her work blooms when the lights go on, and sees a total *yin-yang* experience in the darkening and "blooming" cycle, but insists that even without electricity the sculptural forms work.

Chryssa explored all the rich and complicated possibilities of neon. She set her timers to light up a variety of emotional effects—alarm, meditation, rage, suspense; she illuminated the solid shapes and then the negative spaces around them to create a dynamic interplay of form. She was given a show at the Museum of Modern Art in 1963 and at the Whitney Museum in 1972.

Chryssa's work came as a reaction against the fervid emotionalism of 1950s action painting. For the tumultuous confusion of Abstract Expressionism she substituted the controlled precision of mechanical forms: clear rectangular plexiglass, aluminum,

steel. Whereas in action painting it was the hand of the artist in the act of creating that was emphasized, in this work the hand of the artist is totally effaced. The artist's ideas are realized by craftsmen who machine the metal, cast the steel, bend the neon tubes, and blow the glass.

In a major work, *The Gates of Times Square* (1964–66), all the avenues she had been pursuing—assemblages, letter boxes, and neon tubes—came together. She started out with pieces of real commercial signs and incorporated these with many other elements into a monumental $10 \times 10 \times 10$ foot construction in neon, steel, aluminum, and plexiglass, a three-dimensional triangle with a steeply sloping roof, containing stacks of vertical rows of large metal letters and neon script.

Production of *The Gates of Times Square* demanded all of Chryssa's toughness and practicality. For this project, she became a kind of designer-general contractor, supervising subcontractors who were not accustomed to her new forms and strange demands. Driving, fiery, impatient with mediocrity, she eventually set up her own shop in a vacant building and built most of it with her own two hands, helped by hired glass blowers and foundries. She had the same experience in Europe two years later in producing her monumental sixteen-foot-high *Clytemnestra* (1968) for the Kassel "Documenta 4" show in Germany. She had to chase around Europe to find subcontractors to assist her with the work.

It is impossible to overestimate the chronic tension and super-human effort involved in producing works like these. Chryssa invests her money, her health, her entire life in them. Sometimes she works for weeks around the clock, sleeping in her clothes. The works must be marketed at high prices to recoup their skyrocketing costs.

Nevertheless, the key word in Chryssa's vocabulary, perhaps, has been *cool*. In a lecture at New York University she stressed the need for the artist to retain a "cool mind," which she seems to identify

Fig. 8-9. Chryssa, GATES TO TIMES SQUARE
(1964–66), welded stainless steel, neon tubing, plexi-
glass, fragments of commercial signs, rolled plans for
the forms and cast aluminum, 120″ × 120″ × 120″

with artistic detachment of every kind. The cool mind is bombarded by information in modern society and constantly tries to organize it in new ways. It should never do the same thing twice. The "discoveries of yesterday should not become the Mannerisms of tomorrow. A new logic should be found. The mind must always be of 'today.'"[60] The detached, cool mind must not succumb to emotional impulses—even those of which it is not conscious. The mind must be engaged in a constant effort "to be aware of its own reality."[61] The attitude is antiromantic—classical in the extreme.

There is a contradiction here between the fanatical devotion that has led Chryssa to take tremendous risks repeatedly in her massive works and her philosophy of "cool." Personally, this dark handsome woman is reputed to be mercurial, fiery-tempered, and a demanding perfectionist in her work; among friends she has a marvelous playful side, and has been described as a delightful mimic—particularly of pretentious members of the art community. She enjoys personal artist-patron relationships and is entertained in the homes of patrons among European royalty, in contrast with many New York artists who deal with their patrons only through their agents.

The contradiction between Chryssa's "hot" personality and her public adjurations to be "cool" is perhaps embodied in her huge *Clytemnestra II,* a sixteen-foot high *S* in neon, inspired by the curve of the actress Irene Pappas's body, as she screams on learning of the death of Iphigenia. *Clytemnestra II* is a universal symbol of horror at the taking of human life. The abstract *S* may have seemed too "warm" with its emotional curve; so Chryssa has broken it up into sections, each attached to a separate timer, so that pieces of the *S* flash on and off separately— breaking up the form and cooling it off.

Recently, Chryssa has been working on murals for Count Peter Wolf Metternich's castle at Adelebsen, near Kassel, Germany. An exhibition of her work was held at the Paris Museum of Modern Art in 1980.

Lee Bontecou (1931–) posed for *Life* magazine in 1964, standing in front of a twenty-foot wide wall relief she had just completed for the Lincoln Center in New York. The article appeared with the caption "Young Sculptor Brings Jet Age to Lincoln Center," and went on to point out that the work looked something like a mythical "flying machine"—and that Bontecou herself had "soared spectacularly up through the art world."[62] At age thirty-three, Bontecou was recognized as one of the most original assemblage sculptors in the United States, and was the only woman artist whose work was carried at that time by the prestigious art dealer Leo Castelli.

Bontecou's assemblages of canvas lashed to frames of welded steel rods are frightening, innovative, and at the same time elegant. They have reminded critics of everything from machines and monsters to airplanes, ancient goddesses, and kayaks. Their gaping central holes have been referred to as "an obsessive image of face-vagina frequently with frightening zipper teeth"[63] and "wells, tunnels, sequestered and mysterious places that are not necessarily menacing."[64] These holes are also reminiscent of the concave nose of a jet plane. They seem to derive from some deep place in the psyche that calls forth all these various associations.

Born in Providence, Rhode Island, Bontecou grew up in Westchester County, New York, and spent summers close to nature in Nova Scotia. In her Westchester elementary schoolyard there was an old World War I airplane that the children played and climbed on. Childhood fantasies associated with this plane may be the source of some of her imagery.

Bontecou studied in New York at the Art Students League from 1952 to 1955 with William Zorach and John Hovannes and won a Fulbright Fellowship to

Rome, in 1957–58. In 1959 she received the Louis Comfort Tiffany Award.

Her first show at the G Gallery in New York in 1959 was of fantasy birds and animals and also of figures "made of cast bronze sections, welded together."[65] She often made even these early works in sections, attaching them to an armature, the parts floating separately in much the same way that parts of her wall reliefs later seemed to be floating separately within an armature frame. These early animal forms already have an aggressive abstract quality in which the organic natural forms sometimes resemble hollow machine-like parts. A pair of her cast bronze images of the human figure were described as showing "mechano-organic innards seen through openings in the metal skin,"[66] as in *Seated Man and Woman I* (1958).

In 1959 Bontecou made her first simple pieces using canvas attached to a welded rod frame with a central hole opening. She had returned to New York from Rome and was living in an unheated loft at 6th Street and Avenue C, searching for a form in which she could get sculpture up off the floor and onto the walls—a form that would function simultaneously as painting and sculpture. The artist needed a material that would be strong but light.

She was living over a laundry—in fact, she heated her loft by drilling a hole in the floor to allow the steam to come up from below. When she noticed that the laundry frequently threw out used canvas conveyor belts—a cheap, strong, readily available material—she knew that her search for a sculpture medium was over. This kind of artistic "gestalt," in which the artist makes use of random occurrences in her environment, is typical of the creative personality. (Similarly, Louise Nevelson saw the possibilities for her huge and awesome boxed walls when she noticed the form of a liquor crate delivered to her home.)

Bontecou's first reliefs were simple. She lashed trapezoids of canvas to a welded iron frame. From this simple idea, rich and complex variations poured forth in profusion—her "Untitled" series (*Untitled I* [1960], *Untitled II* [1961], etc.). By allowing the metal armatures to be visible, and lashing the cloth to them with rusty wire, she often produced an effect of *leading,* as in the lead outlines of a stained glass window, or in cloisonné. She foraged for all kinds of used and weathered canvas fabrics—finding them in old laundry bags, tents, knapsacks, and even, in one case, slitting open an old firehose for her material. Natural colors—weathered grays, browns, blacks, and rusts—with sooty shading at the edges of the forms, emphasized the organic and primitive quality of the pieces.

The mysterious gaping central hole is clearly the focus of these works. In one variation, Bontecou lined the deep hole with black velvet, causing an effect of infinite recession (*Untitled* [1961]). In another, she painted the interior of the central opening white, prompting one critic to comment, "Within the deep gloom of the heart of the composition a white structure, like the ribbing of an abandoned hull, creates a mood that welcomes hypnagogic revery."[67] In other works she produced an effect of cruel aggression by incorporating steel saw blades or zippers in the center, looking like the monstrous teeth (*Untitled* [1961], now in the Whitney Museum).

After these works were shown, beginning around 1961, Bontecou's fame was immediate. Her sculptures were bought by prestigious museums and collectors in many countries, and she appeared in major shows and won awards, such as the first prize from the National Institute of Arts and Letters, 1966. She also made etchings and lithographs at Tatyana Grosman's famed print workshop on Long Island.

The climax to this phase of her career was the commission for a wall relief entitled *1964* for the New York State Theater at Lincoln Center. In this giant work, bulging out from the wall with wings spread out from the center like the front view of a mythical anthropomorphic flying machine, she in-

Fig. 8-10. Lee Bontecou, UNTITLED (1961), canvas
and welded metal, 72″ × 66½″ × 26″

corporated the plexiglass turret of an old World War II bomber, molded fiberglass forms, and velvety pieces of yellow chamois in contrast with the canvas shapes. To get variations of shading or tone, she blew soot on it from her welding torch. Philip Johnson, the architect, while criticizing other commissions for his building, said of Bontecou, "Her piece fits as well as a baroque statue in the niche of a baroque hall."[68]

One of very few women who made it into the art mainstream in the 1960s, she was much admired by the young, ambitious sculptor Eva Hesse, who had been looking around anxiously and unsuccessfully for female role models. After visiting Bontecou's home, Hesse wrote in her diary that she was "absolutely floored"[69] by the complexity and difficulty of Bontecou's technique and vowed to spare no pains in mastering all the techniques and crafts that she might need in her own work.

Bontecou married, and in 1969, two years after her daughter was born, her oeuvre changed radically. Abandoning the sinister, steel-and-canvas totems, she created a group of lyrical, icy flower and fish forms of frosted transparent vacuum-formed plastic. Giant flower petals out of which tendrils or feelers hung and crystalline fish, suspended from the ceiling were described by one critic as "innocent."[70] Artist Lil Picard, reviewing the show at the Castelli gallery in 1971, said that "all is glassy and lovely"[71] and described the forms as nearly art nouveau but nine feet high. Bontecou later said that she was attempting a statement about ecology, suggesting that the human race would be left with only plastic flowers, if it continued to destroy the environment.

Not content to repeat earlier forms (no matter how successful), Bontecou is currently searching for a new direction.

Mary Bauermeister (1934–) makes lens boxes and other fantastic assemblages that grow out of her early association with philosophical thinkers, scientists, and musicians in postwar Germany. Born in Frankfurt, she grew up in a country devastated by war, and began to paint in 1954. In 1957 she opened a studio in Cologne that soon became a center for musical events, art exhibits, and happenings.

Among the participants was Karlheinz Stockhausen, the famous composer of electronic music, who was working at the nearby electronic music laboratory of the West German Rundfunk (radio station). He attracted composer John Cage, modern dancer Merce Cunningham, artist Nam Jun Paik, and other experimenters to Cologne. Bauermeister found herself amidst a postwar renaissance of writers, architects, and other cultural leaders. The assemblages of Neo-Dadaists such as Jean Tinguely and Arman, shown in nearby Düsseldorf, also influenced her work.

In 1961, at age twenty-seven, Bauermeister took a seminar with Stockhausen and began to apply musical theory concepts to the visual arts. Breaking down the elements of the visual world, she assigned a scale of five degrees to each: frequency of light, intensity, volume, time, and material, and designed her works with these in mind. For instance, following the example of music, in one exhibition she tried to introduce the element of time and continual change by having pieces and parts of one work distributed around the room among other works, as in *Gruppenbilder* (1962).

Her first one-woman show was at the Stedelijk Museum in Amsterdam in 1962. Bauermeister came to New York (and became an American citizen) when Pop Art was flourishing, but she did not adopt its commercial imagery. At first, she exhibited assemblages of graduated pebbles and sand on various sizes of square boards (*Progressions* [1963]) and also covered the gallery floor with pebbles and sand.

Delighting in metaphysical and philosophical games concerning the nature of illusion versus reality, she began to create provocative lens-box assemblages, combining lenses with drawing, writing, painting, bones, shells, and other materials, all woven together with a fine, decorative pen-and-ink

Fig. 8-11. Mary Bauermeister, NEEDLESS, NEED-LESS (1976), mixed media with lenses, 16″ × 19″

line. In these works the lenses create prismatic reflections and mysterious undulations of the objects and drawings underneath them (*Absolute Masterpiece/peace* [1969]). She may show a lens distorting something and next to it draw her view of that distorted object, then draw a hand that is in turn drawing the object. In *Poème Optique* (1964) Bauermeister mounted lenses and drawings on movable panes of glass. As they are rotated, letters, words, and images rearrange themselves in unexpected phrases and visual paradoxes.

At the gala opening of her 1964 exhibition at New York's Bonino Gallery (attended by Jacqueline Kennedy and other distinguished patrons of the arts), Heinz Stockhausen gave a concert of electronic music to accompany slides of Bauermeister's assemblages. The Whitney, Hirschhorn, and Guggenheim Museums purchased her work.

In 1970 she cut up artists' easels and combined them in spiral forms or sculptures that moved up staircases and around corners. Perhaps this was symbolic of the fact that art was entering a new

phase, or that she and her art were going to move elsewhere.

Bauermeister married her mentor Heinz Stockhausen in the 1960s and returned to Germany in 1972. She has five children and lives and works outside of Cologne.

Niki de Saint Phalle (1930–) has emerged as one of the major sculptors on the European continent since her 1980 retrospective at the Georges Pompidou National Museum of Modern Art in Paris. Her large frolicking and dancing Nana woman-figures, covered with gaily painted patterns, have come to symbolize joyous, liberated womanhood, but the artist says that she now looks upon them as harbingers of a new matriarchal era in which women will exert a positive, creative, and wholesome influence in the world.

Born to a distinguished old French family in Paris, she moved to the United States with them at the age of three and became an American citizen. She was educated at the Brearley School and at the Convent of the Sacred Heart, came out as a debutante, got married, and had two children. But at the age of twenty-two she suffered a brief but severe depression.

In her remarkably candid and revealing statements written for the catalogues of her recent Paris and Berlin retrospectives, Saint Phalle tells of the deep rebellion she felt in the late 1950s against the stifling roles played by women in society. At this time she discovered depression, but she also discovered its cure—work. She turned to art in a search for identity and in 1952 began a great flow of creativity that has never ceased.

Returning to Europe in search of herself, Saint Phalle was tremendously impressed by the fantasy forms of Gaudi's architecture in Barcelona (this influence is still apparent in her work) and by certain kinds of folk art. Soon after arriving in Paris she became part of the daring avant-garde New Realist group, described as being "40 degrees beyond

Dada," and, in this group, met Jean Tinguely, who became her friend—later her husband. Tinguely encouraged her to disregard problems of technique and concentrate on her dreams—the ideas she wanted to express—because technique, he said, would develop in the course of the work. Now amicably separated, they still work together on projects.

Saint Phalle achieved instant notoriety in her early works. She exorcised her pain and rage by shooting a gun at plastic bags of paint which exploded and dripped Abstract Expressionist paintings onto surfaces below them. She began to make plaster assemblages, densely embedded with found objects—toy models of guns, bombs, skulls, lizards, and other objects, as well as spaghetti–like pieces of yarn and bits of artificial flowers. Some of these works were exhibited in the New York Museum of Modern Art's 1961 exhibition "The Art of Assemblage." In an important panel called *King Kong* (1963) she identified her own personal life with the violence and malaise in the world at large. On the left are symbols of her childhood, youth, and first love; in the center she is marrying death; on the right, a monster, King Kong, is carrying off a figure while all of New York is being destroyed by bombs and missiles.

Around 1964 Saint Phalle began to turn away from eroded images of violence, and fashioned bizarre and forceful female goddesses who seem to embody overwhelming creative forces. *Pink Birth* (1964), a matriarchal deity densely covered with bits of flowers, cows, dolls, and other objects, is shown in the act of giving birth in a standing position. In 1965 the artist began to build large rounded, polyester females called *Nanas*, decorated with hearts, flowers, and other brilliantly colored patterns. These gamboling and flying figures, sometimes supported on thin black rods, caused outrage and delight when they were shown on the roof of the French Pavilion at Expo 1967 in Montreal, Canada. The public viewed them as assertive, ag-

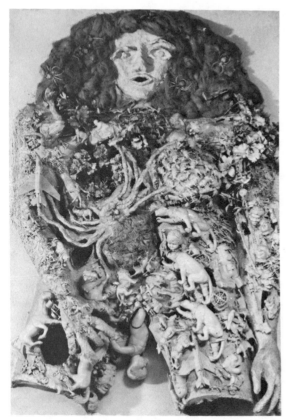

Fig. 8-12. Niki de Saint Phalle, PINK BIRTH (1964), assemblage/mixed media, 219 × 152 × 40 cm

gressive symbols of the emerging women's liberation movement. Looking back, these brightly patterned figures also anticipate the era of "Pattern and Decoration" in the 1970s.

In 1966 the artist, in collaboration with Jean Tinguely and Per Olof Ultvedt, created an audacious "woman-cathedral"—a huge, hollow, reclining sculpture figure called *Hon* ("She")—at the Modern Museum in Stockholm, Sweden. It was a temporary installation, but before it was destroyed, thousands of visitors entered it through a doorway between the legs, drank milk shakes in the milk bar located in one breast, and attended the movie theater built into an arm. Among her many ambitious public commissions is a children's playground in

Jerusalem, in the form of a black and white monster, *The Golem* (1971), with three red tongues coming out of its mouth that serve as sliding ponds.

Today the artist is engaged on visionary projects such as the *Garden of the Gods* in Italy (her white, shiny gold, pink, and bright blue and green birds, beasts, and figures are set off against Tinguely's black assemblages made of machine parts). A new spirituality has entered her work; a mystical vision of light, air, and nature, in open, linear forms. Saint Phalle's sculpture has the brilliant color and spontaneity of Mexican folk art combined with challenging thematic content. She has created a Garden of Eden where the creative woman cavorts amidst gaily painted mythic creatures. Most of her career has been spent in France, but America also lays claim to this prolific artist, who works in films, theater, and print-making as well as sculpture.

Ruth Landshoff Vollmer (1899–) creates chaste mathematical sculptures, consisting of variations of simple geometric forms, with names like *Pseudosphere* (1970), *Heptahedron* (1970), and *Spherical Tetrahedon* (1970). Conceptual artist Sol LeWitt has said of them, "These pieces are not sculpture, they are ideas made into solid forms."[72]

Today, Vollmer is understood to be a forerunner, influential figure, and theoretician of the Minimal and Conceptual Art movements of the sixties. Her work and ideas are revered by much younger and better-known figures. A friend of physicists, architects, and psychiatrists, she gathered at her home, in the early sixties, younger vanguard artists—Eva Hesse, Robert Smithson, Donald Judd, Carl André, and Sol LeWitt—to discuss the relationships between science, philosophy, and art.

Ruth Landshoff grew up in Munich before World War I in a cultured home. Her father was a distinguished orchestra conductor, her mother a singer, and her uncle a publisher. House guests included Thomas Mann, Bruno Walter, Paul Hindemith, Albert Einstein, Rainer Maria Rilke, and playwrights

Fig. 8-13. Ruth Vollmer, THE SHELL II (1973), blue ink printing on molded acrylic, height 15", diameter 12"

Gerhardt Hauptmann and Ernst Toller. Also part of her early years were the beauty of Italy, the vineyards on the Rhine, and mountain climbing in Switzerland.

After World War I she lived in Berlin and experienced the modern art revolution of the Bauhaus; the purity of constructivism of the twenties can still be felt in her work. In 1930 she married a pediatrician, Hermann Vollmer, who shared her cultural interests. Together they lived in an apartment building designed by the avant-garde architect Erich Mendelsohn and surrounded themselves with specially crafted modern furniture.

Fascism destroyed this *gemütlich* world. In 1935 the Vollmers came to New York, became American citizens in 1943, and like so many others went through the ordeal of adjusting to a new culture. By the early sixties, however, Ruth Vollmer's quiet, generous spirit and the authenticity of her interests soon attracted a coterie to her apartment.

Her early sculptures in the forties were made out of wire mesh and industrial materials. For the Museum of Modern Art she designed whimsical animals and toys. She made wall sculptures for the Plaza Hotel and for 575 Madison Avenue in New York City. After acquiring a kiln and going through a period of experimentation with clay forms, Vollmer began to have them cast in bronze. Works like *Obelisk* (1962)—a cast bronze—are vaguely reminiscent of Albert Giacometti's early surrealist sculptures.

Vollmer loves science, archaeology, and Bach. She has increasingly explored the forms of speculative geometry, and many of her recent works are actually concrete models of mathematical formulas. During an extended period she investigated in depth the nature of the sphere and at another time studied different kinds of spiral forms that can be developed from squares, arcs, hexagons, and so forth. *Archimedian Screw* is a vertical spiral rotation on an axis that looks like a drill bit, translated into wood, standing on end. *Spherical Tetrahedon*

(1970) constructed of curved triangles, is a bronze form that balances on one point and can rock in the wind. Vollmer tries to make visible the inexorable mathematical laws, the systems that lie at the heart of all forms.

Visitors to her exhibition at the Everson Museum in Syracuse in 1974 might have at first mistakenly thought themselves in a Museum of Science and Industry, but as Sol LeWitt has said,

The pieces are not about mathematics, they are about art. Geometry is used as a beginning just as a nineteenth-century artist might have used the landscape. . . . The form is in harmony with the idea. The scale is perfect. . . . The material used . . . [is] useful to the form.[73]

Anne Truitt (1921–) was a forerunner in sculpture of the literalist-minimalist movement of the sixties. This movement rejected illusionism of any kind in favor of actual forms and space. Jasper Johns's flag that occupied the entire canvas (and hence was a real flag), Andy Warhol's Brillo boxes, and Truitt's painted minimalist boxes all share the same literalism. Her boxes, even more than Johns's flag, are not representations of something or the abstraction of something, but the thing itself. They are among the first objects of the sixties to be characterized as *presences;* that is, as having the character of real entities.

Why is a painting on a three-dimensional object less illusionistic than on a canvas? Because no matter how the picture plane is controlled, even a single line on a flat surface creates an illusion. It can be an illusion of a space, a depth, a mass. Extending the picture into a third dimension destroys the illusion by creating a reality (that is a real space) that obliterates it. The third dimension is one that art shares with non-art, making the two more alike.

Born in 1921 in Baltimore, Anne Truitt did not come to art until 1945, after she had received a degree in psychology from Bryn Mawr and had done psychological research at Massachusetts General Hospital. In that year she took an evening sculpture class. She married a journalist whose work required a tremendous amount of travel. As a result, she worked on her art throughout the U.S. and Japan during the next twenty years while raising her children. Among her teachers were Alexander Giampetro and Kenneth Noland at the Institute of Contemporary Art, Washington, D.C., and Octavo Medillin at the Dallas Museum School.

Back in Washington between 1960 and 1964, she developed her mature artistic style. She had been working with simplified horizontal slab forms inspired by a trip to Mayan ruins in Yucatan. The turning point came in 1961 when she saw the paintings of Barnett Newman and Ad Reinhardt at the Guggenheim Museum, and had a vision of space, color, and pure stripped-down geometric form. She immediately ordered tall vertical boxes (some are thirteen feet high) fabricated to her design by carpenters, which she painted with simple, minimal bands of color.

When Kenneth Noland, her former teacher and friend, brought critic Clement Greenberg to see her, he was enthusiastic about her work. Later Greenberg wrote an article pointing out that her boxes had changed the direction of American sculpture,[74] and spoke of their power to "move and affect."

Truitt speaks of her boxes as "three-dimensional paintings."[75] Ideally, she would like them to seem to dissolve into pure color and shimmer—disembodied—in space. They convey different moods and are metaphorical icons. For example, in *Spring Snow,* according to the artist, "Icy green falls from the top of the sculpture through the tender air of early spring onto the warming earth below, which flattens itself to receive it."[76]

Truitt received a Guggenheim fellowship in 1971 and solo shows at the Whitney Museum in 1973 and at the Corcoran in 1974. She was included in the 1976 Whitney Bicentennial exhibition, "200 Years of American Sculpture."

Beverly Stoll Pepper (1924–) lives in an ancient castle in Perugia, Italy, and creates monu-

mental abstract sculptures in a nearby workshop. Her commissions in welded steel go to sites as far apart as the Albany (New York) Mall, the Federal Building in San Diego, and the Kennedy Memorial in Israel.

Raised in a middle-class Jewish family in Brooklyn, New York, Beverly Stoll was so precocious that at age seventeen she earned a B.A. in industrial and advertising design at Pratt Institute. That year she married a fellow student, had a son, and between 1942 and 1948 worked as art director for several advertising agencies in New York. She handled big accounts, made lots of money, was very inventive, attractive, flamboyant, and stunningly dressed. But at age twenty-one she realized that despite her success, she was very unhappy in the commercial world of advertising. After evening classes at the Art Students League, and a divorce, she threw over her lucrative profession and left for Europe in 1948. In Paris she studied painting with André L'Hote and at the atelier Fernand Léger, and then married the author-journalist Bill Pepper. She traveled widely in Europe and the Middle East in the following years.

At first she painted pictures with social themes, described in Art News as "romantic realism shading into expressionist distortion."[77] The Peppers lived in Paris and in Haut du Cagnes, France (1949–50), in Positano, Italy (1951–52), and settled in Rome in 1952 with her son and small daughter.

In 1960 Pepper was greatly affected by Cambodian Khmer carvings during a trip to the Far East. After her return, she decided to carve sculptures out of thirty-six olive, elm, and mimosa trees that had fallen in her garden in Rome. Her early works in wood and rough-textured bronze, related somewhat to the "grainy, scumbled impasto"[78] of her paintings.

A turning point came for Pepper when she was invited to submit welded sculpture to the 1962 outdoor sculpture exhibition in the medieval town of Spoleto, Italy, along with the eminent American sculptors David Smith and Alexander Calder. The sponsors of the exhibition did not know that she had never welded before. Without hesitation she apprenticed herself to an ironmonger and began a spurt of frenetically enthusiastic production. Metal welding drew her, by its very nature, away from expressionism and into more geometric forms.

David Smith, working nearby in Voltri, saw Pepper working on her pieces for the Spoleto exhibition at a steel plant in Piombino. Discovering a surprising strength in her coiled loops and bands, he encouraged her to continue in this medium. After several faltering starts, she had found her true artistic medium when she was close to forty years old.

In 1965 she was in the "Sculture in Metallo" show in Turin. In 1972 she was selected for the Venice Biennale, and in 1975 she was in Houston's "Monumental Sculpture of the Seventies." Her 1975 exhibition at the André Emmerich Gallery in New York caused art critic Robert Hughes to describe her in Time as "one of the most serious and disciplined American artists of her generation."[79]

Pepper moved to Todi, Perugia, in 1972, where she and her husband live in a fourteenth century castle overlooking the gently terraced slopes of the northern Italian countryside. Nearby is a large industrial workshop equipped with cranes, pulleys, and other heavy equipment. Pepper has not lost the exuberant characteristics of her early life. She still has a great deal of personal style and entertains with panache and flair in her old world setting. To one interviewer she has said, "You don't have to be rich; you just have to learn to live rich."[80]

In her work, Pepper tries to create a tension between the cold forms of welded steel and an inner, incomprehensible, mysterious quality. In the late sixties she developed this contradiction by using highly polished mirror surfaces of steel that made the big heavy work almost seem to disappear in reflections of sky, grass, and environment. Surfaces reflecting into one another caused complex illusions. The insides of these forms, contrasting with the silvery exterior, were in brilliant color—blue,

Fig. 8-14. Beverly Pepper, EXCALIBUR (1976), painted steel, 35′ × 45′ × 45′

orange, black, or white baked enamel. Many of the pieces were constructed of box-like forms, as shiny as mirrors, falling like shuffled cards, teetering in precarious vertical stacks, or cantilevering out into space.

In the 1970s she began to work with triangular forms, which suggest "tents, architecture and pyramids,"[81] and invite the viewer to go under, into, and around them. In these works she again tries to create mysterious contradictions. Hollows seen from one side, when viewed from another appear to go in contradictory directions. *Alpha* (1975), in orange steel, looks heavy and massive from the

side, but shows itself to be light and open from the front. She seeks "precarious balance between the physically self-evident and the sense of an elusive inner logic. . . . I wish to make an object that has a powerful physical presence but is at the same time inwardly turned, seeming capable of intense self-absorption."[82]

Pepper has admitted quite openly that there are also sexual implications in the hollows, "innards," and openings in her triangular pieces: "They deal with all the inner mystery that is the cavity that can be entered through several gates."[83] The sharp outer points are defensive and aggressive, the inner

Fig. 8-15. Beverly Pepper, AMPHISCULPTURE (1974–76),
concrete and ground covering, 270' diameter × 14' deep × 8' high

forms are vulnerable.

Pepper has gone beyond sculpture in creating ambitious environmental forms. Her first large environmental project was the *Land Canal Hillside* (1971–74) in Dallas, Texas. Along the center-strip divider of a highway, she built a changing succession of rust-colored, corten-steel triangular forms, tilted at different angles, set into grass that grows over some of it in angular patterns. This provides a pleasurable 300-foot changing vista for the passing driver.

Another large project is *Amphisculpture* (1974–77), built on the grounds of the A.T.&T. Long Lines Headquarters at Bedminster, New Jersey. It is an outdoor amphitheater of concrete set in grass, "created to bring people out of their offices and into an involvement with the site. It allows them to enter into it, to sit down or to walk, to be alone or in groups . . . to withdraw in silence."[84] A site work at Dartmouth, New Hampshire, changes color with the seasons—it is buried in white snow in the winter, looks brown and white in the spring as the snow melts, and green and white in the summer, as the grass grows over part of it.

Pepper's dream is of a vast project for the top of Mt. Vesuvius in Italy—an International Cultural Park in the form of a terraced grape-bearing vineyard near the top, lined with sculptural forms in

steel, leading up to a great blue lake created by filling the venerable volcano crater with water. Visitors could stroll up garden paths to a yearly festival at the top, with boat regattas on the lake, art shows at the rim, and wine from the vineyard flowing freely.

Sylvia Stone (1928–) creates large-scale environmental sculptures of transparent plexiglass and opaque acrylic sheets, often as much as thirty feet long. Her work represents an extension of the constructivist and technological interests that have formed a part of much contemporary art.

Born in Toronto, Stone was educated in Canada and experienced a very insecure childhood of poverty and constant movement. Art was a refuge for her; she created private symbols of the beauty, serenity, and security she longed for.

She moved to New York in 1947, married, and while raising small children, managed to study painting at the Art Students League with Vaclav Vytlacil. Stone has said that her intense involve-

Fig. 8-16. Sylvia Stone, GREEN FALL (1969–1970), plexiglass and stainless steel, 67½″ × 201½″

ment with art bothered her husband, and they were divorced. She is now married to artist Al Held and is a professor at Brooklyn College.

Stone moved into sculpture as a result of experiments with shaped paintings on plastic in the sixties. The large environmental sculptures of Stone's maturity arise out of a desire to create a poetic, aesthetic environment as an alternative to the real world and present the spectator with the illusion of a fantastic architecture, which can often only apparently be entered. Typical of these is *Another Place* (1972), in which large green-tinted plexiglas arcs play against wedges and flat plexiglas sheets. In *Green Fall* (1970) and *Grand Illusion* (1974) a mirrored base denies and maintains the base simultaneously. As one moves around her work, the reflections change, producing a dynamic effect of moving lights and surfaces. Her work is a fusion of constructivist technology and illusionist romanticism. Stone has had one-woman shows at Andre Emmerich Gallery, and was in the Whitney Museum's Bicentennial exhibition, "200 Years of American Sculpture" (1976).

Lila Katzen (1932–), after an extended career encompassing various experimental "walk-in" environments (including light floors and a sixty-five-foot tunnel lined with opalescent vinyl pouches, filled with fluorescent-colored liquids), is now working with monumental forms in steel. Her curved, ribbon-like pieces bend and roll and entice the viewer to interact with their surfaces. She designs monuments that relate to specific sites.

Lin Emery, a leading New Orleans sculptor who was trained in Paris by Ossip Zadkine, designs kinetic bronze, steel, and aluminum sculptures and fountains driven by water, wind, and other forces. These moving three-dimensional abstractions, frequently composed of crescent shapes that suggest birds in flight, stand in front of many public buildings in the South (e.g., *Aquamobile*, Fidelity Center, Oklahoma).

Eva Hesse (1936–1970) created limping, trailing, tangled, erotic sculptures that break all the stereotypes of "beauty." They convey a sense of vulnerability and absurdity. In her short life—she died at 33 of a brain tumor—Hesse helped move abstract art away from the geometric, the hard-edged, and the orderly, and reintroduced sensibility, sexuality, and a new kind of *antiform,* of which she said in the year of her death that "chaos can be as structured as non-chaos."

Because Hesse died young, there has been a tendency to canonize her along with Diane Arbus, Sylvia Plath, and Virginia Woolf, all of whom committed suicide. Hesse, however, was far from a suicide. She knew in advance, of the brain tumor that would kill her, and she worked with a brave and desperate urgency to accomplish as much as she possibly could in the time left to her.

Hesse was peculiarly suited to bring a new sensibility into art. Outwardly beautiful and talented, her inner spirit was scarred by a childhood made terrifying by the Nazis. She and her sister Helen were born in Hamburg, Germany, to Wilhelm Hesse, a Jewish lawyer. The family had to flee in 1938, and the children were sent to Amsterdam. When their uncle was unable to meet the train, Eva, aged two, was separated from her sister and placed in a Catholic home. The parents were eventually able to rejoin the children, and they all came to New York, settling in Washington Heights, where by a weird coincidence, they lived across the street from the local Nazi Party.

Hesse's mother went mad from the stresses of the war years and killed herself. Her father was unable to resume his law profession and went into insurance instead, but remarried and was very supportive of his daughter. Hesse spent most of her life in therapy. Determined to develop, to grow, and to become healthy despite these searing early experiences, she was, at the end, a powerful artist who had found a unique path and who was deeply satisfied in that accomplishment.

Fig. 8-17. Lin Emery, AQUAMOBILE (1977), bronze, 16' × 20'

An intellectual child, brilliant in all her subjects, Hesse studied at Pratt Institute and at Cooper Union. From there she received a scholarship to Yale University Art School, where she became a favorite of her teacher Josef Albers, and was soon generally recognized as an outstanding student. She plunged into a period of intense reading—James Joyce, Feodor Dostoevsky, Samuel Beckett, and others—searching for clues to her art.

After graduating from Yale in 1959, Hesse returned to New York determined to make her mark in the art world. She wrote in her diary that she longed to discover a new vision, to break all the rules. While supporting herself at mundane jobs, she thrashed around, looking for a personal expression, and made sufficiently competent drawings and Abstract Expressionist pictures to be accepted in several group shows.

The artist met, and in 1961 married, Tom Doyle, an older, newly emerging abstract sculptor. She was ecstatically happy for a while, but soon found herself facing the classic problems of the woman

artist—she was treated as "the artist's wife" and was not taken seriously on her own merit. Faltering in reaction to her husband's self-assured sense of direction, she wrote in her diary (the poignant repository of wishes, goals, and the reflections of a brilliantly creative mind) that she was continually oppressed by anxiety.

In 1964, a German tycoon, Arnhard Scheidt, offered Doyle the chance to work for a year, with all materials and living expenses paid for, in return for his output, in a huge empty factory in Kettwig-am-Ruhr, Germany. Hesse, of course, could come along as an appendage.

At first—returning to the country where everyone in her family except her parents had been destroyed—Hesse had nightmares. She sectioned off a small studio in the huge loft and huddled there for security, trying to work, while Doyle confidently tackled his big sculptures.

At this time, Hesse read Simone de Beauvoir's *The Second Sex* (1949). The book was critically important to her; it externalized her problems and helped her to gain the detachment and courage she needed. She realized how much her position as a woman had undermined her belief in herself as an artist.

As she continued to work despite her fears, her drawings developed into absurd machine forms that combined human and mechanical properties. Something quirky and personal emerged in them. She permitted herself to play with an unlimited supply of cord that fell her way, left over from de-mounted weaving machines in the factory.[85] The drawings developed into collages and reliefs built up from the wrapped cord and other materials, on masonite supports (*Ring Around Rose* [1965], *An Ear in a Pond* [1965]).

"They are becoming real *nonsense,*" she wrote in her journal. "Have . . . been discovering my weird humor and maybe sick but I can only see things that way."[86] By the end of 1965 there were enough of these reliefs for an exhibition at the Düsseldorf Kunsthalle. Hesse felt for the first time that there was something authentic and original in her work. Meanwhile, stresses within her marriage had reached the point where Hesse wrote to herself that she had better throw herself into the work because "I might well soon be on my own."[87] (Doyle and Hesse separated in 1956.)

The year in Germany, free from distractions and the pressures of the New York art community, had resulted in an artistic breakthrough for Hesse. Shortly after returning, she created *Hang-Up* (1965–66), a wooden frame hanging on the wall, wrapped so neatly and obsessively with cord that it takes on the look of a hospital-bandaged organism. Out of it, unaccountably, a thin metal rod, bent into a free-formed, curved loop, juts ten feet into the room. Hesse told interviewer Cindy Nemser:

It was the first time my idea of absurdity or extreme feeling came through. . . . It's so absurd to have that long thin metal rod coming out of that structure. And it comes out a lot . . . and what is it coming out of? It is coming out of this frame, something and yet nothing . . . and—oh, more absurdity!—is very finely done. The colors on the frame were carefully gradated from light to dark. . . . The whole thing is ludicrous. It is the most ridiculous structure . . . I ever made and that is why it is really good. It has . . . the kind of depth or soul or absurdity or meaning . . . or feeling . . . that I want to get.[88]

After *Hang-Up,* Hesse knew where she was going. Unexpected contrasts, obsessive repetitions of form, orderly forms deflating into limp chaos, materials such as surgical hose or flimsy layers of rubberized latex, were the means by which she produced shocking and poignant effects. She evoked an odd, new kind of beauty out of colorless industrial materials such as fiberglass.

Out of breast-shaped circles, Hesse dangled drooping strings that tangled on the floor; they suggest umbilical cords, bleeding breasts, mother's milk, and yet are wholly abstract (*Addendum* [1967]). In *Untitled: Seven Poles* (1970), fiberglass-wrapped forms that look like spindly legs and feet

Fig. 8-18. Eva Hesse, UNTITLED: SEVEN POLES (1970),
fiberglass over polyethylene over aluminum wire, 7 units, each 7'2"

stand around in a mournful cluster, suspended un-
easily from the ceiling.

When Lucy Lippard included her in a 1967 land-
mark show, "Eccentric Abstraction," at New York's
Fischbach Gallery, Hesse was wildly excited as she
began to see that people in the art world were
beginning to recognize a mysterious power in her
work. Toward the end, she was surrounded by
friends and respected peers, particularly Sol LeWitt,
Robert Smithson, Carl Andre, and Ruth Vollmer,
who believed in her and helped her.

Symptoms of fatigue and extreme headaches de-
veloped, and she was operated on for a brain tumor
in 1969. Pressed by presentiments of mortality,
Hesse entered an intense period of work. Her symp-
toms returned and she had two more operations. In
1969, in a wheelchair, she attended the opening of
the Whitney Museum exhibition, "Anti-Illusion,"
which included her work. Her ideas were at a peak,
but by this time she was forced to accept the help of
friends and students who assisted her in carrying
out her projects.

From this group effort, new possibilities opened up. In rapid, large-scale production—letting go of total control to some extent—she stumbled onto still newer forms. Long, loose strings were dipped in fiberglass and looped in arcs from hooks in the ceiling, like translucent cobwebs with dew or morning ice on them.

Untitled (1970) had to be carried out by others under her direction—a knotted tangle of rope, string, and wire, dipped in rubber latex and suspended from wires and nails in ceiling and walls. Here she got the effect she wanted—a chaos that somehow suggests a new kind of order.

Hesse achieved in her work a peculiar visceral or bodily identification with materials. She created a kind of "ugly" beauty to say something about humanity's absurd situation, which she saw at the same time as its only triumph. A posthumous exhibition was held in 1972 at New York's Guggenheim Museum, and Lucy Lippard wrote the book *Eva Hesse* (1976) in tribute to her friend.

Other Sculptors

Marjorie Strider (1934–) exhibited cut-out standing figures of bathing beauties with their breasts and other anatomical parts protruding, and then began to create witty images in which polyurethane foam oozes out of brooms, windows, and household objects.

Yayoi Kusama (1929–), a Japanese artist living in New York, created surreal furniture, chairs, couches, boats, and other objects bristling with phallus-like forms of stuffed canvas that seemed to turn these objects into living organisms. She is a well-known performance artist.

Craft As Art

Lenore Tawney (1925–) is a pioneer among those in the sixties and seventies who have raised weaving from the status of a craft to that of a new visual art form. In choosing and developing a medium that has been traditionally women's work, and in the manner in which she handled this medium, Tawney has contributed to the growth of a feminist aesthetic in contemporary American art. Her *woven forms* (a term she coined, but which has since become generic for this type of work) are created on a major architectural scale, often reaching to heights of twelve, sixteen, even twenty feet. In addition, she has invented technical innovations in weaving that have made possible a new flexibility in the forms that can be created with this medium.

Tawney was born to a Catholic family in Lorain, Ohio. From 1943 to 1945 she attended the University of Illinois, and between 1946 and 1948 she attended the Chicago Institute of Design (modeled after the Bauhaus) and studied drawing with Moholy Nagy, weaving with Marli Ehrman, and sculpture with Alexander Archipenko.

Archipenko, in his sculpture, had opened up voids within the mass of the figure, and had adapted the technique of collage to sculpture, making constructions of various materials. When he invited four of his students to work with him in Woodstock, New York, Tawney went along. In his studio, she experienced the ecstatic exhilaration that comes with total absorption in creative work, but after returning to Chicago she decided to leave sculpture to explore other media. At that time Tawney had a terror of being sucked into the creative vortex, with no time for a personal life. She thought that perhaps weaving could be done on a part-time basis, but inevitably her talent drew her into a total commitment.

From 1949 to 1951 she lived in Paris and traveled through Europe and into Morocco. She was fascinated by the ancient art and architecture she discovered abroad. After returning to this country, she studied weaving for a short time in Penland, North Carolina, with Martta Taipale of Finland, and in 1955 began her own creative work in weaving.

At first she produced "open constructions with exposed warps, shadow weavings almost like drawings made in yarn, suspended in a sheer open warp

Fig. 8-19. Lenore Tawney working on DOVE (1974)

of linen.''[89] (The warp is the vertical or lengthwise element that is placed on the loom; the weft is woven into the warp. Normally in cloth one does not see the warp.) Traditional weavers on exhibition juries did not appreciate these new creations at all, which to them looked like bad weaving. Only painters seemed to understand and like Tawney's contribution—they recognized an innovative kind of open form in her work.

In 1957 Tawney moved to the Coentes Slip section of New York on the East River, where she met Ann Wilson and Agnes Martin, among other artists who lived and worked there. The work of these three women prefigured two of the major characteristics of later art: the minimalist use of the grid as the basic scheme and the use of craft media and techniques in "high art"—an idea embraced by feminists of the seventies. The resemblance of Agnes Martin's grids to weaving and the roots of both women's work in traditional feminine concerns have been noted by feminist critics.

At Coentes Slip, Tawney's work was at first rich in texture and sumptuous color. She was one of the first to make intricately woven hangings in which bones and feathers were combined with rope, string, and other materials. During this period she traveled extensively in the Near East, where she studied Egyptian art, and in South America and India. Later she joined the Vedanta and the Zen Studies Society. The upshot of her thinking about basic issues was that she decided, as had Agnes Martin, to simplify her work.

She stripped her work of sensuous materials and color, throwing out baskets of brilliant yarns. In their place she ordered linen made to her order, and worked in natural undyed fibers, black, and a few primary colors. Then she made a series of innovations that permitted her to shape the warp with great flexibility into a sculpture as a given work was woven. She invented a special reed with an open top that permitted great freedom in widening and narrowing the woven plane. She combined this capability with the introduction of dowels and other stiffeners into the fabrics so that the three-dimensional shapes she created would be retained. These devices were combined with the ancient open-slit weaving technique to produce woven sculpture with Archipenko-like openings, so that light becomes a structural part of the composition.

At her one-woman show at the Staten Island Museum in 1962 and later at the Museum of Contemporary Crafts, she exhibited tall narrow pieces—up to twenty-seven feet high—and called these works "woven forms" (*King* [1962], *Queen* [1962], *Bride* [1962]). When the Museum of Contemporary Crafts mounted the first major show of nontraditional weaving the following year, it was called "Woven Forms," after her work.

In 1965, Tawney began to make small assemblages, using feathers, eggs, bits of manuscript or sheet music, and other small objects in boxes and cage-like enclosures. In the seventies she began to weave austere works reminiscent of the grids of her friend Agnes Martin. In fact, she has been called an "Agnes Martin in Flax,"[90] for her meditative weavings.

A practitioner of Zen and a believer in Jungian and Eastern mysticism, Tawney has given her work titles—*The Path* (1962), *The Pilgrim* (1962), *The Four-Petalled Flower* (1973)—that suggest mystical content. For Tawney, work is a path, and the artist and viewer are pilgrims on the path to the right way—the Way of Enlightenment. Similarly, her assemblages, with their caged eggs and feathers, are symbols of the maternal body with the egg of universal generation in it—or of the body with the soul in it.

According to author Gloria Orenstein, Tawney's works also have feminist content.[91] In the assemblage *The Great Mother Goddess*, a box contains a small pelvic bone with a mirror behind it. The viewer, peering in, sees her own face in the mirror, through the pelvis, suggesting that we are all reflections of the great Mother Goddess. Woven

pieces such as *Queen* and *The Bride* are exaltations of women, according to Orenstein.

Tawney said in her introductory lecture to a 1975 exhibition of her work at California State University at Fullerton:

In her character as spinster, the great mother not only spins human life but also the fate of the world. . . . The great Goddesses are weavers in Egypt as in Greece, among the Germanic peoples, and the Mayan peoples, and because reality is wrought by the great weaver, all such activity as plaiting, weaving and knotting belong to the chief governing activities of the woman who is the spinner and weaver in her natural aspect, mythologically speaking.

Lenore Tawney has restored the dignity and worth implied by this mythology to an ancient art.

Other Craft-Artists

Lenore Tawney is a symbol of a current movement to break down the traditional boundaries between High Art and Low Art (the crafts). Today many women are using stitchery, weaving, ceramics, and other crafts as their "fine arts" media.

Sheila Hicks (1934–), born in Hastings, Nebraska, works in an artistic frame of reference somewhere between weaving, architecture, and sculpture. She studied with Josef Albers at the Yale School of Art and Architecture, where she received the M.F.A. in 1959. After years in Chile and Mexico she established herself in Paris and now has two extremely successful ateliers running full blast in that city—the Atelier des Grands Augustins and the Atelier Bourdonnais. Hicks has done large commissions for the National Assembly and the Rothschild Bank in Paris, for the Ford Foundation, and elsewhere.

She creates bas-reliefs of tapestry called "thread explorations," and sometimes builds huge installations of soft materials, which almost become architecture. For a 1978 project at the Konsthall in Lund, Sweden, she requested thousands of bed sheets, bandages, blanket netsacks, and eight hundred birth bands from the University of Lund Hospital. Tying, knotting, stitching, and wrapping with long cores and brightly colored threads, she created "soft villages"—towers and walls of cloth forms.

Claire Zeisler, of Chicago, and **Barbara Shawcroft,** of San Francisco, also work in huge woven forms. many others are discussed in *Beyond Craft: The Art Fabric* by Mildred Constantine and Jack Lenor Larsen (New York: Van Nostrand Reinhold, 1973).

Chapter 9
The Feminist Art Movement

In the 1970s women artists began to come into their own after many centuries of being denigrated, overlooked or, at best, allowed into the hallowed halls of high art in small, token numbers. Major exhibitions and new imagery developing out of feminism poured forth, as women demanded their fair share of gallery and museum space, art reviews, and teaching jobs. This new position of women in the arts emerged out of a changed atmosphere in American life in the early seventies.

The Seventies and the Women's Movement

In the 1970s the myth of an omniscient and omnipotent United States collided with the realities of Vietnam, the Arab oil embargo, Watergate, and the erosion of the environment. It is not surprising that many people began to revaluate and question the values of post–World War II American society.

Several important books had a widespread influence on women's self-awareness. Simone de Beauvoir's *The Second Sex* (1949) and Doris Lessing's *Golden Notebook* (1962), were followed by Betty Friedan's *The Feminine Mystique* (1963),

Germaine Greer's *The Female Eunuch* (1970), and Kate Millett's *Sexual Politics* (1970). With mounting rage, women began to realize that since the peak of activity that surrounded the fight for the vote at the turn of the century, they had actually made little headway in obtaining job equality or a share of power and influence in American life.

Art Movements in the Seventies and Eighties

In line with the general skepticism of the seventies, artists, the general public, and, particularly, the feminist art critics, began to question every aspect of the art establishment—the judgment of the St. Peters who had the mysterious power of the keys; the atmosphere in which only certain trends had official sanction and hence commercial value; and the total denigration of content, feelings, and reality in much of contemporary art. Looking back at postwar art trends, people began to ask, first in whispers and then out loud, "Is less really more," and "Is nothing really something?"

There was a widespread demand for a more open, pluralistic, and humanistic art scene. A revival of realism began for the first time since the 1930s, ranging from photo-realism to expressionism. Realist artists who had been consigned to oblivion (such as Alice Neel) reemerged as survivors.

Other artists rebelled against the official art world as they had known it, and tried to find new forms that would take art out of the museums and galleries and reach people more directly in performances, site works, videotapes, and street murals.

The Women's Movement in Art

Women artists, stimulated by the new feminist consciousness, realized that their situation was appalling:

Ten major galleries in New York in 1970 showed the work of 190 men, but only 18 women.[1]

In 1972 a national survey of commercial galleries revealed that only 18 percent carried the work of women at all![2]

The New York Museum of Modern Art and the Los Angeles County Museum of Art (typical of most museums) had sponsored practically no solo shows of women artists during the previous ten years.[3]

In 1969 the Whitney's big annual exhibition carried the work of 143 men and 8 women.[4]

And yet, more than 60 percent of students in art schools and 50 percent of practicing professional artists were women.

June Wayne's Tamarind Lithography Workshop conducted a statistical survey of newspaper and magazine reviews and found that male artists received a grossly disproportionate amount of coverage.[5] The critics were not even paying women artists the courtesy of reviewing their shows. In fact, the position of women in the arts was worse in many ways than it had been in the twenties and thirties. After all, from 25 to 41 percent (depending on the area) of the artists on the Federal Art Project had been women, and approximately 30 percent of the artists in large group shows in the thirties were women.[6]

In the field of art history, the leading survey textbooks did not include a single woman in 50,000 years of art. Women were being brainwashed without even being aware of it, with the idea that there never were, and never could be, any great women artists. This prejudice was reinforced by the fact that their university art professor was almost always a man. (In 1970–71 only 11 percent were women.[7] The situation was even worse in studio art.)

Women artists began to organize and protest, and feminist art historians and critics joined them. In *Art News* (January 1971) professor Linda Nochlin published a now-famous article, "Why Have There Been No Great Women Artists?" Documenting the ways in which women had been denied access to art academies, the nude model, travel, and other requirements of their profession in past centuries, Nochlin brilliantly analyzed the social forces that have operated against women artists throughout history.

In 1972 the Women's Caucus for Art was formed within the College Art Association (the national organization of art historians, artists, and museum professionals). It soon split off and began to campaign vigorously for equal opportunity for women in museum exhibitions, and on college faculties, museum staffs, and elsewhere. At annual meetings of the Caucus, its members began to question the litany of opinion emanating from the world of male-dominated art historical scholarship. Books and periodicals flowed forth, illuminating the buried genius of outstanding women (see bibliography). The *Feminist Art Journal*, was soon joined by the *Women Artists News, Heresies, Chrysalis, Helicon Nine, Woman's Art Journal*, and other publications in various parts of the country.[8]

The East Coast

W.A.R. (Women Artists in Revolution) was started in 1969, when Juliette Gordon, Nancy Spero, and other women in so-called "radical" art groups found that the men in those groups were not the least bit interested in helping them achieve equality in museums and galleries. W.A.R. pressured the museums and commercial galleries to show the work of women artists, and helped create the New York Women's Inter-Art Center, with its women's museum and archives.

The following year, critic Lucy Lippard and artists Faith Ringgold, Brenda Miller, and Poppy Johnson formed an Ad Hoc Committee that demanded equality at the Whitney Museum annual shows. Forced into guerilla tactics, they left eggs and Tampax all over the shiny Whitney Museum floors and staged a sit-down in the middle of the opening of the 1970 Whitney Annual. Following these dem-

onstrations, 20 percent of the sculptors chosen for the Whitney Sculpture Annual were women.

Another group, Women in the Arts, spearheaded an important 1973 exhibition, "Women Choose Women," at the New York Cultural Center. Many other exhibitions, activities, and organizations mushroomed in this period.

The West Coast

On the West Coast, artist Judy Chicago became enraged at the discouraging sexism she had experienced, and set out to liberate younger women art students by setting up the first feminist art course at California State University, Fresno, in 1970. Working with a group of fifteen women, she invented new techniques for releasing the energy of her students. Consciousness-raising, psychodrama, and research into the history of great women artists of the past were all part of a new pioneering approach.

The following year, artist Miriam Schapiro and Chicago set up an entire department—the Feminist Art Program—at the California Institute of the Arts. One of their extraordinary projects was *Womanhouse* (1972)—a female fantasy environment of women's lives, hopes, despair, and frustration—which they and their students created by remodeling all the rooms in an abandoned old Los Angeles house scheduled for demolition. Although *Womanhouse* was only in existence for a month, it was visited by thousands and became a kind of rallying point for the feminist movement.

In 1970, when the huge Art and Technology show at the Los Angeles County Museum of Art did not include a single woman artist, the Los Angeles Council of Women Artists was formed and descended on museum officials. As a direct outgrowth of this pressure, the historic exhibition "Women Artists: 1550–1950," organized by Ann Sutherland Harris and Linda Nochlin, opened in 1976 at the Los Angeles County Museum of Art and then traveled to the Brooklyn Museum in New York. Thousands attended this landmark exhibition.

Another coalition of women artists opened a center, Womanspace, in 1973, where a busy schedule of shows and events soon necessitated a move to a large, remodeled factory building on Spring Street in downtown Los Angeles. This new Woman's Building was named after that earlier one at the World's Columbian Exposition (discussed in chapter 4)—a link with the long buried history of women artists in America. Founded by Judy Chicago, designer Sheila de Bretteville, and art historian Arlene Raven (all from the Feminist Art Program at the California Institute of the Arts), the Woman's Building is a center for exhibitions and women's culture. It also houses the Feminist Studio Workshop, an art and design school for women. The history of the West Coast women's art movement has been beautifully described by Faith Wilding in her book *By Our Own Hands* (1977).

Women's Cooperative Galleries

For the most part, dealers refused to show the innovative, strong, new women artists. Therefore feminists began to set up their own cooperative galleries—AIR and Soho 20 in New York (1972–1973), Artemisia, Inc., and ARC in Chicago in 1973, and others in Boston, Providence, Atlanta, Minneapolis, Washington, D.C., and elsewhere. Black women artists set up their own exhibition group, entitled "Where We At," in New York City.

Lawrence Alloway, writing of "Women's Art in the '70s," said:

The effect of . . . the founding of women's co-ops . . . should not be underestimated. Most people, including women artists had not seen much art by women grouped together before. It was widely known that there were many women artists, but they usually appeared, disadvantaged by a male-favoring selection system. . . . In the '70s, for the first time, women's art began to be accessible in quantity. . . . Women artists could begin to work knowingly in relation to the works of other women; the traditional question—are men's and women's art different?—could be discussed again, but with adequate samples of women's art for the first time. . . . Not since

the Museum of Modern Art's mixed shows . . . had the group exhibition been as essential a medium of communication, revealing an extraordinary wealth of new work.[9]

Women's Art: A New Avant-Garde

A great many fresh new trends came out of this avant-garde. Male artists throughout history have depicted women as passive, erotic objects, suffering victims, idealized virgins, inscrutable sphinxes, and so forth. The world has taken for granted such grotesque imagery as Peter Paul Rubens's *The Rape of the Daughters of Leucippus* (1617), which shows buxom nudes waving limp arms and feet in delight as they are carried off by smiling and muscular men.

In the 1970s many long standing artistic stereotypes were reversed. Sylvia Sleigh, for example, painted herself as the dressed, active artist at

Fig. 9-1. Mary Beth Edelson, CALLING SERIES, GODDESSHEAD (1975), photo/collage/drawing, 6" × 6"

the easel, with the passive nude male model stretched out before her. Reversing the time-honored Titians and Picassos, women painted men as seen from *their* viewpoint—sometimes frail, vulnerable, or erotic. In exhibitions like ''Sons and Others: Women Artists See Men'' (1975), there was a new vision of man—the viewpoint of the other half of humanity.

There were powerful statements of rage against patriarchal oppression. May Stevens's *Big Daddy* (1967–1975) series equated male symbols with a warlike oppressive society. Nancy Spero created a mural, *Tortures of Women* (1971), incorporating newsclippings and other verbal documentation along with expressionistic images.

Other artists paid homage to female role models, heroines, figures of power, and other images of worship or inspiration. Mary Beth Edelson, for instance, created a photo-montage *Goddess* series, and staged rituals to celebrate a new feminist consciousness. *The Sister Chapel* (1978)—a group project in which eleven women painted eleven female heroes larger than life, ranging from Joan of Arc to artist Frida Kahlo—is a counterattack against the patriarchal worldview expressed in Michelangelo's Sistine Chapel frescoes.[10] It consists of an eleven-sided traveling pavilion. The mirrored roof, designed by Ilise Greenstein (who conceived and organized the project) permits the viewer to look up and see herself as part of this pageant of female power.

Some women artists reacted against the values they associated with an overly-logical, heartless, and technical male society. They embraced a deliberate primitivism, a return to the earth, as it were, in earthworks, constructions, and paintings that carry overtones of prehistoric times, when the agricultural goddess images prevailed.

Female Eroticism

Women began to feel free to express their erotic feelings, previously repressed and suppressed in

Fig. 9-2. THE SISTER CHAPEL (1977–78). Installation at State University of New York, Stonybrook. Visible from left to right: ARTEMISIA GENTILESCHI by May Stevens, JOAN OF ARC by Elsa Goldsmith, BELLA ABZUG by Alice Neel, BETTY FRIEDAN by June Blum, DURGA: HINDU GODDESS by Diana Kurz, FRIDA KAHLO by Shirley Gorelick

art—ranging from heterosexual to lesbian and masturbatory imagery. Barbara Rose has pointed out that images of vaginal forms, shown as clean, well-made and beautiful, became a kind of flag or banner.[11] Serving as the woman's equivalent of "black is beautiful," these images asserted that "female is fine." Reversing patriarchal Freudian ideas of "penis envy," Elsa Fine has pointed out that women "removed the female sexual organ from its hidden recesses and displayed it openly like a powerful male organ, thereby inviting 'vagina envy.'"[12]

The Pattern and Decoration Movement

In a deliberate expression of their femaleness, women artists began to incorporate needlework, embroidery, weaving, fabrics, glitter, beads, lace, quilts, and ornamentation of all kinds in their work. They rejected the cool, hard-edged reductionism of the 1960s and introduced a rich and opulent decorative abstract style. This new approach strongly influenced the "Pattern and Decoration" movement, which developed among both men and women in the 1970s. "For the first time in the

history of Western art, women were leading, not following," a major art movement (Kay Larson, *Art News*, Oct. 1980).

Women also broke down the elitist separation between "high art" and "low craft." Judy Chicago revived the despised craft of china painting and used it as a principal element in *The Dinner Party*; Harmony Hammond made "braided rug" paintings; and many other artists incorporated craft techniques in their art forms.

Realism

The women's art movement must certainly be credited with its share in the recent revival of realism and humanistic art. Although women are by no means wholly responsible for this trend, artists such as Alice Neel, Audrey Flack, and Janet Fish have insisted on their right to portray the real world, even when, in some cases, they had to pay a heavy price for this insistence, especially in their early careers. They were challenging the "art cartel" of critics, dealers, and curators. Often women introduced a new content and approach—as in Flack's vanity tables laden with lipstick, jewelry, and other female debris, or Alice Neel's bursting nude pregnant women.

Collective Art

In the 1970s women began to work together on monumental collective projects like *Womanhouse, The Sister Chapel,* and *The Dinner Party*.

Street Art

Other women artists, such as Eva Cockcroft and Caryl Yasko, have painted wall murals in public places—so-called street art. Collectively or alone, in many American cities, women have dealt with feminist themes, racial equality, and other issues in large public paintings on the sides of buildings and on other public sites. The People's Painters, the City-Arts Group, the Haight-Ashbury Muralists, and the Mujeres Muralistas are a few of the groups in which women, sometimes side-by-side with men, created murals in such cities as New York, San Francisco, and Chicago.

Performance, Autobiography, Environments

Anxious to break out of museums and bring their message to a wider audience, artists Lynn Hershman, Suzanne Lacy, Leslie Labowitz, Barbara Smith, Rachel Rosenthal, Faith Wilding, Laurie Anderson and others, have staged events and used videotapes and other media to reach people where they really live. Hershman, for instance, took over the windows of Bergdorf Goodman on Fifth Avenue in New York and created an environment seen by thousands. Suzanne Lacy and Leslie Labowitz staged a costumed, week-long media event, *In Mourning and in Rage* (1977), on the steps of Los Angeles City Hall, protesting the wave of rape-murders in that city. Betsy Damon played the role of the "Thousand Year Old Woman" on the sidewalks of New York.

Environmental site works and other innovative forms are being created. For example, Helen and Newton Harrison of San Diego, a husband-wife team, design environmental projects, sometimes using plants, fish, and living elements to make a statement about ecology. Bonnie Shirk built a "farm" alongside the San Francisco freeway and Muriel Magenta created a haunting film, *The Bride*, out of still photographs.

Female Imagery or Female "Form"

One faction of the feminist art movement contends that there is a built-in biologically and socially based difference in form between the art of men and women. *Vive la différence* is their position, as they try to identify the formal qualities found universally in women's art, which have been suppressed and denigrated in male-dominated art schools and by male critics.

Among these qualities, feminist critic Lucy Lippard has suggested:

a central focus (often "empty," often circular or oval),

parabolic bag-like forms, obsessive line and detail, veiled strata, tactile or sensuous surfaces and forms . . . and autobiographical emphasis.[13]

Designer Sheila de Bretteville has said that women's art often shows multiple peaks instead of a single center of interest. Others maintain that the collage, the grid, and the patchwork quilt express the democratic, nonhierarchical, cooperative spirit that women wish to introduce into society, as well as the fragmented and multifaceted character of women's lives.

Many artists, historians, and critics—male and female—disagree with this position, finding it confining and limiting. Their stance is that women artists—like male artists—can, should, and do work in a vast variety of ways, unlimited by any "feminine" determinant. They agree, however, that social conditions will affect the form and content. Lawrence Alloway, for instance, declares that women artists today often have common concerns and themes arising out of their situation, but that their art is linked by what he calls "non-stylistic homogeneity."[14] This debate continues to rage and in the process has produced much close examination of the work of women artists.

Prospects for the Women's Art Movement

The Women's Caucus for Art now has chapters all over the country, and in 1979 President Carter presented the first annual awards of the Caucus to five senior women artists in the Oval Office of the White House. This was public recognition, at the highest level, of the contributions of American women to American culture.

A national Women's Coalition of Art Organizations (WCAO), representing 75,000 American women in various art groups, was organized. A Feminist Art Institute opened in New York to further women's studies in art.

Even the art history textbooks are changing. Revised editions of several (though not all) are including some women artists for the first time in the 1980s.

Non-Feminist Women's Art

Needless to say, many women artists continue to work outside the feminist movement, and some are strenuously opposed to it. They object to any attempt to identify their work with "women's themes" or "female form," and decry the whole notion of a women's movement in art. Nevertheless, the opportunities for all women artists have increased because of the actions and efforts of organized groups.

The Eighties and Beyond

Calvin Tompkins, reviewing the 1981 Whitney Biennial exhibition in *The New Yorker,* expressed surprise at its "energy, exuberance, and high spirits." He added:

The highest spirits in the show appear to be female. . . . Judy Pfaff's "Dragon," a room-filled assemblage of brilliant-colored sticks, uncoiling wire (ceiling to floor), mill-end fabrics, and other impedimenta, make it possible to forget that there had ever been such a thing as Minimal art. The same could be said of Katherine Porter's large abstract painting. (13 April, 1981, p. 112)

In these last two decades of the twentieth century, unparalleled opportunities are opening up to women artists; their audacity, fearlessness, "energy, exuberance, and high spirits," seem to know no bounds. They are creating site works that extend over acres, and even miles; they are inventing new forms that break all rules; at the same time, they show themselves capable of the most rigorous realist draftsmanship.

However, history shows that the opportunities that now exist can easily be lost. There were several peaks before the present period, but they were followed by backward movement. At the turn of the century there was a feminist-inspired outpouring of work, and in the 1930s women artists were given unprecedented opportunities for the New Deal. But

these periods were followed by the 1960s, when they were largely shut out of galleries and museums.

The present climate of opportunity did not come about by itself. It was created in the 1970s by women who picketed the museums and by individual historians who wrote brilliant scholarly articles in American and European art journals. Even earlier, in the nineteenth century, women had set a precedent for action by insisting on their right to draw from the nude model and attend the academies as equals to men.

With continued vigilance and effort, American women artists, who have already enriched the world so much with their genius, will at last achieve their goal of parity of opportunity with their male colleagues.

Realism

The return to realism has been one of the vigorous trends of the 1970s. Women artists have been active in every phase of the movement, from the photo-realism of Audrey Flack to the expressionism of Alice Neel. Other figurative artists not discussed here include Vija Celmins (b. 1939), Jillian Denby (b. 1944), Rebecca Davenport (b. 1943), Martha Erlebacher (b. 1937), Patricia Tobacco Forrester (b. 1940), Yvonne Jacquette (b. 1934), Sylvia Mangold (b. 1938), D. J. Hall, Carolyn Brady, Sylvia Shap and Marcia Marcus.

Expressionist Realism

Is man no more than this? Consider him well. . . . Unaccomodated man is no more but such a poor, bare forked animal as thou art. Off, off, you lendings! Come, unbutton here.''
 Shakespeare, *King Lear*
 Act III, Scene 4

Alice Neel (1900–) has called herself a ''collector of souls,'' and over a period that spans practically the entire twentieth century, she has been painting superb expressionist portraits. Their primary interest lies in the personality, the vulnerability, the inadequacies, and the mortality—in short, the humanity of her sitters.

Critics for over forty years turned away from her unbendingly honest art; even her sitters ran from her razor-sharp images, which showed too much about them. During all that time she worked outside the mainstream, virtually ignored, living as a bohemian and refusing to accommodate the passing trends in the art world.

Neel was born in Merion, Pennsylvania, and brought up in the small town of Colwyn, which she later described as stifling and puritanical. Her father was an Irish railroad clerk. Her autocratic mother (whose ancestors went back to a signer of the Declaration of Independence) breathed forth an atmosphere of despair because she felt trapped in a penurious and confining life. A hypersensitive child, Neel had to be brought home from church because she wept hysterically on hearing about the crucifixion. She knew early that she wanted to be an artist.

Realizing that her family would consider her ambition impractical, Neel pretended that she wanted to study commercial illustration and enrolled at the Philadelphia School of Design for Women in 1921. There she spent four years drawing from plaster casts and learning anatomy from Paula Himmelsbach Balano, a teacher she greatly admired. During this short, peaceful period, Neel mastered her craft. She has said that when she first began to paint, she felt a sense of freedom for the first time and has hung onto that freedom when all other aspects of her life seemed to be in bondage.

During a summer session run by the Pennsylvania Academy of Fine Arts, she fell in love with and married a fellow art student from a wealthy and aristocratic Cuban family. In 1926 she returned with him to Havana, where she had a baby girl. Neel continued to paint, and that same year held her first solo exhibition, in Havana, of about a dozen works—canvases of Cuban beggars and poor

mothers with children, foreshadowing her later interests.

Neel and her husband returned to New York to live the bohemian artist life and promptly, as she puts it, "began to starve to death."[15] A series of tragedies followed, beginning with the death of her daughter of diptheria in 1927. Then her husband took their second child to his family in Cuba and went off to begin a new life without her in Paris in 1930. As a result, Neel broke down and was hospitalized in Philadelphia. Recovering with her family, she attempted suicide and was hospitalized again, in the suicide ward of Philadelphia General Hospital.

It was over a year before she was fully recovered, and during that time a social worker helped her to see how she could use her art to release her feelings. For Neel, painting was not just a career; it was, and has remained, literally, a means of survival.

From these stormy early years come powerful works like *Futility of Effort* (1930), a tilted-up view of a dead child with head caught in the bars of a crib, reduced to a few shapes, with a kind of wispy line that conveys helplessness. She also drew the *Philadelphia Suicide Ward* (1931), a terrifying view of the "mad and the miserable."[16] *Well Baby Clinic* (1928) shows pitiful ghetto mothers with their babies, in contrast with a cold institutional background. These early paintings and drawings are distorted and almost primitive expressions of emotion, reminiscent of the works of James Ensor, Edvard Munch, and the German Expressionists. But Neel had never seen the work of those artists; her style grew out of her own raw feelings.

Neel moved to Greenwich Village with an intellectual sailor (described as "interesting," but a drug addict) and began to produce the portraits for which she is best known. In the early thirties she painted unconventional studies of members of the subculture. The most outrageous of these is the exhibitionist-poet Joe Gould, who sits facing out, grinning madly, stark naked with knees apart to reveal three sets of genitals, one above the other. One can almost hear the ribald, running commentary of the sitter, who according to Neel, had to be restrained from displaying his assets at the window. In such details as the bald head and sprouts of stringy hair, one senses an edge of pity in the artist, as she observes the male need for self-assertion, which so often masks depths of insecurity. This daring painting could not be exhibited until decades later.

When Neel began to date a wealthy Harvard graduate (he subsequently remained her good friend until his death), the sailor slashed sixty of her paintings and hundreds of drawings in a jealous rage. She barely escaped his curved Turkish knife.

In the thirties Neel survived on the Federal Art Project, where her artist-status was always in jeopardy because the hospitals, schools, and other institutions that were supposed to absorb the work of WPA artists did not want her wildly expressionist pictures any more than private collectors. Ironically, in a recent show of WPA art, Hilton Kramer singled out her painting *Magistrate's Court* as one of the outstanding works.

Neel was also involved in politics in the thirties. In *Magistrate's Court* she shows a poor victim ("He never had a chance")[17] caught in the toils of the law, a Daumier view of justice that she glimpsed when she herself was hauled into court for picketing. Never tolerant of bureaucracy of any kind, Neel describes herself today as an "anarchic humanist."

In 1935 she fell in love with a Puerto Rican singer–guitar player, José, and in 1938 moved to Spanish Harlem with him. Although they parted in 1938, Neel remained in the area for twenty-five years, painting her neighbors and the people of that district. She found a certain "truth" in the life there, and an admirable courage and dignity in the people who doggedly persisted under conditions of misery and deprivation. From this period came dark, brooding paintings like *Fish Market* (1950) and *T.B., Harlem* (1940), which has been called a kind of

modern crucifixion. Neel's work was still largely unknown. Abstract Expressionism soon dominated the art scene and she was ignored except for a few shows at the A.C.A. Galleries and elsewhere, which drew little attention.

Neel's two sons were born in 1939 and 1941. A devoted mother, she nevertheless continued to paint at night when her children were small. Her brilliant boys, in a kind of reverse rebellion, became a lawyer and a doctor. They and their families sit for her portraits frequently, and through them she has painted an era of youth, as she showed their change, in succeeding portraits, from rebellion and bewilderment to the growing assurance of maturity.

Even with the return of figurative art in the sixties, Neel was left out of major shows at the Whitney and the Museum of Modern Art. It was not until she was chosen for a kind of *Salon des Réfusés* (a show of artists not included in the 1962 Museum of Modern Art exhibition "Recent Painting, U.S.A.: The Figure") that the influential art critic Thomas B. Hess noticed her work. Returning to her apartment with another critic, Harold Rosenberg, he told her that he was going to award her the prestigious Longview Purchase Prize. The Graham Gallery began to show her paintings in 1963 and has given her many exhibitions since that time. In the sixties Neel began to paint portraits of New York intellectuals and luminaries of the art world. Her work became brighter in color, more precisely realistic and often shows an acerbic wit.

With the groundswell of the women's movement, Neel's work finally began to surface. She was seventy-four when she was finally given her first one-woman show at a major museum—the Whitney—and even then it took a petition from the art community to bring this about. Cindy Nemser included a lengthy interview with her in her book *Art Talk* and wrote a catalogue essay for Neel's retrospective at the Georgia Museum of Art in 1975.

Neel has been attacked by certain critics because she sometimes emphasizes the head while leaving backgrounds sketchy and hands and limbs shrunken or limp. Her pictures have been called caricatures. But these devices are intentional. Using a vigorous outline, she seizes the gesture and body language of her sitter with great economy. She then focuses on what she wishes to emphasize, which is usually the head—the "seat of the soul." Limp or shrunken limbs merely accentuate the helplessness, ennui, or decadence of the sitter. She is perfectly capable of painting bony, large hands when she wants to emphasize strength, as in her portrait of the discerning former director of the Whitney Museum, John Baur.

The expressiveness and variety of the hands of Neel's sitters is remarkable. From the rabbinical, thoughtful gesture of the Soyer brother who cups his chin in philosophical hand, to the strong work-worn hands of the proletarian mother in *Carmen and Baby* (1972), to the nervous clutching of a new young mother in *Nancy and Olivia* (1967), class and social position are revealed.

After suffering the "gratuitous insults" of discrimination throughout her life, Neel is a staunch feminist. Her portraits of women and children show a different image from the sweetness and light of many other paintings on the subject. Working-class Carmen offers her limp breast to the hapless, retarded infant that she holds with gnarled hands. Her face shows the ravages of oppression but still retains dignity and kindness despite the outrages of fortune. The nude *Pregnant Betty* (1963) poignantly contrasts the artificial, sophisticated, urban woman with mascara eyes and painted toe nails, and the vulnerable animal condition in which she finds herself, as Professor Nochlin has observed.[18]

Neel has said, "When portraits are good art they reflect the culture, the time, and many other things."[19] Also: "The artist can be socially committed without lowering his level."[20] She adds, "One of the primary motives of my work has been to reveal the inequalities and pressures as shown in the psychology of the people I painted."[21]

Fig. 9-3. Alice Neel, DAVID BOURDON AND GRE-
GORY BATTCOCK (1970), oil on canvas, 59¾″ × 56″

The subject of *Timothy Collins* (1973), "The Wall Street Warrior," sits in head-on assurance with a neatly pressed, broad-shouldered suit, shiny shoes, and a sense of pent-up energy. Abdul Rahman, a black nationalist, "jabs his index finger accusingly."[22] Art critic John Gruen and his family, obviously devoted to one another, sit lined up in urbane sophistication, in hip costume and pointed patent leather shoes. The Puerto Rican victim of Harlem's epidemic disease, tuberculosis, lies dying of a collapsed lung in the hospital.

Neel's subject matter is so powerful that it is difficult to draw back and scrutinize the formal elements in her work; yet close study reveals that every millimeter of space is carefully felt. A tense placement sometimes just barely cuts off the top of a head or the toe of a shoe so as to carve out better negative shapes on the canvas. Her economical brushwork elicits daring color schemes, as in *Jackie Curtis and Rita Red* (1970). This portrait of a gay couple has been described as "an astonishing piece of painterly bravado by an artist then seventy years old, with a luscious color scheme of reds, yellows and creams."[23]

In the 75th Anniversary issue of *Art News,* art historian Ann Sutherland Harris chose Neel as the most underrated artist of the last seventy-five years. Harris threw out the challenge: "What is the finest portraitist that America has produced since 1900 doing in a run-down apartment building on the Upper West Side surrounded by her own masterpieces? Why are people afraid of these bold images of humanity, bereft of flattery but brimming with life . . . ?"[24]

Neel was elected to the prestigious National Institute of Arts and Letters in 1976. She is recognized today as a kind of American Van Gogh, whose relentless characterizations probe not only the personality of her sitters, but through them, the mutilating effects of the society in which they live.

Photo-Realism

Audrey Flack (1931–) is committed to realism and to direct communication with the public in her art. She was one of the first artists to use the photograph openly as a direct source of imagery for her paintings. When she projected color slides onto the canvas and painted over the image in a darkened room, she saw halos around forms and light-filled visual details that she had never seen before.

Flack uses the photo-image to show her admiration for strong women, her hatred of oppression, or her delight in the beauty of the world, particularly her own feminine ambience. She has not hesitated to include taboo objects, such as jewelry, cosmetics, perfume bottles, nail polish bottles, decorated china cups, and ceramic angels, for which some critics view her work as a triumph of bad taste.

Flack grew up in Washington Heights, New York City, and decided at age five that she was an artist when she did a collage on a shirt cardboard in kindergarten. Although her parents were worried by her seriousness, she attended the High School of Music and Art, where she was told to draw like Picasso. She won the prestigious Saint-Gaudens Medal at graduation and was accepted at Cooper Union.

In 1951 Flack was recruited by Josef Albers, the newly arrived chairman at the Yale School of Art and Architecture, who was trying to import top students as part of a total program to energize the department. At Yale, Flack refused to accept Albers's hard-edged abstraction. She argued furiously with him and finally kept an armed truce until she got her degree in 1952.

Abstract Expressionism was, as she put it, "the mythology of the time."[25] She threw paint on huge canvases with the best of them, but even then had a desire to paint realistically. When she submitted a figurative painting to a show at the Stable Gallery, it

was moved out of sight. Such subjects were not considered high art, and no school at the time offered sufficient training in realism to prepare a student for mastery.

Flack has recounted her experiences with the male art leaders of the fifties. She visited the famed "Club," the exclusive gathering place for the leading New York School painters. With awe, she looked forward to meeting one of the legendary masters of action painting, hoping to discuss with him some of the secrets of his work and his approach to art. The approach consisted of a dead-drunken belch, accompanied by a pinch on the behind, which according to Flack, was par for the course with many members of that male in-group, who countered their insecurities by adopting a super-macho image.[26]

Flack's behavior, in turn, was considered too "bourgeois," since she refused to act tough like the boys or play the role of "groupie" to male art leaders and teachers. Worst of all, she refused to pursue elitist avant-garde objectives, having adopted the point of view that most avant-garde art is a case of "the emperor's new clothes." The great artist, in her opinion, has always been, and always should be, in communication with a mass audience. Her role model is the seventeenth century Spanish baroque woman sculptor, Luisa Roldan, whose crowned weeping madonna, the *Macarena Esperanza,* is carried through the streets of Seville by adoring worshippers. Flack has said:

For me art is a continuous discovery into reality, an exploration of visual data which has been going on for centuries, each artist contributing to the next generation's advancement. I wanted to go a step further and extend the boundaries. I also believe people have a deep need to understand their world and that art clarifies reality for them.[27]

Finding that she was just at the beginning of her training, she registered with Robert Beverly Hale at the Art Students League and arduously set about studying anatomy and perspective. She began to paint from the model with a sympathetic group of realists, including Philip Pearlstein and Sidney Tillim. They worked together for a number of years. In the sixties, Flack painted social and political themes—anti-war marches, civil rights subjects, and so forth. When she painted a picture of the Kennedy motorcade, with no attempt to disguise the source (a newspaper photograph), it caused a falling out with most of her realist painter-friends.

But Flack persisted. The photograph was just another tool in the pursuit of a new kind of reality, as far as she was concerned—one that had been used by Edgar Degas, Thomas Eakins, Eugene Delacroix, and Jan Vermeer, with his seventeenth century camera obscura.

In 1969, when Flack was commissioned to paint the family of Oriole Farb (ex-director of Riverside Museum), for the first time she projected the image directly from a slide onto the canvas. Observing the brilliant color of light as it strained through dots of red, blue, and yellow, she began to use airbrush to achieve some of the same brilliance with controlled sprays of pure red, blue, and yellow over one another.

Using this technique, she embarked on a series of still lifes depicting cherished objects from her own life. Sensuous satin, roses with drops of water on them, shiny jewelry, beautiful fruit and cheese, and playing cards (she loves to gamble) became the contents for a new kind of *vanitas* statement. Her work carries echoes, in its succulent brightness, of the American tradition of advertising art. But also, as Eleanor Tufts pointed out, it is an extension of an old tradition going back to the Dutch, Flemish, and Spanish painters of the seventeenth century, for whom the still life, meticulously and lovingly rendered, was at the same time a metaphor.[28] Symbols are included that speak of the joys of this life, and also suggest the fleeting nature of the material world. Flack's devotion to perfection in these paintings limits her output to three or four large compo-

Fig. 9-4. Audrey Flack, ROYAL FLUSH (1973), oil over acrylic on canvas, 70″ × 96″

sitions a year, and she is continually experimenting with concepts of space and form.

In the painting *Royal Flush* (1973)—a scene of a poker table with cards, surrounded by objects—the royal flush may be regarded as a symbol of luck and success. Other symbols of death and passing time—a stopped watch, melting ice cubes, a half-burned cigarette—are reminders that life is played for high stakes and the clock ticks on. This composition is composed of powerfully opposed diagonals.

In her *Gray Border* series of 1975–76, Flack pushes the peripheries of realism to new limits. Using a gray border as a neutral picture plane, she experiments with visual and psychological effects, sometimes using extremes that are almost anti-realist. In some pictures the objects appear to be squeezing forward into the viewer's space. In others there is ambiguity—some objects are seen from overhead, and others are seen from the side—further complicated by reflections in a mirror. Often the picture is tipped up exaggeratedly, parallel with the viewer's face. Flack spends months taking hundreds of photos and rearranging her subject and lighting before beginning a painting.

In three paintings (1977–78), Flack has applied ten years of photo-realist training and skill to tragic

themes. There is *Marilyn*—Monroe as the tragic symbol of woman as a commodity in a sexist society; *World War II,* painted from Margaret Bourke-White's photos of the concentration camps; and *Wheel of Fortune.*

There is a fundamental difference between Flack and other macro-photo-realists like Chuck Close, who does giant blow-ups of heads, or pop realists like Andy Warhol, with his silk-screened news photos, or Pearlstein, who paints from the model.

Flack differs from all of them in her emotional commitment. Close denies any psychological insight and professes to be mechanically enlarging, dot by dot, his giant heads of people. Pearlstein insists that his nudes are primarily vehicles for new abstract forms (verified by the fact that heads are frequently lopped off by the frames). And Warhol announces, "I am a machine." Audrey Flack clearly reveals that she loves, hates, fears, or delights in the subjects she portrays. In this she affirms an aspect of art emphasized by the women's movement: the element of genuine emotion and the communication of that emotion to an audience.

Idelle Weber (1932–), one of the few women Pop artists of the sixties, became a leading photo-realist who paints "beautiful garbage"—literally the offal and sludge of New York City—which she transforms into a new kind of urban poetry. Old tin cans lying on subway grates, torn wrappers and shattered glass on greasy pavements become the starting point for subtle orchestrations of color, texture, light, and form. These evoke the atmosphere of particular neighborhoods or districts, and provoke meditations on the nature of modern industrial society.

Born in Chicago in 1932, Weber claims that she started painting at the age of three, and that in kindergarten she could draw Brenda Starr comics better than anyone in the class. When she was eight her family moved to Beverly Hills, California, and she became the youngest student at Chouinard Art

Institute in Los Angeles. (She was too young to attend the life class.) At Beverly Hills High School she won a National Scholastic Art Award scholarship to Scripps College, Claremont. In 1955 she received an M.F.A. in painting from the University of California at Los Angeles. While studying there with William Brice, Jan Stussy, and Stanton MacDonald Wright, she was a teaching assistant—a singular honor, since sexism pervaded university art departments at that time. She taught briefly in Hollywood High School in 1956, and was married and divorced.

In 1956 Weber came to New York and turned a fresh, West Coast eye on the city. Excited by the sight of the everyday rush of business men in grey flannel suits who carried briefcases and rode the escalators and elevators of the big city skyscrapers, she soon abandoned the minimal, grayish, all-over abstractions she had been painting in California. Here she began her distinctive Munchkin series—large striking silhouette paintings of people caught in arrested motion in stores, offices, and lobbies, set against checkerboard backgrounds (*Munchkins I, II, III,* etc. [1964]).

She froze the revealing silhouette forms of figures in a way that conveyed the loneliness and emptiness of men in urban modern life—somewhat reminiscent of George Segal's cast-plaster environments. The strong outlines reveal the slump of shoulder, rumple of tie, and double chin—what art critic Douglas MacAgy calls a vision of "soft people in a hard environment. . . . Lone men stand on endless belts; bridge is played like solitaire."[29] MacAgy compared these images to the frozen figures of people caught in a volcanic eruption: "Like running Pompeians immobilized and grayed in a twinkling by lava, these transfixed shadows of people are bent, if not shaped by an oblivious destiny."[30]

By 1964, in her painting *Boston Lettuce* (1964), Weber began to focus on city still lifes—at first the pushcarts and fruit stands with their hastily

scrawled signs, later the cast-off litter and trash of gutters and sidewalks. She painstakingly searched for evocative accidents of form and color—"not every heap of junk works"—and laboriously composed the 35 mm. slides she used as source material for her paintings. Sometimes she rearranged objects on the site, and brought some of them back with her for further study in the studio. Carefully recording the harsh early morning city light as it falls on debris, Weber works her material into compositions like *Gutter I* (1974); *Heineken* (1976), named for the beer cans and *East 126th Street Harlem* (1977), de-

bris on a Harlem lot. Although Weber denies any sociological intent in her work, the fact that the garbage of Harlem is obviously quite different from that of an affluent neighborhood inspires reflection on the flux, decay, irony, and injustices of modern life. Her eroded subjects contrast with Flack's glorified visions.

Weber had married in 1957, soon after arriving in New York, and the birth of her children in 1958 and 1964 delayed her career somewhat; so she started to exhibit relatively late. After her first one-woman show at Bertha Schaefer's in 1964, her work was

Fig. 9-5. Idelle Weber, HEINEKEN (1976), oil on linen, 47½″ × 72½″

389

bought by Yale University Art Gallery, the National Collection of Fine Arts, and other prestigious collections. In 1978 she began to exhibit at the O.K. Harris Gallery. She has been teaching graduate painting at New York University.

Joan Semmel (1932–) paints large photorealist pictures in which erotic subjects are depicted from a woman's point of view. Sometimes they are pictures of people making love; sometimes pictures of her own body—perhaps with her hand resting on a thigh—seen through her own eyes. Semmel has said:

Women have never allowed themselves to admit their sexual fantasies. They have been encouraged to create themselves in terms of male fantasy. I wanted to make imagery that would respond to female feelings. My paintings deal with communication, how a hand touches a body, rather than male or female domination.[31]

Semmel was born in New York. She attended the High School of Music and Art, Cooper Union, and the Art Students League; she received a B.F.A. from Pratt in 1963 and an M.F.A. in 1972. In 1963 Semmel went to Spain because her husband, from whom she has since separated, had a job there. She lived in Spain for seven years, and during part of that time she was raising two children alone.

In 1965 and 1966 she exhibited abstract expressionist paintings in Madrid and later in Uruguay and Buenos Aires. Her color was an intense expressionist clash of red and green, and her compositions were centrally focused, with linear networks extending out to the edges. She describes them as having an overlay of surrealism because of the European influence.

Semmel had been isolated as a woman artist in Spain, and when she returned to New York in 1970 she felt that many of the feminist ideas that had been on her mind were echoed by the women she met. As a result, she found the opportunity to communicate with other women in the arts very exciting.

Semmel has explained that her use of erotic themes came about because of her reaction to American life when she came back to New York: "The girlie magazines, the sexploitation all over was a shocker. . . . It wasn't even sexual, it was just hard sell . . . demeaning of women."[32] She wanted to replace these images with a woman's view of the sexual experience as a mutually shared and communicative one between equals.

The artist returned to studies of the figure, and from her initial abstract and expressionist figure studies she began to paint three-dimensional modeled forms, and then used photographs as source material. Her first erotic paintings were of two models seen from the outside making love, for example, *Untitled* (1973), for which she used photographs as drawings, but painted the flesh tones in unnaturalistic sensuous colors—green, orange, pink. Because no New York gallery would take the pictures, she hired the gallery at 141 Prince Street and staged her own show.

Later, wanting the pictures to reflect more of her own feelings, her "own view" of herself, Semmel did a series of paintings of her own body seen through her own eyes with a partner such as *Touch* (1975) and *Intimacy-Autonomy* (1974). These were followed by "headless" self-portrait nudes in which the entire picture space is taken up by a large close-up of a part of the body, which is observed from the artist's viewpoint. The effect is like that of an abstract form or a landscape. Recently, Semmel has begun to return in the direction of abstract expressionism by combining painterly passages with photo-realist images.

In 1977, while teaching at the Brooklyn Museum School, Semmel was the curator of an important exhibition at the museum entitled "Contemporary Women: Consciousness and Content." In the statement she wrote to accompany the show, the following passage occurs:

Women's sexual art tends to stress either the strongly positive or strongly negative aspects of their experience.

Fig. 9-6. Joan Semmel, PINK FINGERTIPS (1977), oil on canvas, 49″ × 56″

Feelings of victimization and anger often become politically directed, especially in the more recent works. When female sexuality is celebrated as joyous, liberating and creative, the influence of feminist ideals is strongly sensed.[33]

Diane Burko (1945–) is a photo-realist painter of mountain peaks from the Alps to the Himalayas to the Rockies. The general effect of her pictures is what the eighteenth century would have called ''sublime''—vast panoramas of awesome peaks and canyons reminiscent of the Hudson River School, or of Frederick Church. Unlike the Hudson River painters, however, Burko's panoramas are an excuse to create new arrangements of abstract form and color.

Born in Brooklyn, New York, Burko was the only child of doting first generation immigrant parents. Her father took her on the train to children's art classes at the Brooklyn Museum. At Skidmore, a women's college, she became an abstract ex-

pressionist painter, and the "star" art student on the campus. It was a shock to enter the University of Pennsylvania and find herself the only woman in the graduate art program trying to survive in an all-male environment of faculty and students. The one other woman student committed suicide, but Burko persisted and earned an M.F.A. in 1969.

In graduate school she began to paint cars and motorcycles, concentrating on reflections from chrome and glass. One day, while sitting in her station wagon painting an interior view, she noticed the fascinating counterpoint between the landscape reflected in the rear view mirror and the real landscape behind it. This triggered a series of "double landscapes" and a permanent interest in landscape painting.

Burko's photo-realism is qualified by her primary interest in the abstract qualities of her subjects. Seen from close up, her pictures of mountains and canyons break into arrangements of lozenge-shaped forms with no realistically verifiable, rational structure. The paintings, therefore, function on two levels—the known image seen from a distance and the abstraction seen from closer up. Although she works from slides and photographs, she crops and edits, often taking materials for a single picture from a number of different sources and combining them freely. Her colors are often not naturalistic, but are arbitrarily selected to fit her artistic purpose.

Burko worked for years without ever seeing the actual mountains, but in 1978 she went west and took photographs from an airplane for her *Grand Canyon* and *Lake Powell* series (1978). As a result, her colors changed from icy blues and whites to a warmer range of rust, orange, and blue. The state of Pennsylvania awarded her a 1981 grant enabling her to fly over Pennsylvania and take photographs, so that she could paint, for the first time, the mountains of her home state.

When asked why she paints mountains, Burko answered, "There is a humanity and romanticism in them that is part of me. I am in awe of nature."[34]

These feelings are clear in paintings such as *Bernese Alps* (1974), *Grandus Jorass* (1975), or *Canyon Wall #2* (1978).

Burko lives in Philadelphia with her husband and daughter. A full professor at Philadelphia Community College, she was a founder of the Women's Caucus for Art and helped organize a city–wide festival of women in the arts in 1974.

Other Kinds of Realism, Surrealism, Social Realism, etc.

Janet Fish (1938–) paints large still lifes of common objects like vinegar bottles and water glasses in a style that combines realism with abstract expressionist tendencies. Because her subject matter includes such ordinary commercial items, the work of Fish could be compared to the soup cans of Andy Warhol and the hamburgers of Claes Oldenberg. However, their approach has been cool, commercial, or satirical, whereas she has spoken of:

the aspect of painting still lifes that is like contemplation or meditation. . . . You sit there with something very quiet. You are looking at it all day and you are constantly pushing through the thing you are looking at.[35]

Born in New England, Janet Fish wanted to be an artist from her earliest childhood. Her grandfather was a painter and her mother a sculptor, and her initial ambition was to be a sculptor. Fish studied sculpture and printmaking at Smith College with Leonard Baskin and then went to Yale in 1960. But sculpture at Yale was under the domination of the Bauhaus tradition and, because of her interest in realism she found herself going against the grain. She has said that her professors treated her with contempt when she started to paint "feminine" subjects like flowers. During her three years there, however, she learned abstract expressionist paint-

Fig. 9-7. Janet Fish, RAIN AND DUSK (1978), oil on canvas, 58″ × 85″

ing, and eventually it became a major influence on her mature work.

After graduation in 1963 Fish moved to New York. She married another painter, but the competitiveness between them broke up the marriage in two years. She remarried a nonpainter and this time tried to be a "good" conventional housewife, but that did not work out either. She has observed that men find it hard to cope with the fact of a wife's artistic success.

Fellow artists in the sixties found it hard to accept

the new realists. Fish had trouble finding human models who could sit still for the long periods she needed for her type of work; so she took to painting vegetables. One night she was painting a table with vegetables scattered on it when a male artist friend came in, an abstract sculptor. He started pounding the table and shouting at her about what a terrible thing she was doing—as if she were committing some kind of a crime against art.

Primarily interested in the way light plays on surfaces and breaks up the forms, she began to paint

glasses and bottles, as in *Vinegar Bottles* (1972), *Wine and Cheese Glasses* (1975), and *Glass Garden* (1974). In several of these, the glasses are partly filled and placed on mirrored surfaces so that there is a very complex interplay between the light from outside, coming through the glass, and the light reflected from glass, water, and mirrors. The slightest shift in the weather, the light, or the background, completely changes the kaleidoscope of colors. Thus Fish has to keep two different paintings going—one for a sunny day and one for a cloudy one.

Fish is a realist whose work is influenced by the way abstract expressionists use paint. "What I like about Abstract Expressionism," she has said, "is the energy of the painting, the sense of air that works through the painting."[36] Unlike some other realists, she is interested in the painterly quality of every inch of the picture surface. "I get more out of the marks—out of a very active surface."[37] Her most recent work has become increasingly complex. A picture like *Rain and Yellow Walls* (1976) is hard to read literally; light passes through so many distorting surfaces that yellows, blues, and rose tones flicker through one another.

In seeing and capturing the beauty in mundane subjects, Fish is part of a tradition that comes down to us from the Spanish realists of the seventeenth century, whom she admires. She has said of her Spanish predecessors that "they took solid things and gave them the incredible suggestion of spirit beyond."[38]

Catherine Murphy (1946–) was recognized as a master of realism at the young age of thirty and given a 1976 retrospective at the Phillips Collection in Washington, D.C. Her scenes of the city and of people in lower-middle-class wooden frame houses have a mysterious, laconic, distinctly American quality reminiscent of Edward Hopper. The light, the mood, the honesty and lack of idealization, and the solid composition are the re-

sult of very long, hard concentration; she produces only a few canvases a year.

Although at first glance her paintings appear photo-realist, Murphy actually works directly from nature, modeling herself on such earlier American painterly realists as Fairfield Porter and Jane Wilson. She starts her very convincing illusionism with a broadly brushed, expressive underpainting, becoming more and more precise as she works over it with finer and finer brushes. It is this painterly approach that produces the vibrant "felt" surface in her work.

Murphy was born in Lexington, Massachusetts, the daughter of an Irish musician who supported his family by working in a post office. As a child, the only art she was exposed to was in the *Saturday Evening Post* (Norman Rockwell was her favorite). She studied at Pratt Institute from 1963 to 1967. Her mentors there were Stephen Pace and particularly Eugene Beerman, who taught her to revere the old masters Leonardo da Vinci, Jan Vermeer, and Jan Van Eyck, to trust her own vision, and to take infinite pains in her work.

Murphy was first discovered in 1971 by June Blum, a leading feminist artist and curator who put her before the public in an exhibition on Long Island, where the prominent art critic John Canaday noticed Murphy's work and reviewed it in the *New York Times* on 19 September:

Miss Murphy's picture of her mother napping in a corner of a garden is as fine a portrait as I have seen for a long time, going far beyond mere likeness and, for that matter, beyond the suggestion of character to fuse both within an evocation of mood and place.

The artist met her husband, Harry Roseman, a realist sculptor when they were both students at Pratt, and they have had a mutually supportive working relationship. The two young artists lived in Hoboken and Jersey City at the beginning of their careers because they could not afford New York rents, and her paintings of that period reflect the milieu.

Fig. 9-8. Catherine Murphy, VIEW OF WORLD
TRADE CENTER FROM ROSE GARDEN (1976),
oil on canvas, 37″ × 29″

Self Portrait With Pansy (1975) is a somber study of Murphy and her cat before a window vista of dreary Jersey rooftops. Another New Jersey painting, *View of World Trade Center From a Rose Garden* (1976), captures the curious flavor of certain aspects of American life. In this work the foreground is dominated by a dewy bush of yellow roses on a green New Jersey lawn; behind it a mosaic of cars stretches out in a parking lot, and the distant New York skyline looms in the light. Although the artist records the scene with total detachment, an eery quality arises from the juxtaposition of the natural and man-made environment—the painting becomes a kind of metaphor for the

Fig. 9-9. Catherine Murphy, FRANK MURPHY AND HIS FAMILY (1980), oil on canvas, 41" × 46"

encroachment of the industrial society on rural America.

Murphy and Roseman moved back to her hometown of Lexington for several years and now live in upstate New York. In Lexington she painted her father, husband, and sister's children in the garden (*Frank Murphy and His Family* [1978]). Every leaf and blade of grass appears to be meticulously rendered, but the artist says:

Most of the time I put in much less than I see. . . . I put in only as much as I need to make things clear. . . . What moves me is a clarity of surface.[39]

A timeless stillness hangs over these scenes of families in backyards or friends seated at a table in simple, light-filled interiors. Art historian Susan Willand has said:

Though inspired by photography in areas of subject matter and composition [her paintings] transcend the commonplace and arrive at an enigmatic almost mysterious reality . . . intimate in scale and yet distant and aloof.[40]

Ellen Lanyon (1926–) is a surrealist painter who sometimes conveys a feminist message through fantastic imagery reminiscent of René Magritte and Giorgio de Chirico. A recurrent motif in her pictures is the box—the die box, the sewing box, or the magician's box—which has somehow come open and is teeming with reptiles, insects, and other strange objects. In *Super Production Die Box* (1970) a small magician's die box appears open in the upper left and then closed lower in the picture, as if in the sequences of a magic trick. In the center of the picture the box is seen open again at the climax of the trick. Reptiles, amphibians, and insects are pouring out. The box has been seen as a symbol of female sexuality, and the creatures as symbols of the repulsion many woman feel toward their bodies. Lanyon's boxes have also been interpreted as Pandora's boxes—open to release havoc on the world or to free themselves of evil. Sometimes a house is substituted for the box, as in *Cobra*

Fig. 9-10. Ellen Lanyon, SUPER DIE-BOX (1970), acrylic on canvas, 43″ × 51¼″

(1975), where an enormous, phallic cobra has stuck itself into the back of a house, and its huge head is thrusting up out of the chimney. In *Thimblebox* (1973) the box stands on top of a snake that is devouring an egg—"an obvious Freudian symbol," Lanyon has called it.[41]

Ellen Lanyon was born on the South Side of Chicago. Her grandfathers were both involved with the arts; one of them was a muralist for the 1893 Columbian Exposition and the 1933 Chicago World's Fair. She inherited paints and brushes from one grandfather at the age of twelve, and with her family's blessing did her first oil painting. During high school she attended Saturday classes at the Chicago Art Institute and won a scholarship to the Institute School after graduation. There she specialized in egg tempera painting of Chicago cityscapes in a kind of "sophisticated primitivism." In the late forties she won prizes in the museum's "Chicago and Vicinity" shows. She received a B.F.A. from the Institute in 1948 and an M.F.A. from the University of Iowa in 1950. That year she was awarded a Fulbright Scholarship to study at the Courtauld Institute of the University of London.

Returning to Chicago, Lanyon did a series of nostalgic monochromatic oil paintings of an earlier generation in that city—interiors peopled by relatives, dead or alive—painted from old photos. This element of nostalgia is still an influence on her mature work.

A trip to the Mediterranean with her husband and children in 1962 led to an interest in the mystical and the fantastic. Around this time her husband brought home an old book on magic, and she started a series of paintings on table magic. Soon, her friends began to give her catalogues of magic equipment, and she took her imagery both from them and from nature.

Lanyon developed an allergy to turpentine in the early sixties and began to use acrylics. While working on her magic series, she realized that she could use the acrylics the way she had much earlier used

tempera—with glazing and overpainting on fine linen covered with several sanded coats of gesso (an old Flemish technique).

In the early seventies, influenced by feminism, Lanyon combined symbols of women—boxes and houses—with insects, birds, snakes, lizards, and nostalgia objects such as scissors, thimbles, teacups, and playing cards (e.g., *Thimblebox* [1973]). While producing these paintings, the artist also involved herself in the women's movement and helped organize the Chicago branch of the West East Coast Bag (WEB), a national and international women's art organization.

Lanyon has suffered from all the problems that the triple career of wife, mother, and artist usually entails. "In those days," she recalls, "one had to be a superwoman."[42] But now, as a result of consciousness-raising experiences in the women's movement, she feels free to leave her household to teach elsewhere. She has in fact lectured and taught at numerous colleges and universities, was a member of the board of directors of the College Art Association, has been visiting artist at leading universities, and has received an imposing list of fellowships and other honors.

In recent years Lanyon has moved out of the "box" imagery and into other subjects—birds, flower, fans—painted with an almost Audubon-like precision. Unlike Audubon's work, however, Lanyon's images shift from the real to the unreal in magical ways.

Barbara Rossi, Christina Ramberg, Gladys Nilsson, Irene Siegel, Miyoko Ito, and June Leaf are other outstanding women artists associated with the Chicago Imagist school. In general, the work of Chicago artists has been characterized by a kind of funky, aggressive surreal imagery of great vitality. Since the early sixties **May Stevens (1924–)** has been a painter of large acrylic canvases dealing with political themes such as the freedom riders, the Vietnam War, and the women's movement. Her ideas in these paintings of social protest are em-

bodied in symbolic figures painted in a kind of brilliant-hued, post-Pop realism. She has symbolized what she sees as the imperialist, sexist, and racist aspects of American society in a bullet-phallic-headed, undershirted figure called "Big Daddy."

Stevens was born in Quincy, Massachusetts. She has described her mother as crushed and distorted—by poverty, by her lack of education, and above all, by the male domination of society. At an early age her mother had been forced to leave elementary school to go out and do housework, while her brother was kept in school. After Stevens left home, her mother was committed to a state mental hospital.

She said that her father, a shipyard worker, attempted to make up for his failure in life by being a racist and a bigot. He considered only the English, the Scots (of which he was one), and Germans acceptable.

Stevens received a B.A. from the Massachusetts College of Art in Boston in 1946. After illustrating a textbook and working on ads for a local newspaper, she went to New York in 1948 and attended the Art Students League, where she met and married the artist Rudolf Baranik.

Stevens went to Paris with Baranik, since he was studying there on the G.I. Bill. For a short time she attended the Académie Julian, but quit when she became pregnant. After their son was born, she lived in the suburbs and painted at home, freezing and getting arthritis in a cold, damp house. Despite these obstacles, her work was shown in a cooperative gallery run by American students, the Galerie Huit, and received favorable notices.

One of the pictures in this show was Stevens's first picture with political content. It was called *The Martinsville Seven* and dealt with seven black men who were accused of rape. The picture was abstract, and the critic for the *Paris Herald* said his only objection to it was the title, since he did not approve of political emphasis in art. Stevens was to

find this a recurring theme with her critics in the ensuing years.

Returning to New York in 1951, she taught in the high schools for five years, but left her secure job at the High School of Music and Art in 1957 to complete work for an exhibition. Since then she has taught at Parsons School of Design and elsewhere.

In the early sixties, Stevens became interested in the civil rights movement. When Malcolm X was killed in 1965, she went to see him laid out, and she also followed the news of the bus burnings in Alabama. Out of this absorption came an exhibition called "Freedom Riders" in 1964. Martin Luther King, Jr., wrote the introduction to the catalogue, and the show traveled through the South. Stevens was also active in the anti–Vietnam War movement. It was out of these interests and out of her thoughts about her own life and family and their relation to the political currents of the late sixties that her Big Daddy series originated.

She painted, she has told us, "out of love for those lower-middle class Americans . . . and out of a great anger for what had happened to them and what they were letting happen, making happen in the South and in Vietnam."[43]

Because dealing with her mother caused her impossible pain, Stevens began to paint her father. Although she loved him, she saw him as a prototype of the American psychology that made Vietnam possible. In 1969 she did a portrait of her father in an undershirt before a blank TV screen (*Prime Time*). The figure is stylized, bullet-headed, but human. Gradually, the figure changed in successive treatments of the theme. She took the name Big Daddy from the character in Tennessee Williams's play *Cat on a Hot Tin Roof* (1955). The concept ceased to be her father and became more stylized, with bright colors and clear, sharp edges.[44]

The first painting to be called *Big Daddy* (1968) shows a figure with a bulldog in his lap and an army fatigue cap on his head. In *Big Daddy Paper Doll* (1970), a large acrylic, six feet high by fourteen feet

long, the Big Daddy figure sits with his bulldog, his nude white body pudgy, with a self-satisfied smile on his face. Ranged alongside of him are empty uniforms that can be attached to him, as in a child's paper doll dress-up set. The uniforms are of the Klu Klux Klan, the army, and the police. These pictures are painted in flat, bright, hard color—usually suggesting red, white, and blue. In fact, in *Pax Americana* (1973) Big Daddy is literally wrapped in the American flag. When the women's movement came along, Stevens decided that the same symbol also represented male chauvinism and the patriarchy.

She started to introduce her friends into her work in the mid-1970s. These pictures embody humanism, creativity, and other positive values. *May Stevens, Benny Andrews, the Artist, and Big Daddy Paper Doll* (1976) shows human figures painted and modeled realistically against the flat areas of the symbols of force.

In recent years, inspired by the feminist movement, the artist has turned away from vitriolic satire and has begun to celebrate the lives of women from history, myth, and from her own circle. In twelve-foot "history paintings," such as *Soho Women Artists* (1978) and *Mysteries and Politics* (1978), Stevens combines several levels of reality in unorthodox ways, juxtaposing portraits of her friends from the art world with symbolic figures of the Great Goddess, the revolutionary leader Rosa Luxemburg, the seventeenth century artist Artemisia Gentileschi, and her own mother. Her colors are deep jewel tones of blues, purples, and grays, and the shapes in her compositions are organized with keen sensitivity to the space relationships on the picture plane.

Stevens's political paintings have all run up against hostile criticism because the dominant trend in American aesthetics of the fifties, sixties, and seventies has been against political propaganda art. Stevens has been categorized as a caricaturist for her symbolic figures. With the ad-

Fig. 9-11. May Stevens, PAX AMERICANA (1973), acrylic on canvas, 60″ × 38″

vent of the women's movement in the seventies and its emphasis on political commitment, the inventiveness of her compositions and the power of her symbols were recognized and appreciated.

Sylvia Sleigh has added a new dimension to art by painting the male nude from a woman's viewpoint. For centuries men have painted the nude female, but in the 1970s women felt free for the first time to reverse these traditional roles.

Raised in the seaside town of Brighton, England, Sleigh felt the full brunt of European sexism—which she claims is much worse than that in the United States—when she was growing up. Her father was disappointed that she was not a boy, and was strongly opposed to her desire to study art, calling it "a mug's game." At the Brighton School of Art in Sussex, the male faculty denigrated her work, and Sleigh remembers: "I was so discouraged when I graduated that I abandoned painting entirely for a while, thinking it was futile, and went to work as a dressmaker."[45] (When she tried to get a job as a commercial artist, she discovered that British publications did not hire women for those positions.)

But Sleigh became depressed without painting; so a psychologist urged her to resume it. It made her very happy to paint again, despite the fact that she worked in obscurity for seven years without showing her work to anyone.

Sleigh met art historian Lawrence Alloway in evening art history classes at the National Gallery in London, and after marrying him, accompanied him to the United States, eventually settling in New York City. She was already exhibiting at the Hemingway Gallery in New York in 1970 when she became friends with artists Nancy Spero and May Stevens, both ardent feminists, who drew her into the Ad Hoc Committee and Women in the Arts— organizations that were pressuring the museums to end discrimination. For the first time Sleigh found herself surrounded by encouraging women with whom she could share her experiences, and who made her suddenly realize that her early struggles were part of the general experience of women artists.

She became active in the women's art movement and was one of the principal organizers of the 1973 exhibition "Women Choose Women" at the New York Cultural Center. One result of her cooperation with other women was that her own work took on a new content and even a new form. The artist has said that her color schemes have even changed. At first, because she was still filled with repressed anger, she used strong, acid color schemes, which she describes as "angry." Today her colors have a high-key, blonde tonality—airy, soft, transparent.

Sleigh began to challenge the viewer by overturning the stereotypical relationships of the past. In *Philip Golub Reclining* (1972), for example, she reverses the traditional artist-model relationship found in Rembrandt, Picasso, and other male artists. Showing herself reflected in a mirror in the background—the fully dressed, active artist at the easel—she paints her passive nude male model stretched out in the foreground, exposed in all his sensual beauty.

In *Paul Reclining* (1974), the male nude "odalisque" is stretched out on his back, arms cut off by the picture frame. Body hair is painted in minute detail, not only for the full enjoyment of its sensuous, ornamental qualities, but also as a kind of rebellion against the dishonesty of the slippery, hairless nudes of academic tradition. Art historian Linda Nochlin has said that Sleigh "refuses to consider her naked subjects as anonymous models. Sleigh's male nudes are all portraits, and so to speak portraits all the way, down to the most idiosyncratic details of skin tone, configuration of genitalia or body-hair pattern."[46]

Sleigh, a scholar of art history, religion, and mythology, admires and identifies strongly with the great tradition of western history painting. For this reason she chose to paint new and more democratic versions of several masterpieces of the past.

Works like Giorgione's *Concert Champetre* (c. 1508) and Edouard Manet's *Luncheon on the Grass* (1863) have shown fully dressed males, accompanied in arcadian settings by naked female figures. (The patronizing implication has been obvious—the men's minds are important, therefore they are clothed; whereas in the case of the women it is the body that counts.) In Sleigh's version of *The Concert Champetre* (1975), both men and women are democratically nude.

The Turkish Bath (1973), a free intepretation of a nineteenth century harem scene by Jean Auguste Ingres, is a group portrait of four well-known New York male art critics and a model posed nude against the patterned background of a Turkish rug. The old master, Ingres, is shown up as exploitatively erotic by contrast with Sleigh. The vapid identical faces of his female figures are as devoid of character as buttocks or breasts; their pink hairless, bodies are truly interchangeable "sex objects." Sleigh, on the

Fig. 9-12. Sylvia Sleigh, THE TURKISH BATH (1973), oil on canvas, 76" × 102". Left to right: Paul Rosano, Scott Burton, John Perreault, Carter Ratcliffe, Paul Rosano, Lawrence Alloway (foreground)

other hand, shows varied and individualized male bodies, complete with lovingly painted patterns of hairy fur and sharply differentiated portrait heads. Thus Sleigh's painting makes a wry indirect comment on the male chauvinism hidden in the great works of the past.

Beyond such ideological considerations, Sleigh offers us a feast of color and form. She particularly enjoys patterns, as in rugs, plants, flowers, and leaves—an interest that has made her a close student of Pre-Raphaelite painting. She has been active in the AIR cooperative gallery and is now in Soho 20, believing strongly in the value of such alternative women's spaces. She has painted group portraits of the women in both organizations.

Shirley Gorelick (1924–), a psychological realist who explores relationships between father and daughter, husband and wife, and between siblings, is a good example of the dedicated and talented woman artist who has still not received the full recognition she deserves. Neither a devoted photo-realist nor an expressionist, she uses all sources of information, working both from photos and the live model, and even from her own sculptures made from life, to get as close to the core of her subject as possible.

After receiving an M.A. from Teachers College, Columbia University, and studying with Hans Hofmann, she began as an Abstract Expressionist in the fifties. Becoming more and more uncomfortable with the distortion and fracturing of the figure in modern art, Gorelick worked her way back to realism in a series of reinterpretations of the masters. In 1967 she redid Picasso's *Demoiselles D'Avignon* (1906), using figures with real volume instead of fracturing them into Cubist facets. She included Picasso's portrait on the right, as if to say that he was her model, but she was going to reject his arbitrary reinvention of the figure.

In the early seventies, while working on a series called "The Three Graces," Gorelick decided to do

Fig. 9-13. Shirley Gorelick, WILLY, BILLY JOE AND LEROY (1974), acrylic on canvas, 80" × 80"

a Three Graces celebrating black women. She became friends with her model and painted a series of interracial families, followed by the powerfully individualized *Willie, Billie Joe, and Leroy* (1972), posed against the background of a previous painting on the easel.

Gorelick paints probing portraits of her friends and their children. *Sid and Lisa* (1976) contrasts the assured strength of a father with the insecurity of his daughter. The figures are presented frontally with contrasting hand gestures. Broad masses of dark and light and a red-and-black color scheme reinforce the strong theme.

Gorelick's study of *Three Sisters II* (1977), based on models ranging in age from seventeen to twenty-one, is a blunt, almost repellently honest portrayal of female adolescence. It is totally different from the stereotype of a nubile Lolita. The young women, robed and nude, in a leaf-patterned garden, are shown filled with varying degrees of pain,

questioning, anger, and confusion, which are communicated by nuances of position, gesture, or facial expression.

Gorelick is a member of the Soho 20 cooperative gallery in New York. She received a 1975 New York State Caps grant for painting.

Abstract Painting

Miriam Schapiro (1923–) expanded the role of abstract art by putting it at the service of women's liberation. By introducing new symbols, metaphors, and sumptuous materials—fabrics and decorative patterns—growing out of women's life experience, she created a new fusion of form and content.

Like many other women artists in history, Schapiro had the support of her father, who encouraged her and even set weekly drawing assignments from the time she was a small child. She identified with her father, an industrial designer who also ran for Congress on the Socialist Party ticket and served as director of the Rand School of Social Science in New York. Like him, she has combined a life as an artist with a role in public life. But today, as a feminist, she identifies equally with her mother—a warm, capable housewife.

Viewing herself as a professional from early childhood, she took classes at the New York Museum of Modern Art and drew from the nude model in Federal Art Project classes at night while still in high school. She was so proficient when she went to Iowa State University in 1943 for a Master's degree in art, that Mauricio Lasansky made her his first printmaking assistant. She also helped form the Iowa Print Group.

Fig. 9-14. Miriam Schapiro, MY NOSEGAYS ARE FOR CAPTIVES (1976), acrylic and fabric on canvas, 40″ × 30″, collage incorporating embroidered apron and handkerchiefs

At Iowa, Schapiro met and married fellow artist Paul Brach. When they both graduated, in the typical pattern of the forties, he was able to obtain a full-time position at the University of Missouri, while she found herself in limbo, facing the hard fact that in American society marriage was based on the unwritten assumption that the husband's career comes first. Fortunately, Brach was a liberated man, and in two years they moved to New York where opportunities were available to both of them.

In that heyday of Abstract Expressionism, Schapiro and her husband lived on 10th Street in a studio building where Joan Mitchell, Philip Guston, and other young artists lived. They became part of the exciting New York art community, and she was soon a well-known member of the "second generation" of Abstract Expressionists. Selected for the "New Talent" exhibition at the Museum of Modern Art, Schapiro exhibited at the Tanager and Stable galleries, and in 1958 at the prestigious André Emmerich Gallery.

At thirty-two Schapiro had a much-wanted child. Although deeply gratified to fulfill this previously unexpressed side of her nature, she was once again shocked to find her days fragmented by the conflicting demands that face a woman artist who also wants to lead a full and rounded family life. She took a job at the Parsons School of Design so that she could afford domestic help, and was able to salvage a certain number of uninterrupted hours in the studio. But suddenly, she was seized by paralyzing self-doubt and found that, despite years of success as a professional, she was unable to paint at all. Fortunately, her job gave her the means to enter therapy,[47] and she began to work her way into a new kind of form imagery. In her essay in *Working it Out* (1977), a book about the lives and work of creative women, Schapiro explains that she was suffering from the cumulative effects of being an isolated "token" woman artist in an overwhelmingly male art world.

Her sense of isolation as an artist, as well as the confusion caused by the multiple roles of wife, mother, and artist, and all the mixed messages that came from friends, parents, and society in general, contributed to Schapiro's sudden loss of identity. Converted by society into "Mrs. Paul Brach" when she and her husband socialized with collectors, writers, and artists, she felt inadequate because she could not accept the stereotyped roles that were foisted on her.

Up to this time Schapiro had worked in a successful version of the dominant Abstract Expressionist style, but starting in 1962, she felt a need to express herself in a powerfully individual way. Her new "shrine paintings" (1962–63), totally different from previous work, are vertical, altar-like icons that celebrate a new sense of self. Each "shrine" has four compartments; at the bottom is a mirror, indicating that she had to look into her own psyche to find artistic forms. Above that is a kind of female image, an egg, symbol of her creative self; next comes a carefully rendered segment of a great work of art; and the arched top section in gold expresses "Aspiration." In these works, for the first time—before she even became aware of the feminist movement—Schapiro was expressing feminist content.

In California in 1970, where she and her husband had both taken jobs at the University of San Diego, she began to use a computer. In collaboration with physicist David Nalibof, she programmed images (which she secretly identified with the "self") into all kinds of strange perspective forms and used them in a 1970 series of paintings. These were, incidentally, among the earliest efforts by an artist to use the computer as a creative tool—resulting in startling hard-edge forms that Barbara Rose has referred to as "abstract illusionism."

The original source of these images was an earlier (1968) painting called *Ox,* a metaphor for her female self. In the center of a strong, assertive, red *X* form, she put an open center painted in tender, soft

pink, symbolically expressing the idea that vigorous actions and logical thoughts could come from a woman's body. This painting, with its obvious vaginal and sexual allusions, had so embarrassed her that she kept it turned to the wall for six months.

It was not until Schapiro was invited to lecture to Judy Chicago's feminist art class in Fresno, California, that she told anyone about the hidden iconography in her work. To her astonishment, she found that Chicago had noticed similar imagery in the work of many women artists of the past. As a result of their discussions, they wrote an essay together for *Womanspace Journal* (Summer 1973), in which they theorized about "female imagery" in women's art. (She has since moved on to additional concepts.)

Impressed by the enthusiastic feminist activity that she saw in the Fresno women's art class, she invited Chicago to help her start a new Feminist Art Program at the California Institute of the Arts in Valencia. Schapiro was acutely aware for the first time that the conflicts and problems she had faced were caused by the sexist attitudes of the society at large.

A major project which grew out of the Feminist Art Program was *Womanhouse* (1972). Chicago, Schapiro, their students, and several Los Angeles artists converted an old house into a repository of the fantasies, frustrations, and nightmares of women. Schapiro threw herself intensely into this project for several months, and went through a consciousness-raising experience in which she reexamined her own past and her feelings about her role as a woman and as an artist. Part of the preparation was research into the long tradition of crafts, quilts, and other forms of anonymous and inadequately recognized art that women have created through the ages.

With another artist, Sherry Brody, she built a dollhouse for *Womanhouse*, which contained rooms—nursery, living room, kitchen, seraglio, studio. In each room she symbolically recreated her own woman's world. She included threatening and sinister images—a snake, or a menacing crowd at the window—but there were also images of joyful femininity.

Returning to her own painting after this experience, Schapiro found that she had entered a very productive phase of her own work. Images came welling up out of a new awareness; she no longer experienced feelings of isolation; she felt connected with the world of other women and now felt that she was painting for that audience. Into the strongly defined formal structure that remained with her from years of training, she introduced new symbols and materials that came from the new experience—patchwork, pieces of fabric, handkerchiefs, embroidery—which affirmed her sense of comradeship with women who had through the centuries made the unrecognized art forms of society. In the six-panel screen *Nightsong* (1973), she showed these patterned materials flying out of window-like openings—a metaphor for female liberation.

Schapiro has described the abstract symbols in *Lady Gengi's Maze* (1972), her first painting after working on *Womanhouse*:

Lady Gengi's Maze has three spaces. The foreground shows a plan for a garden . . . the middle space has three flying carpets . . . a distant space includes a black and silver flight of stairs leading to . . . a silver door. . . . The metaphors are all aspirational. The garden will be planted . . . the carpets will be ridden . . . the door will be opened.[48]

In this work the exuberant sensuosity of the three "flying carpets," with their evocation of female experiences in patterned chintz and calico patchwork, are contrasted with the austere black, white, and gray linear patterns in front of and behind them. The patchwork on the right has a torn "wound" through which the staircase may be seen, suggesting perhaps that through woman's suffering, and simultaneously through the feminine hollow, central space, can be seen the aspiring hope of the

ascending staircase. All of the shapes work cleverly on two- and three-dimensional levels at the same time.

When Schapiro tried to find reproductions of the work of women artists to use in her "Collaboration" series of collages, she discovered that there were only a few by Mary Cassatt and Berthe Morisot. Enraged at the knowledge that art history was totally shutting women artists out of textbooks, as well as the world of commercial reproductions, she began to challenge the male historians who sat with her on the board of the College Art Association. She became a thorn in their side, but perhaps has led some of them out into a broader consciousness.

Schapiro returned to New York in 1975 and helped start Heresies, a collective of feminists (including Lucy Lippard) who publish a journal and study the relationship between art and society. She

has lectured widely, served on the governing board of the Woman's Caucus for Art and on the board of the College Art Association, and was a founder of the Feminist Art Institute in New York. In recent ambitious large-scale works, such as *Anatomy of a Kimono* (1976) and her large "femmages" (as she calls them)—richly layered with fabrics, needlework, brocades, and painted patterns in fan shapes and other forms—she continues to infuse abstract art with a new sensuousness born of her feeling of joy and harmony as a woman and a woman artist.

In 1971, when **Judy Chicago (1939–)** was asked to speak to a class of well-bred upper-class girls at a small private California college, she began to talk to them about "cunt art." The professor who had invited her did not recover for months. Chicago's deliberate use of female genital imagery as a symbol for "the complete reversal of the way

Fig. 9-15. Miriam Schapiro, THEODORA'S FAN (1980), acrylic and fabric on paper, 15″ × 30″

women are seen in the culture"[49] has been controversial to say the least.

However one may disagree with the stance Chicago has taken, she is recognized today as an important figure who has contributed to the growing self-awareness of women artists and women in general. In her art, her teaching, and in her book *Through the Flower* (1975), she has raised issues women have never dared to deal with openly before.

Born Judith Cohen in Chicago to a family in which both parents worked, and in which it was taken for granted that women could achieve equally with men, she carried this assumption with her into adulthood. It was a great shock when she was gradually forced to recognize that she would be hindered in her profession because of her sex.

She identified particularly with her beloved father, a union organizer. At her home there were often meetings and discussions about the state of the world and how to improve it—a background that encouraged outspokenness and leadership. Deciding early to be an artist, she took classes at the Art Institute of Chicago while still in elementary and high school. There she spent much of her free time gazing at the magnificent Georges Seurat and Henri Toulouse-Lautrec paintings in that collection.

Chicago's father, under constant stress during the McCarthy witch-hunt era, was forced to resign from his union and slowly deteriorated in health after losing the job that had given purpose to his life. He died of a bleeding ulcer when she was thirteen, and she carried her grief around with her until her own bleeding ulcer forced her into therapy eight years later. Her widowed mother struggled to send her through school, and Chicago, when she became a feminist, expressed her appreciation in such works as her china-painted triptych *Did You Know Your Mother Had a Sacred Heart?* (1976).

A leader by nature, she was on the student council in high school. The boys working with her in student government acted threatened, and hurt her feelings by calling her "bossy" because she was direct and assertive. Confused, she did not realize until years later that men were offended at that time by women who came on strong as leaders; this was part of society's double standard.

She moved to California and in 1960 became a hard-working art student at U.C.L.A., and married a young writer, Jerry Gerowitz. When he was killed in a car accident she was overwhelmed with grief. Later she discovered with her therapist that she had internalized the idea that she was some kind of a monster whose aggressiveness had probably killed her father, and now her husband as well. One of the hardest problems she had to overcome was her fear of her own strength in a society that is more comfortable with docile women. Chicago helped to change society's attitudes in subsequent years.

As she entered the serious competitive arena of graduate school, she began to experience pressures that she felt were distorting her art and personality. Serious women students began to disappear from the ranks. Male peers made disparaging remarks about those who remained and about the two lone women teachers on the faculty. At first, proud to be "different," a token woman in a male art world, she joined in with these attitudes, but soon saw that male teachers were censoring her work. When she tried to express her grief about her father and husband in certain abstract paintings, she was greeted with shocked disgust. It was the heyday of minimal art; the emphasis in all the galleries and schools was on perfect, mechanical "fetish finish" and cold geometry devoid of content and feeling.

She found, she said, "[I had] begun to compensate for my situation as a woman by trying to continually prove that I was as tough as a man, and I had begun to change my work so that it would be accepted by men."[50] She adopted a "one of the boys" stance in dress and tough talk and even went to auto body school in 1964 to learn spray painting. She was the only woman in the class.

After getting her M.F.A. degree in 1964, she lived

with, and later married Lloyd Hamrol, an up-and-coming sculptor. Again, she was shocked to see how differently he was treated by curators, critics, and fellow artists. She was constantly told at Barney's Beanery (Los Angeles' answer to the Cedar Bar, the local hang-out for artists in the sixties) that no woman could really be an artist. She was referred to as a ''bitch'' when she and her husband agreed to share the household chores.

By 1968, despite these obstacles, she had achieved considerable recognition for her minimalist sculptures, and *Ten Part Cylinder* (1966–67) was in the 1967 ''Sculpture of the Sixties'' exhibition at the Los Angeles County Museum of Art.

In that year she reached a turning point. Certain personal experiences revealed to her that her real sexual nature had been previously repressed, and she decided to use female sexual symbols in her art, and to express her genuine female feelings instead of conforming to the male-dominated standards around her.

In 1970, she had a one-woman show at California State University in Fullerton arranged by gallery director, Dextra Frankel. As a symbol of a complete change of attitude, she decided to give herself a new name, Judy Chicago. In large letters on the exhibit wall, facing visitors as they entered was the following statement:

Judy Gerowitz hereby divests herself of all names imposed upon her through male social dominance and freely chooses her own name, Judy Chicago.[51]

She was disappointed when the critics and public failed to see the female sexual content in her abstract art. (For instance, the fading hexagonal forms sprayed on plexiglass in *Pasadena Lifesavers* (1969) were symbols of multiple female orgasms.) She came to the conclusion that she wanted to break with the male art world entirely and strike out in a new direction.

She applied to California State University at Fresno and received permission to start the first feminist art class in the country. Chicago developed innovative methods for releasing the energies of her fifteen women students. She taught them how to use tools; she encouraged them to do research into the history of women artists so that they could identify with the great role models that were at that time totally obliterated from establishment classrooms; but even more important, she developed techniques for consciousness-raising, performance, and role-playing, which brought out deep feelings about being a woman in a sexist society. The feelings that came pouring out were so violent that Chicago was at first frightened. But gradually, as her students worked their emotions through, they began to replace these negative feelings with optimistic attitudes about their own strength and capability.

When Miriam Schapiro, a well-known painter from the East Coast (whom she greatly admired), came to lecture to Chicago's class, a fruitful partnership developed between the two artists. In a discussion after the lecture, they discovered that they had independently arrived at many of the same theoretical ideas in their work. An open central core was the key to these concepts. They wrote an article for *Womanspace Journal* (1973) and helped organize an exhibition that attempted to uncover a previously unrecognized world of female imagery. Dextra Frankel was the curator of this landmark show, ''Invisible/Visible: 21 Artists,'' at the Long Beach (California) Museum of Art in 1972.

Working as a team, Chicago and Schapiro set about organizing a new department—the Feminist Art Program at the California Institute of the Arts in Valencia. Their goal was to create a womb-like study environment in which their women students would be protected against the biased criticism of male instructors and encouraged to express themselves honestly. A project called *Womanhouse* (1972)—conceived and executed with their Cal Arts students and several women artists from Los Angeles—caught the imagination of the public and

Fig. 9-16. Judy Chicago, FEMALE REJECTION DRAWING (1974), colored pencil on paper, 30″ × 40″

was filmed and televised.

When the public walked through the various rooms they found themselves in another world, a world of female psychological content. A bathtub was filled with sand into which a female figure seemed to be sinking and disappearing. The kitchen ceiling was covered with fried eggs made out of plastic that also resembled breasts. In a bedroom, a woman modeled on Leah, a character from a novel by Colette, sat endlessly painting her face with makeup, hour after hour. A mannikin was stuck fast in a linen closet, trapped in the sheets and pillow cases. According to news reports, some women walked through the rooms and burst into tears, overwhelmed by a sudden sense of the futility of their own lives.

When her students were criticized by male instructors at the California School of the Arts, Chicago decided there was no point in trying to work within male-dominated institutions. For this reason she left Valencia, and became one of the founders of the Woman's Building in Los Angeles. (She now has her own independent workshop.)

Meanwhile, Chicago was creating "female icons"—abstract paintings based on the vagina form, which, through changes of color and shape, are made to convey different feelings or ideas. For example, in her *Female Rejection Drawing* (1974) the forms are painfully peeled back to expose a vulnerable center. *Through the Flower: Chrysanthemum* (1973) is a petal-like circular image with a glowing center space, something like a sky, that beckons all women to "go through the flower" into the open space of freedom.

In the early seventies, Chicago had been turning over in her mind various possibilities for a major creative effort, and had considered a female Last Supper. At an academic dinner party in 1974 she was struck by the fact that the "men at the table were all professors and the women all had doctorates but weren't professors."[52] The men carried on a discussion while all these talented women sat silent. "I started thinking that women have never had a Last Supper but they have had dinner parties. Lots and lots of dinner parties where they facilitated conversation and nourished the people."[53]

The Dinner Party project emerged from this experience. It is a kind of room-sized sculpture—a permanent memorial to women's contributions to culture and history—in the form of an enormous triangular table (139.5 feet around its sides), so large that it cannot fit into most exhibition spaces. On it are 39 place settings symbolizing 39 great women of the past, beginning with a prehistoric goddess and ending with Georgia O'Keeffe. Each setting contains a plate, glazed and carved with an appropriate symbol (based on a variant of the female butterfly-vagina form), and a porcelain chalice and flatware on a runner. The runner, or placemat, is embroidered and ornamented with some form of traditional stitchery related to the historical period of the particular woman. On the white porcelain tile floor below the table, the names of 999 important women in history are painted in gold. A film documentary and a book describing the *Dinner Party* project are also part of this multimedia production.

Chicago enlisted the aid of hundreds of women and several men, and labored for five years to complete *The Dinner Party*. With the aid of trained experts, she taught her students the crafts of ceramics, weaving, stitchery, and needlepoint. She delved deeply into historical research. The use of decorated dishes as her symbols came naturally out of her new interest in china painting, a neglected woman's craft carried on in the United States since the nineteenth century in a kind of denigrated female sub-culture. Chicago reached out and converted this "put-down" art form into a proud new medium, deliberately using it to reverse the way women are seen in the culture.

Chicago describes the basic impulse behind this large cooperative effort, which opened in 1978 at the San Francisco Museum of Art and traveled to

Fig. 9-17. Judy Chicago and the Dinner Party Project, THE DINNER PARTY (1979), 39 porcelain place settings on embroidered fabric runners, 48′ × 48′ × 48′

Boston and the Brooklyn Museum:

One thing I find myself very uncomfortable with is the present role of art—its powerlessness. In the Middle Ages art functioned educatively, spiritually. I really believe that art has an incredible capacity to illuminate reality, bring a new perspective and bridge gaps.[54]

Chicago wants her art form to have an impact on society, and *The Dinner Party* has certainly had an impact—it has been a media event wherever it was shown. In fact, the Brooklyn Museum had to sell Ticketron tickets to accommodate the overflow crowds of 75,000 people who came to see it.

No exhibition since the 1913 Armory Show has aroused so much controversy or polarized the art community to such a degree. Many women viewing it experienced an almost religious exaltation, and critic Lucy Lippard called it "awesome . . . one of the most ambitious works of art made in the postwar period, [which] succeeds as few others have" (*Art in America* [April 1980]). On the other hand, Hilton Kramer of the *New York Times* called it "an outrageous libel on the female imagination" (17 October 1980, p. C7).

Many critics and artists—including women—disagree with Chicago's orientation. In their opinion, Chicago is creating new ghettos and reinforcing old stereotypes about the differences between men and women. Whether or not one agrees with Chicago's art theories, it is undeniable that she has had an impact. Through her books, her lectures, her paintings, and her role as leader, she has made women look around and question the standards they have accepted from the sexist society in which they live and work. She has documented the thousands of ways in which women slowly lose their strength and initiative in a culture bent on keeping them in the position of the second sex.

Looking at the work of **Joyce Kozloff (1942–)** at the Tibor de Nagy Gallery in New York, a male critic sniffed contemptuously, "It looks like embroidery." Kozloff laughed: "Good. That's just what it's supposed to look like." She is one of those feminist artists who in the early 1970s refused to be intimidated from expressing their feelings for decorative motifs and patterns. A worker for various feminist causes, she has been particularly influential in removing the stigma traditional aesthetics has attached to decoration. In so doing, she has helped to break down the barriers between the so-called "high" and decorative arts. Her work uses patterns from such diverse sources as quilts, Navajo rugs, pre-Columbian folk art, and Berber rugs woven by Moroccan hill women.

Born Joyce Blumberg in Somerville, New Jersey, she studied at the Art Student's League in New York and at the Carnegie Institute of Technology in Pittsburgh, where she received a B.F.A. in 1964. After study at the University of Florence (Italy), she returned to Columbia University to study with Theodore Stamos, and received an M.F.A. in 1967. In that year she married Max Kozloff; they have one child.

The dominant trend in art schools when Kozloff was at Columbia was the hard-edge minimalist painting in which two or three shapes were put on the canvas in flat, unmodulated color. She painted this way for two years after leaving school. Finding such reductive work personally unsatisfying, she began to incorporate the folk art patterns that characterize her mature work. Her paintings became ostentatiously decorative, and she aggressively defended women's right to satisfy their love for sensuous patterning in art. Kozloff traveled the world to find her source material in places as far apart as Mexico and the Islamic countries.

Sometimes she bases her large acrylic canvases on one pattern with a border, as in *Notions of Finish: The Portal* (1974), but in others she mixes several different patterns from different cultures, as in *Tent-Roof-Floor-Carpet* (1975). Today she designs entire rooms in decorative patterns and calls them "Interiors Decorated."

Kozloff's paintings integrate three different facets of contemporary art: hard edge, color field, and decoration. She still retains the powerful structure

413

of hard-edge painting, with its interlocking and reversing negative-positive forms, but enriches it with the intricate textures of lines and strokes that cause the viewer to examine and savor the work carefully at close range.

Kozloff has taught at Queens College, the New York School of Visual Arts, the University of New Mexico, and elsewhere. In recent years her interests have expanded into the field of decorative ceramic tile. She is presently employed on such ambitious projects as a wall in the new Harvard Square subway station in Cambridge, Massachusetts. Other women working in the "Pattern Painting" movement are Valerie Jaudon, Mary Grigoriadis, Dee Shapiro, and Susan Michod.

Howardena (Doreen) Pindell (1943–) explores daring and "dangerous" new formal structures in subtle paintings and collages. Some of her complex layered drawings are made of thousands of small circles of painted paper, pushed out with a hole puncher and reglued into compositions. (She has also begun to incorporate photographs in some of these.) Her canvases, loosely sewn together out of grid-like strips, are thickly embedded with paint, tempera, colored dots, glitter, and even talcum powder. She has also made "video drawings" by photographing images from the video screen and overlaying the ghostly images with random numbers and arrows.

Pindell is one of the small number of black women artists who have at last achieved the long-overdue opportunity to study at the most prestigious graduate schools and are securing first-rank academic positions. She received a Master's degree from the Yale School of Art and Architecture in 1967, was associate curator of prints at the New York Museum of Modern Art, and is now a full professor at the State University of New York at Stonybrook.

Pindell was an early member of the AIR women's cooperative gallery and worked with the *Heresies* collective and other feminist groups. She is also active in cross-racial groups promoting the work of minority artists. Because of her exceptional talent and education, Pindell has said that she has often found herself in the painful position of being used as a token black woman in various organizations. She has expressed her feelings about this in a videotape entitled *Free, White & 21,* in which she reverses the stereotypes by appearing in "white face."

Joan Snyder (1940–) is a painterly abstractionist who has added to her canvases symbolic imagery such as valentines, clumsily sewn slits in the fabric, cheesecloth, chickenwire, as well as words. In the 1970s, the form and content of her paintings were greatly influenced by the women's movement and her own feminist consciousness-raising.

In *Small Symphony for Women I* (1974) the words on the left side of the picture grew out of a protest over the refusal of the Rutgers University art faculty to show women's art. They read:

If there is a female sensibility language art
emerging how can all male faculty
at Douglass [the Rutgers all women's college] choose
select judge
Women artists who apply? They can 4 if they didn't they
only
chose 4 in 20 in 2 years
They would protest—of course.[55]

Other words read, "Women hunger, I hunger."

The slits, gauze, loose mattress stuffing, and sewing in some of her pictures are clearly female sexual imagery. These elements are combined with a richly pigmented surface, sometimes worked as in traditional Abstract Expressionist painting, and sometimes consisting of separate horizontal strips of color or discrete rectangles.

Snyder was born in Highland Park, New Jersey, received a B.A. and an M.F.A. (1966) from Rutgers's Douglass College, and then moved to New York City. She married a photographer, and in 1974 they moved to Martins Creek, Pennsylvania, for a while to escape the pressures of the city. Today she lives in a New York studio loft with her young daughter.

Her earliest work, done in the years after she came to New York, was abstract in the manner of Paul Klee, Hans Hofmann, Willem de Kooning, and Robert Rauschenberg. Her paintings consisted of separate strokes of oil or acrylic, with some drip-

ping of the paint, as in *No Skeleton for Evsa* (1971). Often these strokes formed a kind of open grid with random letters like the *D*s, *L*s, and *M*s in *Moonshine for D, L, & M* (1973).

In 1971 Snyder participated in a feminist consciousness-raising group and began to put on a series of shows of women's art in the library at Rutgers because the all-male faculty would not show it in the art school gallery. Periodic discussions were organized around these shows over the years 1971–1974 and by the end of this period, three hundred people were attending them. Snyder

Fig. 9-18. Joan Snyder, HEART-ON (1975), oil, acrylic, mixed media on canvas, 6½' × 8'

said, "It was the most inspiring thing for me to see how suddenly the program that I had started . . . became so successful."[56]

At this point she went home and painted *Small Symphony for Women I* (1974). A fairly large triptych measuring two feet square in each of three panels, the painting "was the beginning of a lot of my conscious efforts toward talking about women, women's place in the world, women's pain and strength."[57] The first panel includes a listing of words and political ideas; the second is an expressionistic, stormy abstraction that, according to the artist, says the same things visually as the first panel does verbally. The third panel, with its ordered vertical and horizontal stripes of paint and its orderly rectangles, is a resolution of the first two.

Vanishing Theatre (1975) has a similar organization. On the left a panel of words carries the label, "Lament in Words." In a center section, the left panel is labeled, "Vanishing Theatre, The Cut." The work's large central image consists of a long diagonal rip in the canvas, packed with papier mache and resembling large, swollen vaginal lips. On the right, there are ordered horizontal and vertical rectangles. Snyder has said that *Vanishing Theatre* is about "cutting a very close friend out of my life."[58] The title comes from a phrase in George Eliot's novel *Middlemarch* (1872) in which the heroine says of her close friend who has died, "The theatre of all my ideas has vanished."

Snyder's art is extremely personal and cannot be described simply in political or formalistic terms. In *Heart On* (1975) the array of thick projecting hearts on the canvas, the vaginal slits (one with the adjuration to "sew here"), and the dripping thread, obviously have autobiographical significance, as do the pulling tearing lines in *Mom's Just Out There Tryin to Break That Grid* (1975).

Snyder has shown a remarkable ability to reveal naked intimate feelings through abstract means. She has taught at Princeton University, and was in the Museum of Modern Art's "Works on Paper" exhibition in 1981.

Jennifer Bartlett (1941–) combines the film-computer-systems mentality of the late twentieth century with the sensual qualities of a painterly painter. Bored with Abstract Expressionism and the limitations of the single image, after graduating from the Yale School of Art and Architecture, she began to "program" certain themes into a logically organized progression of related images that move across the walls in a changing rhythm of time and space.

In her *tour de force, Rhapsody* (1975–76), she covered the walls of the Paula Cooper Gallery with 988 variations of house, tree, mountain, and ocean, painted in Testor's enamel (the kind used to paint airplane models) on twelve-inch steel plates. Each plate was silk-screened with a grid containing 2,304 cells for variations of "bits" of information. The images move back and forth between realistic forms and abstract rhythms and textures, ending with a transcendental, blue "ocean" theme.

For the Federal Building in Atlanta, Georgia, Bartlett created a two hundred-foot mural combining painted steel plates and painted canvas (*Swimmers: Atlanta* [1979]). In 1981 she "programmed" a theme throughout the building of the Institute for Scientific Information in Philadelphia. The theme, *In the Garden,* is stated in a thirty-foot multiple view of the garden in the lobby. On the other floors of the building, she dispersed smaller units that are variations of the "garden" theme.

Sculpture

Nancy Graves (1940–) has produced works in a number of media and styles. She is perhaps best known for her life-sized sculptures of camels and of paleontological sculptural forms. But she has also painted gouaches of undersea creatures, map-like pictures of the moon, and calligraphic oils, and has made several films. According to prominent art critic Barbara Rose, she is related to contemporary artists such as Jackson Pollock, who in their work use "Jungian archetypes and primordial sub-

jects.''[59] Graves has herself indicated on several occasions that her art belongs to science: to anthropology, to paleontology, to computer mapping, to oceanography, and to the psychology of perception. In fact, in her recent work she seems most interested in semiology—the science of signs—and has spoken of her calligraphic brush strokes as ''gestures'' that are ''coequal to sign and symbol.''[60] In general, from her early camels, with their literal presence, to her most recent gestural ''signs,'' her work has become increasingly abstract.

Born in Pittsfield, Massachusetts, Graves received a B.A. from Vassar College in 1961 and an M.F.A. from Yale in 1964. The following year, on a Fulbright-Hayes grant in painting, she studied in Paris; in 1966 she lived and worked in Florence.

While working in Florence, Graves discovered in the Museum of Natural History there the inspiration for her camels and skeletal forms in the work of an eighteenth century anatomist named Susini. Susini had made drawings and wax models of human anatomy, and Graves found an uncanny quality in them. ''The results,'' she said, ''were art. . . . The attempt to be rigorous about whatever the problem was, was much more thorough and complete than most artists are. . . . The significance of this for me was that Susini had produced a complex body of work from a single point of origin.''[61]

Graves picked the anatomy of the camel as her ''point of origin.'' She made a film of camels and analyzed their motion, and visited Los Angeles to see the pleistocene forms at the tar pits there. From

Fig. 9-19. Nancy Graves, VARIABILITY OF SIMILAR FORMS (1970), steel, wax, marble dust, acrylic, 7′ × 18′ × 15′

this literal base she developed the abstract quality of her forms. After the life-sized camels she exhibited in 1968, she went on to do a series of paleontological skeletal forms in 1969–70. Sometimes the forms stood on armatures; sometimes they were scattered in abstract patterns on the floor, as if they were fossils discovered in the field. The area covered by some of these pieces was quite large—20 × 25 feet—and part of the experience of the work was achieved by the spectator's moving around in it to see the relation of the parts from different angles. Some of these skeletal forms hung from the ceiling.

In 1971, as a further development of this idea, Graves exhibited hanging, abstract figures—among them, some made of latex, muslin, and wire—inspired by ceremonial costumes of the Northwest American Indians. Robert Hughes, writing in *Time,* found in them a "poignant memorial to dying primitive cultures."[62] Some of these hanging sculptures were made of bones, skin, membranes, and other parts of animals.

Also in 1971, Graves did a series of pictures painted in dots that resemble the kind of computer print-out used in undersea and aerial mapping, including *Lion Fish in Grotto, Sea Anemone,* and *Julius Caesar Quadrangle of the Moon.* In 1976 she did a series of gestural paintings, such as *Bish, Duir,* and *Luis,* in which calligraphic lines in various colors are drawn on a predominantly white canvas, each in a single stroke of the brush. Today she layers her paintings with gestural systems derived from all of her previous investigations, producing complex movements in spatial depth on the canvas.

Graves started from a single point of origin to explore a problem thoroughly. So far she has explored several. The unifying thread running through all this apparent eclecticism has been her interest in the way people perceive and the signs through which they realize their perceptions and communicate them to others.

Betye Saar (1926–) makes collages and boxes that most immediately call to mind the work of Joseph Cornell. Saar's prints and boxes, however, are filled with symbols of the black experience, the occult, and nostalgia. Perhaps her best-known symbol of black militancy is the imposing figure of Aunt Jemima holding a rifle and pistol against a background of small labels showing the "happy darky" face of Aunt Jemima on the pancake box in *The Liberation of Aunt Jemima* (1972).

Saar was born in Pasadena, California. She had a grandmother living in the Watts neighborhood of Los Angeles near the famous Simon Rodia Towers, and as a child she watched them being built. The so-called Watts Towers were built by an Italian immigrant named Simon Rodia, out of pieces of junk—broken glass, bottle tops, and shards of crockery set into cement. The character of Saar's work was permanently influenced by her early experience of seeing the towers under construction.

Her mother was interested in the occult and believed that Betye was clairvoyant. Although Saar soon recognized that she did not have special "powers," she has retained an interest in mysticism since that time.

She drew a lot as a child, but did not make the decision to be an artist until she was thirty-four. She received a B.A. from the University of California at Los Angeles in 1949, then married an artist and had three daughters. In 1956 she went back to school—California State University at Long Beach—to get a teaching credential. There she became so interested in printmaking that she decided to work on a Master's degree in graphic design. After winning some prizes for her prints, encouraged by a teacher at Long Beach, Saar decided to become an artist rather than a designer. Perhaps one result of her increasing success is that her artist-husband began to have competitive feelings, and these feelings may have contributed to the couple's subsequent divorce.

Initially Saar produced color etchings. Toward the end of the sixties, however, she saw Cornell's boxes at an exhibit in Pasadena. She had always liked collecting and assembling small objects, and had already been putting her prints into deep frames and behind windows, as in *Black Girl's Window* (1969); so the move into assembled boxes was natural for her.

Saar's mystical, occult works include symbols such as the tarot deck (*House of Tarot* [1966]), the signs of the zodiac (*Window for Leo* [1966]), or moons and stars (*Black Girl's Window* [1969]). Some are based on African and Oceanic motifs. A *mojo* is a fetish or good luck charm. *Nine Mojo Secrets* (1971) is an assemblage with the eye of the universe at the top, a picture of an African ceremony in the center, and a skirt of fibers, beads, and bits of seed below.

Deeply moved by the death of Martin Luther King, Saar began to produce a second group of works in the late 1960s. She collected the anti-black racial slurs found on commercial products and in the stereotypes of white folklore, and used them to create militant liberation art. *The Liberation of Aunt Jemima* (1972) turns the "mammy" of the pancake box into a gun-toting revolutionary. *Whitey's Way* (1970) is a box full of white alligators; the sides of the box are covered by American flags. This work is a sardonic commentary on the white "joke" that pickaninies are alligator food. *My Last Buffalo* (1973) memorializes the Wounded Knee incident and shows Saar's identification with other minorities.

Saar's black nostalgia pieces are, in her own words, softer and gentler. They evoke a bittersweet nostalgia for the days of her childhood—the twenties and thirties. Boxes with faded old photographs of black children, bits of feathers and lace, old gloves, butterflies, tarnished silver spoons, and dried flower petals—with titles like *Gone are the Days* (1970) and *Grandma's Garden* (1972)—give a

Fig. 9-20. Betye Saar, THE LIBERATION OF AUNT JEMIMA (1972), mixed media, 11¾" × 8" × 3¾"

sense, through intermingled symbols of mortality, of the beauty and the transience of life.

But even in these pieces there is social criticism. The *Shield of Quality* (1974), for example, shows upper-middle-class black people surrounded by

419

symbols of elegance—lace, a painted dish, a bit of a feather boa, a silver spoon. These pieces come in a yellow box, symbolizing the high yellow color (lighter skin color) that in black society is sometimes considered necessary for upper-class status. In this way the piece criticizes the idea in American black culture that whiteness or lightness is superior.

Paradoxically, Saar's work has a universality that transcends the ethnicity that sometimes motivates it. At one group show she was approached by an older Jewish woman whose memory of childhood was reawakened by one of Saar's boxes. Her occult pieces sometimes suggest, in mixtures of Moslem, Jewish, Christian, Chinese, and other symbols, the essential nature of the mystical side of all religions.

In recent years Saar has begun to explore buried personal feelings. She consulted a psychic and discovered her deeply repressed sadness over the death of her father when she was six years old. Recognizing that much of her work contains symbols related to death, she is now moving "beyond the past" into new themes and techniques in a series of collages incorporating color xerox images. Saar was given a solo show at the Whitney Museum in 1975 and is an art professor at Otis-Parsons Institute in Los Angeles.

Nancy Grossman (1940–) is known for her disturbing sculptures and drawings of leather-bound heads and figures. She was born in New York City, the eldest in a family of five children. When she was six, her Italian mother and Jewish father, along with two aunts, bought a farm in Oneonta, New York. There the three families, including sixteen children, moved.

Unhappy (and always in "hot water") in the rural high school, she decided she wanted to be an artist with no real knowledge of what that was. She went to Pratt Institute in 1958, and when the family fell on hard times and had to move to Arizona, she defied her father's command to return home, getting a scholarship and a job so that she could remain at Pratt. She remembers feeling terrible about standing up for herself against her father's will.

Her childhood memories appear to be rather stormy. A rebellious and non-conforming child, she recalls that she was punished a lot, and she claims to have internalized the hostility of adults into anger against herself.[63]

Her earliest drawings, exhibited in 1964 at the Oscar Krasner Gallery in New York, showed the failure of communication between men and women and already revealed a disturbing, visceral quality. In 1966–67, after receiving a John Simon Guggenheim grant, she began to show collages of found objects. The tubes and lacings of these collages had a ruptured, violated quality, like torn-open viscera. *Untitled* (1967) looks like a group of organic tubes ripped open.

After her Guggenheim she decided to accumulate a sum of money doing book illustrations so that she could take off another year for her art. At the end of this period, when she finally got back into her studio, she was unable to carry on with her collages. Instead, Grossman picked up the repeatograph pen she had been using for the book illustrations and began to draw what came into her arm. The first thing she did "was the drawing of a head, belted up, closed up, and I felt as if I had done something dirty and secret."[64] Although she had not done figurative work for many years, she now felt a compulsion to make more of these drawings and also sculptures of similar subjects. Since she had been working with leather in some of the collages, it seemed natural that the coverings should be leather.

Grossman showed these works to no one—hiding them like a guilty secret for a year and a half. She was appalled at the images that were beginning to emerge, but her integrity as an artist compelled her to go on with these honest statements.

Fig. 9-21. Nancy Grossman, FIGURE SCULPTURE (1971), wood and leather, 68″ high

Sometimes, as in *Horn* (1974), her heads will have a large phallic looking horn sprouting out from above their blindly bound eyes. Sometimes there is a closed zipper over the mouth, and sometimes gritted teeth show through, as in *Kazakh* (1971) and *Figure Sculpture* (1971). On some of the heads—for example, the *Unfinished Andro Series* (1969–71)—there are laces over the mouth shutting it tightly, and the head is completely bound in leather, with only the nose poking through. In *Portrait of AE,* a 1973 drawing of a nude figure with a bound head has a pistol with a telephoto sight tied close to its eye.

These strange figures are both terrifying and pitiable. While they sometimes suggest sadomasochistic aggressiveness, at the same time the figures appear to be prisoners: bound in leather, tied and blindfolded by straps, from which they are writhing vainly to escape, as in *Male Figure Study* (1969) and *Figure Sculpture* (1971). The leather coverings seem to be a kind of second skin which is needed to protect the vulnerable psyche of her subjects.

Grossman's amazing technique and powerful draftsmanship immediately brought her to the attention of the art world when these works were shown at the Cordier and Ekstrom Gallery, New York, in 1969, 1971, and 1973. She received the National Institute of Arts and Letters Award in 1974.

Grossman denies that her figures are explicitly male in their symbolism. When asked, she has said:

Whenever I wanted to say something specific, personal to the effect that I am a woman I would use a woman's image if the work were figurative. It seemed natural. But if I wanted to say something in general, I would use a man. It's as if a man were our society.[65]

Presumably, she feels that her figures are general depictions of the human condition rather than statements about men versus women.

Grossman's leather-bound and blinded figures move spectators deeply and irrationally. They arouse complex fears of aggression and of being

Fig. 9-22. Mary Frank, UNTITLED (WOMAN) (1975),
stoneware, 8 parts, 22″ × 18″ × 9″

bound in the same way ourselves. At the same time, we fear having the same impulses that we read into the figures.

Mary Frank (1933–) does stoneware sculptures that have the look of terra cotta fragments dug up at an archeological site. Sometimes a half-finished relief head barely escapes from the clay; sometimes a figure, as in *Untitled* (1975), lies in pieces.

Born in England in 1933, Frank had her first one woman show at the Poindexter Gallery in New York in 1958 and has shown at least once a year ever since then. She has taught at the New School for Social Research and Queens College and has been the recipient of numerous awards, including a National Council of the Arts Grant and a Guggenheim award.

Frank's terra cottas transmit complex emotions, often of an inexpressible melancholy and quiet pathos. In *Lovers* (1973–74) intertwined male and female figures made up of large, broken shards of clay lie in ancient-looking fragments that suggest both the transitory nature of passion and its endurance through time. Fossil-like imprints of the stems of ferns and leaves are pressed into the clay of the torsos, reinforcing the sense of nature and of life long gone, yet leaving its forms behind.

This emotional quality is combined in Frank's work, with an intense interest in the formal qualities of clay sculpture. Broken edges and contours of the forms curl in and out and alternate between jagged and smooth, positive and negative. The wings on some figures and the edges of the draperies wave to give them an airy, floating quality. As in all fine clay sculpture, there is the ever-present sense of the artist's hand shaping the material and feeling its way around the form.

Barbara Chase-Riboud (1936–) is one of the new generation of black artists who are entering the great universities—in her case, Yale—and earning international recognition. Since 1970 she has be-

come well known for her awesome, African-inspired abstract sculptures that combine polished bronze with silk and wool fibers.

Barbara Chase was born to a middle-class family in Philadelphia. Like many outstanding women artists in history, her father was an artist (in this case, a frustrated artist) who encouraged her talents. She was already taking art classes at the Fletcher Art School in Philadelphia at the age of seven and won her first prize in art at the age of eight. Chase earned a B.F.A. from the Tyler Art School of Temple University in 1957.

A 1957 John Hay Whitney Foundation Fellowship to Rome changed her entire outlook. (Whitney fellowships, awarded to gifted minority artists, have been critically important to a number of women.) During a side trip from the Academy in Rome, where she was working on bronze sculptures, she was accidentally left stranded in Egypt. As a result of this mishap, she was taken into the home of the American cultural attaché in Cairo (who happened to be black) and lived with his family for three months. In Egypt she was exposed for the first time to nonwestern art. She later told author Eleanor Munro:

I suddenly saw how insular the Western world was. The blast of Egyptian culture was irresistible . . . the sheer elegance . . . perfection . . . timelessness . . . depth. After that, Greek and Roman art looked like pastry to me.[66]

Chase-Riboud exhibited thin, linear bronzes in Europe such as *The Last Supper* (1958) that already show the influence of African masks. Then she returned to the United States long enough to earn a Master's degree at the Yale School of Art and Architecture with Josef Albers (she was the only black woman at the school). Immediately after graduating in 1960, she returned to Europe and has been based in Paris until recently.

In 1961 she married the noted French journalist-photographer Marc Riboud, had two sons, and during the next few years traveled widely in Asia and Africa with her husband. She was one of the first

Fig. 9-23. Barbara Chase-Riboud, CONFESSIONS FOR MYSELF (1972), bronze painted black and black wool, 120″ × 40″ × 12″

American women to travel in the People's Republic of China in 1965, and attended a Pan-African festival in Algeria in 1968. Greatly moved by her African-Asian experiences, Chase-Riboud returned to sculpture in 1966 after a five-year hiatus and began to do the work for which she is best known.

Her primary influence was African and Oceanic art, in which wooden masks, adorned with raffia and other soft fibers, cover the face of the wearer. The fibers hang down, concealing the body, and an imposing supernatural personage is created—the magical personage of tribal ceremonies. Chase-Riboud reinterpreted these images in modern, abstract terms. Using the lost wax process, she made bronze forms and then hung thickly braided, coiled, and knotted wool or silk fibers from them to the floor, so that they cover the base or armature on which the sculpture rests, as in *Confessions for Myself* (1972).

These sculptures have many-layered meanings. Chase-Riboud has indicated that *Zanzibar* (1972) can be described as black; that its beautiful surface has a "not far from threatening underbelly," which has "the same emotional effect as some African sculptures have on Westerners. . . ."[67] In her *Malcolm X* series (1970), she has said she wanted to create sculpture embodying the *idea* of Malcolm X, rather than a memorial to a dead man. The tall image in a sense embodies the qualities of the dead leader.

Fundamentally, however, these sculptures are abstractions exploiting the contrast between the polished, hard surface of the bronze and the softness of the fibers. Because the hard, "masculine" bronze has soft flowing forms, while the soft, "feminine" fibers in the skirt take on a hard form and appear to be supporting the bronze, she says that her work shows "the continuous relationship between the male and female elements as one takes on the characteristics of the other."[68] She is also uniting the traditional male "high art" of bronze sculpture with the traditional female "craft" of

weaving. Thus her work can be viewed as a primal, universal symbol of humanity.

Since her divorce in 1981, Chase-Riboud has maintained residences in New York, Paris, and Italy. Like many gifted women artists, she has notable literary talents and has published a book of poetry (*From Memphis and Peking* [1974]) and a novel about the slave mistress of Thomas Jefferson (*Sally Hemings* [1979]).

Chase-Riboud's magnificent design and craftsmanship have earned her individual shows at the Betty Parsons Gallery in New York, the University Art Gallery in Berkeley (1973) and the Massachusetts Institute of Technology. She has also had solo exhibitions in Paris, Düsseldorf, and Zürich, and is as well known in Europe as in the United States.

Jackie Winsor (1941–), an abstract sculptor born in Newfoundland, is the descendant of three hundred years of Canadian ships' captains and farmers. She moved to Boston with her family in adolescence and earned an M.F.A. in art at Douglass College of Rutgers University in 1967.

Winsor's sculptures of rope, brick, saplings, and pine, have a certain brute strength and power. Characteristic works are a half-dome of bricks set into cement, a bundle of trees wrapped around the middle with hemp (resembling a new form of haystack), a round coil of rope as thick as a truck tire, and a grid of criss-crossed saplings bound at the intersections with unraveled hemp. Often based on the sphere, the grid, or the cube, her pieces have a density, weight and tautness that grow out of the processes of wrapping and twining materials, or nailing boards in layers until they build up to an inevitable form.

Faith Ringgold (1930–) has invented an innovative art form to express themes of black awareness and feminism. She uses soft sculpture figures, masks, and painted hangings in performances that directly involve her audience.

Born and raised in Harlem, she has been interested in art since the age of two. She married a jazz musician, had two daughters, and after a divorce, finished college and taught art in secondary schools. While completing a Master's degree at City College of New York in 1959 with Robert Gwathmey and Yasuo Kuniyoshi, she decided to become a full-time artist.

At first Ringgold painted in the western tradition, but gradually she began to realize that this art was alien to her. In her first exhibition, "American People" at New York's Spectrum Gallery in 1967, she turned for inspiration to civil rights and political themes and to African rather than European design sources. In *Die* (1967), a mural of a street riot, she abstracted the forms into harsh angular patterns. Black and white people are shown scattering and bleeding against the gray, geometric blocks of the sidewalk, while in the foreground a black and white child hold each other, bewildered by the destructiveness around them.

Ringgold was one of the first activists to challenge discrimination against women in art exhibitions. In 1970, when the leading American male artists represented in the Venice Biennale pulled their work out in an "artists' strike against racism, sexism, repression and war," she and her daughter, Michelle Wallace, protested against the racism and sexism of the "striking" artists. The work removed from the Biennale was to be hung in a show at the New York School of Visual Arts, but Ringgold pointed out that the new show had no women or blacks in it either. As a result, the exhibition was opened up to women and minorities.

After helping to organize the Ad Hoc Committee that pressured museums to accept the work of women, Ringgold began to agitate against the exclusion of black women from exhibitions in an organization called Women Artists and Students for Black Liberation. This led to the formation of an exhibiting group of black women artists in New York called "Where We At."

Fig. 9-24. Faith Ringgold, DIE (1967), oil on canvas, 6′ × 12′

Ringgold reached a turning point in her work when she received a New York State grant to paint a mural for the Women's House of Detention on Rikers Island. The mural, which shows a world of achieving women,[69] was a success. But after hauling the heavy painting down fourteen flights of stairs (it was too big for the elevator), she began to reconsider her approach to art.

Deciding to create lightweight, portable art, Ringgold first painted thin cloth hangings that could be rolled up in the manner of Tibetan Tankas. Then she turned to soft sculpture figures and began to use them in performances. She told an interviewer:

Oil painting isolated me. It was a time in my life when I needed community around me; I needed the support. I found that sculpture communicated that need. At the time, I was teaching African crafts [at Banks Street College] and I thought "Why am I not using some of these techniques?"[70]

Ringgold's sewn, stuffed figures unite faces resembling African masks with beading, stitchery, fabrics, and furniture in arrangements that she uses to convey a social message. Her *Family of Women* is a group of figures of strong women she had loved and admired as a child in Harlem, such as *Aunt Edith and Bessie* (1974). In another series, *Weeping Women,* the mask-like heads have hair of raffia, faces of tapestry, tears of strung beads, and wide-open mouths to indicate that "women should speak out." She also fashioned larger-than-life-sized figures of black heroes such as Martin Luther King and Adam Clayton Powell, as well as images of "bag ladies" and other Harlem street people.

All of these light, portable art works can be easily thrown into a suitcase and brought to college campuses and lecture halls, where Ringgold involves her audiences in happenings centering on her soft sculpture characters.

Ringgold's unconventional political art is still not accepted by the leading New York museums and galleries, but she attracts wider and wider audiences in various parts of the country. Her synergistic art form—combining painting, sculpture, crafts, music, and drama—reaches out directly to the community in a way that presents an interesting challenge to the insular world of the avant-garde.

Other Sculptors of the Seventies and Eighties

The few sculptors discussed in depth were chosen as samples of several trends. Many more outstanding women sculptors are working today.

Environmental Sculpture and Site Works

Alice Aycock (1946–) builds strange archaeological-architectural structures that she calls "psycho-architecture." Sometimes they invite the viewer to look into or enter mystifying interiors; sometimes they play on feelings of claustrophobia, agrophobia, or vertigo.

Aycock's early works were underground forms in outdoor settings like *A Simple Network of Underground Wells and Tunnels* (1975). She progressed to "tower" or "garret" pieces approached by ramps or ladders, reminiscent of medieval cityscapes, as in *Flights of Fancy* (1979). She then began to introduce pulleys, water wheels, and other forms inspired by

Fig. 9-25. Alice Aycock, COLLECTED GHOST STORIES FROM THE WORKHOUSE (1980), cable, copper, galvanized steel, glass piping, motors, steel, wire, and wood, 30' × 75' × 120'

the industrial revolution, to create poetic metaphors such as *Machine that Makes the World* (1979) and *How to Catch and Manufacture Ghosts* (1979). Recent works, suggested by the roller coasters and ferris wheels of amusement parks, induce sensations of whirling in space (*The Savage Sparkler* [1981]). Aycock is receiving many major commissions and built one of her structures in the Projects Room of the Museum of Modern Art.

Mary Miss (1944–) lived in many parts of the world as a child. She visited abandoned forts, mines, and Indian sites in the West, as well as castle ruins in Germany, with her father, a military officer. Today her site works (architectural structures in open spaces) carry echoes of those romantic early experiences.

Among her ambitious projects is *Perimeters/Pavilions/Decoys* (1978), on the grounds of the Nassau County Museum of Fine Arts in Roslyn, New York. The viewer walks through changing vistas, from a square, wooden tower enclosed by screening, to a second and third one, and then over an earth embankment to the "decoy," a sunken pit entered by a ladder. The echoing of positive and negative square forms set amidst greenery, and the surprising pit that reveals its mystifying underground side rooms as it is approached, evoke memories of Egyptian tombs, Islamic gardens, and English pergolas.

Patricia Johanson (1940–) constructs gardens and sculptural paths and walkways that move around in the landscape. On a grant from the Guggenheim Foundation in 1970, she built a mile and a half of *Cyrus Field*. This continuous line of marble, redwood, and cement block, curves and weaves in an interplay with a woodland setting. Sculptures that also function as parks, gardens, staircases, and bridges are being designed by this Bennington-trained artist. Johanson also studied civil engineering at City College School of Architecture in New York.

Michelle Stuart maps the earth in new art forms that express her feeling for geology, archaeology, and the long, slow processes of change in nature. In one of these forms she crushes and pounds earth and rocks into long sheets of muslin-backed paper and then rubs them down with the palm of her hand. This produces textured and dented surfaces, varying from a silvery sheen to earthen colors, depending on the geology of the area. One of these scrolls was a 450-foot ribbon of paper unfurled from the top of Niagara Gorge to the bottom, and then rubbed with the earth of succeeding layers (*Niagara Gorge Path Relocated* [1975]).

In another work, she combines color photographs of archaeological sites from all over America, with positive and negative relief impressions of ancient tools used by the people in those areas (*Stone Tool Morphology* [1977–1979]). In 1979 Stuart created a site work something like Stonehenge—a circle of great boulders on a plateau above the Columbia River Gorge in Oregon—called *Alignments/Solstice/Cairns*.

Stuart is one of a group of young artists who are expanding the range of art into innovative new dimensions and moving across the conventional boundaries of media. Other environmental sculptors include Nancy Holt, Susan Elder, Patsy Norvell, Jackie Ferrara, and Jody Pinto. Athena Tacha creates staircase sculptures that ripple and flow like forms in nature.

Soft Sculpture

Rosemary Mayer creates structures of veils of fabric, billowing or hanging in great flower-like forms, which are reminiscent of Morris Louis paintings. Even stone carvers; such as Isabel Case Borgatta, have experimented with varied modes of fabric or soft, stuffed sculpture.

Poured Forms

Lynda Benglis and Marjorie Strider have made use of the metamorphic, oozing forms that can be

Fig. 9-26. Michelle Stuart, STONE ALIGNMENTS/
SOLSTICE CAIRNS (1979), boulders from Mount
Hood on the Hood River, brought to the site, 1000′ ×
800′ (overall area), cairns: 5′ high, circle: 100′ in
circumference

created with poured polyurethane. Benglis is now
designing golden knots whose abstract forms con-
vey emotional states.

"Maximal" Sculpture

Women sculptors have felt free to flout the "cool,"
minimal aesthetic of the 1960s and express them-
selves in forms not normally associated with

sculpture. Barbara Zucker's sculptures sometimes
sport fantails covered with pink flocking; Pat Lasch
creates sculptures that look like giant decorated
cakes; Dorothy Gillespie adorns rolling metal rib-
bons with brilliantly colored painted patterns; Judy
Pfaff's room-sized environments are a glorious ex-
plosion of colored wires, sticks, and fabrics that
spring from the walls and ceilings like confetti on
New Year's eve.

Chicana and Latina Artists in the 1970s

One of the exciting developments of the 1970s has been the emergence of Chicana (Mexican-American) and Latina (Latin American) women artists as a significant new force in American art. When Jacinto Quirarte wrote *Mexican American Artists* (1973), he could find only two women to put into it—**Margaret Herrera Chavez (1912–)**, an expressionist painter of New Mexico mountains and villages, and **Consuelo Amezcua (1903–1975)**, a self-taught artist. Special conditions of oppression up to that time had prevented the development of Chicana artists, but since then the situation has changed. The growth of the "Raza" spirit of ethnic pride, combined with the women's liberation movement, has produced a crop of new talent.

These artists are just beginning to be identified—indeed, the National Endowment of the Arts set up a task force on Hispanic American art in 1979 for just this purpose. The following discussion is far from comprehensive, but it will give some idea of the new spirit arising in this group of women artists.

Consuelo ("Chelo") Gonzales Amezcua (1903–1975) made ballpoint-pen drawings of Mexican, biblical, and fantasy subjects. She referred to her paintings as "Filigree Art, A New Texas Culture," because her pictures in their detailed, linear, decorative patterns resemble the intricate metalwork in the jewelry she wore.[71]

Judith F. Baca (1949–) exemplifies the new spirit among Hispanic-American women artists. Born and raised in Los Angeles, she is recognized both as an outstanding leader-organizer and as a socially conscious mural painter. After receiving a B.A. in 1969 from California State University at Northridge, she was hired as resident artist by the Cultural Affairs Division of the city of Los Angeles. Baca went into the East Los Angeles *barrio* and convinced youths in warring street gangs to work together cooperatively in teen muralist brigades; she led them in the constructive task of creating large murals in the community.

Baca was made director of an innovative public art program—the City-Wide Mural Project. Between 1974 and 1977 she supervised forty muralists and four hundred apprentice artists in the production of forty public murals in various parts of Los Angeles. At the same time, Baca carried out her own murals (with assistants) at the California Institute for Women (a state prison) and at the Little Sisters of the Poor convalescent home.

Since 1976 Baca has been directing the creation of the longest mural in the world—*The Great Wall of Los Angeles*—a visual history of the city, showing the contributions of ethnic and immigrant groups to its culture, on the wall of the Tujunga Wash flood control channel in the San Fernando Valley. In preparation for this colossal task, Baca traveled to the Taller Siqueiros workshop in Cuernavaca, Mexico, to take intensive training in the technique and chemistry of mural painting. After returning, she and two associates formed the Social and Public Art Resource Center (SPARC), an agency that conducts many workshops and activities in the melting-pot community of Venice. With the support of SPARC and with the backing of the city of Los Angeles and the County Corps of Engineers, Baca was able to hire youths on parole from the juvenile justice program and then from the Summer Youth Employment Program.

Young people from different ethnic backgrounds are working together in harmony and are learning history, mathematics, and other skills in the process of creating *The Great Wall*. Baca designed the second and third section of the wall by herself to develop a unified tone for the huge project. But much of it is a collaborative effort, involving the talents of her assistants and the young people working with them.

Although Baca is heavily involved in public commitments, she continues to paint her own mur-

Fig. 9-27. Judy Baca and assistants, "ILLUSION OF PROSPERITY AND CYCLE OF DEPRESSION," from THE GREAT WALL OF LOS ANGELES, 1980 section of a mile-long mural

als in a style influenced by the Mexican muralist David Alfaro Siqueiros. *When God Was Woman* is a two-sided, rotating triptych portraying goddess images from Africa, Asia, and the Americas.

Las Mujeres Muralistas, a group of Chicana and Latina artists who studied at the San Francisco Art Institute, worked together between 1973 and 1976 and painted eleven large outdoor murals, principally in the Mission district of San Francisco. They were an outgrowth of the Chicano mural movement that resulted in many paintings on the outside of buildings in the San Francisco Bay area. In public statements, the Muralistas emphasized the collec-tive character of their work: "We feel that this work is really important because it takes us beyond the level of individualism."[72]

The murals *Latino-America* (1974), by Graciela Carillo de Lopez, Consuelo Mendez Castillo, Irene Perez, and Patricia Rodriguez, on Mission Street, and *Para El Mercado* (1974), by Carillo and Mendez at Paco's Tacos on Van Ness Street, are good examples of their work. They present bold, colorful, upbeat views of life in Latin American culture.

Although the principal message of the murals is ethnic pride and self-determination for Latin people, the Muralistas avoided the harsh, political images sometimes used by their male colleagues.

Fig. 9-28. Consuelo Mendez Castillo, Graciela Carrillo, Irene Perez, and Patricia Rodriguez, PANAMERICA (MODEL MISSION MURAL), (1974) acrylic, 20' × 75'

Their goal was to put healthy images of life where they are most needed—that is, among the poor and disadvantaged. Muralista Susan Cervantes said:

I feel like beautifying the walls of the city with murals for the people. Color and light are the essence of man's spirit and so is my painting palette. . . . Color heals and gives joy. As proof, I saw the happiness in the faces of everyone, the retired, the workers, the mothers, the children. . . .[73]

The Muralistas disbanded around 1976, but individual members of the group continue to do their own work. Graciela Carillo showed her miniature books at the San Francisco Museum and has recently completed a billboard mural. Patricia Rodriguez is an art consultant. Consuelo Mendez re-

turned to Venezuela and wrote back, "The experience in the States was a strong one for me. . . . I learned most of all, that as a Latin American artist I had responsibilities to fulfill."[74] Mendez is emerging as one of the leading young artists of Venezuela. Her work was shown at the Pan-American Union in Washington, D.C. (Other members of the group were Ester Hernandez, Miriam Olivo, Ruth Rodriguez, and Susan Cervantes.)

Judithe E. Hernandez (1948–) is the only woman member of Los Four, a cooperative of artists and photographers who promote a spirit of ethnic pride in the *barrio* of East Los Angeles. Beginning in

1968, Hernandez painted public murals for eight years and received a National Endowment for the Arts grant in 1974. Her last outdoor mural at Ramona Gardens Housing Project in East Los Angeles is called *Daughters, Mothers, and Grandmothers of Aztlan* (1976).

Hernandez has an M.F.A. degree from Otis Art Institute, and is a graphic designer for the city of Los Angeles.

Born in Kingsville, Texas, **Carmen Lomas Garza (1948–)** lives in San Francisco and makes lithographs and etchings of Chicano family life, usually drawn from her memories of childhood. Influenced by Mexican folk art, she works in a sophisticated neoprimitive style. *Loteria* (1973), for example, shows a bird's eye view of people sitting at a lottery table with cards, cakes, and street lights. Garza earned an M.A. from the Juarez-Lincoln Center in Austin, Texas, and studied in Mexico. She belonged to the *Con Safos,* a group of socially conscious Chicano artists in San Antonio, Texas, and is now associated with the Galeria de la Raza in San Francisco. She was a member of the national task force on Hispanic-American art set up by the National Endowment for the Arts.

The 1977–78 exhibition "Ancient Roots/New Visions" at the Tucson (Arizona) Museum showed the work of three Latina women inspired by the "inner eye" of mysticism and surrealism. Cuban-born **Eloisa Castellanos-Sanchez (1938–)**, of New York painted *Meditation I* (1976), a head opened up to reveal the inner essence of identity. **Susana Lasta (1945–)**, born in Argentina and now of Tucson, exhibited a *Self-Portrait with Easel* (1975), which shows roots growing up all around her and reaching into the sky, where they wrap around a solid form—"the concrete idea," as she has stated. **Luchita Hurtado,** born in Venezuela, was trained at the Art Students League, New York and now lives in Los Angeles; she painted a mystical night sky.

Some Hispanic-American women artists work in avant-garde forms. The outstanding example, of course, is the distinguished sculptor Marisol (see chapter 8). Born in Paris of Venezuelan parents, she had special opportunities of wealth, education, and encouragement from her family, which permitted her great talent to flourish.

Ana Mendieta has made poetic photo-images showing women as part of nature and ancient mythology, derived from her site works. She received a John Simon Guggenheim Memorial grant in 1980. Born in Cuba, Mendieta was sent to the United States when her father became a political prisoner, and was raised in an Iowa orphanage. She is a member of the A.I.R. women's cooperative gallery in New York.

Another Cuban, **Maria Lino (1951–)**, now of New York, uses masks and wood, plaster, wire, and mesh to show the shared oppression of women of all races.

Geny Dignac (1932–) was born in Argentina and now lives in Phoenix, Arizona. She was part of the Art and Technology movement of the late sixties and today works with environmental fire forms.

Patricia Murillo, a Chicana artist who received an M.A. from California State University at Fullerton, creates three dimensional abstract prints, incorporating wire, plastic, and other materials.

Linda Vallejo (1951–), of Los Angeles, studied lithography in Madrid and earned an M.A. from California State University at Long Beach. She has received grants from the California Arts Council and the National Endowment for the Humanities for her experimental prints, which combine lithography, silk screen, and monotype with stop-outs and dyes.

Vallejo started out as a surrealist, but now says: "All of my pieces contain archetypal, mythological, or dream world imagery. I use archetypal subject matter found in ancient cultures, combined with the modern idea of self knowledge through the interpretation of dreams."[75] She works with Self-Help

Graphics, a studio and gallery serving the East Los Angeles community.

Performance Art

Eleanor Antin (1935–) is a prototype for the many women who are using performance as their art medium today. She refers to herself as a "post-conceptual" artist, producing art in a variety of forms that defy the traditional definitions of that term. Often, they seem closer to drama, film, photography, and television than to painting or sculpture.

Born Eleanor Fineman in New York City, she went to the High School of Music and Art and received a B.A. in creative writing and art from the City College of New York. After studying philosophy at the New School for Social Research, and drama at the Tamara Daykarhanova School for the stage in New York, Antin spent two years working as a professional actress on stage and television (1955–1958). She is married to David Antin and they have one child. Since 1968 she has taught at the University of California in San Diego and has been a visiting lecturer at the University of California in Irvine.

Antin's art has brought together all of the varied interests evident in her educational background. Her *Consumer Goods* (1970) pieces consist of assemblages of ordinary objects—a box of cat litter, a towel, stockings—which serve as portraits of people. Her *100 Boots Piece* (1972–73) consists of a series of photographs of one hundred black rubber boots placed in various arrangements in a series of locations between San Diego and Los Angeles. The photos were mailed to a list of one hundred people at intervals over a two and one-half year period, and presumably told in installments a story of the journey and adventures of the boots, although all the photographs were taken on the first day. She has referred to her *Boots* as a picaresque novel, and in a way it is. The boots get jobs, they take a hill in a war,

trespass leaving a parking lot of a theatre and escape down a road.

In *Carving: A Traditional Sculpture* (1972), Antin exhibited 148 nude photographs of herself in the course of a diet, and in *Representational Art* she produced a videotape of herself putting on makeup. More recently, she has done dramatic scenes in which she plays the roles of characters from her own fantasy life—characters like the "King of Solana Beach" (Solana Beach is the California town where she lives), or a nurse or a ballerina.

Work of this kind is reminiscent of the "happenings" staged by the Dadaist Tristan Tzara in Zurich, or by Richard Hulsenbeck in Berlin in the early twenties. In fact, at an early stage Antin was doing dada-like paintings, and her work has always had this affinity. Perhaps the most significant difference between these proto-conceptualists and Antin is in the way in which she uses media and the extent to which her work is autobiographical. The viewer, however, is never allowed to forget that the King for example, who obviously has a bust, is a fantasy of Eleanor Antin's. Her art is a kind of Byronic personal romanticism.

She has written the scripts for her fantasy character dramas, which are in fact short plays in which she acts. In some of them cutouts take the place of actors, and with her assistants Antin moves these flat figures around on the stage and speaks for them in different voices and dialects.

Her work *The Blood of the Poet* (1965–68) of course suggests the film by Jean Cocteau. But it is a sendup, in that Antin's *Blood of a Poet* is quite literally a box of one hundred microscope slides, each of which has a smear of a different poet's blood on it.

Unlike dada, Antin's work is not antiart, but a searching attempt to use the communications resources of our time to make original and personal artistic statements. The exploration of the self in her fantasy dramas is a romantic theme that has become important in recent feminist art.

Fig. 9-29. Eleanor Antin as THE LITTLE NURSE, "With a Little Help From Her Friends," performance with props

Fig. 9-30. Athena Tacha, RIPPLES (1978–79), white concrete, 3′ × 30′ × 80′

Fig. 9-31. Marjorie Strider, BROOMS (1972), mixed media, 5′ × 2′ × 12′

Notes

Chapter 1: Native Americans: The First American Women Artists

1. Ruth Bunzel, *The Pueblo Potter* (New York: Columbia University Press, 1929), p. 51.

2. Ibid.

3. Elsie Parsons, ed., *American Indian Life* (Lincoln: University of Nebraska Press, 1967), p. 171.

4. Max Weber, "Chinese Dolls and Modern Colorists," *Camera Work*, no. 31 (July 1910):51; quoted in Barbara Rose, *American Art Since 1900: A Critical History,* 2d ed., (New York: Praeger Publishers, 1975) p. 34.

5. Arnold B. Glimcher, *Louise Nevelson* (New York: E. P. Dutton, 1972), pp. 22, 41.

6. George Catlin, *Illustrations of the Manners, Customs, and Condition of the North American Indians,* vol. 1 (London: Henry G. Bohn, 1851), pp. 96–97.

7. Wolfgang Haberland, *The Art of North America* (New York: Crown Publishers, 1964), pp. 155, 158.

8. Royal B. Hassrick, *The Sioux: Life and Customs of a Warrior Society* (Norman: University of Oklahoma Press, 1964), p. 194.

9. Fr. Peter J. Powell, "Beauty for New Life," in *The Native American Heritage,* ed. Evan M. Maurer (Chicago: Art Institute of Chicago, 1977), p. 35. This essay contains a discussion of the symbolism in Plains Indian art and the important and sacred role of women quillworkers.

10. Ibid., p. 55, n. 31.

11. Ibid., p. 46.

12. Jane Green Gigli, "Dat So La Lee, Queen of the Washo Basket Makers," Nevada State Museum Anthropological Papers, no. 16, paper no. 1, Carson City, Nev., March 1974, p. 8. Most details are from this essay.

13. Marvin Cohodas, "Dat So La Lee's Basketry Design," *American Indian Art* 4 (Autumn 1976):22.

14. Roy Hathcock, *Ancient Indian Pottery of the Mississippi River Valley* (Camden, Ark.: Hurley Press, 1976), p. 9.

15. John E. Collins, *Nampeyo, Hopi Potter: Her Artistry and Her Legacy* (Fullerton, Calif.: Muckenthaler Cultural Center, 1974), p. 21.

16. See Doris Cole, *From Tipi to Skyscraper: A History of Women in Architecture* (Boston: i. press incorporated and George Brazilier, 1973), and *Women in American Architecture: A Historic and Contemporary Perspective.* (New York: Watson-Guptill, 1977). These books describe the contributions of American women in architecture despite the forces that operated to discourage them.

17. Johann George Kohl, *Kitchi-Gami: Wanderings Round Lake Superior* (London: Chapman and Hall, 1860), p. 4; quoted in Elizabeth Weatherford, "Women's Traditional Architecture," *Heresies: A Feminist Publication on Art and Politics,* May 1977, p. 37

18. Donna M. Terrell and John U. Terrell, *Indian Women of the Western Morning* (New York: Dial Press, 1974), p. 43; quoting *Narrative of the Expedition of Coronado,* trans. George Winship (Washington, D.C.: Bureau of American Ethnology, 14th report, 1896).

19. Quoted in Marjel de Lauer, "Helen Hardin," *Arizona Highways* (August 1976), p. 44.

Chapter 2: Colonial Women Artists and American Folk Artists

1. Eleanor Flexner, *Century of Struggle: The Woman's Rights Movement in the United States* (Cambridge, Mass.: Harvard University Press, 1959), p. 4.

2. Jonathan Holstein's "Abstract Design in American Quilts" at the Whitney Museum of American Art, was one of many exhibitions that stressed the design quality of quilts.

3. Charles Francis Adams, ed., *Familiar Letters of John Adams and His Wife Abigail Adams During the Revolution* (New York: Hurd & Houghton, 1876), pp. 149–50. Letter dated 31 March 1777.

4. Frank J. Klingberg, ed., *Carolina Chronicle: The Papers of Commissary Gideon Johnston, 1707–1716,* University of California Publications in History, vol. 35 (Berkeley and Los Angeles: University of California Press, 1946), p. 31.

5. Margaret Simons Middleton, *Henrietta Johnston of Charles Town, South Carolina: America's First Pastellist* (Columbia: University of South Carolina Press, 1966, p. 19). This is the definitive biography of Johnston.

6. Klingberg, *Carolina Chronicle of Gideon Johnston,* p. 22.

7. Frank J. Klingberg, ed., *The Carolina Chronicle of Dr. Francis Le Jau, 1706–1717,* University of California Publications in History, vol. 50 (Berkeley: University of California Press, 1956), p. 159. Dr. Le Jau was a good friend who spoke of Henrietta Johnston's graciousness during this time of trouble. She was a great help to her husband in building good relations with the local citizenry, but after his death the missionary society gave her no assistance.

8. Middleton, *Henrietta Johnston,* p. 47.

9. Anna Wells Rutledge, "Henrietta Johnston," in James T. Edwards et al., eds., *Notable American Women: 1607–1950* (Cambridge, Mass.: Harvard University Press, Belknap Press, 1971), p. 282.

10. Anna Wells Rutledge was the first scholar to realize that Johnston was the wife of the Reverend Johnston, and made it possible to recover her history through his documents. See "Who Was Henrietta Johnston?" *Antiques* 51 (March 1947):183–85.

11. Carvers of tombstones and ships' figureheads came earlier, but are usually classified as craftspersons.

12. Elkanah C. F. Watson, *Men and Times of the Revolution; Or, Memoirs of Elkanah Watson, including His Journals of Travels in Europe and America, from the Year 1777 to 1842, and His Correspondence With Public Men, and Reminiscences and Incidents of the American Revolution,* ed. Winslow C. Watson, 2d ed., (New York: Dana & Co., 1857), pp. 137.

13. Charles Coleman Sellers, *Patience Wright: American Artist and Spy in George III's London* (Middletown, Conn.: Wesleyan University Press, 1976), p. 5. The definitive biography.

14. See Watson, *Men and Times,* pp. 137–38. William Dunlap describes Wright in *History of the Rise and Progress of the Arts of Design in the United States,* vol. 1 (New York: Harper & Bros., 1834), p. 134.

15. Sellers, *Patience Wright,* p. 84; quoting a letter from Patience Wright to John Dickinson, 6 April 1775. Wright was laying plots against the crown; she had a Quaker vision and was attempting to carry it out.

16. Dunlap, *History of the Arts of Design,* vol. 1, p. 135.

17. *Letters of Mrs. Adams, the Wife of John Adams, with an introductory Memoir by her Grandson, Charles Francis Adams* (Boston: Little & Brown, 1840), reprinted 1977 by Scholarly Press, Inc., St. Clair Shores, Michigan, pp. 229–230.

18. Ibid.

19. Lawrence E. Tanner, "On Some Later Funeral Effigies in Westminster Abbey," *Archaeologia* 85 (1935):196; quoted in Sellers, *Patience Wright,* p. 129.

20. *South Carolina Gazette,* 5 April 1773; quoted in Anna Wells Rutledge, "Henry Benbridge (1743–1812?) American Portrait Painter," *American Collector* (October–November 1948):10.

21. Charles Willson Peale Papers, MSS of the American Philosophical Society, Philadelphia; quoted in Robert G. Stewart, *Henry Benbridge (1743–1812):American Portrait Painter* (Washington, D.C.: Smithsonian Institution Press, 1971). This is the principal source of information about Hetty Benbridge.

22. Henry Benbridge Papers, MSS of the Gordon Saltar Collection, Winthertur Museum; quoted in Stewart, *Henry Benbridge,* p. 19.

23. Quoted in Stewart, *Henry Benbridge,* p. 20.

24. Ibid. p. 82.

25. William H. Gerdts and Russell Burke, *American Still Life Painting* (New York: Praeger Publishers, 1971), p. 54.

26. Ruth Piwonka and Roderic H. Blackburn, "New Discoveries about Emma J. Cady," *Antiques* (February 1978), p. 418.

27. Jean Lipman, *American Primitive Painting* (London: Oxford University Press, 1942). The author quotes detailed instructions and "recipes" found in a portfolio owned by Lucy McFarland Sherman (pp. 78–101).

28. G. Kurt Dewhurst, Betty MacDowell, and Marsha MacDowell, *Artists in Aprons: Folk Art by American Women* (New York: E. P. Dutton and the Museum of American Folk Art, 1979).

29. Quoted in Jean Lipman and Alice Winchester, eds., *Primitive Painters in America, 1750–1950: An Anthology* (New York: Dodd, Mead & Co., 1950), p. 22.

30. Jean Lipman, "Mary Ann Willson," in Lipman and Winchester, *Primitive Painters*, p. 50.

31. Ibid.

32. Agnes M. Dods, "Ruth Bascom," in Lipman and Winchester, *Primitive Painters*, p. 31.

33. Ibid.; quoting Bascom's journals.

34. Quoted in Dewhurst, *Artists in Aprons*, p. 6.

35. Quoted in Jean Lipman, "Deborah Goldsmith," in Lipman and Winchester, *Primitive Painters*, pp. 90–96.

36. Quoted in Helen Kellogg. "Found: Two Lost American Painters," *Antiques World* (December 1978), p. 46

37. Ibid., p. 45.

38. Otto Kallir, *Grandma Moses* (New York: Harry N. Abrams, New Concise New American Library Edition, 1973), p. 16.

Chapter 3: The Golden Age

1. Barbara Welter, *Dimity Convictions: The American Woman in the Nineteenth Century* (Athens: Ohio University Press, 1976), p. 21.

2. Elizabeth Cady Stanton, Susan B. Anthony, and Matilda Joslyn Gage, eds., *History of Woman Suffrage,* vol. 1 (New York: Fowler & Wells, 1881), p. 70.

3. The Pennsylvania Academy first admitted women students in 1844; the first segregated women's life class with female models was organized in 1868. The National Academy of Design admitted women in 1831, but then kept them out until 1846, when they were admitted on a regular basis. The Life School for women began in 1871. In 1914 women were admitted to anatomy lectures.

4. In addition to the only full member, Ann Hall, women associate and honorary members before 1900 included: Cecilia Beaux, 1894; Margaret Bogardus, 1842–1844, 1845; Fidelia Bridges, 1873; Herminia Dassel (Honorary), 1850; Mary Ann Delafield Dubois (Elect), 1842; Sarah C. Frothingham, 1840–1945; Julia (Blight) Fulton, 1828–1832; Eliza Greatorex, 1879–1888; Jeanette Shephard Harrison Loop, 1873; Emily and Maria Maverick, 1828–1830; Rosalba Peale (Honorary), 1828; Lilly Martin Spencer (Honorary), 1850; Emma Stebbins (Elect), 1842; and Jane Cooper (Darley) Sully (Honorary), 1827. This information is from Julie Graham, "American Women Artists' Groups: 1867–1930," *Woman's Art Journal* (Spring–Summer 1980), p. 12. Between 1825 and 1953 only 75 women were Members and Associate Members out of a total membership of 1300. See Eliot Clark, *History of the National Academy of Design, 1825–1953* (New York: Columbia University Press, 1954).

5. Katherine McCook Knox, *The Sharples: Their Portraits of George Washington and His Contemporaries: A Diary and Account of the Life and Work of James Sharples and His Family in England and America* (New Haven: Yale University Press, 1930), pp. 12–13.

6. Ibid., p. 13.

7. Ibid., p. 17.

8. Ibid., p. 52.

9. Elizabeth Fries Lummis Ellet, *Women Artists in All Ages and Countries* (New York: Harper & Bros., 1859), p. 300.

10. Ibid.

11. Reported by painter John Neagle, in Dunlap, *History of the Arts of Design,* vol. 2 (1834), p. 445.

12. Reported by painter Colonel Henry Sargent, in Dunlap, *History of the Arts of Design,* vol. 2, p. 445.

13. James Thomas Flexner, *Gilbert Stuart: A Great Life in Brief* (New York: Alfred A. Knopf, 1955), p. 186.

14. Mary E. Powel, "Miss Jane Stuart: Her Grandparents and Parents," *Bulletin of the Newport Historical Society (R.I.),* no. 21 (January 1920):11.

15. Jane Stuart, "Anecdotes of Gilbert Stuart by His Daughter," *Scribner's Monthly Magazine* (July 1877):377.

16. Powel, "Miss Jane Stuart," p. 15.

17. Flexner, *Gilbert Stuart,* p. 185.

18. Powel, "Miss Jane Stuart," p. 10.

19. George C. Mason, *Life and Works of Gilbert Stuart* (New York: Charles Scribner's Sons, 1879), p. 80.

20. Stuart, "Anecdotes of Gilbert Stuart," p. 379.

21. Wolfgang Born, "The Female Peales, Their Art and Its Tradition," *The American Collector* (August 1946)15:12–14.

22. These were the spellings Peale used. Spellings used today are: Sofonisba Anguissola, Angelica Kauffman, and Maria Sibylla Merian.

23. Letter from Charles Willson Peale to Angelica Kauffmann Peale Robinson, 10 March 1923, quoted in Charles Coleman Sellers, *Charles Willson Peale* (New York: Charles Scribner's Sons, 1969), p. 408.

24. Charles Coleman Sellers, "Sarah Miriam Peale," in James T. Edwards et al., eds., *Notable American Women: 1607–1950* (Cambridge, Mass.: Harvard University Press, 1971), p. 39.

25. Ibid.

26. Although women were in the exhibitions and were elected Academicians, they did not study in classes at the Pennsylvania or National Academies until later.

27. Many of these sitters were in the coterie of President Tyler.

Notes

28. Wilbur H. Hunter and John Mahey, *Miss Sarah Miriam Peale, 1800–1885: Portraits and Still Life* (Baltimore: Peale Museum, 1967), p. 12.

29. Ibid., p. 5.

30. Charles Coleman Sellers, "Anna Claypoole Peale," in *Notable American Women: 1607–1950*, p. 39.

31. Sellers, *Charles Willson Peale,* p. 389.

32. Ellet, *Women Artists,* p. 292.

33. Sellers, "Anna Claypoole Peale," p. 39.

34. Dunlap, *History of the Arts of Design,* vol. 2, p. 180n.

35. William H. Gerdts and Russell Burke, *American Still Life Painting* (New York: Praeger Publishers, 1971), p. 37.

36. John Frankenstein, *American Art: Its Awful Attitude: A Satire* (Cincinnati: 1864); quoted in Robin Bolton-Smith and William H. Truettner, *Lilly Martin Spencer, 1822–1902: The Joys of Sentiment* (Washington, D.C.: National Collection of Fine Arts, Smithsonian Institution Press, 1973), p. 45. This is an exhaustively researched monograph.

37. See Linda Nochlin, "Why Have There Been No Great Women Artists?" *Art News* (January 1971):23.

38. Unidentified St. Louis newspaper (c. 1854); quoted in Bolton-Smith and Truettner, *Joys of Sentiment,* p. 12.

39. Morton, "The Arts in the West," *Marietta Intelligencer,* 12 September 1839; quoted in Bolton-Smith and Truettner, *Joy of Sentiment,* p. 13.

40. Letter from Spencer to her mother, 1842; quoted in Bolton-Smith and Truettner, *Joys of Sentiment,* p. 17.

41. Letter from Spencer to her mother, 1848; quoted in Bolton-Smith and Truettner, *Joys of Sentiment,* p. 28.

42. Letter from Spencer to her mother, 1850, quoted in Bolton-Smith and Truettner, *Joys of Sentiment,* p. 28.

43. *Cosmopolitan Art Journal* 1, no. 5 (September 1857):165;quoted in Bolton-Smith and Truettner, *Joys of Sentiment,* p. 42.

44. *Cosmopolitan Art Journal* 2, no. 1 (December 1957):55; quoted in Bolton-Smith and Truettner, *Joys of Sentiment, p. 42.*

45. Letter from Spencer to her parents, December 1859; quoted in Bolton-Smith and Truettner, *Joys of Sentiment,* p. 55.

46. *The Crayon* 5 (1858):26; an obituary reproduced in Ellet, *Women Artists,* pp. 312–15. It is the source of most of the information about Dassel.

47. *The Crayon,* p. 26.

48. Ibid., p. 27.

49. Ibid.

50. Records of the Proprietors of the Nantucket Atheneum: Annual Meeting, 5 January 1852: "During the past year a number of friends of art, at an expense of $77 presented to the Institution for the Library . . . a picture of Abraham Quary, represented as sitting in his hut. The picture was painted by Mrs. Dassel, an artist of merit. . . ."

51. Maria Mitchell was a feminist and, later, a professor at Vassar College. It is interesting to consider any possible connection of Dassel with the early feminist movement.

52. Clara Erskine Clement, *Women in the Fine Arts from the Seventh Century* B.C. *to the Twentieth Century* A.D. (Boston: Houghton Mifflin, 1904), p. 121.

53. It is not clear whether this came before or just after her marriage, or whether her husband was studying with her.

54. *The Arcadian* (New York); quoted in Clara Erskine Clement and Laurence Hutton, *Artists of the Nineteenth Century,* vol. 1 (Boston: Houghton, Osgood & Co., 1879), p. 248.

55. The Architect of the U.S. Capitol has sent the author a copy of the actual payment.

56. David S. Barry, *Pearson's Magazine;* quoted in Clement, *Women in the Fine Arts,* p. 121.

57. Mary Black and Lloyd Goodrich, *What is American in American Art?* (New York: Clarkson N. Potter, 1971), p. 36.

58. Phebe Hanaford, *Daughters of America,* (Augusta, Maine: True & Co., 1889), p. 304.

59. Ibid., p. 303.

60. Ibid.

61. Mr. and Mrs. Dunnan, of Exeter, New Hampshire, descendants of Elizabeth Gardner, are working on a book that will shed more light on the lives and friendship of Gardner and Morrell, two adventurous women artists of the nineteenth century. The author thanks the Dunnans and Judith Stein of Philadelphia, for providing Morrell's obituary.

62. H. Vance Swope, "An Appreciation of Charlotte B. Coman," *Art News* (22 November 1924):6.

63. Ibid. This article describes Coman's deafness, career, and personality.

64. Frederic Alan Sharf, "Fidelia Bridges: Painter of Birds and Flowers," *Essex Institute Historical Collectors Journal* (Salem, Mass.) 104, no. 3 (July 1968):217–38.

65. Frederic H. Sharf, "Fidelia Bridges," in *Notable American Women: 1607–1950,* p. 239.

66. *The Graphic* (Chicago; an illustrated weekly newspaper), 6 February 1892, pp. 99–100. In "Art Notes," the first of a series on leading Chicago women artists, Shaw is described as "the first woman artist in the city . . . recognized on every hand. . . ."

67. Ibid., p. 100.

68. Ibid.

69. The *Graphic* article names Henry Reed of Chicago, C. L. Hutchinson, A. A. Munger, Walter C. Larned, and E. B. Haskell of Boston.

70. The author repeatedly found this to be the case in research for this book.

71. Walter Shaw Sparrow, *Women Painters of the World: From the Time of Caterina Vigri, 1413–1463, to Rosa Bonheur and the Present Day* (London: Hodder & Stoughton, 1905), p. 76.

72. Chris Petteys, "Colorado's First Women Artists," *Denver Post, Empire Magazine,* 6 May 1979, p. 37.

Notes

73. Gerdts and Burke, *American Still Life Painting*, p. 37.

74. Ibid., p. 98.

75. Francis Hobart Herrick, *Audubon the Naturalist: A History of His Life and Time*, vol. 2 (New York: Appleton, 1917), p. 61.

76. John Cole, "The Woman Behind the Wildflower That Stopped a Dam," *Horticulture* (December 1977):30–35.

77. Harry T. Peters, *Currier and Ives, Printmakers to the American People* (Garden City, N.Y.: Doubleday, Doran & Co., 1942), p. 28. Palmer was one of the few "in-house," full-time staff artists.

78. Ibid.

79. Palmer's sister and her brother Robert, a still-life painter, may have helped with some of her still-life compositions.

80. Mary Bartlett Cowdrey, "Fanny Palmer, An American Lithographer," in *Prints: Thirteen Illustrated Essays on the Art of the Print*, ed. Carl Zigrosser (New York: Holt, Rinehart & Winston, 1962), p. 227.

81. Roy King and Burke Davis, *The World of Currier and Ives* (New York: Random House, 1968), p. 65.

82. Peters, *Currier and Ives*, p. 28.

83. Cowdrey, "Fanny Palmer," p. 223.

84. Charles Shively, "Eliza Greatorex," in *Notable American Women, 1607–1950*, p. 77.

85. Eliza Greatorex, *Summer Etchings in Colorado* (New York: G. P. Putnam's Sons, 1873), p. 48, as quoted in Shively, "Eliza Greatorex."

86. E. P. Richardson, *Painting in America: From 1502 to the Present* (Thomas Y. Crowell, 1965), p. 276.

87. De Kay and Hallock met as classmates at Cooper Union and remained devoted friends. See Rodman W. Paul, *A Victorian Gentlewoman in the Far West* (San Marino, Calif.: The Huntington Library, 1972).

88. Sartain would turn over in her grave if she could read Patt Likos's article in the Fall 1975 *Feminist Art Journal*, pp. 34–35, describing subsequent "Sexism at the First Woman's Art College" from the predominantly male faculty in the 1960s.

89. Henry James, *William Wetmore Story and His Friends* (Boston: Houghton, Mifflin, 1903/ New York: Grove Press, 1957), p. 257.

90. Ibid.

91. Crow's daughter, Cornelia Crow Carr (her school chum), edited *Harriet Hosmer: Letters and Memories* (New York: Moffat Yard & Co., 1912).

92. Joseph Leach, "Harriet Hosmer: Feminist in Bronze and Marble," *Feminist Art Journal* 5, no. 2 (Summer 1976):9.

93. James, *William Wetmore Story*, p. 257.

94. Quoted in William H. Gerdts, *The White Marmorean Flock: Nineteenth Century American Women Neo-Classical Sculptors* (Poughkeepsie, N.Y.: Vassar College Art Gallery, 1972).

95. Carr, *Harriet Hosmer: Letters and Memories*, p. 35.

96. Phebe Hanaford, *Daughters of America,* pp. 321–22.

97. David C. Driskell, *Two Centuries of Black American Art* (Los Angeles: Los Angeles County Museum of Art, 1976), p. 48.

98. James Porter, "Edmonia Lewis," in *Notable American Women, 1607–1950,* p. 397. This information is hearsay gleaned from interviews and articles, but is generally believed. There are gaps and contradictions in reports of her early years.

99. Interview with Lewis, *Lorain County News;* quoted in Sylvia G. L. Dannett, *Profiles of Negro Womanhood,* vol. 1 (Yonkers, N.Y.: Negro Heritage Library, Educational Heritage, Inc., 1964), p. 119.

100. Samella S. Lewis, *Art: African American* (New York: Harcourt Brace Jovanovich, 1978), p. 41.

101. Ibid. John Mercer Langston describes the case in *From the Virginia Plantation to the National Capitol* (Hartford: American Publishing Co., 1894). Lewis had engaged in pranks with these girls, her best friends. At the start of a lengthy sleigh ride with two male friends, she offered them a drink of hot mulled wine. During the journey they had stomach cramps. The judges concluded that if Lewis did put the aphrodisiac "Spanish fly," or Canthardies, in the drink, it was intended as mischief, rather than murder. The mob that had hauled Lewis to a nearby field and brutally beaten her was never arraigned, nor their names made public.

102. Driskell, *Black American Art,* p. 49.

103. William Wells Brown, *The Rising Son; or, the Antecedents and Advancement of the Colored Race* (Boston: A. G. Brown & Co., 1874), p. 466–67. Varying dates are given for *Hagar* in different texts.

104. Quoted in Clement and Hutton, *Artists of the Nineteenth Century,* vol. 2, pp. 66–67.

105. Laura Curtis Bullard, "Edmonia Lewis," *The Revolution,* (Rome) no. 16 (20 April 1871); cited in Eleanor Tufts, *Our Hidden Heritage: Five Centuries of Women Artists,* (New York: Paddington Press, 1974), p. 162.

106. Arna Bontemps, *100 Years of Negro Freedom* (New York: Dodd, Mead, & Co., 1962), p. 121.

107. Quoted in Porter, "Edmonia Lewis," p. 398.

108. Elizabeth Rogers Payne, "Anne Whitney: Sculptures: Art and Social Justice," *Massachusetts Review* (Spring 1971):246.

109. Ibid., p. 257.

110. Gerdts, *White Marmorean Flock.*

111. Wayne Craven, *Sculpture in America* (New York: Thomas Y. Crowell, 1968), p. 231.

112. Milton W. Brown, *American Art to 1900: Painting, Sculpture, Architecture* (New York: Harry N. Abrams, 1977), p. 565.

113. Gerdts, *White Marmorean Flock.*

114. Lorado Taft, *History of American Sculpture,* rev. ed. (New York: Macmillan, 1924), p. 212.

115. Quoted in Margaret Farrand Thorp, *The Literary Sculptors* (Durham, N.C.: Duke University Press, 1965), p. 91.

116. Letter from John Rogers, 13 February 1859; quoted in Craven, *Sculpture in America,* p. 332.

117. Aycock Brown, "Strange Story of Virginia Dare's Statue in Elizabethan Garden," mimeographed, (Manteo, N.C.).

118. Phillip T. Sandhurst, *The Great Centennial Exhibition* (Philadelphia: P. W. Ziegler & Co., 1876), p. 60.

119. Judith Paine, "The Women's Pavilion of 1876," *Feminist Art Journal* 4, no. 5 (Winter 1975–76):5–12.

120. Elizabeth Cady Stanton, *Eighty Years and More* (New York: Schocken Books, 1971), p. 316.

121. Paine, "The Women's Pavilion," p. 5.

Chapter 4: The Gilded Age

1. The remarkable socialite wife of millionaire Potter Palmer also had a social conscience; she was largely responsible for organizing the Chicago millinery workers; helped the Women's Trade Union League and Hull House; was a leading spirit in the "uplift movement" that raised Chicago from a raw industrial town to a cultural center; supported the Chicago Academy of Design; and was a trustee of Northwestern University. She also doubled her husband's $8,000,000 estate!

2. In 1854 the indefatigable Sarah Worthington King Peter, organizer of the Philadelphia School of Design for Women, descended like a whirlwind on Cincinnati and immediately organized the Ladies Academy of the Fine Arts to "aid in the cultivation of public taste." She brought the first antique plaster casts to the city from Europe, which resulted in the founding of the McMicken School of Design (at the University of Cincinnati), later known as the Cincinnati School of Design, and ultimately the Academy. See Carol Macht, *The Ladies God Bless 'em* (Cincinnati: Cincinnati Art Museum, 1976).

3. A few pioneers were lawyers and were opening the field of medicine (e.g., Elizabeth Blackwell), in separate but unequal women's medical colleges; women were prohibited from entering many professional schools by law; some began to earn Ph.Ds. Nursing became a paid profession for the first time during the Civil War.

4. Letter (signed R. S.) to James Claghorn, president of the Pennsylvania Academy of the Fine Arts; quoted in Christine Jones Huber, *The Pennsylvania Academy and Its Women* (Philadelphia: Pennsylvania Academy of the Fine Arts, 1973), p. 21. The Academy, a progressive institution, opened up coeducational life-classes earlier, but the women were so inhibited by the culture that they could not bring themselves to attend these classes with men.

5. From a paper delivered by Diane Radycki at the College Art Association annual meeting, 1980. Women could not compete for the Prix de Rome until 1903. The school was shut down by an angry mob of men when women were temporarily granted scholarships. The scholarships were rescinded.

6. The precise date is unknown. Art historian Judith Stein researched this and found that early records at the Académie Julian were lost in a fire.

7. May Alcott, *Studying Art Abroad and How to Do it Cheaply* (Boston: Roberts Bros., 1879), p. 48. Alcott, sister of Louisa May Alcott, was a talented young artist who died of childbirth

complicatons after marrying M. Nieriker. Conditions were so bad at the Julian that she recommended private classes for women. Teachers who accepted women students privately by that time included Chaplin, Carolus-Duran, Cabanel, Luminais, Bouguereau, Robert-Fleury, Lefebvre, Couture, and her teacher, Krug.

8. Linda Nochlin, *Women Artists: 1550–1950* (New York: Knopf, 1976), p. 52.

9. Janet Scudder, *Modeling My Life* (New York: Harcourt Brace, & Co., 1925), p. 20.

10. Woodcarving became an accepted craft for women when Benn Pitman, a remarkable social reformer from England, came to Cincinnati to promote his brother's shorthand system and started a woodcarving class for upper-class women in that city. A disciple of the Arts and Crafts movement, he believed in the special talents of women in decoration. Woodcarving became the craze among Cincinnati women. Their work was shown at the Philadelphia Centennial and woodcarving became an accepted course of study for women in that period. Pitman, his wife, and his daughter Agnes Pitman carved the woodwork in their own house, which is still standing in Cincinnati. See Macht, *The Ladies God Bless 'Em.*

11. Scudder, *Modeling My Life,* p. 46.

12. Ibid., p. 51.

13. Ibid., p. 58.

14. His wife was the painter Mary Fairchild MacMonnies, discussed later in this chapter.

15. Lorado Taft, *The History of American Sculpture,* rev. ed., (New York: Macmillan, 1924), p. 528.

16. Wendt's pieces were too heavy to move; so she continued to do most of her work in her Los Angeles studio.

17. Quoted in Gretchen Sibley, "An Heroic Sculpture Hidden Beneath the Minerals," *Terra* (Los Angeles County Museum of Natural History) 14, no. 1, (Summer 1975):12.

18. Ibid., p. 9.

19. Taft, *History of American Sculpture,* p. 571.

20. Ibid., p. 449.

21. Clara Erskine Clement, *Women in the Fine Arts* (Boston: Houghton Mifflin, 1904), p. 370.

22. Susan Porter Green, *Helen Farnsworth Mears* (Oshkosh, Wisc.: Paine Art Center and Arboretum, 1972), p. 54. The definitive biography of Mears.

23. See Karal Ann Marling, introduction to *Woodstock: An American Colony, 1902–1977* (Poughkeepsie, N.Y.: Vassar College Art Gallery, 1977).

24. Green, *Helen Farnsworth Mears,* p. 80.

25. Jonathan A. Rawson, Jr., "Evelyn Beatrice Longman: Feminine Sculptor," *International Studio* 45:99 (supplement).

26. Taft, *History of American Sculpture,* p. 490.

27. She was distantly related to Napoleon's famed Marshal Ney.

28. Vernon Coggins, "Elizabeth Ney," in James T. Edwards et al., eds., *Notable American Women: 1607–1950* (Cambridge, Mass.: Harvard University Press, Belknap Press, 1971), p. 624. Coggins wrote *Two Romantics and Their Ideal Life* (New York: Odyssey Press, 1946) about their life.

29. Ibid.

30. Clement, *Women in the Fine Arts,* p. 380.

31. This trend has been related to the democratic revolutions taking place in European countries. See Linda Nochlin, *Realism* (New York: Penguin, 1976).

32. There are several different birthdates in various sources. Gardner's descendants provided the accurate date.

33. Linda Rose McCabe, "Mme. Bouguereau, Pathfinder," *New York Times Book Review and Magazine,* 19 February 1922, p. 16.

34. Ibid. Gardner may be exaggerating; Cassatt secured admission to Chaplin's studio in 1875. It was probably true, however, that no art school or academy was open at that time.

35. Ibid.

36. Ibid.

37. Miriam Dunnan and Donald Dunnan, *The Exeter News-Letter* (N.H.), 8 June 1977, p. A3. They are descendants writing a biography of Gardner. According to them, Bouguereau's mother was a Huguenot who had married a Catholic, and believed that intermarriage caused unhappiness. I am indebted to the Dunnans and to art historian Judith Stein for this and other information about Bouguereau.

38. McCabe, "Mme. Bouguereau," p. 16.

39. Henry Merritt, *Henry Merritt: Art Criticism and Romance* (London: C. K. Paul & Co., 1879); quoted in Germaine Greer, *The Obstacle Race* (New York: Farrar, Straus & Giroux, 1979), p. 46.

40. Anna Lea Merritt, "A Letter to Artists, Especially Women Artists," *Lippincott's Monthly Magazine* 65 (1900):463–69.

41. Henry Sturgis Drinker was Beaux's brother-in-law and the subject of one of her finest portraits, *The Man With the Cat.*

42. Huber, *The Pennsylvania Academy,* p. 22. Drinker's letter to George Corliss, 27 December 1878, from archives of the Pennsylvania Academy of the Fine Arts.

43. *Art Interchange,* (April, 1899); quoted in Clara Erskine Clement, *Women in the Fine Arts from the Seventh Century* B.C. *to the Twentieth Century* A.D. (Boston: Houghton Mifflin, 1904), p. 221.

44. Josephine Duveneck, *Frank Duveneck: Painter-Teacher* (San Francisco: John Howell Books,1970), p. 111; describes this influential "ladies class."

45. Anna Seaton Schmidt, "The Paintings of Elizabeth Nourse," *International Studio* 27, (1905–6):249. Thanks to Betty Zimmerman, Cincinnati Museum, for this.

46. All three Nourse sisters were artists. See note 10 about Pitman.

47. Michael Quick, *American Expatriate Painters of the Late Nineteenth Century* (Dayton, Ohio: Dayton Art Institute, 1976), p. 25; discusses these trends.

48. Schmidt, "The Paintings of Elizabeth Nourse, p. 249.

49. *Art and Progress* (December 1914):41.

50. Henry Seldis, review of "Expatriate Painters" exhibition, *Los Angeles Times,* 24 April 1977, p. 76 (calendar section).

51. Henry James, *Portrait of a Lady* (Boston: Houghton Mifflin, 1963), p. 232. Although James drew upon the Bootts for his material, his characters depart from the originals; they are free inventions.

52. Duveneck, *Frank Duveneck,* p. 116.

53. Ibid., p. 118. Upper-class women were so sheltered and got so little exercise in the Victorian era that they were extremely delicate; mortality was high. This accounts for the father's anxiety.

54. Ibid.

55. Ronald B. Pisano, *The Students of William Merritt Chase* (Huntington, N.Y.: Hecksher Museum, 1973), p. 38.

56. Frank Goodyear and Elizabeth Bailey, *Cecilia Beaux, Portrait of an Artist* (Philadelphia: Pennsylvania Academy of the Fine Arts, 1974), title page.

57. Cecilia Beaux, *Background with Figures* (Boston: Houghton Mifflin, 1930), p. 87. Despite her disclaimer, Academy records show that she was registered for classes there in 1877–1879.

58. Ibid., p. 85.

59. Ibid.

60. Bush-Brown was a capable portrait painter, trained at the Pennsylvania Academy (wife of sculptor Henry Kirk Bush-Brown), and was a close friend of Beaux throughout her life.

61. Goodyear and Bailey, *Cecilia Beaux,* p. 26 (from Cecilia Beaux Papers, Archives of American Art).

62. Ibid., p. 19.

63. Stated in a 1907 lecture on "Portraiture" at Simmons College, Boston.

64. Goodyear and Bailey, *Cecilia Beaux,* p. 18.

65. Ibid., p. 110.

66. Judith E. Stein, "Profile of Cecilia Beaux," *Feminist Art Journal,* (Winter 1975–76):25. An excellent analysis of Beaux's psychology.

67. Goodyear and Bailey, *Cecilia Beaux,* p. 19.

68. Ibid. (foreword by Richard Boyle), p. 7.

69. Ann Sutherland Harris and Linda Nochlin, *Women Artists: 1550–1950,* (Los Angeles: Los Angeles County Museum of Art and Alfred A. Knopf, 1976), p. 58. Of Cassatt's generation, only Eakins, Homer, Sargent, and Whistler were her equals. Eakins and Homer may be greater artists in some ways, but they were relatively traditional in style. Cassatt's *Picking Flowers in a Field* (c. 1875), a truly impressionistic work, seems to put her first among her contemporaries as an Impressionist.

70. Adelyn Breeskin, *The Graphic Work of Mary Cassatt: A Catalogue Raisonné* (New York: H. Bittner & Co., 1948), p. 10.

71. William H. Gerdts, *American Impressionism,* (Seattle: Henry Art Gallery, University of Washington, 1980), p. 47.

72. Achille Ségard, *Un Peintre des enfants et des mères: Mary Cassatt* (Paris: Ollendorff, 1913), p. 5. This unreliable account was the only biography that Cassatt permitted, at age 69. She was a very private person.

Notes

73. André Mellario, *Expositions Mary Cassatt, Novembre–decembre 1893* (Paris: Durand-Ruel, 1893). Catalogue of her second one-woman show.

74. Frederick A. Sweet, *Miss Mary Cassatt: Impressionist From Pennsylvania* (Norman: University of Oklahoma Press, 1966), p. 20. Alexander's letter to his fiancée, Lois Buchanan. This sister-in-law found Cassatt's independent lifestyle and Alexander's affection for her threatening and was hostile to her throughout her life. See also Nancy Hale's biography.

75. Nancy Hale, *Mary Cassatt: A Biography of a Great Modern Painter* (New York: Doubleday & Co., 1975), p. 35.

76. Jo Ann Wein, "The Parisian Training of American Women Artists." *Woman's Art Journal* (Spring–Summer 1981):43.

77. Quoted in Hale, *Mary Cassatt,* p. 43.

78. Quoted in Eleanor Munro, *Originals: American Women Artists* (New York: Simon & Schuster, 1979), p. 64.

79. Sweet discusses this, *Miss Mary Cassatt,* p. 24.

80. E. John Bullard, *Mary Cassatt: Oils and Pastels* (New York: Watson-Guptill Publications, 1972), p. 12. "On the line" was a favored position, near eye level.

81. Quote from Cassatt's letter in Munro, *Originals,* p. 65.

82. William H. Gerdts, *American Impressionism* (Seattle: Henry Art Gallery, 1980), p. 46. Describes these paintings as "unidealized figures caught in informal moments . . . glowing richly in dark and vivid colors. . . . A group of the most important of these pictures were shown at the Cincinnati Industrial Exposition of 1873, works amazingly advanced for their time, though not yet Impressionistic."

83. Quoted in Caroline Ticknor, *May Alcott, A Memoir* (Boston: Little, Brown & Co., 1927), pp. 151–52.

84. Reminiscence by Mrs. Havemeyer, in *The Pennsylvania Museum Bulletin,* (May 1927):377; quoted in many books.

85. Ségard, *Un Peintre,* p. 35.

86. Quoted in Ellen Wilson, *An American Painter in Paris: A Life of Mary Cassatt* (New York: Farrar, Straus & Giroux, 1971), p. 72.

87. Ségard, p. 35; quoted in Bullard, *Mary Cassatt;* Breeskin, *Graphic Work of Mary Cassatt;* and elsewhere.

88. Daniel Halévy, *My Friend Degas,* trans. Mina Curtiss (Middletown, Conn.: Wesleyan University Press, 1964), p. 78; quoting from an undated letter from Degas.

89. Bullard, *Mary Cassatt,* p. 19.

90. Bullard, *Mary Cassatt,* p. 16.

91. J. K. Huysmans, *L'Art Moderne,* (Paris, 1883), Gregg International Publishers Limited, 1969.

92. This is pointed out in Adelyn Breeskin, *Mary Cassatt: A Catalogue Raisonné of the Oils, Pastels, Watercolors, and Drawings* (Washington, D.C.: Smithsonian Institution Press, 1970).

93. Wilson, *An American Painter,* p. 169.

94. Munro, *Originals,* p. 487; Also, see Bullard, p. 12.

95. Ségard, *Un Peintre;* quoted in Wilson, *An American Painter,* and elsewhere.

96. Hale, *Mary Cassatt,* p. 165.

97. Bullard, *Mary Cassatt,* p. 14.

98. Sweet, *Miss Mary Cassatt,* p. 182.

99. Bullard, *Mary Cassatt;* quoting Cassatt's letter to George Biddle.

100. Sweet, *Miss Mary Cassatt,* p. 144.

101. Ibid., p. 187.

102. Ibid., p. 56.

103. Ibid., p. 187.

104. Quoted in Hale, *Mary Cassatt,* p. 262.

105. Sweet, *Miss Mary Cassatt,* p. 199.

106. Ibid., p. 146.

107. Bullard, *Mary Cassatt,* p. 20.

108. Lilla Cabot Perry, "Reminiscences of Claude Monet from 1889 to 1909," *American Magazine of Art* 18, no. 3 (March 1927):119.

109. Stuart P. Feld, *Lilla Cabot Perry: A Retrospective Exhibition* (New York: Hirschl & Adler Galleries, 1969).

110. Sara Dodge Kimbrough, *Drawn From Life* (Jackson: University of Mississippi Press, 1976), p. 66.

111. Quoted in Jennifer A. Martin, "The Rediscovery of Maria Oakey Dewing," *Feminist Art Journal* (Summer 1976):24.

112. Ibid., p. 26.

113. Ibid., p. 25.

114. Royal Cortissoz, obituary of Dewing, *New York Herald Tribune,* 18 December 1927.

115. Jennifer A. Martin, "Portraits of Flowers: The Out-of-Door Still Life Paintings of Maria Oakey Dewing," *American Art Review* (December 1977):116.

116. Susan Casteras and Seymour Adelman, *Susan Macdowell Eakins: 1851–1938* (Philadelphia: Pennsylvania Academy of the Fine Arts, 1973). Most of this information comes from Ms. Casteras's fine essay.

117. Gordon Hendricks, *The Life and Work of Thomas Eakins* (New York: Grossman Publishers, 1974), p. 283.

118. Lucy Lippard, review of "19th Century Women Artists," exhibition at downtown Whitney Museum, *Art in America,* (September–October 1976):113.

119. Clement, *Women in the Fine Arts,* p. 166.

120. See footnote 10 about Benn Pitman and the woodcarving movement in Cincinnati. Pitman's art classes at the McMicken School of Design were made up largely of women.

121. Althea Callen, *Women Artists of the Arts and Crafts Movement: 1870–1914* (New York: Pantheon Books, 1979), p. 20.

122. Madeline B. Stern, *We the Women: Career Firsts of Nineteenth Century America* (New York: Schulte Publishing Co., 1963), p. 279.

123. Marling, *Woodstock.*

124. Candace Wheeler, *Yesterdays From a Busy Life* (New York: Harper & Bros., 1918), p. 294; Wheeler's autobiography, quoted in Marling, *Woodstock.*

125. Timothy J. Anderson, Eudora M. Moore, and Robert W. Winter, eds., *California Design, 1910* (Pasadena, Calif.: Pasadena Design Publications, 1974) p. 42.

126. Ibid., p. 91.

127. Joelynn Snyder-Ott, "Woman's Place in the Home (That She Built)," *Feminist Art Journal* (Fall 1974):708.

128. Ibid., p. 8; quoting the critic for *American Architect Magazine.*

129. Ibid.

130. Maude Howe Elliott, *Art and Handicraft in the Woman's Building of the World's Columbian Exposition* (Chicago: Rand, McNally & Co., 1894), p. 38.

131. Judith Paine, "Sophia Hayden and the Woman's Building Competition," in *Women in American Architecture: A Historic and Contemporary Perspective,* ed. Susana Torre (New York: Whitney Library of Design, 1977), p. 71.

132. Elliot, *Art and Handicraft,* p. 40.

133. Ibid., p. 47. Does this suggest an emerging liberated female eroticism?

134. Jeanne Weimann, *The Fair Women* (Chicago: Academy Chicago, 1981), p. 211. A detailed account of events surrounding the Woman's Building.

Chapter 5: Ash Can School and Armory Show

1. Wanda M. Corn, *The Color of Mood: American Tonalism, 1880–1910* (San Francisco: M. H. De Young Memorial Museum and the California Palace of the Legion of Honor, 1972).

2. Barbara Pollack, *The Collectors: Dr. Claribel and Miss Etta Cone; with a Portrait by Gertrude Stein* (Indianapolis: Bobbs-Merrill, 1962). An intimate glimpse of the circle around Gertrude Stein.

3. Zelda Fitzgerald, wife of author F. Scott Fitzgerald, has come to symbolize the illusory nature of the so-called liberated twenties. The Fitzgeralds were the archetypal Jazz Age couple, but many people believe she went mad from the various conflicts in her personal life and the competition in her marriage. She was a painter, novelist, and dancer.

4. Elenore Plaisted Abbott illustrated *Treasure Island* (Philadelphia: G. W. Jacobs & Co., 1911) and Jesse Willcox Smith illustrated *Little Women* (Boston: Little, Brown & Co., 1915).

5. Henry C. Pitz, *The Brandywine Tradition* (New York: Weathervane Books, 1968), p. 178.

6. Catherine Connell Stryker, *The Studios at Cogslea* (Wilmington: Delaware Art Museum, 1976), p. 27; quoting Violet Oakley, "Art as a Stimulus to Civic Righteousness," *Philadelphia Forum* (August 1922):11.

7. Regina Armstrong, "Representative American Women Illustrators: The Decorative Workers," *The Critic* 36 (1900):520.

8. Violet Oakley, *The Holy Experiment* (privately printed, 1922); *The Holy Experiment: Our Heritage from William Penn* (Philadelphia: Cogslea Studio Publications, 1950).

9. Oakley's studio is preserved at Cogslea, Mt. Airy, Pennsylvania.

10. "The Secret Was About Covers," *Good Housekeeping* 60 (1917):7.

11. Stryker, *Studios at Cogslea*, p. 9.

12. Henry Wadsworth Longfellow, *Evangeline: A Tale of Acadie* (Boston: Houghton Mifflin, 1897); introd. Howard Pyle, p. xix.

13. Stryker, *Studios at Cogslea*, p. 10; quoting Harrison S. Morris, "Jessie Willcox Smith," *The Book Buyer* 24 (1902):201.

14. The artist's daughter, Nancy Hale, has written a book about her mother, *The Life in the Studio* (Boston: Little, Brown & Co., 1969).

15. The portrait of Franklin D. Roosevelt is reproduced in chapter 6.

16. Ira Glackens, *William Glackens and the Ashcan Group* (New York: Crown Publishers, 1957), p. 32.

17. Bruce St. John, *The Fiftieth Anniversary of the Exhibition of Independent Artists* (Wilmington: Delaware Art Center, 1960).

18. William Inness Homer, *Robert Henri and His Circle* (Ithaca: Cornell University Press, 1969), p. 151. Describes their life together.

19. Ibid., pp. 199–200.

20. Quoted in Wayne Craven, "Mary Abastenia St. Leger Eberle," in *Notable American Women: 1607–1950,* edited by James T. Edwards et al. (Cambridge, Mass.: Harvard University Press, Belknap Press, 1971), pp. 548–49.

21. Ibid.

22. Christina Merriman, "New Bottles for New Wine," *Survey* 30 (3 May 1913):196–99.

23. Daniel Robbins, "Statues to Sculpture," in Tom Armstrong et al., *200 Years of American Sculpture* (New York: Whitney Museum of American Art and David R. Godine, Publisher, 1976), p. 135.

24. Milton Brown, *The Story of the Armory Show* (New York: Joseph H. Hirshhorn Foundation, 1963); lists all exhibitors. Women in the show included: Marion Beckett, Florence Howell Barkley (1880?–1954), Bessie Marsh Brewer (1884–1952), Fannie Miller Brown (1882–?), Edith Woodman Burroughs (1871–1916), Myra Mussleman Carr (1880–?), Mary Cassatt (1844–1926), Nessa Cohen (1885–?), Kate T. Cory, Edith Dimock (1876–1955), Katherine Sophie Dreier (1877–1952), Florence Dreyfous, Abastenia St. Leger Eberle (1878–1942), Jean Eels, Florence Este (1860–1926?), Lily Everett, Mary A. Hallock Foote (1847–1938), Anne Goldthwaite (1875–1944), Edith Haworth, Margaret Hoard (1879–1944), Mrs. Thomas Hunt, Margaret Wendell Huntington, Grace Mott Johnson (1882–?), Edith L. King, Hermine E. Kleinert (1880–1943), Amy Londoner (1878–195?), Carolyn C. Mase (?–1948), Kathleen McEnery, Charlotte Meltzer, Ethel Myers (1881–1960), Marjorie Organ (1886–1931), Josephine Paddock (1885–?), Agnes Pelton (1881–1961), Harriet Sophia Philips (1849–1928), Louise Pope, May Wilson Preston (1873–1949), Katherine N. Rhoades (1895–), Mary C. Rogers (1881–1920), Bessie Potter Vonnoh (1872–1955), Hilda Ward (1878–1950), Enid Yandell (1870–1934), Marguerite Zorach (1887–1968).

Notes

25. Roberta K. Tarbell, *Marguerite Zorach: The Early Years, 1908–1920* (Washington, D.C.: National Collection of Fine Arts, Smithsonian Institution Press, 1973). The principal source of information about Marguerite Zorach.

26. William Zorach, *Art Is My Life* (Cleveland: World Publishing Co., 1967), p. 23.

27. Tarbell, *Marguerite Zorach;* quoting Aloysius P. Levy, "The International Exhibition of Modern Art," *New York American,* 22 February 1913.

28. Thanks to Professor Steven M. Gelber, History Department, Santa Clara University, California, for this article from Fresno newspaper, 1939, in his archives of New Deal art in California. From artist's biographical files, Office of Fine Art and Historical Preservation General Services Administration, Wash. D.C.

29. Ibid. Although the government favored upbeat pictures of farmers and workers, local conservative politicians were always labeling the W.P.A. murals "communistic."

30. From artist's biographical files, Office of Fine Art and Historical Preservation, General Services Administration, Wash. D.C., In Professor Gelber's file, New Deal Art: California.

31. Katherine S. Dreier, introduction to *Collection of the Société Anonyme: Museum of Modern Art 1920,* ed. George Heard Hamilton (New Haven: Yale University Press, 1950).

32. Ibid.

33. Katherine S. Dreier, *Western Art and the New Era* (New York: Brentano, 1923).

34. Adelyn Breeskin, *Anne Goldthwaite: 1869–1944* (Montgomery, Ala.: Montgomery Museum of Fine Arts, 1977).

35. Ibid.

36. Adelyn Breeskin, *Memorial Exhibition for Anne Goldthwaite* (New York: Knoedler Galleries, 1944).

37. Other women shown at Stieglitz's galleries were Katharine N. Rhoades, painter-poet (1915) at 291, Peggy Bacon (1928) at An Intimate Gallery, and Helen Torr, in a joint exhibition with Arthur Dove, March 1933, at an American Place. Also Marion Beckett (1915).

38. Georgia O'Keeffe, *Georgia O'Keeffe* (New York: Viking Press, 1976).

39. Laurie Lisle, *Portrait of An Artist: A Biography of Georgia O'Keeffe* (New York: Seaview Books, 1980), p. 165.

40. Ibid., pp. 195–97.

41. Ibid., p. 205. Stieglitz, an elitist, called mural painting a "Mexican disease." The more democratic O'Keeffe was interested in trying murals, according to Lisle.

42. Ibid., p. 206.

43. Barbara Rose, "Georgia O'Keeffe, The Paintings of the Sixties," *Artforum* (November 1970):42–46.

44. Lloyd Goodrich and Doris Bry, *Georgia O'Keeffe* (New York: Whitney Museum of American Art and Praeger Publishers, 1970); discusses these phases.

45. Milton W. Brown, *American Painting from the Armory Show to the Depression* (Princeton, N.J.: Princeton University Press, 1955), p. 127.

46. Barbara Rose, "O'Keeffe's Trail," *New York Review of Books,* 31 March 1977, pp. 29–33. Discusses the artist's connections with American transcendental thought.

47. Quoted in Martin L. Friedman, *Precisionist View in American Art* (Minneapolis: Walker Art Center, 1960), p. 37.

48. Barbara Goldsmith, *Little Gloria . . . Happy at Last* (New York, Alfred A. Knopf, 1980), p. 229. This book reviews the sensational trial for custody of Gloria Vanderbilt, Jr.

49. The base was designed by Henry Bacon, architect of the Lincoln Memorial. Whitney's brother went down in another sea tragedy soon after—the sinking of the Lusitania—giving her added emotional involvement with the statue.

50. James Goode, *Outdoor Sculpture of Washington, D.C.* (Washington, D.C.: Smithsonian Institution Press, 1974), p. 391.

51. B. H. Friedman, *Gertrude Vanderbilt Whitney: A Biography,* (New York: Doubleday, 1978) and Goldsmith, *Little Gloria,* pp. 220–21.

52. Goldsmith, *Little Gloria,* p. 581.

53. Ibid. The case is described in detail.

54. From *Animosities* by Peggy Bacon, Copyright 1931 by Harcourt Brace Jovanovich, Inc; copyright © 1959 by Peggy Bacon. Reprinted by permission of the publisher.

55. Roberta K. Tarbell, *Peggy Bacon: Personalities and Places* (Washington, D.C., Smithsonian Institution Press, 1975), p. 9

56. Tarbell analyses her style, Ibid., p. 10.

57. Ibid., p. 19; letter from Peggy Bacon Papers, Syracuse University.

58. Ibid.

59. Ibid.

60. Ibid., p. 36; quoting untitled manuscript by Peggy Bacon (no date), Peggy Bacon Papers, Syracuse University.

61. Linda Nochlin, "Florine Stettheimer: Rococo Subversive," *Art in America* (September 1980):65.

62. Ann Sutherland Harris and Linda Nochlin, *Women Artists: 1550–1950* (Los Angeles: Los Angeles County Museum of Art, 1976), p. 266.

63. Stettheimer's brother Walter's daughter married Julius Adler, publisher of the *New York Times;* her oldest sister Stella's son became the Hollywood producer Walter Wanger.

64. Robert de Montesquiou, "Cambrioleurs d'Ames," *Le Figaro,* May 1910. From this title Adelyn Breeskin drew the name of her monograph for the National Collection of Fine Arts.

65. Doubts have been raised about the veracity of this account by the imaginative artist. See Harris and Nochlin, *Women Artists: 1550–1950,* p. 268.

66. Meryl Secrest, *Between Me and Life: A Biography of Romaine Brooks* (New York: Doubleday & Co., 1974); quoted on the frontispiece (dedication page).

67. Ibid., p. 21. From Ella Waterman's poem.

68. Adelyn Breeskin, *Romaine Brooks, Thief of Souls* (Washington, D.C.: National Collection of Fine Arts, 1971).

69. Secrest, *Between Me and Life,* p. 22.

70. Harris and Nochlin, *Women Artists: 1550–1950,* p. 268.

71. Secrest, *Between Me and Life,* p. 181.

72. Claude Roger-Marx, *Tableaux par Romaine Brooks,* (Paris: Galeries Durand-Ruel, 1910); quoted in Breeskin, *Romaine Brooks,* p. 19.

73. Alice Pike Barney, a wealthy woman who abandoned a stifling society life, became a symbolist painter at the turn of the century. She was a friend of Oscar Wilde and Whistler, living much of the time in Paris, and bequeathed her Whistlerian Studio House in Washington, D.C., to the Smithsonian Institution. She wrote plays and conducted a salon. Interestingly, she first studied with Elizabeth Nourse at the McMicken School of Design in Cincinnati.

74. Mary Blume, "Natalie Barney, Legendary Lady of the Rue Jacob," *Réalités,* no. 183 (February 1966):201.

75. Edouard MacAvoy, "Romaine Brooks," *Bizarre* (Paris), number 46, March 1968, p. 8.

76. Hilton Kramer, "Romaine Brooks: Revelation in Art," *New York Times* 14 April 1971; "Revival of Romaine Brooks," *New York Times,* 25 April 1971.

77. Natalie Clifford Barney, "The Weeping Venus"; reprinted in the appendix to Secrest, *Between Me and Life,* p. 413. Secrest observed the relationship between the poem and the painting.

78. Richard J. Boyle, *American Impressionism,* (Boston: New York Graphic Society, 1974) p. 216.

79. Barbara Rose, *American Art Since 1900,* 2d ed. (New York: Praeger Publishers, 1975), p. 241.

80. See Robbins, *200 years of American Sculpture,* pp. 138–40.

81. Ibid., p. 281.

82. This was one of many contributions the Huntingtons made to American culture. They founded the Mariners Museum (for study of the sea) at Newport News, Virginia, gave huge tracts of land to the government parks, and established sculpture awards.

83. Malvina Hoffman, *Heads and Tales* (New York: Charles Scribner's Sons, 136), p. 31.

84. Ibid., p. 32.

85. Ibid., p. 58.

Chapter 6: Daughters of the Depression

1. Other women who served on the national executive board were: Gwendolyn Bennett (a black artist and director of the Harlem Art Center), Minna Harkavy, Ruth Reeves, Katharine Schmidt, Grace Clements (a Los Angeles painter), and Mabel Frazer.

2. Helen A. Harrison and Karal Ann Marling, *7 American Women: The Depression Decade* (Poughkeepsie, N.Y.: Vassar College Art Gallery and A.I.R. Gallery (New York), 1976), p. 13. Contains an essay on the history of American women artists, analyzing social forces ("American Art and the American Woman," by Marling, pp. 7–14).

3. McMahon had been an officer of the College Art Association, editor of *Parnassus;* she began to secure assistance for destitute artists before the government projects began. Often under attack by the artists (although she had their interests at heart) because she had to issue the "pink

slips" when the government cut the program (as it frequently did), she also fought off meddling from the government officials who tried to censor artists' subjects, often pleading with them to continue the program.

4. Nan Sheets, a well-known Oklahoma landscape painter, director of the Oklahoma Art Center (1936–1965) and art critic for the *Daily Oklahoman* (1934–1962), is in the Oklahoma Hall of Fame.

5. The index was conceived by Ramona Javitz, a librarian at the New York Public Library who saw the need for an archive of American resource material for designers. She discussed it with Ruth Reeves, who initiated the project. Constance Rourke was editor of the index (1935–36).

6. "Women Artists from the Age of Chivalry to the New Deal," colloquium chaired by Eleanor Tufts at the College Art Association annual meeting, 1975.

7. Barbara Rose, *American Art Since 1900,* 2d ed. (New York: Praeger Publishers, 1975), p. 93.

8. Marling, *7 American Women,* p. 12–14

9. Obituary in Woodstock newspaper, the *Ulster County Townsman,* 26 February 1970, p. 8. Thanks to Robert Plate for this item.

10. A short-lived, elite government project, earmarked for very talented artists.

11. Marling and Harrison, *7 American Women,* p. 29.

12. Ibid., pp. 21–23. Most of the facts about Bloch are from this entry.

13. Ibid., p. 22.

14. Lucienne Bloch, "Murals for Use," in *Art for the Millions,* ed. Francis V. O'Connor (Greenwich, Conn.: New York Graphic Society, 1973), pp. 76–77. This article was written for the Federal Art Project in 1936.

15. Emily Genauer, *New York World Telegram,* 12 September 1936, p. 14B. As quoted by Elizabeth Shepherd in "Elizabeth Olds," *7 American Women,* p. 35

16. Elizabeth Olds, "Prints for Mass Production," in *Arts For the Millions,* pp. 142–144.

17. Carl Zigrosser, "Mabel Dwight, Master of the Comédie Humaine," *American Artist* (June 1949):42.

18. Mabel Dwight, "Satire in Art," in *Art for the Millions,* p. 151.

19. Ibid.

20. Zigrosser, "Mabel Dwight," p. 43. Zigrosser quotes from Dwight's unpublished poetic autobiography in which she tells of seeing this moment.

21. Richard D. McKinzie, *The New Deal for Artists* (Princeton, N.J.: Princeton University Press, 1973), p. 14.

22. This women's college, founded in 1882 by Josephine Newcomb in memory of her daughter, originated the famous Newcomb Pottery and trained many Art Nouveau designers. Ida Kohlmeyer, abstract painter, studied and taught there.

23. Juliette H. Bowles "Lois Mailou Jones, Portrait of an Artist," *New Directions* (Howard University, July 1977), p. 7.

Notes

24. Cindy Nemser, "Conversation with Isabel Bishop," *Feminist Art Journal* 5, no. 1 (Spring 1976):17.

25. Ibid.

26. Ibid., p. 15. Bishop remembered it as, "I hadn't realized that death had done in so many."

27. Karl Lunde, *Isabel Bishop* (New York: Harry N. Abrams, 1975), p. 48. Lunde discusses these concepts.

28. Donna Marxer, "Getting Old is Just As Good," *Women Artists Newsletter*, December 1977, p. 2.

29. Many women, before the feminist movement, ridiculed their own sex, just as Jews and Negroes have expressed self-hatred in Jewish or black jokes.

30. Bradley Merrithew, "Doris Lee," in *7 American Women*, p. 32.

31. Ibid., p. 33.

32. Ernest W. Watson, "Magafan and Mountains," *American Artist* (December 1957):57.

33. Robert Goodnough, "Reviews and Previews," *Art News* 49 (December 1950):60.

34. Letter to the author, 1977.

35. Marjorie Phillips, *Duncan Phillips and His Collection* (Boston: Little, Brown & Co., 1970), p. 3.

36. Joseph S. Provato, *Marjorie Phillips*, (New York: Edward Root Art Center, Hamilton College, 1965).

37. Ibid.

38. Quoted in Louise Bruner, "The Paintings of Constance Richardson," *American Artist* (January 1961):21.

39. Ibid., p. 65.

40. Rebay was later criticized for excessive acquisitions of the work of Bauer for the Solomon Guggenheim collection. Many people considered his paintings third-rate imitations of Kandinsky. See Peggy Guggenheim, *Confessions of an Art Addict* (New York: Macmillan, 1960).

41. Thomas M. Messer, *A Selection of Paintings, Watercolors, and Drawings in Tribute to Hilla Rebay* (New York: The Solomon R. Guggenheim Museum, 1967).

42. See Joan M. Łukach, "Hilla Rebay," in *Notable American Women: The Modern Period*, edited by Barbara Sicherman, et al. (Cambridge, Mass.: Harvard University Press, Belknap Press, 1980), pp. 571–72. The Baroness helped refugees from the Nazis. When Jeanne Miles, abstract painter, and her little daughter fled here from France, Rebay turned over her Carnegie Hall apartment to her and left the refrigerator well stocked with food. Here are descriptions of the Baroness by artists who knew her: "She ran the museum like a duchy, but she could be very generous. The baroness was blonde, bosomy, impressive, authoritarian, outspoken, and literally sailed into a room. She was a student of the occult and believed that she had magical powers. She could use strong language at times and liked to 'review the troops'—artists whom she made custodians of the museum. She could tell the devil himself to go to hell." (personal conversation with an artist friend who prefers to remain anonymous).

43. Peter Walch, "American Abstract Artists," *College Art Journal* (Fall 1977):48.

44. Quoted in obituary, *New York Times,* 27 November 1956, p. 38.

45. Alice Trumbull Mason, "Concerning Plastic Significance," in *American Abstract Artists Yearbook, 1938* (New York: American Abstract Artists, 1938).

46. Ibid.

47. May Brawley Hill, *Three American Purists: Mason, Miles, von Wiegand* (Springfield, Mass.: Museum of Fine Arts, 1975).

48. Rosalind Bengelsdorf (Browne), "The American Abstract Artists and the W.P.A. Federal Art Project," in *The New Deal Art Projects: An Anthology of Memoirs,* ed. Francis V. O'Connor (Washington, D.C.: Smithsonian Institution Press, 1972), p. 236.

49. Marling and Harrison, *7 American Women,* p. 18.

50. Rosalind Bengelsdorf, "The New Realism," in *American Abstract Artists Yearbook, 1938.*

51. Ibid.

52. Anni Albers, *On Designing* (Middletown, Conn.: Wesleyan University Press, 1943), p. 7.

53. Gene Baro and Nicholas Fox Weber, *Anni Albers: Drawings and Prints* (Brooklyn, N.Y.: Brooklyn Museum, 1977), p. 7. Albers was one of many women for whom June Wayne's lithography workshop served as a catalyst.

54. Mildred Constantine and Jack Lenor Larsen, *Beyond Craft: The Art fabric* (New York: Van Nostrand Reinhold Co., 1973), p. 22.

55. John I. H. Baur, *Loren MacIver, I. Rice Pereira* (New York: Whitney Museum of American Art, 1953), p. 39.

56. Ibid., p. 52.

57. I. Rice Pereira; quoted in *American Painting Today,* ed. Nathaniel Pousette-Dart (New York: Hastings House, 1956), p. 42.

58. Donald Miller, "The Timeless Landscapes of I. Rice Pereira," *Arts Magazine* 53 (October 1978):132–33.

59. James Thrall Soby, *Contemporary Painters* (New York: Museum of Modern Art, 1948), p. 56.

60. Baur, *Loren MacIver, I. Rice Pereira.* The principal source of biographical details about MacIver.

61. James Thrall Soby, *Romantic Painting in America* (New York: Museum of Modern Art, 1943), p. 48.

62. Letter to the author, 1977.

63. Edward Alden Jewell, *New York Times,* 17 May 1936, sect. 9, p. 10.

64. Letter to author, 1977.

65. Concetta Scaravaglione, "My Enjoyment in Sculpture," *Magazine of Art* (August 1939):450–55.

66. Ibid.

67. Ibid.

68. Archives of American Art, N/7065, Dorothea Greenbaum, frame 32.

69. Ibid.

70. This episode is described in William Zorach, *Art is My Life.*

71. Suzanne Corlette, *Paintings by Bishop: Sculpture by Dorothea Greenbaum* (Trenton: New Jersey State Museum, 1970).

72. John I. H. Baur, *Four American Expressionists* (New York: Whitney Museum of American Art, 1959), p. 23.

73. Ibid., p. 27.

74. Steven M. Gelber, "The New Deal and Public Art in California," in *New Deal Art: California* (Santa Clara: de Saisset Art Gallery and Museum, University of Santa Clara, 1976), p. 77.

75. Merle Armitage, Edward Weston, and Reginald Poland, *Henrietta Shore* (New York: E. Weyhe, 1933), p. 7.

76. Ibid., p. 10. In addition, Ben Maddow quotes from Weston's Daybook in *Edward Weston: 50 Years* (Millerton, N.Y.: Aperture, 1973), p. 68: "I was awakened to shells by a painting of Henry's. . . . Henry's influence or stimulation, I see not just in shell subject matter. . . . It is in all my late work, not as an extraneous matter but as a freshened tide swelling within myself" (February 1927).

77. Before, Arthur Ames and Jean Goodwin had to live together unmarried because husband and wife could not both draw a salary on the government project.

Chapter 7: The 1940s and 1950s

1. Art of this Century: Exhibition of "31 Women," originally suggested by Marcel Duchamp, was the third show at the gallery. The jurors were Max Ernst, Marcel Duchamp, André Breton, the critics James Johnson Sweeney and James Soby, Guggenheim, and her two assistants, Howard Putzel and Jimmy Ernst. "31 Women" included (in addition to those already mentioned) Xenia Cage (John Cage's wife), Vieira da Silva, Eyre de Lanux, Leonor Fini, Meraud Guevara, Anne Harvey, Valentine Hugo, Jacqueline Lamba (married to André Breton), Gypsy Rose Lee (!), Aline Myer Liebman, Hazel McKinley (sister of Peggy Guggenheim), Milena, Barbara Reis, Gretchen Schoeninger, Sophie Taueber-Arp, and Pegeen Vail (Guggenheim's daughter). The 1945 show also included Virginia Admiral, Xenia Cage, Leonora Carrington, Anne Harvey, Jacqueline Lamba, Muriel Levy, McKee, Peter Miller, Anne Neagoe, Alice Taalen, Helen Phillips, Kay Sage, Sonia Secula, Janet Sobel, Pegeen Vail, Isabel Waldberg, Katherine Yarrow. Jackson Pollock claimed that Janet Sobel's work had a big influence on him. Thanks to Buffie Johnson for this list.

2. The museum is open to the public during certain summer hours.

3. Eleanor Munro, *Originals: American Women Artists* (New York: Simon & Schuster, 1979), p. 484, n. 16.

4. Phone interview with Dehner, 1980.

5. Barnett Newman, Letter to the Editor, *Art News* (June 1959), p. 6.

6. Louise Nevelson (taped conversations with Diana Mackown), *Dawns + Dusks* (New York: Charles Scribner's Sons, 1976), p. 69.

7. Cindy Nemser, *Art Talk: Conversations with 12 Women Artists* (New York: Charles Scribner's Sons, 1975) p. 238.

8. Norman Mailer, *Advertisements for Myself* (New York: G. P. Putnam's Sons, 1959), p. 472.

9. One problem women faced in recent times was the fact that they wanted a full life, like those of their mates; they wanted love *and* career *and* children, and deluded themselves that now that they had won equality all of these would be possible. They found, however, that there was no one to share the chores; their time and concentration were shattered, and chauvinism pervaded the art world. Artists like Harriet Hosmer and Sara Peale in the nineteenth century made the decision to avoid marriage. In that period, before birth control, they knew that marriage meant the end of a career.

10. Miriam Schapiro, "Notes from a Conversation on Art, Feminism and Work," in *Working it Out: 23 Women Writers, Artists, Scientists and Scholars Talk About Their Lives and Work,* ed. Sara Ruddick and Pamela Daniels (New York: Pantheon Books, 1977), p. 287.

11. Cindy Nemser, *Art Talk,* p. 83.

12. Gaby Rodgers, "She Has Been There Once or Twice: A Talk with Lee Krasner," *Women Artists Newsletter* (New York), December 1977, p. 2.

13. Ibid.

14. *Newsday,* 12 November 1973. Quoted in *Current Biography Yearbook, 1974,* p. 216.

15. Munro, *Originals,* p. 107.

16. Barbara Rose, "American Great: Lee Krasner," *Vogue* (June 1972):121.

17. Barbara Rose first made these observations in "Lee Krasner and the Origins of Abstract Expressionism," *Arts Magazine* (February 1977):96–100.

18. John Graham, *System and Dialectics of Art* (Baltimore: Johns Hopkins University Press, 1971); reprint of 1937 edition; quoted in Rose, "Origins,"p. 98.

19. Rose, "Origins," p. 96.

20. Ibid., p. 99.

21. Nemser, *Art Talk,* p. 87.

22. B. H. Friedman, *Jackson Pollock* (New York: McGraw Hill, 1972) p. 87.

23. Peggy Guggenheim, *Confessions of an Art Addict* (New York: Macmillan, 1960), p. 10.

24. Cindy Nemser, "The Indomitable Lee Krasner," *Feminist Art Journal* (Spring 1975), p. 7.

25. John Gruen, *The Party's Over Now* (New York: Viking Press, 1967), p. 232.

26. *Newsday,* 12 November 1973. Quoted in *Current Biography Yearbook, 1974,* p. 217.

27. Rodgers, "She Has Been There," p. 2.

28. Typical of such surveys is Irving Sandler's *Triumph of American Painting,* which does not include a single woman.

29. Rose, "American Great: Lee Krasner," p. 154. Rose said that it was time to recognize that Krasner had the same history, the same content as her male colleagues.

30. Hilton Kramer, "Making Vivid the Spirit of the New York School," *New York Times,* 16 April 1978, p. D26.

31. Elsa Honig Fine, *Women & Art: A History of Women Painters and Sculptors from the Renaissance to the 20th Century* (Montclair, N.J., and London: Allanheld & Schram; Prior; 1978), pp. 210–11.

32. Marcia Tucker, catalogue essay in *Lee Krasner: Large Paintings* (New York: Whitney Museum of American Art, 1973), p. 11.

33. Rodgers, "She Has Been There," p. 8.

34. Kathryn E. Gamble, "Hedda Sterne Retrospective" (Montclair, N.J.: Montclair Art Museum, 1977), p. 11.

35. Ibid.

36. "Steinberg and Sterne," *Life* (27 August 1951), pp.50–52.

37. *Art News* (December 1963):14.

38. Quoted in Kathryn E. Gamble, *Betty Parsons Retrospective,* (Montclair, N.J.: Montclair Art Museum, 1974); contains several poems by Parsons.

39. Bryan Robertson and Lawrence Alloway, *Betty Parsons: Paintings, Gouaches, and Sculpture, 1955–68* (London: Whitechapel Gallery, 1968), p. 3.

40. Interview with Suzanne Muchnic, "Parsons at 80: Dealing Artfully," *Los Angeles Times,* 20 May 1980, sect. 6, p. 1.

41. From radio broadcast, WNYC, New York, 1952; quoted in Robertson and Alloway, *Betty Parsons,* p. 13.

42. Muchnic, "Parsons at 80," p. 5.

43. Robertson and Alloway, *Betty Parsons,* p. 15.

44. Lawrence Alloway, "The Art of Betty Parsons," in *Betty Parsons,* p. 7.

45. Quoted in *Current Biography Yearbook, 1962,* p. 194.

46. Joellen Bard, "Tenth Street Days: An Interview with Charles Cajori and Lois Dodd," *Arts Magazine* (December 1977):98.

47. Nemser, *Art Talk,* p. 152.

48. Ibid., p. 153.

49. Ibid., p. 157.

50. Irving Sandler, *The New York School: The Painters and Sculptors of the Fifties* (New York: Harper & Row, 1978), p. 113.

51. Dorothy Miller, ed., *12 Americans* (New York: Museum of Modern Art, 1956), p. 53.

52. *Current Biography Yearbook, 1962,* p. 194.

53. Quoted in *American Artists '76: A Celebration, 1976* (San Antonio, Texas: Marion Koogler McNay Art Institute, 1976).

54. Marcia Tucker, *Joan Mitchell* (New York: Whitney Museum of American Art, 1974), p. 7.

55. Cindy Nemser, "An Afternoon with Joan Mitchell," *Feminist Art Journal* (Spring 1974):6.

56. Munro, *Originals,* p. 244.

57. Tucker, *Joan Mitchell,* p. 7.

58. Munro, *Originals,* p. 245.

59. Betty Holliday, "Reviews and Previews: Joan Mitchell," *Art News* (November 1951):48.

60. John Ashbery, "An Expressionist in Paris," *Art News* (April 1965):63.

61. Tucker, *Joan Mitchell,* pp. 7–8.

62. Munro, *Originals,* p. 237.

63. Tucker, *Joan Mitchell,* p. 7.

64. Ibid.

65. Irving Sandler, "Joan Mitchell Paints a Picture," *Art News* (October 1957):45.

66. Tucker, *Joan Mitchell,* p. 15.

67. Marcia Tucker's interpretation.

68. "Dialogue by Elaine de Kooning with Rosalyn Drexler," in *Art and Sexual Politics: Why Have There Been No Great Women Artists?,* ed. Thomas B. Hess and Elizabeth C. Baker (New York: Macmillan, 1973), p. 66.

69. Munro, *Originals,* p. 251.

70. Ibid., pp. 248, 251.

71. Described in Gruen, *The Party's Over* and Munro, *Originals,* p. 253.

72. Gruen, *The Party's Over,* p. 213.

73. Ibid., p. 209.

74. Ibid., pp. 206–20.

75. Ibid., p. 181 and 212.

76. Lawrence Campbell, "Elaine de Kooning Paints a Picture," *Art News* (December 1960):42.

77. De Kooning later said she was identifying the bull with Caryl Chessman, fighting for his life against the gas chamber in California.

78. Elaine de Kooning, "Painting a portrait of the President," *Art News* (Summer 1964):33.

79. Ibid. For an in-depth account see Munro, *Originals,* pp. 256–60.

80. Munro, *Originals,* p. 260.

81. "Instant Summing," *Time* (3 May 1963):68.

82. "Sports as Seen Through the Eyes of an Artist," *The New York Times,* 8 May 1981.

83. Ibid.

84. Martica Sawin, "Good Painting—No Label," *Arts Magazine* (September 1963)., p. 41.

85. Alan Gussow, *A Sense of Place: The Artist and the American Land* (San Francisco, New York, London, and Paris: Friends of the Earth and Seabury Press, 1971), p. 136.

86. Interview with the artist, New York, January 1978.

87. Ibid.

88. A well-known abstract painter included in the Museum of Modern Art group shows.

89. Nell Blaine, "Getting with Lester and Mondrian in the Forties," introduction to *Jazz and Painting* (Keene, N.H.: Louise E. Thorne Memorial Art Gallery, Keene State College, 1972).

90. Ibid.

91. Interview with Blaine, New York, January 1978.

92. C. O. Selle, *Larry Rivers: Drawings, 1949–1969* (Chicago: Art Institute of Chicago, 1970).

93. Munro, *Originals,* p. 271.

94. Gussow, *A Sense of Place,* p. 138.

95. Diane Cochane, "Nell Blaine: High Wire Painting," *American Artist* (August 1973):22.

96. Interview with Blaine.

97. Lawrence Campbell, *Nell Blaine* (Richmond: Virginia Museum of Fine Arts, 1973), p. 9.

98. Contains funny and vivid reminiscences of the New York School.

99. Diane Cochrane, "Remembrance of Images Past and Present," *American Artist* (December 1974):26.

100. Fairfield Porter, "Jane Freilicher Paints a Picture," *Art News* (September 1956):65.

101. Ibid., p. 47.

102. Peter Schjeldahl, "Urban Pastorals," *Art News* (February 1971):32.

103. Ibid., p. 33.

104. Regine Tessier Krieger, *Kay Sage* (Ithaca, N.Y.: Herbert F. Johnson Museum of Art, Cornell University, 1977), p. 1. Most personal details are from this fine essay.

105. Ibid., p. 2.

106. Ibid., p. 6; quoted from Kay Sage's notebooks, translated by Krieger.

107. Quoted in Krieger, *Kay Sage.* From *Demain, Monsieur Silber* (Paris: Piérre Seghers, 1958).

108. Peggy Guggenheim, *Confessions of an Art Addict,* p. 103.

109. Alain Jouffroy, interview with Tanning, in *Dorothea Tanning* (Paris: Centre National d'Art Contemporain, 1974), p. 47.

110. Ibid., p. 48.

111. Ibid., p. 51.

112. John Berry, "View From the Wind Palace," *Mankind* 5, no. 1 (June 1975):44.

113. In *Ynez Johnston: Selected Works, 1950–1977,* (New York: Wiener Gallery, 1977).

114. Interview with the artist, New York, January 1978.

115. Ibid.

116. Ibid.

117. Ibid.

118. Ibid.

119. Ibid.

120. Herta Wescher, *Collage,* trans. Robert E. Wolf (New York: Harry N. Abrams, 1971), p. 302.

121. Charmon von Wiegand, "The Oriental Tradition and Abstract Art," in *The World of Abstract Art* (New York: American Abstract Artists, 1957), pp. 55–67.

122. Charmion von Wiegand, "The Adamantine Way," *Art News* (April 1969):39.

123. Perle Fine, *Art: A Woman's Sensibility,* ed. Miriam Schapiro (Valencia: California Institute of the Arts, 1975).

124. Telephone interview, 1978.

125. "Reviews and Previews," *Art News* (1 March 1945), p. 7.

126. Telephone interview, 1978.

127. Ibid.

128. "Reviews and Previews," *Art News* (April 1963), p. 53.

129. Quoted in Josephine Withers, "Anne Ryan," *Women Artists in Washington Collections,* p. 82.

130. John Bernard Myers, *Arts Magazine* (May 1977):21.

131. Dorothy Seckler, "Sharrer Paints a Picture," *Art News* (April 1951):42.

132. Artist's statement.

133. Mathew Josephson, *Ruth Gikow* (New York: Random House, 1970), p. 9.

134. Ibid.

135. Arnold B. Glimcher, *Louise Nevelson* (New York: E. P. Dutton, 1972), p. 23.

136. Nevelson, *Dawns + Dusks,* p. 7.

137. Nevelson, *Dawns + Dusks,* p. 96; Glimcher, *Louise Nevelson,* p. 29.

138. Glimcher, *Louise Nevelson,* p. 19.

139. Robert Hughes, "Sculpture's Queen Bee," *Time* (12 January 1981):69.

140. Glimcher, *Louise Nevelson,* p. 28.

141. Ibid., p. 20.

142. Ibid.

143. Nevelson, *Dawns + Dusks,* p. 44.

144. Ibid., p. 42.

145. *Cue* (4 October 1941):16.

146. Emily Genauer, *New York World-Telegram,* 28 October 1944. Quoted in Glimcher, *Louise Nevelson,* p. 56

147. Glimcher, *Louise Nevelson,* p. 78.

Notes

148. Hilton Kramer, *Arts* 32, no. 9, Special Sculpture Number (June 1958), p. 54.

149. Robert Rosenblum, "Louise Nevelson," *Arts Yearbook* 3 (1959), p. 137.

150. Nemser, *Art Talk,* p. 58.

151. Hughes, "Sculpture's Queen Bee," p. 72.

152. Ibid.

153. Mary Callery, "The Last Time I Saw Picasso," *Art News* 41, no. 21, (1 March 1942):23.

154. Ibid.

155. Philip R. Adams, *Mary Callery: Sculpture* (New York: Wittenborn & Co., 1961), p. 7.

156. Judith Kaye Reed, "Slenderized Callerys," *Arts Digest* (1 April 1955):18.

157. Aline B. Loucheim, "Spotlight on Sculptresses: Callery, Hesketh, Orloff," *Art News* (May 1947):24. Review of Buchholz show.

158. Interview with Bourgeois, January 1978.

159. Lucy Lippard, *From the Center: Feminist Essays on Women's Art,* (New York: E. P. Dutton, 1976), p. 240.

160. Interview with the artist: January 1978.

161. Lippard, *From the Center,* p. 241.

162. Interview with the artist, January 1978.

163. *Yale Alumni Magazine and Journal* (May 1977):1.

164. Interview with Falkenstein, 1978.

165. Ibid.

166. Letter to the author, 1978.

167. Rosalind Bengelsdorf Browne, "Sue Fuller: Threading Transparency," *Art International* 16, no. 1 (20 January 1972):37–40.

168. Letter to the author, 1978.

169. Eugen Neuhaus, *The Art of Treasure Island* (Berkeley: University of California Press, 1939), p. 60. Kent did two relief figures in the Court of Honor and a group of three figures, *Islands of the Pacific,* on the central fountain.

170. Quoted in Mildred Hamilton, "A Tour of Ruth Asawa's San Francisco," *San Francisco Examiner,* 19 September 1976, Scene Arts sect. Asawa, with art historian Sally Woodbridge, has since 1968 spearheaded the Alvarado Art Workshop. Funded by local corporations, she brought professional artists into the schools and found a department store willing to sell the work of the children-artists. The group is now pushing for an arts-centered public school.

171. Samella S. Lewis and Ruth G. Waddy, *Black Artists on Art,* vol. 2 (Los Angeles: Contemporary Crafts, 1971), p. 107.

172. Samella S. Lewis, *Art: African American* (New York: Harcourt Brace Jovanovich, 1978), p. 125.

173. See Elton C. Fax, *Seventeen Black Artists* (New York: Dodd, Mead & Co., 1971).

Chapter 8: The Sixties: Pop Art and Hard Edge

1. "Eccentric Abstraction" is the title of an exhibition organized in 1966 by Lucy Lippard at the Fischbach Gallery. She featured abstractionists whose works expressed feelings in contrast with the cold formalism prevailing in the sixties.

2. Barbara Rose, *Frankenthaler* (New York: Harry N. Abrams, 1972), p. 64.

3. Lawrence Alloway, "Frankenthaler as Pastoral," *Art News* (November 1971):67.

4. From *Frankenthaler: Toward a New Climate,* a film directed by Perry Lee Adato (Films Incorporated), 1978.

5. Ibid.

6. Rose, *Frankenthaler,* p. 29.

7. Gene Baro, "The Achievement of Helen Frankenthaler," *Art International* (20 September 1967):34.

8. Henry Geldzahler, "An Interview With Helen Frankenthaler," *Artforum* (October 1965):37.

9. J[ames] S[chuyler], "Reviews and Previews: Helen Frankenthaler," *Art News* (May 1960):13.

10. Robert Motherwell, "Two Famous Painters' Collection," *Vogue,* (15 January 1964), pp. 88–91+.

11. Rose, *Frankenthaler,* p. 85.

12. Ibid., p. 105.

13. Cindy Nemser, "Interview with Helen Frankenthaler," *Arts Magazine* (November 1971):53.

14. Eugene C. Goossen, *Helen Frankenthaler* (New York: Whitney Museum of American Art, 1969), p. 13.

15. Gene Baro and Roy Slade, *Helen Frankenthaler: Paintings 1969–1974* (Washington, D.C.: Corcoran Gallery of Art, 1975).

16. Ibid.

17. Eleanor Munro, *Originals: American Women Artists* (New York: Simon & Schuster, 1979), p. 192.

18. Ibid., p. 192.

19. Ibid., p. 194.

20. Quoted in *Women Artists in Washington Collections,* University of Maryland Art Gallery, 1979, p. 87.

21. Alma Thomas, in *American Artists '76: A Celebration* (San Antonio, Texas: Marion Koogler McNay Art Institute, 1976).

22. Quoted in Carter Ratcliff, "Agnes Martin and the 'Artificial Infinite,'" *Art News* (May 1973):27.

23. Quoted in Lawrence Alloway, *Agnes Martin,* (Philadelphia: Institute of Contemporary Art, University of Pennsylvania, 1973), p. 32.

24. Ratcliff, "Agnes Martin," p. 27.

25. Alloway, *Agnes Martin,* p. 10. Alloway was one of the first to recognize Martin's importance and to coin the term "systemic" to apply to her kind of all-over field painting.

26. Quoted by Ann Wilson, "Linear Webs," *Art and Artists* (October 1966):48.

27. Quoted in Alloway, *Agnes Martin,* p. 10.

28. Ratcliff, "Agnes Martin," p. 26.

29. Lynda Morris, "Strata Paintings, Drawings and Prints," *Studio* (February 1974).

30. Alloway, *Agnes Martin,* p. 12.

31. Brown is discussed among figurative artists in this chapter. She also attended the California School of Fine Arts.

32. Miriam Brumer, "Deborah Remington: Fascinating Contradiction," *Feminist Art Journal* (Spring 1974):3.

33. Philip Leider, "Joan Brown: Her Work Illustrates the Progress of a San Francisco Mood," *Artforum* (June 1973):28–31.

34. Brenda Richardson, *Joan Brown* (Berkeley, Calif.: University Art Museum, 1974), p. 28.

35. Interview with the author, 1976.

36. Ibid.

37. Lester D. Longman, introd. *Joyce Treiman: A Retrospective* (Los Angeles: Hennessey and Ingalls, 1978), p. 10.

38. William Wilson, *Joyce Treiman: Paintings, 1961–1972* (La Jolla, Calif.: La Jolla Museum of Contemporary Art, 1972).

39. Interview with the artist.

40. Mary Baskett, *The Art of June Wayne,* (New York: Harry N. Abrams, 1968), p. 83.

41. Quoted in Gay Weaver, "A Champion in the Fight for Artists' Rights," *Palo Alto Times,* 7 January 1977, sect. 3, p. 13.

42. Quoted in Pamela Rothon, "A Conversation with Corita Kent," *American Way* (November 1970):13.

43. Quoted in interview with Chris Braithwaite, *Newsweek* (4 December 1967), "The Painting Nun," p. 89.

44. Survey of American Council of Education, Office of Women, 1976–1977.

45. *Current Biography Yearbook, 1969,* p. 128.

46. Catholic priests who were active in the antiwar movement. Daniel Berrigan wrote the play *The Catonsville Nine.*

47. John Gruen, *The Party's Over Now: Reminiscences of the Fifties* (New York: Viking Press, 1967), p. 200.

48. Cindy Nemser, *Art Talk: Conversations with 12 Women Artists* (New York: Charles Scribner's Sons, 1975), p. 189.

49. Gruen, *The Party's Over,* pp. 198–99. Describes various episodes.

50. Ibid., p. 209.

51. Quoted in Elsa Fine, *Women & Art: A History of Women Painters and Sculptors from the Renaissance to the 20th Century* (Montclair, N.J., and London: Allanheld and Schram; Prior; 1978), p. 219.

52. Quoted in Grace Glueck, "It's Not Pop, It's Not Op—It's Marisol," *New York Times Magazine* (7 March 1956):46.

53. Lawrence Campbell, "Marisol's Magic Mixtures," *Art News* (March 1964):39.

54. "Marisol," Worcester (Massachusetts) Art Museum, September–November 1971.

55. Glueck, "It's Not Pop," p. 34.

56. Fine, *Women & Art,* p. 221.

57. Quoted in Pierre Restany, *Chryssa* (New York: Harry N. Abrams, 1977), p. 45.

58. Quoted in Sam Hunter, *Chryssa* (New York: Harry N. Abrams, 1974), p. 10.

59. Vivian Campbell, "Chryssa: Some Observations," *Art International* (April 1973):29.

60. Quoted in Hunter, *Chryssa,* p. 18.

61. Ibid.

62. "It's Art—But Will it Fly?" *Life* (10 April 1964):43–44.

63. H. H. Arnason, *History of Modern Art* (New York: Harry N. Abrams, 1968), p. 570.

64. Dore Ashton, "Illusion and Fantasy: Lee," *Metro,* no. 8, (1962), p. 29.

65. "Reviews and Previews," *Art News* (February 1959):19.

66. Ibid.

67. Ashton, "Illusion and Fantasy," p. 33.

68. Philip Johnson, "Young Artists at Lincoln Center," *Art in America,* no. 4 (1964):123.

69. Quoted in Lucy Lippard, *Eva Hesse* (New York: New York University Press, 1976), p. 56.

70. C[arter] R[atcliff], "Reviews and Previews," *Art News* (September 1971):14.

71. Lil Picard, "Die Neuen Kulte," *Kunstwerk* (September 1971):74.

72. Sol LeWitt, "Ruth Vollmer: Mathematical Forms," *Studio International* 180, no. 928 (December 1970):256–57.

73. Ibid.

74. Clement Greenberg, "Changer: Anne Truitt," *Vogue* (May 1968):212.

75. Quoted in Marcia Tucker, *200 Years of American Sculpture* (New York: Whitney Museum of American Art, 1976), p. 218.

76. *Anne Truitt: Sculpture and Painting* (Charlottesville: University of Virginia Art Museum, 1976), p. 6.

77. L[awrence] C[ampbell], "Reviews and Previews" of a one-woman show at Barone Gallery, New York, *Art News* (December 1954):54.

78. E[leanor] C. M[unro], "Reviews and Previews" of a one-woman show at Barone Gallery, *Art News* (December 1956):11.

79. Robert Hughes, "A Red-Hot Mama Returns," *Time* (16 June 1975):51.

80. Ibid.

81. Ibid.

82. Pepper, quoted in Colin Naylor and Genesis P-Orridge, eds., *Contemporary Artists* (New York: St. Martin's Press, 1977), pp. 742, 741.

83. Quoted in *Beverly Pepper: Sculpture 1971–1975* (San Diego: Fine Arts Gallery of San Diego, 1975).

84. Ibid.

85. Here is another example of creative "serendipity," seen before in Lee Bontecou's laundry bags and Louise Nevelson's liquor crate. Lucy Lippard describes this period in *Eva Hesse*. New York University Press, 1976.

86. Quoted in Lucy Lippard, *From The Center* (New York: E. P. Dutton, 1976), p. 156.

87. Quoted in Lippard, *Eva Hesse*, p. 35.

88. Quoted in Cindy Nemser, "An Interview with Eva Hesse," *Artforum* (May 1970):60.

89. Bernard Kester, introduction to *Lenore Tawney: An Exhibition of Weaving, Collage, Assemblage* (Fullerton: California State University Art Gallery, 1975), p. 5.

90. Richard Howard, "Tawney," *Craft Horizons* (February 1975):71.

91. See Gloria Orenstein, "Lenore Tawney, The Craft of the Spirit," *Feminist Art Journal* 2, no. 4 (Winter 1973–74):11–13.

Chapter 9: The Feminist Art Movement

1. Thomas B. Hess and Elizabeth C. Baker, eds., *Art and Sexual Politics: Women's Liberation, Women Artists, and Art History* (New York: Collier Books, 1973), p. 118.

2. Elsa Honig Fine, *Women & Art: A History of Women Painters and Sculptors from the Renaissance to the 20th Century* (Montclair, N.J., and London: Allanheld and Schram; Prior; 1978), p. 147.

3. Lucy Lippard, "Sexual Politics, Art Style," *Art in America* 59 (September 1971):19–20.

4. Hess and Baker, "Sexual Art-Politics," p. 119.

5. Rosalie Braeutigam and Betty Fiske, *Sex Differentials in Art Exhibition Reviews: A Statistical Study,* foreword by June Wayne (Los Angeles: Tamarind Lithography Workshop, 1972).

6. Hess and Baker, "Sexual Art-Politics," p. 114.

7. Ann Sutherland Harris, "Women in College Art Departments and Museums," *Art Journal* 32 (Summer 1973):417–19.

8. *The Feminist Art Journal, Womanart,* and *Chrysalis* are no longer in publication.

9. Lawrence Alloway, "Women's Art in the 70's," *Art in America* (May–June 1976):66.

10. The eleven follow: Martha Edelheit painted *Womanhero* (a female version of Michelangelo's *David*); Alice Neel painted *Bella Abzug;* Elsa Goldsmith painted *Joan of Arc;* Sylvia Sleigh painted *Lilith;* Shirley Gorelick painted artist *Frida Kahlo;* Diana Kurz painted the goddess *Durga;* Betty Holliday painted poet *Marianne Moore;* Sharon Wybrants did a *Self Portrait as Superwoman;* June Blum painted *Betty Friedan as The Prophet;* May Stevens painted *Artemisia Gentileschi;* and Cynthia Mailman painted *God* (as a female); Maureen Connor designed the pavilion. Ilise Greenstein owns the copyright for the concept.

11. Barbara Rose, "Vaginal Iconology," *New York Magazine* (11 February 1974):59. Rose makes the analogy with the Black movement.

12. Fine, *Women & Art,* p. 147.

13. Lucy Lippard, "The Women Artists Movement: What Next?" A catalogue essay for the 1975 Paris Biennale quoted in Alloway, "Women's Art," p. 68.

14. Alloway, "Women's Art," p. 72.

15. Quoted in Cindy Nemser, *Art Talk: Conversations with 12 Women Artists* (New York: Charles Scribner's Sons, 1975), p. 116.

16. Alice Neel, doctoral address to Moore College of Art; reprinted in *Women and Art* 1, no. 1, (Winter 1971):12–13.

17. Interview with the artist, January 1978.

18. Linda Nochlin, "Some Women Realists: Painters of the Figure," *Arts Magazine* (May 1974):31.

19. Doctoral address, Moore College of Art, June 1971; quoted in Cindy Nemser, *Alice Neel: The Woman and Her Work* (Athens: Georgia Museum of Art, the University of Georgia, 1975).

20. Ibid.

21. Ibid.

22. Patricia Mainardi, "Alice Neel at the Whitney Museum," *Art in America* (May–June 1974):108. Mainardi discusses body language in Neel's work.

23. Ann Sutherland Harris, *Art News* (November 1977):113.

24. Ibid.

25. Nemser, *Art Talk,* p. 306.

26. Cindy Nemser, "Audrey Flack: Photorealist Rebel," *Feminist Art Journal* (Fall 1975):10.

27. Nemser, *Art Talk,* pp. 306–7.

28. Eleanor Tufts, "The Veristic Eye: Some Contemporary American Affinities with Luis Melendez, Spanish Painter of Still-Life Phenomenology," *Arts Magazine* (December 1977):142–44.

29. Douglas MacAgy, "City Idyll," *Lugano Review* 1, no. 1 (1965):138–45.

30. Ibid., p. 139.

31. Quoted in Dorothy Seiberling, "The Female View of Erotica," *New York* (11 February 1974):55.

Notes

32. Quoted in Ellen Lubell, "Joan Semmel: Interview," *Womanart* (Winter 1977–78):15, 19.

33. Ibid., p. 19.

34. Cindy Nemser, "Conversation with Diane Burko," *Feminist Art Journal* (Spring 1977):8.

35. Quoted in Cindy Nemser, "Conversation with Janet Fish," *Feminist Art Journal* (Fall 1976):7.

36. Ibid.

37. Ibid., p. 9.

38. Ibid., p. 8.

39. John Gruen, "Catherine Murphy: The Rise of a Cult Figure," *Art News* (December 1978):57.

40. Susan Willand, "Catherine Murphy," in *Women Artists in Washington Collections,* ed. Josephine Withers (College Park: University of Maryland Art Gallery and Women's Caucus for Art, 1979), p. 70.

41. Quoted in Ruth Iskin, "Ellen Lanyon," *Visual Dialog* (Spring 1977):10.

42. Ibid., p. 9.

43. May Stevens, "My Work and My Working Class Father," in *Working It Out: 23 Women Writers, Artists, Scientists and Scholars Talk about Their Lives and Work,* ed. Sara Ruddick and Pamela Daniels (New York: Pantheon Books, 1977), p. 112.

44. Ibid., p. 113.

45. Interview with Sleigh, February 1978.

46. Linda Nochlin, "Some Women Realists: Painters of the Figure," *Arts Magazine* (May 1974):32.

47. Miriam Schapiro, "Notes from a Conversation on Art, Feminism and Work," in *Working It Out.* Schapiro's therapist was a follower of Karen Horney, the famous woman analyst who attacked Freudian notions that "biology is destiny." p. 228.

48. Miriam Schapiro, catalogue statement in *American Artists '76: A Celebration,* (San Antonio, Texas: Marion Koogler McNay Art Institute, 1976), p. 48.

49. Judy Chicago and Miriam Schapiro, "Female Imagery," *Womanspace Journal* (Summer 1973):14.

50. Judy Chicago, *Through the Flower* (New York: Doubleday & Co., 1975), p. 35.

51. Ibid., p. 63.

52. Quoted in Barbara Isenberg, "Invitation to a Dinner Party," *Los Angeles Times,* 6 April 1978, sect. 4, pp. 1, 13.

53. Ibid.

54. Quoted in Charlie Haas, "Judy Chicago's *The Dinner Party:* A Room of Her Own," *New West* (1 August 1977):46–48.

55. Ruth E. Iskin, "Toward a Feminist Imperative: The Art of Joan Snyder," *Chrysalis: A Magazine of Women's Culture* 1, no. 1, (1977):104.

56. Ibid.

57. Ibid.

58. Ibid., p. 110.

59. Barbara Rose, *American Art Since 1900,* 2d ed. (New York: Praeger Publishers, 1975), p. 234.

60. Susan Heinemann, "Nancy Graves," *Arts Magazine* (March 1977):140.

61. Emily Wasserman, "A Conversation with Nancy Graves," *Artforum* (October 1970):44.

62. Robert Hughes, *Time* (4 January 1971):50.

63. Nemser, *Art Talk,* p. 334.

64. Ibid., p. 342.

65. Ibid., p. 344.

66. Quoted in Eleanor Munro, *The Originals: American Women Artists* (New York: Simon & Schuster, 1979), p. 372.

67. Quoted in Françoise Nora-Cochin and F. W. Heckmanns, *Chase-Riboud* (Berkeley, Calif.: University Art Museum, 1973).

68. Ibid.

69. It is interesting to compare this mural with Lucienne Bloch's prison mural in chapter 6. Bloch showed an integrated world of black and white mothers and children. Ringgold, in the new era of women's liberation, painted a woman president, policewoman, and so on.

70. Quoted in Niki Guyer, "Woman on a Pedestal and Other Everyday Folks," *Fiberarts* (March 1981):22.

71. Quoted in Jacinto Quirarte, *Mexican American Artists,* (Austin: University of Texas Press, 1973), p. 45.

72. Quoted by Victoria Quintero, "A Mural is a Painting on a Wall Done By Human Hands," *El Tecolote* (San Francisco), 13 September 1974, pp. 6–7.

73. Quoted in *The San Francisco Street Artist Guild* (Late Spring 1973).

74. Quoted in Zuver, *Ancient Roots/New Visions* (Tucson: Tucson Museum of Art, 1977), p. 51.

75. Quoted in *Spinning Off,* publication of the Los Angeles Woman's Building, October-November 1979, p. 5.

Selected
Bibliography

Selected Bibliography

This bibliography deals primarily with women in American art. The reader should also consult basic texts, such as Edgar Richardson's *Painting in America* and Daniel M. Mendelowitz's *A History of American Art* for further references to various phases of American art. There are also many standard dictionaries, such as Mantle Fielding's *Dictionary of American Painters, Sculptors and Engravers, Dictionary of American Biography, National Cyclopedia of American Biography, Appleton's Cyclopedia, Biographical Index of American Artists,* and international artists' dictionaries, such as those of U. Thieme and F. Becker, or E. Bénézit.

The following selected bibliographies for individual artists are intended to point the reader toward further sources of information.

General List

Armstrong, Tom, et al. *200 Years of American Sculpture.* New York: Whitney Museum of American Art and David R. Godine, Publisher, 1976.

Art Journal (College Art Association of America) 35 (Summer 1976). Entire issue devoted to women artists.

Art News 69, no. 9 (January 1971). Special issue on women artists.

Bachmann, Donna G., and Piland, Sherry. *Women Artists: An Historical Contemporary and Feminist Bibliography.* Metuchen, N.J.: Scarecrow Press, 1978.

Bontemps, Arna Alexander, et al. *Forever Free: Art by African-American Women 1862–1980.* Normal, Illinois, 1980. For information contact the Center for Ethnic Studies, Illinois State University. A splendid overview with extensive bibliographies.

Brown, Milton W., et al. *American Art: Painting, Sculpture, Architecture, Decorative Arts, Photography.* New York: Harry N. Abrams, 1979.

Clement, Clara Erksine (Waters). *Women in the Fine Arts from the Seventh Century B. C. to the Twentieth Century A. D.* Boston: Houghton Mifflin, 1904

Cole, Doris. *From Tipi to Skyscraper: A History of Women in Architecture.* Boston: i pressn incorporated and George Braziller, 1973.

Collins, J. L. *Women Artists in America: Eighteenth Century to the Present.* 2 vols. Chattanooga: University of Tennessee Art Department, 1973–1975.

Dewhurst, C. Kurt et al. *Artists in Aprons: Folk Art by American Women.* New York: E. P. Dutton and the Museum of American Folk Art, 1979.

Driskell, David C. *Two Centuries of Black American Art.* With catalogue notes by Leonard Simon. New York: Alfred A. Knopf and the Los Angeles County Museum of Art, 1976.

Dunlap, William. *A History of the Rise and Progress of the Arts of Design in the United States.* 3 vols. 1834. Rev. ed. New York: Benjamin Blom, 1965.

Edwards, James T.; James, Janet Wilson; Boyer, Paul S.; eds. *Notable American Women: 1607–1950.* 3 vols. Cambridge, Mass.: Harvard University Press, Belknap Press, 1971.

Ellett, Elizabeth Fries Lummis. *Women Artists in All Ages and Countries.* New York: Harper & Bros., 1859. Chapters 18 and 19 discuss American artists (pp. 285–316, 317–45).

Fine, Amy Minna, et al. *The Working Woman, 1840–1945.* New York: Whitney Museum of American Art, Downtown Branch, 1980. Exhibition catalogue.

Fine, Elsa Honig. *The Afro-American Artist: A Search for Identity.* New York: Holt, Rinehart & Winston, 1973.

————. *Women & Art: A History of Women Painters and Sculptors from the Renaissance to the 20th Century.* Montclair, N.J., and London: Allanheld & Schram; Prior; 1978.

Gabhart, Ann, and Broun, Elizabeth. "Old Mistresses: Women Artists of the Past." *Bulletin of the Walters Art Gallery* (Baltimore) 24, no. 7 (1972).

Gardner, Albert Ten Eyck. "A Century of Women," *Metropolitan Museum of Art Bulletin,* n.s. 7 (December 1948):110–18.

Gerdts, William H., *Women Artists of America: 1707–1964.* Newark, N.J.: Newark Museum, 1965. Exhibition catalogue.

Graham, Julie. "American Women Artists' Groups: 1867–1930." *Woman's Art Journal* 1, no. 1 (Spring–Summer 1980):7–12.

Greer, Germaine. *The Obstacle Race.* New York: Farrar, Straus & Giroux, 1979.

Groce, George C., and Wallace, David H. *The New York Historical Society's Dictionary of Artists in America, 1564–1860.* New Haven: Yale University Press, 1957.

Hanaford, Phebe A. *Daughters of America.* Augusta, Maine: True & Co., 1883. Chapter 10 discusses women artists (pp. 271–304).

Harris, Ann Sutherland. "The Second Sex in Academe (Fine Arts Division)." *Art in America* 60 (May 1972):18–19.

Harris, Ann Sutherland, and Nochlin, Linda. *Women Artists: 1550–1950.* New York: Alfred A. Knopf and the Los Angeles County Museum of Art, 1976.

Hedges, Elaine, and Wendt, Ingrid. *In Her Own Image: Women Working in the Arts.* Old Westbury, N.Y.: Feminist Press, 1980.

Hess, Thomas B., and Baker, Elizabeth, eds. *Art and Sexual Politics: Women's Liberation, Women Artists, and Art History,* New York: Collier Books, 1973.

Hill, M. Brawley. *Women: A Historical Survey of Works by Women Artists.* Winston-Salem, N.C.: Salem Fine Arts Center, 1972. Exhibition catalogue.

Hill, Vicki-Lynn, ed. *Female Artists Past and Present.* Berkeley, Calif.: Women's History Research Center, 1974. A bibliography arranged by genre; includes ceramics, pottery, crafts, painting and collage, teachers, museum personnel, slide registries, etc.

Huber, Christine Jones. *The Pennsylvania Academy and Its Women: 1850–1920.* Philadelphia: Pennsylvania Academy of the Fine Arts, 1973. Exhibition catalogue.

Kohlmeyer, Ida. Introduction to *American Women: 20th Century.* Peoria, Ill.: Lakeview Center for the Arts and Sciences, 1972. Exhibition catalogue.

Kovinick, Phil. *The Woman Artist in the American West: 1860–1960.* Fullerton, Calif.: Muckenthaler Cultural Center, 1976. Exhibition catalogue.

Lewis, Samella S. *Art: African American.* New York: Harcourt Brace Jovanovich, 1978.

Lewis, Samella S., and Waddy, Ruth G. *black artists on art.* 2 vols. Los Angeles: Contemporary Crafts Publishers, 1969–1971.

Lippard, Lucy R. *From the Center: Feminist Essays on Women's Art.* New York: E. P. Dutton, 1976.

Loeb, Judy, ed. *Feminist Collage: Educating Women in the Visual Arts.* New York: Teachers College Press, 1979.

Marling, Karal Ann. "American Art and the American Woman." In *7 American Women: The Depression Decade.* Poughkeepsie, N.Y.: Vassar College Art Gallery and A.I.R. Gallery (New York), 1976.

Marling, Karal Ann, and Morrin, Peter. *Woodstock: An American Art Colony, 1902–1977.* Poughkeepsie, N.Y.: Vassar College Art Gallery, 1977. Exhibition catalogue.

Munro, Eleanor. *Originals: American Women Artists.* New York: Simon & Schuster, 1979.

Munsterberg, Hugo. *A History of Women Artists.* New York: Clarkson N. Potter and Crown Publishers, 1975.

Naylor, Colin and P-Orridge, Genesis, eds. *Contemporary Artists.* New York: St. Martin's Press, 1977.

Nemser, Cindy. *Art Talk: Conversations with 12 Women Artists.* New York: Charles Scribner's Sons, 1975.

19th Century American Women Artists. New York: Whitney Museum of American Art, Downtown

Branch, 1976. Exhibition catalogue.

Nochlin, Linda. "How Feminism in the Arts Can Implement Cultural Change." *Arts in Society* 11, no. 1 (Spring–Summer 1974):81–89.

——————. "Why Have There Been No Great Women Artists?" *Art News* 69, no. 9 (January 1971): 22–39, 67–71.

Orenstein, Gloria F. "Art History." *Signs: Journal of Women in Culture* 1 (Winter 1975):505–25. Evaluates the discipline of art history from a feminist point of view.

Petersen, Karen, and Wilson, J. J. *Women Artists: Recognition and Reappraisal, From the Early Middle Ages to the Twentieth Century.* New York: Harper Colophon Books and New York University Press, 1976.

Proske, Beatrice Gilman. *Brookgreen Gardens Sculpture.* Rev. ed. Brookgreen Gardens, S.C.: Brookgreen Gardens, 1968.

——————. "American Women Sculptors." *National Sculpture Review* 24 (Summer–Fall 1975):8–15, 28; (Winter 1975–76):8–17+.

Rose, Barbara. *American Art Since 1900: A Critical History.* 2d ed. New York: Praeger Publishers, 1975.

Schapiro, Miriam, ed. *Art: A Woman's Sensibility,* Valencia, Calif.: California Institute of the Arts, 1975. Contains statements by seventy-five contemporary women artists.

Seifert, Carolyn J. "Images of Domestic Madness in the Art and Poetry of American Women." *Woman's Art Journal* 1, no. 2 (Fall 1980–Winter 1981):1–6.

Sicherman, Barbara; Green, Carol Hurd; Kantrov, Ilene; and Walker, Hariette, eds. *Notable American Women: The Modern Period.* Cambridge, Mass.: Harvard University Press, Belknap Press, 1980.

Simkins, Alice C. Introduction to *American Artists '76: A Celebration.* San Antonio, Texas: Marion Koogler McNay Art Institute, 1976. Catalogue of an exhibition of contemporary women artists.

Sparrow, Walter Shaw. *Women Painters of the World: From the Time of Caterina Vigri, 1413–1463, to Rosa Bonheur and the Present Day.* London: Hodder & Stoughton, 1905.

Taft, Lorado. *The History of American Sculpture.* Rev. ed. New York: Macmillan 1924.

Torre, Susana, ed. *Women in American Architecture: A Historic and Contemporary Perspective.* New York: Whitney Library of Design and Watson-Guptill Publications, 1977.

Tuckerman, Henry T. *Book of the Artists: American Artist Life.* 1867. Reprint. New York: James F. Carr, 1966.

Tufts, Eleanor. *Our Hidden Heritage: Five Centuries of Women Artists.* New York and London: Paddington Press, 1974. In-depth studies of twenty-two major artists from the Renaissance to the present.

Visual Dialog 1, no. 2 (Winter 1975–76); 2, no. 3 (Winter 1976–77). Two issues devoted to women in the visual arts.

Willard, Frances Elizabeth, and Livermore, Mary Ashton, eds. *American Women.* New York: Mast, Crowell & Kirkpatrick, 1897. Reprint. Detroit: Gale Research Co., 1973.

Withers, Josephine, et al., eds. *Women Artists in Washington Collections.* College Park: University of Maryland and Women's Caucus for Art, 1979. Exhibition catalogue.

"Women and the Arts." *Arts in Society* (Madison, Wisc.) 11, no. 1 (Spring–Summer 1974). Published by the Research and Statewide Programs in the Arts, University of Wisconsin–Extension. This special issue contains major essays and reports on the National Conference on Women and the Arts, 1973, Racine, Wisconsin.

Women Artists and Women in the Arts: A Bibliography of Art Exhibition Catalogues. Boston: Worldwide Books, 1978.

Women Printmakers, Past and Present. New York: Prints Division, New York Public Library, and Astor, Lenox, and Tilden Foundations, 1973. Exhibition catalogue.

Chapter 1

General

Brody, J. J. *Indian Painters—White Patrons*. Albuquerque: University of New Mexico Press, 1971.

Bunzel, Ruth. *The Pueblo Potter*. New York: Columbia University Press, 1929.

Dunn, Dorothy. *American Indian Painting of the Southwest and Plains Areas*. Albuquerque: University of New Mexico Press, 1968.

Douglas, Frederick H., and D'Harnoncourt, Rene. *Indian Art of the United States*. New York: Museum of Modern Art, 1941.

Broder, Patricia Janis. *American Indian Painting and Sculpture*. New York: Abbeville Press, 1980.

Ellison, Rosemary. *Contemporary Southern Plains Indian Painting*, edited by Miles Libhart. Anadarko, Okla.: Oklahoma Indian Arts and Crafts Cooperative, 1972. Catalogue of an exhibition organized by the Indian Arts and Crafts Board of the U.S. Department of Interior. Contains discussion of parflèche painting and lists several modern Native American Plains women painters.

Feder, Norman. *American Indian Art*. New York: Harry N. Abrams, 1965.

Hathcock, Roy. *Ancient Indian Pottery of the Mississippi River Valley*. Camden, Ark.: Hurley Press, 1976.

Kahlenberg, Mary Hunt, and Berlant, Anthony. *The Navajo Blanket*. Los Angeles: Los Angeles County Museum of Art, 1972.

Niethammer, Carolyn. *Daughters of the Earth: The Lives and Legends of American Indian Women*. New York: Collier Books, 1977.

Powell, Fr. Peter J. "Beauty for New Life: An Introduction to Cheyenne and Lakota Sacred Art." In *The Native American Heritage: Survey of North American Indian Art*, edited by Evan M. Maurer, pp. 33–56. Chicago: Art Institute of Chicago, 1977. Discusses symbolism and women's role in Plains Indian quillwork.

Snodgrass, Jeanne O. *American Indian Painters: A Biographical Directory*. New York: Museum of the American Indian and Heye Foundation, 1968.

Tanner, Clara Lee. *Southwest Indian Painting: A Changing Art*. Rev. ed. Tucson: University of Arizona Press, 1973.

Terrell, Donna M., and Terrell, John J. *Indian Women of the Western Morning*. New York: Dial Press, 1974.

Weatherford, Elizabeth. "Women's Traditional Architecture." *Heresies: A Feminist Publication on Art and Politics* (May 1977):35–39.

The Artists

Pop Chalee

Dunn. *American Indian Painting*.

Amanda Crowe

Highwater, Jamake. *The Sweet Grass Lives On*. New York: Thomas Y. Crowell, 1981.

"Cherokee Craftsmen." *Smoke Signals*, no. 44 (1965):6, 17. (Indian Arts and Crafts Board, Room 4004, U.S. Department of the Interior, Washington, D.C. 20240.)

Dat So La Lee

Cohodas, Marvin. "Dat So La Lee's Basketry Design." *American Indian Art* 1, no. 4 (Autumn 1976):22–31.

Gigli, Jane Green. "Dat So La Lee, Queen of the Washo Basket Makers." Nevada State Museum Anthropological Papers, no. 16. paper #1, pp. 1–27. Carson City, Nev. March 1974.

Phyllis Fife

Highwater. *Sweet Grass.*

Helen Hardin

de Lauer, Marjel. "Helen Hardin." *Arizona Highways* (August 1976):44.
Silberman, Arthur. *100 Years of Native American Painting.* Oklahoma City: Oklahoma Museum of Art, 1978. Exhibition catalogue.

Valjean Hessing

Broder, Patricia Janis. *American Indian Painting and Sculpture.* New York: Abbeville Press, 1981.

Joan Hill

Silberman. *100 Years.*

Yeffe Kimball

Highwater. *Sweet Grass.*
Snodgrass. *American Indian Painters.*

Lucy Lewis

Collins, John E. *A Tribute to Lucy M. Lewis, Acoma Potter.* Fullerton, Calif.: Museum of North Orange County, 1975. Exhibition catalogue.

Linda Lomahaftewa

Highwater. *Sweet Grass.*

Maria Martinez

Marriott, Alice. *Maria of San Ildefonso.* Norman: University of Oklahoma Press, 1946.
Peterson, Susan. *The Living Tradition of Maria Martinez.* Tokyo and New York: Kodansha International; Harper & Row; 1977.
———. *Maria Martinez: Five Generations of Potters.* Washington, D.C.: Smithsonian Institution Press, 1978.

Nampeyo

Collins, John E. *Nampeyo, Hopi Potter: Her Artistry and Her Legacy.* Fullerton, Calif.: Muckenthaler Cultural Center, 1974.

Tonita Peña

Dunn. *American Indian Painting.*

Jaune Quick-To-See Smith

Highwater. *Sweet Grass.*

Pablita Velarde

Nelson, Mary Carroll. *Pablita Velarde.* Minneapolis: Dillon Press, 1971.
Silberman. *100 Years.*

Tanner. *Southwest Indian Painting*.

Velarde, Pablita. *Old Father the Story Teller*. Globe, Ariz.: Dale Stuart King, 1960.

Chapter 2

General

Bacon, Lenice Ingram. *American Patchwork Quilts*. New York: William Morrow & Co., 1973.

Bank, Mirra. *Anonymous Was a Woman*. New York: St. Martin's Press, 1979.

Black, Mary, and Lipman, Jean. *American Folk Painting*. New York: Clarkson N. Potter, 1966.

De Pauw, Linda Grant, and Hunt, Conover. *"Remember the Ladies": Women in America, 1750–1815*. New York: Viking Press, 1976.

Dewhurst, G. Kurt; MacDowell, Betty; and MacDowell, Marsha. *Artists in Aprons: Folk Art by American Women*. New York: E. P. Dutton and the Museum of American Folk Art, 1979.

The Gift of Inspiration: Religious Art of the Shakers. Hancock, Mass.: Hancock Shaker Village, 1970.

Gordon, Jean. "Early American Women Artists and the Social Context in Which They Worked." *American Quarterly* 30 (Spring 1978):54–69.

Janis, Sidney. *They Taught Themselves: American Primitive Painters of the Twentieth Century*. New York: Dial Press, 1942.

Lipman, Jean. *American Primitive Painting*. New York: Oxford University Press, 1942. New York: Dover, 1972.

Lipman, Jean, and Winchester, Alice. *The Flowering of American Folk Art, 1776–1886*. New York: Viking Press and the Whitney Museum of American Art, 1974.

————, eds. *Primitive Painters in America, 1750–1950: An Anthology*. New York: Dodd, Mead & Co., 1950. Freeport, N.Y.: Books for Libraries Press, 1971.

Maines, Rachel. "Fancywork: The Archaeology of lives." *Feminist Art Journal* 3, no. 4 (Winter 1974–75):1, 3.

Muto, Laverne. "A Feminist Art—The American Memorial Picture." *Art Journal* 35, no. 4 (Summer 1976):352–58.

Sears, Clara E. *Some American Primitives: A Study of New England Faces and Folk Portraits*. Boston: Houghton Mifflin, 1941.

Swan, Susan Burrows. *Plain and Fancy: American Women and Their Needlework, 1700–1850*. New York: Holt, Rinehart & Winston, 1977.

Troop, Miriam. "A Little Known Fact of History: Mistresses Wright and Johnston Were Leading Colonial Artists." *Smithsonian* 8 (February 1978):114–24.

Wolfe, Ruth. "When Art was a Household Word." *Ms.* 2, no. 8 (February 1974):29–33.

The Artists

Ruth Bascom

Dewhurst. *Artists in Aprons*.

Dods, Agnes M. "Ruth Henshaw Bascom." In Lipman and Winchester, *Primitive Painters*, pp. 31–38.

Sears. *Some American Primitives*.

Hetty Benbridge

Stewart, Robert G. *Henry Benbridge (1743–1812): American Portrait Painter*. Washington, D.C.: Smithsonian Institution Press, 1971.

Minnie Evans

Starr, Nina Howell. *Minnie Evans.* New York: Whitney Museum of American Art, 1975. *Exhibition catalogue.*

Deborah Goldsmith

Lipman and Winchester. *Primitive Painters.*

Clementine Hunter

Driskell. *Two Centuries of Black American Art.*
Rankin, A. "Hidden Genius of Melrose Plantation." *Readers Digest* 107 (December 1975):118.

Henrietta Johnston

Middleton, Margaret Simons. *Henrietta Johnston of Charles Town, South Carolina: America's First Pastellist.* Columbia: University of South Carolina Press, 1966.
Rutledge, Anna Wells. "Who Was Henrietta Johnston?" *Antiques* 51 (March 1947):183–85.

Anna Mary Robertson Moses ("Grandma Moses")

Humez, Jean McMahon. "The Life and Art of Anna Mary Robertson Moses." *Woman's Art Journal* 1, no. 2 (Fall 1980–Winter 1981):7–12.
Kallir, Otto. *Grandma Moses.* New York: Harry N. Abrams, 1973.
Moses, Anna Mary Robertson. *My Life's History.* Edited by Otto Kallir. New York: Harper & Row, 1952.

Tressa Prisbrey ("Grandma Prisbrey")

McCoy, Esther. "Grandma Prisbrey's Bottle Village." *Naives and Visionaries.* New York: E. P. Dutton and the Walker Art Center (Minneapolis), 1974.

Mary Ann Willson

Karlins, N.F. "Mary Ann Willson." *Antiques* (November 1976):1040–45
Lipman and Winchester. *Primitive Painters.*
Miller, Isabel [pseud.]. *Patience and Sarah.* New York: McGraw-Hill, 1972. A novel based on the life of Willson and her friend Brundage.

Patience Wright

Bizardel, Yvon. *American Painters in Paris.* Translated by Richard Howard. New York: Macmillan Co., 1960.
Sellers, Charles Coleman. *Patience Wright: American Artist and Spy in George III's London.* Middletown, Conn.: Wesleyan University Press, 1976.
Watson, C. F. Elkanah. *Men and Times of the Revolution; or Memoirs of Elkanah Watson, including His Journals of Travels in Europe and America, from the Year 1777 to 1842, and His Correspondence with Public Men and Reminiscences and Incidents of the American Revolution.* Edited by Winslow C. Watson. 2d ed. New York: Dana & Co., 1857.

Eunice Pinney

Black, Mary. "Pinney, Eunice Griswold." In *Notable American Women: 1607–1950,* vol. 3, pp. 72–73.
Lipman, Jean. "Eunice Pinney, An Early Connecticut Watercolorist." *Art Quarterly* 6 (Summer 1943):213–21.

————. "Eunice Pinney." In Lipman and Winchester, *Primitive Painters,* pp. 22–29.

Ruth Shute

Kellogg, Helen. "Found: Two Lost American Painters." *Antiques World* (December 1978):37–46.

Chapter 3

General

Barry, William D. "Women Painters in Portland's Golden Age; They Were Many and Talented, but Where's Their Work Now?," *Maine Sunday Telegram, 13 January 1980, p. 7D.*

Cowdrey, Mary Bartlett. *American Academy of Fine Arts and American Art-Union Exhibition Record, 1816–1852.* New York: New York Historical Society, 1953.

————, ed. *National Academy of Design Exhibition Record, 1826–1860.* 2 vols. New York: New York Historical Society, 1943.

Gerdts, William H., *The White Marmorean Flock: Nineteenth Century American Women Neoclassical Sculptors.* Poughkeepsie, N.Y.: Vassar College Art Gallery, 1o72. Exhibition catalogue and essay.

Paine, Judith. "The Women's Pavilion of 1876." *Feminist Art Journal* 4, no. 4 (Winter 1975–76):5–12.

Sandhurst, Philip T. *The Great Centennial Exhibition.* Philadelphia: P. W. Ziegler & Co., 1876.

Swan, Mabel Munson. *The Athenaeum Gallery, 1827–1873: The Boston Athenaeum as an Early Patron of Art.* Boston: D. B, Updike and Merrymount Press, 1940.

United States Centennial Commission, Philadelphia, Official Catalogue. Cambridge, Mass.: John R. Nagle & Co., 1876.

The Artists

Mary Elizabeth Michael Achey

Kovinick, Phil. *The Woman Artist in the American West, 1860–1960.* Fullerton, Calif.: Muckenthaler Cultural Center, 1976.

Petteys, Chris. "Colorado's First Women Artists." *Denver Post, Empire Magazine,* 6 May 1979, pp. 1, 36–38, 40.

Francesca Alexander

Alexander, Constance Grosvenor. *Francesca Alexander: A "Hidden Servant."* Cambridge, Mass.: Harvard University Press, 1927.

Baker, Paul R. "Alexander, Francesca." In *Notable American Women: 1607–1950,* edited by James T. Edwards et al. Cambridge, Mass.: Harvard University Press, Belknap Press, 1971, vol. 1, pp. 34–35.

Swett, *Lucia Gray. John Ruskin's Letters to Francesca and Memoirs of the Alexanders.* Boston: Lothrop, Lee & Shepard, 1931.

Sarah Fisher Clampitt (Ames)

"Sarah Fisher Clampitt Ames." In *The New York Historical Society's Dictionary of Artists in America, 1564–1860,* edited by George C. Groce and David H. Wallace. New Haven: Yale University Press, 1957, p. 8.

Fidelia Bridges

Hill, May Brawley. *Fidelia Bridges: American Pre-Raphaelite,* Connecticut: New Britain
 Museum of Art, 1981.
Sharf, Frederic Alan. "Fidelia Bridges, 1834–1923, Painter of Birds and Flowers." *Essex Institute
 Historical Collections* (Salem, Mass.) 104, no. 3 (July 1968):217–38.

Helen Tanner Brodt

Kovinick. *The Woman Artist in the American West.*

Helen Henderson Chain

Kovinick. *The Woman Artist in the American West.*
Petteys. "Colorado's First Women Artists."

Charlotte Buell Coman

Clement, Clara Erskine, and Hutton, Laurence. *Artists of the Nineteenth Century and Their Works.*
 vol. 1. Boston: Houghton, Osgood & Co., 1879.
Dictionary of American Biography.
New York Historical Society's Dictionary of Artists, p. 142.
Searle, Helen, ed. *Biographical Sketches of American Artists.* Lansing: Michigan State Library,
 1924, p. 74.
Swope, H. Vance. "An Appreciation of Charlotte Buell Coman" *Art News* (22 November 1924):6.

Anna Botsford Comstock

Jacklin, Kathleen. "Comstock, Anna Botsford." In *Notable American Women: 1607–1950,* vol. 1,
 pp. 367–68.
Yost, Edna. *Famous American Pioneering Women.* New York: Dodd, Mead & Co., 1961.

Ann Sophia Towne Darrah

Huber, Christine Jones. *The Pennsylvania Academy and Its Women.* Philadelphia: Pennsylvania
 Academy of the Fine Arts, 1973.

Herminia Borchard Dassel

Ellet, Elizabeth. *Women Artists in All Ages and Countries.* New York: Harper & Bros., 1859, pp.
 312–15. Similar material may be found in *The Crayon 5* (1858):26–27.
Wright, Helen. *Sweeper in the Sky: The Life of Maria Mitchell First Woman Astronomer in America.*
 New York: Macmillan, 1949, p. 89.

Cornelia Adele Fassett

Clement, Clara Erskine. *Women in the Fine Arts from the Seventh Century* B.C. *to the Twentieth
 Century* A.D. Boston: Houghton Mifflin, 1904.
"Famous Artist Dead." *Washington Post,* 5 January 1898.

Margaret Foley

Craven, Wayne. *Sculpture in America.* New York: Thomas Y. Crowell, 1968.
Gerdts. *White Marmorean Flock.*
Tufts, Eleanor. "Margaret Foley's Metamorphosis: A Merrimack 'Female Operative' in Neo-
 Classical Rome." *Arts Magazine* (January 1982):88–95.

Mary Hallock Foote

Kovinick. *The Woman Artist in the American West.*

Paul, Rodman W. *A Victorian Gentlewoman in the Far West: The Reminiscences of Mary Hallock Foote.* San Marino, Calif.: Huntington Library, 1972.

Stegner, Wallace. *Angle of Repose.* New York: Doubleday, 1971. A Pulitzer Prize winning novel based on Foote's life.

Wilkins, Thurman. "Foote, Mary Anna Hallock." In *Notable American Women: 1607–1950,* vol. 1, pp. 643–44.

Katherine Furbish

Cole, John. "The Woman Behind the Wildflower That Stopped a Dam." *Horticulture* (December 1977):30–35.

Sarah Goodridge

Dods, Agnes M. "Sarah Goodridge." *Antiques* 51 (May 1947):328–29.

Morgan, John Hill. *Gilbert Stuart and His Pupils.* New York: Kennedy Galleries and Da Capo Press, 1969.

Parker, Barbara N. "Goodridge, Sarah." In *Notable American Women: 1607–1950,* vol. 2, pp. 62–63.

Virginia Granbery

Gerdts, William H. and Burke, Russell. *American Still-life Painting.* New York: Praeger Publishers, 1971.

Willard, Frances Elizabeth, and Livermore, Mary Ashton, eds. *American Women.* New York: Mast, Crowell & Kirkpatrick, 1897. Reprint. Detroit: Gale Research Co., 1973.

Eliza Pratt Greatorex

Hanaford, Phebe. *Daughters of America.* Augusta, Maine: True & Co., 1883.

Shively, Charles. "Greatorex, Eliza Pratt." In *Notable American Women: 1607–1950,* vol. 2, pp. 76–77.

Anne Hall

Gerdts, William H., "Hall, Anne." In *Notable American Women: 1607–1950,* vol. 2, pp. 117–18.

Anna Eliza Hardy

Gerdts and Burke. *American Still-life Painting.*

"Hardy, Anna Eliza." In *Notable American Women: 1607–1950,* vol. 2, 133–34.

Harriet Hosmer

Carr, Cornelia, ed. *Harriet Hosmer: Letters and Memories.* New York: Moffat, Yard, 1912.

Craven. *Sculpture in America.*

Faxon, Alicia. "Images of Women in the Sculpture of Harriet Hosmer." *Woman's Art Journal* 2, no. 1 (Spring–Summer 1981):25–29.

Gerdts. *White Marmorean Flock.*

Leach, Joseph. "Harriet Hosmer: Feminist in Bronze and Marble." *Feminist Art Journal* 5, no. 2 (Summer 1976):9–13, 44–45.

Louisa Lander

Brown, Aycock. "Strange Story of Virginia Dare's Statue in Elizabethan Garden." Mimeographed. Manteo, N.C., n.d.
Craven. *Sculpture in America*.
Gerdts. *White Marmorean Flock*.
Thorp, Margaret Farrand. *The Literary Sculptors*. Durham, N.C.: Duke University Press, 1965.

Edmonia Lewis

Gerdts, William H. *White Marmorean Flock*.
Lewis, Samella S. *Art: African American*. New York: Harcourt Brace Jovanovich, 1978.
Porter, James A. "Lewis, Edmonia." In *Notable American Women: 1697–1950*, vol. 2 pp. 397–.
Tufts, Eleanor. *Our Hidden Heritage: Five Centuries of Women Artists*. New York: Paddington Press, 1974.

Maria Martin (Bachman)

Williams, Margot, and Elliot, Paul. "Maria Martin: The Brush Behind Audubon's Birds." *Ms.* (April 1977):14–18.

Ann, Emily, Maria Ann, and Octavia Maverick

"Maverick, Ann," "Maverick, Emily," "Maverick, Maria Ann," and "Maverick, Octavia." In *New York Historical Society's Dictionary of Artists*.

Mary Nimmo Moran

Everett, Morris T. "The Etchings of Mrs. Mary Nimmo Moran." *Brush and Pencil* 8 (April 1901):3–16.
"Moran, Mary Nimmo." In *Biographical Sketches of American Artists*, p. 219.
Weitenkampf, Frank. "Some Women Etchers." *Scribner's Magazine* 46 (December 1909):731–39.
Wilkins, Thurman. *Thomas Moran: Artist of the Mountains*. Norman: University of Oklahoma Press, 1956.
————. "Moran, Mary Nimmo." In *Notable American Women: 1607–1950*, vol. 2, pp. 576–77.

Imogene Robinson Morrell

Clement. *Women in the Fine Arts*.
Hanaford. *Daughters of America*.
"Probe Artist's Death." *Washington Post*, 23 November 1908. An obituary.

Blanche Nevin

Strahan, Edward. *Masterpieces of the Centennial International Exhibition*, vol. 1. Philadelphia: Gebbie & Barrie, 1876. Reprint. New York: Garland Publishing, 1977.

Fanny Palmer

Cowdrey, Mary Bartlett. "Fanny Palmer, An American Lithographer." In *Prints: Thirteen Illustrated Essays on the Art of the Print*, edited by Carl Zigrosser. New York: Holt, Rinehart & Winston, 1962.
Peters, Harry T. *Currier and Ives, Printmakers to the American People*. Garden City, N.Y.: Doubleday, Doran & Co., 1942.

Selected Bibliography

Anna Claypoole Peale

Born, Wolfgang. "The Female Peales: Their Art and its Tradition." *American Collector* 15 (August 1946):12–14.

Elam, Charles H., ed. *The Peale Family: Three Generations of American Artists*. Detroit: Detroit Institute of Arts, 1967.

Ellet. *Women Artists*.

Fine, Elsa Honig. *Women & Art*. Montclair, N.J., and London: Allanheld & Schram; Prior, 1978.

Sellers, Charles Coleman. *Charles Willson Peale*. New York: Charles Scribner's Sons, 1969.

————. "Peale, Anna Claypoole, Margaretta Angelica and Sarah Miriam." In *Notable American Women: 1607–1950*, Vol. 3, pp. 38–40.

Margaretta Angelica Peale

Elam. *The Peale Family*.

Gerdts and Russell. *American Still-life Painting*.

Gerson, Sareen R. "Margaretta Angelica Peale." In *Women Artists in Washington Collections*, edited by Josephine Withers. College Park: University of Maryland Art Gallery and Women's Caucus for Art, 1979, pp. 75–76.

Mary Jane Peale

Elam. *The Peale Family*.

Gerdts and Russell. *American Still-life Painting*.

Sarah Miriam Peale

Harris, Ann Sutherland and Nochlin, Linda. *Women Artists: 1550–1950*. New York: Alfred A. Knopf and the Los Angeles County Museum of Art, 1976.

Hunter, Wilbur H., and Mahey, John. *Miss Sarah Miriam Peale, 1800–1885: Portraits and Still Life*. Baltimore: Peale Museum, 1967.

Tufts. *Our Hidden Heritage*.

Sarah Perkins

Dewhurst, C. Kurt; MacDowell, Betty; and MacDowell, Marsha. *Artists in Aprons: Folk Art by American Women*. New York: E. P. Dutton and the Museum of American Folk Art, 1979.

Vinnie Ream (Hoxie)

Becker, Carolyn Berry. "Vinnie Ream: Portrait of a Young Sculptor." *Feminist Art Journal* 5, no. 3 (Fall 1976):29–31.

Gerdts. *White Marmorean Flock*.

Wilkins, Thurman. "Ream, Vinnie." In *Notable American Women: 1607–1950*, vol. 3, pp. 122–23.

Emily Sartain

Gilchrist, Agnes Addison. "Sartain, Emily." In *Notable American Women: 1607–1950*, vol. 3, pp. 235–36.

Huber. *The Pennsylvania Academy*.

Ellen Sharples

Knox, Katherine McCook. *The Sharples: Their Portraits of George Washington and His Contemporaries: A Diary and Account of the Life and Work of James Sharples and His Family in*

England and America. New Haven: Yale University Press, 1930. Reprint. New York: Library of American Art, 1972.

Petersen, Karen, and Wilson, J. J. *Women Artists: Recognition and Reappraisal.* New York: Harper & Row, 1976.

"Sharples, Ellen." In *New York Historical Society's Dictionary of Artists.*

Sharples, Ellen. Unpublished diary. County Central Reference Library, Deanery Road, Bristol 1, England.

Rolinda Sharples

Knox. *The Sharples.*

Wilson, Donald. "The Sharples Family of Painters." *Antiques,* (November 1971):741–43.

Annie Cornelia Shaw

"Art Notes." *Graphic,* Chicago, An Illustrated Weekly Newspaper. 6 February, 1892, pp. 99–100.

Lilly Martin Spencer

Bolton-Smith, Robin, and Truettner, William H. *Lilly Martin Spencer, 1822–1902: The Joys of Sentiment.* Washington, D.C.: National Collection of Fine Arts, Smithsonian Institution Press, 1973.

Freivogel, Elsie F. "Lilly Martin Spencer: Feminist without Politics." *Archives of American Art Journal* 12, no. 4 (1972):9–14.

Harris and Nochlin. *Women Artists.*

Emma Stebbins

Craven. *Sculpture in America.*

Ellet. *Women Artists.*

Gerdts, William H. "Stebbins, Emma." In *Notable American Women: 1607–1950,* vol. 3, pp. 354–55.

————. *White Marmorean Flock.*

Jane Stuart

Flexner, James Thomas. *Gilbert Stuart: A Great Life in Brief.* New York: Alfred A. Knopf, 1955.

Morgan, John Hill. *Gilbert Stuart and His Pupils.* New York: Kennedy Galleries; Da Capo Press, 1969.

Powel, Mary E. "Miss Jane Stuart." *Bulletin of the Newport Historical Society* (Newport, R.I.) 31 (January 1920):1–16.

Stuart, Jane. "Anecdotes of Gilbert Stuart by His Daughter." *Scribner's Monthly Magazine* (July 1877):377.

Maria Louisa Wagner

"Daniel and Maria Louisa Wagner." *New York Interior Illustrated Magazine,* no. 1 (July–September 1907):52.

"Death of Miss M. L. Wagner." *Norwich Semi Weekly Telegraph* 24 October 1888.

Gallinger, Roy. *Smoke Rings over the Valley.* Sherburne, N.Y.: Heritage Press, 1970.

"Wagner, Maria Louisa." In *New York Historical Society's Dictionary of Artists,* p. 653.

Susan Waters

Gerdts and Burke. *American Still-life Painting.*

Heslip, Colleen Cowles. *Mrs. Susan C. Waters: 19th Century Itinerant Painter.* Farmville, Va.: Bedford Gallery, Longwood Fine Arts Center, Longwood College, 1979.

Ida Waugh

Huber. *The Pennsylvania Academy.*
Sheldon, George William. *Recent Ideals of American Art.* New York and London: D. Appleton &
Co., 1888. Reprint. New York: Garland Publishing Co., 1977.

Anne Whitney

Craven. *Sculpture in America.*
Gerdts. *White Marmorean Flock.*
Hoyt, Edwin. *The Whitneys: An Informal Portrait.* New York: Weybright & Talley, 1976.
Payne, Elizabeth Rogers. "Anne Whitney, Sculptor." *Art Quarterly* 25 (Autumn 1962):244–61.
————. "Anne Whitney: Sculptures; Art and Social Justice." *Massachusetts Review* (Spring
1971):245–60.

Chapter 4

General

Callen, Anthea. *Women Artists of the Arts and Crafts Movement: 1870–1914.* New York: Pantheon
Books, 1979.
Elliot, Maud Howe. *Art and Handicraft in the Woman's Building of the World's Columbian
Exposition, Chicago, 1893.* Chicago: Rand, McNally & Co., 1894.
Hoppin, Martha J. "Women Artists in Boston, 1870–1900: The Pupils of William Morris Hunt." *The
American Art Journal,* (Winter 1981):17–46.
Macht, Carol. *The Ladies God Bless 'em.* Cincinnati: Cincinnati Art Museum, 1976.
Nieriker, May Alcott. *Studying Art Abroad and How to do It Cheaply.* Boston: Roberts Bros., 1879.
19th Century American Women Artists. New York: Whitney Museum of American Art, Downtown
Branch, 1976.
Paine, Judith. "Sophia Hayden and the Woman's Building Competition." In *Women in American
Architecture: A Historic and Contemporary Perspective,* edited by Susana Torre. New York:
Whitney Library of Design and Watson-Guptill Publications, 1977.
Pisano, Ronald G. *The Students of William Merritt Chase.* Huntington, N.Y.: Heckscher Museum,
1973. Exhibition catalogue.
Quick, Michael. *American Expatriate Painters of the Late Nineteenth Century.* Dayton, Ohio:
Dayton Art Institute, 1976.
Snyder-Ott, Joelynn. "Woman's Place in the Home (That She Built)." *Feminist Art Journal* 3, no. 3
(Fall 1974):7–8, 18.
Stetson, Erlene."A Note on the Woman's Building and Black Exclusion." *Heresies: A Feminist
Publication on Art & Politics,* no. 8 ("Third World Women"):45–47.
Weimann, Jeanne Madeline. *The Fair Women.* Chicago: Academy Chicago, 1981. A detailed study
of events and circumstances surrounding the Woman's Building at the World's Columbian
Exposition, 1893.
Wein, Jo Ann. "The Parisian Training of American Women Artists." *Woman's Art Journal* 2
(Spring–Summer, 1981):41–44.
Wilson, Richard Guy; Pilgrim, Dianne H.; and Murray, Richard N. *The American Renaissance:
1876–1917.* Brooklyn, N.Y.: Brooklyn Museum, 1979.
World's Columbian Exposition Revised Catalogue. Department of Fine Arts, United States Division,
Department of Publicity and Promotion. Chicago: W. B. Conkey Co., 1893.

The Artists

May Alcott (Nieriker)

Ticknor, Caroline. *May Alcott: A Memoir.* Boston: Little, Brown & Co., 1928. Describes the life
led by an American woman art student (the sister of Louisa May Alcott) in Paris in the
1870s.

Alice Pike Barney

McClelland, Donald R. *Where Shadows Live: Alice Pike Barney and Her Friends*. Washington, D.C.: National Collection of Fine Arts, Smithsonian Institution Press, 1978. Exhibition catalogue.

Cecilia Beaux

Beaux, Cecilia. *Background with Figures*. Boston and New York: Houghton Mifflin, 1930. Her autobiography.

Evans, Dorinda. "Cecilia Beaux, Portraitist." *American Art Review* 11, no. 1 (January–February 1975):92–102.

Goodyear, Frank H., Jr. Introduction to *Cecilia Beaux: Portrait of an Artist*. Philadelphia: Pennsylvania Academy of the Fine Arts, 1974. Contains bibliography and checklist.

Harris, Ann Sutherland, and Nochlin, Linda. *Women Artists, 1550–1950*. New York: Alfred A. Knopf and the Los Angeles County Museum of Art, 1976.

Stein, Judith E. "Profile of Cecilia Beaux." *Feminist Art Journal* 4, no. 4 (Winter 1975–76):25–33.

Elizabeth Gardner Bouguereau

Clement, Clara Erskine, and Hutton, Laurence. "Gardner, Elizabeth Jane." In *Artists of the Nineteenth Century and their Works*, vol. 1. Boston: Houghton, Osgood & Co., 1879.

Dunnan, Miriam, and Dunnan, Donald. "Elizabeth Gardner Bouguereau." *The Exeter News-Letter* (N.H.), 8 June 1977, p. A3.

McCabe, Linda Rose. "Mme. Bouguereau, Path-Finder." *New York Times Book Review and Magazine*, 19 February 1922, p. 16. An obituary.

Anna Mary Richards Brewster

Brewster, William Tenney. *A Book of Sketches by Anna Richards Brewster*. 4 vols. New York: 1954–1960. Volume 1 contains biographical essay.

Ferguson, Charles B., and White, Nelson C. *He Knew the Sea: William Trost Richards and His Daughter Anna Richards Brewster*. New Britain, Conn.: New Britain Museum of Art, 1973.

Jennie Augusta Brownscombe

Ahrens, Kent. "Jennie Brownscombe: American History Painter." *Woman's Art Journal* 1, no. 2 (Fall 1980–Winter 1981):25–29.

Hazzard, Florence Woolsey. "Brownscombe, Jennie Augusta." In *Notable American Women: 1607–1950*, edited by James T. Edwards et al., vol. 1. Cambridge, Mass.: Harvard University Press, Belknap Press, 1971, pp. 258–59.

Mary Cassatt

Breeskin, Adelyn Dohme. *The Graphic Work of Mary Cassatt: A Catalogue Raisonné*. New York: H. Bittner & Co., 1948.

——————. *Mary Cassatt: A Catalogue Raisonné of the Oils, Water-Colors, and Drawings*. Washington, D.C.: Smithsonian Institution Press, 1970.

Bullard, E. John. *Mary Cassatt: Oils and Pastels*. New York: Watson-Guptill Publications, 1972.

Hale, Nancy. *Mary Cassatt*. New York: Doubleday & Co. 1975.

Sweet, Frederick A. *Miss Mary Cassatt, Impressionist from Pennsylvania*. Norman: University of Oklahoma Press, 1966.

Yeh, Susan Fillin. "Mary Cassatt's Images of Women." *Art Journal* (Summer 1976).

Selected Bibliography

Minerva J. Chapman

Minerva J. Chapman: A Retrospective Exhibition. Washington, D.C.: Adams, Davidson Galleries, 1971. Exhibition catalogue.

Maria Richards Oakey Dewing

Martin, Jennifer A. "Portraits of Flowers: The Out-of-Door Still-life Paintings of Maria Oakey Dewing." *American Art Review* 4, no. 3 (December 1977):48–55.
——————. "The Rediscovery of Maria Oakey Dewing." *Feminist Art Journal* 5, no. 2 (Summer 1976):24–27.

Sarah Paxton Ball Dodson

Gerdts, William H. *Revealed Masters.* New York: American Federation of Arts, 1974.
Quick. *American Expatriate Painters.*
Trask, John E. D. "Sarah Ball Dodson: An Appreciation." *International Studio* 45 (December 1911):xxxvii–xli.

Catherine Ann Drinker (Janvier)

Huber, Christine Jones. *The Pennsylvania Academy and Its Women: 1850–1920.* Philadelphia: Pennsylvania Academy of the Fine Arts, 1973. Exhibition catalogue.
"Janvier, Catharine Ann." In *Dictionary of American Biography.*

Elizabeth Otis Lyman Boott Duveneck

Duveneck, Josephine W. *Frank Duveneck: Painter-Teacher.* San Francisco: John Howell Books, 1970.
Vargas, Michael P. *Elizabeth Boott Duveneck: Her Life and Times.* Santa Clara, Calif.: Triton Museum of Art, 1979. Exhibition catalogue.

Susan Hannah Macdowell Eakins

Casteras, Susan. "Mr. and Mrs. Eakins: Two Painters, One Reputation." *Harper's* (October 1977).
Casteras, Susan P., and Adelman, Seymour. *Susan Macdowell Eakins.* Philadelphia: Pennsylvania Academy of the Fine Arts, 1973. Exhibition catalogue.

Lucia Fairchild Fuller

Clement, Clara Erskine. *Women in the Fine Arts.*
Jewell, William M. "Fuller, Lucia Fairchild." In *Notable American Women: 1607–1950),* vol. 1, pp. 677–78.

Helena de Kay Gilder

Beaux. *Background With Figures.*
Gilder, Rosamond. Letters of Richard Watson Gilder. Boston and New York: Houghton Mifflin, 1916.
19th Century American Women Artists.

Claude Raguet Hirst

Frankenstein, Alfred V. *After the Hunt: William Michael Harnett and Other American Still Life Painters.* 2d ed. Berkeley and Los Angeles: University of California Press, 1969.
Hoopes, Donald. *American Watercolor Painting.* New York: Watson-Guptill Publications, 1977.

Grace Carpenter Hudson

Andersen, T. J.; Moore, Eudora; and Winter, Robert; eds. *California Design, 1910.* Pasadena, Calif.: Pasadena Design Publications, 1974. Exhibition catalogue.

Boynton, Searles R. *The Painter Lady: Grace Carpenter Hudson.* Eureka, Calif.: Interface California Corporation, 1978.

Kovinick, Phil. *The Woman Artist in the American West, 1860–1960.* Fullerton, Calif.: Muckenthaler Cultural Center, 1976.

Adelaide Johnson

Mayo, Edith. "Johnson, Adelaide." In *Notable American Women: The Modern Period,* edited by Barbara Sicherman et al. Cambridge, Mass.: Harvard University Press, Belknap Press, 1980, pp. 380–81.

Weimann. *The Fair Women.*

Mrs. Theodore Alice Ruggles Kitson

Goode, James. *Outdoor Sculpture of Washington, D.C.* Washington, D.C.: Smithsonian Institution Press, 1974.

Taft, Lorado. *History of American Sculpture.* Rev. ed. New York: Macmillan, 1924.

Anna Elizabeth Klumpke

Fine, Elsa Honig. *Women & Art.* Montclair, N.J. and London: Allanheld & Schram; Prior; 1978.

Klumpke, Anna Elizabeth. *Memoirs of an Artist.* Edited by Lillian Whiting. Boston: Wright & Potter Printing Co., 1940.

Helen Mary Knowlton

Duveneck. *Frank Duveneck.*

Hoppin. "Women Artists in Boston, 1870–1900."

Hunt, William Morris. *Talks on Art.* Edited by Helen Mary Knowlton. Boston: H. O. Houghton, 1875.

Sharf, Frederic A. "Knowlton, Helen Mary." In *Notable American Women: 1607–1950,* vol. 2, pp. 342–43.

Evelyn Beatrice Longman

Obituary. *New York Times,* 11 March 1954, p. 34.

Proske, Beatrice Gilman. *Brookgreen Gardens Sculpture.* Rev. ed. Brookgreen Gardens, S.C.: Brookgreen Gardens, 1968.

Rawson, Jonathan A., Jr. "Evelyn Beatrice Longman: Feminine Sculptor." *International Studio* 45:99 (supplement).

Mary Fairchild MacMonnies (Low)

Kimbrough, Sara Dodge. *Drawn From Life.* Jackson: University Press of Mississippi, 1976.

Obituary. *New York Herald Tribune,* 24 May 1946.

Weimann. *The Fair Women.*

Mary Lizzie Macomber

Gerdts, William H. and Burke, Russell. *American Still-life Painting.* New York: Praeger Publishers, 1971.

"Macomber, Mary Lizzie." In *Dictionary of American Biography.*

Selected Bibliography

Lucia K. Mathews

Andersen et al. *California Design, 1910.*
Jones, Harvey L. *Mathews: Masterpieces of the California Decorative Style.* Oakland, Calif.: Oakland Museum, 1972.

Helen Farnsworth Mears

Ela, Janet S. "Mears, Helen Farnsworth." In *Notable American Women: 1607–1950,* vol. 2, pp. 522–23.
Green, Susan Porter. *Helen Farnsworth Mears.* Oshkosh, Wisc.: Paine Art Center and Arboretum, and Castle-Pierce Press, 1972. A full biography.

Anna Lea Merritt

Clement. *Women in the Fine Arts.*
Huber. *The Pennsylvania Academy.*
"Merritt, Anna Lea." In *Dictionary of American Biography.*
Merritt, Anna Lea. *Henry Merritt: Art Criticism and Romance.* London: 1879.
—————. "A Letter to Artists, Especially Women Artists." *Lippincott's Monthly Magazine* 65 (1900):463–69.

Elisabet Ney

Fortune, Jan, and Burton, Jean. *Elisabet Ney.* New York: Alfred A. Knopf, 1943.
Loggins, Vernon, "Elisabet Ney." In *Notable American Women: 1607–1950,* vol. 2, pp. 623–24.
—————. *Two Romantics And Their Ideal Life.* New York: Odyssey Press, 1946.
"Ney, Elisabet." In *Dictionary of American Biography.*
Stephens, I. K. *The Hermit Philosopher of Liendo.* Dallas, Texas: Southern Methodist University Press, 1951.

Elizabeth Nourse

Carter, Denny, and Weber, Bruce. *The Golden Age: Cincinnati Painters of the Nineteenth Century Represented in the Cincinnati Art Museum,* Cincinnati: Cincinnati Art Museum, 1979. Exhibition catalogue.
Clark, Edna H. *Ohio Art and Artists.* Richmond, Va.: Garrett and Massie, 1932.
Quick. *American Expatriate Painters.*

Lilla Cabot Perry

Feld, Stuart P. *Lilla Cabot Perry, A Retrospective Exhibition.* New York: Hirschl & Adler Galleries, 1969.
Harris and Nochlin. *Women Artists.*

Janet Scudder

Gardner, Albert Ten Eyck. *American Sculpture: A Catalogue of the Collection of the Metropolitan Museum of Art.* Greenwich, Conn.: New York Graphic Society, 1965.
Scudder, Janet. *Modeling My Life.* New York: Harcourt, Brace & Co., 1925.
Williams, Lewis W. II. "Janet Scudder." In *Notable American Women: 1607–1950,* vol. 3, pp. 252–53.

Alice Barber Stephens

Gilchrist, Agnes Addison. "Stephens, Alice Barber." In *Notable American Women: 1607–1950,* vol. 3, pp. 359–60.

Three Centuries of American Art. Philadelphia: Philadelphia Museum of Art, 1976. Exhibition catalogue.

Bessie Potter Vonnoh

Armstrong, Tom, et al. *200 Years of American Sculpture.* New York: Whitney Museum of American Art and David R. Godine, Publisher, 1976.
Craven, Wayne. *Sculpture in America.* New York: Thomas Y. Crowell, 1968.
Gardner. *American Sculpture.*
Proske. *Brookgreen Gardens Sculpture.*

Julia Bracken Wendt

Millier, Arthur. "Our Artists in Person." *Los Angeles Times,* 29 November 1931, pp. 3, 16.
Moure, Nancy, and Smith, Lyn Wall. *Dictionary of Art and Artists in Southern California Before 1930.* Los Angeles: Dustin Publications, 1975. Gives detailed sources.
Moure, Nancy, et al. *Southern California Artists: 1890–1940.* Laguna Beach, Calif.: Laguna Beach Museum of Art, 1979. Exhibition catalogue.
Sibley, Gretchen. "An Heroic Sculpture Hidden Beneath the Minerals." *Terra: Bulletin of the Los Angeles County Museum of Natural History* 14, no. 1 (Summer 1975):9–12.
Taft, Lorado. *The History of American Sculpture.* Rev. ed. New York: Macmillan, 1924.

Cecile Smith de Wentworth

C., G. A. "Wentworth, Cecile de." In *Dictionary of American Biography.* vol. 10, pp. 654–55.

Candace Wheeler

Stern, Madeleine. *We The Women.* New York: Schulte Publishing Co., 1963.
Wheeler, Candace. *Yesterdays in a Busy Life.* New York and London: Harper & Bros., 1918. An autobiography.

Enid Yandell

Lonergan, Elizabeth. "America's Woman Sculptors." *Harper's Bazaar* 45 (1911):360.
Taft. *History of American Sculpture.*
Weimann. *The Fair Women.*

Chapter 5

General

Broder, Patricia Janis. *Taos: A Painter's Dream.* Boston: Little, Brown & Co. and the New York Graphic Society, 1980.
Brown, Milton. *American Painting from the Armory Show to the Depression.* Princeton, N.J.: Princeton University Press, 1955.
—————. *The Story of the Armory Show.* New York: Joseph H. Hirshhorn Foundation, 1963.
Calder, A. Stirling, and Perry, Stella G. S. *The Sculpture and Mural Decorations of the Exposition: A Pictorial Survey of The Art of the Panama-Pacific International Exposition.* San Francisco: Paul Elder & Co., 1915.
Contemporary American Sculpture. New York: National Sculpture Society and California Palace of the Legion of Honor, 1929.
Corn, Wanda M. *The Color of Mood: American Tonalism, 1880–1910.* San Francisco: M. H. De Young Memorial Museum and the California Palace of the Legion of Honor, 1972.

Selected Bibliography

Glackens, Ira. *William Glackens and the Ashcan Group: The Emergence of Realism in American Art*. New York: Crown Publishers, 1957.

Hills, Patricia. *Turn-of-the-Century America: Paintings, Graphics, Photographs, 1890–1910*. New York: Whitney Museum of American Art, 1977.

Mayer, Anne E. Introduction to *Women Artists in the Howard Pyle Tradition*. Chadds Ford, Pa.: Brandywine River Museum, 1975. Exhibition catalogue.

Nelson, Mary Carroll. *The Legendary Artists of Taos*. New York: Watson-Guptill Publications, 1980.

Pierce, Patricia Jobe. *The Ten*. Concord, New Hampshire; Rumford Press and Pierce Galleries (Hingham, Mass.), 1976. Refers to several turn-of-the-century women impressionists.

Pitz, Henry C. *The Brandywine Tradition*. Boston: Houghton Mifflin, 1969.

──────. *Howard Pyle: Writer, Illustrator, Founder of the Brandywine School*. New York: Clarkson N. Potter, 1975.

Pollack, Barbara. *The Collectors: Dr. Claribel and Miss Etta Cone; With a Portrait by Gertrude Stein*. Indianapolis: Bobbs-Merrill, 1962.

St. John, Bruce. Introduction to *The Fiftieth Anniversary of the Exhibition of Independent Artists in 1910*. Wilmington: Delaware Art Center, 1960. Exhibition catalogue; includes many biographies of women artists.

Van Deren, Coke. *Taos and Santa Fe: The Artist's Environment, 1882–1942*. Fort Worth, Texas: University of New Mexico Press for the Amon Carter Museum of Western Art, 1963.

Weber, Nicholas Fox. "Rediscovered American Impressionists." *American Art Review* (January–February 1976):100–11.

Artists

Peggy Bacon

Bacon, Peggy. *Off with Their Heads*. New York: Robert M. McBride & Co., 1934.

Tarbell, Roberta K. *Peggy Bacon: Personalities and Places*. Washington, D.C.: National Collection of Fine Arts, Smithsonian Institution Press, 1975.

Dorothy Brett

Brett, Dorothy. *Lawrence and Brett: A Friendship*. Philadelphia: Lippincott, 1933.

Kovinick, Phil. *The Woman Artist in the American West, 1860–1960*. Fullerton, Calif.: Muckenthaler Cultural Center, 1976.

Romaine Brooks

Breeskin, Adelyn. *Romaine Brooks, "Thief of Souls."* Washington, D.C.: National Collection of Fine Arts, Smithsonian Institution Press, 1971.

Secrest, Meryle. *Between Me and Life: A Biography of Romaine Brooks*. New York: Doubleday, 1974.

Edith Dimock

Glackens. *William Glackens*.

Katherine Dreier

Apter, Eleanor S. "Dreier, Katherine Sophie." In *Notable American Women: The Modern Period*. Edited by Barbara Sicherman et al. Cambridge, Mass.: Harvard University Press, Belknap Press, 1980.

Dreier, Katherine. *Collection of the Société Anonyme: Museum of Modern Art, 1920.* Edited by George Heard Hamilton. New Haven: Yale University Art Gallery, 1950.

Saarinen, Aline B. *The Proud Possessors: The Lives, Times and Tastes of Some Adventurous American Art Collectors.* New York: Random House, 1958.

Elsie Driggs

Friedman, Martin L. *The Precisionist View in American Art.* Minneapolis: Walker Art Center, 1960.

Lyle, Cindy. "Return from 30 Years at the Edge of a Ravine." *Women Artists News* (May 1980):1, 4, 6.

Mary Abastenia St. Leger Eberle

Armstrong, Tom, et al. *200 Years of American Sculpture.* New York: Whitney Museum of American Art, and David R. Godine, Publisher, 1976.

Craven, Wayne. "Eberle, Mary Abastenia St. Leger." In *Notable American Women: 1607–1950,* edited by James T. Edwards et al. Cambridge, Mass.: Harvard University Press, Belknap Press, 1971, vol. 1, pp. 548–49. Rev. ed.

Noun, Louise R. *Abastenia St. Leger Eberle: Sculptor (1878–1942).* Des Moines, Iowa: Des Moines Art Center, 1980. Exhibition catalogue.

Proske, Beatrice Gilman. *Brookgreen Gardens Sculpture.* Brookgreen Gardens, S.C.: Brookgreen Gardens, 1968.

Euphemia Charlton Fortune

Kovinick, Phil. *The Woman Artist in the American West.*

Robbins, Millie. "Millie's Column: S.F.'s Own." *San Francisco Chronicle* 23 June 1969, p. 22. An obituary.

Laura Gardin Fraser

Krakel, Dean. *End of the Trail: The Odyssey of a Statue.* Norman: University of Oklahoma Press, 1973. Contains a checklist of works and a biography.

Meta Vaux Warrick Fuller

Lewis, Samella S. *Art: African American.* New York: Harcourt Brace Jovanovich. 1978.

Logan, Rayford W. "Fuller, Meta Vaux Warrick." In *Notable American Women: The Modern Period,* pp. 255–56.

Lillian Genth

"Genth, Lillian." In *Biographical Sketches of American Artist,* edited by Helen Searle. Lansing: Michigan State Library, 1924.

"Genth, Lillian." In *National Cyclopedia of American Biography,* vol. D, New York: James T. White & Co., 1934.

Anne Goldthwaite

Breeskin, Adelyn. *Anne Goldthwaite, 1869–1944.* Montgomery, Ala.: Montgomery Museum of Fine Arts, 1977. Exhibition catalogue.

Harry B. Wehle. "Goldthwaite, Anne Wilson." In *Notable American Women: 1607–1950,* vol. 2, pp. 61–62.

Elizabeth Shippen Green

Likos, Patt. "The Ladies of the Red Rose." *Feminist Art Journal* 5, no. 3 (Fall 1976):11–43.

Stryker, Catherine Connell. *The Studios at Cogslea.* Wilmington: Delaware Art Museum, 1976.

Lilian Westcott Hale

Hale, Nancy. *The Life in the Studio.* Boston: Little, Brown & Co., 1969.

Louise Herreshoff

Whitehead, James W. *Louise Herreshoff: An American Artist Discovered.* Lexington, Va.: Washington and Lee University and the Corcoran Gallery of Art (Washington, D.C.), 1976.

Malvina Hoffman

Armstrong et al. *200 Years of American Sculpture.*
Hoffman, Malvina. *Heads and Tales.* New York: Charles Scribner's Sons, 1936.
————. *Yesterday is Tomorrow: A Personal History.* New York: Crown Publishers, 1965.
Proske. *Brookgreen Gardens Sculpture.*

Anna Hyatt Huntington

Armstrong et al. *200 Years of American Sculpture.*
Evans, Cerinda W. *Anna Hyatt Huntington.* Newport News, Va.: Mariners Museum, 1965.
Proske. *Brookgreen Gardens Sculpture.*
Smith, Bertha H. "Two Women Who Collaborate in Sculpture." *The Craftsman* 8 (June–September 1905):623–33.

Ethel Myers

Katz, Leslie. "The Sculpture of Ethel Myers." In *Ethel Myers.* New York: Robert Schoelkopf Gallery, 1963. Exhibition catalogue.
"Myers, May Ethel Klinck." In *The National Cyclopedia of American Biography,* vol. 46. New York: James T. White & Co., 1963, p. 201.

Violet Oakley

Likos, Pat. "Violet Oakley." *Philadelphia Museum of Art Bulletin,* June 1979.
Stryker, *Studios at Cogslea.*

Georgia O'Keeffe

Goodrich, Lloyd, and Bry, Doris. *Georgia O'Keeffe.* New York: Praeger Publishers for the Whitney Museum of Art, 1970.
Harris, Ann Sutherland, and Nochlin, Linda. *Women Artists: 1550–1950.* New York: Alfred A. Knopf and the Los Angeles County Museum of Art, 1976.
Lisle, Laurie. *Portrait of an Artist: A Biography of Georgia O'Keeffe.* New York: Seaview Books, 1980. Contains a bibliography.
O'Keeffe, Georgia. *Georgia O'Keeffe.* New York: Viking Press Studio Book, 1976.
Rose, Barbara. "Georgia O'Keeffe: The Paintings of the Sixties." *Artforum* (November 1970).
————. "O'Keeffe's Trail." *New York Review of Books,* 31 March 1977.

Marjorie Organ

Homer, William Inness. *Robert Henri and His Circle.* Ithaca, N.Y.: Cornell University Press, 1969.

Jane Peterson

Feld, Stuart P. *Jane Peterson: A Retrospective Exhibition.* New York: Hirschl & Adler Galleries, 1970. Exhibition catalogue.

May Wilson Preston

Glackens. *William Glackens.*
Grant, Jane. "Preston, May Wilson." In *Notable American Women: 1607–1950,* vol. 3, pp. 98–99.

Ellen Emmet Rand

McLean, Albert F., Jr. "Rand, Ellen Gertrude Emmet." In *Notable American Women: 1607–1950,*
 vol. 3, pp. 115–16.

Florence Scovel Shinn

Deshazo, Edith. *Everett Shinn, 1876–1953, A Figure in His Time.* New York: Clarkson N. Potter,
 1974.
Glackens. *William Glackens.*

Eugenie Shonnard

Proske. *Brookgreen Gardens Sculpture.*

Jessie Willcox Smith

Schnessel, S. Michael. *Jessie Willcox Smith.* New York: Thomas Y. Crowell, n.d.
Stryker. *Studios at Cogslea.*

Pamela Colman Smith

Parsons, Melinda Boyd. *To All Believers: The Art of Pamela Colman Smith.* Wilmington: Delaware
 Art Museum, 1975.

Florine Stettheimer

Harris and Nochlin. *Women Artists.*
McBride, Henry. *Florine Stettheimer.* New York: Museum of Modern Art, 1946.
Nochlin. Linda. "Rococo Subversive." *Art in America* (September 1980):64–83.
Tyler, Parker. *Florine Stettheimer: A Life in Art.* New York: Farrar, Straus & Co., 1963.

Martha Walter

David, Carl E. "Martha Walter." *American Art Review* (May 1978).

Gertrude Vanderbilt Whitney

Armstrong et al. *200·Years of American Sculpture.*
Friedman, B. H. *Gertrude Vanderbilt Whitney: A Biography.* New York: Doubleday, 1978.
Goldsmith, Barbara. *Little Gloria . . . Happy at Last.* New York: Alfred A. Knopf, 1980.

Alice Morgan Wright

Fahlman, Betsy. *Sculpture and Suffrage: the art and life of Alice Morgan Wright.* Albany, N.Y.: The
 Albany Institute of History and Art, 1978. Exhibition catalogue.

Marguerite Zorach

Tarbell, Roberta K. *Marguerite Zorach: The Early Years, 1908–1920.* Washington, D.C.: National
 Collection of Fine Arts, Smithsonian Institution Press, 1973.
Zorach, William. *Art is My Life.* New York: World Publishing Co., 1967.

Chapter 6

General

American Art Today. New York: National Art Society, 1939. Juried exhibition at the New York World's Fair.

American Abstract Artists: Three Yearbooks (1938, 1939, 1946). Reprint. New York: Arno Press, 1969.

Baigell, Matthew. *The American Scene: American Painting of the 1930s.* New York: Praeger Publishers, 1974.

A Century of Progress: Exhibition of Paintings and Sculpture Lent from American Collections. Chicago: Art Institute of Chicago, 1933.

McKinzie, Richard D. *The New Deal for Artists.* Princeton, N.J.: Princeton University Press, 1973.

Marling, Karal Ann, and Harrison, Helen A. *7 American Women: The Depression Decade.* Poughkeepsie, N.Y.: Vassar College Art Gallery and A.I.R. Gallery (New York), 1976.

Neuhaus, Eugen. *The Art of Treasure Island.* Berkeley: University of California Press, 1939.

New Deal Art: California. Santa Clara, Calif.: de Saisset Art Gallery and Museum, University of Santa Clara, 1976. Exhibition catalogue. Contains several essays and a checklist of works.

O'Connor, Francis V., ed. *Art for the Millions; Essays from the 1930s by Artists and Administrators of the WPA Federal Art Project.* Boston: New York Graphic Society, 1973.

Official Guide Book: New York World's Fair, 1939. New York: Exposition Publications, 1939.

Outdoor Sculpture Exhibition. New York: Sculptors Guild, 1938. First membership exhibition of the Sculptors Guild.

Rose, Barbara. *American Art Since 1900.* 2d. ed. New York: Praeger Publishers, 1975.

The Artists

Anni Albers

Albers, Anni. *On Designing.* New Haven: Pellango Press, 1959. Reprint. Middletown, Conn.: Wesleyan University Press, 1962.

Baro, Gene, and Weber, Nicholas Fox. *Anni Albers: Drawings and Prints.* Brooklyn, N.Y.: Brooklyn Museum, 1977.

Fine, Elsa Honig. *Women & Art.* Montclair, N.J., and London: Allanheld & Schram; Prior; 1978.

Gertrude Abercrombie

Gillespie, Dizzy; Purdy, James; and Wilcox, Wendell. *Gertrude Abercrombie: A Retrospective Exhibition.* Chicago: Hyde Park Art Center, 1977. Exhibition catalogue.

Jean Goodwin Ames

Ames, Jean. "Jean and Arthur Ames, Artist-Craftsmen of California." *American Artist* (December 1955):19–22, 56–57.

Goodwin, Jean. "California Mosaics." In *Art for the Millions.*

Rosalind Bengelsdorf (Browne)

Bengelsdorf, Rosalind. "The New Realism." In *American Abstract Artists Yearbook, 1938.* New York: American Abstract Artists, 1938.

Browne, Rosalind Bengelsdorf. "The American Abstract Artists and the WPA Federal Art Project." In *The New Deal Art Projects: An Anthology of Memoirs,* edited by Francis V. O'Connor. Washington, D.C.: Smithsonian Institution Press, 1972.

Marling and Harrison. *7 American Women.*

Isabel Bishop

Alloway, Lawrence. "Isabel Bishop, the Grand Manner and the Working Girl." *Art in America* (September–October 1975):61–65.

Harris and Nochlin. *Women Artists: 1550–1950.* New York: Alfred A. Knopf and Los Angeles County Museum of Art, 1976.

Lunde, Karl. *Isabel Bishop.* New York: Harry N. Abrams, 1975.

Nemser, Cindy. "Conversation with Isabel Bishop." *Feminist Art Journal* 5, no. 1 (Spring 1976):14–20.

Lucienne Bloch

Bloch, Lucienne. "Murals for Use." In *Art For the Millions.*

Marling and Harrison. *7 American Women.*

Selma Burke

Driskell, David C. *Two Centuries of Black American Art.* With catalogue notes by Leonard Simon. New York: Alfred A. Knopf and Los Angeles County Museum of Art, 1976.

Lewis, Samella S. *Art: African American.* New York: Harcourt Brace Jovanovich, 1978.

Doris Caesar

Bush, Martin. *Doris Caesar.* Syracuse, N.Y.: Syracuse University Press, 1970.

Goodrich, Lloyd, and Baur, John. *Four American Expressionists.* New York: Praeger Publishers and the Whitney Museum of American Art, 1959.

Minna Citron

Marling and Harrison. *7 American Women.*

Marxer, Donna. "Minna Citron: Getting Old is Just as Good." *Women Artists Newsletter,* December 1977, p. 2.

Caroline Durieux

Cox, Richard. *Caroline Durieux: Lithographs of the Thirties and Forties.* Baton Rouge: Louisiana State University Press, 1977.

Zigrosser, Carl. *The Artist in America: Contemporary Printmakers.* New York: Alfred A. Knopf, 1942; Repring. N.Y.: Hacker Art ooks, 1978.

Mabel Dwight

Dwight, Mabel. "Satire in Art." In *Art for the Millions.*

Zigrosser, Carl. "Mabel Dwight: Master of Comédie Humaine." *American Artist* (June 1949):42–45.

Edris Eckhardt

Marling, Karal Ann. *Federal Art in Cleveland: 1933–1943.* Cleveland, Ohio: Cleveland Public Library, 1974.

Lauren Ford

Boswell. *Modern American Painting.*

Gertrude Greene

Armstrong, Tom, et al. *200 Years of American Sculpture.* New York: Whitney Museum of American Art and David R. Godine, Publisher, 1976.

"Gertrude Greene Dies; Painter, 52." *New York Times,* 27 November 1956, p. 38.

Dorothea Greenbaum

Corlette, Suzanne. *Paintings by Bishop; Sculpture by Dorothea Greenbaum*. Foreword by Kenneth Prescott. Trenton: New Jersey State Museum, 1970.

Marion Greenwood

Marling and Harrison. *7 American Women*.
Salpeter, Henry. "Marion Greenwood, An American Artist of Originality and Power." *American Artist* 12 (January 1948):14–19.

Edith Hamlin

Kovinick, Phil. *The Woman Artist in the American West, 1860–1960*. Fullerton, Calif.: Muckenthaler Cultural Center, 1976.

Lois Mailou Jones

Bowles, Juliette H. "Lois Mailou Jones: Portrait of an Artist." *New Directions* (Howard University) 4, no. 3 (July 1977):4–23.
Gaither, Edmund Barry. *Reflective Moments: Lois Mailou Jones, Retrospective 1930–1972*. Boston: Museum of the National Center of Afro-American Artists and the Boston Museum of Fine Arts, 1973. Exhibition catalogue.
Striar, Margurite M. "Artist in Transition." *Essence* (November 1972):44, 70–72.

Doris Lee

"Doris Lee: An American Painter With a Humorous Sense of Violence." *Life* (20 September 1937):44–47.
"Lee, Doris." *Current Biography Yearbook* 1954, pp. 401–403.
Marling and Harrison. *7 American Women*.

Molly Luce

Lloyd Goodrich and D. Roger Howlett. *Molly Luce: Eight Decades of the American Scene. A major retrospective exhibition of paintings from 1917 to 1980*. Exhibition catalogue.

Helen Lundeberg

Moran, Diane Degasis. *Helen Lundeberg: A Retrospective Exhibition*. Los Angeles: Los Angeles Municipal Art Gallery, 1979.
—————. *Lorser Feitelson and Helen Lundeberg: A Retrospective Exhibition*. San Francisco: San Francisco Museum of Modern Art, 1980.
Munro. *Originals*.
Young, Joseph E. "Helen Lundeberg: An American Independent." *Art International* (September 1971):46–53, 72.

Loren MacIver

Baur, John I. H. *Loren MacIver; I. Rice Pereira.* New York: Macmillan, for the Whitney Museum of American Art, 1953.
Harris and Nochlin. *Women Artists.*

Ethel Magafan

Watson, Ernest W. "Magafan and Mountains." *American Artist* (December 1957):57–64.

Alice Trumbull Mason

Harris and Nochlin. *Women Artists.*
Pincus-Witten, R. *Alice Trumbull Mason Retrospective.* New York: Whitney Museum of American Art, 1973.

Elizabeth Olds

Marling and Harrison. *7 American Women.*
Olds, Elizabeth. "Prints for Mass Production." In *Art for the Millions.*

Irene Rice Pereira

Baur, John I. H. *I. Rice Pereira.* New York: Andrew Crispo Gallery, 1976.
—————. *Loren MacIver; I. Rice Pereira.*
Miller, Donald. "The Timeless Landscapes of I. Rice Pereira." *Arts Magazine* (October 1978).
Tufts, Eleanor. *Our Hidden Heritage.* New York and London: Paddington Press, 1974.
Van Wagner, Judith K. "I. Rice Pereira: Vision Superceding Style." *Woman's Art Journal* 1, no. 4 (Spring–Summer 1980):33–38.

Marjorie Phillips

Phillips, Marjorie. *Duncan Phillips and His Collection.* Boston: Little, Brown & Co., 1970.
Withers, Josephine, ed. *Women Artists in Washington Collections.* College Park: University of Maryland Art Gallery and Women's Caucus for Art, 1979. Entry by Susan Willard.

Hilla Rebay

Messer, Thomas M. *A Selection of Paintings, Watercolors, and Drawings in Tribute to Baroness Hilla von Rebay, 1890–1967: Acquisitions of the 1930's and 1940's.* New York: Solomon R. Guggenheim Museum, 1967.
Lukach, Joan M. "Rebay, Hilla." In *Notable American Women: The Modern Period,* edited by Barbara Sicherman et al. Cambridge, Mass.: Harvard University Press, Belknap Press, 1980.

Constance Richardson

Bruner, Louise. "The Paintings of Constance Richardson." *American Artist* (January 1961):21–25, 64–66.
Gussow, Allan. *A Sense of Place: The Artist and the American Land.* Introduction by Richard Wilbur. San Francisco, New York, London, and Paris: Friends of the Earth and Seabury Press, 1971.
Young, Mahonri Sharp. *Constance Richardson.* New York: Kennedy Galleries, 1970.

Augusta Savage

Bearden, Romare, and Henderson, Harry. *Six Black Masters of American Art.* Garden City, N.Y.: Zenith Books and Doubleday, 1972.

Concetta Scaravaglione

Marling and Harrison. *7 American Women.*
The Sculpture of Concetta Scaravaglione. (Richmond: Virginia Museum of Fine Arts, 1941). Exhibition catalogue. Contains reprints of Scaravaglione's essay "My Enjoyment in Sculpture" from *Magazine of Art* (August 1939).

Katherine Schmidt

The Katherine Schmidt Shubert Bequest and A Selective View of Her Art. Whitney Museum of American Art, 1982. Exhibition catalogue.

Henrietta Shore

Armitage, Merle; Weston, Edward; and Poland, Reginald. *Henrietta Shore.* New York: E. Weyhe, 1933.
Maddow, Ben. *Edward Weston: 50 Years.* Millerton, N.Y.: Aperture, 1973, pp. 67–69, 253.

Laura Wheeler Waring

Driskell. *Black American Art.*
Lewis. *Art: African American.*

Chapter 7

General

Ashton, Dore. *The New York School: A Cultural Reckoning.* New York: Viking Press, 1972.
Bard, Joellen. "Tenth Street Days: An Interview with Charles Cajori and Lois Dodd." *Arts Magazine* (December 1977):98.
Friedman, B. H. *School of New York: Some Younger Artists.* New York: Grove Press, 1959.
Gruen, John. *The Party's Over Now: Reminiscences of the Fifties.* New York: Viking Press, 1967.
Hobbs, Robert Carleton, and Levin, Gail. *Abstract Expressionism: The Formative Years.* Ithaca, N.Y.: Herbert F. Johnson Museum of Art, Cornell University, 1978. Exhibition catalogue.
The New American Painting. New York: Museum of Modern Art, 1959.
Rosenzweig, Phyllis. *The Fifties: Aspects of Painting in New York.* Washington, D.C.: Smithsonian Institution Press, 1980.
Sandler, Irving. *The New York School: The Painters and Sculptors of the Fifties.* Icon Editions. New York: Harper & Row, 1978.

The Artists

Ruth Asawa

Hamilton, Mildred. "A Tour of Ruth Asawa's San Francisco." *San Francisco Examiner,* 19 September 1976, Scene/Arts sect., p. 1.
Ruth Asawa: Retrospective. San Francisco: San Francisco Museum of Art, 1973.
Woodridge, Sally. *Ruth Asawa's San Francisco Fountain.* San Francisco: Sally B. Woodbridge, Ruth Asawa, Laurence Cuneo, 1973.

Nell Blaine

Cochrane, Diane. "Nell Blaine and High Wire Painting." *American Artist* (August 1973):20–25.
Campbell, Lawrence. "Blaine Paints a Picture." *Art News* (May 1959).
Mellow, James R. "The Flowering Summer of Nell Blaine." *New York Times,* 11 October 1970.
Munro, Eleanor. *Originals: American Women Artists.* New York: Simon & Schuster, 1979.

Louise Bourgeois

Armstrong, Tom, et al. *200 Years of American Sculpture*. New York: Whitney Museum of American Art and David R. Godine, Publisher, 1976.
Lippard, Lucy. "Louise Bourgeois: From the Inside Out." *Artforum* 13, no. 7 (March 1975):26–33.
Munro. *Originals*.
Ratcliff, Carter. "People Are Talking About . . . Louise Bourgeois." *Vogue* (October 1980):343–77.

Mary Callery

Adams, Philip R., and Zervos, Christian. *Mary Callery: Sculpture*. New York: Wittenborn & Co., 1961.
Callery, Mary. "The Last Time I Saw Picasso." *Art News* 40 (May 1942):23–36.

Elizabeth Catlett

Bontemps, Arna, et al. *Forever Free: Art by African-American Women 1867–1980*. Normal, Illinois, 1980.
Driskell, David C. *Two Centuries of Black American Art*. New York: Alfred A. Knopf and the Los Angeles County Museum of Art, 1976.
Fax, Elton C. *Seventeen Black Artist*. New York: Dodd, Mead & Co., 1971.
Lewis, Samella S. *Art: African American*. New York: Harcourt Brace Jovanovich, 1978.

Elaine de Kooning

Campbell, Lawrence. "Elaine de Kooning Paints a Picture." *Art News*, (December 1960):40–44.
Fine. *Women & Art*.
Munro. *Originals*.
"Quest for a Famous Likeness." *Life* (8 May 1964):120–22.
Sandler. *The New York School*.

Claire Falkenstein

Alf, Martha. *The Structural Language of Claire Falkenstein*. Art Week 7, no. 14 (3 April 1976):1.
Larinde, Noreen. "Claire Falkenstein." *Woman's Art Journal* 1, no. 1 (Spring–Summer 1980):44–55.
Tapié, Michel. *Claire Falkenstein*. Rome: De Luca Art Monographs, 1958.

Perle Fine

Baldwin, Benjamin. "Perle Fine." *Arts and Architecture* (May 1947).
Deitcher, David. *Perle Fine: Major Works, 1954–1978 (A Selection of Drawings, Paintings and Collages)*. East Hampton, N.Y.: Guild Hall of East Hampton, 1978. Exhibition catalogue.
Tannenbaum, Judith. "Perle Fine." *Arts Magazine* (December 1977):24

Jean Follett

Sandler. *The New York School*.

Jane Freilicher

Porter, Fairfield. "Jane Freilicher Paints a Picture." *Art News* (September 1956):46–66.
Schjeldahl, Peter. "Urban Pastorals." *Art News* (February 1971):32–62.
Schuyler, James. "The Painting of Jane Freilicher." *Art and Literature* (Autumn 1966).
Shorr, Harriet. "Jane Freilicher." *Arts Magazine* (May 1977):9.

Selected Bibliography

Sue Fuller

Browne, Rosalind Bengelsdorf. "Sue Fuller: Threading Transparency." *Art International* 16, no. 1 (January 1972):37–40.
Fuller, Sue. "String Compositions: Transparency, Light, and Balance." *Christian Science Monitor,* 22 September 1965.
Seitz, Peter. *The Responsive Eye.* New York: Museum of Modern Art, 1965.

Ruth Gikow

Josephson, Mathew. *Ruth Gikow.* New York: Random House, 1970.

Peggy Guggenheim

Guggenheim, Peggy. *Confessions of an Art Addict.* New York: Macmillan Co., 1960.
——————. *Out of This Century.* New York: Dial Press, 1946.
Saarinen, Aline B. *The Proud Possessors.* New York: Random House, 1958.

Grace Hartigan

Ketner, Joseph D., II. "The Continuing Search of Grace Hartigan." *Art News* (February 1981):128–29.
Nemser, Cindy. *Art Talk: Conversations with 12 Women Artists.* New York: Charles Scribner's Sons, 1975.

Ynez Johnston

Berry, John. "An Interview with Painter Ynez Johnston: View from the Wind Palace." *Mankind* 5, no. 1 (June 1975):43–74.
Berry, John, and Johnston, Ynez. *Selected Works, 1950–1977.* New York: Wiener Gallery, 1977. Exhibition catalogue.

Luise Kaish

Kampf, Avram. *Contemporary Synagogue Art: Developments in the United States, 1945–65.* Philadelphia: Jewish Publication Society of America, 1966.
Luise Kaish: Sculpture. New York: Jewish Museum, 1973.

Lila Katzen

Munro. *Originals.*
Nemser. *Art Talk.*

Adaline Kent

Neuhaus, Eugen. *The Art of Treasure Island.* Berkeley: University of California Press, 1939. Shows pictures of her work at the San Francisco fair.
Anderson, Wayne. *American Sculpture in Process: 1930/1970.* Boston: New York Graphic Society, 1975.

Lee Krasner

Harris, Ann Sutherland, and Nochlin, Linda. *Women Artists: 1550–19t0.* New York: Alfred A. Knopf and the Los Angeles County Museum of Art, 1976.
Munro. *Originals.*
Nemser. *Art Talk.*

Robertson, Bryan. "The Nature of Lee Krasner." *Art in America* (November–December 1973):84–87.
Rose, Barbara. *Krasner/Pollock: A Working Relationship*. East Hampton, Long Island: Guild Hall Museum, 1981. Exhibition catalogue.
Rose, Barbara. "Lee Krasner and the Origins of Abstract Expressionism." *Arts* (February 1o77):96–100.
Tucker, Marcia. *Lee Krasner: Large Paintings*. New York: Whitney Museum of American Art, 1974.

Jeanne Miles

Davis, Mary R. "Jeanne Miles: An Interview." *Arts Magazine* (April 1977):136–39.
Hill, May Brawley. *Three American Purists: Mason, Miles, von Wiegand*. Springfield, Mass.: Museum of Fine Arts, 1975. Exhibition catalogue.

Joan Mitchell

Munro. *Originals*.
Nemser, Cindy. "An Afternoon with Joan Mitchell." *Feminist Art Journal* (Spring 1976):5–6†.
Sandler. *The New York School*.
Tucker, Marcia. *Joan Mitchell*. New York:. Whitney Museum of American Art, 1974.

Louise Nevelson

Albee, Edward. *Louise Nevelson: Atmospheres and Environments*. New York: Whitney Museum of American Art, 1980.
Glimcher, Arnold. *Louise Nevelson*. New York: Praeger Publishers, 1972.
Hughes, Robert. "Sculpture's Queen Bee." *Time* (12 January 1981):66–72.
Munro. *Originals*.
Nemser. *Art Talk*.
Nevelson, Louise. *Dawns and Dusks*. New York: Charles Scribner's Sons, 1976.

Betty Parsons

Alloway, Lawrence, and Robertson, Bryan. *Paintings, Gouaches, and Sculpture, 1955–68*. London: Whitechapel Gallery, 1968.
Gamble, Kathryn E., et al. *Betty Parsons Retrospective: An Exhibition of Paintings and Sculpture*. Montclair, N.J.: Montclair Art Museum, 1974.

Anne Ryan

Faunce, Sarah. "Anne Ryan Collages." Washington, D.C.: National Collection of Fine Arts, Smithsonian Institution Press, 1974.
Myers, John Bernard. "Anne Ryan." *Arts Magazine* (May 1977):21.
Withers. *Women Artists in Washington Collections*.

Kay Sage

Harris and Nochlin. *Women Artists*.
Krieger, Règine Tessier. *Kay Sage, 1898–1963*. Ithaca, N.Y.: The Herbert F. Johnson Museum of Art, 1977.
Soby, James and Clapp, Talcott B. *A Tribute to Kay Sage*. Waterbury, Conn.: Mattatuck Museum (Publication 35), 1965.

Honoré Sharrer

Seckler, Dorothy. "Sharrer Paints a Picture." *Art News* (April 1951).
Soby, James Thrall. *Contemporary Painters*. New York: Simon & Schuster, 1948.

Hedda Sterne

Gamble, Kathryn E., and Hall, Lee. *Hedda Sterne: Retrospective*. Montclair, N.J.: Montclair Art Museum, 1977.
Henry, Grace. "Artist and the Face." *Art in America* 63 (January 1975):40–41.
"Steinberg and Sterne." *Life* (27 August 1951):pp. 50–52.

Dorothea Tanning

Bosquet, A. *La Peinture de Dorothea Tanning*. Paris: 1966.
Harris and Nochlin. *Women Artists*.
Tanning, Dorothea and Jouffroy, Alain, *Dorothea Tanning*. Paris: Centre National d'Art Contemporain, 1974.
Dorothea Tanning: Ten Recent Paintings and a Biography. New York: Gimpel & Weitzenhoffer Gallery, 1979.

Charmion von Wiegand

Hill. *Three American Purists*.
von Wiegand, Charmion. "The Adamantine Way." *Art News* (April 1969):39.
Wescher, Herta. *Collage*. New York: Harry N. Abrams, 1968.

Jane Wilson

Cochrane, Diane. "Jane Wilson: Remembrance of Images Past and Present." *American Artist* (December 1974):26–31, 66–67.
Gruen. *The Party's Over*.
Gussow. *A Sense of Place*.

Chapter 8

General

Alloway, Lawrence. *Systemic Painting*. New York: Solomon R. Guggenheim Museum, 1966.
Battcock, Gregory, ed. *Minimal Art: A Critical Anthology*. New York: E. P. Dutton, 1968.
Greenberg, Clement. *Post-Painterly Abstraction*. Los Angeles: Los Angeles County Museum of Art, 1964.
Lippard, Lucy R., et al., eds. *Pop Art*. New York: Praeger Publishers, 1966.
Seitz, William. *The Responsive Eye*. New York: Museum of Modern Art, 1964.
Tuchman, Maurice, ed. *American Sculpture of the Sixties*. Los Angeles: Los Angeles County Museum of Art, 1967.

The Artists

Jo Baer

Haskell, Barbara. *Jo Baer.* New York: Whitney Museum of American Art, 1975. Exhibition catalogue.

Lee Bontecou

Ashton, Dore. *Modern American Sculpture.* New York: Harry N. Abrams, 1968.
Judd, Donald. "Lee Bontecou." *Arts Magazine* (April 1965):17–20.
"It's Art—But Will It Fly?" *Life* (10 April 1964).
Munro, Eleanor. *Originals: American Women Artists.* New York: Simon & Schuster, 1979.
"What I Do Just Is." *Vogue* (May 1969).

Joan Brown

Goldeen, Dorothy. *Joan Brown Paintings.* Akron, Ohio: Emily H. Davis Art Gallery, University of Akron, 1978.
Leider, Philip. "Joan Brown: Her Work Illustrates the Progress of a San Francisco Mood." *Art Forum* (June 1963):28–31.
Richardson, Brenda. *Joan Brown.* Berkeley, Calif.: University Art Museum, 1974.
Turnbull, Betty. *Joan Brown: The Acrobat Series.* Newport Beach, Calif.: Newport Harbor Art Museum 1978. Exhibition catalogue.

Chryssa

Calas, Nicolas. "Chryssa and Time's Magic Square." *Art International* 6, no. 1 (February 1962):35–37.
Campbell, Vivian. "Chryssa—Some Observations." *Art International* 17, no. 4 (April 1973):28–30.
Hunter, Sam. *Chryssa.* New York: Harry N. Abrams, 1974.
Restany, Pierre. *Chryssa.* New York: Harry N. Abrams, 1977.

Lin Emery

Green, Roger. "The Kinetic Sculpture of Lin Emery." *Arts Magazine* 54, no. 4 (December 1979):106–7.

Helen Frankenthaler

Baro, Gene. "The Achievement of Helen Frankenthaler." *Art International* 11 (20 September 1967):33–38.
Baro, Gene, and Slade, Roy. *Helen Frankenthaler: Paintings, 1969–1974.* Washington, D.C.: Corcoran Gallery of Art, 1975.
Geldzahler, Henry. "An Interview with Helen Frankenthaler." *Artforum* 4 (October 1965):36–38.
Krens, Thomas, et al. *Helen Frankenthaler Prints: 1961–1979.* New York: Harper & Row, 1980.
Munro. *Originals.*
Rose, Barbara. *Frankenthaler.* Rev. ed. New York: Harry N. Abrams, 1974.
Sandler, Irving. *The New York School: The Painters and Sculptors of the Fifties.* New York: Harper & Row, 1978.

Honoré Sharrer

Seckler, Dorothy. "Sharrer Paints a Picture." *Art News* (April 1951).
Soby, James Thrall. *Contemporary Painters*. New York: Simon & Schuster, 1948.

Hedda Sterne

Gamble, Kathryn E., and Hall, Lee. *Hedda Sterne: Retrospective*. Montclair, N.J.: Montclair Art
 Museum, 1977.
Henry, Grace. "Artist and the Face." *Art in America* 63 (January 1975):40–41.
"Steinberg and Sterne." *Life* (27 August 1951):pp. 50–52.

Dorothea Tanning

Bosquet, A. *La Peinture de Dorothea Tanning*. Paris: 1966.
Harris and Nochlin. *Women Artists*.
Tanning, Dorothea and Jouffroy, Alain, *Dorothea Tanning*. Paris: Centre National d'Art Contempo-
 rain, 1974.
Dorothea Tanning: Ten Recent Paintings and a Biography. New York: Gimpel & Weitzenhoffer
 Gallery, 1979.

Charmion von Wiegand

Hill. *Three American Purists*.
von Wiegand, Charmion. "The Adamantine Way." *Art News* (April 1969):39.
Wescher, Herta. *Collage*. New York: Harry N. Abrams, 1968.

Jane Wilson

Cochrane, Diane. "Jane Wilson: Remembrance of Images Past and Present." *American Artist*
 (December 1974):26–31, 66–67.
Gruen. *The Party's Over*.
Gussow. *A Sense of Place*.

Chapter 8

General

Alloway, Lawrence. *Systemic Painting*. New York: Solomon R. Guggenheim Museum, 1966.
Battcock, Gregory, ed. *Minimal Art: A Critical Anthology*. New York: E. P. Dutton, 1968.
Greenberg, Clement. *Post-Painterly Abstraction*. Los Angeles: Los Angeles County Museum of Art,
 1964.
Lippard, Lucy R., et al., eds. *Pop Art*. New York: Praeger Publishers, 1966.
Seitz, William. *The Responsive Eye*. New York: Museum of Modern Art, 1964.
Tuchman, Maurice, ed. *American Sculpture of the Sixties*. Los Angeles: Los Angeles County
 Museum of Art, 1967.

The Artists

Jo Baer

Haskell, Barbara. *Jo Baer.* New York: Whitney Museum of American Art, 1975. Exhibition catalogue.

Lee Bontecou

Ashton, Dore. *Modern American Sculpture.* New York: Harry N. Abrams, 1968.
Judd, Donald. "Lee Bontecou." *Arts Magazine* (April 1965):17–20.
"It's Art—But Will It Fly?" *Life* (10 April 1964).
Munro, Eleanor. *Originals: American Women Artists.* New York: Simon & Schuster, 1979.
"What I Do Just Is." *Vogue* (May 1969).

Joan Brown

Goldeen, Dorothy. *Joan Brown Paintings.* Akron, Ohio: Emily H. Davis Art Gallery, University of Akron, 1978.
Leider, Philip. "Joan Brown: Her Work Illustrates the Progress of a San Francisco Mood." *Art Forum* (June 1963):28–31.
Richardson, Brenda. *Joan Brown.* Berkeley, Calif.: University Art Museum, 1974.
Turnbull, Betty. *Joan Brown: The Acrobat Series.* Newport Beach, Calif.: Newport Harbor Art Museum 1978. Exhibition catalogue.

Chryssa

Calas, Nicolas. "Chryssa and Time's Magic Square." *Art International* 6, no. 1 (February 1962):35–37.
Campbell, Vivian. "Chryssa—Some Observations." *Art International* 17, no. 4 (April 1973):28–30.
Hunter, Sam. *Chryssa.* New York: Harry N. Abrams, 1974.
Restany, Pierre. *Chryssa.* New York: Harry N. Abrams, 1977.

Lin Emery

Green, Roger. "The Kinetic Sculpture of Lin Emery." *Arts Magazine* 54, no. 4 (December 1979):106–7.

Helen Frankenthaler

Baro, Gene. "The Achievement of Helen Frankenthaler." *Art International* 11 (20 September 1967):33–38.
Baro, Gene, and Slade, Roy. *Helen Frankenthaler: Paintings, 1969–1974.* Washington, D.C.: Corcoran Gallery of Art, 1975.
Geldzahler, Henry. "An Interview with Helen Frankenthaler." *Artforum* 4 (October 1965):36–38.
Krens, Thomas, et al. *Helen Frankenthaler Prints: 1961–1979.* New York: Harper & Row, 1980.
Munro. *Originals.*
Rose, Barbara. *Frankenthaler.* Rev. ed. New York: Harry N. Abrams, 1974.
Sandler, Irving. *The New York School: The Painters and Sculptors of the Fifties.* New York: Harper & Row, 1978.

Selected Bibliography

Eva Hesse

Lippard, Lucy. *Eva Hesse*. New York: New York University Press, 1976.

Nemser, Cindy. *Art Talk: Conversations with 12 Women Artists*. New York: Charles Scribner's Sons, 1975.

Sheila Hicks

Lévi-Strauss, Monique. *Sheila Hicks*. Paris: Pierre Horay & Suzy Langlois, 1973; London: Studio Vista, 1974.

Munro. *Originals*.

Corita Kent

Kent, Mary Corita, et al. *Sister Corita*. Philadelphia: Pilgrim Press, 1968.

La Porte, Paul. *Corita: At the DeCordova Museum; a Retrospective Exhibition*. Lincoln, Mass.: De Cordova Museum, 1980.

Rothon, Pamela. "A Conversation with Corita Kent." *American Way,* (November 1970):7–14.

Ida Kohlmeyer

Clark, Marjorie. "Ida Kohlmeyer." In *Women Artists in Washington Collections,* edited by Josephine Withers, pp. 58–59. College Park: University of Maryland Art Gallery and Women's Caucus for Art, 1979.

Ida Kohlmeyer, A Retrospective Exhibition. Atlanta, Ga.: High Museum of Art, 1972.

Marisol Escobar

Campbell, Lawrence. "Marisol's Magic Mixtures." *Art News* (March 1964):38–41.

Fine, Elsa Honig. *Women & Art: A History of Women Painters and Sculptors from the Renaissance to the 20th Century*. Montclair, N.J., and London: Alanheld & Schram; Prior; 1978.

Nemser. *Art Talk*.

Agnes Martin

Alloway, Lawrence. *Agnes Martin*. Philadelphia: Institute of Contemporary Art, University of Pennsylvania, 1973. Exhibition catalogue.

Linville, Kasha. "Agnes Martin: An Appreciation." *Artforum* (June 1971).

Ratcliff, Carter. "Agnes Martin and the 'Artificial Infinite.'" *Art News* (May 1973):26–27.

Beverly Pepper

Fry, Edward F. *Beverly Pepper, Sculpture, 1971–1975*. San Francisco: San Francisco Museum of Art, 1975. Exhibition catalogue.

Munro. *Originals*.

Deborah Remington

Brumer, Miriam. "Deborah Remington: Fascinating Contradictions." *Feminist Art Journal* (Spring 1974):1–4.

Robins, Corinne. "Deborah Remington: Paintings Without Answers." *Arts Magazine* (April 1977):140–42.

Tanning, Dorothea and Jouffroy, Alain, *Dorothea Tanning*. Paris: Centre National d'Art Contemporain, 1974.

Dorothea Rockburne

Rose, Barbara. *American Painting: The 20th Century*. Rev. ed. New York: Skira, 1977.
Spector, Naomi. "New Color Work by D. Rockburne." In *Working with the Golden Section 1974–1976*. New York: John Weber Gallery 1976

Niki de Saint Phalle

Hulten, Pontus et al. *Niki de Saint Phalle, exposition rétrospective*. Paris: Centre Georges Pompidou, Musée National d'Art Moderne, 1980.
Niki de Saint Phalle: Retrospektive 1954–1980. Wilhelm-Lehmbruck-Museum der Stadt Duisberg; Neue Galerie der Stadt Linz (A); Kunsthalle, Nürnberg; Haus am Waldsee, Berlin; Kunstmuseum Hannover mit Sammlung Sprengel, 1980–81. A traveling exhibition through five German museums. (Contains several essays and statements by the artist.)

Sylvia Stone

Armstrong, Tom, et al. *200 Years of American Sculpture*. New York: Whitney Museum of American Art and David R. Godine, Publisher, 1976.
Munro. *Originals*.
Sandler, Irving. "Sylvia Stone's Egyptian Stones." *Arts Magazine* (April 1977).
Sylvia Stone. Bennington, Vt.: Bennington College, 1978. Exhibition catalogue.

Lenore Tawney

Lenore Tawney: An Exhibition of Weaving, Collage, Assemblage. Fullerton, Calif.: Art Gallery, California State University, 1975. Exhibition catalogue.
Munro. *Originals*.
Orenstein, Gloria. "Lenore Tawney: The Craft of the Spirit." *Feminist Art Journal* 2, no. 4 (Winter 1973–74):11–13.

Alma Thomas

Alma W. Thomas: Retrospective Exhibition. Washington, D.C.: Corcoran Gallery of Art, 1972.
Munro. *Originals*.

Joyce Treiman

Longman, Lester D., and Bloch, Maurice. *Joyce Treiman: A Retrospective*. Los Angeles: Hennessey & Ingalls, 1978. Los Angeles Municipal Art Gallery.
Luban, Frances. "Joyce Treiman: Painting from Within." *American Artist* (September 1975):44–49, 68.
Wilson, William. *Joyce Treiman: Paintings, 1961–1972*. La Jolla, Calif.: La Jolla Museum of Contemporary Art, 1972.

Anne Truitt

Armstrong et al. *200 Years of American Sculpture*.
Greenberg, Clement. "Changer: Anne Truitt, American Artist Whose Painted Structures Helped to Change the Course of American Sculpture." *Vogue* (May 1968).
Munro. *Originals*.

Selected Bibliography

Ruth Vollmer

B. H. Friedman. "The Quiet World of Ruth Vollmer." *Art International* 9 no. 2 (March 12, 1965):26–28.

June Wayne

Baskett, Mary. *The Art of June Wayne.* New York: Harry N. Abrams, 1969.
Munro. *Originals.*
Wayne, June. "The Creative Process." *Craft Horizons* (October 1976).
——————. "The Male Artist as a Stereotypical Female." *Art News* (December 1973).

Chapter 9

General

Consult general index at the beginning for basic works, such as Lucy Lippard, *From the Center,* Cindy Nemser, *Art Talk,* etc.
Alloway, Lawrence. "Women's Art in the '70s." *Art in America* 64 (May–June 1976):64–72.
Berman, Avis. "A Decade of Progress, But Could a Female Chardin Make a Living?" *Art News* (October 1980):73–79.
Cockcroft, Eva, et al. *Toward a People's Art: The Contemporary Mural Movement.* New York: Dutton, 1977.
Frankel, Dextra, and Chicago, Judy. *Invisible/Twenty-One Artists/Visible.* Long Beach, Calif.: Long Beach Museum of Art, 1972. Exhibition catalogue.
Goodyear, Frank H. *Contemporary American Realism Since 1960.* Boston: New York Graphic Society, 1981.
International Feminist Art. Haags Gemenemuseum, the Hague: Netherlands, 1979–1980. Exhibition catalogue.
Kingsley, April. "Six Women at Work in the Landscape." *Arts* 52, no. 8 (April 1978):110–11.
Larson, Kay. "For the First Time Women Are Leading, not Following." *Art News* (October 1980):64–72.
Lippard, Lucy. "Household Images in Art." *Ms.* 1 (March 1973):22–25.
——————. "The Pains and Pleasures of Rebirth: Women's Body Art." *Art in America* 64 (May–June 1976):73–81.
——————. "Quite Contrary: Body, Nature, Ritual in Women's Art." *Chrysalis* 2 (1977):31–47.
——————. "Sexual Politics, Art Style." *Art in America* 59 (September–October 1971):19–20.
——————. "Sweeping Exchanges: The Contribution of Feminism to the Art of the 1970s." *Art Journal* 40, nos. 1–2 (Fall–Winter 1980):362–65.
——————. *Twenty-Six Contemporary Women Artists.* Ridgefield, Conn.: Aldrich Museum of Contemporary Art, 1971.
Meisel, Louis K. *Photorealism.* New York: Harry Abrams, 1980.
Navaretta, Cynthia, ed. *Guide to Women's Art Organizations: Groups/Activities/Networks/ Publications.* New York: Midmarch Associates and Women Artists News, 1979.
Nemser, Cindy. "Stereotypes and Women Artists." *Feminist Art Journal* 1, no. 1 (April 1972):1, 22, 23.
——————. "The Women Artists' Movement." *Feminist Art Journal* 2, no. 4 (Winter 1973–74):8–10.
Out of the House. New York: Whitney Museum of American Art, Downtown Branch, 1978. Exhibition catalogue.

Perreault, John. "The New Decorativeness." *Portfolio.* June/July 1979.

"Pluralism in Art and in Art Criticism (A Roundtable Discussion)." *Art Journal* 40, nos. 1–2 (Fall–Winter 1980):377–79. Shows the increasing openness of art criticism, influenced by the feminist movement.

Rose, Barbara. "Vaginal Iconology." *New York* (11 February 1974):59.

Ruddick, Sara, and Daniels, Pamela, eds. *Working It Out: 23 Women Writers, Artists, Scientists, and Scholars Talk About Their Lives and Work.* New York: Pantheon Books, 1977.

Seiberling, Dorothy. "The Female View of Erotica." *New York* (11 February 1974):54–56.

Sons and Others: Women Artists See Men. Flushing, N.Y.: Queens County Art and Cultural Center, 1975.

Vogel, Lise. "Fine Arts and Feminism: The Awakening Consciousness." *Feminist Studies* 2, no. 1 (1974):3–37.

Wilding, Faith. *By Our Own Hands: The Women Artists' Movement: Southern California, 1970–1976.* Santa Monica, Calif.: Double X Collective, 1977.

"Women Artists '80." *Art News* (October 1980):58–88. Sums up the accomplishments of the seventies and evaluates the present position of women artists.

Women: USA. Laguna Beach, Calif.: Laguna Beach Museum of Art, 1973.

Women Choose Women. New York: Women in the Arts, New York City and the New York Cultural Center, 1972.

The Artists

Alice Aycock

Kuspit, Donald B. "Aycock's Dream House." *Art in America* (September 1980):84–87.

Larson, Kay. "Alice in Duchamp-Land." *New York* (25 May 1981):66–67.

Judy Baca

Rickey, Carrie. "The Writing on the Wall." *Art in America* (May 1981):54–57.

Jennifer Bartlett

Hess, Thomas. "Ceremonies of Measurement." *New York* (21 March 1977).

Munro, Eleanor. *Originals: American Women Artists.* New York: Simon & Schuster, 1979.

Diane Burko

Cochrane, Diane. "Diane Burko: Going Places." *American Artist* (June 1975):24–68.

Nemser, Cindy. "Conversation with Diane Burko." *Feminist Art Journal* 6, no. 1 (Spring 1977):5–13.

Graciela Carillo de Lopez

Clark, Yoko, and Hama, Chizu. *California Murals.* Berkeley, Calif.: Lancaster-Miller, 1979.

Maradiaga, Ralph, ed. *The Fifth Sun: Contemporary/Traditional Chicano & Latino Art.* Berkeley, Calif.: University Art Museum, 1977. Exhibition catalogue.

Consuelo Mendez Castillo

Zuver, Marc, et. al. *Ancient Roots. New Visions.* Tucson Museum of Art, Arizona, 1977.

Barbara Chase-Riboud

Heckmanns, F. W., and Nora-Cachin, François. *Chase-Riboud.* Berkeley, Calif.: University Art Museum, 1973.

Munro. *Originals.*

Selected Bibliography

Judy Chicago

Butterfield, Jan. "Guess Who's Coming to Dinner?" *Mother Jones* (January 1979):20–28.
Caldwell, Susan Havens. "Experiencing *The Dinner Party.*" *Woman's Art Journal* 1, no. 2 (Fall 1980–Winter 1981):35–37.
Chicago, Judy. *The Dinner Party: A Symbol of Our Heritage.* Garden City, N.Y.: Doubleday Anchor Books, 1979.
————. *Through the Flower.* Garden City, N.Y.: Doubleday Anchor Books, 1977.
Kramer, Hilton. "Art: Judy Chicago's *Dinner Party* Comes to Brooklyn Museum." *New York Times.* 17 October 1980, p. C1.
Lippard, Lucy. *From the Center.* New York: E. P. Dutton, 1976.
Snyder, Carol. "Reading the Language of *The Dinner Party.*" *Woman's Art Journal* 1, no. 2 (Fall 1980–Winter 1981):30–34.
Richardson, John. "Strictly from Hunger." *New York Review of Books,* 30 April 1981, pp. 18–24.

Geny Dignac

Zuver. *Ancient Roots.*

Mary Beth Edelson

Edelson, Mary Beth. *Seven Cycles: Public Rituals.* New York: 110 Mercer St., 1980.

Janet Fish

Ellenzweig, Allen. "Janet Fish." *Arts Magazine* (October 1976):12.
Nemser, Cindy. "Conversation with Janet Fish." *Feminist Art Journal* (Fall 1976):4–10.
Tufts, Eleanor. "The Veristic Eye: Some Contemporary American Affinities with Luis Melendez, Spanish Painter of Still-life Phenomenology." *Arts Magazine* (December 1977):142–44.

Audrey Flack

Flack, Audrey. *Audrey Flack on Painting.* With introductory essays by Ann Sutherland Harris and Lawrence Alloway. New York: Harry N. Abrams, 1981.
Meisel, Louis K. *Photorealism.* New York: Harry Abrams, 1980.
Nemser, Cindy. "Audrey Flack: Photorealist Rebel." *Feminist Art Journal* 4, no. 3 (Fall 1975):5–11.

Mary Frank

Herrera, Hayden. *Mary Frank: Sculpture/Drawings/Prints.* Purchase, N.Y.: Neuberger Museum, State University of New York, 1978. Exhibition catalogue.
Munro. *Originals.*

Carmen Lomas Garza

Zuver. *Ancient Roots.*

Shirley Gorelick

Harrison, Helen A. "People as Paint in shirley Gorelick's World." *New York Times,* 11 February 1978, Long Island sect., p. 16

Nancy Graves

Armstrong, Tom, et al. *200 Years of American Sculpture.*
Heinemann, Susan. "Nancy Graves: The Painting Seen." *Arts Magazine* (March 1977):pp. 139–41.
Munro. *Originals.*
Nancy Graves: Sculpture and Drawing, 1970–1972. Philadelphia: Institute of Contemporary Art, University of Pennsylvania, 1972.

Rose, Barbara. *American Painting: The Eighties.* New York: Barbara Rose, 1979.

Wasserman, Emily. "A Conversation with Nancy Graves." *Artforum,* no. 2 (October 1970):42–47.

Judithe E. Hernandez

Rosenstone, Robert A. *In Search of . . . Four Women/Four Cultures.* Pasadena, Calif.: Baxter Art Gallery, California Institute of Technology, 1976. Catalogue of an exhibition of Judithe E. Hernandez, Donna Nakao, Cheri Pamm, and Betye Saar.

Patricia Johanson

Munro. *Originals.*

Torre, Susana, ed. *Women in American Architecture.* New York: Whitney Library of Design, 1977.

Ellen Lanyon

Frueh, Joanna. "The Psychological Realism of Ellen Lanyon." *Feminist Art Journal* (Spring 1977):17–21.

Iskin, Ruth. "Ellen Lanyon." *Visual Dialog* 2, no. 3 (Spring 1977):9–13.

Joyce Kozloff

Seigel, Judy. "Joyce Kozloff." *Visual Dialog* 1, no. 2 (December 1975–January/February 1976):7–10.

Rosemary Mayer

Cavaliere, Barbara. "Rosemary Mayer." *Arts Magazine* (January 1977):4.

Ana Mendieta

Heit, Janet. "Ana Mendieta." *Arts Magazine* (January 1980):5.

Mary Miss

Onorato, R. J. *Mary Miss: Perimeters/Pavilions/Decoys.* Roslyn, N.Y.: Nassau County Museum of Fine Arts, 1978.

Catherine Murphy

Catherine Murphy. Washington, D.C.: Phillips Collection, 1976.

Gruen, John. "Catherine Murphy: The Rise of a Cult Figure." *Art News* (December 1978):54–57.

Alice Neel

Harris, Ann Sutherland. "The Human Creature: Engaging and Outrageous at Eighty, Alice Neel still Creates Psychological Portraits of Extraordinary Strength." *Portfolio* 1, no. 5 (December, 1979–January, 1980):70–75.

Harris, Ann Sutherland, and Nochlin, Linda. *Women Artists: 1550–1950.* New York: Alfred A. Knopf and the Los Angeles County Museum of Art, 1976.

Mainardi, Pat. "Alice Neel at the Whitney Museum." *Art in America* 62, no. 3 (1974):107–8.

Nemser, Cindy. *Alice Neel: The Woman and Her Work.* Athens: Georgia Museum of Art, 1975. Exhibition catalogue.

Howardena Pindell

Bryant, Linda. *Contextures.* New York: Just Above Midtown Gallery, 1978. Exhibition catalogue.

Lorber, Richard. "Women Artists on Women in Art." *Portfolio* (February–March 1980).

Staniszewski, Mary Anne. "Howardena Pindell." *Art News* (September 1980):248.

Wilson, Judith. "Private Commentary Goes Public." *Village Voice,* 15–21 April 1981, p. 84.

Faith Ringgold

Fax, Elton. *17 Black Artists.* New York: Dodd, Mead & Co., 1971.

Munro. *Originals.*

Patricia Rodriguez

Clark and Hama. *California Murals.*

Rodriguez, Patricia. "Mujeres Muralistas." In *The Fifth Sun.*

Betye Saar

Lewis. *Art: African American.*

Munro. *Originals.*

Nemser, Cindy. "Conversation with Betye Saar." *Feminist Art Journal* 4, no. 4 (Winter 1975–76):19–24.

Miriam Schapiro

Munro. *Originals.*

Gouma-Peterson, Thalia. *Miriam Schapiro: A Retrospective, 1953–1980.* Wooster, Ohio. The College of Wooster Art Museum, 1980.

Roth, Moira. *Miriam Schapiro: The Shrine, the Computer and the Dollhouse.* San Diego: Mandeville Art Gallery, University of California, 1975.

Schapiro, Miriam. "Notes from a Conversation on Art, Feminism and Work." In *Working It Out.*

Joan Semmel

Alloway, Lawrence. *Joan Semmel.* Kutztown, Pa.: Sharadin Gallery, Kutztown State College, 1980. Exhibition catalogue.

Lubell, Ellen. "Joan Semmel: Interview." *Womanart* 2, no. 2 (Winter 1977–78):14–21, 29.

Seiberling, Dorothy. "The Female View of Erotica." *New York* (11 February 1974):55.

Sylvia Sleigh

Derfner, Phyllis. *Paintings by Three American Realists: Alice Neel, Sylvia Sleigh, May Stevens.* Syracuse, N.Y.: Everson Museum of Art, 1976.

Nochlin, Linda. "Some Women Realists, Painters of the Figure." *Arts Magazine* (May 1974):25–33.

Joan Snyder

Iskin, Ruth E. "Toward a Feminist Imperative: The Art of Joan Snyder." *Chrysalis* 1, no. 1 (1977):101–15.

Joan Snyder: Seven Years of Work. Purchase, N.Y.: Neuberger Museum, State University of New York, 1978. Exhibition catalogue.

Tucker, Marcia. "The Anatomy of a Stroke: The Recent Paintings of Joan Snyder." *Artforum* (May 1971).

May Stevens

Alloway, Lawrence. *May Stevens,* Ithaca, N.Y.: Herbert F. Johnson Museum of Art, Cornell University, 1973.

Nemser, Cindy. "Conversations with May Stevens." *Feminist Art Journal* (Winter 1974–75):4–7.

Stevens, May. "My Work and My Working-Class Father." In *Working It Out.*

Wallach, Alan. "May Stevens: On the Stage of History." *Arts Magazine* (November 1978):150–51.

Strider, Marjorie

Strider: Sculpture and Drawings. Greensboro: Witherspoon Art Gallery, University of North Carolina, 1974.

Michelle Stuart

Alloway, Lawrence. *Michelle Stuart*. Oneonta, N.Y.: Fine Arts Center Gallery, State University of New York, 1975. Exhibition catalogue.
Lubell, Ellen. "Michelle Stuart: Icons from the Archives of Time." *Arts Magazine* (June 1979).
Munro. *Originals*.

Athena Tacha

Wolff, Theodore F. "Artist Athena Tacha." *Christian Science Monitor* 9 April 1981, Arts sect., p. 18.

Idelle Weber

Lippard, Lucy R., et al. *Pop Art*. New York: Praeger Publishers, 1966.
Lubell, Ellen. "Idelle Weber." *Arts Magazine* (September 1977):8.
Goodyear, Frank H. *Contemporary American Realism Since 1960*. Boston: New York Graphic Society, 1981.
Meisel, Louis K. *Photorealism*. New York: Harry Abrams, 1980.

Jackie Winsor

Lippard, *From the Center*.
Munro. *Originals*.
Pincus-Witten, Robert. "Winsor Knots: The Sculpture of Jackie Winsor." *Arts* (June 1977):127–33.

Appendix A

John Simon Guggenheim Memorial Foundation Fellowships in Art Awarded to Women, 1925–1981

Alice Adams 1981
Peggy Bacon 1934
Frances Barth 1977
Linda Benglis 1975
Pamela Bianco 1930
Nell Blaine 1974
Lucile Blanch 1933
Joan Brown 1977
Beverly Buchanan 1980
Deborah Butterfield 1980
Karen A. Carson 1981
Rosemarie Castoro 1971
Vija Celmins 1980
Chryssa 1973
Virginia Cuppaidge 1976
Worden Day 1952, 1961
Janet de Coux 1938, 1939
Donna Dennis 1979
Sally Hazelet Drummond 1967
Lu Duble 1937, 1938
Edris Eckhardt 1955, 1959
Claire Falkenstein 1978
Jackie Ferrara 1975
Louise Fishman 1979
Patricia Tobacco Forrester 1967
Mary Frank 1973
Sue Fuller 1948
Nancy Grossman 1965
Rosella Hartman 1934
Mary Heilmann 1977
Phoebe Helman 1979
Nancy Holt 1978
Sandria Hu 1974
Victoria Hutson Huntley 1948
Miyoko Ito 1977
Patricia Johanson 1970, 1980
Ynez Johnston 1952
Luise Kaish 1959

Jane Kaufman 1974
Vera Klement 1980
Georgina Klitgaard 1933
Alison Knowles 1968
Freda Koblick 1970
Irene Kubota 1969
Barbara Hult Lekberg 1957, 1959
Pamela Levy 1980
Gwen Lux 1933
Loren MacIver 1976
Berta Margoulies 1946
Ana Mendieta 1980
Eleanore Mikus 1966
Brenda Miller 1978
Laura Newman 1981
Ruth Nickerson 1946
Maria Nordman 1979
Dorothy Ochtman 1927
Elizabeth Olds 1926
Carlotta Petrina 1933, 1935
Eleanor Platt (Flavin) 1945
Joanna Pousette-Dart 1981
Ruth Reeves 1940, 1941 (textiles)
Ione Robinson 1931
Dorothea Rockburne 1972
Lorinda Roland 1963
Doris Rosenthal 1931, 1936
Susan Rothenberg 1980
Andrée Ruellan 1950
Marion Sanford 1941, 1942
Marlene (Venezia) Scott 1977
Doris Spiegel 1928
Anne C. Steinbrocker 1962
Michelle Stuart 1975
Mary L. Tarleton 1933
Ann Truitt 1970
Janet Turner 1952
Susan Weil 1977
Jacqueline Winsor 1978

Appendix B

The American Academy and Institute of Arts and Letters

Outstanding artists, writers, and musicians are honored by admission to the American Academy and Institute of Arts and Letters. The first woman admitted was Julia Ward Howe, author and leader, in 1907. No woman was admitted for the following twenty years. In 1918 Edith Wharton, Margaret Deland, and Mary E. Wilkins Freeman were chosen by the Literary Section, but the annual meeting did not confirm their election. In 1927 sculptor Anna Hyatt Huntington was admitted and others soon followed.

Women Artists Who Have Been Elected to the Institute

Peggy Bacon
Cecilia Beaux (deceased)
Helen Frankenthaler
Laura Gardin Fraser (deceased)
Dorothea Greenbaum
Malvina Hoffman (deceased)
Anna Hyatt Huntington (deceased)
Gertrude K. Lathrop
Claire Leighton
Loren MacIver
Jean MacLane (deceased)
Marisol
Joan Mitchell
Alice Neel
Georgia O'Keeffe
Brenda Putnam (deceased)
Bessie Potter Vonnoh (deceased)
Katherine Lane Weems

Women Artists Who Have Been Elected to the Academy

A small number of members of the Institute are further honored by election to the Academy.

Cecilia Beaux (deceased)
Isabel Bishop
Anna Hyatt Huntington (deceased)
Louise Nevelson
Georgia O'Keeffe

Appendix C

Chicago World's Fair 1933

Women sculptors and painters selected for "A Century of Progress: Exhibition of Paintings and Sculpture Lent From American Collections," at the Art Institute of Chicago, June–November 1933. (From the Catalogue).

Painting

Jean Crawford Adams
Katherine Langhorne Adams
Rifka Angel
Macena Barton
Cecilia Beaux
Tressa Emerson Benson
Theresa F. Bernstein
Isabel Bishop
Lauren Ford
Ruth Van Sickle Ford
Frances Cranmer Greenman
Anne Goldthwaite
Felicie W. Howell
Camille Andrene Kauffmann
Alice Riddle Kindler
Georgina Klitgaard
Beatrice S. Levy
Virginia Armitage McCall
Jean MacLane
Pauline Palmer
Marjorie Phillips
Grace Ravlin

Doris Rosenthal
Helen Sawyer
Flora Schofield
Elizabeth Sparhawk-Jones
Helen J. Taylor
Laura Van Pappelendam
Dorothy Varian
Martha Walter
Marguerite Zorach

Sculpture

Olga Chassaing
Dorothea S. Greenbaum
Elizabeth Haseltine
Sylvia Shaw Judson
Viola Norman
Mabel C. Perry
Margaret Sargent
Janet Scudder
Ruth Sherwood
Eugenie T. Shonnard
Bessie Potter Vonnoh
Gertrude Vanderbilt Whitney

Appendix D

New York World's Fair 1939

Women sculptors and painters in the national juried contemporary art exhibition. (From the index of *American Art Today* [New York: National Art Society, 1939]).

Painters

Gertrude Abercrombie, Illinois
Rifka Angel, New York
Elise Armitage, California
Frances Avery, New York
Helen Louise Beccard, Missouri
Jeanne Begien, Virginia
Bernece Berkman, Illinois
Virginia Berresford, New York
Isabel Bishop, New York
Mary Green Blumenschein, New Mexico
Rosina Boardman, New York
Gladys Brannigan, New Hampshire
Michele A. Cafarelli, New Jersey
Vina Cames, Wyoming
Rachel H. Cartledge, Pennsylvania
Dorothy M. Cogswell, Connecticut
Laura Alexander Coleman, Virginia
Ethel Blanchard Collver, Connecticut
Sarah Cowan, New York
Adelyne S. Cross, Indiana
Beatrice Cuming, Connecticut
Marie Delleney, Texas
Helen Dickson, Massachusetts
Irma Engel, California
Ethel Evans, Nevada
Paulina Everitt, Missouri
Marjorie Finch, New York
Gertrude Fiske, Massachusetts
Constance Forsythe, Indiana
Elizabeth Fuller, New York
Priscilla A. Gilmore, New York
Anne Goldthwaite, New York
Gertrude Goodrich, New York
Florence T. Green, New Jersey
Lena Gurr, New York
Alexandrina Harris, New York
Jean Hogan, Connecticut
Loretta Howard, Ohio
Isabella Howland, New York
Marie Hull, Mississippi
Lillyan Jacobs, Iowa
Jeanne Payne Johnson, New York
Marion Junkin, Virginia
Eleanora Kissel, New Mexico
Georgina Klitgaard, New York
Gina Knee, New Mexico
Eve Kottgen, New York
Doris Lee, New York

Dorothy Sherman Leech, Florida
Martha Levy, New York
Lydia Longacre, New York
Amy Lorimer, Michigan
Amalia Ludwig, New Jersey
Gladys Marie Lux, Nebraska
Freda Macadam, Delaware
Helen McAuslan, New Jersey
Florence McClung, Texas
Ethel Magafan, Colorado
Caroline Martin, California
Elizabeth Mills, California
Olga Mohr, Ohio
M. Lois Murphy, New York
Faith C. Murray, South Carolina
Dale Nichols, Nebraska
Jane Ninas, Louisiana
Elsie Dodge Pattee, New York
Elizabeth Okie Paxton, Massachusetts
Marjorie Phillips, Washington, D.C.
Esther Pressoir, New York
Ellen Emmet Rand, New York
Constance C. Richardson, Michigan
M. Antoinette Ritter, Maryland
Louisa W. Robins, New York
Katherine Schmidt, New York
Aimee Schweig, Missouri
Nan Sheets, Oklahoma
Helen Harvey Shotwell, New York
A. Katherine Skeele, California
Olga Sorenson, New York
Elizabeth Spalding, Colorado
Ethel Spears, Illinois
Thelma G. Speed, New York
Agnes Tait, New York
Elizabeth Terrell, New York
Margaret Tomkins, California
Yvonne Twining, Massachusetts
Elinor Ulman, Maryland
Evelyn Van Norman, New York
Dorothy Varian, New York
Muriel Walcoff, New York
Jean Watson, Pennsylvania
Carol Weinstock, New York
Mabel R. Welch, New York
Henriette S. Whiteside, Delaware
Gladys Wiles, New York
Marguerite Zorach, New York

Sculptors

Jean Abels, New York
Drusilla Albert, Washington
Lili Auer, Illinois
Dorothy Austin, Texas
Enid Bell, New Jersey
Simone B. Boas, Maryland
Beonne Boronda, New York
Eleanor Boudin, New York
Anne Bretzfelder, Missouri
Ann M. Brown, Missouri
Sonia Gordon Brown, New York
Marion Buchan, Colorado
Mary Byrd, Maryland
Doris Caesar, New York
Cornelia Van A. Chapin, New York
Marie Craig, Massachusetts
Ruth Cravath, California
Margaret French Cresson, Massachusetts
Lu Duble, New York
Edris Eckhardt, Ohio
Franc Epping, New York
Clara Fasano, New York
Beatrice Fenton, Pennsylvania
Gladys Caldwell Fisher, Colorado
Harriet W. Frishmuth, Pennsylvania
Eugenie Gershoy, New York
Anna Glenny, New York
Frances B. Godwin, New York
Angela Gregory, Louisiana
Dorothea Greenbaum, New York
Helen Haas, France
Mildred Welsh Hammond, Missouri
Minna Harkavy, New York
Lydia Herrick Hodge, Oregon
Malvina Hoffman, New York
Anna Hyatt Huntington, New York
Caroline Risque Janis, Missouri
Josephine Jenks, New Jersey
Jean Johanson, Washington
Sylvia Shaw Judson, Illinois
Margaret Brassler Kane, New York
Zena Kavin, New Mexico
Adaline Kent, California
Bertha Kling, Pennsylvania

Katharine W. Lane, Massachusetts
Katharine G. Lange, Ohio
Mary Metcalf Langs, New York
Henlen F. Lanpher, Louisiana
Gertrude K. Lathrop, New York
Caroline A. Lloyd, France
Lois Mahier, Louisiana
Berta Margoulies, New York
Dina Melicov, New York
Eleanor M. Mellon, New York
Emily Winthrop Miles, New York
Harriette G. Miller, Vermont
Charlotte Millis, Minnesota
Frances Mallory Morgan, New York
Mathilde M. Mylander, Maryland
Amelia Peabody, Massachusetts
Elizabeth Poucher, New York
Ebba Rapp, Washington
Frances Rich, Michigan
Sally Ryan, Connecticut
Nina Saemundsson, California
Jane Sage, New York
Concetta Scaravaglione, New York
Mathilde Schaefer, Arizona
Janet Scudder, New York
Elisabeth Seaver, Ohio
Evaline C. Sellors, Texas
Eugenie F. Shonnard, New Mexico
Lilian Swann, Michigan
Mary Tarleton, Connecticut
Allie Victoria Tennant, Texas
Florence Thomas, Oregon
Lenore Thomas, Maryland
Grace H. Turnbull, Maryland
Marion Walton, New York
Helen Warner, Illinois
Anita Weschler, New York
Gertrude Whitney, New York
Helen Wilson, New York
Pegot Wolf, California
Beverly Woodner, New York
Elizabeth Wrenn, Maryland
Alice Morgan Wright, New York
Esther Zolott, Illinois

Appendix E

Women Artists in the National Academy of Design 1825–1981

(From *A Century and a Half of American Art* [New York: National Academy of Design, 1975]; Julie Graham, "American Women Artists' Groups," *Woman's Art Journal* [Spring-Summer 1980]: 12; and other sources.)

Academicians

Painters

	Elected	Deceased
Cecilia Beaux	1902	1942
Margit Beck	1975	
Hilda Belcher	1932	1963
Isabel Bishop	1941	
Colleen Browning	1966	
Gladys Rockmore Davis	1943	1963
Lydia Field Emmet	1912	1952
Anna Fisher	1932	1942
Gertrude Fiske	1930	1961
Nan Greacen	1962	
Marion Greenwood	1959	1970
Lillian Westcott Hale	1931	1963
Ann Hall	1833	1863
Lily Harmon	1970	
Jean MacLane	1926	1964
Emma Fordyce MacRae	1951	1974
Ethel Magafan	1968	
Felicie Howell Mixter	1945	1968
Violet Oakley	1929	1961
Dorothy Ochtman	1971	1971
Ann Poor	1975	
Ruth Ray	1968	1977
Priscilla Roberts	1957	
Margery Ryerson	1959	
Helen Sawyer	1950	
Helen M. Turner	1921	1958
Jane Wilson	1979	
Catherine M. Wright	1969	

	Elected	Deceased
Hazel Brill Jackson	1961	
Sylvia Shaw Judson	1965	1979
Bessie P.V. Keyes	1921	1955
Gertrude S. Lathrop	1940	
Evelyn Longman	1919	1954
Eleanor M. Mellon	1950	1980
Ruth Nickerson	1966	
Brenda Putnam	1936	1975
Eleanor Platt	1963	1974
Marion Sanford	1963	
Katharine Lane Weems	1939	
Nina Winkel	1973	
Linda Wu	1977	

Graphic Artists

	Elected	Deceased
Grace Albee	1946	
Gene Kloss	1972	
Clare Leighton	1949	
Helen Loggie	1971	1975
Clare Romano	1979	
Janet E. Turner	1974	
Nora S. Unwin	1976	

Watercolorists

	Elected
Dale Meyers	1979
Gertrude Schweitzer	1951
Eileen Monaghan Whitaker	1978

Sculptors

	Elected	Deceased
Cornelia Van A. Chapin	1945	1972
Margaret French Cresson	1959	1973
Elizabeth Gordon Chandler	1979	
Janet de Coux	1967	
Lu Duble	1967	1970
Charlotte Dunwiddie	1978	
Clara Fasano	1968	
Laura Gardin Fraser	1931	1966
Harriet Frishmuth	1929	
Frances Grimes	1945	1963
Cleo Hartwig	1971	
Malvina Hoffman	1931	1966
Anna Hyatt Huntington	1922	1973

Associates

Painters

	Elected	Deceased
Rosemarie Beck	1980	
Nell Blaine	1980	
Mary G. Blumenschein	1913	1958
Margaret Bogardus	1845	1878
Fidelia Bridges	1873	1923
Adelaide C. Chase	1906	1944
C.B. Coman	1910	1924
Louise Cox	1902	1945
Mary Ann Delafield Dubois (Elect)	1842	
Jane Freilicher	1980	
Sara C. Frothingham	1840	
Lucia Fairchild Fuller	1906	1924
Julia (Blight) Fulton	1828	
Lillian Genth	1908	1953
Ruth Gikow	1980	
Mary Gray	1929	1964
Laura Coombs Hills	1906	1952
Hilde Kayn	1943	1950
Dora Wheeler Keith	1906	1940
Jeanette Shephard H. Loop	1873	1909
Hildreth Meiere	1942	1961
Marie D. Page	1927	1940
Ellen Emmet Rand	1926	1941
Susana Serpell	1912	1913
A.B. Sewell	1903	1926
R.E. Sherwood	1906	1948
Alice Kent Stoddard	1938	1976
Gladys Wiles	1934	

	Elected	Deceased
Eliza Greatorex	1869	1897
Helen West Heller	1948	1955
Victoria Hutson Huntley	1942	1971
Dorothy P. Lathrop	1949	1980
Emily Maverick	1828	1850
Maria Maverick	1828	1832
Alice H. Murphy	1949	1966
Margaret Philbrick	1970	

Watercolorists

	Elected	
Betty M. Bowes	1975	
Ruth Cobb	1975	
Virginia Cobb	1975	
Carol Pyle Jones	1974	

Elects

Henriette Wyeth
Louisa Matthiasdottir
Alice Neel
Doris White

Honorary Members

(This category, for out-of-towners, existed before 1900)

	Elected	
Herminia Borchard Dassel	1850	
Rosalba Peale	1828	
Lily Martin Spencer	1850	
Jane Cooper (Darley) Sully	1827	

Sculptors

	Elected	Deceased
Anne Arnold	1981	
Edith Woodman Burroughs	1913	1916
Jean Donnergrove	1980	
Abastenia St. Leger Eberle	1920	1942
Katherine Thayer Hobson	1979	
Hilda Lascari	1935	1937
Madeleine Park	1960	1960
Rhoda Sherbell	1979	
Emma Stebbins (Elect)	1842	1882
Gertrude Vanderbilt Whitney	1940	1942

Graphic Artists

	Elected	Deceased
Peggy Bacon	1947	
Ruth Gannett	1969	1980

List of Black and White Illustrations

Fig. 1-16. Eva Mirabal (Ea-Ha-Wa), PICKING WILD BERRIES (1937), tempera. *The Dorothy Dunn Collection (from the original Margretta Stewart Dietrich Collection, Santa Fe.)*

Fig. 1-17. Tonita Peña (Quah Ah), GREEN CORN DANCE, COCHITI PUEBLO (c. 1930), watercolor on paper, 20" × 24". *Courtesy of Collection of School of American Research in the Museum of New Mexico.*

Fig. 1-18. Pablita Velarde, KOSHARES OF TAOS (1947), tempera on board, 13⅞" × 22½". *Philbrook Art Center, Tulsa, Okla.*

Fig. 1-19. Pop Chalee, BLACK FOREST (1979), opaque watercolor or casein on black paper, 19" × 25½". *Buck Saunders Gallery, Scottsdale, Ariz.*

Fig. 1-20. Linda Lomahaftewa, NEW MEXICO SUNSET (1977), acrylic, 48" × 36". *Courtesy of the artist.*

Fig. 1-21. Phyllis Fife, BURY ME NOT AT WOUNDED KNEE (1973), etching, 18" × 24". *Courtesy of the artist.*

Fig. 1-22. Valjean Hessing, THE GOSSIPERS (1976), opaque watercolor, 30" × 26". *Courtesy of The Squash Blossom Gallery, Highland Park, Ill.*

Chapter 2

Fig. 2-1. Prudence Punderson, THE FIRST, SECOND AND LAST SCENE OF MORTALITY (c. 1775), silk stitchery painting, 12½" × 16½". *Connecticut Historical Society.*

Fig. 2-2. Henrietta Johnston, COLONEL SAMUEL PRIOLEAU (1715), pastel on paper, 12" × 9". *Museum of Early Southern Decorative Arts, Winston-Salem, N.C.*

Fig. 2-3. Patience Wright, WILLIAM PITT, EARL OF CHATHAM (1779), wax effigy. *Undercroft Museum of Westminster Abbey, London. By courtesy of the Dean and Chapter of Westminster.*

Fig. 2-4. Hetty Benbridge, JOHN POAGE (c. 1775), miniature, watercolor on ivory, 2⅛" × 17/16". *Collections of Greenfield Village and the Henry Ford Museum.*

Fig. 2-5. Signed Sarah A. Shafer, BALTIMORE BRIDE'S QUILT (1850), 103" × 103". *America Hurrah Antiques, N.Y.C.*

Fig. 2-6. Ruth Downer, NEW ENGLAND GODDESS (early 19th century), watercolor on silk, 22" × 26". *Museum of Art, Rhode Island School of Design.*

Fig. 2-7. Collata Holcomb, STILL LIFE, FLUTED BOWL (c. 1820), theorem painting, oil on velvet, 14⅞" × 17¼". *New York State Historical Association, Cooperstown.*

Fig. 2-8. Harriet Moore, RICHARDSON MEMORIAL (c. 1817), 18" × 23¾". *Courtesy of the New York State Historical Association, Cooperstown.*

Fig. 2-9. Eunice Pinney, LOLOTTE AND WERTHER (1810), watercolor, 15⅛" × 11⅝". *National Gallery of Art, Washington. Gift of Edgar William and Bernice Chrysler Garbisch.*

Fig. 2-10. Mary Ann Willson, THE PRODIGAL SON RECLAIMED (c. 1820), ink and watercolor, 12⅝" × 10". *National Gallery of Art, Washington, D.C. Gift of Edgar William and Bernice Chrysler Garbisch.*

Fig. 2-11. Ruth Henshaw Bascom, WOMAN IN A LACE CAP AND COLLAR (n.d.), pastel and pencil, 19³/₁₆" × 14⅛". *Courtesy of Museum of Fine Arts, Boston. M. and M. Karolik Collection.*

Fig. 2-12. Deborah Goldsmith, THE TALCOTT FAMILY (1832), watercolor on paper, 18″ × 21⁷/₁₆″. *Abby Aldrich Rockefeller Folk Art Center.*

Fig. 2-13. Grandma Moses, HOOSICK FALLS, WINTER (1944), oil on masonite, 19¾″ × 23¾″. *The Phillips Collection, Washington, D.C. © 1982, Grandma Moses Properties Co., New York.*

Chapter 3

Fig. 3-1. Ellen Sharples, GEORGE WASHINGTON (n.d.), pastel on gray paper, 9″ × 7″. *City of Bristol Museum and Art Gallery, Bristol, England.*

Fig. 3-2. Rolinda Sharples, THE STOPPAGE OF THE BANK (1822), oil on panel, 33″ × 47½″. *Courtesy of City of Bristol Museum and Art Gallery, Bristol, England.*

Fig. 3-3. Ann Hall, ANN HALL, MRS. HENRY WARD (ELIZA HALL) AND HENRY HALL WARD (1828), miniature watercolor on ivory, 4″ × 4″. *Courtesy of The New York Historical Society, N.Y.C.*

Fig. 3-4. Jane Stuart, SCENE FROM A NOVEL: OR A SUBJECT FROM LITERATURE (1834), oil on canvas, 36″ × 28″. *Collection of Victor D. Spark, N.Y.C.*

Fig. 3-5. Sarah Goodridge, PORTRAIT OF GILBERT STUART (c. 1825), miniature on ivory. *The Metropolitan Museum of Art, The Moses Lazarus Collection. Gift of Sarah and Josephine Lazarus, 1888.*

Fig. 3-6. Sarah Miriam Peale, MRS. RICHARD COOKE TILGHMAN (c. 1830), oil on canvas, 30½″ × 25½″. *The Baltimore Museum of Art. Bequest of Mrs. S. D. Tilghman Horner.*

Fig. 3-7. Lilly Martin Spencer, THE WAR SPIRIT AT HOME. CELEBRATING THE VICTORY AT VICKSBURG (1866), oil on canvas, 30″ × 32½″. *Collection of the Newark Museum. Purchase 1944, Wallace M. Scudder Bequest.*

Fig. 3-8. Lilly Martin Spencer, FI! FO! FUM! (1858), oil on canvas, 35⅞″ × 28⅝″ *Courtesy of Mrs. Joseph J. Betz.*

Fig. 3-9. Herminia Borchard Dassel, ABRAM QUARY, THE LAST INDIAN ON NANTUCKET ISLAND (1851), oil on canvas, 33″ × 30″. *Courtesy of Nantucket Atheneum, Massachusetts. Photo: W. Frederic Lucas.*

Fig. 3-10. Cornelia Adele Fassett, THE ELECTORAL COMMISSION OF 1877 (1879), oil on canvas, 61″ × 75″, in the Senate wing, The United States Capitol. *Courtesy of Architect of the Capitol.*

Fig. 3-11. Cornelia Adele Fassett, MRS. LAMB IN HER STUDY (1878), oil on millboard, 15¼″ × 24¼″. *Courtesy of The New York Historical Society, N.Y.C.*

Fig. 3-12. Charlotte B. Coman, A FARMER'S COTTAGE, PICARDY, FRANCE (1884), oil on canvas, 23″ × 34″. *The Hoyt Institute of Fine Arts, New Castle, Pa. Purchased in memory of Alex Crawford Hoyt.*

Fig. 3-13. Charlotte B. Coman, EARLY SUMMER (n.d.), oil on canvas, 75.9 × 91.4 cm. *National Museum of American Art (formerly National Collection of Fine Arts). Smithsonian Institution; Gift of William T. Evans.*

Fig. 3-14. Fidelia Bridges, MILKWEEDS (1861), watercolor, 16″ × 9½″. *Munson-Williams-Proctor Institute, Utica, N.Y. Proctor Collection.*

Fig. 3-15. Fidelia Bridges, UNTITLED (c. 1876), watercolor, 35.5 × 25.4 cm. *National Museum of American Art (formerly National Collection of Fine Arts). Smithsonian Institution; Gift of Oliver I. Lay, Alice Lay Lane, David Lay and George C. Lay, in memory of their parents, Charles Downing Lay and Laura Gill Lay.*

Fig. 3-16. Anna Eliza Hardy, BASKET OF ARBUTUS (n.d.), oil on canvas, 13½" × 11½". *Private Collection.*

Fig. 3-17. Maria Louisa Wagner, SPRING FLOWERS (c. 1849), oil on canvas, 13⅜" × 16¼". *Private Collection.*

Fig. 3-18. Susan C. Waters, SHEEP IN A LANDSCAPE (1880s?), oil on canvas, 24" × 36". *Collection of the Newark Museum. Purchase 1975 Sophronia Anderson Bequest Fund. Photo: Armen.*

Fig. 3-19. Fanny Palmer, SEASON OF BLOSSOMS (1865), colored lithograph for Currier & Ives (large), 15.12" × 23.4". *Courtesy of the Travelers Insurance Companies.*

Fig. 3-20. Mary Nimmo Moran, VIEW OF NEWARK FROM THE MEADOWS (1880 or before), oil on canvas, 8¼" × 16". *Collection of the Newark Museum. Gift of Allan McIntosh. Photo: Witt.*

Fig. 3-21. Francesca Alexander, SAINT CHRISTOPHER AT THE SHORE, illustration in *Roadside Songs of Tuscany* (1885), translated and illustrated by Francesca Alexander and edited by John Ruskin, Sunmnyside, Orpington, Kent: George Allen.

Fig. 3-22. Mary Hallock Foote, A PRETTY GIRL IN THE WEST (1889), pencil and wash drawing, 5¼" × 7⅞", illustration for ''Pretty Girls in the West,'' *Century Magazine* (October 1889). *Courtesy of Library of Congress, Cabinet of Illustration.*

Fig. 3-23. Photograph of Harriet Hosmer working on statue of Senator Thomas Hart Benton.

Fig. 3-24. Harriet Hosmer, MEDUSA (profile view) (1854), marble, height 27". *The Detroit Institute of Arts: Founders Society Purchase, Robert H. Tannahill Foundation Fund.*

Fig. 3-25. Harriet Hosmer, ZENOBIA IN CHAINS (1859), marble, height 49". *Wadsworth Atheneum, Hartford. Gift of Josephine M. J. Dodge.*

Fig. 3-26. Edmonia Lewis, HAGAR (1868), marble, height 52". *Museum of African Art: Smithsonian Institution, Eliot Elisofon Archives.*

Fig. 3-27. Anne Whitney, ROMA (1869), bronze, height 27". *Wellesley College Art Museum, Wellesley, Mass. Photo: Herbert P. Vose, Wellesley.*

Fig. 3-28. Vinnie Ream Hoxie, ABRAHAM LINCOLN (1871), marble, Statuary Hall, U.S. Capitol. *Courtesy of the architect of the Capitol.*

Fig. 3-29. Vinnie Ream Hoxie, SAPPHO, TYPIFYING THE MUSE OF POETRY (1865–1870), marble, 62" × 25" × 16". *National Museum of American Art (formerly National Collection of Fine Arts). Smithsonian Institution; Gift of General Richard L. Hoxie.*

Fig. 3-30. Emma Stebbins, ANGEL OF THE WATERS (BETHESDA FOUNTAIN) (c. 1862), bronze, Central Park, N.Y.C. Photograph of ''Angel of the Waters'' by Arley Bondarin from *All Around the Town* is used with the permission of Charles Scribner's Sons. © 1975 Arley Bondarin.

Fig. 3-31. Margaret Foley, FOUNTAIN (c. 1874–76), marble, photographed in Horticulture Hall, Philadelphia Centennial Exposition 1876. *Courtesy of the Free Library of Philadelphia. This fountain is now in the Horticulture Center, West Fairmount Park, Philadelphia.*

Fig. 3-32. Lithograph of the Women's Pavilion, Philadelphia Centennial Exposition (1876). *Courtesy of the Historical Society of Pennsylvania.*

Chapter 4

Fig. 4-1. SCULPTURAL STUDIO IN HORTICULTURAL BUILDING, (August 24, 1892) (preparing sculpture for the Chicago World's Columbian Exposition, 1893). *Courtesy of Chicago Historical Society.*

Fig. 4-2. Janet Scudder, FROG FOUNTAIN (1901), bronze statuette, height 37½". *The Metropolitan Museum of Art, Rogers Fund, 1906.*

Fig. 4-3. Julia Bracken Wendt, THE THREE GRACES: HISTORY, SCIENCE AND ART (1914), in rotunda setting, Los Angeles County Museum of Natural History, bronze on stone base, height 11'. *Courtesy of History Division, Los Angeles County Museum of Natural History. Photo: Julia Bracken Wendt, 1931.*

Fig. 4-4. Bessie Potter Vonnoh, DAYDREAMS (1903), bronze, 10½" × 21¼" × 11". *In the Collection of the Corcoran Gallery of Art.*

Fig. 4-5. Bessie Potter Vonnoh, GIRL DANCING (1897), bronze, height 14". *The Metropolitan Museum of Art, Rogers Fund, 1906.*

Fig. 4-6. Enid Yandell, KISS TANKARD (c. 1899), Art Nouveau Lidded Tankard, bronze, height 11⅝". *Museum of Art, Rhode Island School of Design, Providence. Gift of Miss Elizabeth Hazard.*

Fig. 4-7. Helen Farnsworth Mears, DAWN AND LABOR (1909), bronze, 28" × 18" × 15" (photo shows work in plaster before casting). *The Paine Art Center and Arboretum, Oshkosh, Wis. On extended loan from Oshkosh Twentieth Century Club.*

Fig. 4-8. Helen Farnsworth Mears, THE FOUNTAIN OF LIFE (1899–1904) destroyed, plaster, 14' × 13½'. *Photo: Iconographic Collection, State Historical Society of Wisconsin.*

Fig. 4-9. Helen Farnsworth Mears, END OF THE DAY (1914), bronze, 12" × 7" × 11". *The Paine Art Center and Arboretum, Oshkosh, Wis.*

Fig. 4-10. Evelyn Longman, CHAPEL DOORS, UNITED STATES NAVAL ACADEMY, AN-NAPOLIS (1906–9), bronze, 276" × 120". *Courtesy United States Naval Academy Archives.*

Fig. 4-11. Evelyn Longman, THE GENIUS OF ELECTRICITY (1916), gold leaf over bronze, height 24', weight 8 tons. *Courtesy American Telephone and Telegraph Company.*

Fig. 4-12. Elisabet Ney, LADY MACBETH (1905), marble, 73¾" × 25¾" × 29½". *National Museum of American Art (formerly National Collection of Fine Arts), Smithsonian Institution; lent by Mrs. Joseph H. Dibrell.*

Fig. 4-13. Adelaide Johnson, SUSAN B. ANTHONY (1892), marble, height 24". *The Metropolitan Museum of Art. Gift of Mrs. Murray Whiting Ferris, 1906.*

Fig. 4-14. Elizabeth Gardner (Bouguereau), HE CARETH (n.d.), oil on canvas, 47⅜" × 31¾". *Philbrook Art Center, Tusla, Okla. Gift of Laura A. Clubb, 1947.*

Fig. 4-15. Anna Lea Merritt, WAR (1883), 39¾" × 55". *Bury Museum and Art Gallery, Bury, England.*

Fig. 4-34. Anna Elizabeth Klumpke, IN THE WASH HOUSE (1888), oil on canvas, 79″ × 67″. *Courtesy of the Pennsylvania Academy of the Fine Arts. Gift of the artist.*

Fig. 4-35. Anna Elizabeth Klumpke, ROSA BONHEUR (1898), oil on canvas, 46″ × 38½″. *The Metropolitan Museum of Art. Gift of the artist in memory of Rosa Bonheur, 1922.*

Fig. 4-36. Grace Carpenter Hudson, KA-MO-KI-YU (FOUND IN THE BRUSH) (1904), oil on canvas, 23″ × 34″. *Los Angeles Athletic Club Collection.*

Fig. 4-37. Photograph, INTERIOR VIEW OF WOMAN'S BUILDING, looking at Cassatt mural in background, World's Columbian Exposition, Chicago (1893). *Chicago Historical Society.*

Fig. 4-38. Lydia Emmet, Decorative panel, ART, SCIENCE, AND LITERATURE. Halftone from *Art and Handicraft in the Woman's Building* at the World's Columbian Exposition, Chicago (1893).

Fig. 4-39. Mary Fairchild MacMonnies, PRIMITIVE WOMAN. Photo from *Art and Handicraft in the Woman's Building* at the World's Columbian Exposition, Chicago (1893).

Fig. 4-40. Dora Wheeler Keith, CEILING OF LIBRARY. Photo from *Art and Handicraft in the Woman's Building* at the World's Columbian Exposition, Chicago (1893). p.136, Courtesy Chicago Historical Society.

Chapter 5

Fig. 5-1. Violet Oakley, PENN'S VISION (1902–6) mural in the Governor's Reception Room, State Capitol, Harrisburg. *Corutesy of The Pennsylvania Historical and Museum Commission, Harrisburg.*

Fig. 5-2. Lillian M. Genth, DEPTHS OF THE WOODS (n.d.), oil on canvas, 88.7 × 73.7 cm. *National Museum of American Art (formerly National Collection of Fine Arts). Smithsonian Institution. Gift of William T. Evans.*

Fig. 5-3. Lilian Westcott Hale, L'EDITION DE LUXE (1910), oil on canvas, 23″ × 15″. *Courtesy of Museum of Fine Arts, Boston. Gift of Miss Mary C. Wheelwright.*

Fig. 5-4. Florence Scovel Shinn, ON THE FENCES AND WALLS THROUGHOUT ALL OHIO, ink on paper, 14½″ × 11¾″, from "Mr. Perkins of Portland" by Ellis Parker Butler, *Century* (February 1900). *Free Library of Philadelphia.*

Fig. 5-5. Marjorie Organ, STUDIO EVENING (ROBERT HENRI, JOHN BUTLER YEATS, JOHN SLOAN) (c. 1910). *Collection Nancy and Ira Glackens. Copyphoto by Christman; Shepherdstown, W. Va.*

Fig. 5-6. Ethel Myers, THE MATRON (1912), bronze, height 8″. *Courtesy of Kraushaar Galleries, N.Y.C. Photo: Geoffrey Clements.*

Fig. 5-7. Abastenia St. Leger Eberle, ROLLER SKATING (1906), bronze, 13″ × 11¾″ × 6½″. *Collection of Whitney Museum of American Art, New York. Photo: Geoffrey Clements.*

Fig. 5-8. Cover of *The Survey* (May 3, 1913), illustrating THE WHITE SLAVE by Abastenia St. Leger Eberle (probably plaster, presently unlocated). *Courtesy of General Research Division, The New York Public Library. Astor, Lenox and Tilden Foundations.*

Fig. 5-9. Marguerite Zorach, SAILING WIND AND SEA (1919), oil on canvas, 25″ × 30″. *Private Collection, courtesy of Kraushaar Galleries. Photo: Geoffrey Clements.*

Fig. 5-10. Katherine S. Dreier, ABSTRACT PORTRAIT OF MARCEL DUCHAMP (1918), oil on canvas, 18″ × 32″. *Collection, The Museum of Modern Art, New York. Abby Aldrich Rockefeller Fund.*

Fig. 5-11. Jane Peterson, FLAG DAY (n.d.), gouache and charcoal on paper, 23⅛″ × 17⅜″. *Private Collection. Photo: courtesy of Hirschl & Adler Galleries.*

Fig. 5-12. Pamela Colman Smith, BEETHOVEN SONATA (1907), watercolor, 15⅜″ × 11″. *Alfred Stieglitz Collection. Collection of American Literature, Beinecke Rare Book and Manuscript Library, Yale University.*

Fig. 5-13. Georgia O'Keeffe, NEW YORK NIGHT (1929), oil on canvas, 40″ × 19″. *Nebraska Art Association: in memory of Thomas C. Woods.*

Fig. 5-14. Elsie Driggs, PITTSBURGH (1927), oil on canvas, 34¼″ × 40″. *Collection of Whitney Museum of American Art, New York. Photo: Geoffrey Clements.*

Fig. 5-15. Gertrude Vanderbilt Whitney, TITANIC MEMORIAL (1931), granite, height 15′, Washington, D.C. *United States Department of the Interior, National Park Service Photograph.*

Fig. 5-16. Gertrude Vanderbilt Whitney, HEAD FOR TITANIC MEMORIAL (1924), marble, 12¾″ × 7″ × 9″. *Collection of Whitney Museum of American Art, New York. Photo: Geoffrey Clements.*

Fig. 5-17. Peggy Bacon, A FEW IDEAS (1927), drypoint etching, 8″ × 9″. *Guild Hall Museum, East Hampton, N.Y. Gift of Alexander Brook, 1969.*

Fig. 5-18. Florine Stettheimer, THE CATHEDRALS OF FIFTH AVENUE (1931), oil on canvas, 60″ × 50″. *The Metropolitan Museum of Art, Gift of Ettie Stettheimer, 1953.*

Fig. 5-19. Romaine Brooks, SELF PORTRAIT (1923), oil on canvas, 117.5 × 68.3 cm. *National Museum of American Art (formerly National Collection of Fine Arts). Smithsonian Institution; Gift of Romaine Brooks.*

Fig. 5-20. Anna Hyatt Huntington, EL CID CAMPEADOR (1927), bronze, 176¾″ × 74″ × 139⅜″. *Permission of The Fine Arts Museums, San Francisco; Gift of Herbert Fleishhacker.*

Fig. 5-21. Malvina Hoffman, SENEGALESE SOLDIER (1928), black stone, height 20¹/₁₆″. *The Brooklyn Museum, Dick S. Ramsay Fund.*

Fig. 5-22. Meta Vaux Warrick Fuller, THE TALKING SKULL (1939), bronze, 42″ × 30″ × 18″. *Museum of Afro-American History, Boston. Photo: Courtesy of National Archives, Harmon Foundation Collection.* (Photo shows this work in plaster before casting in bronze).

Fig. 5-23. Sally James Farnham, SIMON BOLIVAR (1921), bronze, Columbus Circle, New York. *Courtesy of the Department of Parks, The City of New York.*

Fig. 5-24. Alice Morgan Wright, study for MEDEA (1920), plaster, 11½″ × 4½″. Collection: *Albany Institute of History and Art, gift of Mrs. Clark Flemming. Photo: Peter A. Juley and Son Collection, Smithsonian Institution, Washington, D.C.*

Fig. 5-25. Edith Woodman Burroughs, ON THE THRESHHOLD (1912), limestone, height 62½″. *The Metropolitan Museum of Art. Purchase: Amelia B. Lazarus Fund, 1919.*

Fig. 5-26. Eugenie Shonnard, PUEBLO INDIAN WOMAN (1926), hardwood (satina), 17¼″ × 6½″ × 5⅛″. *Colorado Springs Fine Arts Center Collection.*

Fig. 5-27. Eugenie Gershoy, FIGURE (1930), alabaster, 17¼″ × 7″ × 9½″. *Collection of Whitney Museum of American Art, New York.*

Chapter 6

Fig. 6-1. Ellen Emmet Rand, PORTRAIT OF PRESIDENT FRANKLIN DELANO ROOSEVELT (1934). *Collection of the Franklin D. Roosevelt Library, Hyde Park, N.Y.*

Fig. 6-2. Marion Greenwood, DETAIL OF MURAL ON AMERICAN MUSIC (Memphis Jazz and Cottonfield Songs and Dances Section) (1954–55), oil on canvas, 6′ × 35′. University Center, University of Tennessee, Knoxville. Photo courtesy of Robert Plate, Woodstock, N.Y.

Fig. 6-3. Lucienne Bloch, panel, CHILDHOOD, from the fresco mural, CYCLE OF A WOMAN'S LIFE (1935), WPA/FAP, House of Detention for Women, New York (demolished). *Photo: National Archives.*

Fig. 6-4. Elizabeth Olds, SCRAP IRON (c. 1935–39), lithograph, 30.1 × 42.1 cm. *National Museum of American Art (formerly National Collection of Fine Arts), Smithsonian Institution. Gift of Mrs. Audrey McMahon.*

Fig. 6-5. Mabel Dwight, QUEER FISH (1936), lithograph, 10⅝″ × 13″. *Philadelphia Museum of Art. Purchased: The Harrison Fund.*

Fig. 6-6. Lois Mailou Jones, DANS UN CAFÉ A PARIS: LEIGH WHIPPER (1939), oil on canvas, 36″ × 28¼″. *Collection of the artist.*

Fig. 6-7. Isabel Bishop, ON THE STREET (c. 1932), oil on canvas, 14½″ × 26″. *Collection of Mr. & Mrs. Paul Wachs, courtesy of Midtown Galleries. Photo: Otto Nelson, N.Y.*

Fig. 6-8. Isabel Bishop, TIDYING UP (c. 1938), oil on masonite, 15⅛″ × 11⅝″. *Indianapolis Museum of Art, Delavan Smith Fund.*

Fig. 6-9. Doris Lee, THANKSGIVING (1935), oil on canvas, 28⅛″ × 40″. *Courtesy of the Art Institute of Chicago. Gift of Mr. and Mrs. Frank G. Logan.*

Fig. 6-10. Jenne Magafan, WESTERN TOWN (1940), Post Office mural, Helper, Utah. *Treasury Section of Fine Arts, Public Building Administration. Photo: Courtesy of Ethel Magafan.*

Fig. 6-11. Marjorie Phillips, NIGHT BASEBALL (1951), oil on canvas, 24″ × 36″. *The Phillips Collection, Washington, D.C.*

Fig. 6-12. Constance C. Richardson, FREIGHT YARDS, DULUTH (1954), 16″ × 30″. *Collection of Mr. and Mrs. Lawrence A. Fleishman.*

Fig. 6-13. Hilla von Rebay, ANIMATO (1941–42), oil on canvas, 37″ × 50¼″. *Collection of The Solomon R. Guggenheim Museum Collection, New York. Photo: Robert E. Mates.*

Fig. 6-14. Gertrude Greene, CONSTRUCTION IN BLUE (1937), mixed media, painted wood. *Collection of Barbara Millhouse. Photo: John A. Ferrari, N.Y.*

Fig. 7-4. Betty Parsons, SENTINEL (1976), painted wood sculpture, 63¼″ × 44¼″. *Courtesy of Kornblee Gallery. Photo: Gwyn Metz.*

Fig. 7-5. Grace Hartigan, CITY LIFE (1956), oil on canvas, 81″ × 98½″. *National Trust for Historic Preservation. Bequest of Nelson A. Rockefeller.*

Fig. 7-6. Joan Mitchell, LADYBUG (1957), oil on canvas, 6′5⅞″ × 9′. *Collection, The Museum of Modern Art, N.Y. Photo: Rudolph Burckhardt.*

Fig. 7-7. Elaine de Kooning, PORTRAIT OF JOHN F. KENNEDY (1962–63), oil on canvas, 61″ × 49″. *Courtesy of John F. Kennedy Library, Dorchester, Mass.*

Fig. 7-8. Jane Wilson, INDIA SILK (1970), oil on canvas, 60″ × 50″. *Collection of Mrs. Alice Esty. Photo: Geoffrey Clements.*

Fig. 7-9. Kay Sage, ON THE FIRST OF MARCH CROWS BEGIN TO SEARCH (1947), oil on canvas, 18″ × 24″. *Wellesley College Museum. Photo: Herbert P. Vose, Wellesley Hills, Mass.*

Fig. 7-10. Kay Sage, THE INSTANT (1949), oil on canvas, 38″ × 54″. *The Mattatuck Museum, Waterbury, Conn.*

Fig. 7-11. Dorothea Tanning, GUARDIAN ANGELS (1946), oil on canvas, 48″ × 36″. *New Orleans Museum of Art, New Orleans, La.*

Fig. 7-12. Charmion von Wiegand, DARK JOURNEY: COLLAGE #207 (1958), 19¼″ × 15½″. *Collection of the artist. Courtesy of Marilyn Pearl Gallery, N.Y.C. Photographer: O. E. Nelson, N.Y.*

Fig. 7-13. Perle Fine, TAURUS (c. 1946), oil on canvas, 28″ × 24″. *Munson-Williams-Proctor Institute, Utica, N.Y. Edward W. Root Bequest.*

Fig. 7-14. Anne Ryan, UNTITLED (#461) (1952), paper and fabric on paper, 6¹³/₁₆″ × 5⅛″, *National Museum of American Art (formerly National Collection of Fine Arts), Smithsonian Institution. Gift of Elizabeth McFadden.*

Fig. 7-15. Honore Sharrer, TRIBUTE TO THE AMERICAN WORKING PEOPLE (1951), oil on composition board, 33¼″ × 27″ (center panel), 11⅜″ × 16⅜″ (smaller panels). *The Sara Roby Foundation Collection.*

Fig. 7-16. Honore Sharrer, center panel, TRIBUTE TO THE AMERICAN WORKING PEOPLE (1951), oil on composition board, 33¼″ × 27″. *The Sara Roby Foundation Collection.*

Fig. 7-17. Louise Nevelson, SKY CATHEDRAL (1958), assemblage (wood construction painted black), 11′3½″ × 10′¼″ × 18″. *Collection of The Museum of Modern Art, N.Y.C. Gift of Mr. and Mrs. Ben Mildwoff.*

Fig. 7-18. Mary Callery, AMITY (1947), bronze, 5′ × 16′. *Courtesy of Washburn Gallery, Inc., N.Y.C.*

Fig. 7-19. Louise Bourgeois, CUMUL I (1968), white carrara marble, 3′6″ × 3′6″ × 3′. *Beaubourg Museum: Musee d'Art Moderne, Paris. Photo: Peter Moore, N.Y.*

Fig. 7-20. Claire Falkenstein, ''U'' AS A SET (1965), piece for a reflecting pool, copper tubing, 20′ × 18′ × 18′. Designed for the First International Sculpture Symposium, California State University, Long Beach, 1965. *Photo: courtesy of the artist. Photographer: Audio-Visual Center, California State University, Long Beach.*

Fig. 7-21. Sue Fuller, STRING COMPOSITION #901 (1970), © Sue Fuller, patent #3,451,879. Plastic embedment, 30″ × 52″. *Photo: Eileen Darby Lester.*

Fig. 8-13. Ruth Vollmer, THE SHELL II (1973), blue ink printing on molded acrylic, height 15", diameter 12". *Courtesy Betty Parsons Gallery. Photo: H. Landshoff, N.Y.C.*

Fig. 8-14. Beverly Pepper, EXCALIBUR (1976), painted steel, 35' × 45' × 45'. *San Diego Federal Building, San Diego, Calif.*

Fig. 8-15. Beverly Pepper, AMPHISCULPTURE (1974–76), concrete and ground covering, 270' diameter × 14' deep × 8' high. *A.T.&.T. Long Lines Building, Bedminster, N.J. Photo: © Gianfranco Gorgoni, N.Y.*

Fig. 8-16. Sylvia Stone, GREEN FALL (1969–1970), plexiglass and stainless steel, 67½" × 201½". *Collection of Whitney Museum of American Art. Gift of the Howard and Jean Lipman Foundation, Inc. Photo: Geofrey Clements.*

Fig. 8-17. Lin Emery, AQUAMOBILE (1977), bronze, 16' × 20'. *Helmerich Park, Tulsa, Okla. Photo: Hopkins Photography Company, Tulsa.*

Fig. 8-18. Eva Hesse, UNTITLED: SEVEN POLES (1970), fiberglass over polyethylene over aluminum wire, 7 units, each 7'2". *Collection of Mr. and Mrs. Victor W. Ganz, New York. Photograph courtesy of Metro Pictures, N.Y.C.*

Fig. 8-19. Lenore Tawney working on DOVE (1974), photo for catalogue *Lenore Tawney: An Exhibition of Weaving, Collage, Assemblage,* Art Gallery, California State University, Fullerton, November 14–December 11, 1975. Photo: Clayton J. Price, N.Y.

Chapter 9

Fig. 9-1. Mary Beth Edelson, CALLING SERIES, GODDESSHEAD (1975), photo/collage/drawing, 6" × 6". *Courtesy of the artist.*

Fig. 9-2. THE SISTER CHAPEL (1978). © 1978 by Elise Greenstein, initiator of the project and creator of the ceiling painting. Photo by Maurice Blum of temporary installation at State University of New York, Stonybrook, November 1978. Visible from left to right: ARTEMISIA GENTILESCHI by May Stevens, JOAN OF ARC by Elsa Goldsmith, BELLA ABZUG by Alice Neel, BETTY FRIEDAN by June Blum, DURGA: HINDU GODDESS by Diana Kurz, FRIDA KAHLO by Shirley Gorelick.

Fig. 9-3. Alice Neel, DAVID BOURDON AND GREGORY BATTCOCK (1970), oil on canvas, 59¾" × 56". *Collection of the artist. Photo: courtesy of Graham Gallery, N.Y. Photo: Eric Pollitzer.*

Fig. 9-4. Audrey Flack, ROYAL FLUSH (1973), oil over acrylic on canvas, 70" × 96". *Private collection, Paris. Courtesy Louis K. Meisel Gallery, N.Y. Photo: Bruce C. Jones.*

Fig. 9-5. Idelle Weber, HEINEKEN (1976), oil on linen, 47½" × 72½". *Aranson collection. Photo: Bruce C. Jones.*

Fig. 9-6. Joan Semmel, PINK FINGERTIPS (1977), oil on canvas, 49" × 56". *Collection of the artist. Photo courtesy of Lerner-Heller Gallery, New York. Photographer: Bevan Davies.*

Fig. 9-7. Janet Fish, RAIN AND DUSK (1978), oil on canvas, 58" × 85". *Private collection. Photo courtesy of Robert Miller Gallery, New York. Photo: eeva-inkeri.*

Fig. 9-8. Catherine Murphy, VIEW OF WORLD TRADE CENTER FROM ROSE GARDEN (1976), oil on canvas, 37" × 29". *Hirshhorn Museum and Sculpture Garden, Smithsonian Institution.*

Fig. 9-26. Michelle Stuart, STONE ALIGNMENTS/SOLSTICE CAIRNS (1979), boulders from Mount Hood on the Hood River, brought to the site, 1000' × 800' (overall area), cairns: 5' high, circle: 100' in circumference. Site: Columbia River Gorge, Rowena Dell Plateau, Oregon. *Sponsored by the Portland Center for the Visual Arts.*

Fig. 9-27. Judy Baca and assistants, "ILLUSION OF PROSPERITY AND CYCLE OF DEPRESSION," from THE GREAT WALL OF LOS ANGELES, © SPARC. 1980 section of a mile-long mural. *San Fernando Valley, Calif.*

Fig. 9-28. Consuelo Mendez Castillo, Graciela Carrillo, Irene Perez, and Patricia Rodriguez, PAN-AMERICA (MODEL MISSION MURAL) (1974), San Francisco, acrylic, 20' × 75'. *Mission and 25th Street, San Francisco. Photo: Eva Cockcroft.*

Fig. 9-29. Eleanor Antin as The Little Nurse, "With a Little Help From Her Friends," performance with props. *Photo: Philip Steinmetz.*

Fig. 9-30. Athena Tacha, © RIPPLES (1978–79), white concrete, 3' × 30' × 80'. *Federal Building, Norfolk, Va.*

Fig. 9-31. Marjorie Strider, BROOMS (1972), mixed media, 5' × 2' × 12'. *Collection of the artist. Photo: Stu Chernoff.*

List of Color Plates

Plate 1. NAVAJO EYE-DAZZLER BLANKET (c. 1880–90), 84¼" × 59¼". *Collection of Anthony Berlant, Santa Monica, Calif.*

Plate 2. BOWLS BY NAMPEYO AND HER DAUGHTER FANNIE NAMPEYO. *Collection of Mr. and Mrs. Dennis Lyon. Photo: Jerry D. Jacka, Phoenix.*

Plate 3. Pablita Velarde, OLD FATHER THE STORY TELLER (1960). *Courtesy of the artist. Photo: Cradoc Bagshaw, Albuquerque.*

Plate 4. Helen Hardin, WINTER AWAKENING OF THE O-KHOO-WAH (1972), acrylic on masonite, 15" × 30". *Courtesy of James T. Bialac. Photo: Cradoc Bagshaw, Albuquerque.*

Plate 5. Anonymous, BABY BLOCKS (c. 1860), pieced quilt top, 102" × 88", Springfield, Mass. area. *Collection of David M. S. Pettigrew. Reproduced from A Calendar of American Folk Art 1976 by permission of the publishers, E. P. Dutton, Inc., New York.*

Plate 6. Mary Foot, BED RUG (1778), wool, 83½" × 77½". *Courtesy of The Henry Francis du Pont Winterthur Museum.*

Plate 7. Henrietta Johnston, COLONEL SAMUEL PRIOLEAU (1715). pastel on paper, 12" × 9" *Courtesy of Museum of Early Southern Decorative Arts, Winston-Salem, N.C.*

Plate 8. Sarah Miriam Peale, PORTRAIT OF HENRY A. WISE (1842), oil on canvas, 39½" × 24½". *Virginia Museum of Fine Arts. Gift of The Duchess de Richelieu, 1963.*

Plate 9. Fanny Palmer, THE ROCKY MOUNTAINS (1866), lithograph for Currier & Ives. *From the Esmark Collection of Currier & Ives.*

Plate 10. Lilly Martin Spencer, FI! FO! FUM! (1858), oil on canvas, 35⅞" × 28⅝". *Courtesy of Mrs. Joseph J. Betz.*

Plate 11. Sarah Paxton Ball Dodson, THE BACIDAE (1883), oil on canvas, 79½" × 61¹¹/₁₆". *Courtesy of Indianapolis Museum of Art. Gift of Richard B. Dodson.*

Plate 12. Elizabeth Boott Duveneck, HEAD OF A NEGRO BOY (JERRY) (1883), oil on canvas, 23¾" × 19¾". *Collection of Mr. Melvin Holmes, San Francisco.*

Plate 13. Elizabeth Nourse, THE HUMBLE MENAGE (before 1911), oil on canvas, 39½" × 39½". *Courtesy of Grand Rapids Art Museum. Gift of Mrs. Cyrus E. Perkins. Photo: W. D. Pieri III.*

Plate 14. Mary Cassatt, BABY REACHING FOR AN APPLE (1893), oil on canvas, 39½" × 25¾". *Courtesy of Virginia Museum of Fine Arts. Gift of an anonymous donor, 1975.*

Plate 15. Susan Macdowell Eakins, TWO SISTERS (1879), oil on canvas, 57¼" × 45¾". *Collection of Peggy Macdowell Thomas, Roanoke. Photo: Wayne Newcomb, Roanoke.*

Plate 16. Lilla Cabot Perry, BRIDGE-WILLOW-EARLY SPRING (c. 1905), pastel, 25¼" × 31¼". *Private Collection. Courtesy of Hirschl & Adler Galleries, New York.*

Plate 17. Cecilia Beaux, MAN WITH THE CAT (HENRY STURGIS DRINKER) (1898), oil on canvas, 48" × 34⅝". *National Museum of American Art (formerly National Collection of Fine Arts), Smithsonian Institution. Bequest of Henry Ward Ranger through the National Academy of Design.*

Plate 18. Marguerite Zorach, MAN AMONG THE REDWOODS (1912), oil on canvas, 25¾" × 20¼". *Collection of Roberta K. and James V. Tarbell, Hockessin, Delaware.*

Plate 19. Violet Oakley, ANNE ASKEW REFUSING TO RECANT (1902–6), mural, 6' × 11' 10". *Governor's Reception Room, State Capitol Building, Harrisburg, Pennsylvania. Reproduced in The Holy Experiment (plate size 7" × 9"). Collection of the Violet Oakley Memorial Foundation, Philadelphia, Pa. Photo: Victor Fried.*

Plate 20. Georgia O'Keeffe, THE GREY HILLS (1942), oil on canvas, 20" × 30". *Indianapolis Museum of Art. Gift of Mr. and Mrs. James W. Fesler.*

Plate 21. Florine Stettheimer, SPRING SALE AT BENDEL'S (1921), oil on canvas, 50″ × 40″. *Philadelphia Museum of Art. Gift of Miss Ettie Stettheimer.*

Plate 22. Romaine Brooks, UNA, LADY TROUBRIDGE (1924), oil on canvas, 50⅛″ × 30½″. *National Museum of American Art (formerly National Collection of Fine Arts), Smithsonian Institution. Gift of the artist.*

Plate 23. Maxine Albro, detail of mural CALIFORNIA AGRICULTURE (1934), fresco. Public Works of Art Project, Coit Tower, San Francisco. *Photograph ©1976 de Saisset Art Gallery, a division of the University of Santa Clara.*

Plate 24. Marion Greenwood, photo of study for PLANNED COMMUNITY LIFE (BLUEPRINT FOR LIVING) (c. 1940), fresco in Red Hook Houses, Community Center Lobby, Brooklyn (now destroyed except for section over doors to gym), WPA/FAP. *Photo courtesy of Vassar College Art Gallery, Poughkeepsie, N.Y.*

Plate 25. Isabel Bishop, VIRGIL AND DANTE IN UNION SQUARE (1932), oil on canvas, 27″ × 52″. *Delaware Art Museum, Wilmington.*

Plate 26. Isabel Bishop, MEN AND GIRLS WALKING (1969), oil and tempera on gesso panel, 29″ × 40″. *Mt. Holyoke College Art Museum. Anonymous gift.*

Plate 27. Irene Rice Pereira, BRIGHT DEPTHS (1950), oil on canvas, 30″ × 34″. *Hirshhorn Museum and Sculpture Garden, Smithsonian Institution.*

Plate 28. Gertrude Greene, COMPOSITION (1937), wood construction, 20″ × 40″. *Collection of The Berkshire Museum, Pittsfield, Mass. Gift of A. E. Gallatin.*

Plate 29. Kay Sage, SMALL PORTRAIT (1950), oil on canvas, 14½″ × 11½″. *Vassar College Art Gallery, Poughkeepsie, N.Y.*

Plate 30. Dorothea Tanning, GUARDIAN ANGELS (1946), oil on canvas, 48″ × 36″. *New Orleans Museum of Art, New Orleans, La.*

Plate 31. Lee Krasner, ABSTRACT NO. 2 (1946–48), oil on canvas, 20½″ × 23½″. *Courtesy of Robert Miller Gallery, New York.*

Plate 32. Joan Mitchell, CASINO (1956), oil on canvas, 61¾″ × 68″. *Courtesy of Xavier Fourcade, Inc., New York.*

Plate 33. Grace Hartigan, CITY LIFE (1956), oil on canvas, 6′9″ × 8′2½″. *National Trust for Historic Preservation. Bequest of Nelson A. Rockefeller. Photo: Lee Boltin.*

Plate 34. Louise Nevelson, installation, Whitney Museum of American Art, 1967. (Left): AN AMERICAN TRIBUTE TO THE BRITISH PEOPLE (1960–65), painted wood, 10′2″ × 14′3″. *The Tate Gallery, London.* (Right): SUNGARDEN NO. 1. (1964), painted wood, height 72″. *Private collection, New York. Photo courtesy The Pace Gallery, New York.*

Plate 35. Jane Wilson, INDIA SILK (1970), oil on canvas, 60″ × 50″. *Collection of Mrs. Alice Esty.*

Plate 36. Nell Blaine, GLOUCESTER NIGHT STILL LIFE (1975), oil on canvas, 20″ × 28″. *Collection of Mr. and Mrs. Bruce C. Gottwald.*

Plate 37. Jane Freilicher, IN BROAD DAYLIGHT (1979), oil on canvas, 70″ × 80″. *McNay Art Institute, San Antonio. Gift of the Semmes Foundation.*

Plate 38. Alma Thomas, WIND AND CREPE MYRTLE CONCERTO (1973), synthetic polymer on canvas, 35″ × 52″. *National Museum of American Art (formerly National Collection of Fine Arts), Smithsonian Institution. Gift of Vincent Melzac.*

Plate 39. Helen Lundeberg, AEGEAN LIGHT (1973), acrylic on canvas, 60″ × 60″. *Courtesy of Tobey C. Moss Gallery, Los Angeles.*

Plate 40. Helen Frankenthaler, TANGERINE (1964), acrylic on canvas, 76″ × 66″. *Private collection.*

Plate 41. Joan Brown, DANCERS IN THE CITY #3 (1973), enamel on canvas, 8′ × 10′. *Collection of Dorothy Goldeen, San Francisco.*

Plate 42. Joyce Treiman, DEAR FRIENDS (1972), oil on canvas, 70″ × 70″. *Private Collection. Photo: Frank Thomas, Los Angeles.*

Plate 43. Alice Neel, CARMEN AND BABY (1972), oil on canvas, 40″ × 30″. *Courtesy of the artist. Photo: Eric Pollitzer, New York.*

Plate 44. Janet Fish, WINE AND CHEESE GLASSES (1975). *Collection of Indiana University Art Museum. Photo: Courtesy Robert Miller Gallery, New York.*

Plate 45. Catherine Murphy, VIEW OF WORLD TRADE CENTER FROM ROSE GARDEN (1976), oil on canvas, 37″ × 29″. *Hirshhorn Museum and Sculpture Garden, Smithsonian Institution.*

Plate 46. Audrey Flack, CHANEL (1974), acrylic on canvas, 60″ × 84″. *Collection of Mr. and Mrs. Morton G. Neumann, Chicago. Photo: Bruce C. Jones. Courtesy Louis K. Meisel Gallery, New York.*

Plate 47. Idelle Weber, CHA-CHA: BROOKLYN TERMINAL MARKET (1979), oil on canvas, 36¼″ × 73″. *Private collection. Courtesy of O. K. Harris Gallery, New York.*

Plate 48. Miriam Schapiro, COEUR DES FLEURS (1980), acrylic and collage on canvas, 69″ × 50″. *Collection of Norma and William Roth.*

Plate 49. May Stevens, SOHO WOMEN ARTISTS (1978), acrylic on canvas, 78″ × 142″. *Collection of the artist. Courtesy of Lerner-Heller Gallery, New York.*

Index

Index

Index

Index

About the Author

Charlotte Streifer Rubinstein, an artist herself, is a teacher of art and art history and an early innovator in the development of a course on the history of women artists. She received the Master of Fine Arts in printmaking and design from the Otis-Parsons Art Institute and the Master of Arts in art and education from Teachers College of Columbia University. In 1973, with the support of a grant from the National Endowment for the Arts, she organized a major all-media show of contemporary women artists entitled *Women U.S.A.* She lives in Laguna Beach, California, with her husband, and has three grown children.

Photo by Betsy Groban